ADVENTUS DOMINI

SUPPLEMENTS TO

VIGILIAE CHRISTIANAE

Formerly Philosophia Patrum

TEXTS AND STUDIES OF EARLY CHRISTIAN LIFE
AND LANGUAGE

EDITORS

A. F. J. KLIJN — J. DEN BOEFT — G. QUISPEL
J. H. WASZINK — J. C. M. VAN WINDEN

VOLUME V

ADVENTUS DOMINI

ESCHATOLOGICAL THOUGHT
IN 4TH-CENTURY APSES AND CATECHESES

BY

GEIR HELLEMO

E.J. BRILL

LEIDEN · NEW YORK · KØBENHAVN · KÖLN
1989

Library of Congress Cataloging-in-Publication Data

Hellemo, Geir, 1950-
 [Kristus på keisertronen. English]
 Adventus Domini: eschatological thought in 4th-century apses and
catecheses/by Geir Hellemo.
 p. cm.—(Supplements to Vigiliae Christianae, ISSN
0920-623X; v. 5)
 Translation of: Kristus på keisertronen.
 Translated from the Norwegian.
 Bibliography: p.
 Includes index.
 ISBN 90-04-08836-9
 1. Theology—Early church, ca. 30-600. 2. Eschatology—History of
doctrines—Early church, ca. 30-600. 3. Christian art and
symbolism—To 500. 4. Catechetics—History—Early church, ca.
30-600. 5. Liturgics—History. I. Title. II. Series.
BT25.H4513 1988
246'.9593'09015—dc19 88-22291
 CIP

Translated by Elinor Ruth Waaler

ISSN 0920-623X
ISBN 90 04 08836 9

PRINTED IN THE NETHERLANDS BY E. J. BRILL

To my family

CONTENTS

LIST OF ILLUSTRATIONS

ABBREVIATIONS

Abbreviations of periodicals, reference works and series in accordance with Theologische Realenzyklopädie's Abkürzungsverzeichnis.
Abbreviations for photo library conform with Deichmann, Repertorium's abbreviations p. IX-XI.

ArtB.	Art bulletin
Aug.	Augustinianum. Periodicum quadrimestre collegii internationale Augustiniani
Byz.	Byzantinische Zeitschrift
CAr.	Cahiers archéologiques
CChrSL.	Corpus Christianorum. Series Latina
ChH.	Church history
CSEL	Corpus scriptorum ecclesiasticorum Latinorum
DACL	Dictionnaire d'archéologie chrétienne et de liturgie
DOP	Dumbarton Oaks Papers
GCS	Die griechischen christlichen Schriftsteller der ersten drei Jahrhunderte
Hey J	Heythrop journal. A quarterly review of philosophy and theology
HThR	Harvard theological review
Inst.Rom	Deutsches Archäologisches Institut Rom
JAC	Jahrbuch für Antike und Christentum
JLH	Jahrbuch für Liturgik und Hymnologie
JLW	Jahrbuch für Liturgiewissenschaft
JR	Journal of religion
JThS	Journal of theological studies
LCI	Lexicon der christlichen Ikonographie
LCL	Loeb classical library
LThK	Lexicon für Theologie und Kirche
MDAI.R	Mitteilungen des deutschen archäologischen Instituts. Römische Abteilung
Mün.	Das Münster. Zeitschrift für christliche Kunst und Kunstwissenschaft
Muséon	Muséon. Revue d'études orientales
OrChrP	Orientalia Christiana periodica
PCAS	Pont. Commissione di Archeologia Sacra
PG	Patrologiae cursus completus. Accurante Jacques-Paul Migne. Series Graeca
PL	Patrologiae cursus completus. Accurante Jacques-Paul Migne. Series Latina
RAC	Reallexicon für Antike und Christentum
RevSR	Revue des sciences religieuses
RGG²	Religion in Geschichte und Gegenwart, Zweite Auflage
RHE	Revue d'histoire ecclésiastique
RivAC	Rivista di archeologia christiana
RSR	Recherches de science religieuse
RQ	Römische Quartalschrift für christliche Altertumskunde
SC	Sources chrétiennes
StLi	Studia liturgica
Theoph.	Theophaneia. Beiträge zur Religions- und Kirchengeschichte des Altertums
ThGl	Theologie und Glaube. Zeitschrift für den katholischen Klerus
TRE	Theologische Realenzyklopädie
TS	Theological Studies

TU	Texte und Untersuchungen zur Geschichte der altchristlichen Literatur
VetChr	Vetera Christianorum
VigChr	Vigiliae Christianae. Review of early Christian life and language
ZKG	Zeitschrift für Kirchengeschichte
ZKTh	Zeitschrift für katholische Theologie
ZNW	Zeitschrift für die neutestamentliche Wissenschaft und die Kunde der älteren Kirche

PREFACE

My initial encounter with early Christian art and architecture took place in Rome while studying there in 1972. Under the auspices of Professor Einar Molland of the Faculty of Theology, University of Oslo I was introduced not only to this subject but to the early church and its theology. I realized rather quickly that early Christian art presented a theological challenge and for this I shall always be greatly indebted to Professor Molland. In the years to follow it was Professor Hjalmar Torp of the Institute of Art History and Classical Archeology at the University of Oslo who became my principal advisor, not only regarding the wealth of monuments in Italy but also as to their interpretation. Professor Torp taught me how to appreciate art and to love Italy. Professor Jacob Jervell of the Faculty of Theology, University of Oslo has been of special significance. I am extremely grateful to him for exegetical training and not least of all for his invaluable inspiration. Throughout the years he has given me unfailing support.

This study could not have been undertaken without my engagement as Senior Research Assistant at the Institute of Church History, University of Oslo nor without the help of a fellowship (universitetsstipend) from the University of Oslo. I am further indebted to the Norwegian Institute of Art History and Classical Archeology in Rome which, on a number of occasions has extended both courtesy and great helpfulness. This applies as well to the Gregoriana University Library and the Vatican Library in Rome and to the University of Oslo Library.

This doctoral thesis in Theology was presented at the University of Oslo, March, 1985.

I acknowledge with gratitude the economic support given by the Norwegian Research Council for Science and the Humanities which allowed many opportunities for research in Italy, the typing of this book in Norwegian, the translation and printing. In addition, I am also grateful to the Fridtjof Nansen and Affiliated Funds for the Advancement of Science and the Humanities for the financial support which made this translation possible.

I wish to express my thanks to Bjørg Tosterud Danielsen who with great skill typed the Norwegian edition. Finally, my thanks also to Elinor Ruth Waaler for her competence and co-operation in the translation of this study into English.

June, 1987.

THE APPROACH TO THE PROBLEM, SOURCE MATERIAL AND BASIC QUESTIONS OF METHODOLOGY

The title of this study shows clearly that we shall employ iconographical as well as literary sources. As a result the work assumes an interdisciplinary character, making it an exciting but difficult challenge as are all projects of this kind. In this case we have good reason to believe that the linking of iconographical and literary sources reveals not only richer perspectives in the interpretation of both but also helps to clarify the relationship between theological thinking and the social situation in the 4th century. This last statement requires justification. To begin with, it is necessary to emphasize the importance of iconography in this context.

It is proven beyond doubt that Christian iconography in the second half of the 4th century was strongly influenced by contemporary imperial iconography.[1] Further, it seems that this dependence on imperial art in some way reflects the contemporary religious-political situation. An imperially slanted iconography is unthinkable during the period of Christian persecutions.[2] It is equally clear that this politically inclined iconography professes to mirror official state ideology in a minor way only. It appears rather, first and foremost, as an art directly related to internal church affairs. The iconography is bound to the internal life and work of the church while at the same time it refers to a clearly defined political reality.

Thus, the pattern of approach to the problem is set, a pattern governing the whole of our study. With our point of departure in an iconography directly related to a particular socio-political situation we shall attempt to distinguish special features pertaining to contemporary theological thinking.

We must immediately set the limits for our choice of sources and make exact thematic definitions. First it is necessary to state our theme precisely; our particular centre of attention will be 4th century eschatological thought. Eschatology, in this work, is to be understood as a tension between the present and the future which helps to determine

[1] Grabar has pointed out "the priority of the Imperial models", see Grabar, Iconography p. 42 and Grabar, L'empereur, especially the chapter "L'art impérial et l'art chrétien" p. 189-195.
[2] Brenk, Imperial Heritage p. 39f.

the situation between the church and the world.[3] In the introductory chapters to the iconographical section and to the textual matter, we shall examine the connections between eschatology and socio-political reality.

Secondly, limitations on our choice of sources imply that the field of primary material objects used for purposes of iconographical analysis is narrowed to apsidal iconography. The choice of exactly this type of picture was not made at random. Although what has survived of 4th century monumental decorations is modest in quantity, there is much which leads us to believe that it was programs for this milieu which mainly dominated the iconographical development in the latter part of the century. The striking likeness between extant monumental decorations on one hand and plastic sarcophagus art and various forms of "Kleinkunst" on the other is usually seen as a result of the influential power of monumental church decoration.[4]

Furthermore, interpreting this type of iconography is extraordinarily fascinating. The complicated combinations of motifs, the equivalents of which are not found in either the Bible or patristic texts are an exciting challenge in interpretation.

The most important reason, however, for putting the main emphasis on apsidal iconography is to be found in the central location of this art in the liturgical space. In working with an iconography set within a specific functional context, one which also sets the framework for our literary sources, we have a unique opportunity to trace the connecting links between images and texts in a very useful way. Apsidal iconography leads naturally to an interest in the liturgical ritual itself.

It will be seen rather quickly that our approach raises considerable methodological problems of various kinds. In the first place, primary liturgical sources from the 4th century are just as fragmentary as apsidal iconography. In general, they are limited to information about the sacrament of Baptism and the Eucharist. As liturgical sources are scanty, the material at our disposal is meager.

Our literary sources, nevertheless, have proven be more useful than was expected to begin with. A dearth of detailed information concerning certain liturgical forms is, in the case of several sources, made up for by their context. In a number of cases the liturgical information is to be found in a catechetical context which, amongst other things, is meant to

[3] This conception of eschatology is not only regarded as representative within the New Testament, see Klein, Eschatologie IV p. 270-299, especially p. 296, but can also be used in a normative way when evaluating the eschatological thinking in the 4th century, see May, Eschatology V, p. 303ff.

[4] Gerke, Malerei und Plastik p. 119-163; Kollwitz, Christus als Lehrer p. 54. See, however, Brenk's reservations in Imperial Heritage p. 45.

interpret what takes place during Divine service. Our textual work is centred around just this type of liturgical source. As mystagogical catecheses are the summit of Lenten instruction, it is only natural to examine the whole of catechetical teaching in which individual liturgical pieces of information belong.

Methodologically, we surmount two problems by taking advantage of just such a material. In the first place, we utilize texts which are directly related to the same milieu in which the apsidal pictures belong. This means that the relevance of the texts is evident.[5] In addition, we shall be able to study literary correlations more thoroughly than is usual in early Christian iconographical analyses where textual studies tend to be limited to producing fragments of texts with bearing on one or another specific pictorial element. We are convinced that our approach will, in quite a different way, allow us to penetrate more deeply into the relationship between text and image than is often the case in iconographical analyses.

In the meantime it is necessary to note the special problems which such a method creates for the analytical process. The iconographical work is based on analyses of single motifs which are inclined to be explained by the help of another iconography which, in addition, has been supplemented by relevant textual fragments. In our study this level of the analytical work will be carried further by working with larger textual units, in this case catecheses. There are great differences in the organization of theological questions in catechetical instruction and in iconography. One aspect will be stressed here. Whereas 4th century iconography developed a new pictorial program inspired by official state iconography catechetical instruction continued its development based on unbroken theological traditions only indirectly influenced by changed modes of life. As a result, a gulf developed between iconography and catechetical teaching, a fact which cannot be overlooked. This separation can only be resolved if we succeed in finding a correspondence between the two types of sources. This means that literary research may only be considered a continuation of iconographical analyses if we succeed in discovering structures in textual units which can be understood as supplementary to the results we have reached in the iconographical analyses.

If we are to attempt a closer identification of the relationship between the iconographical part and the textual part, it seems natural to make use of well-known interpretation models. In this context the distinction drawn by E. Panofsky between iconographical analysis and

[5] For the catechetical relevance of pictures, see Pietri, Roma Christiana p. 1414 note 1.

iconographical interpretation (iconology) is of interest. According to Panofsky, iconographical analysis is the identification of specific pictorial motifs and pictorial combinations by means of connecting them with "themes" or "concepts". Iconological interpretation, however, serves to place these themes in a more comprehensive relationship, a connection of a synthetic nature.[6] The relationship between our iconographical section and literary analysis may be seen in the same light. In the first main section we endeavor to arrive at an understanding of individual pictorial motifs as well as of texts closely connected to the image presentation. In the second main section, we attempt to discover the totality behind the pictorial presentation.[7]

The weakness in Panofsky's analysis model is to be found, first, foremost, in the lack of interest shown in iconography's functional aspect. S. Sinding-Larsen, in a direct controversy over Panofsky's theoretical research, has discussed such problems within a specific liturgical functional context.[8] He emphasizes that the connection between iconography and the liturgy is such that all iconographical decoration in the church is, in principle, related to the iconography around the altar and to the texts which form the basis of the rituals taking place there.[9] Sinding-Larsen also intimates the way in which he imagines a picture to become liturgically- active: "Liturgy determines specific

[6] Panofsky, Studies in icon. p. 6ff.

[7] Dinkler, too holds with Panofsky and separates the analysis into an iconographical and an iconological part. Here, however, the interpretive range is narrowed already in the summing up of the iconographical analysis. This takes place by means of collecting the many layers of meaning which the analysis has led to (die Vergangenheit auf Tabor, die Zukunft des Secundus Adventus, die Gegenwart der Kirche in ihren Amtsträgern) in under "eine Hauptstimme", i.e. the parousia theme p. 76. The iconological study also begins with an interpretation of the Sign of the cross in which all interest is concentrated on the futuristic-eschatological aspect. The sole purpose of the ensuing study is to gather the other motifs together and place them under this main theme, see p. 77.

The iconological interpretation is organized in quite another way in Sieger, Pictor ignotus. Sieger's main purpose in studying a number of monuments from the transition between the 4th and 5th century is "to understand them iconologically", p. 8, but, preceding this iconological interpretation no satisfactory iconographical analysis is to be found. On the other hand, the first part of the work is a study of "visual thought patterns", which in point of fact is an examination of Irenaeus' and Origen's "visual thought world", p. 6. The danger of arbitrary interpretation is conspicuous in a work which shows no interest in detailed studies of iconographical motifs, but, on the contrary, is content to compare pictorial material with textual structures from a period far earlier than that of the monuments. Nevertheless, the wish to perceive the pictorial programs in connection with "the entire exegesis of a theme" is of value.

[8] Sinding-Larsen, Iconography p. 37ff. Already in Monumentum resurrectionis from 1962 Torp gives a functional interpretation of the Easter candelabrum in Cori. In the summary he says that the candelabrum has to "be a liturgical utility article, made in such a way as to light up and bring to life the changing symbolic language of the ritual".

[9] Ibid. p. 81, see also p. 9f.

modes of relationship in action and idea between the onlooker or con-
gregation and the subject illustrated in the liturgical iconography. One
may speak of the regulating effect of the liturgy. The liturgy is an
articulate system which makes itself manifest all through the liturgical
time-span in which the iconography functions fully, a system through
which the human participant perceives those entities, such as the present
divinity, the sacrifice, that are illustrated in the iconography—and
perceives them within a space context which is also perceptionally
affected by the same system.''[10] Of particular importance in our context
is the close connection which Sinding-Larsen finds between liturgical
practice and the decoration linked to the altar section. Between the
iconography belonging to the altar or chancel walls, vault or apse and
eucharistic presence there exist natural connections.[11] We agree with
Sinding-Larsen's theoretical considerations but do, at the same time,
maintain that the complicated "dogmatical and doctrinal concepts
expressed in the liturgy", can only be captured by a sort of iconological
investigation.[12]

In this study we shall attempt to find a structural agreement between
picture and text, one which also reflects the picture's function within the
context of the ritual. In order to realize this, it is useful to differentiate
between two dissimilar aspects of the sources. In the first place, the pic-
torial programs refer to the dogmatic framework for the liturgical
ceremony. The main accent on these questions is in chapter 2 where we
attempt to reveal the fundamental elements of pictorial programs.
Chapter 3 and particularly chapter 4 impart nuances and amplifications
of the results reached in chapter 2. The investigation of this subject is
continued within the textual analysis mainly in sections entitled "the

[10] Ibid. p. 95. According to Sinding-Larsen the pictures' meaning changes in accord-
ance with the liturgy as it progresses. In connection with the apse in S. Clemente he says:
"The figure of Christ obtains a complete sense only when evaluated in its functional con-
text, which is that of the altar, and the point is that this meaning is changing, consisting
as it does of multiple elements in varying relations to one another—rather like large
molecules in reaction", p. 38.

[11] Ibid. p. 96. Thus we suppose that the ritual influence on art has been of greater
importance than the influence of literary conventions (rhetoric), as Maguire stresses in
Art and Eloquence. However, our point of view does not necessarily contradict
Maguire's. He concludes "I have tried to show in these pages that Byzantine artists bor-
rowed several techniques from ancient rhetoric, but I wish to stress again that I do not
believe that the artists themselves were conscious of the rhetorical origins of these
methods. It is unlikely that many Byzantine artists received a formal education in
rhetoric. If they exploited rhetorical techniques, it was only because these techniques had
become part of the fabric of the literature, liturgy, and thought of the Byzantine church,
to which both they and their patrons were exposed", Maguire, Art and Eloquence p.
110.

[12] Ibid. p. 15.

dogmatic framework" where "God and God's works" are the dominant themes. Secondly, the pictorial programs have an unequivocal actualizing function. Problems concerning function lie at the root of all pictorial analyses but are explicitly placed in this program under traditio-legis thematic treatment in chapter 3 in which the actualizing problem is tied in with the thematic treatment of visions. In literary analyses the threads are gathered together in the sections dealing with "the ritual representation" in which decisive importance is attached to the visionary character of the ritual. In the treatment of visions connected with ritual we attempt to establish how pictorial structure merges with and supplements the ritual structure during the celebration of the Eucharist.

Both Panofsky and Sinding-Larsen assume that the process of interpretation is exclusively directed towards the most satisfactory understanding of a pictorial representation. In this case our point of departure is slightly different. As mentioned before, we wish to regard apsidal imagery as a contemporary liturgical expression of certain tendencies within the 4th century church. Thus, the interpretation of apsidal representations is not meant to be the goal of this work but is of interest for the insight it gives into liturgical procedures during the 4th century. In the methodology itself, we hardly differ from, for example, that which G. Danbolt recommends for iconographical function analysis[13] but our results are used in a somewhat different way. This is clearly seen in the way we utilize the textual material. Danbolt is, in point of fact, satisfied when in his interpretation of Leonardo's Last Supper he finds evidence that the picture must be connected to an historical as well as actualizing plan.[14] In rendering an account of the inner connection and relationship between these aspects he is content with extremely general considerations.[15] For us, however, the connection between the image's various levels of meaning becomes, mutatis mutandis, one of the central problems requiring extensive processing of the literary source material itself. This is not alone due to the fact that an understanding of the interplay of these elements is decisive in the interpretation of the iconography. A study of the connections between the different meaning levels shows to an equal degree that the main interest in this work is focused on the 4th century's attitude towards the eschatological problem. As eschatology concerns an emphasis on elements within "the dogmatic framework" which appear to be relevant within a specific ritual and social context, the main endeavor of this work will be closely related to source treatment of exactly this question.

[13] Danbolt, Estetisk praksis.
[14] Ibid. p. 84f.
[15] Ibid. p. 85f.

With Sinding-Larsen's considerations as a background it is natural to put particular emphasis on the connection between apsidal decorations and rituals taking place at the altar. Here we shall only expand upon what has been said earlier by emphasizing the *visual* connections between the altar and apsidal decoration. We know that the arrangement of the sanctuary as well as the position of the altar varied greatly during the 4th century. T. Klauser affirms, nevertheless, the existence of a typical arrangement in the relationship between them in Roman churches in which the altar was usually placed on the long axis of the church nave and in front of the terminating apse.[16] This has, in all probability, been the normal position of the altar even though the distance between altar and apse has varied greatly.[17] To this we must add that throughout the entire period of the early church the altar was used only during the celebration of the Eucharist.[18] Thus, the actual arrangement of the church makes it seem reasonable to search for specific relations between the apsidal decoration and celebration of the Eucharist.

We must admit, however, that the geographical distance between our pictorial material and our literary sources causes difficulties in methodology.[19] Whereas the iconographical sources largely originate in western areas, two of our three catechetical sources have their origins in the east and have, therefore, no geographical connection with our apsidal decoration. A comparison of such sources demands that they be representative of the period in which we are working. Such a supposition is not unreasonable. In almost all work covering iconography from this period, the geographical distance between the extant decoration has been a rather moderate obstacle in analytical research. Accordingly, in our study we draw on all material which by thematic criteria is relevant for our apses, independent of their geographical situation.

Likewise, it is usual to consider the liturgical structure as being strikingly similar all over the Roman Empire during the 4th century (see p. 134). We must, furthermore, take into account the considerable theological influence emanating from the east throughout our period. Around mid-century Athanasius emerges as an important intermediary in the spread of eastern theological traditions to the west.[20] Towards the end of the 4th century we have not only Ambrose (see p. 258) but

[16] Klauser, Konst. Altäre p. 156.
[17] Kirsch, Altar col. 336; see also Nussbaum, Standort. See especially the specific Syriac and North African way of locating the altar p. 59-61; 178f.; 190f.; 197-203.
[18] Klauser, Altar col. 350.
[19] Mathews, Early Churches p. 5, insists that the archeological and liturgical sources must come from the same geographical area in order to be comparable.
[20] See Tetz, Athanasius p. 333-349.

amongst others Rufinus, Jerome and Egeria to testify to a lively cultural interplay between east and west.[21] We have, nevertheless, chosen to work with not one but with three catechetical traditions in our second main section. We wish thereby to give a survey of common elements as well as nuances of difference which do exist between the various liturgical and catechetical traditions.

We introduce both main sections with information and a discussion of the background material for our analyses. We wish to comment here that we consider the background material used in these sections as a framework with no pretence of its rendering more than the horizon for our analyses. The main emphasis is on the analytical work itself, the iconographical as well as the textual.

[21] For Rufinus see Altaner, Patrologie p. 392; for Jerome see Altaner, Patrologie p. 394ff; for Egeria see p. 149.

PART ONE

ICONOGRAPHICAL ANALYSIS

CHAPTER ONE

BACKGROUND

Fourth century pictorial art plays a part in the origins of Christian art. Although we are aware of the existence of Christian imagery as early as the beginning of the third century, it is not until the period around the transition into the fourth century that we find indisputable presentations of Christ in an historical setting. Thus, an examination of the development of the image of Christ up until the Theodosian period becomes a study in new iconographical formulas.

The growth of an iconographical tradition with the image of Christ as the central point has obviously presented problems. At the beginning of the century Eusebius of Caesarea evinces clear disapproval of images of Christ[1] and at the end of the century Epiphanius of Salamis shows a hostile attitude.[2] Nonetheless, the number of monuments is evidence that the use of Christian images is firmly rooted in a religious context at the end of the century and a number of theologians have defended the use of presentations of Christ at this time.[3]

The limited sources from the previous centuries make it difficult to give a reasonably clear background to the controversy over imagery between theologians of the 300's. Research, resulting in various opinions, shows clearly how difficult it is to form an impression of the Christian attitude towards images in the earliest years of the church.

On one hand, E. Dobschütz finds a widespread anti-imagery attitude, analogous to that of Epiphanius, during the first centuries. He maintains that there was nothing within Christianity which could possibly resemble pagan religious cults in which images of the gods, sacrifices and similar ceremonies played such an important part. With this fundamental viewpoint he is able to establish that the earliest Christians looked upon imagery of any kind with abhorrence. The polemics of the apologists are interpreted not only as the expression of hostility towards images of the gods but for all imagery as such. In support of this interpretation, Dobschütz refers to statements maintaining that stonecarving and paint-

[1] See Eusebius of Caesarea, Epist. ad Const. (PG. 20.1545), see also Schönborn, L'icône p. 55-85.

[2] Greek and Latin text variants are given in Murray, Art p. 339f. For text critical problems see ibid. p. 337 note 2.

[3] See Elliger, Stellung p. 60-94.

ing were occupations incompatible with Christianity.[4] A. Grabar, on the other hand, finds it probable that the first generations of Christians possessed images of Christ, the apostles and the martyrs and in addition surrounded them with various material symbols such as were fitting in accordance with contemporary custom.[5]

The disagreement shown here is of greater interest than the uncertainty it reveals concerning the early Christian attitude to imagery. The differences of opinion give the first hint that varying kinds of relevant source material have formed the foundation for dissimilar research results. Dobschütz, the interpreter of texts, prefers to concentrate on literary sources which say nothing about the Christian use of imagery but are essentially concerned with the polemics of the church against the worship of pagan idols. According to him, the arguments put forward in this context, render the use of any form of imagery impossible. Grabar, the archeologist, on the contrary devotes himself to the meager archeological material from the first centuries of the church's existence supplemented by texts of more sectarian nature. Even though this material may suggest a certain open-mindedness towards certain groups of images, it tells little of the attitude towards imagery among the leading clergy.[6]

Dobschütz and Grabar, however, also represent two different attitudes towards the questions which occupy us here. Dobschütz as a theologian shows clearly where his main interest lies in his interpretation. It seems that for him the original period with no imagery was the ideal—a condi-

[4] Dobschütz, Christusbilder p. 26f. A hostile attitude towards imagery shown by the leading clergy before the 4th century is stressed in nearly all studies after Dobschütz, see Koch, Bilderfrage; Elliger, Stellung; Klauser, Erwägungen; Kitzinger, Cult of Images.

[5] Grabar, Iconography p. 85. At the same time Grabar stresses that the pictorial art which we know from the beginning of the 200's, reflects "a movement in favor of religious iconography which affected Jews and Christians alike", Grabar, Iconography p. 24. Grabar considers Christian iconography as "a response or a counterpart to the concurrent Jewish iconography born a short while before", Grabar, Iconography p. 27.

[6] Grabar presumes the existence of a certain tension between ordinary believers and the clergy in their views about imagery: "Its utilitarian character implies an impetus coming from the faithful, which means that it need not have been inspired or even approved by the clergy", Grabar, Iconography p. 22. Murray on the other hand claims that the distance between the faithful and the clergy has been over-estimated, see Murray, Art p. 316 together with p. 304. Murray, in analysing the relevant textual material shows a positive attitude towards imagery and maintains that the Fathers' negative viewpoint has been exaggerated: "If the foregoing analysis of the literary evidence is correct, it seems a reasonable assessment of the case to say that there is very little indication indeed that the Fathers of the early Church were in any way opposed to art", Murray, Art p. 342. Murray rightly stresses that the early patristic sources primarily reveal a hostile attitude towards pagan idolatry. The rejection of a negative attitude towards pictures in Eusebius of Caesarea's writings is on the other hand not convincing, see Murray, Art p. 326f.

tion which, if not before, ceased with Constantine.[7] Thus, he not only reveals a theological tendency but in addition the traditional Protestant attitude towards events round about the year 300. O. Casel, the Benedictine, characteristically interprets the changes in cult practice during the Constantinian period in quite another way. Casel maintains that the openness of the 4th century church towards customs from Antiquity arises from the wish to enrich her own ritual.[8] Here, contrary to Dobschütz' view, there is no assumption of an ideal period without pictorial presentations but rather the attitude that elements of Antiquity's mystery religions are closely related to the deepest characteristics of the nature of Christianity.[9]

Grabar, on the contrary, occupied as he is with Roman official iconography is interested in placing Christian imagery in a broader cultural and historical perspective in which various surrounding milieus are perceived as the most likely framework for interpretation. It is not how the church views herself but the influence brought to bear on her activities by the outside world which is his field of interest.[10]

If we return now to the attitude of the early church towards imagery, we find that neither Grabar nor Dobschütz has come forth with any certain knowledge of ecclesiastical utilization of imagery in the first and second centuries.[11] The lack of both imagery and directly relevant literary material from the earliest period must, however, not be interpreted as an expression of hostility nor of approval in principle of imagery; it may be seen as a manifestation of *unfamiliarity with art* among Christians. G. Kittel maintains that the early church showed hardly any

[7] Distinctive is his interpretation of the events in the 4th century: "So brach auch mit den jetzt in die weitgeöffneten Thore der christlichen Kirche einströmenden Massen nicht nur der gottesdienstliche Gebrauch, sondern zugleich die abergläubische Verehrung der Bilder in die christliche Kirche ein", Dobschütz, Christusbilder p. 29.

[8] "Seit dem Frieden Konstantins, wo die Kirche siegreich über das Heidentum erhob, hat man noch unbedenklicher die antike Mysteriensprache benutzt, um den unerschöpflichen Inhalt des eigenen Besitzes einigermassen aussprechen zu können; ja, es werden manche antike Formen und Gebräuche übernommen, um die Einfachheit des christlichen Ritus zu bereichern und auszuschmücken. Das Gold und Silber Ägyptens wurde nach einem bei den Vätern beliebten Bilde umgeschmolzen, um die heiligen Gefässe der Kirche zu zieren", Casel, Kultmysterium p. 54f.

[9] "Gott hatte aber in seiner Vorsehung gewisse religiöse Formen entstehen lassen, die zwar nicht von weitem an die christliche Wirklichkeit heranreichten, die aber die Worte und die Formen bieten konnten, um das unerhört Neue in menschlich verständlicher Weise auszudrücken", Casel, Kultmysterium p. 52.

[10] The following assertion is characteristic: "contemporary motifs and formulas played a large part in Paleo-Christian art, which was nothing else than one branch of the art of the Imperial epoch", Grabar, Iconography p. 37.

[11] Grabar holds that the earliest archeological material belongs to "the Severan period", Grabar, Iconography p. 27.

interest in imagery, positive or negative. Since no inclination towards the creation of pictorial representations existed, neither was there any necessity for opposition. According to Kittel the early church did not, therefore, prohibit imagery such as we know it within Judaism.[12] Such unfamiliarity with imagery does not necessarily imply the church's hostility towards art. But, the historical cultural background as well as the actual life style made an extensive use of images hardly likely.

Around the year 200, if not before, a certain open attitude is to be found in the Alexandrian church. It is here that Clement's views on imagery seem to reflect the conflict of that period in an illuminating manner. Clement was one of the Fathers passionately engaged in the battle against pagan images. In this struggle he pointed out, among other things, that man is the image of God created by God but the pictorial representation of the image is untrue and should therefore not be produced.[13] This same Clement, however, allows Christians to wear signet rings on which a ship, lyre or anchor or even dove or fish is pictured.[14] This open view towards pictorial presentations is seen by J. Daniélou as a result of adaptation to a contemporary life style, something which inevitably entailed the risk of contact with phenomena closely connected to pagan idol worship.[15] It was without doubt a difficult situation. On one side was a well-developed pictorial art which emerged as the quintessence of paganism; on the other side the church had a missionizing duty which must have entailed some form of dialogue.

In the third century literary documentation testifying to a circumspect approach to imagery is supported by iconographical material which is comparatively abundant in the latter part of the century. In our context it is particularly contemporary Christ types which are of interest. Clement's assertion seems to reveal a special opposition to portrait-like presentations. The iconographical material reveals a corresponding reserve. Kollwitz divides third century Christ figures into the following groups: shepherd, teacher, Orpheus, choirmaster, fisherman, skipper and king.[16] Little concern is shown for presentations of Christ in an historical setting but rather in a sort of paradigmatic art. Even though we know that the teacher type as well as the king type existed in the third

[12] Kittel, εἰκών p. 385.
[13] Clement of Alexandria, Protrept. 10.98.3 (GCS. 12.71).
[14] Clement of Alexandria, Paedagog. 3.59.2 (GCS. 12.270); see Altendorf, Siegelbildvorschläge p. 129-138 and Klauser, Erwägungen p. 3f.
[15] Daniélou, La catéchèse p. 152.
[16] Kollwitz, Christusbild col. 5-10.

century we shall find that here the concern is with quite other iconographical traditions than those we shall be dealing with later.[17]

The teacher type which will dominate pictorial art in the 400's emerges, according to Kollwitz, shortly before the peace between church and state was declared[18] while the king types dates from the latter part of the reign of Constantine.[19] These indications show already that Kollwitz presupposes that pictorial development changes character in important ways around the transition from the third to fourth century without, however, directing attention to "the Peace of the Church" itself. There are nuances in Kollwitz' interpretation of iconographical development in connection with his treatment of king themes. Here he points out that the Arian controversy brought about a theological clarification which was formulated as a homoousion Christology at the Council of Nicaea. Kollwitz maintains that it was natural to use a kingship terminology within the theological work necessary to develop such a formulation.[20]

Kollwitz also uses another interpretative framework for king themes from the early fourth century. This time he argues that the new Christian empire needed a theoretical basis.[21] In this context, Kollwitz considers the role of the "court theologian" Eusebius of Caesarea as decisive. He attempts also to establish that the use of king terminology increases in the later writings of Eusebius. Kollwitz places these interpretations side by side but leaves them unprocessed. A more thorough investigation into research traditions shows that the two interpretations have appeared as alternative solutions.

P. Beskow criticizes Kollwitz' emphasis on the importance of Eusebius in the development of imagery. As for himself, he would in no way allot Eusebius a central role in this context. Beskow argues this by pointing out that Eusebius cannot be considered a creative theologian. On the contrary he appears to be first and foremost an apologist highly dependent upon other theologians. To Beskow it seems quite unlikely that a writer which so little originality should stand forth as the leading representative for the new Christological tendencies discussed here.[22]

[17] About the teacher-type from the 4th century Kollwitz says: "Die grosse repräsentative Komposition der Zeit aber sind nun nicht mehr diese alten Bildtypen der Frühzeit, sondern eine neue Erfindung", Kollwitz, Christusbild col. 13.
[18] Kollwitz, Christusbild col. 14.
[19] Ibid. col. 15, see also Kollwitz, Christus als Lehrer and Kollwitz, Oströmische Plastik p. 145-152.
[20] "Stärker als bisher betont man sein Königtum u. seine Weltherrschaft: deum de deo, regem de rege, dominum de domino", Kollwitz, Christus II col. 1259.
[21] Ibid. col. 1259.
[22] Beskow, Rex Gloriae p. 262. For details in Beskow's argumentation, see p. 259-268.

The decisive innovative thinking which creates the premise for an expanded use of the king theme in 4th century theology is, according to Beskow, to be found in Athanasius who emphasizes that the Kingdom of Christ is not only to be connected with the glorification of Christ but also with his incarnation.[23] This conception has its roots in the Antiochene tradition where, amongst others, Marcellus of Ancyra drew radical conclusions from such thinking.[24] On the other hand, the transference of the παντοκράτωρ title from Father to Son is considered by Beskow to be the original idea of Athanasius himself; he is, at least, credited as the theologian who made the conception generally acceptable within the fourth century church.[25] Beskow is, thereby, supported by his sources in one of his main concerns, namely that the ideological background for the so-called image of Christ in Majesty is not to be sought after in Eusebius' political metaphysics but rather in Nicene theology.[26] Thus, not only does the imagery correspond to the theology considered orthodox by the Councils in 325 and 381 but at the same time its connection with fourth century political events is weakened. Although Beskow insists that the Constantinian empire and the breakthrough of Christological king terminology are "in some way related",[27] he maintains that this terminology has not played any great role in the relation of power between church and state. According to Beskow, the utilization of king terminology must be seen against a background of internal church affairs.[28]

K. Berger develops further an immanent system of interpretation in a way which also has direct methodological consequences for the research process itself. Berger shakes the very foundations of the political interpretation of pictorial presentations. Attacking archeological methods which interpret presentations of Christ in the light of emperor cult, he maintains that Christian presentations must be interpreted in the light of Christian literature.[29]

[23] Beskow, Rex Gloriae p. 277; see also the chapter "The Nicene Theologians and the Kingship of Christ" p. 276-294.
[24] Ibid. p. 284.
[25] Ibid. p. 298.
[26] Ibid. p. 293.
[27] Ibid. p. 313.
[28] Ibid. p. 329f.
[29] About the archeological method Berger says: "auch am ungeeigneten Objekt wird ständig die alte These der religionsgeschichtlichen Schule erneuert, die Auffassung Christi sei wesentlich als Übertragung aus dem Kaiserkult zu begreifen", Berger, Ursprung der Traditio p. 104f. Berger elaborates the methodological consequences of this polemic attitude against the archeologists in the following way: "Methodisch gesehen erscheint es als vorrangig, christliche Darstellungen zunächst aus christlichen, jüdischen oder wie auch immer popularisierten erbaulichen oder apokalyptischen Traditionen dieser Herkunft zu erklären zu versuchen," Berger, Ursprung der Traditio note 4 p. 105.

U. Süssenbach assumes a rather condescending attitude towards the research models we have sketched here. He maintains that in theology and Christian archeology, just as in other professional fields, the search is for interpretations within the subject which must, first and foremost, justify the developments taking place.[30] He, himself, prefers explanatory models "die mehr auch die eigentlichen Voraussetzungen der Rezeption, die Entwicklung der kaiserlichen Repräsentation zum byzantinischen Hofzeremoniell, ins Auge fasst."[31] This statement seems somewhat diffuse. Süssenbach certainly cannot mean that the so-called immanent system of interpretation is *unable* to reveal the real premises for a development. His point, however, is clear enough; the correct point of departure for a relevant interpretation of early Christian king themes is found in court ceremony which also presents the key to an understanding of the function of the new Christian art.[32]

Süssenbach's work is to a great extent dependent upon R. Hernegger who attempts to map the changes through which the church passes after its conversion to the status of the official church.[33] As Hernegger sees it, the changes in the relationship between church and state during the fourth century were the ripened fruit of the Hellenizing process which marked the church throughout all Antiquity.

In the Constantinian period, according to Hernegger, the new church and state relationship is complete in that Constantine "Christianizes" Roman triumphal ideology.[34] This ideology presupposes that the emperor is the manifestation and representative of the Deity just as a political victory is considered the expression of the autonomous Divine power manifested in the emperor.[35] "Christianizing" is the process by which the name of the Divinity who brings about victories changes; now Jupiter must give way to Christ. But, this change is not deep-seated and according to Hernegger, Christianized triumphal ideology is simply a disguised Roman paganism.[36] Constantine, nevertheless, manages to turn his political triumphal ideology into a Christian state ideology in

[30] Süssenbach, Christuskult p. 27.
[31] Ibid. p. 17.
[32] Ibid. p. 19.
[33] See Hernegger, Macht.
[34] Hernegger, Macht p. 167. According to Hernegger this way of thinking is inconsistent with Christianity: "Die Königsherrschaft Gottes, die Jesus verkündigt hatte, konnte mit keinem politischen Reich identifiziert werden, und der Gottvater Jesu ist kein Sieges- und Kriegsgott im antik-heidnischen Verständnis. Darum ist eine Verchristlichung der römischen Siegestheologie, von der neutestamentlichen Botschaft her, ein unmögliches Unterfangen", Hernegger, Macht p. 167.
[35] Ibid. p. 160.
[36] Ibid. p. 167.

which the emperor's triumph is seen as Christ's triumph just as Christ's triumph is perceived as the emperor's triumph.[37]

It is important for Hernegger to keep to the wide effect of these conceptions. Thus, the work of Eusebius of Caesarea in building Constantine's achievement into a theological system is seen as an expression of what the majority within the church thought and felt.[38] He is the "seismograph" and theological spokesman in the process of transformation, something in which the entire church takes part.[39] Here, however, it must be said that Hernegger did not perceive this triumphal theology as merely the result of pressure from the top but also as a reflection of the victorious spirit which marked the church following Constantine's introduction of a new religious policy.[40] Even though Eusebius' political theology is perceived as the results of a lengthy process of Hellenization, the new political situation after the battle of the Milvian Bridge must, nevertheless, be taken as the releasing factor in the theological reflections under consideration here.[41] The result is an elimination of all existing boundaries between acts of salvation and political actions.[42]

The representational importance of Eusebius' political theology is corroborated for Hernegger by fourth century Christian art, which combined with the liturgy is considered to be the most powerful and effective medium in the spread of political theory throughout the whole of the Middle Ages.[43] By making use of symbols and motifs taken from imperial triumphal ideology, the triumphant emperor appears, within a liturgical framework, as a visible image of a triumphant Christ.[44] Constantinian basilical complexes may be seen in the same light. Sacralization of a secular-political state not only finds its pictorial expression but also its cult.[45]

[37] Ibid. p. 166.

[38] Ibid. p. 211f.

[39] Ibid. p. 274, see also p. 252: "Die politische Theologie des Eusebius war Ausdruck der kirchlichen Siegesstimmung und des kirchlichen Fühlens, daher ihre schnelle Durchsetzung und allgemeine Verbreitung in Ost und West. Ihre hellenistischen Wurzeln gerieten zwar allmählich in Vergessenheit, behalten aber wurden die Ergebnisse der politischen Theologie."

[40] "Die Sieges- und Herrlichkeitstheologie ist der Spiegel der neuen soziologischen Stellung der Kirche in der Welt; sie waren die ideologische Rechtfertigung des neuerworbenen Glanzes und Reichtums der Kirche im konstantinischen Reich", Hernegger, Macht p. 257.

[41] Ibid. p. 221.

[42] Ibid. p. 240.

[43] Ibid. p. 212 and p. 254.

[44] "Für den irdischen Kaiser wurden während des Gottesdienstes nicht nur eigene Gebete verrichtet, er war im christlichen Kultbild, das Christus in seiner Gestalt, Haltung und Kleidung zeigte, präsent", Hernegger, Macht p. 266.

[45] "Die christliche Liturgie war nicht nur ein Gott erwiesener Kult, sondern zugleich—ganz im archaischen Sinne—die Zelebration der Sakralität der politischen Ge-

Although Süssenbach sympathises with Hernegger's interpretation, he contends that also he puts too much stress on the importance of theological speculations as explanatory causal factors. Süssenbach is skeptical of every form of argument not based entirely on political events.[46] He, himself emphasizes state interests as being directly responsible for the creation of pictorial imagery. Accordingly, he puts decisive emphasis on the direct importance of Constantine in imperially influenced pictorial art. Already in 312, according to Süssenbach, the emperor promotes the deliberate use of imperially influenced Christian imagery in order to lend a sacred character to his regime.[47] But, in taking this stand, Süssenbach is also forced to dispute Kollwitz' viewpoint that imperial themes first enter the iconography towards the middle of the century.[48] Süssenbach bases his interpretation first and foremost on literary sources, amongst others, the Liber Pontificalis and on texts of Eusebius which relate that the Emperor Constantine contributed sculptures, a number of liturgical objects in precious metal, textiles and magnificent bibles to the church.[49] In our opinion the controversial sources used by Süssenbach do not lend definite support to the use of distinctly imperial insignia in Christian iconography at the beginning of the 300's. The cases mentioned are concerned mainly with the use of imperial grandeur in a cult context. Süssenbach, nevertheless, has an answer; the use of precious metal is in itself a demonstration of the utilization of the imperial insignia because precious metal is seen as the symbol of eternity and power in theological as well as related political contexts. This implies that gold in representations of kings, at least in an ideal sense, is to be taken as a royal insignium.[50] This interpretation, meanwhile, becomes somewhat problematical when Süssenbach maintains that such use of insignia did not occur before 312. In this connection, his explanation of the Aberkios inscription is of interest. As is well known, we have here a description of an empress clad and shod in gold which, according to Dölger symbolizes the spiritual kingdom of the church.[51] As the inscription is from before 216 it becomes somewhat of

sellschaft und ihre kultische Repräsentation. Darum war die christliche Liturgie öffentlicher Kult: sie zelebrierte den Kult für den Staat und repräsentierte im Kult den Staat; sie setzte überdies das öffentliche Zeichen für die Sakralität des politischen Reiches und seines Herrschers," Hernegger, Macht p. 266.

[46] "Zweifellos diente die neue Repräsentation auch dem Lobpreis Gottes und dem neuen Siegesgefühl der Kirche. Doch sind damit nur die teils erst später zugewachsenen innerkirchlichen Teilaspekte erfasst", Süssenbach, Christuskult p. 26, see also p. 28.

[47] Süssenbach, Christuskult p. 26, p. 36, p. 40, p. 49.

[48] Ibid. p. 36. See also the rejection of Kollwitz' interpretation of Eusebius at p. 16.

[49] Ibid. p. 43-55.

[50] Ibid. p. 48.

[51] Strathmann/Klauser, Aberkios col. 15.

a problem for Süssenbach. He is obliged to maintain that the empress clothed in gold refers to a timeless concept. In support of this view he refers to the king's bride in Psalm 45:9, 13.[52] We question that an interpretation so theologically immanent is usable in explaining exactly this monument as distinct from all the others.

That the material is somewhat unmanageable within the context of Süssenbach's hypothesis may also be seen in his attitude to the basilical church building. This material too is organized on the basis of the sharp division brought about by the year 312. Süssenbach does not consider his hypothesis sufficiently well-based until he has refuted every sign of monumental church architecture before 312.[53] Here again he collides with accepted views which he does not manage to refute to any great extent.[54]

Our objection to Süssenbach's interpretation is directed first of all towards his rigid utilization of explanatory models. His interest in emphasizing the importance of political events in the development of Christian iconography is directed by his conviction that it is solely the Emperor Constantine's need of a religious basis for the empire that has led iconographical development. In taking this course he is forced not only into an uncritical use of source material but also into the loss of any opportunity of perceptual nuances in the actual material. For Süssenbach the year 312 becomes the explanation for at least one century's iconographical development.

Süssenbach, nevertheless, draws our attention in a thought-provoking way to the problems involved in an imperial thematic program. His approach focuses interest on precisely the function of the images. Is their primary task to express the state ideology of the 4th century or are they meant as a pictorial formulation of 4th century theological thinking?

We have already suggested that the general character of the discussion makes it impossible to bring out any nuances within the iconographical development. Thus, we find it unfortunate that Süssenbach places all Christian pictorial art with imperial characteristics in the same group

[52] Süssenbach, Christuskult p. 30, see also: "Anders als mit der späteren Rezeption haben wir es hier mit einer zeitlosen und vor allen Dingen indirekten allegorischen Verbildlichung zu tun, in der wir nicht immer tiefgründige Zeichen des Königstums Christi erblicken dürfen", Süssenbach, Christuskult p. 30f.

[53] Ibid. p. 108.

[54] Ibid. p. 114. Süssenbach's way of arguing against the monumentality of S. Crisogono which Krautheimer has underlined, is contradicted by the size and the decorations of the building. On the other hand it is necessary to mention that the form of architecture which we find in S. Crisogono, is clearly separated from the imperial buildings from the 4th century. The point in this context is that S. Crisogono represents a basilical type of building which is inspired by secular, public buildings.

while at the same time hardly seeming to take into account any perspective in development in 4th century use of insignia. Here we consider Grabar's contribution a valuable and necessary corrective.

Grabar takes his point of departure in the actual monuments which have survived from the first decades of the 4th century and builds his theory with their direct support. Such a method assures without any doubt the most reliable basis for interpretive work. Grabar points out that the earliest presentations of Christian and imperial motifs in one and the same work belong within an imperial context. This concerns, in the first place, the Christogram on the labarum, shield and the emperor's helmet.[55] Within this context the motif has a distinct function; by utilizing such a symbol on war equipment, the army indicates the desire to be under the protection of Christ as represented by the monogram.[56] Thus, the Christogram functions in the context of power politics. It seems a very likely assumption that the initiative for such a utilization derives from imperial quarters.[57] Grabar presumes that at this time hardly any decorative art was to be found in connection with church buildings. According to him, it took some time before the clergy realized the possibilities of iconography. It was first toward the year 400 that church leaders saw how useful iconographical methods of expression could become if existing images could be successfully adapted to their own needs. In the Constantinian epoch the clergy was not prepared to take on such tasks. The existing Christian iconographical tradition from this period allowed little opportunity of solving the kind of task in question here.[58]

In this way, Grabar emphasizes two central aspects. First of all he stresses that imperially inspired iconography containing Christian motifs is connected with two different milieus, thereby serving different functions. We maintain that such nuances based on function are a necessary premise for a satisfactory iconographical interpretation. Next, he emphasizes that it was only after realizing the actual advantage of an

[55] Grabar, Iconography p. 38f.

[56] Ibid. p. 39.

[57] "It is extremely significant that the initiative for a Christian iconography of universal import, concerned with essential ideas instead of with the personal anxieties of individuals, comes from the government of the Empire, and follows closely upon its conversion", Grabar, Iconography p. 41.

[58] "If Christian iconography reflected so scantily the Christological and dogmatic problems which were the central concerns of the Christian elite after the Peace of the Church, it was because the Christian image-makers had nothing on which to build images devoted to the illustration of these newer and more abstract ideas. Accessible precedents in Imperial iconography, however, gave the image-makers the means of representing symbolically the power of God", Grabar, Iconography p. 45.

imperially inspired iconography to the church herself that it was adopted. Grabar, quite rightly, points out that 3rd century art was minimally suited to dogmatically based liturgical decoration. On the other hand, he finds imperial themes, familiar to us from the second half of the 300's, a possible basis for such a pictorial development.

We find Grabar's approach engaging. When imperially slanted iconography is utilized in a liturgical context, it does not necessarily imply that Christian imagery has been completely governed by imperial interests and needs. On the contrary, we find it reasonable that church leaders wished to indicate particular liturgical points within a process of iconographical development taking place largely within the church itself.

Such an orientation does not mean that we underestimate, as does Beskow, the socio-political context in which this liturgical decoration belongs. We are convinced that Grabar is right in maintaining that it is the peace between church and state which opens the door to increased iconographical development within the church.[59] But, this iconography may not only reflect imperial interests but also the church's interpretation of her own situation in the post-Constantinian era.

Hernegger is one of the few who attempts to connect the new socio-political situation directly to the theological content of 4th century iconography. The basis for Hernegger's interpretation is a fading eschatology which he finds evident in all fields of church life in the 300's. Here again Eusebius plays a central role in that the transposition of the time of eschatological salvation into the history of the Roman Empire is perceived as the basic tenet in Eusebian ideology (cf. p. 142).[60] Hernegger finds the same tendency in the iconography of the 300's where the participation of the church in Christ's triumph is not considered an eschatological goal but a present reality.[61]

A corresponding interest in stressing a present-time salvation aspect, although unrelated to a socio-historical context, is to be found in Y.

[59] Ibid. p. 37.

[60] Hernegger, Macht p. 240.

[61] Ibid. p. 278. The interpretation of the mosaic in S. Pudenziana (Ill.14) is representative for Hernegger's way of reading Christian iconography from the 4th century: "In dieser triumphierenden Kirche erkennt die irdische Kirche aber nicht ihr Vorbild und Endziel, sondern sich selber in der neuen Stellung im Reiche. Im himmlischen Jerusalem wird ihr eigentliches Wesen sichtbar, das auch den Glanz und Triumph der irdischen Kirche rechtfertigt. In der irdischen Kirche ist das himmlische Jerusalem gegenwärtig, darum nimmt die erstere am Triumphe der letzteren teil; der irdischen Kirche gebührt die privilegierte und hohe Stellung im Reiche, die der Kaiser ihr verliehen hat", ibid. p. 279. As interpretation of iconography this statement has a limited value because it is not a result of iconographical research. See, nevertheless, Dassmann whose attempt of connecting iconographical interpretation and social context leads in the same direction, Dassmann, Dominus legem dat p. 23.

Christe. He emphasizes that the eschatological vision in S. Pudenziana (Ill. 14) is not directed toward the coming of Christ and the end of time but is rather a manifestation of an already realized cosmic kingdom. Christe points out that if one wishes to call such a vision eschatological, it is necessary to emphasize that it concerns a present or realized eschatology as distinct from a future eschatology at the end of time.[62]

It is not, however, this tendency which has dominated research into apsidal art of the 300's. On the contrary, apsidal imagery has usually been given a clearly futuristic character. Typical of this is E.Dinkler's interpretation of the S. Pudenziana mosaic which is described as a composition designed on a large scale with an unambiguous eschatological program.[63] This interpretation is sometimes associated with a perception of Christianity which puts particular stress on a futuristic orientation.[64] We realize immediately that such an interpretation comes into conflict with the opinion held by Hernegger.

It is not, however, mainly theological thinking which has created this dominating futuristic-eschatological tradition of interpretation. An important motivation behind the wish to see the S. Pudenziana mosaic as a judgement scene is a question of methodology. It is largely the wish to create an unambiguous imagery interpretation which has led to a strong concentration on futuristic-eschatological perspectives.[65]

[62] Christ, Gegenwärtige Eschatologie p. 52.

[63] Dinkler, S. Apollinare p. 54. Brenk adopts this view and in a research from 1966 he restates the futuristic-eschatological way of interpreting the mosaic: "Das Kreuz deutet den Adventus an. Die Apostel dürfen ... als Beisitzer beim Gericht im Sinne von Mt. 19. 28 angesprochen werden, während die Stadt auf das zukünftige, himmlische Jerusalem nach dem Gericht hinweist. Wir haben hier ein erstes monumentales Bild der frühchristlichen Kunst, welches den thronenden Richter inmitten der 12 thronenden Apostel zeigt", Brenk, Tradition und Neuerung p. 65.

[64] Klauser's way of summing up characteristic elements within Christianity is typical: "Die christliche Religion ist ihrem Wesen nach eschatologisch, anders ausgedrückt: sie ist auf ein jenseitiges Endziel ausgerichtet. Erst im Jenseits, so sagt das Christentum, vollendet sich das Reich Gottes; auf Erden ist es nur vorbereitet und eingeleitet", Klauser/Deichmann, Bild und Wort p. 14. See also Dassmann, Das Apsisbild, who asks for a deepened treatment of the conceptions linked to Christ's judgment at the end of time. Nevertheless, he is not in doubt that the judging Christ played a dominating role at the end of the 300's theological thinking, p. 78f. But this statement is not well documented. The reference on p. 80, note 76 to Kötting, Endzeitprognosen, which points to "das Anschwellen der Endzeiterwartungen im 4. Jhdt", is in any case not well-chosen. Kötting's assertion that theologians in the 4th century made "Endzeitprognosen", refers not to more than one single aspect within the eschatological problem of that time. Dassmann is dependant of Brenk, Tradition und Neuerung p. 31, see also note 25.

[65] Dassmann connects explicitly the wish for "einheitliche Bildaussage" with interpretations dominated by futuristic-eschatological thinking, see Apsismosaik p. 75f. See, however, Engemann's criticism of this position: "In der Forschungsliteratur etwa zu den Apsismosaiken in S. Pudenziana in Rom ... und S. Apollinare in Classe ... oder zu den frühchristlichen 'Hetoimasia'-Darstellungen ... ist nämlich in den letzten Jahren eine

In this study we shall also research the eschatological content within the apsidal programs. But, this does not mean that our intent is an unambiguous imagery interpretation as is so often found in such analyses.[66] As a methodological point of departure we incline rather to the position taken by E. Stommel who stresses the necessity of allowing room for ambiguity in pictorial interpretation.[67] Stommel rejects attempts to interpret early Christian art by the use of a uniform basic theory as the point of departure. He states that in using such an approach it is often impossible to find a reasonable place for all the elements of the imagery. Instead Stommel stresses that early Christian art is an art of intimation.[68] Such an approach allows for a whole complex of ideas within one single pictorial program.[69] J. Engemann has profited by this method in, among other things, his article on Paulinus' tituli.[70] Brenk too has agreed with this method in a work on early Christian art published in 1977.[71]

unverkennbare Tendenz zu beobachten, die zeitliche und thematische Mehrdimensionalität der Darstellungsprogramme im Bemühen um eine 'einheitliche' Deutung der Bilder in den Hintergrund treten zu lassen'', Engemann, Zu den Apsis-Tituli p. 34. Engemann's research survey demonstates that the interpretations of unambigous character very often point to a futuristic-eschatological reading of the imagery, see p. 34ff.

[66] See Engemann's criticism of the unambiguous interpretation of imagery in Engemann, Zu den Apsis-Tituli, see especially p. 33f.

[67] Stommel points out with further reference to Bettini: ''Die Schematisierung der ikonographischen Form aber und die eigenartige Zuordnung der einzelnen Bilder zueinander weisen sehr deutlich darauf hin, dass sie Bilder nicht einfach erzählen oder illustrieren wollen; sie wollen vielmehr aussagen. Ihre Sprechweise ist dabei notwendigerweise diejenige der gesamten gleichzeitigen Kunst, die im 2. und 3. Jahrhundert 'durch die Entrücktheit der Berichte, real und symbolisch in einem, durch die zeitlose Idealität dessen, was sich vor uns abspielt', den 'Zusammenhangen des Ganzen äusserst dünn, verwickelt, mehrdeutig' macht'', Stommel, Beiträge p. 59.

[68] ''Es ist viel eher möglich und auch eher gefordert, die Art und Weise des Ausspechens festzustellen, die für die gesamte altchristliche Kunst verbindlich ist. Das ist jene Art der Andeutung, die stets ahnen lässt, dass sich in der Darstellung eines äusseren Vorganges ihre Absicht nicht erschöpft. Dieses 'Andeutende' ist tatsächlich ein Nenner, auf den sich die gesamten frühchristlichen Kunstäusserungen bringen lassen. Die Frühchristliche Kunst ist 'signifikativ' '', ibid. p. 65f.

[69] Stommel's more exhaustive exposition is of interest: ''Es spinnen sich Beziehungen hin und her, die durch die Zusammenstellung mit weiteren Bildern in eine noch bestimmtere Richtung festgelegt werden können. So will dasselbe Bild in je anderer Nachbarschaft oder Umgebung auch je einem anders gefärbten Gedanken Ausdruck verleihen. Die Auslegung bekommt von der Umgebung her die entscheidende Richtung. Wenn die Vielschichtigkeit des gedanklichen Gehaltes und die dadurch gegebene Fülle von Möglichkeiten nicht in allen Fällen mehr eindeutig erkennen lässt, was der Künstler beabsichtigt hat, dann ist daran nicht die Methode der Auslegung schuld, sondern eben jene Eigenart der 'signifikativen' Kunst der alten Kirche'', Stommel, Beiträge p. 67. Deichmann who says that he utilizes Stommel's method, will, however, not give room for the multiplicity of interpretational possibilities within one and the same program. According to Deichmann the problem within interpretation consists in choosing the only correct among the different alternatives, see especially Deichmann, Einführung p. 198f.

[70] See Engemann, Zu den Apsis-Tituli.

[71] Brenk, Spätantike.

Our reservations concerning Brenk's results are not directed at his choice of method but rather at a lack of will to utilize the various interpretive possibilities as an approach to a deeper understanding of the apsidal programs. Instead of a uniform pictorial program we are, according to Brenk, faced with programs which are equivocal. But, he is satisfied when he can ascertain that the images refer to several levels of meaning. Here we want to go a step further. We wish to clarify how ambiguity is a prerequisite in the pictorial program in order that it may serve as a valuable part in the liturgical context.

In our study we hope to be able to substantiate that such an approach is a truly fruitful one in the interpretive process. We hope also that this method may prove of use in the understanding of the eschatological elements in the pictorial programs.

THEME GROUP I: CHRIST AS SOVEREIGN IN THE APOSTOLIC COLLEGIUM

We have chosen to concentrate the first main section of the iconographic analysis on two apsidal shaped mosaics, namely, the south-west niche mosaic in S. Aquilino (Ill. 10)[1] and the one in the apse of S. Pudenziana (Ill. 14).[2] Of the two, only S. Pudenziana's mosaic is an apsidal decoration intended for the ordinary congregational space.[3] It is thought, how-

[1] Ihm, Programme, catalogue number XX p. 158f.

[2] Ibid. catalogue number II p. 130ff.

[3] The S. Aquilino-mosaic is situated in an octagonal building which is connected to S. Lorenzo (Milan), see plan (from Brandenburg, Frühchristliche Kunst p. 122 fig. 8).

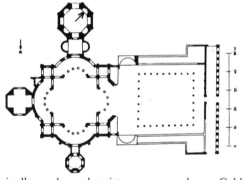

The chapel was originally used as a baptistery or mausoleum. Calderini/Chierici/Cecchelli, Basilica di S. Lorenzo regard the building as baptistery. See, however, the critical remarks in Grabar, Calderini p. 347 and Bovini, Antiquità p. 327f.
The apse vault in S. Pudenziana is also unusual as it is a part of an old bath complex, see plan (from Krautheimer, Corpus Basilicarum).

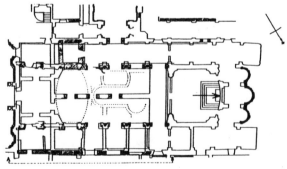

Regarding the building complex, see Petrignani, Basilica di S. Pudenziana; Krautheimer, Corpus Basilicarum vol. 3 p. 278-302 and Vanmaele, L'Église pudentienne.

ever, that S. Aquilino's decoration also reflects a program originally planned for the same type of ecclesiastical space.[4]

The two works share a common characteristic which makes it natural to examine them within the same section. Both depict a seated Christ surrounded by the complete apostolic assembly.[5] Although both works are ascribed to the 4th to 5th century transitional period,[6] the S. Aquilino mosaic is generally considered to represent an earlier stage of iconographical development than S. Pudenziana.[7] Thus, it seems reasonable to concentrate the first part of the chapter on this work.

1. From a Teaching Scene to a Representational Image

The decoration of the so-called *fastigium* which, according to the Liber Pontificalis was placed in the Lateran Basilica during the Constantinian era, is sometimes referred to as the prototype for the iconography we find in S. Aquilino.[8] It mentions, among other things, a sculpture group in which Christ is depicted seated, surrounded by his twelve apostles. There is, meanwhile, some uncertainty attached to this material from the Liber Pontificalis. Not only has doubt arisen as to the reliability of the source,[9] but scepticism towards the iconographic information in question here, is increased by a total lack of corresponding iconography from the same period.[10]

This has not prevented a number of attempts at reconstructions of the monument.[11] An arresting argument in support of a sculptural group of

[4] Ihm, Programme p. 1 note 1; see Kollwitz, Christus als Lehrer p. 53f.

[5] The collegium of the apostles in S. Pudenziana was reduced during the rebuilding operations in the church in 1588, Ihm, Programme p. 131.

[6] For dating of the teacher scene in S. Aquilino, see Calderini/Chierici/Cecchelli, Basilica di S. Lorenzo p. 241 where the mosaic is dated to the time between 360 and 370. See, however, Grabar who dates the mosaic to the beginning of the 5th century, as does Lewis, S. Lorenzo p. 219. Further proposals for dating are to be found in Lewis, S. Lorenzo p. 219 note 113 and in Bovini, Antiquità p. 349. The mosaic in S. Pudenziana is normally dated to the time of Pope Innocent I (401-417) because of an inscription read by O. Panvinio in the 16th century. De Rossi supplements it in the following way:

SALvo INNOCENtIO episcopo iliCIO MAXIMO ET ...
PREsbyTERIS LEopardus presb. sumptu proprio ...
marmORIBVS ET PICTuris DECORAVIt,

see Vanmaele, L'Église pudentienne p. 48. See, however, the inscription read by Suarez in Paul's book which gives a certain basis for dating the mosaic to the 390's, Vanmaele, L'Église pudentienne p. 48.

[7] See Kollwitz, Christus als Lehrer p. 55.

[8] Nilgen, Fastigium p. 3f.

[9] See Beskow, Rex Gloriae, p. 22 note 1; see Deichmann, Einführung p. 145.

[10] See Kollwitz, Christus als Lehrer p. 54 note 43 and Krautheimer, Constantinian Basilica p. 130 Anm. 47.

[11] See Smith, Fastigium with a proposal for reconstruction on p. 157 (fig. 3) and Nilgen, Fastigium Taf. 1.

Christ and the apostles actually being in the Lateran Basilica is the information given in the Liber Pontificalis that the fastigium was restored after Alaric's plundering of Rome, but this time probably without the sculpture group.[12] This may imply that the early 5th century church held a negative attitude towards sculptural depictions of Christ. If such is the case, the Lateran Basilica's fastigium reveals an early attempt at monumental church decoration which was subsequently rejected. Fully sculptural depictions of Christ, moreover, are barely documented in the 4th century.[13] In all likelihood the resemblence to pagan cult figures was considered too close.

Our sources give no information about details in the iconographical formula in question. The reconstructions, besides, are also based on iconographical structures from the last half of the 300's.

Better evidence for detailed and more certain studies of figural presentations of Christ and the apostles is to be found in a closer examination of one of the earliest Christ types evidenced in the iconography.[14] On the so-called polychrome fragment, dating back to about 300,[15] there are depicted a number of evangelical scenes which may best be seen as a further development in relation to the characteristic paradigmatic art of the catacombs.[16] In these scenes we shall pay particular attention to the depiction of Christ holding a scroll, with his right hand raised in a speaking gesture (Ill. 1). In front of Christ sit six small figures in short tunics, their heads raised towards the speaker. The program obviously refers to the typical teacher situation so often related in the Gospels.[17] Compared to the other scenes, all of which depict stories of miracles,[18] the teaching scene holds a unique position. Whereas each of the miracle stories has a distinct individuality which can be used as a springboard for a pictorial presentation, the teaching scene refers in a general way to Christ's teaching activities.

[12] Nilgen, Fastigium p. 4f.

[13] See, however, the statuette of Christ in Museo Nazionale Romano from c. 370-380. This statuette may have the sculpture of Christ in the Lateran Church as prototype, see Weitzmann, Age of Spirituality catalogue number 469 p. 524f.

[14] Gerke, Christus p. 11. Kollwitz, Christus als Lehrer regards a catacomb painting from Coemeterium ad duas lauros as the earliest preserved presentation of Christ as teacher p. 54, see also p. 45. Sansoni, on the other hand, maintains, in Sarc. a porte di città a fresco painting from the Pietro e Marcellino-catacomb as the earliest presentation of Christ among the apostles, p. 80. The paintings referred to are both dated to the transition from the 3rd to the 4th century.

[15] See Deichmann, Repertorium no. 773 p. 320ff.

[16] Gerke, Christus p. 9.

[17] The introduction to the Sermon on the Mount, according to the Gospel of Matthew, indicates the typical setting for this type of teaching, see Matthew 5:1.

[18] See Deichmann, Repertorium Taf. 123.733a.

We see, nevertheless, that when Jesus as teacher is rendered pic-
torially, it entails an interpretation of teaching as such. This is reflected
in the Christ type itself. In most of the scenes in the polychrome fragment
Christ is depicted with a mass of untidy hair and a long beard. Besides,
in a number of scenes (among them the teaching scene) he wears the
pallium in such a way that the greater part of his upper body is exposed.
We see, too, that the figure is barefoot. A presentation of this type refers
clearly and explicitly to the Cynic philosopher type.[19] We note, in addi-
tion, that in the teaching scene, Christ sits alone facing a listening flock.
This element also may be interpreted as an allusion to the Cynic philoso-
pher who also preached his message individually. We must, nevertheless,
be careful when interpreting the Cynic philosopher in our teacher image.
We know that this type was in general iconographical use in the second
half of the 3rd century to express *the philosopher* without necessarily referr-
ing to the Cynics rather than other schools of philosophy.[20] At the same
time we see that in several scenes in the polychrome fragment Christ
wears a tunic under the pallium and thus does not represent the Cynic
philosopher. Against this background we cannot claim with certainty that
we are faced here with a Christ type wishing to emphasize an ideal of
poverty and dissociation with cultural activities as the Cynics do—but
such an interpretation is a possibility.[21]

We add that the teaching scene on the polychrome fragment shows
signs of a symmetrical composition by the way in which the motif is con-
structed around a frontal Christ. This method of arrangement, already
a part of Italian art tradition (''arte plebea'') by the middle of the 1st cen-
tury,[22] contributes an intimation of symbolic meaning to the scene. We
see too that the teaching Christ has a tidier hair style than the other
images of Christ on the fragment.[23] F. Gerke draws attention to the
similarity to imperial portraits and maintains that just as the Cynics con-
sidered themselves the delegates of Zeus/Jupiter, this Christ type may be
seen as the delegate of the Father.[24] F. W. Deichmann too, notes Christ's
distinctive characteristics in the teaching scene but he connects this type
directly with Zeus/Jupiter presentations.[25]

[19] Gerke, Christus p. 6.
[20] See the sarcophagus from Via Salaria, Deichmann, Repertorium no. 66 p. 62f, see
also Bianchi Bandinelli, Rome p. 56.
[21] Gerke suggests such a connection: ''Es ist der Christus der Armut, der in der
Atmosphäre der ersten Fischerzeugnisse aus Galiläa atmet'', Gerke, Christus p. 10.
[22] Bianchi Bandinelli, Rome p. 80; for the definition of arte plebea see p. 457.
[23] Ibid, p. 58.
[24] Gerke, Christus p. 10f.
[25] Deichmann, Repertorium p. 321.

Finally, there is reason to stress that the figural group is placed in an historic milieu only by means of a cautiously indicated background. But, we see that Christ is seated at a higher level than the disciples, possibly on a mountain. As in the other scenes on the fragment, it seems likely that this scene refers to Jesus' activity in Palestine.

The keen interest in figural presentation is equally pronounced in catacomb paintings from the Tetrarchic-Constantinian era where Christ is depicted as a teacher among his disciples.[26] A watercolour painting in the Coemeterium Majus (Ill. 2) from the first half of the 4th century depicts Christ surrounded by six disciples but in this case the disciples are placed in a semicircle which also includes the teacher. The group is shown against a pale, anonymous background. Here we find, however, that it is not only Christ who makes the speaking gesture but also the disciples seated around him. Participation by the disciples when Jesus is giving instruction finds only slight support in the Gospels where it is only occasionally that the disciples ask a question or give a short reply. The number in the group, moreover, is surprising. This system of arranging the figures is the result of influences from pagan presentations of philosophers in discussion, gathered in groups of seven.[27] The group's clothing points in the same direction. All are clad in tunics with clavi and pallium. Likewise, all are wearing sandals. The concern is still with the philosopher attire which is mainly shown by the use of the pallium,[28] but it is no longer a question of the Cynics' garb. In this way the biblical teaching scene becomes tied to imagery's philosophical terminology although it is no longer possible to indicate a specific philosophical tendency. Christ appears simply as a classical philosopher. In our interpretation of this pictorial element we must, nevertheless, be careful in asserting that the teachings of Jesus are perceived here as a philosophy akin to contemporary philosophical schools. When the teaching Christ is to be depicted, the most closely related vocabulary is that of the philosophers. This obtains even when the teaching aspect is particularly emphasized.[29]

On this monument, as well, it is of interest to examine the shape of Christ's head more closely. Although the features are destroyed, the

[26] Survey of 4th century teaching scenes in Kollwitz, Christus als Lehrer p. 45-66.

[27] See the mosaics in Villa Albani and Museo Nazionale in Naples, Kollwitz, Christus als Lehrer p. 49. See also the mosaic in Apamea depicting Socrates directing a group of seven wisemen, Weitzmann, Age of Spirituality fig. 70 p. 514.

[28] Delbrück, Consulardiptychen p. 33.

[29] Although it is generally accepted that within learned circles at that time, Christianity was considered a philosophy, see for example Justin, Dialog. 8.2.1 (Van Winden, Philosopher p. 14, see also commentary at p. 119), I hesitate to transfer this interpretation automatically to iconography.

impression is of a youthful and beardless Christ. In any case it is quite evident that the hair is arranged in regular curls, a fact which clearly distinguishes him from the disciples. This hair style is reminiscent of the type usually used for dioscuri and heroes on mythologically decorated sarcophagi.[30] Gerke calls this Christ type Christus heroicus. The particular facial type on this monument is utilized to emphasize Christ's special position in the philosopher group. The *suppedaneum* on which Christ's feet rest also emphasizes that he is the central figure while at the same time this type of presentation heralds a new pictorial genre, that of king and ruler. So, in this way, we are led from the polychrome fragment's presentation of Christ in an historical setting to a more general type. This type is primarily determined by a philosophically influenced teaching situation but in it may also be found elements of hero and ruler themes.

The special position held by Christ within the group is further established by a painting in the lunette of an arcosolium in the crypt of Ampliatus from about 340 in the Domitilla catacomb. Here Christ and the apostles are depicted as youthful and without beards (Ill. 3). Christ's physiognomy appears to be of the same type as we have seen in the previous monument. In this case, Christ is just slightly raised above the apostles but is emphasized in relation to them by a high back rest. Furthermore, his right hand is raised in a more commanding than teaching gesture while at the same time he demonstratively holds forward the scroll in his left hand. His decisive gaze follows the right hand gesture. The impression conveyed is the wish to interpret the teaching scene as one of authority—it is Christ who conveys the obligatory learning as depicted here. This effect is obtained by inserting into the teaching scene elements from the enthroned Christ type. It is, however, not only the high back rest behind Christ which suggests a closer relationship to a throne scene. An addition has been made to the teaching scene by the depiction of two neutral persons behind the Christ figure. This may possibly be an allusion to imperial bodyguards—*protectores divini lateris Augusti*—with which we are familiar from such as the Oratio scene on the Arch of Constantine where they are placed behind the senators surrounding the emperor (Ill. 27). Thus, a closer approach to imperial themes is more clearly expressed in the Domitilla catacomb teaching scene than in the already discussed painting from the Coemeterium Majus.

On the Junius Bassus sarcophagus from 359 all caution has been abandoned (Ill. 4).[31] In the central niche of the upper register (Ill. 5) a

[30] Gerke, Christus p. 19, see also note 55.
[31] Deichmann, Repertorium no. 680 p. 279ff.

youthful, beardless Christ with medium length curled locks, is seated on an armless throne. In his left hand he holds a scroll and his missing right hand has probably been lifted in the speaking gesture. Apostles stand on each side. The apostle to the right of Christ holds a scroll. The presentation is clearly based on earlier teaching scenes—both the speaking gesture and scroll corroborate this. We recognize, furthermore, the symmetrical figure group from earlier monuments. The frontality of the image, however, has a somewhat different character than that of the teaching scene in the Catacomb of Domitilla. Christ's gaze is now straight forward and similarly the whole figure is directed straight at the onlooker. At the same time, the actively speaking character of the Domitilla Catacomb is subdued— Christ sits almost motionless on his throne surrounded by the apostles.

In considering the polychrome fragment the use of frontality was seen as alluding to a symbolic content. The elevation to be found on the Bassus sarcophagus supplements and amplifies this symbolic value. The inspiration seems to derive mainly from the historical frieze on the Arch of Constantine which reflects the obvious ideological influence of court ceremony. In the Largitio scene (Ill. 6), where the affinity to the Bassus sarcophagus is clearest, the emperor is placed in the centre of the pictorial program in a stiff frontal position, undoubtedly reflecting the absolute immobility required by court etiquette.[32] The object of such a presentation technique is to draw attention to the importance of the emperor.[33] In all probability, this same aim lies behind the presentation of Christ on the Bassus sarcophagus. Just as the imperial scene presents the emperor and his attendants as "Repräsentanten und Begriffe der kaiserlichen Majestät",[34] the Bassus sarcophagus is an expression of Christ's sovereign authority.

Christ's physiognomy on the Bassus sarcophagus, which clearly distinguishes him from the previously discussed monument, supports

[32] Bianchi Bandinelli underlines that the oriental influence is "ideological rather than artistic", see Bianchi Bandinelli, Rome p. 80.

[33] "The iconographic structure of the composition, in fact, is determined by its ideology, yet at the same time worked out through local formal elements, in which plebeian and official trends have met and fused", Bianchi Bandinelli, Rome p. 80. See, however, Brandenburg, Stilprobleme, who does not want to connect the Arch of Constantine stylistically to popular art, but rather holds that it expresses "genuin römische Kräfte" p. 449f. See also Budde, Entstehung who finds eastern elements of style. For the symbolic content, see also Budde, Entstehung p. 8: "Dies fast bewegungslose Frontalität der Figuren, ... das Abstrakte und Unbelebte ihrer neutralen und idealen Hintergrundflächen, auf denen die Gestalten erscheinen, dienen letzten Endes alle der gleichen Aufgabe, der Vertiefung geistiger Vorgänge und eines gedanklichen Zusammenhanges."

[34] Budde, Entstehung p. 8.

such an interpretation. In the Bassus sarcophagus' "beautiful" Christ, Gerke finds elements of the so-called Christ of the seasons, in which association to a symbolism of the seasons relates him to the concept of Rome's growth and prosperity,[35] but he finds also a connecting link to the puerile Christ type in which he is presented as eternally young.[36] By means of such characteristics the beautiful Christ type emerges with the indisputable dignity of a sovereign.[37]

That supreme authority dominates the presentation of Christ on the Bassus sarcophagus is elaborated upon by the other iconographical elements in the composition. In the Christ scene in the Domitilla Catacomb we saw a back rest behind Christ. Here, on the contrary, he is placed on a throne. A new aspect is added to the original teaching scene which results in a shift in the main point of the meaning. The scene is still related to the teaching scene but, in addition, it emerges as the unequivocal presentation of a ruler. The key to the interpretation of the sovereign theme as indicated here is to be found in the motif beneath Christ's feet where we see a figure under an outspread veil as a personification of Heaven. By the use of this symbolism the sovereign is placed in Heaven. A more precise meaning must be sought in ancient religious conceptions associated with such pictorial imagery.

According to F. Cumont, the motif originates in concepts related to the Persian Ahura-Mazda, the ancient god of the vault of heaven who was simply called Coelus or Jupiter Caelestis, Ζεὺς Οὐράνιος. This supreme god according to uranography had his abode in the world's most elevated region, above the planets and fixed stars. This was expressed by the term Ὕψιστος which is used on Syrian coins but also by the conception that he resided in an enormous globe containing the spheres of the stars and which embraced the entire universe which was subject to his rule.[38] Conceptions of a deity above the vault of heaven emphasize the superior as well as the cosmic perspective of the deity. So we see that in a Roman context images of Jupiter above the veil of Coelus symbolize alike that Jupiter is the foremost god and has universal sovereign power.[39]

This symbolism, however, does not belong solely in a religious context. On the Arch of Galerius in Salonica, Diocletian and Maximian "Herculius" have their feet on similar semicircular veils which in turn

[35] Gerke, Christus p. 23. It is of interest that seasonal symbolism is utilized on the narrow sides of the Bassus-sarcophagus, see Deichmann, Repertorium Taf. 105 no. 680, 2 and 3.

[36] Gerke, Christus p. 29.

[37] Ibid, p. 32f.

[38] Cumont, Oriental Religions p. 127f.

[39] Alföldi, Zum Panserschmuck p. 58, see also Taf. 19. For the identification of the God of Heaven and Jupiter, see Wissowa, Caelus col. 1276f.

are drawn over busts.[40] In the interpretation of these elements we follow
H. P. Laubscher who emphasizes that the figure beneath Diocletian's
feet is a male as distinct from the figure beneath Maximian.[41] The male
figure is interpreted as a rendering of Coelus, but the bust underneath
Maximian is perceived as a personification of the earth seen as Orbis
Terrarum.[42] Laubscher sees them as cosmocrator images in which the
emperors as Jupiter's representatives exercise the function of supreme
authority over the world understood as heaven and earth.[43]

Coelus symbolism has thus been utilized in a religious as well as
political context. When this iconography is taken into use in Christian
sarcophagus art it seems very likely that it is meant to characterize
Christ's sovereign authority in the same way as it is expressed in contem-
porary conceptions of theology relating to his cosmic dominion. There is
no doubt, however, that the clearly defined religious-political aim to
which the Coelus symbolism has been adapted at an early stage may
influence the interpretation of the symbolic use. This seems, however, to
cause particular problems. For, when Christ is associated with pictorial
elements utilized in presentations of Jupiter or emperors, also indicating
a more comprehensive ideological framework, the following inter-
pretative areas are revealed immediately as relevant possibilities: Does
Christ now assume the same function which Jupiter previously held in
relation to imperial authority or does he challenge state authority by
being placed on the vault of heaven?

The subsequent fate of this symbolism shows that this pictorial theme
was found difficult at that time. On one hand, the emperor hesitated to
use the pictorial element in imperial iconography after it was taken into
use in a Christian context.[44] The presentation of the emperor as
cosmocrator emerges as an impossibility for Christian emperors. On the
other hand, creators of Christian art were aware of the risks involved in
utilizing an iconographical formula too closely associated with pagan
imperial models. Thus, Coelus symbolism never became established as
an iconographical element in Christian pictorial art. The emperor is
forced to abandon the pictorial element because of it religious content;
Christians come to reject it because of its political associations.[44A]

[40] Laubscher, Reliefschmuck Taf. 45. 1 and 60. 1.
 [41] Ibid, p. 75f referring to Kirch, Alföldi, Kollwitz and L'Orange's interpretations of
the motif.
 [42] Ibid, p. 75.
 [43] Ibid, p. 77.
 [44] MacCormack, Art and Ceremony p. 130.
 [44A] P. Beskow has drawn my attention to the coelus motif which has survived within
byzantine art on the pentacostal icon.

Against this background the Bassus sarcophagus' Christ type emerges as a first attempt to give pictorial expression to Christ's universal sovereign authority. The intention behind the Coelus Christ type must be to represent him as ruler of the cosmos. Seen in relation to the previously discussed teaching scenes we are faced here with a presentation of Christ containing essentially new characteristics. The anonymous backgrounds of these previous teaching scenes show that no attempt has been made to put the scenes into an historic milieu. It is evident, all the same, that the scenes primarily refer to Christ's activities on earth. On the Bassus sarcophagus the presentations of Jesus' activities while on earth are adapted to a totally new thematic program. Interest shifts from earthly activities to cosmic orientated conceptions.

2. Towards a Specifically Christianized Setting

We have already stated that the use and spread of Coelus symbolism within Christian pictorial art was limited. Shortly after its introduction into a Christian context it disappears to be replaced by other settings for the Christ figure. We have also suggested that the close association of Coelus renditions with pagan conceptions has most probably been seen as more of a problem than a positive challenge. In any case it is evident that the setting for the representational image of Christ in the last half of the 4th century becomes associated with Biblical traditions in quite a different way than does Coelus symbolism. From the pictorial programs it emerges clearly, meanwhile, that it was no easy task to find a representative image which would satisfy the church.

The west niche mosaic in S. Costanza (Ill. 8)[45] suggests that, to begin with, experiments using motifs other than those showing Coelus symbolism were made. In its present state, the mosaic depicts Christ on the sphere of the world. It has, however, been subjected to so many restorations that not only is there uncertainty concerning the interpretation of the pictorial program as a whole,[46] but also as to whether the sphere was a part of the original composition. In the Via Latina catacomb there is a scene in which Christ is seated upon a throne merely indicated by a cushion hardly distinguishable from the outline of the body.[47] By comparing this scene with that of S. Costanza, Schumacher contends that the same has been the case with the S. Costanza mosaic.[48] Schumacher's assumption, however, cannot be taken as a conclusive argument against

[45] Ihm, Programme, catalogus number I p. 129f.
[46] Alternative suggestions for interpretation in Ihm, Programme p. 129.
[47] Schumacher, Römische Apsiskomposition Taf. 22. 2.
[48] Ibid, p. 144.

an interpretation of the sphere as Christ's seat. The apsidal program of
S. Agata dei Goti, destroyed in 1589 or 1592, has come down to us in
the form of 14 coloured drawings which form the basis for Ciampini's
reconstruction of the program.[49] Here a long-haired, bearded Christ clad
in a tunic with clavi, pallium and sandals is shown on a blue sphere. His
left hand holds an open book while the right hand is raised in the speak-
ing gesture. He is surrounded by acclaiming apostles, each carrying a
scroll except Peter who holds a key. This rendering of Christ has carried
the inscription SALVS TOTIVS GENERIS HVMANI which again has
its parallel in imperial titular tradition.[50] We have, thereby, also an inter-
pretation of the program; Christ placed on a sphere is not primarily a
Christ raised up and away from the world but rather a Christ as the
saviour of mankind. The purpose of the sphere is to lend to Christ's work
a universal quality where the validity of salvation for everyone is
emphasized. The sphere motif points in the same direction as when in
an imperial context where it is usually utilized to denote universal
authority.[51]

It is useless to attempt further detailed examinations of the S. Costanza
pictorial program. The many restorations, as has been said, disturb the
formula to such a degree that the remaining details of interest, such as
the article Christ presents to the figure on the right, are unidentifiable.[52]
We shall, therefore, content ourselves with pointing out that it probably
belongs within a development of tradition leading from the Coelus to the
Christianized image of the heavenly Christ.[53]

Another example of the experimental in contemporary presentations
is found in the so-called Concordius' 11-niche sarcophagus in Musée
d'art chrétien in Arles (Ill. 9), dating from the last quarter of the 4th cen-
tury.[54] Here Christ is raised above the apostles and his feet placed on a
suppedaneum. As so often is the case, his right hand is held up in speak-
ing gesture and he holds a book in his left hand. He deviates from the
teaching type we have met earlier by having a beard, a characteristic
possibly adopted from traditio-legis presentations (see p. 42). The twelve

[49] Ihm, Programme, catalogue number XVI p. 153 and Taf. IV. 1.
[50] Ibid, p. 15 note 15.
[51] Alföldi, Monarchische Repräsentation p. 235ff.
[52] According to Schumacher, "das Mosaik erlitt so zahlreiche Restaurationen, dass
der Urzustand nicht mehr auszumachen ist; wir können nur den Umkreis der
Möglichkeiten abzuschreiten versuchen", Schumacher, Römische Apsiskomposition p.
139.
[53] The globe is not replaced by other ways of indicating the setting of Christ's activity
(see e.g. S. Vitale where the setting is maintained in the beginning of the 6th century),
but it is forced into the background in favour of other motives.
[54] Klauser/Deichmann, Bild und Wort p. 33f.

apostles are seated on chairs which have arms in the form of dolphins. It is striking that here the apostles are not only listening to the discourse but by their gesticulations and actions give the impression of greater participation than seen earlier in the catacomb paintings. One turns aside and talks with the man beside him while two of the others read in their open scrolls where their names are inscribed. Only the two apostles closest to Christ give him their full attention. Here we lack the Coelus theme but find instead a colonnade which may be taken as alluding to a secular arched hall[55] or to a basilica projected onto a plane.[56] Whereas the basilica interpretation relates the teaching scene to a liturgical space, the columned hall interpretation points towards a council chamber where Christ appears as a high official surrounded by his assistants. The pictorial program itself reveals no grounds from which to choose one or the other interpretation. We find, meanwhile, that the figures in the gabled areas cause some adjustments to be made in the background's association with a liturgical or bureaucratic context. The male figure with covered hands in the left gabled niche is attended by an upright male figure while the woman on the right is accompanied by another woman. In all probability the scene depicts the dead being led before Christ and his disciples. Thus, interest is not only focused on an ecclesiastical space or a council hall but equally towards an eschatological courtroom, an interpretation which is, moreover, supported by the inscription on the lid. We note, meanwhile, that the judgement to come is anticipated in that Bishop Concordius, for whom the sarcophagus was made, is spoken of as already having risen up to the hall of the Almighty.[57] The background in this way becomes an ambiguous pictorial element with an ambivalent meaning. It is in this equivocal setting that Christ sits enthroned among his apostles.

Nor is it this setting which will dominate scenes of the teaching Christ in the second half of the 4th century. In S. Aquilino's niche mosaic (Ill. 10) we find the basic element of the setting which will have great influence on teaching scenes in the last half of the century. In S. Aquilino, Christ is depicted seated, surrounded by the apostles. He is raised high above the apostolic group and shown with strict frontality. In his left hand he holds a half-open scroll in which the writing is turned

[55] Ibid, p. 69.

[56] Gerke, Malerei und Plastik p. 136ff; see also Duval, Representation p. 248f.

[57] Klauser/Deichmann, Bild und Wort p. 70. According to Klauser the following is carved on the lid of the sarcophagus: "der Bischof Concordius sei plötzlich an den 'Hof des Allmächtigen in der Sternwelt (*siderea aula*) hinweggerafft' worden. Die hinterbliebenen Familieangehörigen, Mutter und Bruder, 'suchen ihn noch unter den Lebendigen' (*sine funere quaerunt*)''.

towards the onlooker. The right hand is lifted in a gesture frequently found in traditio-legis presentations and will, therefore, be treated in that section (see p. 72). Immediately in front of Christ's feet is a box of scrolls which maintains the scene's association with the teaching motif. In the first place, indications of the scene's location are of interest. We have said that all the figures are sitting but note that only in the case of Christ is it possible to make out a sort of seat, one which, moreover, is provided with cushion and suppedaneum. But the bench and footstool glide almost unnoticeably into a rocky landscape.[58] So, a throne motif is combined with a mountain motif which, furthermore, includes a spring.[59]

We perceive the S. Aquilino combination of a mountain with a particular seating arrangement as an attempt to "Christianize" the teaching scene. We are, of course, aware that the mountain does not represent a pictorial element peculiar to Christianity but has a wide religio-historical usage. The "Christian" in this context, implies that the use of the motif within the type of iconography being examined here, appears to have biblical literary material as its primary source of inspiration.

The development towards a pictorial program mainly rooted in biblical imagery is carried further in the apses of Paulinus of Nola (see p. 90) and very likely reflects one of the most important driving forces behind the process of iconographical development in the 4th century. G. Schiller supports such a tendency by referring—without, however, evidence of source material—to Ambrose who is supposed to have encouraged artists to free themselves from ancient traditional motifs.[60]

In working with so-called "Christian" pictorial motifs, searching for pagan iconographical models will naturally play a minor role. We prefer here to support our interpretation by means of biblical references and patristic texts as well as iconographical parallels which contemporary Christian art has to offer. It seems natural in this connection to emphasize the figurative language of the Scriptures. If the goal of the artist was to work towards an apsidal presentation not too greatly indebted to, for example, imperial models, the source for alternative pictorial elements would quite naturally be the Bible where a wealth of religious motifs—developed throughout the centuries—was readily available.

[58] "Ma più che un vero subsellio e vero suppedaneo, sembrano roccie più eminenti", Calderini/Chierici/Cecchelli, Basilica di S. Lorenzo p. 203.

[59] Cecchelli suggests that water is depicted on the front of the mosaic: "Il terreno erboreo su cui si spiega questo *Collegium Apostolorum* s'interrompe sul davanti come in una frangiatura di roccia (ma non in mezzo) e rivela, a destra e a manca l'esistenza forse di acque", Calderini/Chierici/Cecchelli, Basilica di S. Lorenzo p. 203. P. J. Nordhagen's investigations confirm the presence of water in a narrow zone at both sides of the throne.

[60] Schiller, Ikonographie III p. 174.

In our work with the mountain motif we shall first of all draw attention to existing Christian iconographical antecedents to our motif before making a closer examination of the supporting textual material. Christian sarcophagi from the beginning of the 4th century often show a mountain beneath the left foot of Moses in scenes depicting the agreement of the Covenant on Sinai. Moses climbs to the top of the mountain and receives the Law presented to him from God's right hand. The scene is frequently rendered on the left side of the clipeus with Abraham's sacrifice on the opposite side.[61] This motif group has clearly been given a typological interpretation—the Moses scene presages Christ as teacher while the sacrificial scene refers to the death of Christ. Teaching scenes placed in the central niche of a sarcophagus as we have seen in the Bassus sarcophagus may thus be seen as a further development of this Moses theme from the beginning of the century.

The account in Exodus of Moses receiving the Law tablets shows the importance attributed here to the mountain. Exodus 19:2 f. reads, "and there Israel encamped before the mountain. And Moses went up to God, and the Lord called to him out of the mountain" Further on it relates, "And the Lord came down upon Mount Sinai, to the top of the mountain; and the Lord called Moses to the top of the mountain ..."[62] The mountain emerges here as the place where God reveals himself to the people and which Moses, as the chosen, may climb. The mountain is, indeed, an earthly reality but simultaneously refers to God's own sphere—it becomes a transcendental motif.[63]

When consecrating the church in Tyre, Eusebius of Caesarea formulates related conceptions when Mount Zion, the heavenly mount is perceived as a paradigm for the earthly Zion.[64] Here the mountain refers to a reality which can only be grasped in figural relationships in which an earthly reality reflects a Divine reality.

[61] Examples of this combination of motifs are found on the sarcophagi no's 184 and 189 from the Lateran collection, see Deichmann, Repertorium no. 39 and 40 p. 33-36, see also Taf. 12. 39 and 12. 40.

[62] Ex. 19:20.

[63] P. Brown says that revelation for people in the Late-Antique meant "the joining of two spheres". As support for this statement he refers to Exodus rabbah, Wa'era XII. 4 which comments on the meeting between Moses and God on Mount Sinai. We quote Brown's text: "When the Holy One, blessed be he, created the world, he decreed and said, 'The heavens are the heavens of the Lord, and the earth he gave to the sons of men' (Ps. 115:16). When he sought to give the Torah, he repealed the first decree and said, Those which are below shall come up, and those which are above shall come down. And I shall begin; as it is written, 'And the Lord came down upon Mount Sinai' (Exod. 19:20). And it is also written, 'And he said to Moses, Come up to the Lord' (Exod. 24:1)'', Brown, Making p. 17.

[64] Eusebius of Caesarea, Hist. Eccl. X. IV. 70 (LCL. 265. 442).

To perceive the iconographic utilization of the mountain in presenta-
tions of Christ in the same way suggests itself. When Christ is seated
upon the mountain, he is placed in God's abode. The interesting point
in the choice of this motif is that it can serve as a meeting place between
God and man. It becomes God's own sphere and that which is earthly
at one and the same time. Thus, Christ is placed intentionally on the
mount of God instead of the vault of heaven or in a basilica/council hall
in order to establish exactly this aspect of meeting. In this way, the
presentation avoids suggesting related pagan conceptions as did Coelus
symbolism. It is not confined to the domain of the church space nor does
it refer to the somewhat irrelevant council hall as in the Concordius sar-
cophagus. In S. Aquilino Christ appears as sovereign of the world—no
longer placed in heaven but yet no closer to earth than the top of the
sacred mount allows. As a result, the depiction takes on an intended
ambiguity with the mountain becoming a physical reality and a Divine
place simultaneously. Christ on the mount emphasizes both proximity to
and distance from the world. On this point mountain symbolism goes
beyond previous indications of a setting and at the same time a
background motif which is well supported in the Scriptures has emerged.
The representational image is now Christianized.

3. The Utilization of Light Symbolism

We have drawn attention to the fact that the representational image
reflects Christ's sovereign dignity. The mountain indicates that his
almighty power issues from God's abode. In these motifs lies the implica-
tion that Christ represents God. This conception, however, is most
clearly and precisely expressed in another element in S. Aquilino's apse.
Here we see Christ's head surrounded by a halo carrying not only
Christ's monogram but the letters A and Ω as well (Ill. 10). The halo,
it seems, was hardly used in Christian pre-Theodosian pictorial art,[65]
and even in the Theodosian era Christ appears frequently without it. It
is only the frontal, representational Christ who, towards the end of the
century, is depicted with a halo.[66] Again it is imperial art which supplies
the direct iconographic model. This pictorial type has its premises in con-
ceptions related to the sun god. In this connection the radiate crown used
by the diadochi and which gradually becomes identified with the sun
radiate, comes to play a considerable role.[67] Already on Nero's coins the

[65] Gerke, Christus p. 52. Gerke's statement presupposes a late dating of the niche
mosaics in S. Costanza.
[66] Ibid, p. 52.
[67] Alföldi, Monarchische Repräsentation p. 225.

emperor has himself portrayed radiate.[68] In this case, however, it is hardly a case of an unequivocal use of the sun god theme. It is first during the Severan era that the radiate crown is interpreted as a definite sun symbol.[69] According to A. Alföldi, Geta is the first to be depicted on an official coin as the sun (in reality as a descendent of the sun king) and then not with the usual radiating crown but with the sun god's "Strahlenreif".[70] It is not until the Constantinian period that the radiate crown becomes usual in presentations of the emperor. Here we see, however, that Constantine's "conversion" leads to its discredit and replacement by the halo which first comes into frequent use under the regents of Diocletian but which the Christian emperors retain.[71]

The imperial use of sun symbolism is by no means arbitrary. This is first seen clearly under Aurelian. From now on the sun cult is considered an official state affair and likewise it is first during his reign that emperor ideology becomes officially connected to the sun cult.

That the sun god is very closely related to emperor ideology and at the same time utilized in imperial iconography is established. On the other hand it is difficult to form a clear picture of the reason behind imperial usage of precisely the sun theme. The sun cult did not, in fact, hold a strong position in the Roman pantheon and must largely be considered an imported Syrian cult, admittedly adapted to Roman traditions.[72] Our knowledge of this religion is very superficial, equally in its original form and when Romanized. The main source material is inscriptions which, it is true, tell of the spread of this religion at various times but give little information about the conceptions of the cult itself.[73] G. H. Halsberghe connects the sun cult's basic theme with the ancient struggle between the powers of light and darkness in which the god of light, in this case the sun god, triumphs over the powers of darkness.[74] Cumont maintains, for his part, that the cult's origins must be sought in Syrian lightning divinities, later connected to the Persian's heavenly deity Ahura-Mazda and which influenced by cosmological speculation particularly stress the sun's unique position in the universe.[75]

[68] Ibid, p. 261 see Taf. 13. 11 and 7. 2.

[69] Ibid, p. 261.

[70] Ibid, p. 226 see Abb. 9.

[71] Ibid, p. 263.

[72] Halsberghe underlines the Roman background for the sun cult, see Halsberghe, Cult of Sol Invictus p. 26f. This does not mean that there is any doubt about the influence of the Syriac sun cult on Roman territory from the 2nd century onwards, see p. 38ff.

[73] Ibid, p. 162f., see also Cumont, Oriental Religions p. 115.

[74] Halsberghe, Cult of Sol Invictus p. 162.

[75] "The sun was supreme because it led the starry choir, because it was the king and guide of all the other luminaries and therefore the master of the whole world. The astronomical doctrines of the 'Chaldeans' taught that this incandescent globe alternately

It is in these circles holding such conceptions that the seeds of monotheistic thinking are to be found and there is good reason to presume that this is one of the reasons that the Latin world was to be attracted by this form of religion. In any case it is striking that the beginnings of monotheistic features seem to have played a special role in Roman inscriptions.[76] In this way the sun cult probably was a contributary factor in the increased popularity of monotheistic or at least henotheistic concepts which previously had been mainly a philosophic, metaphysical theory in the Latin world. Cumont sums up: "The last formula reached by the religion of the pagan Semites and in consequence by that of the Romans, was a divinity unique, almighty, eternal, universal and ineffable, that revealed itself throughout nature, but whose most splendid and most energetic manifestation was the sun."[77]

These monotheistic features were to become important for the political power required and put into force by the emperors. The demand for world mastery is founded precisely on monotheism. This is clearly seen on some of Diocletian's coins on which the sun god is depicted with whip and globe beneath the inscription: AETERNITATE AUGUSTORUM or SOLI INVICTO.[78] With the help of the sun cult the emperors evidently wished to be regarded as an emanation of the sun god. The sun god rules the world through the emperor who himself becomes a supernatural being. Just as the cosmic laws are invested in the sun so is worldly law invested in the emperor. Imperial politics thus attains a religious cover through its connection with sun symbolism; the emperor perceives his own power as divine.[79]

When this iconography is adopted by Christianity it is put into an ideological context in many ways alien to Roman imperial ideology. The basis for the iconographic transfer to a Christian context is, nevertheless, straightforward enough; the emperor just as Christian image-makers could, by using sun god attributes, express a monotheistic perception of God with special emphasis on the function of sovereign. Here, undoubtedly, the Emperor Constantine's utilization of Sol Invictus as

attracted and repelled the other sideral bodies, and from this principal the Oriental theologians had concluded that it must determine the entire life of the universe, inasmuch as it regulated the movements of the heavens", Cumont, Oriental Religions p. 133.

[76] Halsberghe, Cult of Sol Invictus p. 166, see also Wissowa, Religion und Kultus p. 299-307.

[77] Cumont, Oriental Religions p. 134.

[78] Halsberghe, Cult of Sol Invictus p. 166.

[79] "Diese Vorstellungen von dem gottgeborenen und zu Gott werdenen Kaiser wurden seit jeher offiziös als *diis genitus deosque geniturus* fast titular zusammengefasst und gebraucht", Alföldi, Monarchische Repräsentation p. 202. See, however, the religious limitations within the cult of the sovereign, Nilsson, Bedeutung p. 299.

the ideological basis for his absolute power acted as the necessary connecting link between the earlier imperial usage of sun symbolism and the Christian identification of sun and Christ. This image type, however, has not proven to be without difficulties for 4th century creators of pictorial art—whether it concerns Christian or imperial imagery. The problems are most noticeable within imperial iconography. Although the halo is retained by 4th century Christian emperors the impression given is that its religious importance is gradually reduced. This tendency is seen most clearly in imperial titles. Emperors who from the time of Domitian used the title Dominus et Deus abandon such usage in the 4th century and are satisfied with the more neutral dominus noster (in Greek κύριος is replaced by δεσπότης).[80] The imperial, divine epithet must give way to more neutral ruler epithets. We find signs of the same attitude within the iconography. The halo around Herod's head on the triumphal arch of S. Maria Maggiore[81] is not a reference to Herod's divine rank but solely represents him as a ruler over the land of the Jews. In this case the reference is purely to secular power.

On the other hand we shall see that the primary purpose of using light symbolism in patristic theology is to clarify Christ's relationship to the Divinity. We are faced here with a figurative mode of expression with rich traditions within Christian theology throughout the centuries up to the 300's.[82] Seen thus, the utilization of light symbolism has, indeed, been considered as more natural than most of the other elements which Christians were to adopt from imperial imagery. In order to reach a more precise understanding of this use of imagery in a Christian context it is, therefore, natural to examine the utilization of the light theme in patristic theology. Here it will, of course, be only a question of indicating typical tendencies. Our textual references are meant to give an impression of the problems facing the early church in using light symbolism in an acceptable way. Likewise, the texts reveal that it was not to be taken for granted that the symbolism would be utilized to place Christ ontologically on the same footing as the Father as was the case in Nicene theology from the 300's.

The writings of Justin reveal one of the earliest discussions concerning the possibility of light symbolism as an elucidation of the relationship between Christ and God. The point in question here is the transference of the relationship between sunlight and sunrays to the relationship

[80] Rösch, ONOMA ΒΑΣΙΛΕΙΑΣ p. 39.
[81] Karpp, Mosaiken in S.M.M. Taf. 26.
[82] The patristic utilization of sun symbolism is treated thoroughly in Dölger's studies. See Dölger, Sonne und Sonnenstrahl and Sol Salutis.

between God and Christ. Justin is afraid, however, that the identity of
the Logos is threatened when it is said that the Logos cannot be separated
from the Father in the same way than sunshine cannot be separated from
the sun above.[83] The tendency to obliterate the difference between God
the Father and the Son is strengthened in the light symbolism of
Sabellianism where comparison with the sun is utilized in such a way that
the difference between the persons of the Godhead disappear. The sun
is spoken of here as an image of the Trinity. Its one hypostasis comprises
three energies: the power to light, the power to warm and the spherical
form itself which corresponds to the position of the Son, the Holy Spirit
and the Father within the Godhead.[84] Here the differences between the
three persons of the Deity have been done away with outright.

On the other hand, Tertullian in his light symbolism, faces the
opposite problem—how to keep the Son's essential equality to that of the
Father. Tertullian maintains that the Son may be called the sunray in
that the Father is his source and everything issuing from the source is a
progeny (progenies).[85] Although Tertullian clearly strives to maintain
the essential equality of the Father and the Son, it is not possible to escape
the fact that the idea of subordination is obvious within this terminology.
This same tendency is noticeable in Origen as well, even if he emphasizes
the Logos' eternity and his indivisibility from the Father.[86] It is in this
way that Origen has been interpreted by posterity.[87]

In their concern at becoming involved in an unacceptable Christology,
the Fathers of the Church draw more and more away from a concrete
image of the sun and its rays and their terminology takes a new turn.
This emerges already in Dionysius of Alexandria who points out that the
sun is not suited to the expression of the relationship between the Father
and Son because the sun lacks the significant feature of eternity which
is characteristic of the Deity. That the sun rises and sets, thereby deter-
mining the length of the day, clearly shows its limitation.[88] Dionysius,
therefore, uses the term eternal light as the character of that God who is
without beginning and without end. The eternity belongs also to the
radiance which is without a beginning and which may therefore be des-
cribed as φῶς ἐκ φωτός.[89]

[83] Justin, Dialog. 128. 3 (PG. 6. 776).

[84] Epiphanius, Panarion 62. 1 (PG. 41. 1052).

[85] "omne, quod prodit ex aliquo, secundum sit eius necesse est, de quo prodit, non
ideo tamen est separatum", Tertullian, Adv. Prax. 8 (CSEL. 47.239).

[86] Dölger, Sonne und Sonnenstrahl p. 280f.

[87] According to Jerome, Origen taught "deum patrem esse lumen inconprehensibile;
Christum conlatione patris splendorem esse perparuum, qui apud nos pro inbecillitate
nostra magnus esse uideatur", Jerome, Epist. 124. 2 (CSEL. 56. 97).

[88] Athanasius, De sent. Dion. 15 (PG. 25. 501-504).

[89] Ibid, 15.

In times to come, constant attempts are made to clarify just exactly what the term "light of light" implies. Arius' explicit rejection of the image is directly responsible for the emphasis laid upon it in the Nicene Creed.[90]

The Council of Nicaea leads to the term being drawn into the controversy about ὁμοούσιος. Basilius of Caesarea interprets the Nicene Creed's ὁμοούσιος precisely by looking at it in connection with the preceding φῶς ἐκ φωτός. Thus it is ascertained that a comparison with light may not be used only about the Father but also about the Son: "For, true light will show no variation from true light according to the very conception of light. Therefore, since the Father is light without beginning, and the Son light begotten, but one is light and the other is light, they rightly say 'consubstantial' in order that they may show the equal dignity of their nature."[91]

There is every reason to believe that the use of light symbolism as "authorized" at the Council of Nicaea forms the basis for interpretation of the 4th century halo. When Christ is represented with a halo by orthodox patrons it means that he is perceived as ὁμοούσιος with the Father. Through precise theological definition an iconographical element, in itself open to various interpretations, is given an unambiguous meaning content.[92]

The utilization of the halo in S. Aquilino's Christ image also shows that its purpose is to accentuate the Divinity of Christ. The Christogram, as mentioned before, has been worked into the halo. A and Ω refer to statements of the type found in Revelation 1:8, "I am the Alpha and the Omega says the Lord God, who is, and who was, and who is to come, the Almighty." (cf. Revelation 21:6 and 22:13). The purpose of the assertion is to characterize God as being itself, as sovereign, independent of any explicit time. When this characteristic in S. Aquilino is transferred to Christ, it emphasizes clearly that he has the right to the

[90] Dölger, Sonne und Sonnenstrahl p. 284f.

[91] φῶς γὰρ ἀληθινὸν πρὸς φῶς ἀληθινόν, κατ' αὐτὴν τοῦ φωτὸς τὴν ἔννοιαν, οὐδεμίαν ἕξει παραλλαγήν. Ἐπεὶ οὖν ἐστιν ἄναρχον φῶς ὁ Πατήρ, γεννητὸν δὲ φῶς ὁ Υἱός. φῶς δὲ καὶ φῶς ἑκάτερος, ὁμοούσιον εἶπαν δικαίως, ἵνα τὸ τῆς φύσεως ὁμότιμον παραστήσωσιν, Basilius of Caesarea, Epist. 52. 2 (PG. 32. 393).

[92] Grabar takes a sceptical attitude towards a too close relation between Christological formulations and the iconographical motifs. He doubts "the existence at that time of iconographical terms sufficiently precise to express theological notions that were difficult to translate into imagery", Grabar, Iconography p. 121. We agree with Grabar that imagery seldom is precise in itself. On the other hand we find it reasonable to give imagery which correspond to precise theological formulations an unambigous interpretation.

same rank of Deity. This corresponds, moreover, with the use assigned to the term pantocrator in literary sources in the 300's (see p. 8).[93]

The wish to give Christ's Divine dignity an iconographical shape is supported by both the program's compositional form and by the development in style which marks pictorial presentations from the end of the century. Previously (see p. 24) we have discussed the typical pictorial formula which in the west is especially evident in the historical frieze on the Arch of Constantine but which in the east first emerges on the Theodosian missorium (Ill. 7) and on the obelisk of Theodosius.[94] The symbolic meaning behind such programs is supported by the stylistic development familiar to us from the second half of the 300's. On the missorium we see that the presentation is not only marked by frontality, hierarchic proportions and a developed perspective such as we know it from the Arch of Constantine but the relief, in addition, has a flatter character. The same tendency may be found in Christian sarcophagus reliefs. According to Brandenburg, the S. Sebastian fragment (Ill. 21) is a step in a development in this direction. Here the figures appear in decidedly lower relief than for example on the sarcophagus of the brothers.[95] Similar stylistic characteristics are also to be found in the plastic forms of eastern sarcophagi. As early as the Sarigüzel sarcophagus with its classicistic elements (Ill. 37) we find that the figures have a certain flat and non-physical type of outline which associates them stylistically with the Theodosius obelisk.[96] The low relief is even more conspicuous on a relief from the end of the 300's showing four pallium clad men with arms tightly pressed against bodies with firm linear contours.[97] The eastern idiom is also characteristic of for example the Ambrose sarcophagus,[98] which in turn is closely related to the S. Aquilino mosaic in which the figures are described as "flach, schematisch und steif."[99] One must,

[93] For the monogram nimbus (chrismon) with A and Ω, see Calderini/Chierici/Cecchelli, Basilica di S. Lorenzo p. 205f. That this kind of symbolism can be utilized by emperors with sympathy for Arianism, is not surprising (cf. the ambiguity of sun symbolism). On the other hand it is striking that this symbolism is used at all in presentations of Christian emperors. It is possible that the imagery in this context refers to the religious belief of the emperors, and not to the divinity of the emperor himself, see Cabrol, AΩ. col. 20; see also Weigand, Monogramnimbus p. 591.

[94] The obelisk base of Theodosius is given in Bianchi Bandinelli, Rome Pl. 335 and 336.

[95] A stylistic description of the two sarcophagi in Brandenburg, Stilprobleme p. 466.

[96] Kollwitz, Oströmische Plastik p. 142f.

[97] Ibid, p. 160, see also Pl. 48.

[98] Kollwitz perceives the style of the sarcophagus as eastern, but with "eine Umsetzung in italischem Sinne" which later influences Roman stylistic development, Kollwitz, v. Schoenebeck p. 603. Brandenburg, Stilprobleme p. 467 finds both eastern classicism and Roman stylistic elements in the sarcophagus.

[99] Brandenburg, Frühchristliche Kunst p. 117.

nevertheless, be aware of the nuances in stylistic differences which exist within Italian mosaic art in the late 300's. Thus, the S. Giovanni in Fonte mosaic is farther removed from classical principles than the Pudenziana mosaic.[100] The low relief technique noted here emphasizes the symbolic content to be found in our presentations. In S. Aquilino the group around the teacher is almost dissolved; Christ's attention is scarcely directed towards his apostles but rather at the onlooker who is faced frontally by an unapproachable majesty.[101]

R. Bianchi Bandinelli maintains that this development in style is an artistic reflection of the economic and constitutional crisis in the Roman Empire during the 3rd century. He means that in relation to the existing world this forms the basis of a new approach which among other things manifests itself in an interest in the irrational and mystical.[102] This tendency is reflected in pictorial art by naturalistic presentations giving way to symbolism and transcendentalism.[103] Although it is not Christianity which sets off this new approach, it is utilized in Christian monuments precisely in order to capture the transcendental aspect in Christology. Even more obvious than in the S. Aquilino mosaic this is expressed in S. Pudenziana's apse where Christ's robes are inlaid with gold tesserae in order to create the impression of Christ clad in luminous apparel. In this way, not only the halo but the entire form of the presentation is characterized by the interpretation given to the figure of Christ; he is an emanation of light.[104] By his physical presence the dematerialized Christ is a Divine manifestation.

4. Christ as King of the Church

In referring to Revelation 1:8 we have suggested the close connection which exists between the conception of God and the sovereign power this God wields over the world. This has been established repeatedly in an iconographical context. Thus, in representations of Christ it is not sufficient to reveal him as God; it is also desirable to designate him by referring to his works. This is particularly well illustrated on the Bassus sarcophagus' image of Christ.

[100] Ibid, p. 117f.

[101] Compare with Kollwitz' description of stylistically related monuments in Oströmische Plastik p. 160 and 162.

[102] Bianchi Bandinelli, Rome p. 15-21. P. Brown is sceptical concerning the use of irrationalism as a description of typical phenomenon in the 3th. century, see Brown, Making p. 16 and p. 60.

[103] Ibid, p. 337.

[104] For the use of gold to represent light, see Nordhagen, Om gull og sølv; Bodonyi, Entstehung; Averincev, L'or; Sedlmayer, Licht and Ratzinger, Licht.

When Coelus is abandoned as an iconographical motif and replaced by a mountain it does not mean that the ruler aspect is diminished. In fact, in the last half of the century, as a compensation, the throne itself is developed into a main motif in Christ imagery.

In a number of cases we have maintained that Christ has been placed on a throne although the throne is first developed into an independent motif on the Coelus picture. Even stronger emphasis on the throne motif is found in certain monuments from the late 300's, monuments which may be characterized as fully developed representational images. A monument which seems to point in that direction is Eugenia's sarcophagus in Musée Borély in Marseilles (c.400) (Ill. 12)) which is closely related to the 11-niche sarcophagus mentioned earlier. There is a difference, however, as most of the apostles no longer gesticulate excitedly but instead acclaim Christ by stretching forth their right arms.[105] The disciples' gaze is turned more towards Christ than on the Concordius sarcophagus and reflects a shift in the picture program. Attention is now directed more markedly than before towards the elevated Christ. This can only be seen as a change within the teaching scene. When only Christ is shown with his right arm lifted in the speaking gesture and the apostles acclaim him instead of taking part in the conversation, a new step in a withdrawal from the actual disputation scene has taken place. It no longer concerns a teaching scene in the strict meaning of the word. We have instead an acclamation scene in which Christ, perceived as Divine majesty, makes known his authority. On the rear of the city-gate sarcophagus from the 380's now in S. Ambrogio, it is not only the apostles closest to Christ who are depicted in acclamation; the entire apostle group shows the same extolling attitude (Ill. 13).[106] These two sarcophagi also have other characteristics in common; the same Christ type is to be found on both monuments and we see, moreover, a cloth-covered bench instead of individual chairs. The background figures which were seen on the 11-niche sarcophagus have now disappeared. On the other hand both depict a mountain and a lamb in front of Christ's throne. The striking similarities make it probable that both sarcophagi are from the same workshop.[107]

With these common characteristics which separate them from the 11-niche sarcophagus, the sarcophagi point towards a new iconographical

[105] For the gesture of acclamation, see Klauser, Akklamation col. 232. Possibly we can find a hint of acclamation in the presentation of the two apostles closest to Christ in the sarcophagus of Concordius. But the gesture is better seen in the sarcophagus of Eugenia.

[106] Sansoni, Sarc. a porte di città, catalogue number 1 p. 3-12, see also Lawrence, City-gate; Schoenbeck, Mailänder Sark, and Kollwitz, Probl. der theod. Kunst.

[107] Gerke, Malerei und Plastik p. 143.

pattern. The emphasis is on Christ; he alone is enthroned and placed at a much higher level than the apostles. He is, thereby, almost separated from his surroundings. On the Ambrogio sarcophagus, in addition, the motif behind Christ is particularly emphasized; the niche is so large that it takes on the character of a throne niche.

A corresponding development has evidently taken place in apsidal art as well. In S. Aquilino where there is so little emphasis on the throne motif, the twelve apostles are clad in white and wear sandals; some hold scrolls, other raise a hand in the speaking gesture. A similar scene was probably to be found in the Basilica Severiana in Naples,[108] from the time of Bishop Severus (366-412/13) and known to us from the description of Johannes Diaconus, "in cuius (scil. basilicae Severianae) apsidam depinxit ex musivo Salvatorem cum XII apostolis sedentes, habentes subtus quattuor prophetas ..." The reference to the prophets is rather diffuse but the simple description of Christ and the apostles makes it reasonable to relate it to S. Aquilino's program.

The oratory on Monte della Giustizia in Rome, possibly dating from the end of the 4th century is only known to us from de Rossi's sketches and the report from the excavations.[109] Here Christ has been depicted with a halo seated on a sort of throne, his right hand raised in the speaking gesture and in his left an open book. A scrinium is placed before Christ's throne just as in S. Aquilino. The twelve apostles are turned towards Christ; they carry scrolls in their left hands and raise their right hands in acclamation.

In the S. Pudenziana mosaic there is clearer emphasis on the throne aspect than in the examples given thus far. Not only is the seated Christ surrounded by acclaiming apostles, he is placed on a proper throne—a *solium regale*—embellished with precious stones and provided with a purple cushion as well.[110] Again it is a question of direct borrowing from imperial precedents. If we compare the Pudenziana Christ image with the porphyry statue from Alexandria, probably depicting Diocletian,[111] we are immediately struck by their similar characteristics.

The throne, however, has a symbolic content long treated with reservation by the Romans. Thus, the chair depicted on the porphyry statue is unsupported by Roman traditions. For a long time Romans preferred the more unassuming *sella curulis* which was originally reserved for the

[108] Ihm, Programme, catalogue number XXXII p. 175.

[109] Ibid. catalogue number XIII p. 149f., see also fig. 1. p. 16.

[110] For purple as a sign of imperial dignity, see Reinhold, History of Purple. For the objection to purple among the Fathers of the Church in pre-Constantinian time see p. 65.

[111] Delbrück, Antike Porphyrwerke p. 96, and Taf. 40-41. See also Haussig, Einfluss, who compares the porphyry statue with the figure of Christ in S. Pudenziana.

consuls and helped to maintain the fiction of a republic. It is first in
Caesar's day that the beginnings of a trend leading to the use of a real
throne are to be found. During his rule the sella is given "eine monar-
chische Retusche" in that Caesar is given the right to use it as well as
the consuls.[112] The next step is the isolation of the emperor's position in
the Curia. Under Caligula the podium on which the emperor and consuls
were placed is raised; this is followed by a special tribune for the emperor
alone on the pretext that it was necessary as a protection against con-
spiracies.[113] With the passage of time the emperor's sella becomes pro-
gressively more richly appointed. At the time of Herodianus, the sella is
not only changed but in fact supplanted by another type of chair. Hero-
dianus speaks of ἕδρα βασίλειος, βασίλειος θρόνος.[114] This change has a
clearly ideological basis. The sovereign of the world must have a throne
with an ideology borrowed from sacred symbolism.[115] But, this sym-
bolism was met with skepticism and it took time to gain acceptance. We
note, too, that the iconography has played an important part within this
process of development in that it preceded the official state ideology.
Alföldi gives a number of examples of imperial utilization of sacred
throne symbolism stretching right back to the time of Tiberius. The
previously mentioned porphyry statue in Alexandria, however, is the
earliest extant monument depicting a ruler's throne.[116] It is just such a
throne with roots in eastern monarchial ideology which is used in the
Pudenziana mosaic's Christ image. With the help of the throne it is
shown as clearly as possible that here Christ is to be perceived as a
sovereign with absolute power.

S. Pudenziana's Christ type seems to be marked by the growing
interest in ruler themes now becoming evident. In this context we pause
to note Christ's generous beard which distinguishes him from a
number of the Christ types with which we have been dealing. We must,
however, be careful not to put undue emphasis on changes of this kind

[112] Alföldi, Monarchische Repräsentation p. 140. For the sella curulis in Roman
tradition, see Wanscher, Sella curulis p. 121-190.

[113] Alföldi, Monarchische Repräsentation p. 140f.

[114] Ibid, p. 243 note 3.

[115] "Die Darstellungen der Denkmäler vergegenwärtigen es uns, dass auch dieses
Abzeichen der Alleinherrschaft unter dem Deckmantel der religiösen Ehrung des
Souveräns mit dem Zubehör der Göttlichkeit eingeschmuggelt wurde, und sich erst in
der Allegorie und künstlerischen Formengebung festsetzend, dann auch in der
Wirklichkeit eingeführt wurde", Ibid, p. 243. See, however, the critical remarks to this
interpretation in Nilsson, Bedeutung p. 296: "Man scheint manchmal so zu sprechen,
als ob der Königskult bewusst geschaffen worden sei, um der absoluten Monarchie ihre
rechtliche Grundlage zu verleihen. Das heisst m. E. die Sache auf den Kopf stellen.
Jedenfalls ging die tatsächliche Macht voran".

[116] Ibid, p. 244.

when interpreting the picture. It is, nevertheless, curious that no bearded Christ types are to be found in the period between the polychrome fragment and S. Sebastiano fragment.[117] In the Theodosian period, on the other hand, bearded Christ types become quite common. We have already indicated that the representational Christ on the Bassus sarcophagus has a special character which probably contributes to a particular interpretation of this Christ figure (see p. 24). Can it be that the representational, bearded Christ supported definite characteristics in the perception of the Christ figure?

Gerke maintains that the bearded Christ on the S. Sebastiano fragment must be connected with the ruler function here attributed to Christ.[118] Dassmann asserts that Pudenziana's Christ reminds him of representational pictures of the Hellenistic god-kings.[119] If these suppositions are correct Christ's appearance as presented here strengthens the interpretation of him as king and ruler. Furthermore, the use of the Conservator title in the inscription on Christ's book has been related to religious and imperial thematic groups which reinforces the emphasis on the king theme in this presentation.[120]

As on so many other occasions we must turn to literary texts for more exact information as to how Christ's almighty power has been perceived. Earlier we have pointed out that the Divine epithet A and Ω in Revelation is often combined with the ruler title. In Revelation's eulogies this ruler terminology plays an important part. We find the following in Revelation 11:15 ff.: "The kingdom of the world has become the kingdom of our Lord and of his Christ, and he shall reign for ever and ever. And the twenty-four elders, who sit on their thrones before God fell on their faces and worshipped God saying, 'We give thanks to thee Lord God Almighty, who art and who wast,/that thou hast taken thy great power and begun to reign.'" We find two particular characteristics in this

[117] Gerke, Christus p. 39.

[118] Ibid. p. 57. Note, however, that the 'city gate' sarcophagus in S. Ambrogio depicts a bearded Christ in the traditio scene, whereas Christ in the enlarged teaching scene is beardless.

[119] Dassmann, Das Apsismosaik p. 73.

[120] Kollwitz, Das Bild von Christus p. 101 note 37 relates the conservator title to religious traditions (Jupiter conservator), while Dassmann, Das Apsismosaik p. 73 suggests a connection with imperial traditions (conservator orbis). Kollwitz maintains that the use of the conservator title in S. Pudenziana demonstrates that Christians had reached "Abstand und Unbefangenheit" in relation to the pagan connotations associated with the term. We have, on the other hand, stressed that this imagery is rather to be understood as a bold experiment. When Dassmann maintains that the conservator title contributes to the understanding of Christ as a timeless sovereign, we must once again disagree. Our analyses of the catecheses in part II will demonstrate that Christ functions as king not as one who rises beyond the bounds of time, but rather is closely connected to the category of time.

text. In the first place Christ is drawn into the role of ruler at the side of God himself. Secondly, the reverence of those around is expressed by their prostration and thanksgiving. If we compare this with Revelation 4:9 f. we find that homage to God according to Revelation is interpreted in just this way—thanksgiving and worship.[121] Here we have a possible interpretation of the content of the acclamation gesture as we see it in, for example, the S. Pudenziana mosaic.

We have previously suggested that 4th century orthodox theologians made use of the Pantocrator title in developing their Christology (see p. 8). A kingship terminology was also made use of in this context. Now Beskow is able to establish that the king theme has been utilized in theological terminology for centuries and has been alloted various meanings according to different theological positions. In the early 300's, Eusebius of Caesarea connected Christ's kingship mainly to the Logos as God's vice-regent in the world.[122] The Antioch school—represented by Marcellus of Ancyra—on the contrary, primarily relates Christ's almighty power to his being human, or more precisely, to his human nature from its union with the Logos.[123] The "kingship" theme comes more to the fore as the 4th century progresses simply because it is so explicitly connected to the development of theological teaching. Athanasius, for example, relates it directly to his understanding of Christ's two natures as he maintained that Christ's kingdom was a double one; as God he is a king by his very nature, as a human person he has become king by his work of salvation. The dignity of Jesus' kingship is thereby placed within a soteriological framework. This emerges clearly from Athanasius' exegeses of texts such as Philippians 2:9 and Psalms 24:7 which are interpreted as the ascent of Christ's human nature to the throne of God by which the act of salvation is consummated.[124] The ascension is not of Christ himself because he is the highest. Rather, it takes place for our sake that we may enter the gates of heaven which he has opened for us.[125] The dignity of kingship in this context, relates not only to the ascension but to the incarnation.

Gregory of Nazianzus sums up the teaching of the double kingdom as follows: "He is said to be King, in one sense because he is *Pantocrator* and King over those who desire it or not, and in another sense ... because

[121] See Peterson, Das Buch, who considers the apocalyptic shouts of praise to be acclamation p. 26.

[122] Beskow, Rex Gloriae p. 261-275, see especially p. 274f. See also p. 268: "(Eusebius) connected the Kingship to the eternal Logos, a cosmic power which, though revealed in time, belongs to eternity and to the supra-historical sphere".

[123] Ibid, p. 231-236.

[124] Ibid, p. 276-294.

he has placed under his sway ourselves who voluntarily accept his government. Of his Kingdom conceived in the former sense there is no end; of his second Kingdom what shall be the end? The reception of us, saved, under his hand.''[126] Here, the dignity of the pantocrator as well as a soteriologically determined kingship are given a decidely Christological orientation.

The question now is whether or not we find evidence in our pictorial material of a corresponding utilization of the kingship theme. Is Christ's power of kingship comprehended in an iconographical context in the same way as in the quotation from Gregory? In this part of our study we shall use the S. Pudenziana apse (Ill. 14) as the basis for the iconographical analysis. Our question is: does the Pudenziana mosaic refer to a double kingdom—one pertaining to the world—another to the church?

On the Pudenziana presentation of Christ, the open book which he holds in his left hand and which is turned towards the spectator, carries the inscription DOMINVS CONSERVATOR ECCLESIAE PVDEN-TIANAE. The text reveals that a relationship exists between Christ and the congregation taking part in the service of the church of S. Puden-ziana, a relationship in which Christ—the ruler—is the support of the Pudenziana congregation. In other words, in the church of S. Puden-ziana it is Christ who rules because he is the foundation of the con-gregation.

The ecclesiological interpretation of Christ's kingship is further sup-ported by the importance of the apostolic assembly in the mosaic. At an earlier point we recounted the transition from a teaching scene to one of acclamation. If we maintain that the acclamation may be inter-preted as in Revelation 4:9 f., it means that the scene emerges as a thank offering and worship of Christ. Here already we sense an ecclesiological element—as a reply to Christ's support, the surrounding group worship and give thanks.

In this connection it is of interest to note the use made of acclamation in an imperial context. Although a number of different subjects may be included in late-Antiquity acclamations,[127] we notice that the motif of

[125] Athanasius, Orat. 1 c. Arian. 41 (PG. 26. 97), see Beskow, Rex Gloriae p. 279. See also Süssenbach, Christuskult p. 13f. who suggests a connection between Athanasius' interpretation and changes in the conception of eschatology.

[126] Βασιλεύειν γὰρ λέγεται, καθ' ἓν μὲν, ὡς Παντοκράτωρ, καὶ θελόντων, καὶ μὴ, βασιλεύς· καθ' ἕτερον δὲ, ὡς ἐνεργῶν τὴν ὑποταγήν, καὶ ὑπὸ τὴν ἑαυτοῦ βασιλείαν τιθεὶς ἡμᾶς, ἑκόντας δεχομένους τὸ βασιλεύεσθαι. Τῆς μὲν οὖν ἐκείνως νοουμένης βασιλείας οὐκ ἔσται πέρας· τῆς δευτέρας δὲ, τί; Τὸ λαβεῖν ἡμᾶς ὑπὸ χεῖρα σωζομένους. Gregory of Nazianzus, Orat. 30. 4 (PG. 36. 108) see Beskow, Rex Gloriae p. 286.

[127] See Burian, Kaiserliche Akklamation.

gratitude which is determined by imperial benefits bestowed upon society is frequently expressed in the formulas.[128] Furthermore, the spirit of community between the emperor and those venerating him, play an important role in late-Antiquity's shouts of acclamation.[129] This background strengthens our interpretation of the acclamation gesture as an expression of the apostles' thanksgiving to Christ who acts here as *Conservator*.[130]

The ecclesiological interpretation of the apostolic assembly is supported by the mosaic's presentation of an idealized collegium in which the number of twelve in the group is preserved by including Paul—a presentation unsupported by any evidence in the New Testament. The number twelve in itself has obviously been of ecclesiological importance.[131] Through the presentation of a complete apostolic collegium it is possible to maintain the correspondence to the twelve tribes of Israel.[132] Thus, the church stands forth as the restored people of God.

It is not impossible that the apsidal presentation of Christ in the apostolic assembly also reflects the usual group arrangement during Divine service. C. Ihm points out that according to liturgical custom the bishop was required to sit on a raised cathedra between the presbyters,[133] and archeological excavations show that many early Christian basilicas have had a semicircular seating arrangement in the apse.[134] Seen against this background it seems feasible to look for direct connections between apsidal iconography and the actual use of the apse.[135] We recall too that the 11-niche sarcophagus may be interpreted in such a way as to create

[128] We quote a typical example:

"Iuppiter Optime, tibi gratias!

Apollo venerabilis, tibi gratias!

...

Qui amat rem publicam, sic agit!"

Ibid, p. 42.

[129] Burian gives a number of examples of acclamation shouts. We cite an example: "De nostris annis augeat tibi Iuppiter annos! Te salvo salvi et securi sumus! Excubiis tuis salvi et securi sumus! Vestra salus, nostra salus!", Burian, Kaiserliche Akklamation p. 34.

[130] For acclamations in a liturgical context, see Klauser, Akklamation col. 226f. For Sanctus as acclamation, see col. 230.

[131] For the reduction of the collegium of the apostles during the restoration in 1588, see note 5.

[132] See e.g. Matthew 19:28.

[133] Ihm, Programme p. 9 note 7.

[134] Ibid. p. 9 note 8.

[135] "Es gab demnach seit dem 3. und bis ins 5. Jh. eine Ikonographie, die die ganze Szenerei einer wirklichen Apsis selbst noch einmal wiederholt: Achsidal über der Kathedra des Bischofs sass Christus, und den Klerikerbänken folgend sassen auf beiden Seiten je sechs Apostel", Ibid, p. 9, see, however, Nussbaum, Standort, who demonstrates that this arrangement has not been absolute.

close connections between the apostle collegium and the church space itself.[136] In Ignatius' letter to the congregation in Magnesia such a parallel between God and bishop, apostles and prebyters is explicitly emphasized: "I exhort you:—Be zealous to do all things in harmony with God, with the bishop presiding in the place of God and the presbyters in the place of the Council of the Apostles".[137] In the text, Christ surrounded by his apostles provides a frame of reference for the clergy led by the bishop in the celebration of the Divine service. It stands to reason, therefore, that a pictorial presentation of Christ and the apostles placed above such a seating arrangement may be taken as a reference to an ecclesiological thematic group. We must, however, take care in using an apsidal program's placement above the actual apsidal seating arrangement as a source in interpreting the apostolic collegium as a heavenly church symbol as opposed to the worldly church which has its actual place in the church space.

For greater clarity and understanding of the apostle collegium's ecclesiological importance it is useful to make a closer examination of one of the panels in the wooden door of S. Sabina which dates from the pontificate of Celestine I (422-432) (Ill. 18).[138] The panel is divided into two parts representing the heavenly and earthly spheres. In the upper scene Christ stands in majesty. His right hand is lifted in the same gesture we recognize from S. Aquilino while in his left hand he holds a scroll with the formula-like inscription ΙΧΥΘΣ.[139] As Lord and Saviour, invested with a halo, Christ stands within a triumphal laurel wreath which is surrounded by the four living creatures. Beneath Christ's heaven, the physical heaven with sun, moon and stars curves downward towards the earth. Under the great star placed on the central axis—a possible reference to the incarnation—stands a female figure lifting head and hands towards heaven; above her again is a cross within a circle held by two male figures who are probably to be interpreted as apostles. The division of space in this relief deserves attention. Here Christ is set apart from the apostles who are shown beneath the vault of heaven, in other words, on earth. In this case, the apostles refer conclusively to a worldly-ecclesiological aspect which is not eliminated when the apostles are depicted with Christ in a single scene such as in the Pudenziana

[136] See Gerke, Malerei und Plastik p. 137f.

[137] Παραινῶ, ἐν ὁμονοίᾳ θεοῦ σπουδάζετε πάντα πράσσειν, προκαθημένου τοῦ ἐπισκόπου εἰς τόπον θεοῦ καὶ τῶν πρεσβυτέρων εἰς τόπον συνεδρίου τῶν ἀποστόλων, Ignatius of Antiochia, Ep. ad Magn. VI. 1 (LCL. 24. 200-202).

[138] The panel has recently been interpreted in Jeremias, Holztür p. 80-88 and Maser, Parusi Christi. For further study, see Maser, Parusi Christi p. 30 note 1.

[139] See Jeremias, Holztür p. 83f. Maser, Parusi Christi p. 131 reads ICHYTH.

mosaic. We perceive the composition of the motif in S. Pudenziana as a fusion of the two separate scenes on the S. Sabina door which now becomes a single ambiguous scene. As a personification of the church the apostles are a reference to the church as it is on earth while at the same time functioning as a model for that same church.

In the S. Sabina relief we find a female figure which is similar to the female figures in the S. Pudenziana mosaic. The former interpretation of the S. Pudenziana figures as Pudenziana and Praxedes has long since been abandoned.[140] Greater assistance in the interpretation of this motif is to be gained by a comparison with the Sabina relief where the woman is surrounded by apostles and definitely on earth. She faces the heavenly Christ but, in such a way that the incarnation and cross come between them. Surrounded by apostles—beneath the cross—the woman is quite definitely in the church sphere; she becomes the church personified.

A more precise interpretation of the S. Pudenziana female figures is made possible when we consider them in connection with the two women on the interior of the S. Sabina entrance.[141] The inscription beneath them tells us that they represent ECCLESIA EX CIRCUMCISIONE and ECCLESIA EX GENTIBUS. Ecclesia ex circumcisione is clad in a white palla and carries an open book displaying Hebrew characters. Ecclesia ex gentibus, on the other hand, appears as a Roman matron and in her book the characters are in italics.[142]

The female figures in the Pudenziana mosaic must be seen as analogous to the church personifications in S. Sabina. They differ, mean-while, from the Sabina mosaic presentation by holding forth wreaths instead of bearing books. A certain lack of agreement prevails in the interpretation of these wreaths. Are they being held above the heads of Peter and Paul who are the apostles of the Jews and heathens or are they being held forth to Christ?[143]

In any case the basic idea behind such a scene is clear; it is a tribute to the one to whom the wreath is extended.[144] It is usually apostles, mar-tyrs or holy ones who hold forth wreaths on occasions when the wreath refers to corona martyrii which the faithful one presents to his master.[145] That the wreath is presented to Christ emphasizes that the reward for a life of righteousness really belongs to Christ. In our mosaic it is not

[140] Dassmann, Das Apsismosaik p. 73, see also note 31.

[141] Wilpert/Schumacher, Die römische Mosaiken Taf. 24a and 24b.

[142] According to Grabar this imagery is further developed on the triumphal arch of S. Maria Maggiore, see Grabar, L'empereur p. 213.

[143] See Dassmann, Das Apsismosaik p. 73, see also note 33.

[144] See Baus, Kranz p. 190-201, see especially p. 193.

[145] See Baus, Kranz p. 194f.

individual Christians presenting wreaths but the entire church universal which pays tribute and gives thanks to its leader.[146] K. Baus establishes that presenting wreaths may also involve submission and recognition of the ruler's sovereignty.[147] It is not unlikely that this thought plays a part in our mosaic.[148] All the interpretations considered here indicate that the wreaths are primarily extended towards Christ. The gaze of the woman on the left (which has escaped any considerable restoration) (see Ill. 16), is also directed towards Christ.

Still another motif belongs within this ecclesiologically determined group of themes. Admittedly it is not given explicit expression in the Pudenziana mosaic but we find it on the back of the theme-related S. Ambrogio sarcophagus (Ill. 13). At the feet of Peter and Paul we find two figures depicted with covered hands and with their attention fixed on the scene's central theme. It is very likely that these figures refer to the deceased for whom the sarcophagus was made. Their bowed heads and the disparity in size between them and the row of apostles presumably show a difference in rank between the groups. The sepulchral aspect which the scene hereby acquires and which probably should be seen as a secondary use of the program, clearly shows the ambiguity of the presentation.[149] The main scene can easily be placed in a new context— in this case a person's death. In this way the ecclesiological group of motifs is given a new value. Christ's ruling power is exercised not only over the living congregation but also over the dead. It is possible to apply a similarly widened perspective to the S. Aquilino mosaic which has served a decorative purpose in a mausoleum or baptistery.[150] If the context has been sepulchral it is natural to stress the kingship motif's futuristic-eschatological implications. As the program itself gives no ground for such an interpretation and the spatial function is not clear, caution should be shown here.

On the other hand, in a terracotta plaque from the Barberini Collection, now in the Dumbarton Oaks Collection (Ill. 19), the futuristic-eschatological aspect is so fully developed that it dominates the entire presentation. The plaque is divided into two scenes. In the upper section

[146] Paulinus of Nola "democratizes" the wreath-imagery, see the quotation on p. 97.

[147] Baus, Kranz p. 196ff.

[148] For imperial application of the wreath, see in addition to Baus, Kranz p. 196ff also Grabar, L'empereur p. 230ff.

[149] See Gerke, Malerei und Plastik p. 131.

[150] For further study, see note 3. The decoration in the other preserved niche which is supposed to be the ascension of Elijah (Bovini, Antichità p. 336-348) (a part of the imagery on one of the narrow ends of the sarcophagus of S. Ambrogio), can be given a sepulchral interpretation, even if it functions in a baptismal context, Bovini, Antichità p. 336-344.

the enthroned Christ is shown with six of his apostles. A whip and tesserae (entrance tickets) lie by his feet. Before him is a latticed balustrade separating him and the apostles from the small figures entering from gates on either side (only summarily indicated). These come to a halt before Christ, acclaiming him with lifted hands. This scene is quite rightly found to be a depiction of the last judgment. The whip signifies the punishment of the wicked whereas the tesserae represent the reward to the righteous. No sinners are shown on the plaque as obviously all the figures in the lower zone are facing Christ whom they are hailing. Thus, the act of judgment becomes an act of acclamation. The judgement's character of victory and triumph is the only aspect which is shown here. The interpretation, moreover, is also supported by the interpretation VICTORIA above the heads of the apostles.[151]

It is impossible to decide whether such an interpretation should be considered in the Pudenziana enthronement scene as we have no clear evidence to justify this in the pictorial material itself. The possibility exists and the terracotta plaque makes it probable but in this case we have a typical case of ambiguity which makes any final valid conclusions impossible. Even so we find it natural to emphasize that the act of judgment fits easily into the kingship theme as the ultimate display of sovereign power. We find, too, textual evidence that judgment presentations can be directly related to the throne motif.[152]

Our work with the ecclesiological theme-group has thus revealed interesting tensions within the iconographical material: our interpretation of the apostolic assembly suggested tension between the wordly and the heavenly church; the terracotta plaque indicated a futuristic-eschatological element as supplementary to a one-sided concentration on the actual situation of the congregation.

That the image-makers have shown positive interest in giving the depictions such a character of tension finds further support if we examine the motif behind the apostolic assembly in S. Pudenziana. The scene is enacted against an urban background.[153] The twelve apostles are in fact surrounded by an arcaded portico. Behind this portico is a collection of buildings which seem too specific merely to reproduce a general urban

[151] This interpretation, given by Grabar, L'empereur p. 207f., has been doubted by Brenk, Imperial Heritage note 25.

[152] Victorinus of Pettau interprets the throne located in heaven (Apoc. 4:2) as the throne of the king and judge: "Significanter *solium positum*, quod est sedes iudicii et regis", Victorinus of Pettau, Comm. in apoc. 4.2 (CSEL. 49. 46).

[153] The arrangement is based on elements from the collonade/basilica seen in the sarcophagus of Concordius. The setting is supposed to be made for an apse decoration, see Sansoni, Sarc. a porte di città p. 77.

scene. Some have recognized 4th century Rome, others see 4th century Jerusalem in the buildings.[154] The first opinion is mere speculation for which no argument of any weight is to be found. The other location seems more likely but in this case too, it can only be a representation in the broadest sense.

How this resemblance is to be interpreted depends upon how one reconstructs the Constantinian mausoleum complex in Jerusalem. E. Dyggve considers that the rotunda was not a part of the original building complex. In his opinion Christ sits by the holy grave in the atrium which has been connected to the basilica complex (martyrion) itself (Ill. 17). According to Dyggve the buildings in the background reveal a locally influenced background setting for the scene.[155]

In contrast to Dyggve's theory, G. Matthiae attempts to identify the two distinctive buildings in Jerusalem. One is a circular domed building while the other is octagonal with a quadrangular opening in the roof. The remainder of the urban scene is largely a reconstruction and therefore of little archeological interest (Ill. 14, see Ill. 16). The circular domed building which is joined to a basilica-like building is reminiscent of the so-called "Anastasis" within the Holy Sepulchre complex. In its present form the octagon on the right side can be a reminder of the Constantinian church of the Nativity at Bethlehem. Matthiae, however, repudiates this solution as it presupposes that the octagon is to be seen in connection with the aula to the right of it.[156] Matthiae considers this connection to be a result of restoration work. He maintains that the octagon should be interpreted as the Church of the Ascension on the Mount of Olives. This theory is supported by a floor mosaic in Madaba.[157] Considering these factors it appears highly likely that we have an imitation of 4th century Jerusalem with special emphasis on the Holy Sepulchre complex.

A mountain crowned by a cross rises between the buildings directly behind the cross of Jesus. In addition, it looks as though the lamb in front of the throne has been placed on a mountain (Ill. 15).[158] Thus, the background in the Pudenziana mosaic consists of a mountain and an urban scene which is in some way related to the Jerusalem of the 300's.

[154] See Matthiae, Mosaici p. 58f.; see also note 15.
[155] Dyggve, Gravkirken i Jerusalem p. 12. Krautheimer presupposes that the rotunda of the Anastasis has been in use by 350, Krautheimer, Early Christian Architecture p. 77.
[156] Matthiae, Mosaici p. 58.
[157] Ibid. p. 58f. see also note 15.
[158] For the credibility of the sketch of Ciacconio which is rendered in Ill. 15, see p. 117, note 122.

In the New Testament the combination of mountain and Jerusalem is utilized in Galatians 4 and in Hebrews 12; in both places Mt. Zion plays a part. In Galatians 4, Mt. Zion and the earthly Jerusalem represent the old covenant whereas ἡ ἄνω ᾽Ιερουσαλήμ refers to the new covenant.[159] On the other hand, in Hebrews 12, Mount Sinai is set in contrast to Mount Zion and the heavenly Jerusalem. In the epistle, those whose gaze is fixed upon the pioneer and perfecter of the faith "have come to Mount Zion and to the city of the living God, the heavenly Jerusalem".[160] What is of interest in both texts, however, is that that which is heavenly corresponds to realities here on earth. Now a futuristic-eschatological theme is introduced in the epistle to the Hebrews, one which can supplement these conceptions (Hebrews 13:14), and in Revelation the conception of the new Jerusalem is primarily used to emphasize precisely this futuristic-eschatological perspective. In the end God will dwell among men in the new Jerusalem which has come down from heaven to the earth (Revelation 21:2). Here too the city and mountain are joined: "And in the Spirit he carried me away to a great, high mountain, and showed me the holy Jerusalem coming down out of heaven from God" (Revelation 21:10). In all these texts Jerusalem becomes a figural expression of Divine presence realized in different ways within the existing world.

Clear signs of the ambiguity contained here are to be found in patristic texts as well. An example of the ambiguity in the meaning of God's abode, which Jerusalem can represent, is expressed when an Egyptian Christian is interrogated by the governor Firmilianus. When the governor asks the Christian where he lives, the answer is Jerusalem. But, as Jerusalem at that time was known as Aelia, the answer appears meaningless.[161] For the Christian, however, Jerusalem refers to the location of the devout which is thought to be at the sunrise in the east.

Eusebius of Caesarea, on the other hand, is prepared to connect the religious conception of Jerusalem directly to the Constantinian Jerusalem. He relates that Constantine ordered a splendid building to be erected in Jerusalem in memory of the Redeemer's victory over death. This building is interpreted as τὴν καινὴν καὶ νέαν ᾽Ιερουσαλήμ of which the prophets had predicted.[162] In other contexts as well Eusebius relates the city theme to the church space. In his address at the consecration of the

[159] Gal. 4:26.

[160] Hebr. 12:22.

[161] εἶτα πάλιν πολλάκις ἐρομένου τίς εἴη καὶ ποῖ κειμένη ἣν δὴ φράζει πόλιν, μόνων εἶναι τῶν θεοσεβῶν ταύτην ἔλεγεν πατρίδα· μὴ γὰρ ἑτέροις ἢ τούτοις μόνοις αὐτῆς μετεῖναι, κεῖσθαι δὲ πρὸς αὐταῖς ἀνατολαῖς καὶ πρὸς ἀνίσχοντι ἡλίῳ, Eusebius of Caesarea, De mart. Palaest. 11. 11 (GCS. 9/2. 938).

[162] Eusebius of Caesarea, De vita Const. 3. 33 (PG. 20. 1093).

church in Tyre, he maintains that that which previously was only known through a story could now be actually seen by the eyes. This is followed by a reference to Psalm 48:9: "As we have heard, so have we seen in the city of the Lord of hosts, in the city of our God" which is interpreted thus: "And in what city, if it be not the new-made city that God hath builded, which is the church of the living God, the pillar and ground of the truth."[163] Thereafter references to psalms follow in quick succession; Eusebius refers consecutively to Psalms 87:3, 122:1, 26:8, 48:1. His interpretation shows that he comprehends the city of God as an ecclesiological motif where the primary emphasis rests on the actual realization within the members of the congregation during Divine service. Eusebius, by relating the new Jerusalem to Constantinian Jerusalem with further reference to the congregation during Divine service, shows clear connections with S. Pudenziana's rendition of Constantinian Jerusalem in a parish church. Nevertheless, it must be stressed that Jerusalem in the Pudenziana mosaic may also be given a broader significance. John Chrysostom demonstrates that the city theme can be used in such a way that it becomes neither clearly defined as earthly or celestial but is rather to be found in a border area between them. He is preoccupied in elucidating the relationship between the lives of the faithful on earth and Divine reality and in this context utilizes the city theme. Chrysostom points out that we cannot actually say how far the heavenly city is from the earth. For him the distance is relative; if we are negligent the distance is greater than between heaven and earth; if, on the contrary, we endeavour to do our utmost we will shortly stand before the gates of the city: "For not by local space but by moral disposition, are these distances defined."[164]

Thus, the city becomes an ambiguous symbol of God's abode, one which has no definitive location and can therefore be made to fit different interpretations. In the Pudenziana mosaic this open, ambiguous city symbol supports similar tendencies which we have observed in the study of other ecclesiological themes. But, even if the ecclesiological theme-group opens the way for an upwardly orientated perspective as well as one pointed towards the future there is a further aspect which must not be forgotten. The actual congregation present in Pudenziana Church which, through the inscription in Christ's book is put into direct contact with the pictorial sphere, also constitutes an important centre in this group of themes. Christ upholds and rules over the congregation which

[163] ποία δὲ πόλει ἢ τῇδε τῇ νεοπαγεῖ καὶ θεοτεύκτῳ; ἥτις ἐστὶν ἐκκλησία θεοῦ ζῶντος, στῦλος καὶ ἑδραίωμα τῆς ἀληθείας, Eusebius of Caesarea, Hist. Eccl. X. IV. 6-8 (LCL. 265. 400).

[164] John Chrysostom, Hom. in Matt. 1. 16 (PG. 57. 22).

in turn, through the female figures, is connected with the apostles' praise-giving.

The difficulties in interpretation which are brought about by such ambiguous motifs explain the prevailing tendency within recent research. The one-sided futuristic-eschatological interpretation of pictures arises precisely from the perplexity caused by the apparent confusion of meaning levels. The tendency we have suggested (cf. p. 15), is easily supported by several research contributions.

Thus, in his Pudenziana interpretation, Matthiae maintains that the parousia aspect, influenced by the Nicene Council is theologically established. This leads to the domination of the judgement aspect in the iconography of the 300's. Matthiae, nevertheless, is aware that the Pudenziana mosaic is not a true judgement scene in that only the righteous are shown. The second coming motif, therefore, will give no impression of fearing the judgement but, on the contrary, the assurance that Christ's coming will bring about the realization of the kingdom of God and the victory of the universal church.[165] Matthiae has obvious difficulties in making the picture conform with New Testament judgement conceptions.

E. Dassmann is more cautious. He lacks the decisive arguments to enable him to see the Pudenziana mosaic as a rendition of the judgement.[166] If we pursue Dassmann's reasoning, it appears, however, that it is a lack of forensic conceptions which necessitates a certain reservation. On the other hand, he is convinced that the picture bears evidence of a futuristic eschatology.[167] According to Dassmann the human figures, the urban scene in the background (Jerusalem) and the lamb from Ciacconio's drawing belong to the apocalyptic eschatological group of themes.[168]

Here we wish to state our position which we will maintain in all discussions of the so-called apocalyptic elements: a motif cannot be classified as futuristic-eschatological even if it is possible to substantiate that it has an apocalyptic text as its source. It is, for example, erroneous to say that the Revelation of John solely describes futuristic-eschatological events. A number of motifs from Revelation which we find later in an iconographical context are to be found in Revelation in a context just as

[165] Matthiae, Mosaici p. 59f.

[166] "Überblickt man die ikonographischen Argumente für eine Gerichtsdeutung des S. Pudentiana-Mosaiks, dann ergibt sich, dass sie eine solche Interpretation wohl nahelegen, allein aber nicht sicher begründen können", Dassmann, Das Apsismosaik p. 78.

[167] "Die apokalyptische Komponente im Bildprogramm ist so stark, dass die allgemein eschatologische Deutung schwerlich unterdrückt werden kann", Ibid. p. 77.

[168] Ibid. p. 74.

liturgical as apocalyptic.[169] We shall try to demonstrate the various nuances in the interpretation of motifs contained in Revelation as we come to them. In this connection it is sufficient to maintain that the enlarged teaching scene does not show an exclusively futuristic-eschatological content.

Dassmann, however, supports his argument by claiming that patristic literature from the period around 400 underestimates the Christus-rex motif in favour of Christus-iudex. According to Dassmann, as time passed, the title of king was considered unsuitable for expressing Christ's dignity as distinct from that of the emperor especially as the church wished to emphasize the emperors' subordination to Christ's dominion over the church.[170] Beskow's view on the spread of the Christus-rex motif and its relation to imperial ideology reveal a somewhat different picture of the same case. In his opinion the cult utilization of kingship terminology becomes *one* way of reducing possible conflicts when church and state must clarify the conditions of power between them.[171] Beskow thus claims that the church laid no particular stress on the kingdom of Christ in its struggle against the emperor. It has been even easier to take advantage of such themes in internal church affairs such as in the celebration of the service.[172]

Our examination of the iconographical material makes it impossible to support Dassmann's theory. The strong emphasis on the kingship theme in, for instance, the Pudenziana mosaic is impossible to ignore. When Christ is seated on a solium regale exactly the same as that of the emperor's, he is to be understood iconographically as a king.

This does not necessarily imply that such presentations should be taken as a political challenge to imperial power (Dassmann) or as a political legitimization of that same power (Hernegger). On the contrary, it is probable that state and church chose to take advantage of this form of visual art but utilized it within well defined bounds. Just as light symbolism is utilized to stress different aspects within the political and religious sphere it is probable that kingship themes are utilized in different ways in the political and religious world of the 400's. As opposed to Beskow, however, we emphasize that the church has carried out a great deal of research on precisely these politically charged symbols before reaching such an understanding. The entire iconographical development of the 300's reveals a conscious use of imperial motifs. On

[169] See Mowry, Revelation 4-5; Thomson, Cult and Eschatology. See also Christ, Gegenwärtige Eschatologie p. 52.

[170] Dassmann, Das Apsismosaik p. 78.

[171] Beskow, Rex Gloriae p. 327.

[172] Ibid. p. 329f.

one hand it was found that a use of such symbols was considered indispensable for the interpretation of Christ. On the other hand there was an awareness of the dangers of utilizing such strongly charged political imagery. This led to continuous testing, adjustment and adaptation of imperial iconography.

5. Christ as King of the World

Until now we have refrained from commenting on an additional motif in the Pudenziana mosaic which functions compositionally as a sort of parallel to the ecclesiological motif, i.e. the four living creatures. This group has been subject to very little detailed study with the result that interpretations are often superficial and rather arbitrary. Schiller's treatment of the motif is typical. She refers to the adulation which these creatures personify in Revelation and using this source states that the four creatures are alloted this function of glorifying.[173] In the 5th century when these beings are provided with books as attributes and thus interpreted as symbols of the evangelists, this involves, according to Schiller, a broadening of the original symbolism.[174]

U. Nilgen, likewise, emphasizes that in a Roman setting the creatures are based on the apocalyptic vision and their function was to glorify Christ or a symbol of Christ.[175] Nilgen means that even if the earliest depictions cannot unequivocally be interpreted as symbols of the evangelists because they lack books as attributes,[176] they should be interpreted as such on the basis of later depictions. As in Schiller's view the glorifying role of the creatures is emphasized here while simultaneously they are interpreted as evangelist symbols. From this interpretation it is impossible to understand *how* the apocalyptic creatures can be interpreted as evangelistic symbols. The eschatological adulation depicted in Revelation makes it, indeed, difficult to allow an interpretation of the creatures as symbols of the Gospels.[177] Likewise, it is questionable whether or not the glorifying aspect already duly emphasized in the Pudenziana mosaic is a sufficiently good basis for the addition of such a strange motif to the iconographical program.

[173] Schiller, Ikonographie III p. 185.

[174] "Sie bleiben Verherrlichungssymbole, repräsentieren aber zugleich das Heilswirken des inkarnierten Logos und die Einheit des Evangeliums", Ibid. p. 186.

[175] Nilgen, Evangelisten p. 698.

[176] Ibid.

[177] Even Grooth/Moorsel, Lion Calf, focuse on the dominating interpretation of the creatures as symbols for the Evangelists. The visionary aspect of the imagery is focused in an interesting way, which in turn is related to the Hagios shouts.

A closer examination of not only scriptural descriptions of the creatures, but of patristic utilization of this theme, as well as a consideration of the iconographical material, may lead to a greater understanding of the creatures' symbolic meaning.

These strange creatures, as is well known, are not only mentioned in Revelation but also in Ezekiel's visions of heaven. In his visions (Ezekiel 1:1-28, 10:1-22) these creatures are described as tetramorph; each has the face of a man, lion, ox and eagle (Ezekiel 1:10). In addition they have four wings (Ezekiel 1:6) and are provided with wheels which reveal their mobility (Ezekiel 1:15 ff.). Although Ezekiel's description of the creatures is diffuse, their function is obvious: "Over the heads of the living creatures there was a likeness of a firmament, shining like crystal, spread out above their heads ... And above the firmament over their heads there was the likeness of a throne, in appearance like saphire; and seated above the likeness of a throne was a likeness as it were of a human form. And upward from what had the appearance of his loins I saw as it were gleaming bronze, like the appearance of fire enclosed round about; ... Such was the appearance of the likeness of the glory of the Lord" (Ezekiel 1:22-26 ff.). Here the creatures are the bearers of the firmament, the vault of heaven upon which God's throne is placed while at the same time the creatures become symbols of the four corners of the world.[178] This symbolic usage points unequivocally towards cosmic conceptions in that the living creatures become the supporters of the universe over which God upon his throne prevails and rules. The animal symbolism in itself as well is probably related to cosmic conceptions.[179]

Revelation's vision of heaven (see in particular Revelation 4:1-11) is clearly inspired by Ezekiel's vision. In John's depiction most points are simplified as compared to Ezekiel's. Thus, John separates the four living creatures into four different beings; the first is like a lion, the second an ox, the third a person and the fourth a flying eagle (Revelation 4:7). The creatures are now full of eyes (Revelation 4:8), while the wheels and the inexplicable movements have disappeared—now the creatures merely stand around the throne praising, glorifying and giving thanks to God (Revelation 4:9). Thus, their function is somewhat altered. In the

[178] W. Eichrodt gives the following interpretation: "Das Gewölbe oder die Feste, die sie (die Lebewesen) tragen, ist das Abbild jenes Himmelsgewölbes, das der Schöpfer nach 1. Mos. 1. 6 zur Scheidung der irdischen und himmlischen Wasser aufrichtete und über dem er seinen Thron hat. Damit werden die vier Lebewesen zu Repräsentanten der vier Weltecken, also der weltumfassenden Herrschaft des über ihnen Thronenden, worauf auch die Vierzahl ihrer Gesichter und Flügel hindeutet. Während sie der Welt zugewandt sind, hat der Weltherrscher keine Wohnung in der Welt, sondern thront in jenseitiger Glorie über der Himmelskuppel", Eichrodt, Hesekiel p. 8.
[179] Ibid. p. 5ff.

Revelation account the glorifying aspect seems to have been torn away
from its original cosmic context. Nevertheless, signs of cosmic symbolism
are to be found in the animal figures themselves. Remains of it, further-
more, may be seen in the reasons given for the song of praise: "for thou
didst create all things, and by thy will they existed and were created".
(Revelation 4:11), but without any doubt the accent is placed on the act
of glorification.

Biblical animal symbolism has clearly been an inspiration to subse-
quent generations of theologians. Indeed we come across living creatures
again in the writings of a number of the Church Fathers in which they
both expand and shift their symbolic meaning.

Irenaeus draws the creatures into an interesting argument to give the
reason why the church has four gospels.[180] Irenaeus starts from the
premise that the church is spread all over the world which consists of four
parts with four winds. Thus, the gospel which supports this church must
have four pillars. Irenaeus continues: "From which fact, it is evident that
the Word, the Artificer of all, He that sitteth upon the cherubim, and
contains all things, He who was manifested to men, has given us the
Gospel under four aspects."[181] Irenaeus means that the structure of the
world and that of the gospel must conform. He carries this further in
maintaining that there is a conformity between the Creator's throne and
the gospel. The concept of four is also related to the cherubim who in
turn are interpreted as the four creatures: "For the cherubim, too, were
four-faced, and their faces were images of the dispensation of the Son of
God."[182] In his description of the creatures Irenaeus eases unnoticeably
over from Ezekiel's tetramorphic creatures to Revelation's creatures:
"For, (as the Scripture) says, 'The first living creature was like a
lion'."[183] This creature symbolizes Christ's authority, power and
supreme dignity. The ox symbolizes his dignity as sacrificial priest, the
man symbolizes the incarnation, while the flying eagle symbolizes the gift
of the Spirit.[184] Finally, Irenaeus demonstrates that the four gospels may
be characterized in the same way: the gospel of John as represented by
the lion is based on John 1:1 and 1:3, Luke as the ox is taken from Luke
1:9 and 15:30, Matthew as man is decided by genealogy while Mark,

[180] Irenaeus, Adv. Haer. III. 11. 8 (SC. 34. 192ff.).

[181] Ἐξ ὧν φανερὸν ὅτι ὁ τῶν ἀπάντων τεχνίτης Λόγος, ὁ καθήμενος ἐπὶ τῶν Χερουβὶμ καὶ
συνέχων τὰ πάντα, φανερωθεὶς τοῖς ἀνθρώποις ἔδωκεν ἡμῖν τετράμορφον τὸ εὐαγγέλιον, Ibid.
(SC. 34. 194).

[182] καὶ γὰρ τὰ Χερουβὶμ τετραπρόσωπα καὶ τὰ πρόσωπα αὐτῶν εἰκόνες τῆς πραγματείας τοῦ
Υἱοῦ τοῦ Θεοῦ, Ibid. (SC. 34. 194).

[183] Τὸ μὲν γὰρ πρῶτον ζῶον, φησίν ὅμοιον λέοντι, Ibid. (SC. 34. 194).

[184] Ibid. (SC. 34. 194-196).

which opens with a statement of the prophetic spirit, is seen as the eagle.[185]

So, the identification of the creatures with the gospel is made possible by the way in which Irenaeus interprets the structure of the world. Just as the heavenly throne consists of cherubim, seen as the four living creatures, Christ's activity in a world divided into four parts is expressed in the four gospels. The throne concept itself assumes clear, cosmological overtones while at the same time being inextricably united with the Divine work on earth. Indeed, one has the impression that it is precisely by his everlasting activity on earth that Christ enthroned in heaven holds the universe together. The four gospels—understood as expressing Christ's work here on earth—are therefore to be considered the supporters of the entire universe. The reason for interpreting the living creatures as evangelical symbols is in this way insolubly bound to cosmic conceptions. It is clear also that Irenaeus refers to Ezekiel's vision in his explanation of this use of symbols. ὁ καθήμενος ἐπὶ τῶν Χερουβίμ is a quotation from Psalm 80:1 (LXX 79:2) but the conception is close to what is found in Ezekiel. Furthermore, the identification of the cherubim as living creatures has been taken from Ezekiel 10:1 and 14. It is, moreover, typical that Irenaeus only refers to Revelation's account when he describes the individual creatures—he takes the basic meaning of the symbolism itself from the Old Testament.

Hippolytus expresses similar thoughts. In a fragment of a commentary on Ezekiel, he says that Ezekiel speaks of animals which praise God in order to draw attention by this to the four gospels.[186] In the gospels, perceived as the work of the Father fulfilling all four parts of the world, his glory is mirrored. Here, too, the conformity of heavenly and earthly order is reiterated. It is not, however, Hippolytus' conception of the Logos holding the world together by means of these structures which dominates; the emphasis is rather on the glory of the Father brought to earth through Christ and spread by the gospels.

In his commentary on Revelation 4:6, Victorinus of Pettau remarks laconically, "Quattuor animalia quattuor sunt euangelia."[187] Further on in the commentary we are given a somewhat fuller explanation in that the living creatures' glorification of the enthroned one is interpreted in the following way, "cum darent animalia gloriam et honorem: id est cum

[185] Ibid. (SC 34. 196-198).

[186] Hippolytus, Frag. in Ez. (GCS. 1/2. 183): "So hat ja auch Ezechiel jene Tiere gezeigt, die Gott preisen, indem er bei den vier Gestalten der vier Evangelisten zum Erweise der Herrlichkeit des Vaters auf deren Wirkung aufmerksam machte, von der alle vier Weltrichtungen erfüllt werden."

[187] Victorinus of Pettau, Comm. in apoc. 4. 7 (CSEL. 49. 48).

euangelium, actio scilicet domini et doctrina''.[188] Here too the creatures
are a reflection of Christ's works with particular emphasis on his
teaching. The cosmic perspective is no longer conspicuous, something
which possible has to do with this being a commentary on Revelation.

Finally, in this textual analysis we shall examine Jerome's usage of the
living creature symbolism. In his introduction to the gospel according to
Matthew—''Plures fuisse''—Jerome mentions the four gospels saying:
''Haec igitur quattuor euangelia multo ante praedicta Hiezechielis quo-
que uolumen probat in quo prima uisio ita contexitur ...''[189] Subse-
quently Jerome quotes from Ezekiel's description of his vision and con-
nects the four creatures to the four gospels. He relates Matthew to the
person as does Irenaeus; Mark, on the other hand is related to the lion,
based on Mark 1:3; Luke is characterized as an ox which agrees with
Irenaeus but John is connected to the eagle with a basis in John 1:1.
Finally Jerome refers to Revelation's description of heaven which, how-
ever, is not utilized to elaborate on the symbolic meaning of the
creatures. In referring to the narrations of the visions, Jerome has a
predominating aim—he wishes to emphasize that it is not merely
incidental that the church has four gospels.[190] Just as in Victorinus no
grounds are given for an interpretation of the creatures as gospel sym-
bols. The presupposition for both, however, must be that Christ's work
on earth finds its parallel in the heavenly order as described in the narra-
tions of visions. It is, moreover, interesting to note that Jerome bases his
relationship of the creatures and the gospels on Ezekiel's vision.

In the textual material we have examined, it is clear that the earliest
texts are most detailed in their accounts of the actual context for the use
of the symbols. Both Victorinus and Jerome perceive the living creatures
as symbolic animals but neither accounts for the assumption that they
can be assigned a symbolic meaning. Is the creatures' original cosmic
meaning, which creates the basis for perceiving them as evangelistic sym-
bols, in the process of being forgotten around the year 400? Or, to put
it another way; has the earliest iconographical utilization of the creatures
had its source in the original meaning of the symbolic creatures or have
they been perceived as evangelistic symbols without any knowledge of
why they could be understood in such a way?

When we now examine the surviving iconographical material more
closely it is first of all necessary to say a few words about the form in
which the individual creature appeared in the earliest period. Here one

[188] Ibid. Comm. in apoc. 4. 9 (CSEL. 49. 58).
[189] Jerome, Comm. in Math. (CChrSL. 77. 3).
[190] Ibid. (CChrSL. 77. 4).

must be wary of tracing the creatures back to Revelation or Ezekiel on a basis of "Gestalt" iconographical investigations. It is characteristic, for example, that in the earliest period the creatures were depicted with not six nor four but with only two wings.[191] Furthermore, they are presented as four individual creatures even in works which are unmistakably inspired by Ezekiel.[192] The earliest iconographical type must, thus, be seen as a reasonably free adaptation of the two visions and one in which, above all, simplification has been a primary goal. As in the text analysis it is also essential here to consider the function assigned to the creatures. In this context it is important to emphasize that the creatures in the earliest presentations are not equipped with attributes. The wreath as an attribute appears first in S. Maria Maggiore's triumphal arch from c.430 which, besides, is clearly apocalyptically inspired (Ill. 41); books as attributes are found, for example, in the Hosios David mosaic in Salonica from c.450.[193] When interpreting the earliest living creature presentation our sole reference is the pictorial context in which they appear.

One of the earliest surviving examples of this iconography is found as part of the vault decoration in S. Giovanni in Fonte, Naples from c.400 (Ill. 28).[194] Here the creatures are placed in four small niches (squinches) in the four corners of the space and may be considered as supports for the vaulted ceiling construction. At Ravenna in Galla Placidia's mausoleum from the second quarter of the 5th century the creatures are placed around the cross which again is surrounded by stars in a vaulted dome.[195] To be more exact, the creatures are placed above the four interior corners of the building and clearly have a decorative "supporting" function in the dome construction. As the dome in itself is a symbol of heaven,[196] it seems very likely that the creatures placed in the transition between "the four corners of the world" and "the vault of heaven" have a cosmological meaning. The creatures are the supporters of the universe over which Christ—portrayed in the centre of the dome—holds sway. In the S. Pudenziana mosaic the creatures, as in the previously mentioned cases, are placed in a heavenly setting in order to make it

[191] See e.g. the Santa Sabina door panel (Ill. 18) and the triumphal arch of S. Maria Maggiore (Ill. 41).

[192] See e.g. the niche fresco in Bawît where the creatures are rendered as four different creatures even if it is possible to trace influence of Ezekiel's vision through the depiction of the wheels, Schiller, Ikonographie III Abb. 663.

[193] See Ihm, Programme Taf. XIII.

[194] For the mosaic decorations, see Maier, Baptistère de Naples.

[195] Deichmann, Ravenna III Taf. 19 and 20. For dating, see Deichmann, Ravenna II, 1 p. 66.

[196] Lehmann, Dome of Heaven p. 19ff.

quite clear that these are heavenly beings. As the Pudenziana decoration is an apsidal mosaic, this heavenly background is vaulted as well. The creatures, furthermore, are grouped around a vertical axis in which the cross and throne of Christ are the supporting motifs. Can this have been an attempt to transfer the symbolism of the dome to an apsidal vault? Similarly, it seems relevant to ask whether the previously discussed S. Sabina relief from c.430, where Christ is placed within a wreath surrounded by four living creatures, has been an endeavor to transfer the cosmic symbolism of a vault to a flat surface (Ill. 18).

Although it is difficult to draw unequivocal conclusions from this material it is clear that cosmic conceptions have been of importance in the earliest versions of these creatures. With the pictorial material itself as a background it is, however, impossible to say what meaning the living creatures have had beyond this. We have seen that the Fathers, on the basis of fundamental cosmic symbolic meanings interpret them differently—it is not impossible that they can have operated on different levels in the case of pictorial art too. There is one idea within the textual material, meanwhile, which cannot be satisfactorily rendered and that is the conception of the unity of the gospels. In the texts of the Fathers this idea is connected to tetramorphic creatures, something which the iconography from this period made no attempt to depict. The most important aspect of the earliest presentations of these creatures is that by creating a harmony between the iconography and the architectural form of the space itself, they manage to convey the cosmic character of Christ's works.

Thus the symbolism of these creatures in pictorial art as in textual material becomes intimately connected to Christ and his cosmic significance. In both cases emphasis is laid on the connection between the cosmic order and Christ's part in the creation.

With this in mind it is natural to regard the symbolism of the creatures as a motif group intent upon enlarging the understanding of Christ's sovereignty in relation to the results reached in our study of ecclesiological themes. Corresponding to Gregory of Nazianzus' teaching of the double kingdom, we find in the Pudenziana mosaic a presentation of Christ which not only depicts him as king of the church but also allows him to appear as Pantocrator and king over all (see p. 44).

An analysis of the Pudenziana mosaic would not be complete before a closer study of the motifs around the vertical centre axis has been made. In depicting a number of motifs on such an axis, the mosaic clearly departs from the S. Aquilino mosaic. On this axis the primary development is of the Christological and theological group of themes. But, as we are concerned here with motifs which also dominate theme-group III we

have chosen to treat them together. Thus, the analysis of the S. Puden-
ziana mosaic is not actually complete until we have seen it in relation to
the tituli of Paulinus of Nola.

6. Summary

The analysis of theme-group I has, in our presentation, served as an
introduction to a series of problems around which our work with Chris-
tian iconography from the 300's will be centred.

In the first place we looked at the changes which took place in the
teaching scene through the inclusion of elements from other pictorial
traditions. We can almost say that the teaching scene was "overlayed"
by imperial themes. Next we demonstrated that explicit biblical themes
added another layer which partly compensates for and supplements the
imperial theme.

Such a development has made its natural to focus interest on the mean-
ing of imperial and biblical inspired elements in our pictorial program.

It is hardly incidental that imperially inspired pictorial decoration
which actually takes its place in Christian iconography has its roots, first
and foremost in eastern sacred ideology which was only reluctantly
included in Roman imperial ideology. It is mainly the need of imperial
power to find divine support in its demand for world dominion which has
produced iconographical formulations so inspiring to Christian artists.
This parallel usage of pictorial forms in political as well as religious con-
texts has caused obvious difficulties. Not only do creators of religious pic-
tures avoid tendentious political pictorial elements but Christian
emperors too show a degree of reservation towards certain elements in
the inherited imperial use of insignia. As a result it is unreasonable to
draw too close a connection between Christian liturgical pictorial usage
and contemporary political ideology. The church's use of imperial
iconography is directed to a greater degree by its need for clear expres-
sion of liturgically important theological conceptions than by the wish to
clarify the relationship between imperial and ecclesiastical power. In
liturgical work, in any case, the conception of the Divine Christ's cosmic
activity has played an important role. This conception gradually takes on
increasing nuances aided by biblical inspired motifs thus embracing
Christ's activities in the church and in the world.

The utilization of biblical motifs, however, has also included the task
of giving imperially inspired motifs an open and ambiguous framework
which balances on the border between the earthly and the heavenly, of
the present and of the future. This creates wide bounds for interpreta-
tion. The apostolic assembly is seen as both Jesus' disciples on earth and

as a glorifying apostle collegium around the heavenly ruler. In addition, they have their place in the earthly church which praises God in the Divine service while at the same time they are participants in the tribunal on the day of judgement at the end of time. As the iconography appears to have an open form, the interpretive boundaries will be wide. We believe, nevertheless, that it would be wrong to maintain that ambiguity opens the way for arbitrary interpretation. The program under discussion does not present an accumulation of pictorial motifs able to convey an unlimited number of religious conceptions. Behind the presentation lies a totality, a religious pattern in which these individual motifs belong. At this point already, we can establish with certainty that the ambiguity of the pictorial programs causes Christ's work in the church and world to point beyond the limits of life on earth. In the textual analysis we shall take a closer look at such patterns. Before reaching that point, however, we shall look more thoroughly into our understanding of the iconographical form. Particular attention will be paid to several individual motifs which have been utilized in the earliest apsidal art. But, we shall also investigate the functional side of the mosaics. Can we ascertain from the pictorial material itself the part it has played in a liturgical context? This last will be a central question in our work with theme-group II.

THEME GROUP II: CHRIST AS LAWGIVER AMONG THE APOSTLE PRINCES

1. *The Earliest Traditio Scenes*

In the preceding chapter we have given an account of the development in presentations of the enthroned Christ among his apostles. We shall now turn our attention to renditions of the standing Christ in the iconographical program known as *traditio legis* or *dominus legem dat*.[1] The only surviving example of this pictorial program in a monumental, apsidal context from the 4th century is to be found in the south-east side niche of S. Costanza (Ill. 23).[2] Admittedly, here it is not a question of a presentation in an ordinary apsidal vault.[3] Nevertheless, S. Costanza's

[1] While "dominus legem dat" is a direct reference to the scroll inscription in some of the scenes, the term "traditio legis" can be traced to an article written by G. de Saint-Laurent from 1858, see Schumacher, Dominus legem dat p. 2 note 4.

[2] Ihm, Programme, catalogue number I p. 127ff.

[3] S. Costanza is a rotunda connected to a Constantinian basilica construction, see Deichmann, Die Lage and Frutaz, Il complesso. See also the plan (from Brandenburg, Frühchristliche Kunst p. 122 fig. 6).

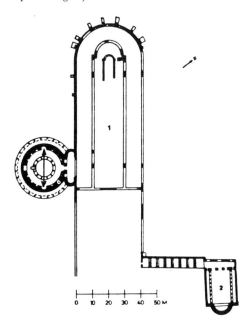

niche mosaic is evidence that this program has been adapted to the apsidal architectural form of the 400's.

An exact dating of S. Costanza's niche mosaics has been difficult. The apses are frequently traced back to the same period as the other mosaic decorations (between 335 and 351),[4] but they may also date from the second half of the 4th century and possibly be connected with a functional change which may have taken place in the building.[5]

We shall attempt to consider the question of dating in relation to the iconographical development which the traditio motif itself undergoes. But, this approach does not render a sure basis for dating because there is no general consensus as to how the earliest development is to be understood. Gerke and Kollwitz maintain that precisely S. Costanza is the earliest surviving monument of this type, one which even includes archaic-like features when compared to the other traditio presentations.[6] G. de Francovich maintains, on the contrary, that the Lateran collection's sarcophagus no. 174 must be seen as the earliest known formulation of this pictorial type.[7]

In any case, Lat. 174 (Ill. 20)[8] appears to be a particular formulation of the pictorial program and for that reason deserves attention. Here we find a number of distinctive characteristics unlike the other traditio scenes. The peculiarity of Lat. 174 is clearly distinguishable when it is compared to, for example, S. Costanza's niche mosaic. First of all, in Lat. 174 Christ is depicted seated, something which never occurs within the Roman type of presentation.[9] Secondly, Christ's right hand is lifted in the usual speaking gesture rather than in the raised, open gesture otherwise so often found in traditio scenes. Furthermore, Christ is not only flanked by Peter and Paul; between him and the apostles appear two youthful men clad in the pallium. Nor does Peter carry a cross and he receives the scroll with hands covered by a cloth instead of the more usual

For the earliest shape of the building, see Stettler, Zur Rekonstruktion. For the discussion about the original function, see Lehmann, Sta Costanza (pagan building), Ferrua, Sul battistero (baptistery) and Stern, Les mosaiques p. 163f. (mausoleum) who gives the most convincing interpretation.

[4] Wilpert/Schumacher, Die römische Mosaiken p. 50 and p. 52; Bovini, Mosaici p. 58-61; de Rossi, Musaici (who considers the building to be Constantinian).

[5] Michel, Die Mosaiken; Stern, Les mosaïques p. 166 suggests the 350's, while Francovich, Studi p. 156 holds to the end of the 4th century.

[6] Gerke, Malerei und Plastik p. 134f; Kollwitz, Christus als Lehrer p. 59; Matthiae, Mosaici p. 37 (relates pacem in the inscription to the Peace between State and Church).

[7] Francovich, Studi p. 119-135.

[8] Deichmann, Repertorium no. 677 p. 274.

[9] For examples of a sitting Christ in Ravenna traditio scene, see the sarcophagus from S. Maria in Porto. Schumacher, Dominus legem dat p. 32 (Taf. 5/2).

corner of his own robe. Finally, here we find no indication of a mountain as so often otherwise in this pictorial program.

Compared to the normal traditio type, Lat. 174 with these peculiarities, approaches the Christ type familiar to us from the Junius Bassus sarcophagus. On both these sarcophagi we see a seated, speaking Christ type with his feet planted on Coelus' outspread swathe. These two sarcophagi are also closely related stylistically.[10] Both have a continuous architrave although the one in Lat. 174 curves backwards over the centre inter-columniation, suggesting an opening to a small exedra.

It is precisely this last feature which relates it also to the Sebastiano fragment (Ill. 21),[11] which has a similar arrangement. In this case, however, we find a standing, bearded Christ who towers above the surrounding apostles and thus the architectural feature becomes the background for his head. Here, furthermore, the personified Coelus is replaced by a mountain and the pallium clad men by palms and lambs. In addition, Peter receives the scroll with his right hand covered in a part of his robe. With his left hand he holds a cross over his shoulder.

C. Davis-Weyer places these three monuments in a small separate group and attempts to place them chronologically within the group. She maintains that the curved architrave and seated Christ on the Lat. 174 is the result of a Bassus type influence which in turn has led to an alteration in the already existing Sebastiano type. Consequently, Lat. 174 cannot be considered a precursor of the "normal type" we recognize from the Sebastiano fragment but is rather a compilation of it and the Bassus sarcophagus' central scene.[12]

The chronology of the monuments is important because the dating is used as an argument against Francovich's theory of the traditio scene's original context. Francovich's primary interest is to trace the derivation of the traditio motif by means of imperial iconography.[13] He sees imperial influence most clearly in precisely Lat. 174 where the Coelus motif leads to a connection with the previously mentioned Arch of Galerius in Salonica (see p. 25). Further, in the presentation of the youthful, pallium-clad men, Francovich finds an influential factor in the largitio scene on the Arch of Constantine. If, in fact, Lat. 174 forms a connecting link between imperial iconography and the normal traditio scene it would seem right to give this sarcophagus an earlier date than that of the Sebas-

[10] Gerke underlines that both belong to the "beautiful" style. He finds, however, a stronger eastern influence in Lat. 174 which is related stylistically to the Sarigüzel-sarcophagus.

[11] Deichmann, Repertorium no. 200 p. 123.

[12] Davis-Weyer, Traditio-Legis-Bild p. 9.

[13] Francovich, Studi p. 134f.

tiano fragment. At the same time, this chronology allows Francovich the
opportunity of claiming that the traditio scene must have originated
within a workshop tradition common to imperial and Christian art. On
this basis Francovich maintains that the traditio program has its origins
in relief sculpture.

We consider Francovich's chronology convincing. Lat. 174 shows
greater signs of antiquated, imperial themes than the Sebastiano frag-
ment which to a large degree utilizes explicit biblical motifs. In placing
Lat. 174 between the Junius Bassus sarcophagus and the Sebastiano frag-
ment, not only is the imperial element in Lat. 174 given a reasonable
explanation but at the same time the isolated, seated traditio Christ
becomes less surprising. In this chronology the traditio program finds
one of its forerunners in the previously discussed teaching scene.

This does not imply, however, that we find sufficient evidence, as does
Francovich, for a derivation of the pictorial program from plastic sar-
cophagus art. Although it is only possible, from the surviving material,
to establish common workshop traditions for Christian and imperial
monuments within the art of relief, this does not prevent the existence
of a corresponding connection in the field of wall decorations.[14] Thus, we
find it unreasonable to assume that the origin of traditio scenes must be
sought in sepulchral art simply because the earliest surviving monuments
are sarcophagi. The monuments which are preserved hardly convey a
reliable picture of the original dispersion of the various types of
monuments.

Davis-Weyer, in detailed studies of extant traditio scenes, has attemp-
ted to penetrate more deeply into the original milieu of the pictorial pro-
gram. She bases her study on a group of presentations related to the
Sebastiano fragment, i.e. Gregory V's sarcophagus (Ill. 22)[15] and Lat.
151.[16] Both are dated somewhat later than the Sebastiano fragment. Of
foremost interest within this group is the placement of Peter and Paul.
While the three-figure scene on the S. Sebastiano and Gregory V sar-
cophagi occupy three intercolumniations, the scene on Lat. 151 occupies
only one. A fixed presentation formula, therefore, cannot have existed at
this time. Davis-Weyer points out that the solution found on Lat. 151
appears unsatisfactory. Here the scroll theme is not properly emphasized
because the figures are too closely crowded together. On the other hand,
as said before, the S. Sebastiano motif is spread over three intercolumn-
iations. Here, however, the distance between the figures is unduly great

[14] See Davis-Weyer, Traditio-Legis-Bild p. 7.
[15] Deichmann, Repertorium no. 676 p. 273.
[16] Ibid. nr. 58 p. 56 (Taf. 19).

in comparison with the usual figure arrangement on the rest of the sar-
cophagus which leads to the necessity of filling in the background with
other motifs. Gregory V's sarcophagus attempts to solve the problems
which the traditio motif creates in the columned sarcophagus by varying
the distance between the columns; here Peter and Paul occupy niches
which are narrower than the other intercolumniations. On this basis
Davis-Weyer establishes that the traditio scene must be considered an
alien element in sarcophagus reliefs. The monuments discussed show
clearly that the pictorial program has its origin in a decorative art with
large, open areas at its disposal.[17]

If this is so, the traditio motif on sarcophagus reliefs must be seen as
a reflection of the mosaic traditio type. Davis-Weyer finds a more direct
reflection of the original traditio presentations in a group of pictures in
which the motif is not broken up by a row of columns. The following
belong within this group: S. Costanza's niche mosaic (Ill. 23), the dome
mosaic in the baptistery of S. Giovanni in Fonte (Ill. 29), a graffito from
a Roman catacomb in Anagni (Ill. 24), a catacomb fresco from Grot-
taferrata,[18] the lid of the Pola casket (Ill. 25),[19] a gilded glass from the
Museo Sacro Vaticano (Ill. 26) and six other articles.[20] A distinctive com-
positional form, uniform right down to the finest details, is found on all
these monuments. These similarities are hardly arbitrary, but in all prob-
ability a consequence of the monuments' reflection of one and the same
model. After detailed studies of form—particularly of the Paul figure's
clothing—Davis-Weyer is left with the Anagni graffito and Pola casket
as the two monuments which reproduce all the motifs of the prototype.[21]
It is out of the question that one of these monuments itself could be the
prototype.[22] When Davis-Weyer commits herself to the premise that
Peter's apse is the source for traditio compositions, she joins a tradition
leading all the way back to R. Garrucci, G. B. de Rossi and J. Wilpert,[23]

[17] Davis-Weyer, Traditio-Legis-Bild p. 10.
[18] See Ihm, Programme Taf. XII. 1.
[19] Volbach, Elfenbeinsarbeiten, catalogue number 120.
[20] Davis-Weyer, Traditio-Legis-Bild p. 12. Survey of traditio compositions in
Nikolash, Zur Deutung p. 71-73.
[21] Ibid. p. 16.
[22] "Das Gefälle zwischen Urbild und Nachahmung ist ja in vielen Fällen nicht nur ein
künstlerisches, sondern auch ein soziologisches, dessen Richtung im allgemeinen vom
öffentlichen zum privaten Bild, vom grossen zum kleinen Format und vom reichen zum
einfacheren Medium verläuft. Da sich aus spätantiker Zeit zwei monumentale Fassungen
der Traditio Legis erhalten haben, dürfen wir auch mit einem monumentalen Prototyp
rechnen. Das Bild war eine Petruskomposition. Seinen natürlichen Platz fand es in S.
Peter", ibid. p. 16.
[23] Ibid. p. 7 notes 2-4.

and which has subsequently gained the support of amongst others, Kollwitz and T. Buddensieg.[24]

Schumacher now takes a sceptical view of this hypothesis. He has launched an alternative reconstruction for S. Peter's, one which is largely based on mediaeval apsidal programs with which we are familiar through 16th century sketches.[25] The degree to which the mediaeval apse reflects the early Christian pictorial program remains an open question.[26] Although we are unable to support Schumacher's reconstruction, we believe there is good reason to stress the mediaeval apse's early Christian prototypes.[27] In the apse of mediaeval S. Peter's, Christ is depicted seated between Peter and Paul. It is credible that this arrangement corresponds to the main characteristics in the early Christian apsidal program. Such an interpretation will cause Peter's apse to fall naturally into the program development we have read into sarcophagus reliefs. The original apse in S. Peter's is usually attributed to the middle of the 4th century, most probably to the century's fifth or sixth decade.[28] Thus, in point of time it is closely related to Lat. 174 which is believed to date from the third quarter of the 4th century.[29] This, however, implies that the apse in S. Peter's is somewhat earlier than the surviving, fully developed traditio formula. In that we can establish a development in the traditio program subsequent to the completion of S. Peter's apsidal decoration it becomes hardly possible that this apse should be the prototype for the fully-developed traditio formula. On the other hand it does suggest that S. Peter's apse represents an early stage in the development of the traditio scene.

The considerations regarding S. Peter's apse play a part in dating the S. Costanza niche mosaic. Finding it highly unlikely that the traditio program was fully-developed round about the middle of the 300's, it is natural to date S. Costanza's apse within the last part of the century. But, by seeing S. Peter's apse as an early step in the development of the traditio scene we lose all evidence in the search for S. Costanza pro-

[24] Kollwitz, Christus als Lehrer p. 59ff.; Buddensieg, Coffret en ivoire p. 163ff. Buddensieg's proposal for the reconstruction of the apse of St. Peter fig. 13. A variant of the same program we find in Ruysschaut, L'inscription absidale Fig. 3.

[25] Schumacher, Römische Apsiskomposition p. 148-178. A proposal for reconstruction in Wilpert/Schumacher, Die römische Mosaiken p. 11.

[26] See Sotomayer's criticism of Schumacher's reconstruction. Rightly Sotomayer doubts the possibility of reconstructing the original apse of St. Peter by making a stylistic comparison between S. Costanza and baroque drawings of the medieval apse of St. Peter, Sotomayer, Herkunft der 'Traditio Legis' p. 220ff.

[27] See Schumacher, Römische Apsiskomposition p. 153ff.

[28] See Krautheimer, Constantinian Basilica p. 120 note 11; Schumacher, Römische Apsiskomposition p. 146f; Ruysschaut, L'inscription absidale p. 188.

[29] Deichmann, Repertorium p. 276.

totype. The prototype for the fully-developed traditio scene remains unknown even though we assume that it has existed within the field of monumental apsidal decoration.

2. The Epiphanic Character of the Traditio Scene

Previously we have stressed that in traditio scenes Christ is almost always depicted standing. This applies to S. Costanza's Christ presentation as well. We have good reason to believe that the creators of the program, with deliberate intent, have chosen a standing Christ type. We saw that the earliest traditio presentation, probably as a result of the influence of the Bassus sarcophagus' Christ type, shows a seated Christ but that this type was quickly abandoned to be first taken up again in the Ravenna sarcophagus reliefs in the 5th century.

In Schumacher's opinion, the key to an interpretation of the standing Christ is to be found in imperial iconography. In scenes showing the emperor appointing a dignitary, he is usually depicted seated as he hands over the *codicilli* of office (Ill. 7). This corresponds with the actual way in which documents were presented according to court ceremony which can be traced back to early imperial times.

Schumacher points out, on the other hand, that the emperor is always shown standing when he speaks to the people from *suggestus* (Ill. 27).[30] On this basis he asserts that the scene cannot reflect a judicial ceremonial presentation of a document. But, does the pictorial program depict a Christ-type speaking to a congregation? Is it not precisely the seated Christ among his apostles who by his speaking gesture and open book is seen as the speaker? Does the traditio-scene then have a distinctive character as compared to the Christ we know from theme-group I? We shall attempt to arrive at a more precise interpretation of the traditio Christ by a closer examination of details and context in the surviving traditio scenes.

In this context the location of the traditio scene within S. Giovanni in Fonte's vault mosaic is of interest (Ill. 28). Despite the fact that three of the eight trapezoid-shaped areas are totally destroyed, the remaining scenes and fragments of scenes convey a certain impression of the dome's thematic program. Apart from the traditio scene, the remaining scenes depict a resurrection motif (the women at the grave) and a number of supplementary themes, to all of which may be given a sacramental meaning as they all circle about the water/bread motif. These include Christ and the Samaritan woman, the miracle at Cana, the miracle of the bread

[30] Schumacher, Dominus legem dat p. 3 with further references in note 9.

and Christ at the sea of Tiberias.[31] The traditio Christ is here placed in a context which focuses on the resurrection and the presence of Christ during the sacrament. It is probable that the traditio scene placed between two sacramental motifs is accorded a meaning corresponding to the rest of the group of themes. The traditio Christ in that case refers in some way to the presence in the baptistery of the resurrected Christ.

In the S. Giovanni traditio presentation Christ is placed on the sphere of the world. The most usual position is on a mountain (cf. Ill. 21-26). We have emphasized previously that the mountain reveals the meeting-place between God and man (see p 31). As such a meeting-place, it not only functions as a suitable way of expressing Christ's relationship to the world but also tells us something about how Christ reveals himself. The mountain is "der klassische Ort der Vision bzw. (ersatzweise) der dort mitgeteilten Belehrung".[32]

> A typical New Testament example of the mountain being assigned an essential meaning within the framework of visionary themes is to be found in the gospel narration of the transfiguration. The scene which is related in Matthew 17:1-9 and par. takes place on a high mountain. Here Christ is placed in a visionary context in that he appears with Moses and Elijah. The event, described as a borderline phenomenon in relation to the historical happening which is the basis for the story, has its theophanic character emphasized by the cloud and the change in Christ's appearance and raiment. In this case it would seem that the object of the theophany is to clarify the relationship between the resurrected Jesus and the Jesus who functioned on earth. Therefore it is said in the account which according to the evangelist, is not to be made known until after the resurrection—"This is my beloved Son ...; listen to him."[33]

The traditio scene's connection to the theophanic theme is strengthened by the depiction of Christ's right-hand gesture which we recognize from the S. Aquilino mosaic. Here it is not a question of the usual speaking gesture, as Christ does not lift his right hand in the familiar way in ordinary teaching scenes. On the other hand we see that the entire arm is raised high with the palm turned towards the onlooker and with outstretched fingers held close together. The gesture has been studied by H. P. L'Orange who maintains that it has a clearly defined meaning which was immediately recognized and understood in Antiquity.[34] The gesture is to be found on a number of monuments which reflect oriental and particularly Semitic cult practices.

[31] For the interpretations of the scenes, see Wilpert/Schumacher p. 304.

[32] Berger, Ursprung der Traditio p. 109 with further reading given in note 19; see also p. 114.

[33] Matthew 17:5 and 9.

[34] L'Orange, Sol invictus p. 87.

In Roman iconography the gesture is closely connected with the sun cult. When the sun-god is depicted in the Severan period, he is frequently shown with a crown of sun-rays, holding a globe while his gaze is directed towards the left and his arm raised in the gesture as described.[35] Such scenes are repeated all through the 3rd century and culminate in the first quarter of the 4th century under the emperor Constantine. In the east arch of the Arch of Constantine and immediately opposite the emperor is a life-size bust of Sol Invictus, his hand raised in this characteristic gesture.[36]

We have previously recounted the basic elements in Antiquity's sun symbolism (see p. 32). We would like to examine one facet of this subject more closely. Light symbolism has a particular meaning in connection with the Epiphany. As an advent symbol the light phenomenon has long traditions.[37] According to Alföldi, all these elements are taken into the Roman ritual of receiving.[38] They are not only related to the emperor taking office but also to "seinem tatsächlichen Einzug".[39]

When Christ is shown making this sun-god gesture it is reasonable to assume that he is not only to be seen as a Divinity with authority (see p. 37) but also as the God who reveals himself to men in the light phenomenon. The ruler scene becomes a theophanic presentation. In the same way in which the emperor makes his appearances in various parts of the empire, Christ makes his in his church. That Christ's parousia has actually been associated with the parousia of a head of state is documented in a prayer from Justinian's time in which Christ's parousia is likened to that of the ruler of Thebais.[40]

The reddish clouds in the background of the S. Costanza mosaic which are seen as well in the S. Giovanni in Fonte traditio scene (Ill. 29), support this interpretation. It is doubtful that it is a question here of a reference to a red evening sky as C. R. Morey assumes.[41] In symbolism

[35] Ibid. p. 90.

[36] Ibid. Abb. 12.

[37] As evidence for the long traditions of the light phenomenon as an advent symbol, we refer to a text by Aristophanes and quote from Alföldi: "O ihr glückliches ... Vogelvolk empfanget eueren Fürsten froh im Prunkpalast. Er kommt daher, lichtstrahlend, wie noch nie ein Stern des Himmels goldgestirnten Dom durchleuchtete, und selbst der Mittagssonne strahlend güldner Ball, er strahlte nie so wunderbar, wie der sich naht, an dessen Seite aller Schönheit Königin, in dessen Hand der Flammenblitz des Zeus! Es senkt ein zaubersüsser Duft sich niederwärts. Ein selig Schauspiel! Und des Weihrauchs stilles Wehen, vom heiligen Altare wallt es, wolkt es sich empor,—da seht ihn selber ... Öffnet jetzt zum Gruss, ihr heiligen Musen, des Gesanges holden Mund", Alföldi, Monarchische Repräsentation p. 88f.

[38] Ibid. p. 89.

[39] Ibid. p. 88; see also Deissmann, Licht vom Osten p. 314-320.

[40] Deissmann, Licht vom Osten p. 319f; see also Schubert, Bildkunst p. 184.

[41] Morey, Lost mosaics p. 35.

based on light phenomena it is above all the dawn which is meaningful.[42]
Consequently, it is more natural that the reddish colour of the sky refers
to an early morning red. This interpretation is supported, moreover, by
the south-east orientation of the mosaic. Christ approaches us on clouds
coloured by morning's light. The eastern sky contains rich figurative
significance usually connected with a paradise/heavenly theme. Accord-
ing to Genesis 2:8, paradise lay in the east and it was generally con-
sidered that it was there the home of the faithful lay.[43] This symbolism
can also be explicitly linked to the sun theme—the place of the righteous
is the place where the sun rises.[44] And, since Christ both ascended into
heaven towards the east and is expected to return from the east, it
immediately suggests itself that Christ's dwelling-place is also there.[45]
Christ, therefore, comes from the east to reveal himself to man and in
consequence one should face the east when praying. Gregory of Nyssa
speaks thus of turning in prayer towards light-filled eastern parts.[46] But,
Gregory, as well as Augustine, know that here it is a question of
figurative language demanding explanation to avoid misunderstan-
ding.[47] In looking east one's gaze is directed towards God who as Christ
appears from God's dwelling-place—the region of the morning sun.

This part of the traditio analysis has been concentrated on the scene's
theophanic character. This aspect cannot be seen as a special
characteristic distinct from, for example, theme-group I, although we see
it especially clearly in precisely the traditio program. We maintain, how-
ever, that the combined mountain/light theme usually lends an aspect of
revelation to the pictorial program. It is important that this aspect be
emphasized as it is decisive in our interpretation of all the pictorial pro-
grams we analyse in this study. The theophanic aspect implies that the
pictorial presentation contains a pronounced element of the presence. It
is not solely past, future or heavenly motifs which appear in these pic-
torial programs but the presence of God here and now in the actual
church. The scenes have a latent aspect of revelation incorporated in the

[42] See Dölger, Sol Salutis where the sun theme is mostly related to "die Gebets-
Ostung".

[43] Ibid. p. 229.

[44] Ibid. p. 232 with reference to Basilius of Caesarea, De spir. sanct. 27. 66 (PG. 32.
189).

[45] Ibid. p. 232.

[46] Gregory of Nyssa, De orat. dom.—oratio V (PG. 44. 1184). See Dölger, Sol Salutis
p. 233.

[47] Augustine says: "cum ad orationem stamus, ad orientem convertimur, unde
coelum surgit: non tanquam ibi habitet et Deus, quasi cæteras mundi partes deseruerit
qui ubique præsens est, non locorum spatiis, sed majestatis potentia; sed ut admoneatur
animus ad naturam excellentiorem se convertere, id est ad Deum", Augustine, De ser-
mone domini in monte 2. 18 (PL. 34. 1277).

motif group itself, one which implies that the main person in the picture can, in a way step out of it and be present, in certain situations, in the church itself.

It is only to be expected that such theophanic scenes, in one way or another, refer to the resurrected Christ. In the kingship theme such a conception is innate in the utilization we have seen of sovereign dignity itself. In the traditio scene, the phoenix which is sometimes depicted in the palm tree at the left of the picture—just beside Christ's head—must be interpreted as an allusion to the resurrection of Christ (Ill. 26).

Stories of the phoenix appear frequently in the writings of the Church Fathers as support for the credibility of the resurrection. Cyril of Jerusalem narrates the following version of the phoenix legend. The bird appears in Egypt every five hundred years. This happens openly and in a place where anyone can touch it. Here it builds its nest of incense, myhrr and other sweet-smelling spices. When its life-span is finished it dies and rots where all can see. But, from the dead bird there emerges a small, crawling thing which in due course becomes a bird. Thereupon it flies upward just as the previous phoenix and in this way gives clear proof of the resurrection of the dead.[48] Thus, when the phoenix is placed close to Christ's head in the traditio scene it indicates that Christ is the resurrected one.

If we are to delve more deeply into the traditio scene's special characteristics, we must look more closely at its most characteristic element, the scroll motif. By studying this motif we shall try to arrive at a more precise determination of the pictorial program's Christological content.

3. Dominus Legem Dat

Our interpretation of the traditio scene's presentation of Christ becomes controversial when we examine the debate concerning this program. The debate has its roots in the turn of the century period but has been particularly intense in recent decades. Although the motif has been one of early Christian iconography's most central research objects since the end of the 1950's, there is little sign of any consensus as yet. Let us look at some important contributions as a background for our treatment of the scroll motif.

An established interpretive tradition which can be traced to Garrucci, de Rossi and Wilpert,[49] sees the traditio scene as a representation of

[48] Cyril of Jerusalem, Cat. 18. 8 (PG. 33. 1025-27); for further reading, see Van den Broek, The Myth of the Phoenix.

[49] Garrucci, Storia dell'arte vol. IV p. 11f; de Rossi, "Utensilie cristiani scoperti in Porto", Nuovo Bulletino di archeologia cristiana 1866 p. 39ff. (reference from Davis-Weyer, Traditio-Legis-Bild note 3); Wilpert, Mosaiken und Malereien vol. I p. 237f.

Peter's investiture. When Peter, prince of the apostles, receives Christ's law, it emphasizes his leadership among the apostles and in the church. In modern times this interpretation has been taken up once more by, amongst others, P. Franke—although in a modified form.[50] Basically, such an interpretation is historically orientated; the motif is perceived as a representation of an historical event related in the Gospels.[51]

Subsequently a number of attempts have been made to find other historical scenes which cover all aspects of the complexity of motifs presented in the traditio-scene. Thus, Kollwitz, for example, sees the picture as a simplified delegating scene.[52]

Reacting against historically orientated interpretations, T. Birt has emphasized that the object of the presentation is to show the veneration and respect due to God's word.[53] Thus, Peter is shown as the representative of the entire church when, with covered hands, he receives the law.

P. Styger represents a different approach. He maintains that Peter holds the scroll as symbolic emphasis on the direct participation in Christ's revelation.[54] It is here that the interpretation of the scene as a revelation has its roots. Schumacher is close to Styger in his interpretation. He maintains that it is a question of a Divine revelation but stresses, at the same time, that it refers to the first time the Lord reveals himself to Peter.[55] In this way, Schumacher introduces once more a clearly historical aspect in his interpretation. For him the Divine revelation is linked to a single historical event, the first eye-witness' encounter with the risen Christ. Schumacher subsequently deviates somewhat in his interpretation when he says that the scroll which symbolizes the word of God also represents Christ's teachings to Peter and

[50] Franke, Traditio legis p. 266f.

[51] See e.g. Matthew 16:18.

[52] Kollwitz, Christus als Lehrer p. 63.

[53] Birt, Die Buchrolle p. 185: "Nichts aber ist törichter als in diesen Fällen an eine Überreichung des Buchs zu denken. Man überreiche einmal eine Binde von einigen Metern Länge in aufgerolltem Zustand; der Empfänger wird verzweifeln; die Stoffmasse fällt schmählich zu Boden und das heilige Buch wird entweiht. Nur darum, die sacra Charta vor Verletzung zu schützen, ist Petrus bemüht und verhindert, dass sie frei herabhängt. Natürlich war dies aber zugleich eine Allegorie: er erschien so als der Schützer des Logos."

[54] "Die Hauptsache der ganzen Komposition ist die Offenbarung der Majestas Domini ... Also Christus *verkündigt* hier sein Gesetz; darum die magistratische Haltung; darum die entfaltete Rolle, das geoffenbarte Wort", Styger, Neue Untersuchungen p. 66.

[55] Schumacher underlines that we have a presentation of a " 'göttliche Erscheinung unseres Herrn Jesus Christus' ... Petrus wohnt ihr als erster der 'Augenzeugen seiner Majestät' bei. Das ist an sich nicht überraschend, werden ja auch andere Visionen Petri in der gleichzeitigen Kunst gestaltet", Schumacher, Dominus legem dat p. 18 with reference to 2. Petr. 1:16.

Paul after the resurrection.[56] In this way Paul too is given a justifiable place in the scene as a whole. Schumacher goes further, however, maintaining that we may assume that this vision also contains eschatological conceptions.[57] Nevertheless, he insists that the picture be given an unequivocal interpretation; it represents "ein österliche Theophanie Christi".[58]

F. Nikolash agrees with Schumacher's eschatological viewpoint.[59] The basis for his interpretation is interesting. He proposes that the scene must have a functional character, which a scene of Jesus' manifestation to Peter can hardly have had for a 4th century Christian. On the other hand, he takes it for granted that a futuristic-eschatological pictorial program is capable of functioning.[60] Berger, too, gives the scene an eschatological accent, but this time he does so on the grounds of similarities with apocalyptic vision accounts. These, according to him, supply the relevant interpretative key to the pictures. From Berger's viewpoint, the book rolls refer to an apocalyptic meaning as they provide instruction concerning the connection between law fulfilment and judgment.[61]

Christe agrees, in a way, to the Styger tradition's interpretation of the pictorial program but in this case presents it in an eschatologically inclined terminology. He maintains, as does Schumacher, that there are apocalyptic motifs in the traditio scene but will not, in contrast to Schumacher, give these apocalyptic pictorial themes a primarily futuristic-eschatological interpretation.[62]

[56] Ibid. p. 19 with reference to Acts 1:3.

[57] Ibid. p. 20.

[58] Ibid. p. 22. In an interesting way Schumacher touches here on the existing tension between the imagery's presentation of theophany motifs and various allusions to elements in salvation history. Schumacher, however, does not penetrate into the problems this raises for the interpretation. His own point of view is summed up in the following way: "In soteriologischer Gesamtschau werden Auferstehung, Erscheinung und Wiederkehr Christi zum Gericht in dem einen Bild des 'Dominus legem dat' zusammengezogen" p. 22. But, this "Gesamtschau" is immediately broken up into details: "Mit dem veränderten Betrachtungspunkt variiert die Aussage" p. 23. We doubt that a definite situation makes the program unambiguous as Schumacher presupposes.

[59] Nikolash says: "Sollte man aber nicht eher von der Überlegung ausgehen, dass den Christen primär dieser eschatologische Aspekt am Herzen liegen musste, dass somit auch die eschatologische Komponente als der primär dominierende Aspekt der Bildkomposition in Erscheinung treten muss?", Nikolash, Zur Deutung p. 38f.

[60] Ibid. p. 38.

[61] Berger, Ursprung der Traditio p. 118.

[62] Christe says: "Dans tous les cas, par une proclamation, une apparition triomphale, l'érection d'un trophée ou une intronisation cosmique est répétée eadem aliter la même réalité: l'instauration d'un règne nouveau, inauguré par la victoire de son fondateur, qui à cette occasion proclame la naissance et la diffusion de l'Eglise, id est regnum Christi. La dominante est donc pascale et ecclésiale, et s'il fallait parler ici d'eschatologie, le terme

Before we tackle a detailed investigation of the scroll motif, we would like to make some general remarks about the research contributions presented here. Based on the iconographical analysis of the Christ figure itself, we find it impossible to support an interpretation which primarily perceives the scene as representing a single gospel story. The problem with such an interpretation becomes greater when one sees how difficult it is to decide just which story is represented. Thus, we cannot accept the program as Peter's investiture to the primacy, a delegating of apostles or as the first Christophany after the resurrection. The composition presents far too many pictorial elements which do not belong within a specific gospel story, whichever one it might be. Neither scroll, lamb, palms nor Paul have a place in any of the stories mentioned. So, we maintain that any attempts to find a connection between the traditio scene and a specific gospel story—whether it concerns events before or after the resurrection—are not very convincing.

At the same time, however, we must admit that the program plays upon and makes allusions to biblical accounts. It is precisely in the pictorial formula's references to a number of *different* elements from biblical texts that we find an important point. It is the ambiguity arising in this way which is interesting and creates interpretive challenges. J.-L. Maier gives a pertinent characterization of the traditio scene in S. Giovanni in Fonte which touches on the real problem of our pictorial analysis. He says that in S. Giovanni it is not a question of a realistic scene as it takes place neither on earth nor in heaven. It is not on earth as Christ's feet are planted in the sky. It is not in heaven since it concerns the earthly mission of the church. Finally, it is not historical because the apostle Paul is present.[63] We find Maier's characterization of what the scene does *not* represent more to the point than his positive description. He says that it concerns an ideal world which makes an abstraction of time and place.[64] In support of such an interpretation Maier looks for textual sources in the Pauline letters instead of in the Gospels. Our attitude is reserved towards his characterization of "ideal world". This easily leads to a perception of the program as abstract, removed from time and place; in other words, far from actual, concrete reality.

devrait être complété puisque le Règne du Christ et de l'Eglise est instauré et que l'essentiel est acquis. Dans ces images d'apparat, et en particulier dans la *traditio legis*, nous verrons donc des formules évidemment orientées vers le futur et le Royaume de Dieu, mais prenant appui sur une réalité déjà présente qui est l'instauration du Règne du Christ. Il conviendrait donc de parler d'eschatologie présente ou en voie de réalisation, l'élément proprement deutéro-parousiasque étant absent des ces images", Christe, Apocalypse p. 44.

[63] Maier, Baptistère de Naples p. 109.
[64] Ibid.

For our own part we wish to emphasize that the scene points to Gospel accounts without necessarily identifying it with a specific story. The Gospel stories seem rather to function as allusions which are combined and organized on the basis of an overall objective.

In the research survey we have found a recurring contrast between historical and actualizing interpretations. In our view the traditio scene contains historical characteristics while at the same time we emphasize its theophanic character. It is our opinion that such an arrangement captures important programmatic characteristics. As a liturgical decoration, the role of the apsidal scene is to function within the context of Divine service. Actualization shown by such pictorial usage is covered by, amongst other things, giving the scene a visionary character. At the same time, the message transmitted by the picture is linked to happenings in the life of Christ as related in the Gospel. It is, however, not any one specific event depicted here but rather Christological aspects, which are also considered important within the liturgical program. Thus, the apsidal scene expresses a Christological group of themes seen from a hermeneutic angle.

On this premise we turn to the scroll motif which has been the basis for the discussion of the traditio scene.

We have seen previously that the scroll plays an important part in pictorial presentations in which the teaching Christ is the central motif. In traditio scenes, meanwhile, we find that the motif has a distinctive form. In his left hand Christ holds a scroll which is partly unrolled so that Peter can receive it in his hands. In some scenes there is an inscription on the unrolled part of the scroll. Such inscriptions are found in S. Costanza, in S. Giovanni in Fonte and are suggested on the Vatican gilded glass and on the catacomb frescoes from Grottaferrata. On the other hand, none of the sarcophagi show remains of inscriptions on scrolls. The surviving texts on several of the monuments are partly destroyed and therefore difficult to decipher. In S. Giovanni in Fonte, however, we read clearly DOMINVS LEGEM DAT (Ill. 29). The inscription on the S. Costanza scroll is less certain. Today it appears as DOMINVS PACEM DAT but there is doubt as to whether or not this is the original inscription. Wilpert, who maintains that the inscription has been changed, bases his interpretation on references to Ugonio's observations from the end of the 1500's.[65] Matthiae maintains,[66] however, as does E.

[65] Wilpert finds support for his interpretation of the inscription in the observations made by Ugonio who at first read ... C LINVS / G EMDAE on the scroll. Later he interpreted this as follows: DOMINUS LUCEM DAT. Ugonios observations show that the inscription was destroyed in about 1600. See Wilpert/Schumacher, Die römische Mosaiken fig. 25 p. 49. Wilpert asserts that the original inscription must have been DOMINUS LEGEM DAT; Ihm agrees, Programme p. 127.

[66] Matthiae, Mosaici p. 36.

Kirschbaum[67] that the surviving inscription is the original. When compared to the other inscriptions, however, we find no other basis for a text containing "pacem". In S. Giovanni, as mentioned, we read "legem". There has been insufficient space on the Vatican gilded glass to do more than inscribe DOMINVS as an indication of a longer inscription. Similarly, the inscription on the glass piece from Porto is shortened to LEX DOMINI.[68] Thus, dominus legem dat is solidly established in the monuments and in all probability constitutes the original scroll inscription in the traditio program. The last inscriptions mentioned (and lack of inscriptions) show in addition that smaller articles are dependent upon monumental works which again suggests that the sepulchral works are derived from the large mosaics (cf. the exchange between Davis-Weyer and Francovich p. 67). There is, indeed, every reason to believe that inscriptions have been a part of the original program and have either been shortened or simply omitted in derivative works.

Schumacher points out that "legem dare" means to enact a law in the sense of issuing but never in the sense of handing over.[69] This interpretation weakens the investiture interpretation. In the text the main emphasis is on the issue, the enactment of the law with clear emphasis on the subject of the action. The object of our further textual research is to substantiate and develop this interpretation more fully.

In this context a text from Revelation 10:1 ff. is relevant. Here it is said: "Then I saw another mighty angel coming down from heaven, wrapped in a cloud, with a rainbow over his head, and his face was like the sun, and his legs like pillars of fire. He had a little scroll open in his hand ... And the angel ... lifted up his right hand to heaven, And swore by him who lives for ever and ever ... that there should be no more delay." The organization of this text has in itself close affinities with our traditio scene. We note particularly the way in which the account builds up towards the transmission of a message—in this case apocalyptic. Victorinus of Pettau's interpretation of the vision is of interest. The shining angel is seen here as the resurrected Christ who has written in his book the events taking place at the end of time; these point towards the judgement which he himself will carry out.[70] For Victorinus the scene becomes a Christological revelation of what will happen at the end of time.

In our traditio scene, however, the content differs to that of Revelation 10. Here it is the law or peace which is revealed. We know that in Chris-

[67] Kirschbaum, Stommel p. 144.

[68] Davis-Weyer, Traditio-Legis-Bild p. 28.

[69] Schumacher, Dominus legem dat p. 10; see Davis-Weyer, Traditio-Legis-Bild p. 28.

[70] Victorinus av Pettau, Comm. in apoc. 10. 1 (CSEL. 49. 88).

tian tradition the law as well as peace are concepts so charged with meaning that they lend themselves to the creation of rich associations. We may assume that the inscription is chosen precisely in order to suggest a theme both central and with many aspects. We shall try to indicate presentations which in the days of the New Testament and early Christianity are usually connected with the term law. In our opinion, a rather loose indication corresponds exactly with the level of intention on such an inscription as this; its function is precisely that of awakening associations.

In the gospel of Matthew the law plays an important role. Thus, the content of the sermon on the mount can be summed up as follows: "Think not that I have come to abolish the law and the prophets; I have come not to abolish them but to fulfil them."[71] Here Christ's interpretation of the law is put into a relationship of contrast and continuity with Mosaic law.[72]

In other parts of the New Testament, too, the law may be found used as a collective term for the Christian message. In Romans 8:2 we read: "For the law of the Spirit of life in Christ Jesus has set me free from the law of sin and death." Here we see, in addition, that a life/death theme is explicitly linked to the distinction which Christ makes in man's relation to the law.[73]

Y. Congar uses a number of textual sources to support a continued utilization of law terminology as a collective expression for the content of Christianity in the following centuries.[74] Tertullian's formulation is typical: "Nunc ad legem proprie nostram, id est, ad Evangelium conversi."[75]

From the 4th century we find an interesting use of law terminology in Egeria's travel account (cf. p. 149). In describing her experiences in Jerusalem she refers, among other things, to the bishop's catechetical teaching which is designated as God's law. Then it is made clear that the content of the law comprises an explanation of the Scriptures, instruction about the resurrection and the faith.[76] In view of our subsequent work with catechetical sources such a connection between law and catechism

[71] Matthew 5:17.

[72] Note that the gospel according to Matthew is brought to a close with a theophanic scene which takes place on a mountain. In this connection the law plays an important part, see Matthew 28:16-20.

[73] Cf. also texts such as 1 Cor. 9:21; Gal. 6:2 and Rom. 13:8.

[74] Congar, 'don de la Loi' p. 915-933.

[75] Tertullian, Monog. 8 (PL. 2. 988).

[76] "Cathecuminus autem ibi non intrat tunc qua episcopus docet illos legem, id est sic: inchoans a Genese per illos dies quadraginta percurret omnes Scripturas, primum exponens carnaliter et sic illud soluens spiritaliter. Nec non etiam et de resurrectione, similiter et de fide omnia docentur per illos dies; hoc autem cathecisis appellatur", Egeria, Itinerarium 46. 2 (SC. 296. 308).

is of interest; but, in addition, the text supports the wide interpretation of law in the 4th century as well.

If we are to suggest a definite theme group of particular importance in the use of law terminology, it is natural to turn to the relationship between Mosaic law and Christian law which we have seen in both our New Testament textual references. John Chrysostom touches on corresponding themes in his commentary on Hebrews 7:19. After having made it clear that the ancient law of the covenant functioned at one time but was now annulled, he asks if this implies that Mosaic law was useless. To this he answers that the law was useful enough but that it was incapable of making man perfect. Characteristically enough, the typical distinguishing features of Mosaic law, such as circumcision, sacrifice and the keeping of the sabbath are described as types and shades, τύποι and σκία for the new things which are heralded by Christ.[77] In Hom. XIV on the gospel of John, this theme is carried further. As an interpretation of Romans 8:2, John Chrysostom describes the relationship between the new and the old law in the following way: "The words in the first case are used as types, in the second as realities, preserving a sameness of sound, though not of sense."[78]

From the texts indicated here it is natural to accent the comprehensive character of the law. The law simply acts as the essence of the new conditions of life brought to the world by Christ. The quality of the conditions of live in question here is accented by contrasting them with Mosaic law.

To assign such a comprehensive interpretation to the scroll inscription in the traditio-scene is an idea which immediately presents itself. We have already seen that the scroll inscription indicates that Christ appears as the founder of the law. Thus, the pictorial motif emphasizes that Christ's law indicates the termination of Mosaic law while simultaneously his own law forecasts a new relationship to God. Through the person of Christ a reality determined by God is introduced into the world.[79]

In this way the traditio scene emphasizes another Christological aspect than that of the ruler scene from theme-group I. The ruler rendition accents Christ's all-embracing activity in the church and in the world; the traditio-Christ marks the decisive point at which the old law is replaced

[77] John Chrysostom, Hom. in epist. ad Hebr. 13 (PG. 63. 105).

[78] John Chrysostom, Hom. in Joh. 14. 1 (PG. 59. 93).

[79] According to Congar the term pax means nearly the same as lex within "l'idéologie de l'époque constantinienne", Congar, 'don de la Loi' p. 933. Maier, likewise, with Historia Augusta as his reference, points out a close connection between lex and pax within the roman milieu: "Ubique pax, ubique romanae leges", Maier, Baptistère de Naples p. 113.

by the new. The focus is on the change which the coming of Christ will bring with it for the world.

4. Peter and Paul

In the traditio scene we see that the scroll which Christ unrolls is received into the covered hands of Peter who is clearly moving forward—possibly a bent-knee position can be detected in the action. The iconographical model for the covered hands is to be found in the east where the custom was connected with royal audiences. Later, this custom was adopted by the Roman imperial court.[80] The gesture is closely linked to Paul's gesture of acclaim which was treated more fully when examining the teaching scene (see p. 40). Through acclamation and with covered hands, devotion and adoration are expressed.

In his eagerness to reject an investiture interpretation, Schumacher attempts to show that no document is being received by Peter's covered hands. As evidence he refers to monuments showing persons with covered hands but in which no handing over of gifts takes place.[81] He proposes that Peter catches the scroll so that it will not touch the ground and sees the action as a personal gesture of reverence.[82] Such an interpretation seems rather far-fetched. The scroll itself, the iconographical link between Christ and Peter, thereby loses all meaning. We maintain, on the contrary, that Peter catches the scroll in order to emphasize that he is the receiver of the law proclaimed by Christ. The law is transferred from Christ to Peter.

Several times we have referred to an interpretation of the traditio program which puts the main emphasis on the Peter motif. In such cases the aim is usually to find a reflection of the papacy's demand for religious and political leadership.[83] An interpretation primarily based on iconographical material, however, reveals small evidence for such an understanding. There are no grounds for emphasis on the connection between Christ and Peter. In sources from Constantinople and later from Ravenna we see that Paul can also be recipient of the scroll.[84] Furthermore, it is characteristic that Peter, customarily shown in earlier presentations in the position of honour on Christ's right hand, is placed on his

[80] See Dieterich, Ritus p. 440-448.

[81] Schumacher, Dominus legem dat p. 7 with reference to monuments in note 35 and 35a.

[82] Ibid. p. 7. For further reading see p. 6 note 32.

[83] Contrary to earlier ultra Montanistic influenced interpretations Pietri deals with the traditio theme as a part of the papacy's growing political power, Pietri, Roma Christiana p. 1413-1535.

[84] Kollwitz, Oströmische Plastik p. 141 and p. 154f.

left hand in this scene.[85] These characteristics suggest that both apostle princes play a central role in the pictorial program.

It is hardly incidental that this theme has been especially popular in the vicinity of Rome.[86] The Sebastiano fragment which was found in a place where an early cult of Peter and Paul existed, indicates that on such monuments the apostle princes should be seen as a Roman element rather than as an expression of the primacy theme.[87] J. M. Huskinson connects this iconography to the political development of Rome in the 4th century. As a reaction to lost power and influence the Roman church now emphasizes more strongly than before its demand for apostolic authority. In this propaganda Paul's role is just as important as Peter's.[88]

Thus, the princes of the apostles supplement the central motif of the traditio scene. With Paul who acclaims the Christ who brings a new relationship with God into the world, Peter by means of his covered hands, emphasizes that Christ's law—which must be respected—is to be spread throughout the world and adhered to through the Roman apostolic church.

Among the details of the traditio scene's apostolic iconography it is well to be aware of Peter's cross which he bears over his left shoulder. This appears in most of the traditio scenes and as in S. Giovanni in Fonte takes the form of Christ's monogram. We have good reason to believe that Peter in S. Costanza has been given a corresponding attribute.[89] The cross theme will be thoroughly analysed in our next main chapter. At this point we shall only emphasize that in this presentation the cross is not primarily a reference to the Easter events but rather to the martyrdom.

It is, of course, obvious that Peter carries a cross because according to tradition he suffered martyrdom on a cross. The tradition is probably

[85] Kollwitz, Christus als Lehrer p. 55ff.

[86] See Ihm, Programme p. 38 note 104.

[87] Franke, Traditio legis p. 269, see also note 66.

[88] "The popularity of the apostle Peter in this period, then, must not be confused with the official emphasis on the primacy of Peter, which came later. The popularity of the apostle Peter was matched, it would seem, in the second half of the century, by the popularity of the apostle Paul. In an increasingly christianized Rome, it was essential for the local Church to make every effort to convert the real rulers of the City, the Roman aristocracy, to Christianity. The apostle Paul was, after all, the *doctor gentium*, the apostle of the *ecclesia ex gentibus*, and it would have been politic, at least, for the bishop of Rome and his advisers to stress this authority", Huskinson, Concordia Apostolorum p. 2.

[89] For the present state of the mosaic, see Wilpert/Schumacher, Die römische Mosaiken Pl. 1. Already at the time of Ugonio the head of Peter was damaged, de Rossi, Musaici. The staff still seen in Peters hand, has not been interpreted as a part of the cross in the last restoration which Wilpert characterizes as "die monströse Ergänzung des Oberkörpers und die partielle Unterdrückung des Stabkreuzes bei Petrus", Wilpert/Schumacher, Die römische Mosaiken p. 5; see also de Rossi, Musaici; Ihm, Programme p. 127f. and Schumacher in Wilpert/Schumacher, p. 299. Matthiae maintains, however, in Musaici p. 36 that it is only a staff Peter holds in his hand.

reflected already in John 21:18. It is not inconceivable that precisely John 21 with its rich allusions has been the inspiration for the presentation of Peter which we find in the traditio scene.

John 21 describes a meeting between Jesus and the disciples after the resurrection. Following their recognition of him, Christ addresses Peter three times instructing him to take care of his sheep. Immediately after these instructions, Peter is told that when he is old he will stretch forth his hands and be led whither he himself did not wish. This statement serves as an omen of the way in which Peter was to die.[90] We have shown earlier that the traditio motif itself does not fit into the context of this task. The scroll which Peter receives has a different content to that of the task assigned here. Nevertheless, we have the impression that this alloting of duties is maintained throughout the traditio composition by depicting lambs in front of or behind the apostle (Ill. 23 and Ill. 24). Since it is natural to link apostle and shepherd closely, such a theme will involuntarily support an interpretation centering around the leader of the church.

But, as we so often have seen within this type of iconography we do not remain on one level of association. This is because, in the traditio scene, we are not only faced with Peter's assignment. Paul too is surrounded by sheep. We pass almost imperceptibly from one allusion level to another—from a single assignment-of-task scene to one which is double—from John 21 to Galatians 2. In the letter to the Galatians it is said that as a result of a vision[91] Paul travels to Jerusalem where, according to his word, "I had been entrusted with the gospel of the uncircumcised, just as Peter had been entrusted with the gospel of the circumcised."[92] Paul's participation in the task presupposes his dramatic conversion when according to Luke he sees Christ in a vision.[93]

In this way it happened that Peter and Paul together become the representatives of the task of preaching the gospel and usually in the way described in Galatians. Peter is responsible for the Jews and Paul for the Gentiles. This belief was preserved right up to the 4th century. It is sufficient here to refer to Ambrosiaster's comments on the letters to the Galatians and his interpretation of Chap. 2:7-10 where we discover a distinct deviation from the New Testament text. The assignment to preach the gospel remains but the accent is now on the importance of the apostle princes as founders of the church. As such Peter has special authority over Jewish Christians while Paul has a corresponding authority over the

[90] John 21:18f.
[91] Gal. 2:2.
[92] Gal. 2:7.
[93] Acts 26:12ff.

Gentile church. Peter and Paul are no longer merely the first missionaries but lend apostolic legitmacy to the established church of the 300's.[94] Thus, these apostle princes become not only apostles with a special task but also representatives of the church, perhaps even personifications of the church.

Unequivocal evidence that such representational symbolism has actually been ascribed to iconographical presentations of the two apostles is found in, amongst others, S. Maria Maggiore's triumphal arch dating from the primacy of Sixtus III (432-440). Here the hetoimasia throne (Ill. 41) is flanked by Peter and Paul each holding an open book in his hands. Now one senses a difference in the inscription indications in these books. Whereas Peter's book shows block-like characters, those in Paul's book are more linear and flowing. L. de Bruyne sees a connection between the characters in Peter's book and Hebrew characters which he takes as a reference to Jewry while Peter's inscription is seen as a rendering of Greek italic characters which are linked with the apostle's task as missionary to the Gentiles.[95] Furthermore, in the arch's lowest zone we find Jerusalem pictured on Peter's side while on Paul's side is a representation of Bethlehem. Six lambs appear in front of each urban scene.

S. Giovanni in Fonte's traditio scene is direct evidence that this symbolism has been connected with traditio-scenes. Beneath the inscription DOMINVS LEGEM DAT are some characters which, using the S. Maria Maggiore mosaic as a background, suggest their interpretation as being a copy of Hebrew characters (Ill. 29).

Relating the intimation of a divided church and the scroll is probably instrumental in giving the law a certain nuance. There is textual evidence that the law motif can be directly linked to this concept of a church divided in two. In the Ambrosiaster commentary on Ephesians 2:14, the author maintains that Christ, in handing down his law, abolished the ancient enmity between Jews and Gentiles and thus created peace between the two groups.[96] This law is closely related to Christ's own person.[97]

[94] "Petrum solum nominat, et sibi comparat, quia primatum ipse acceperat ad fundandam Ecclesiam: se quoque pari modo electum, ut primatum habeat in fundandis gentium Ecclesiis: ita tamen, ut et Petrus gentibus prædicaret, si causa fuisset, et Paulus Judæis. Nam uterque invenitur utrumque fecisse: sed tamen plena auctoritas, Petro in Judaismi prædicatione data dignoscitur, et Pauli perfecta auctoritas in prædicatione gentium invenitur", Ambrosiaster, Comm. in ep. ad Gal. (PL. 17. 368-9).

[95] Bruyne, Mos. dell'arco trionfale p. 259; see also Nikolash, Zur Deutung p. 60.

[96] "Pacem fecit inter circumcisionem et praeputium passio Salvatoris. Inimicitiam enim, quae velut paries media erat, et dividebat circumcisionem a praeputio, et praeputium a circumcisione, hanc solvit Salvator, dans legem ...", Ambrosiaster, Comm. in ep. ad Eph. (PL. 17. 400f).

[97] "Omnia enim quae docuit Salvator, tunc firmavit, cum resurrexit a mortuis", ibid.

We have already suggested the connecting lines between apostle representations, lamb representations and city scenes. Such motif combinations are also to be found in a number of traditio scenes. In the sepulchral slab in Anagni (Ill. 24) we find a combined lamb and city-gate motif as a background for the apostle figures. The same juxtaposition is also to be found in the Vatican gilded glass in which cities, as in S. Maria Maggiore are called Jerusalem and Bethlehem (Ill. 26). On the Vatican gilded glass, however, Peter/Jerusalem and Paul/Bethlehem are not placed together as in S. Maria Maggiore but Peter is related to Bethlehem and Paul to Jerusalem. A problem arises in attempting to give Bethlehem and Jerusalem a meaning derived from the apostle iconography's connection with the theme group Jewish Christianity and Gentile Christianity. Brenk, in trying to find textual evidence for such a connection produces rather thin and uncertain results. He shows that Jerusalem can represent both the Gentile church and the church as a whole.[98] On the other hand he finds no clear evidence which accords with their placement in S. Maria Maggiore in order to show that Jerusalem symbolizes the Jewish church.[99]

As it is impossible to establish whether or not the intention of the city scenes is to cover specific ecclesiological matters we shall have to be content to consider them symbols of the church. S. Costanza's two huts are probably meant to be taken as parallels to these urban scenes. Here, with the lambs, they serve the purpose of accenting an interpretation of the apostles as representing the church.

We have now examined all the individual motifs in S. Costanza's traditio scene except the palm trees which are depicted on the outer edges of the scene. Accenting this background motif, Nikolash advances an eschatological interpretation which he considers has been neglected in studies of traditio presentations.[100] Nikolash asserts that the background motif lends the entire traditio-scene an unequivocal eschatological character (cf. p. 77).[101] In this context the palm trees assume a certain importance. In his opinion, the landscape of palms is to be interpreted as a

[98] Brenk. S. Maria Maggiore p. 46.

[99] "Jerusalem als die Stadt der Juden par excellence dürfte früh schon mit der Judenkirche verglichen worden sein. Leider fehlen für diese Identifikation Texte. Auch sind keine Dokumente bekannt geworden, in welchen Betlehem als die Stadt der Heidenkirche bezeichnet worden wäre ... Wir können aufgrund der uns bekannten Väterzeugnisse kein exakte Identifikation der beiden Städte beweisen", Ibid. p. 46f.

[100] Nikolash, Zur Deutung p. 38 comprehends the resurrection of Christ primarily as an anticipation of the parousia: "die Auferstehung Christi ... stellt ... Typus und conditio sine qua non der Auferstehung von den Toten in der Parusie ... dar." Here eschatology is given a definite futuristic orientation.

[101] Ibid. p. 39.

direct reference to the glory of paradise.[102] A number of other motifs support this interpretation. The phoenix refers to the resurrection; the mountain on which Christ stands refers to Revelation 14:1. Similarly the clouds represent stories of Christ's parousia when he returns on the clouds of heaven for the judgement. (Matthew 26:64 and par.). God's lambs, however, are the clearest expression in support of an eschatological theme as they link the scene to Revelation 14:1-5.

Our analysis has shown that we have quite definite objections to Nikolash' interpretation. We have already demonstrated that Christ on the mountain may be seen as an epiphanic motif and that the clouds are not an image of parousia but of resurrection. Nor can the palms, as it now seems, be interpreted as unambiguous eschatological symbols. It would rather seem that they are related to a triumphal theme. Delbrück establishes that the date palm is a theme belonging to imperial iconography,[103] and Paulinus of Nola links purple and palms to victory and triumph (see p. 93).

It is, however, the apocalyptic lamb on the mount of paradise which becomes Nikolash' decisive argument. Our reply to this interpretation is that the lamb of Christ, which according to Nikolash himself, is only shown in slightly more than half of the traditio scenes can scarcely be accorded too much importance in the interpretation of this particular pictorial program. Thus, S. Costanza's traditio scene does not depict a lamb of Christ on the mount of paradise. As a result we are unable to see any clear reference to Revelation 14:1 ff. in the traditio scene. The unequivocal connection between the 144.000 lambs "who had his name and his Father's name written on their foreheads", and the lambs depicted in the traditio-scenes must at least be made convincing.

Do these objections imply that the traditio scene does not in any way refer to futuristic-eschatological motifs? We maintain that in the S. Costanza presentation at least, there is hardly a single pictorial element which is primarily inclined toward a futuristic eschatology. Admittedly, some of the pictorial elements which refer to a paradise theme have an innate futuristic-eschatological component but this is not sufficient grounds on which to judge the entire picture as eschatological. The symbolism of God's abode is, as we have seen, purposely vague and this vagueness is meant to hinder any unambiguous decision as to where God is.

[102] Ibid.
[103] Delbrück, Spätantike Kaiserporträts p. 127f. See also Baus, Kranz p. 152 and 202. In the gospel according to John branches from the palm tree are used to pay homage to the coming King of Israel (John 12:12ff).

5. Summary

In our analysis of the traditio scene's iconographical program we have tried to show that the interpretation must be based on a study of the central motif which here too is the Christ figure. In the study of this motif we found two aspects which were of particular interest. First of all, our constant aim has been to establish that Christ is presented within a visionary context. As Christ, in addition, is accorded Divine attributes he must be perceived as the conveyor of God's presence in the milieu in which the scene has been placed. Here again imperial iconography is the most important source of inspiration. Next we have shown that the content in the Divine revelation is decided by the scroll inscription which establishes that Christ is the bearer of the new law to be understood as a consummate fellowship in God. In this way Christ creates new conditions for life on earth.

It is through the scrolls that this reality is conveyed to the apostles who had a special relationship with Christ during his sojourn on earth. But, we have also shown that the apostles are characterized as prototypes; they make known the suitable way to approach the Godhead. Furthermore, they function as a bridge between the past and the present in their capacity as founders of the church. It is not only a question of their being the founders of the Roman congregation but of the foundation of a church for all races and tongues. Together they represent the universal church.

In this way the analysis of the traditio-scene has shown results which supplement the insight gained in our study of theme-group I. Not only have we ascertained more exactly how the pictorial program functions, having been given actuality through the vision theme, but we have also enlarged our interpretation of the representational Christ. For here the ruler aspect is expanded because Christ is also depicted as the one to change the conditions of life. The pictorial presentation itself is focused on the question of incarnation. We have seen, moreover, that the ecclesiological motif is related to the same theme. The apostle princes appear as the connecting link between this past happening and the present situation of the congregation.

THEME-GROUP III: THE CROSS AS A CENTRAL CHRISTOLOGICAL MOTIF

1. *Tituli in the Cimitile and Fundi Apses*

The two central apsidal programs within this theme-group differ in one important way from the material previously analysed. Whereas until now we have dealt mainly with surviving monuments, our knowledge of these pictorial programs derives solely from textual sources. These concern the apses which Paulinus of Nola ordered for the so-called Basilica Nova which is an addition to S. Felix' martyrium in Cimitile[1] and for the bishop's church in Fundi.[2] Both are referred to in an exchange of letters between Paulinus and his friend Sulpicius Severus.[3] In Epistula 32 Paulinus repeats the tituli of the mosaics. With these as a basis attempts

[1] Ihm, Programme, catalogue number XXXVI p. 179. See plan (from Brandenburg, Frühchristliche Kunst p. 124 fig. 12).

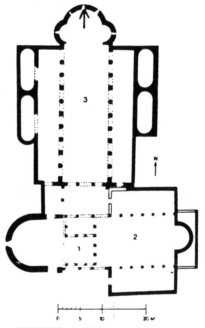

[2] Ibid. catalogue number XXXVII p. 181f.
[3] For further reading regarding Paulinus of Nola and the correspondence with S. Severus, see Goldschmidt, Paulinus' Churches p. 3-20. For Paulinus' biography, see also Frend, Two Worlds p. 100-133.

have been made in modern times to reconstruct the pictorial program of the apses.

Before turning to the proposed reconstructions we shall look more closely at the textual structure of the tituli in question.

The following is the apsis titulus of the Fundi mosaic from 402/3:

> Sanctorum labor et merces sibi rite cohaerent,
> ardua crux pretiumque crucis sublime, corona.
> Ipse deus, nobis princeps crucis atque coronae,
> inter floriferi caeleste nemus paradisi
> sub cruce sanguinea niueo stat Christus in agno,
> —agnus ut innocua iniusto datus hostia leto,—
> alite quem placida sanctus perfundit hiantem
> Spiritus et rutila genitor de nube coronat.
> Et quia praecelsa quasi iudex rupe superstat,
> bisgeminae pecudis discors agnis genus haedi
> circumstant solium, laeuos auertitur haedos
> pastor et emeritos dextra conplectitur agnos.[4]

The titulus may be divided into several sub-groups:

a_1:	Sanctorum labor ...	ecclesiological motif
b_1:	Ipse deus, nobis princeps ...	Christological motif
c:	alite quem placida ...	Trinitarian motif
b_2:	Et quia praecelsa ...	Christological motif
a_2:	bisgeminae pecudis ...	ecclesiological motif

We see immediately that the text is divided into three parts and that these deal with Trinitarian, Christological and ecclesiological motifs. We also note that the titulus is built up around a Trinitarian centre. It is, nevertheless, pertinent to consider the titulus' main theme as Christological. The Trinitarian aspect is in fact a further development of the Christological. The ecclesiological motif as well is directly linked to the Christological theme. The concept of Christ as iudex from b_2 leads directly into a_2's ecclesiological theme and a_1's main motif appears to be

[4] Paulinus of Nola, Ep. 32. 17 (Goldschmidt, Paulinus' Churches p. 46). "The labour and the reward of the saints are justly connected with each other, the high cross and the sublime prize for the cross, the wreath. God Himself, for us the Predecessor in cross and wreath, Christ, stands in the heavenly forest of flower-bearing Paradise under the blood-red cross, in the form of a white lamb, lamb because he was delivered up to unjust death as innocent sacrifice. As a peaceful bird the Holy Ghost overflows this lamb, which yearns for it, and out of a ruddy cloud the Father wreathes it. And because it stands as a judge on a high rock, there are around its throne cattle of a twofold kind, goats which are at discord with lambs; the shepherd turns from the goats on the left and he welcomes the lambs on his right, which have performed their duty." Goldschmidt, Paulinus' Churches p. 47.

directly dependent upon the Christological statement in b_1. Thus, the entire titulus is given a Christological quality.

On the other hand it is a far greater problem to focus on one central point within the Christology. In b_1 it is said that Christ is the precursor of suffering here on earth. An elaboration of this thought takes place with the introduction of a new motif; the lamb and the blood-red cross allow a closer interpretation of Christ's significance. At the same time the scene is set in paradise to emphasize that Christ is also the harbinger of suffering's reward. Thereby we are puzzled. Are we in heaven or on earth? Is this a presentation of Christ's passion or of his triumph? It is here we find the clearest evidence that the central motif of the apsidal scene takes place against a diffuse background. At the same time we sense that this ambiguity is an important premise for the synthesis of imagery in the apse. This becomes further emphasized when the lamb, in addition, introduces a Trinitarian element which finally becomes entwined in the Last Judgement. In this way the lamb, at least in this titulus, takes on a fourfold meaning. It is the sacrificial lamb with a clear reference to the Christological triumph; in addition, it refers to Trinitarian, shepherd and judgement motifs. Within the development of the motif it is impossible to stress one dominating aspect because it is precisely the interwoven relationship between all four motifs—a transition full of associations from one level of meaning to another—which is important.

We see also that the Christological theme is not rendered by depicting a person but solely by means of the symbolic cross and lamb. The titulus text already gives the impression that these symbols open the way to a more varied and differentiated interpretation than would a pictorial presentation of Christ himself.

The titulus of the apse in the new sanctuary at S. Felix' grave in Cimitile, c. 400, is also mentioned in Epistula 32.[5] The titulus was a part of the apsidal mosaic decoration and was worded as follows:

> Pleno coruscat trinitas mysterio:
> stat Christus agno, uox patris caelo tonat
> et per columbam spiritus sanctus fluit.
> Crucem corona lucido cingit globo,
> cui coronae sunt corona apostoli,
> quorum figura est in columbarum choro.
> Pia trinitatis unitas Christo coit
> habente et ipsa trinitate insignia:
> deum reuelat uox paterna et spiritus,
> sanctam fatentur crux et agnus uictimam,

[5] Paulinus of Nola, Ep. 32. 10 (Goldschmidt, Paulinus' Churches p. 38).

regnum et triumphum purpura et palma indicant.
Petram superstat ipse petra ecclesiae,
de qua sonori quattuor fontes meant,
Euangelistae uiua Christi flumina.[6]

The titulus reveals a program corresponding to that found in the Fundi titulus. The thematic division is, however, somewhat different:

a:	Pleno coruscat ...	Trinitarian motifs
b_1	Crucem corona ...	Christo./ecclesiological motifs
c:	Pia trinitatis ...	Christo./Trinitarian motifs
b_2:	Petram superstat ...	Christo./ecclesiological motifs

Here again we find the same three motif groups as in the Fundi but in this case they are even more intricately interwoven. The accent on the Trinitarian motif is greater here than in the Fundi titulus. It is obvious, nevertheless, that the Trinitarian aspect here too is adapted to a Christological context, clearly formulated in c, where the Trinitarian motif is used precisely in order to clarify the Christology. C appears almost as an elaboration and interpretation of a, which has Jesus' Baptism as its thematic point of departure. Likewise, b_1, as well as b_2, has an unequivocal Christological basis. Thus, we can establish that the text is centred around a Christological core. But, here too it is difficult to emphasize one individual aspect more than another. We meet the same synthetic juxtaposition of various Christological motifs as in the Fundi mosaic. The biblical account of Jesus' Baptism is used as a basis for a comprehensive Christological interpretation. We hear, furthermore, of Jesus on a mount and see the shining cross surrounded by doves and as in the Fundi mosaic we are puzzled as to how we are to interpret this scene. The diffuse setting seems to be a precondition for the ambiguous content.

In this way Paulinus' tituli supply important clues in the interpretation of the pictorial composition as a whole. Both tituli revolve around a Christological theme-group but point to Trinitarian as well as ecclesiological theme-groups. To make this possible within one and the same presentation there must be a diffuse setting which balances on the borderline between heaven and earth.

[6] "In full mystery sparkles the Trinity: Christ stands as lamb, the voice of the Father thunders from heaven and in the form of a dove the Holy Ghost flows down. The Cross is surrounded by a wreath, a bright circle, around which wreath the apostles form again a wreath, the image of whom is expressed in a chorus of doves. The holy unity of the Trinity meets in Christ, who likewise has His insignia in threefold: being revealed as God by the Fatherly voice and the Ghost, the Cross and the Lamb testifying Him as the sacred sacrified One, Kingdom and Triumph being indicated by the purple and the palm. He Himself, the Rock of the Church, is standing on a rock from which four seething springs issue, the Evangelists, the living streams of Christ." Goldschmidt, Paulinus' Churches p. 39.

Paulinus' texts, meanwhile, do not describe the apses in sufficient detail to enable us to recapture all the elements in the iconographical program. As a result many points in the reconstructions become uncertain and controversial. But, even after having associated ourselves with one reconstruction proposal in preference to another, we are not faced with iconographical forms which will be made the object of analysis. The particular problem in working with Paulinus' apses is clearly revealed when we compare the method to be used here with our approach in the previous analyses. In an ordinary iconographical analysis, individual motifs are interpreted by comparison with other related iconographical forms. In this case, on the contrary, the iconographical form has been reconstructed on a basis of the iconographical tradition in the surrounding milieu. Thus, in the analysis we are obliged to work with these same forms. As a result greater care must be taken in drawing conclusions based on purely iconographical analyses in themselves.

Garrucci, in a verbal description, has already attempted to form an impression of the Cimitile apse's type of image.[7] Although, in the main, he indicates a reasonable iconographical organization of the titulus, little by little details have been corrected. F. Wickhoff's reconstruction proposal (Ill. 30) is thus a modified visual arrangement of Garrucci's description.[8] The reconstruction, however, is more closely related to apsidal iconography than Garrucci's description. Thus, the palms are no longer seen as the palm branches of catacomb paintings but as palm trees on the outer edges of compositions found in a number of monuments with apsidal connection.[9]

More controversial is Wickhoff's interpretation of purple. With the support of Statius' poetry, he interprets it as the colour of spring flowers growing in the meadow which is probably the background indicated by

[7] Garrucci, Storia dell'arte I p. 486f: "Eravi dunque una pittura in musaico che ci è descritta nei versi, dai quali mi sembra ricavare con certezza che vi si rappresentava Cristo Dio ed uomo in questo modo. Stava nel basso una roccia dal cui seno sgorgavano i quattro fiumi: sulla roccia era posto l'Agnello colla croce, la porpora e la palma, di che diremo tosto. La croce era intorno cinta da una splendida corona, sul cui cerchio esterno si vedevano ordinatamente disposte dodici colombe. In alto era effigiata la mano, simbolo della voce del Padre, e la colomba simbolo dello Spirito Santo spargente dal rostro sull'Agnello la celeste rugiada. Tutto è chiaro, ma il poeta non dice dove avesse fatto rappresentare la porpora e la palma, che non dovevano essere dissociate dalla croce e dall'Agnello. Però io imagino che un panno di porpora piegato, a modo di larga zona, doveva vedersi a bisdosso dell'Agnello, come usavasi allora dai pagani di ornare le vittime colla bianca stola portata indosso a traverso: e ricordo che in una insigne pittura cimiteriale sul dorso dell'agnello è posata la simbolica secchhia del latte, e un ramo di palma gli si vede sorgere allato; quanto alla palma penso che essa fosse posta al fianco dell'Agnello e a piè della croce".

[8] Wickhoff, Das Apsismosaik p. 158-176.

[9] See especially the various preserved presentations of the traditio program Ill. 23-26.

the program.[10] J. Engemann asks quite rightly whether it is natural that such flowers point to Christ's dominion. With Grabar, R. C. Goldschmidt and Dinkler amongst others, he draws attention instead to the purple cloth which in some renditions is draped over the arms of the cross.[11] In that case the pictorial program adopts a familiar motif from imperial symbolism which points unequivocally to a victory theme.

Furthermore, the placement of the cross is disputed. Garrucci places it with the lamb on the mount itself.[12] This gains a certain support from S. Pudenziana's apse. G. Bandmann takes up this interpretation again and gives added evidence that the lamb and cross have been placed together on a rock (Ill. 31).[13] The renditions referred to by Bandmann, however, do not show the ring of light described by Paulinus. In order to give this light a legitimate position, Wickhoff bases his reconstruction on the apsidal program of S. Apollinare in Classe in which the cross floats above the ground.[14] He sees in this presentation an apsidal adaptation of the cross in the vault of S. Giovanni in Fonte (Ill. 28). Iconographically, the floating cross seems the most satisfactory solution in this context. With that, it becomes natural to place the dove immediately above the lamb as in Ciaccaonio's sketch of the Pudenziana mosaic (Ill. 15),[15] and not above the cross as in Bandmann's reconstruction.

We note, furthermore, that the procession of lambs which both Wickhoff and Bandmann include in their reconstructions is not mentioned in the titulus. Such a procession cannot entirely be ruled out as examples may be found in contemporary sarcophagus reliefs,[16] but there are no grounds for including them in this program. Nor is it possible to determine whether the voice of God is expressed by a hand reaching down from heaven.

The titulus of the Fundi apse also has given occasion for reconstruction but as in the Cimitile apse certain points in the description create uncertainty. It is obvious that Paulinus' description of the central motif is somewhat vague. We read that the lamb of God stands as a judge on the

[10] Wickhoff refers to Stat. Silv. 3. 3. 130, Das Apsismosaik p. 166f.

[11] Engemann, Zu den Apsis-Tituli p. 24f; see also Grabar, L'empereur p. 240; Goldschmidt, Paulinus' Churches p. 98; Dinkler, S. Apollinare p. 53.

[12] See note 7.

[13] Bandmann, Ein Fassadenprogram p. 7 refers to the Honorius sarcophagus from the 6th centry.

[14] Deichmann, Ravenna III Taf. 385-387 and Taf. XIV.

[15] See p. 117 note 122.

[16] We find an example on the front of the "city gate" sarcophagus in S. Ambrogio (Ill. 47); see also Engemann's argumentation for a frieze of lambs in Engemann, Zu den Apsis-Tituli p. 24; see also note 10.

rock. Then we hear about goats and lambs surrounding the throne. Does
this description refer to a pictorial rendition of the rock as well as the
throne or does the rock also refer to the throne? Ihm maintains that the
Honorius sarcophagus, among others, speaks in favour of the latter inter-
pretation.[17] She indicates another possibility in which the cross as well
as the lamb are placed on the throne as we have seen in the triumphal
arch in SS. Cosma e Damiano's.[18] She, herself, supports an arrangement
of the motifs corresponding to the central motif on the front of the Pola
casket where the lamb stands before a throne with cross (see Ill. 32 and
Ill. 40). In support of such an interpretation Ihm quotes from a Paulinus
text which connects the cross directly with the throne.[19] Engemann sup-
ports Ihm's interpretation by referring to other monuments which depict
the lamb of God on a rock beneath an enthroned Christ.[20] He then points
out that the Pola casket's relief is usually looked upon as a reflection of
Roman monumental works, a fact which should again vouch for the
apsidal connection of this theme.[21]

On the other hand, Engemann is not satisfied with Ihm's arrangement
of the motifs in the pictorial area where a concentration around the ver-
tical central axis leaves the sides empty. He perceives the description in
the first line of the titulus as a direct reference to concrete pictorial
elements and therefore places wreath-bearing saints as a flanking motif
(Ill. 33). In support of this arrangement he looks to the titulus of Pope
Sixtus in S. Maria Maggiore from c.430.[22]

It is true, as Engemann points out, that Ihm's reconstruction does not
capture the wreath/cross theme in a satisfactory way. But, as it is rather
doubtful that saints holding forth wreaths to Mary have been depicted in
S. Maria Maggiore's apse,[23] there is little to be gained by a discussion of

[17] Ihm, Programme p. 182.

[18] Ibid.

[19] "Vexillumque crucis super omnia sidera fixit,
Corporèum statuit coelesti in sede tropaeum",
Paulinus of Nola, Poema 30 (PL. 61.675).

[20] Engemann, Zu den Apsis-Tituli p. 28 note 37.

[21] Ibid. p. 28.

[22] The titulus reads as follows:
"uirgo Maria, tibi Xystus noua tecta dicaui
digna salutifero munera uentre tuo.
tu genetrix ignara uiri, te denique feta
uisceribus saluis edita nostra salus.
ecce tui testes uteri tibi praemia portant
sub pedibusque iacet passio cuique sua:
ferrum flamma ferae fluuius saeuumque uenenum.
tot tamen has mortes una corona manet."
Diehl. Inscriptiones I no. 976 p. 182f.

[23] Brenk, S. Maria Maggiore: "Dass die Inschrift von einem Apsismosaik redet,
gehört abermals zu den unwahrscheinlichen und nicht beweisbaren Hypothesen." p. 4.

Engemann's most important source. In our opinion the Fundi titulus may just as likely represent the precursor's cross and wreath as the labour and reward of the saints as the latter are already represented in the church by martyr reliquaries beneath the altar.[24] If that is the case, an iconographical parallel to S. Giovanni in Fonte's Christogram would seem very likely (Ill. 28). Here the wreath as well could refer to the Father who crowns Christ from the rose-hued cloud.

What is more, this interpretation is supported by an inscription above the entrance to the church in Cimitile which points to the thematic connection between cross and wreath as a basis for reflections about the lives of the faithful: "Behold the wreathed Cross of Christ the Lord/standing aloft in the halls with promises of high rewards for hard work./Take up the Cross, ye who wish to carry off the wreath."[25]

Nor do we agree with Engemann that a composition without flanking figural motifs is an unsatisfactory solution from an aesthetic point of view. We hold that sheep and goats balance the pictorial composition in an acceptable way.

Even though we can in this way make quite definite estimates of the motif groups in Paulinus' apses, they continue to escape a usual iconographical analysis. We know the motifs and we know the iconographical arrangement of these themes from the surrounding milieu but that is as far as we get. Nevertheless, we should not disregard the value which analyses of the surviving pictorial motifs contribute to the understanding of Paulinus' tituli. Such comparisons become all the more important as a number of the motifs in question here are also to be found in other of our main sources. This applies above all to the cross and the lamb, both of which belong within the S. Pudenziana motif group. Our reason for postponing an examination of these motifs is presicely the wish to study them in the light of Paulinus tituli. An analysis of these particular motifs will enrich our understanding of early Christian decorations in several important ways.

2. The Cross and the Empty Throne

The cross plays a dominant role in the tituli of both the Fundi and the Cimitile mosaics. With a certain amount of truth therefore, Engemann is able to state that none of the other motifs "eine die Darstellung beherr-

[24] Paulinus of Nola, Ep. 32. 11 (Goldschmidt, Paulinus' Churches p. 38).

[25] "Cerne coronatam domini super atria Christi
stare crucem duro spondentem celsa labori
praemia; tolle crucem, qui uis auferre coronam'',
Paulinus of Nola, Ep. 32. 12 (Goldschmidt, Paulinus' Churches p. 40).

schende Grösse besessen haben".[26] We recall that the cross is given a prominent place also in the Pudenziana mosaic which is the most important iconographical source for the reconstruction of Paulinus' cross. The basis of our examination will be built on precisely this form of cross which we know from S. Pudenziana.

In the Pudenziana mosaic a large cross stands on the mount which rises up between the buildings of Jerusalem behind Christ's throne. It is depicted as made of gold and adorned with precious stones. The form is Latin with the ends of the arms curved outward. As usual it is by comparison with earlier iconographical cross types that the obvious approach to an interpretation of the cross in question here is to be found.

a) The Cross and the Death and Resurrection of Christ

It is first during the period of Passion sarcophagi (340-370) that themes taken from the Easter events are introduced into pictorial art. Previously the Christian image-makers restricted themselves to depicting Isaac's sacrifice or the story of Jonah as indirect expressions of the crucifixion.[27]

One of the earliest known examples of the cross used in a pictorial context is the Lateran sarcophagus no. 171 (Ill. 34),[28] in which the cross is placed in the central niche. It is a Latin cross, simple in form. A sort of gable is formed by the outspread wings of an eagle descending to place a large laurel wreath over the cross. At the tip of each wing is a personified sun and moon symbol. The symbolism is derived directly from Roman victory symbolism in which the eagle contains considerable meaning. In an imperial context it is usually used as the symbol of Jupiter protecting the emperor in battle. It is in this sense that it is utilized in the symbolism of Roman standards.[29] The eagle, however, is also found in depictions of battle scenes where it holds the imperishable laurel wreath over the commander.[30] In addition, as a result of eastern influences, the eagle is adopted as a symbol of apotheosis and immortality. In this context it functions as a divine servant and messenger.[31]

[26] Engemann, Zu den Apsis-Tituli p. 25.

[27] See Gerke, Christus p. 31-48.

[28] Deichmann, Repertorium no. 49 p. 48. According to Brenk, a sarcophagus in the Royal Ontario Museum, Toronto, represents the earliest rendition of the program, Brenk, Imperial Heritage p. 43 fig. 8. For pagan prototypes, see Grabar, L'empereur p. 241. For interpretation of the overall program of Passion sarcophagi, see Campenhausen, Passionssarkophage, especially p. 79-85.

[29] Schneider, Adler col. 88f.

[30] Gerke, Christus p. 31.

[31] Halsberghe, Cult of Sol Invictus p. 82. For the wreath of victory, see Baus, Kranz p. 144-161; for the wreath on Lat. 171, see Baus, Kranz p. 206ff. and p. 223ff.

Sun and moon symbolism, which in late Antiquity served as an attribute of the emperor's cosmic dominion, elaborates this triumphal theme.[32]

On our monument these imperial formulas have been adapted to a Christian context. This is seen most clearly in the Christogram placed inside the eagle's wreath.[33] Meanwhile, it is necessary to remember that this symbolism has primarily been used in imperial insignia in the 4th century. The Christogram, in the form we see here was, in fact, used in the early part of the 4th century as an element in the symbolism of imperial standards.[34] It is inspired, of course, by Constantine's legendary vision before the battle at the Milvian Bridge.[35] From the imperial standard it was later transferred to the emperor's helmet and the imperial diadem. We find a late example of Christogram utilization in the symbolism of military standards on a diptych from 406 depicting the emperor Honorius with the so-called labarum in his right hand. The labarum is surmounted by the Christogram and the inscription on the standard reveals a tradition stretching back to Constantine, IN NOMINE XPI. VINCAS SEMPER.[36]

Once more we are faced with a symbolism inspired by political triumphal ideology. In addition, we note that this group of motifs is in fact maintained within Christian imperial ideological propaganda throughout the entire 4th century. The inscription on the Honorius diptych referred to here is the key to the interpretation of the political utilization of the program. Here, Christ's monogram serves to give imperial power a necessary religious foundation.

When this theme is adapted to sarcophagi reliefs, a shift in meaning becomes necessary so that the pictorial program can continue to function. We find a clear example of such reinterpretation when we grasp the meaning of the standard itself which on our sarcophagus has become Christ's cross. Beneath the arms of the cross sit two Roman soldiers, a reference to the guards at Christ's grave as recounted in Matthew 27:64 ff., 28:4 and 28:12 ff., who play a certain part in the account of the resurrection. The victory wreath is placed over this cross. The eagle now func-

[32] Gerke, Christus p. 31

[33] For further reading about the Christogram, see Testini, Sarc. del Tuscolo p. 73 note 13.

[34] See also p. 13.

[35] Eusebius, Vita Constant. I. 28-31 (PG. 20. 944-946); Lactantius, De mort. pers. 44. 5-6 (PL. 7. 260f). That the monogram—not the cross—is the basis for the earliest use of symbolism, see Alföldi, Hoc signo p. 225-232. Eusebius' reference to the cross in Vita Constant. is a result of his own interpretation which, however, has early Christian prototypes, Alföldi, Hoc signo p. 234.

[36] Volbach, Elfenbeinsarbeiten, catalogue number 1 Taf. 1. For imperial use of the labarum in the 4th century, see Kruse, Studien p. 72f.

tions as the divine messenger who, by lowering the wreath over the cross shows that the wreath is placed on Golgotha's cross by God himself. The connection with an apotheosis theme makes it easy to link the victory here in question to an immortality theme. In this way both the passion and resurrection are seen together. This aspect is elaborated upon by the conduct of the soldiers. We see that the soldier to the right of the cross gazes upwards while the one on the other side is asleep. And since sun and moon correspond to awake/sleeping soldier, the idea of introducing "Rechts-Links" symbolism into the presentation immediately suggests itself; the consequence of Christ's death and resurrection is the division between light and darkness, salvation and damnation.

Once again we are faced with a pictorial program which, depending upon its functional context, may be interpreted in different ways. And, once again we see that this form of ambiguity has been considered unsatisfactory. For even though the program lives on in imperial iconography as well as in sarcophagus reliefs we see clear signs of further development in the sepulchral field. The imperial eagle disappears and the simple labarum is replaced by other types of the cross.

The iconographical interest behind a further development of the cross derives first and foremost from the desire to instill an interpretation of the crucifiction into the cross itself. In the Lat. 171 we saw how important it was to maintain the connection with the resurrection.

In other monuments from approximately the same time we find the wish to combine Christ's passion and victory in a single composition. On the vertical central axis of the Junius Bassus sarcophagus (Ill. 4) beneath Christ on the Coelus is a depiction of his entry into Jerusalem. In the Gospels, the entry functions as the prelude to the account of Christ's passion. On the Bassus sarcophagus the superimposed motifs focus attention on the passion and victory, defeat and triumph. In the smiling Christ on his way to Jerusalem, the passion motif becomes marked by and connected to a victory theme; the entry of Jesus is in a way an omen of his entry into heaven. Death is only a transitional stage on the way to life.[37]

It is only towards the end of the 4th century that forms of the cross reminiscent of the one we know in S. Pudenziana appear in art. On the Lateran fragment no. 106 from the Theodosian period we meet, for the first time in the west, a cross adorned with precious stones (Ill. 35).[38] In addition, on the Probus sarcophagus from about the same time, the top

[37] Even some of the ampullas from Monza depict the connection between crucifixion and resurrection. Beneath the cross, which by its location among the robbers refers to the events of Good Friday, we see an angel and the two women at the grave; see Grabar, Ampoules Pl. 16 and Pl. 26.

[38] Deichmann, Repertorium no. 57 p. 54ff.

and arms of the cross curve slightly outwards at the ends (Ill. 36).[39] On both these sarcophagi, as on the S. Sebastiano fragment, Christ stands on a mount but unlike the traditio Christ he holds a staff in the shape of a cross in his right hand and is surrounded by the apostle princes/apostolic collegium in attitudes of acclaim.

The so-called Prince sarcophagus from Sarigüzel is dated somewhat earlier (Ill. 37).[40] A cross surrounded by venerating apostles is depicted on the narrow sides. Here the top and arms of the cross are clearly curved at the ends. The remarkable thing about this presentation first becomes evident when it is compared to the two sarcophagi already mentioned. This cross with its curved arm ends is no longer accompanied by the figure of Christ. The cross has become a substitution, a symbol of Christ.

It is just such a cross—set with gold and jewels—which we find in S. Pudenziana and which appears frequently at this time in depictions of the cross. As we have said already, it is used also in the proposed reconstruction of the Cimitile and Fundi apses.

It is usually thought that the widespread use of this type of cross found in so many monuments from c.400 must be inspired by a real cross which has existed. It is, however, difficult to agree upon the original location of this prototype. It is not impossible that a large and richly ornamented cross was placed on the hill of Golgotha in connection with the Constantinian Golgotha complex. A number of 4th century sources recount the discovery of the true cross on Golgotha,[41] and a memorial cross may have been placed there at an early date.[42] According to Egeria, such a cross existed in Jerusalem in the 4th century.[43] We know too that a jewelled cross was erected on Golgotha around the year 440 by Theodosius II.[44]

Meanwhile, it was not only Jerusalem which had such a cross. The so-called Πάτρια Κωνσταντινουπόλεως describes a cross erected in Constantinople.[45] This cross was gilded and the top and arms each terminated in

[39] Ibid. no. 678 p. 277f.

[40] Kollwitz, Oströmische Plastik p. 132-145. Brandenburg, Stilprobleme, dates it back to the 360's, p. 463.

[41] See Wilkinson, Aegeria's Travel p. 240f.

[42] Ihm, Programme p. 14 note 8.

[43] Egeria, Itinerarium 37. 1 (SC. 296.284). On Good Friday the veneration of the Cross of Christ took place at the cross which was erected within the Golgotha complex, see Egeria, Itinerarium 37. 2.

[44] See Dinkler, Das Kreuz p. 14; Grabar, Martyrium II p. 188. The raising of monumental crosses clearly reflects the religious signification of the cross in Jerusalem in the 4th century. Not only the cult, but also the vision of the Cross, referred to in a letter from Cyril of Jerusalem to the emperor Constantius (see p. 113 note 108), demonstrates the important role played by the cross in Jerusalem at that time, see also Grabar, Martyrium II p. 276.

[45] This is a late source, but probably refers to old traditions, see Dinkler, Das Kreuz p. 14.

a set of double circular faceted gems, thus bearing a striking resemblance to the cross on the Milan diptych (Ill. 38). Dinkler places the Constantinople cross as far back as the period of Theodosius I.[46] On a basis of the available material it remains uncertain as to whether the iconographical use of the cross mentioned here has drawn its inspiration from Constantinople or Jerusalem.

It is not easy to give an immediate interpretation of this type of cross. That the cross appears as a condensed Christological symbol, with particular emphasis on the importance of the Easter events, is established. Such an interpretation is traceable to the period of the New Testament[47] and is still documented in the 4th century.[48] The veneration shown by the apostles on the Sarigüzel sarcophagus suggests that this Christological symbol is to be perceived as a sign of dignity worthy of tribute.

The cross with the curved arm ends becomes, thereby, a symbol of triumph revealing the same Christological character as we elicited from the Lat. 171. In consequence it is reasonable to presume that the cross with outward curving top and arm ends has the same symbolic content which Lat. 171 could only express by placing a triumphal wreath over the cross motif itself.

In S. Pudenziana this cross is used as a supplementary Christological motif. The combining of motifs becomes more common toward the end of the 4th century. In the first place we shall concentrate our attention her on the combination Christ/cross. We have pointed out earlier that the primary intention of the throne motif in S. Pudenziana's mosaic is to express Christ's function of authority in the world and in the church. Thus, we see right away the supplementary function which the cross must have in such a context. For within this framework the cross affords the opportunity of revealing Christ's almighty power against the background of events which lay the foundation for his function of ruler in the world, namely his death and resurrection. This again implies that Christ's dominion is firmly anchored in the historical crucifixion.

b) The Empty Throne

In a number of monuments from our period we find a combination of the two motifs which are separated in S. Pudenziana. In these, throne

[46] Ibid. p. 15.

[47] See e.g. 1 Cor. 1:17f.

[48] Theodore of Mopsuestia says in one of his catechesis: "We remember that we told your love that it is the habit of the Books to include all the Economy of Christ in the mention of the crucifixion, because death came to Him by crucifixion, and He abolished death by death and made manifest the new, immortal and immutable life." (Mingana V. 73). For further reading on the cross theme, see Dölger, Beiträge; Dinkler, Das Kreuz; Rahner, Griech. Mythen p. 73-123 and Sieper, Myst. des Kreuzes.

and cross merge into a single motif; the Christ figure gives way to the cross which is placed directly on the throne. As we see from Ihm's and Engemann's reconstructions, it is reasonable to presume that in the Fundi mosaic the cross and throne have been presented in this contracted form (Ill. 32 and 33).

Paulinus' tituli are of little help in interpreting the combination of cross and throne. We realize, however, that the two motifs are linked to different theme-groups. The throne is inclined to function within a judgement context and in this way points to one of the aspects of the ruler's dignity which we also noted in the analysis of S. Pudenziana's throne motif (see p. 49). The cross, on the other hand belongs primarily within a theme-group concentrated around the cross/wreath problem. In this context the cross refers to the sufferings on earth of Christ and the holy ones. When Paulinus speaks of "cruce sanguinea", it strengthens the impression that the cross as a Christological motif lays particular stress on Christ's passion and death. Enlarging upon his description he speaks of the cross being red because it is dyed by the Lord's blood.[49]

At the same time it is obvious that the meaning of the cross and throne is not fully explored by means of the given references. The titulus links the presentation of Christ as forerunner not only to the saints but also to those reading the titulus. Thus, it is said, he is *our* precursor—"nobis princeps crucis atque coronae". In this way, the present is accented in this theme-group. Now we shall attempt to show that this aspect also has been expressed by the image-makers and so turn our attention to the iconography of the empty throne.

Interest has centred around this pictorial element throughout a long period but has not led to a solution of its meaning.[50] The argument, as with so many other visual forms is concentrated on the extent to which the motif should be interpreted as eschatological. In this case the discussion becomes particularly interesting in that it also has obvious methodological implications. V. Q. van Ufford, who gives the hetoimasia motif an unambiguous futuristic-eschatological interpretation is sceptical towards allowing imperial art to be of decisive importance in the interpretation.[51] Another approach is preferred by Van Ufford; his point of departure is the Sign of the Son of Man (Matthew 24:30), which

[49] "Ardua floriferae crux cingitur orbe coronae et domini fuso tincta cruore rubet", Paulinus of Nola, Ep. 32. 14 (Goldschmidt, Paulinus' Churches p. 42).

[50] For further reading see Bogyay, Hetoimasia col. 1202.

[51] "Wenn man auch voraussetzen darf, dass die frühen Christen die Darstellung des leeren Thrones vom Kaiserkult und von Münzen her kannten, und mag auch die Form des Thrones so wie das Diadem von S. Maria Maggiore der Kaiserkult entnommen sein, ist es darum notwendig, einen so nahen Zusammenhang mit dem Altertum anzunehmen, wie es oft geschieht?", Ufford, Bermerkungen p. 198.

already in the 2nd century is understood as the cross. Since the cross is interpreted as "praecursor Domini", the empty throne is perceived as the judge's seat in the second parousia.[52] In the summarized conclusion referred to here, Van Ufford seems to mean that the cross gives the throne an eschatological character. This is substantiated by many textual references given with the intention of maintaining that the cross in early Christian times is perceived as the Sign of the Son of Man.[53] We find it difficult to see that a connection between Matthew 24:30 and the cross should be the obvious key to an interpretation of these depictions. Van Ufford's somewhat arbitrary interpretation of the cross motif is clearly seen in the interpretation of the Fundi mosaic in which the cross is merely described as the eschatological cross.[54] We recall, however, that Paulinus speaks of the cross as a unifying expression of Christ's acts of redemption here on earth with special emphasis on the aspect of suffering (cf. the term cruce sanguinea). With this in mind it does not seem natural to perceive the cross solely as a futuristic-eschatological element within this program. Nor is it possible, in consequence, to give the throne an eschatological interpretation by referring to the Fundi titulus.

Van Ufford's argumentation is based on patristic texts to which he gives more weight than to imperial influence. It is, meanwhile, quite clear that the choice of texts presented here *can* only capture one single aspect of early Christian cross symbolism. The questionable aspect in Van Ufford's undertaking is clearly revealed when an attempt is made to put the motif being discussed into a functional context. As a decoration related to Baptism he maintains that it is intended as a reference to Christ who *is* not present but who will appear at the parousia.[55] Furthermore, he says that Baptism is actually connected to the coming of Christ.[56] In our main section II we shall demonstrate that such assertions taken out of context give a distorted picture of 4th century baptismal theology.

Thus, Van Ufford's contempt for imperial antecedents allows for a greater degree of arbitrary interpretation than necessary. We shall, therefore, adhere to our earlier use of imperial art as a basis for our interpretations.

In the case of the empty throne this research method has been used by, among others, T. von Bogyay who is critical of the use of the term hetoimasia in monuments dating from the first thousand years. The term derives from inscriptions in middle and late Byzantine judgement

[52] Ibid. p. 207.
[53] Ibid. p. 194f.
[54] Ibid. p. 196.
[55] Ibid. p. 205.
[56] Ibid. p. 193.

scenes[57] and is first used as an iconographical technical term for all similar presentations by P. Durand in 1867.[58] In consequence, according to Bogyay, the parousia which is "eine vielschichtige und beziehungsreiche Thema" is misunderstood. Instead of focusing upon the revelation of the risen Lord in glory, all interest is centred upon one aspect—the judgment.[59] Bogyay wishes, therefore, to differentiate between a general and a specific meaning in the empty throne. According to the broad interpretation which may be applied to our type of monument, the motif is a symbol of God's glory and invisible presence. This interpretation stems from imperial forerunners which are in turn inspired by the east. In Mediterranean and oriental cultures the empty throne, in fact, has served from far back as a symbol of an invisible, spiritual presence in death cults as well as divinity cults.[60] This symbolism gradually makes its way into Roman imperial ceremony. Alföldi gives examples of the throne being honoured in Roman imperial times. Under Gaius a throne was shown cultic honour by the senate in the Capitoline temple.[61]

As for the empty throne, we are fortunate in having evidence from Christian cult and synod practice that the imperial utilization of the throne was adapted and further developed in a Christian context. From eastern parts we are familiar with such usage as early as the 4th century. Egeria relates that the bishop's throne could be moved from place to place according to the demands of the ceremony as it progressed.[62] Furthermore, we know that the gospel placed on the bishop's throne symbolized Christ's presence during the Antiochene schism in the year 370. Despite the apparent disappearance of such customs from liturgical use at an early point, the throne as a sign of Christ's presence assumes a permanent place at the great councils from the 5th century on.[63]

This custom is also attested by archeological excavations. In a number of small Syrian churches from the 4th to 6th centuries, throne-shaped desks on which the gospel could be placed, replace the bishop's throne in the middle of the semicircular seating arrangement for the priests.[64] So we see that God's presence in these contexts takes place through

[57] In Byzantine judgment scenes we read ἡ ἑτοιμασία τοῦ θρόνου—a formulation inspired by Ps. 9:8 (LXX): ἡτοίμασεν ἐν κρίσει τὸν θρόνον αὐτοῦ, see also Ps. 88:15 (LXX), Bogyay, Hetoimasia col. 1189.

[58] Bogyay, Hetoimasia col. 1190.

[59] Ibid. col. 1191.

[60] Bogyay, Thron col. 306.

[61] Alföldi, Monarchische Repräsentation p. 254.

[62] Egeria, Itinerarium 37. 1 and 5 (SC. 296. 284 and 286).

[63] Bogyay, Hetoimasia col. 1192f.

[64] Taft, Some Notes p. 343ff.

ceremony connected to the bishop's throne. The use of a gospel scroll serves to enhance the symbolism.

An arresting iconographical use of the throne motif is to be found in the Baptistery of the Orthodox in Ravenna from 458 (Ill. 43).[65] Here, the dome mosaic is divided into three zones. The central medallion depicting Christ's Baptism is surrounded by venerating apostles in the second register. In the third register is a theme-group in which four empty thrones alternate with four tables and gospels—surrounded by chairs surmounted by diadems.[66] The motifs, tables as well as chairs, are placed against an architectural background in the form of an apse. C.-O. Nordström maintains that the function of the latter zone is decorative with the ruler theme as an additional element,[67] while Deichmann holds that it primarily reflects cosmic sovereignty.[68] We supplement Deichmann's interpretation by stressing that the motifs in the third zone have an important hermeneutic function within the dome's total iconographical program. The object of the scene is to connect the Baptism taking place in the baptistery with the Baptism of Christ. Christ's presence is made known here by his appearance in an opaion, but also by the throne and table which by way of the architectural backgrounds is linked to the church space.[69] Characteristically, we find a garden theme in this architectural setting which gives it a manifold character. It points to the church space which is put into a garden-of-life context with further reference to the ambiguous paradise. In this context, the empty throne is given an explicit actualizing function directly connected to the liturgical space.[70]

In the presentation of the empty throne in S. Maria Maggiore's triumphal arch (Ill. 42) we find clear signs of actualization. The throne is placed in a medallion ringed by a number of different colours and hues: dark blue, pale blue, pale green, white and pale grey. Brenk points out that these were the colours used in Antiquity's iconographical presentation of air.[71] In this way the throne is given a function reminiscent of the baptismal ceremony depicted in the Ravenna dome's opaion. It is the

[65] Deichmann, Ravenna II, 1 p. 15-48; for dating see p. 18.

[66] Deichmann, Ravenna III, Taf. 39 and Taf. 40.

[67] Nordström, Ravennastudien p. 45f.; a cosmic motive is indicated in note 1, p. 46.

[68] Deichmann, Ravenna II, 1 p. 41-43.

[69] See Fink, Beobachtungen, who finds here "eine Symbolik des Kirchenraumes und der Liturgie, ja der Kirche auf Erden schlechthin", p. 5.

[70] Deichmann's wish to separate interpretations of the architectural background which emphasize its ties to the earthly church from interpretations connecting it to the heavenly Jerusalem, seems strange. The "Vermischung der Sphären" which Deichmann dislikes, we regard as an intentional part of the program, see Deichmann, Ravenna II, 1 p. 41.

[71] Brenk, S. Maria Maggiore p. 15, see also Wilpert/Schumacher, Die römischen Mosaiken Pl. 69.

vision of a Divine throne which functions as a sign of Divine presence during the liturgical ceremony.[72]

On this basis we can establish that if the Fundi mosaic's throne is as assumed by the reconstruction, it not only points to Christ's sovereign power at the end of time but also to his dominion here and now—or even better—to the exercise of his sovereign power everywhere and at all times.

Such a use of the empty throne demands that the display of power which the throne in itself reveals be supplemented and put into context with qualifying attributes. The custom of placing insignia on the empty throne also stems from imperial symbolism. Already in the 1st century it was decided by the Roman senate that the emperor should be honoured at games he did not attend by the placing of a wreath decorated with precious stones on a sella curulis.[73] We find a sella curulis decorated in such a way on coins from the reign of Titus.[74] Furthermore, we have examples on Diocletian's coins of Mars' ceremonial couch on which a helmet has been placed.[75] So, in this way, Romans adopted a custom which may be traced back to mythical times whereby the presence of the divinity was manifested by insignia placed on the throne.[76]

One of the earliest examples of Christian use of the throne with imperial insignia is to be found on a marble relief from c.400, now in the Staatliche Museen in Berlin.[77] Here, in an architectonic niche arrangement is a throne with diadem and chlamys. The dove swooping down towards the throne and the two animals standing before it, reveal that in this case it concerns a Christian program. Throne and insignia refer in a general way to Christ's universal dominion,[78] while, according to Brandenburg, the dove symbolizing Logos and the animals symbolizing the faithful link sovereign power to Christological and ecclesiological theme-groups.

On the other hand, on S. Maria Maggiore's throne presentation (Ill. 42) the insignia themselves are utilized to convey a closer characterization

[72] The interpretation is supported by an account of a vision seen by the crucified Maura. During her sufferings an angel brought her into heaven where she saw a throne with a white cloth and a wreath, see Baus, Kranz p. 214, see also note 448.

[73] Alföldi, Monarchische Repräsentation p. 252; see also Baus, Kranz p. 211.

[74] Ibid. Abb. 15. 4.

[75] Ibid. Abb. 15. 5.

[76] Delbrück, Spätantike Kaiserporträts p. 54.

[77] Brandenburg, Relief in Berlin, Taf. 66. For dating, see p. 123-136. The earliest preserved Christian presentation of hetoimasia is a gem from Chalcedon from 3rd/4th century, Brenk, Tradition und Neuerung p. 72 note 63. The gem depicts a throne with a wreath containing a star-shaped Signum of Christ and the inscription ιχθυς on the arms, Brandenburg, Relief in Berlin p. 137.

[78] Ibid. p. 142.

of sovereign power. Here, the purple cape and jewel encrusted diadem are augmented by a jeweled cross placed in front of the throne and a scroll with seven seals on the suppedaneum.[79] Even though we find a number of different insignia combinations on early throne presentations,[80] we note that soon the cross becomes the dominating motif and in fact, on a number of monuments, supplants most other insignia.

A distinctive throne presentation is to be found on a sarcophagus from Tusculum, now in S. Maria in Vivario, Frascati. It is often considered to be from the 4th century,[81] but a recent attempt has been made to date it closer to the second quarter of the 5th century.[82] On the seat of this throne, which is framed by two great columns, lies a drapery hanging over the front of the throne in a sinus-formed curve (Ill. 39). Above the drapery is an oblong object thought to be a cushion or book.[83] The dominating insignia, however, is the Christogram (⳩), placed in a rather sturdy wreath above the throne. We are familiar with plain throne presentations, in which the cross is the predominating insignia, in the Pola casket (Ill. 40) and in both the Orthodox and the Arian baptisteries in Ravenna (Ill. 43).[84]

We have previously emphasized that the primary objective of the cross is to anchor Christ's sovereignty in Jesus' activity on earth. We note, meanwhile, certain distinctive characteristics in the form of the cross on the monuments we have discussed and this suggests a more comprehensive content than the death and resurrection of Christ.

c) The Visionary Character of the Cross

The first sign of an expanded meaning is to be found already in the Pudenziana cross, which is depicted as made of gold encrusted with precious stones. A cross all in precious stones is found in the ivory relief on the Milan diptych from the 5th century (Ill. 38).[85] Here the cross itself is fashioned in silver and amandine champlevé with the ends finished off with two round stones giving them the characteristic outward-curving form. Previous stones and silver give the cross a shining, glittering look.

[79] The scroll is usually interpreted as an eschatological motif. See, however, Baus' remarks on the scroll in S. Prisco, Baus, Kranz p. 213.

[80] Brandenburg, Relief in Berlin p. 137f.

[81] See Brandenburg, Relief in Berlin p. 137; Brenk, Tradition und Neuerung p. 72 note 63.

[82] Testini, Sarc. del Tuscolo p. 98-108.

[83] Ibid. p. 79f.

[84] Regarding the Arian baptistery, see Wilpert/Schumacher, Die römischen Mosaiken Pl. 100.

[85] Volbach, Elfenbeinsarbeiten, catalogue number 119, Taf. 63; see also Volbach, Früchr. Kunst nr. 101 p. 63.

This jeweled type of cross is also found in S. Maria Maggiore's hetoimasia scene. In Ravenna's Orthodox Baptistery, the shining appearance of the cross is even more emphasized as it is worked in white, outlined in red precious gems and set in a yellow aureole (Ill. 43).[86]

The hetoimasia scene in the Baptistery of the Arians, which is obviously the model for Ihm's reconstruction of the Fundi throne, adds yet another element to the light theme. In this case, the throne is covered with a blue-white cloth and upon it is a purple cushion with golden clavi.[87] The striking thing about the jeweled cross, the arms of which are draped by a small purple cloth, is first and foremost its placement. This cross does not stand on the cushion but seems to float in front of it. The throne presentation is situated in the east side of the baptistery above the bishop's throne which stood in the east apse.[88]

The type of cross discussed here cannot be used as a basis for interpretation for the Fundi cross alone. With its shining character it has strong affinities with the Cimitile cross which is described thus: "Crucem corona lucido cingit globo". We have previously said that Wickhoff's reconstruction is inspired by the S. Apollinare in Classe's apsidal scene in which the cross floats freely against a heavenly background strewn with 99 stars and framed by a jeweled clipeus.[89]

The floating cross in a clipeus is evidenced in monuments dating closer to our monument than S. Apollinare. In the dome of S. Giovanni in Fonte we find the Christogram with outward-curved cross ends and with A and Ω on each side (Ill. 28). Here too the pictorial motif is placed against a blue, star-strewn background which may be seen as a sort of aureole. The similarity to the Cimitile mosaic is increased by the wreath surrounding the scene and in which, moreover, the phoenix is placed immediately above the Christogram.

In the dome of Galla Placidia's mausoleum, which in addition has a cruciform ground plan, the floating cross is shown against a starry heaven. Here the cross is orientated and the stars so organized as to form concentric circles around the cross itself.[90] Besides, cross symbolism marks the entire theme-group. The depiction of S. Laurence[91], the good shepherd[92] and the cross in a clipeus at the entrance all contribute towards putting the entire composition into a cross-theme context.

[86] See Wilpert/Schumacher, Die römischen Mosaiken Pl. 90.

[87] Ibid. Pl. 100; see also Deichmann, Ravenna II, 1 p. 251-255. Is dated back to the beginning of the 6th century, see p. 255. See also Nordström, Ravennastudien p. 34.

[88] Deichmann, Ravenna II, 1 p. 254.

[89] Deichmann, Ravenna III, Taf. 385-387 and Taf. XIV.

[90] Ibid. Taf. 19.

[91] Ibid. Taf. 5.

[92] Ibid. Taf. 8.

Recent research shows that it has proved problematical to arrive at a satisfactory interpretation of the light phenomena related to the cross. We shall limit ourselves by referring only to the discussion concerning the floating cross against a heavenly background.

Dinkler's interpretation of this theme in S. Apollinare in Classe is solely futuristic.[93] This interpretation is subsequently somewhat weakened by his emphasizing that the victory theme which dominates 4th century iconography hides, to a degree, its original forensic character. Nonetheless Dinkler maintains that the parousia is decisive for the composition as a whole. Grabar, on the other hand, stresses that the relationship between the cross motif and the figural depiction of S. Apollinare must be the deciding factor in interpretating the cross. According to him, the mosaic renders a theophany in the presence of the local saint.[94]

In a discussion between Deichmann and Maier concerning the Christogram cross in S. Giovanni in Fonte, Deichmann holds to a purely futuristic-eschatological interpretation of this cross presentation. His point of departure is his interpretation of the decoration in the Orthodox Baptistery in Ravenna where the baptismal scene in the dome's opaion is interpreted as a heavenly appearance.[95] Deichmann maintains that the same is to be seen in Naples. For him, however, the cross shown against a blue heaven can only be taken as a reference to parousia. Admittedly the cross is not orientated, but according to Deichmann, this is because of liturgical considerations. On the other hand, the human figures as well as A and Ω show that the dominant theme here is eschatological.

Maier, on the contrary, sees the cross in a functional liturgical context. For his interpretation, the position of the cross within the liturgical space is decisive. Maier perceives the cross as a comprehensive symbol of Christ.[96]

The Galla Placidia cross is also interpreted in various ways. Deichmann emphasizes the motif's exclusive futuristic-eschatological character in his argumentation with Grabar and Nordström.[97] Deichmann admits that the cross includes a reference to Christ's victory and triumph. But, he rejects all other interpretations including the

[93] "(Es) dürfte gesichert sein, dass ein die Apsis beherrschendes Kreuz, zumal wenn es auf blauem Grunde und von Sternen umgeben erscheint und im Osten aufsteigt, *nur und allein* das erwartete Kreuz als praecursor Christi sein kann. Es hat primär doxologisch-eschatologischen und sekundär paränetischen Charakter", Dinkler, S. Apollinare p. 86.

[94] Grabar, Dinkler p. 273.

[95] Deichmann, Maier p. 120.

[96] Maier, Baptistère de Naples p. 78ff., see also p. 141.

[97] Deichmann, Ravenna II, 1 p. 85; see also p. 84.

cosmocrator theme which Nordström finds in the composition and which we emphasized in our work with the creatures (see p. 62).

A satisfactory interpretation must be sought in a study of the pictorial elements to which we have already referred. Here it is a matter of different light phenomena supplanted by a heavenly background and deliberate orientation. We are particularly interested in the way the cross shines with light and hovers in the air. Deichmann's interpretation of the hovering cross in S. Giovanni in Fonte seems to put it into a reasonable context. As we have said, he gives it an epiphanic interpretation—the cross is revealed in a heavenly setting. On the other hand we see no reason to interpret this revelation as a sign of parousia as he does. Earlier in our analysis we have emphasized that the empty throne refers to the actual presence of God. When a shining cross is placed above this throne, nothing is more natural than to interpret it as an expression of the crucifixion as an event taking place in the past and now reappearing to present its meaning. The blood-red cross in the Fundi apse clearly establishes a wish to see God's presence in the light of the crucifixion and resurrection. The Cimitile titulus also shows that the cross in a circle of light continues to retain its relationship with the death of Christ.[98]

We find textual support in an actualizing interpretation of the cross in Acta Xanthippae and Polyxenae. Here it is recorded that Xanthippa when praying in her home after her Baptism sees visions. While praying, a cross appears on the east wall (ἐφάνη σταυρὸς ἐν τῷ ἀνατολικῷ τοίχῳ) and straightway through it enters a beautiful youth. He is surrounded by trembling rays having under him an extended light on which he also walks. Xanthippa, after first thinking it to be Paul, recognizes Christ and addresses him, "Thou art he whose precursor was the cross" (σὺ εἶ ἐκεῖνος οὗ πρόδρομος ἔτυχεν ὁ σταυρός).[99] Here the hovering cross as well as light and orientation are looked upon as an epiphanic occurrence in connection with a revelation during private devotions.

Reports of Constantine's vision before the battle at the Milvian Bridge may well have contributed to the importance which the cross came to play in 4th century imagery (cf. p. 99, note 35). In this connection we draw attention to a letter from Cyril to the emperor Constantius in which he tells of a vision of a cross supposed to have taken place in Jerusalem in 351. In his interpretation, Cyril stresses that the occurrence must be understood as a fulfilment of Matthew 24:30.[100] The purpose behind the

[98] Nordström, Ravennastudien p. 27.
[99] Acta Xanth. 15 (James, Apocrypha p. 68).
[100] Cyril of Jerusalem, Epist. ad Const. 6 (PG. 33. 1172).

letter was probably a desire to strengthen the religious-political position of Jerusalem.[101]

d) The Cross as the Precursor of Christ's Parousia

That the cross should be taken as an expression of the presence of Christ does not imply that we are reserved in our attitude towards a futuristic-eschatological interpretation for this motif as well. But, in this context, we do not consider this to be the most important or the only interpretation. On the other hand we perceive the futuristic-eschatological interpretation as a natural further expansion in the meaning of the cross theme. The presupposition for the expansion lies within the desire to supplement Christology in a particular direction.[102]

Reasons for considering the shining cross in connection with eschatological themes have been explained in a number of contexts. W. Bousset[103] and E. Stommel[104] have both tried to show that Didache already indirectly interprets Matthew 24:30's σημεῖον as a reference to the cross in that τὸ σημεῖον τοῦ υἱοῦ τοῦ ἀνθρώπου ἐν οὐρανῷ from Matthew is replaced by σημεῖον ἐκπετάσεως ἐν οὐρανῷ which is propably a paraphrasing of the cross.[105] In the Coptic Elijah apocalypse the cross is directly related to the parousia conception: "When the Anointed comes, then he comes in the guise of a dove (?) while the wreath of doves surrounds him, while he walks on the clouds of heaven, and while the sign of the Cross precedes him, seen by the whole world as the shining sun from the region of sun-rise to the region of sun-set."[106] Here, three motifs are related to the adventus: 1. a ring of doves surrounding Christ (cf. the Cimitile apse (Ill. 30-31)). 2. Christ who approaches walking on a bed of clouds (cf. S. Costanza (Ill. 23)). 3. The cross as a precursor of Christ. We have already seen that all these motifs can be understood as general theophanic elements. Here, however, it is evident from the context that it is a case of an eschatological utilization of the motifs. It is, meanwhile, striking that in this context the cross, first and foremost, refers to the cosmic consequences of the coming. Elijah's apocalypse does not, however, describe the cross as shining. On the other hand, this aspect is explicitly stressed

[101] See ibid. 7 (PG. 33. 1172).

[102] Brandenburg, Relief in Berlin also regards sovereignty as the original meaning of the hetoimasia presentations. Later this is supplemented by "verschiedenen, sich einander überlagernden Ideen und Vorstellungen", p. 142.

[103] Bousset, Platons Weltseele p. 284.

[104] Stommel, Σημεῖον p. 21-42.

[105] Didache 16. 6 (LCL. 24. 332).

[106] Apoc. El. (Steindorff, Apokalypse p. 87).

in the Coptic Epistola Apostolorum: "I will come in the same way as the sun, which is risen, and I will shine seven times more than she (the sun) in my brilliance. While the wings of the clouds (support) me in brilliance, and while the sign of the Cross is in front of me, I shall descend upon earth, in order to judge the quick and the dead."[107]

The concept of the cross as a precursor of Christ's parousia remains alive in the 4th century. Cyril of Jerusalem could, for example, ask his catechumens preparing for Baptism, what sign they expect at the coming of Jesus. In his answer he cites Matthew 24:30 and comments on the passage as follows: "The true sign, Christ's own, is the Cross" (Σημεῖον δὲ ἀληθὲς ἰδικὸν τοῦ Χριστοῦ ἐστιν ὁ σταυρός). After which the sign preceding the king is described as shining.[108]

Thus, analysis of the shining cross has shown that it not only refers to Christ's death and resurrection but also to his presence here and now and to his coming on the Last Day.

e) The Cosmic Meaning of the Cross

The Elijah apocalypse gives a description of Christ's cross which is very similar to the one we met in Paulinus' titulus for the Cimitile apse. As we have said, it stresses the cosmic consequences of Christ's coming. Traces of cosmic thinking, linked here to the cross-theme, are also to be found in early Christian monuments. The Galla Placidia cross which is placed in a dome "held up" by the four creatures, is the best example of cross-symbolism within a cosmic context (cf. p. 61). But, the depiction of a cross in the centre of a pictorial surface can suggest a cosmic aspect just as the cross which is placed in "the centre of the world" refers to cosmic concepts. Cyril of Jerusalem provides such an interpretation when he points out that the crucifixion took place on Golgotha, the centre of the world. As evidence for his interpretation he refers to the prophetic words: "You wrought salvation in the midst of the earth" (Εἰργάσω σωτηρίαν ἐν μέσῳ τῆς γῆς) in Psalm 74:12. For Cyril, this interpretation is supported by the crucifixion scene itself. Christ spread out his arms on the cross in order to embrace the entire universe.[109]

f) The Cross as the Tree of Life

The association of cross and mountain gives occasion to relate Christology to a paradisical theme, particularly when four rivers flow

[107] Epist. Apost. (Schmidt, Gespräche p. 57).
[108] Cyril of Jerusalem, Cat. 15. 22 (PG. 33. 900).
[109] Ibid. Cat. 13. 28 (PG. 33. 805). See also Jeremias, Golgotha p. 40ff.

from it as we find in the Milan diptych (Ill. 38). The Cimitile titulus pro-
vides clear evidence that the river theme may be assigned a
Christological/ecclesiological interpretation. The titulus concludes with
the words, "Petram superstat ipse petra ecclesiae, de qua sonori quattuor
fontes meant, euangelistae uiua Christi flumina." Here, the rivers flow-
ing from the rock symbolize the evangelists as the intermediaries of the
life originating in Christ. The rivers become a life-giving symbol and
because they are four are linked to the paradisical theme.[110] The
reconstruction too, renders this element as a mountain with four rivers
just as we know it from a number of sarcophagi dating from the second
half of the 4th century. The close connection to be found between
Christology and evangelists on one hand and the paradisical theme on
the other is elaborated upon by Ambrose who maintains that the rivers
in paradise are to be interpreted as the word of God calling mankind to
Grace: "Si quis sitit, ueniat ad me et bibat" serves as textual support for
this interpretation.[111]

Paulinus, in dealing with the rivers, allows for great freedom of inter-
pretation. From a purely iconographical analysis we would only
cautiously suggest such a comprehensive interpretation of the rivers as
that of Paulinus. Here we are faced with an example of how broad the
limits or interpretation evidently have been in the type of iconography
with which we are dealing.

The titulus of the Fundi apse also refers to the paradisical life although
in a somewhat different way. In this case it is written that Christ stands
as a lamb beneath the blood-cross "inter floriferi caeleste nemus
paradisi". This scene, too, links Christ to paradise which in this context
takes on the character of a life theme by the reference to the flowers.
Otherwise, as previously mentioned, we note the ambivalence which
characterizes the paradise scene by its connection with "caeleste
nemus".

Paulinus' desire to maintain an ambiguity in the use of paradisical and
celestial themes is emphatically illustrated in an inscription which he
placed over an entrance from a garden beside the Cimitile church
buildings. Here it is written: "Enter, worshippers of Christ, the heavenly
roads along lovely brushwood;/entering here from a gay garden is very

[110] Gen. 2:10ff.
[111] "est et fluuius qui de Eden exit et circuit uniuersam terram, uerbum dei quo
paradisus intellegibilis inrigatur et omnis anima uocatur ad gratiam Christi dicente ipso
dei uerbo: si quis sitit, ueniat ad me et bibat", Ambrosius, Expl. Ps. 45. 12 (CSEL. 64.
337).

seemly too,/for hence an exit is given, as reward for merit, to holy Paradise''.[112]

The question is whether this life theme, which is deeply rooted in Christology, has been a contributory factor in the forming of the cross itself. In this connection our attention is drawn to the form of the cross familiar to us from Torriti's Lateran apse dating from the end of the 1200's.[113] Here the cross is shell-like in shape and consists of two palm trunks. It may be inspired by early Christian sources and Christe who reconstructs the 5th century Lateran apse with a cross of this type (Ill. 44) evidences his reconstruction partly by pointing to an archaistic strain in Torriti's apse and partly by establishing that this form of cross was in use in early Christian times.[114] Among others, the cross-form in the martyr zone of S. George's rotunda (Ill. 46) is used as evidence in this context. The many small bulges along the edges of the cross which are seen here can be taken as a further development of the date-palm crosses which we recognize from the numerous ampullas from the holy land.[115] A small detail in the S. Maria Maggiore cross (Ill. 42) points in the same direction. Here the upper edges of the arms of the cross are jagged. It is difficult to find any other explanation for this peculiarity than a connection with tree of life symbolism. Typical of the cross-form is the Monza ampulla no. 10 (Ill. 45) on which the inscription substantiates a tree of life theme: +ΕΛΑΙΟΝ ΞΥΛΟΝ ΖΩΗΣ ΤΩΝ ΑΓΙΩΝ ΤΟΥ Χ͞Υ͞ ΤΟΠΩΝ.[116] Grabar links this cross to the cult practised in Jerusalem in connection with relics of the cross.[117]

Sources from Jerusalem show that in the 4th century the cross is usually described as a tree.[118] Thus, Cyril of Jerusalem speaks of the cross as ''the holy wood of the cross'' (τὸ ξύλον τὸ ἅγιον τοῦ σταυροῦ).[119] This type of description is elaborated upon in a number of places. In cat.

[112] ''Caelestes intrate uias per amoena uirecta,
 christicolae; et laetis decet huc ingressus ab hortis,
 unde sacrum meritis datur exitus in paradisum'',
Paulinus of Nola, Ep. 32. 12 (Goldschmidt, Paulinus' Churches p. 40).

[113] Wilpert/Schumacher, Die römischen Mosaiken p. 24 fig. 10.

[114] Christe, Décor absidale de Saint-Jean p. 199 and 202; see also Buddensieg's reconstruction of the apse in the Lateran church in Coffret en ivoire, Fig. 30.

[115] Grabar, Mosaiques de S. Georges p. 73.

[116] See Grabar, Ampoules Pl. 13; see also Grabar's references to other crosses made out of date palms on ampullas, p. 55. For Grabar's interpretation of the cross in this context, see p. 55-58.

[117] Grabar, Ampoules p. 56. For further reading about ampullas, see Engemann, Pilgerampullen p. 7-13.

[118] The cross is described as a tree already in N. T., 1. Petr. 2:24; Acts 5:30; 13:29.

[119] Cyril of Jerusalem, Cat. 10. 19 (PG. 33. 685).

13:20 Cyril links the tree of life to life-giving powers by stating: "Life ever comes from wood" (πάντοτε διὰ ξύλου ἡ ζωή).[118] So, the foundation is laid for putting the concept into a larger theological framework in which, amongs other things, the connection between cross and paradise is emphasized because the tree of the cross is related to the tree of paradise (see p. 172).[121]

With this background the cross emerges with a richly faceted content. Obviously it refers primarily to the crucifixion of Jesus. But, then again crucifixion and resurrection are dealt with as a unity. The victory over death is further outlined by association with life-symbols from concepts of paradise and last day symbols connected to parousia expectations.

At the same time this cross symbolism involves an actualizing aspect as the cross represents an epiphanic phenomenon associated with a liturgical context which is not content to put Christology into an ecclesiological framework alone but which also maintains Christ's cosmic significance.

This analysis leads, needless to say, to a question. Can the crosses in S. Pudenziana, Cimitile and Fundi have been truly intended as references to such a wide variety of meanings? To this we can only reply that the form as well as the placing of the cross allows for many levels of interpretation. Whether all of these levels of meaning really have been associated with the pictorial motif will not least of all be decided by the liturgical context in which the scene belongs, i.e. the Christology expressed in the eucharistic prayer. Later we shall concentrate our interest on such questions. For the present we shall merely establish that the information revealed in Paulinus' tituli clearly allows for broad interpretation. The keywords blood-red cross, victory and triumph, gloriole and paradise direct us well on our way towards the theme groups discussed here.

One thing at least is certain; the cross is unquestionably the pictorial element within our apsidal program which contains most Christological allusions and which, thus, affords the best insight into the iconographical need to develop a comprehensive Christological interpretation. A comparison with the traditio Christ shows very clearly that the cross, in quite a different way, manages to convey a comprehensive statement of the reality which Christ is meant to expose. Against this background it also becomes understandable that those who commissioned the Pudenziana mosaic wished to supplement their teaching scene with a mighty cross.

[120] Ibid. Cat. 13. 20 (PG. 33. 797).
[121] Ibid. Cat. 13. 2 (P.G. 33. 773).

3. *The Lamb*

Both the S. Pudenziana mosaic and Paulinus' tituli add still another motif to the Christological motif group. We find the lamb in Paulinus' tituli as well as in Ciacconio's sketch of the Pudenziana apse from 1595 (Ill. 15).[122]

In the second half of the 4th century, according to Gerke, interest in the allegorical lamb is a particular instance of the general interest shown in allegories during this period—to be seen for example on sarcophagus reliefs.[123]

The tentative use of the lamb symbol is clearly discernible in the Junius Bassus sarcophagus which is the earliest known example of a translation of biblical scenes to a lamb allegory (Ill. 4). In the spandrels of the sarcophagus' lower register are six biblical scenes which we recognize from figural presentations on early 4th century frieze sarcophagi. The three men in the fiery furnace and the raising of Lazarus are placed at each end, beside them are Peter striking the rock and Moses receiving the law while the centre niche is framed by the miracle of the bread and fishes and the Baptism of Christ.[124] In these scenes it is not only Christ who is symbolized by the lamb; all the other figures as well are shown in allegory.

On the Sebastiano fragment (Ill. 21) the lamb-allegory is further developed. On Christ's left side is a lamb shown en face with a plain Latin cross upon its head. The cross is utilized here to identify the lamb as the lamb of God. Simultaneously the close connection between the

[122] The value of Ciacconio's sketch (Cod. Vat. 5407) is disputed. Leclercq maintains that "ce dessin contient trop d'imagination pour qu'on s'en rapporte aveuglément à son témoignage", Leclercq, Mosaïque col. 287. Even Dinkler, is sceptical, Dinkler, S. Apollinare p. 55 note 98. On the other hand both Ihm, Programme p. 131 and Dassmann, Das Apsismosaik p. 69 support the view that the dove with wings spread over the lamb is original. Opinions must be based on a comparison with the preserved apse. As the rendition of the motifs is quite reliable (the sketch simplifies), we find it difficult to believe that the motifs beneath the throne of Christ arise from Ciacconio's own imagination.

[123] "Seit 350 liebte man wieder die Allegorese und die Personifikation, beides immer Zeichen dafür, dass eine Renaissance im Anbruch ist. Man personifizierte den Himmel, auf den theodosianischen Durchzugssärgen dann auch das Meer und die Erde; auch in der theodosianischen Szene der Auffahrt Elias kommt Poseidon wieder, und selbst bei den Berggöttern stecken ihr bärtig zerzaustes Gesicht heraus. Bei diesem gelehrten Zug, der in die christliche Sarkophagplastik eindringt, ist es kein Wunder, wenn auch Allegorien, die von der biblischen Exegese geliefert wurden, in die Kunst eindrangen. So entsteht die Allegorie des Lammes. Erst jetzt verschwindet das gehörnte Schaf, das wir auf der Schulter des Guten Hirten noch in konstantinischer Zeit so häufig finden. In allegorischen Darstellungen hat nur das unschuldige Lamm Platz", Gerke, Lämmerallegorie p. 165f.

[124] Gerke, Iunius Bassus Taf. 42-47.

lamb and the cross motif is suggested. We see here, as well, a row of lambs, with necks out-stretched and heads lifted, placed within the traditio scene itself.

On the front of the city-gate sarcophagus in S. Ambrogio (Ill. 47) we meet a fully developed lamb scene. Instead of a base decorated with vines or a similar pattern, as in other city-gate sarcophagi, we find here an allegorical lamb scene. There is every reason to believe that this frieze of lambs is very closely connected to the figurative scene above. The twelve lambs emerge from two city gates which form the corners of the sarcophagus and from there walk towards the lamb of God, depicted as larger than the others and standing on the mount of paradise in the same manner as the figure of Christ in the scene immediately above. So, this lower scene becomes an allegory corresponding exactly to the figural scene above. Each person is presented as a lamb and even the city gates are repeated in order to maintain the same specific scene. It is a double composition—both figurally and allegorically.

As said before, the composition on the back of the Milan sarcophagus (Ill. 13) is thematically close to the S. Pudenziana mosaic. Instead of a completely allegorical lamb scene as on the front, the allegorical element here is limited to the depiction of the lamb of God. Here, too, the lamb is placed close by the mount of paradise on which Christ's throne stands. In this way the close connection between the figural and allegorical depiction is emphasized.

A certain amount of uncertainty prevails as to whether such allegorical lambs should be considered a characteristic expression of contemporary decorative taste or whether they should also be alloted substantial meaning. F. van der Meer is in no doubt as to the purpose of including lamb allegories in pictorial presentations. In his opinion the lamb allegory underlines the dogmatic meaning of the presentation.[125] Gerke maintains the same view.[126]

In introducing an interpretation of the significance of the lamb, we shall look more closely at some New Testament texts which are clearly connected to the program we have established in the iconographical analysis. The closest textual parallels are to be found in Revelation where it is said in 14:1: ''Then I looked , and lo, on Mount Zion stood the Lamb'', and in Revelation 22:1: ''Then he (the angel) showed me the river of the water of life, bright as crystal, flowing from the throne of God

[125] ''Car il s'agit d'une scène hors du temps, d'une composition abstraite dont l'allégorie semble souligner expressément le caractère dogmatique'', Meer, Maiestas Domini p. 44.

[126] ''Die Allegorie ... klingt vielmehr noch als dogmatischer Unterton in den apostolischen Jubel des Herrlichkeitsbildes hinein'', Gerke, Lammerallegorie p. 178.

and of the Lamb''. The reason, however, for depicting Christ as a lamb is found in Revelation 5:7, "and he (the lamb) went and took the scroll from the right hand of him who was seated on the throne. And when he had taken the scroll, the four living creatures and the twenty-four elders fell down before the Lamb ... and they sang a new song, saying, Worthy thou art to take the scroll and to open its seals,/for thou wast slain and thy blood didst ransom men for God/ from every tribe and tongue and people and nation.'' The text legitimizes the role of Christ in the drama at the end of time on a basis of the function he has previously had for mankind. In this context the lamb refers to the significance of the crucifixion as a sacrificial act in which Christ is identified with the lamb of God. The primary meaning of the lamb is linked thematically to sacrifice. We see then that this act of sacrifice for "every tribe and nation", gives Christ the right to sit in judgement upon mankind at the end of time. We shall attempt to show that the same theme plays an essential role in the patristic use of the lamb.[127] Jerome uses lamb symbolism in a context which is very similar to the one familiar to us from the iconography already referred to as well as the quoted apocalyptical text. Jerome, referring to the lamb standing in front of the throne, explains that this lamb serves as a recapitulating reference to the incarnation. The incarnation in turn, is connected to the terminology of sacrifice—in this case related to the account of Jesus' Baptism in the gospel of John.[128]

Paulinus' tituli also demonstrate that the lamb has been perceived as a sacrificial motif. In the Fundi apse titulus we read, "agnus ut innocua iniusto datus hostia leto". Likewise the Cimitile titulus links the lamb and the sacrificial theme, "sanctam fatentur crux et agnus uictimam". In the last context, however, the lamb is on an equal footing with the cross and at best can only be said to clarify an aspect which in fact the cross also reveals.

John Chrysostom also connects the cross and lamb but in this case the sacrificial motif also serves as a bridge to a eucharistic context. His point turns on an emphasis of the veneration with which Christ will be met. But, since the Christ who hung crucified upon the cross can now be seen as a slaughtered and sacrificed lamb, (ὡς ἀμνὸν ἐσφαγμένον καὶ τεθυμένον),

[127] For the lamb motif in patristic theology, see Nikolash, Lamm als Chr. symbol.

[128] "Et uidi, inquit, in conspectu troni stantem unum agnum. De adsumptione corporis dicitur Saluatoris. 'Ecce agnus Dei, ecce qui tollit peccata mundi'. Et egrediebatur, inquit, fons de subtus medio troni. Videtis igitur quoniam de medio troni fons egreditur gratiarum. Tamen non egreditur fons ille de trono, nisi agnus in contra steterit: nisi enim crediderimus incorporationem Xpisti, non accipimus istas gratias", Jerome, Tract. de ps. 1 (CChrSL. 78. 8).

there is no question of approaching the grave as once the angel did, but of approaching "the table itself, having the Lamb" (αὐτῇ τῇ τραπέζῃ τῇ τὸν ἀμνὸν ἐχούσῃ).[129]

The crucified Christ appears in the Eucharist as a slaughtered and sacrificed lamb. Iconographical material reveals evidence of the association of the lamb and the Eucharist. We have already mentioned that in the spandrels beneath the throne scene on the Junius Bassus sarcophagus both Christ's Baptism and the miracle of the bread and fishes are depicted allegorically by lambs. The position of these motifs on each side of the sarcophagus' central axis suggests that Christ as sovereign is to be connected with the sacramental motifs. With this in mind it is reasonable to infer that sacrificial themes in the tituli in question lead the thoughts of the enlightened onlooker towards a eucharistic context.

The texts reveal, meanwhile, that the lamb motif must not be too narrowly confined to the Eucharist. Because the lamb appears as an incarnation motif it also opens up a view of the significance of Christ for mankind as a whole. Gregory of Nazianzus formulates the significance of the incarnation by pointing out that the lamb is perceived as a depiction of the righteous. He emphasizes that Christ is not chosen only from the flock of lambs on his right side, as in Matthew 25:31 ff., but also from the unrighteous goats on the opposite side. The lamb of God is not slaughtered for the righteous alone but also for the sinners—indeed, first and formost for them. Gregory considers himself as belonging to the latter group which has greater need of God's philanthropy than the righteous.[130] Here Gregory combines conceptions of the lamb of God with a motif in Matthew 25:31 ff., also found in the Fundi titulus, "Et quia praecelsa quasi iudex rupe superstat ...". Paulinus, however, relates the motif to an ecclesiological judgement context in which the division of mankind into two groups is an essential point.[131] This judgement scene, however, conveys a feeling of care and consideration. Iudex can, in fact, in the next moment be replaced by pastor which leads to the domination of a salvation aspect in the judgement scene. The transition from sheep to shepherd which seems rather strange at first, is also found in literary sources: "He is called a Sheep; not a senseless one, but that which cleanses the world from sin by its precious blood, and when led before its shearer knows when to be silent. This Sheep again is called a Shepherd, who says: 'I am the [good] shepherd'; a Sheep because of His

[129] John Chrysostom, De coem. 3 (PG. 49. 397).

[130] Gregory of Nazianzus, Orat. 45. 14 (PG. 36. 641).

[131] Iconography dealing with Christ between lambs and goats is known from the beginning of the 4th century, see Brenk, Imperial Heritage fig. 11.

human nature, a Shepherd because of the loving-kindness of His Godhead".[132]

In this context the lamb is also a characteristic of the faithful. In an interpretation of Matthew 25:31, Clement of Alexandria demonstrates why the lamb is a fitting expression of the righteous. According to Clement, Christ prefers the lambs because, unlike the sheep, they are not full-grown and in consequence still retain "the tenderness and the simplicity of minds, the innocence" (τὴν ἀπαλότητα καὶ ἁπλότητα τῆς διανοίας, τὴν ἀκακίαν).[133] It is those of such a nature who make up the company of the redeemed.

In this way the lamb seems to accentuate certain Christological aspects which are linked to incarnation and sacrificial themes but which contain connecting links to the celebration of the Eucharist and to Christ's functions with mankind as a whole at the end of time.

4. The Trinitarian Motif

We intend to conclude our iconographical analysis by drawing attention to the inclusion of a group of Trinitarian motifs in Paulinus tituli. In the Cimitile titulus it is precisely the lamb which will play an important part in this increase of motifs. The opening of the titulus obviously refers to the Baptism of Christ where Christ himself, according to the Gospel of John, is referred to as the lamb,[134] whereas the synoptists speak of the voice of the Father[135] and all four Gospels refer to the dove.

The same picture of the Trinity is also found in the Fundi titulus and it is possible that the Pudenziana apsidal scene has had a similar Trinitarian central axis. Ciacconio's sketch shows the downward swooping dove as well as the lamb. On the other hand we do not know whether any of these scenes have depicted the voice of God with a specific iconographical motif.

A distinctive combination of Christological motifs is to be seen in the Rotunda Church of S. George in Salonica. In the central part of two of the sections in the martyrs' zone of the dome (Ill. 46) we find a large-scale jeweled cross crowned by a nimbus surrounding a descending dove.[136] The cross stands on a three-footed base which is placed in the forefront

[132] πρόβατον καλεῖται, οὐκ ἄλογον, ἀλλὰ τὸ διὰ τοῦ τιμίου αἵματος αὐτοῦ καθαρίζον τὴν οἰκουμένην τῶν ἁμαρτιῶν· ... Τοῦτο τὸ πρόβατον πάλιν καλεῖται ποιμήν, ὁ λέγων· Ἐγώ εἰμι ὁ ποιμὴν ὁ καλός· πρόβατον διὰ τὴν ἀνθρωπότητα, ποιμὴν διὰ τὴν φιλανθρωπίαν τῆς θεότητος, Cyril of Jerusalem, Cat. 10. 3 (PG. 33. 664).

[133] Clement of Alexandria, Paedag. 1. 5 (PG. 8. 265).

[134] John 1:29.

[135] Matthew 3:17; Mark 1:11; Luke 3:22.

[136] For the whole of area I, see Torp, St. Georg-rotunden p. 24.

of the mosaic. A narrow strip of water appears immediately behind and behind this again, a richly decorated ciborium. The dove, cross and water put the group of motifs into a baptismal context clearly relating it to the Baptism of Jesus. Paulinus, furthermore, has demonstrated that this baptismal scene can be utilized in order to maintain Trinitarian concepts. Thus, here too, it seems reasonable to assume a Trinitarian interpretation in the iconographical program.[137]

In this context it is inviting to look more closely at how this theme can be examined within a textual framework.[138] We note here Ambrose' commentary on Luke in which Trinitarian concepts are joined with the baptismal theme as we find it in our apses.[139]

Ambrose gives an account of the mystery of the Trinity and fastens upon the Father/Son relationship. But, the concept of the Father's presence in the Son leads directly to a Trinitarian aspect. As the Trinity is indivisible, Ambrose just as Paulinus, arrives at the account of Jesus' Baptism. The utilization of the dove is of interest. In a polemic aimed at heretics, Ambrose establishes that the Divine presence did not depart when Christ ascended into heaven.[140] Aided by various textual references, all of which allude to the dove, Ambrose is able to elucidate various sides of the work of the Holy Spirit. We note that the dove's characteristics are not utilized in order to place the Holy Spirit in a relationship with the other Persons of the Trinity, but rather to elaborate upon the gifts of the Holy Spirit to the faithful. Thus, Matthew 10:16 is tied to the baptismal story to demonstrate that the downward swooping dove brings the simplicity of the dove to the baptized. Paulinus, too, is able to interpret the dove as an expression of simplicity: "The doves perched above the heavenly sign intimate that the Kingdom of God is open to the simple of heart."[141]

But Ambrose also connects the dove in the baptismal scene with the one released from Noah's ark.[142] The dove which, in the story of the ark returns to Noah with an olive branch, becomes for Ambrose an illustra-

[137] Torp who has kindly allowed me to read the manuscript of his study on the rotunda of St. Georg, underlines both a baptismal as well as a trinitarian interpretation of the motif.

[138] For dove symbolism in patristic theology, see Sühling, Taube as rel. symbol.

[139] Ambrose, Expositio 2. 92 (SC 45. 116).

[140] Immediately after the quotation from Luke 3:21f Ambrose says: "Quomodo ergo haeretici dicunt quia solus in caelo est, qui non est solus in terris? Aduertamus mysterium! Quare sicut columba? Simplicitatem enim lauacri requirit gratia, ut simus simplices sicut columbae."

[141] "Quaeque super signum resident caeleste columbae
simplicibus produnt regna patere dei'',
Paulinus of Nola, Ep. 32. 14 (Goldschmidt, Paulinus' Churches p. 42).

[142] See note 139.

tion of the Holy Spirit bringing peace to his church. By all appearances
the same theme lies behind Paulinus' talk of the peaceful bird in the
titulus of the Fundi apse. In Cyprian's writings the aspect of peace is
developed to an even greater extent: "In God's house, in the Church of
Christ do those of one mind dwell, there they abide in concord and
simplicity. That is the reason why the Holy Spirit comes in the form of
a dove: it is a simple, joyous creature, not bitter with gall, not biting
savagely, without vicious tearing claws; it loves to dwell with
humankind, it keeps to one house for assembling ... in all things they
fulfil the law of unanimity. The same is the simplicity of the Church
which we need to learn, this is the charity we must acquire, that we may
imitate the doves in our love for the brethren, and rival lambs and sheep
in their meekness and gentleness."[143] Here, the dove symbolism is
transferred from the Holy Spirit to the faithful by the dove becoming a
model for the faithful who are hereby encouraged to live in peace with
one another within the same church. In the transfer of the dove from the
Holy Spirit to the faithful lie the grounds for rendering the apostles as
doves. When Jacob of Sarug makes use of dove symbolism in discussing
the apostles, the symbolism serves to contrast the fear and solidarity of
the apostles with the wickedness represented by the serpent in Caiphos'
house.[144] In addition, we are familiar with the apostle doves in the bap-
tistery decorations from Albenga dating from the end of the 5th
century.[145]

The interpretation of the dove which we have presented here provides
the Trinitarian theme-group with a definite nuance. The Trinitarian
theme is not, first and foremost, utilized to maintain abstract formula-
tions from the theological dispute during the 300's but serves rather to
maintain the consequences of Christ's continuing presence here on earth.

[143] "in domo Dei, in ecclesia Christi unanimes habitant, concordes et simplices
perseuerant. Idcirco et in columba uenit Spiritus sanctus: simplex animal et laetum est,
non felle amarum, non morsibus saeuum, non unguium laceratione uiolentum, hospitia
humana diligere, unius domus consortium nosse, ... legem circa omnia unanimitatis
inplere. haec est in ecclesia noscenda simplicitas, haec caritas obtinenda, ut columbas
dilectio fraternitatis imitetur, ut mansuetudo et lenitas agnis et ouibus aequetur",
Cyprian, De unit. eccl. 8f. (CSEL. 3/1. 217).

[144] "Sie fürchteten sich vor den gereizten Mördern und waren nun versammelt, bis
die Verheissungen sich erfüllten. Im Hause des Kaiphas bellte die verfluchte Schlange
in ihrer Wut, während die Tauben, die Apostel, sich im Abendmahlssaale versammelt
haben. Zusammengedrängt waren sie da in dem gebenedeiten Nest, da sie sich für-
chteten, und erwarteten jene Offenbarung der Wahrheit", Jacob of Sarug, Gedicht
(Landersdorfer, Ausgew. Schriften p. 275).

[145] Wilpert/Schumacher, Die römischen Mosaiken, Taf. 86, see also p. 323.

5. Summary

Our analysis of the tituli in the Cimitile and Fundi apses has opened up wider perspectives to supplement the results reached in the analyses of theme-groups I and II. Here, our study of the cross is of particular importance. There is no doubt that the death and resurrection of Christ constitute the central, meaningful point of the motif. At the same time we discern a clear desire to inject a further Christological interpretation into it. The events which took place at Easter are thus connected to man's existence in paradise and the theme of life which springs thereof as well as the definitive act of God at the end of time. From this framework attention is led further to a cosmic understanding of the events surrounding Christ while simultaneously Christology is put into a leading Trinitarian-dogmatic context.

This Christological investigation aids in broadening our understanding of the purpose of the ambiguity of God's abode which we have so frequently met in our analyses. Christology simply demands an ambiguous setting to allow for the wide scope of Christological points brought up here. Whereas allusions to Christ's death require a setting in this world, the resurrection demands a heavenly background. And, while an interpretation which emphasizes the activities of Christ on earth is, in consequence, associated with themes of vegetation, it seems reasonable to have a heavenly background for an interpretation of Christ which accentuates his importance in the beyond.

By means of the cross it is thus made quite apparent that God's work in the world is not just rooted in Christology but that Christ's activities will only be satisfactorily interpreted when they are placed within the broad framework which we have drawn up here.

Our interest in Christological themes has also circled around the theme of actualization. In Chap. 3, we emphasized that visions, which are clearly modeled on imperial precedent, play an important role in this context. In Chap. 2 we stressed the way in which the pictorial programs emphasized Christ's presence in the congregation. In this chapter the element of actualization has been given further emphasis by an examination of both the empty throne and the lamb. The lamb puts our group of pictorial presentations in direct contact with the Eucharist and thus suggests that the visions are quite naturally connected to the celebration of the Eucharist. In this way we have arrived at a reasonably clear picture of the structural framework which characterizes our apsidal mosaics.

We have also seen that iconographical analyses cannot supply definitive answers as to how the arrangement of the various elements in question are to be understood. Through the iconographical analysis we

have explored individual elements in the pictorial programs without revealing the greater comprehensive relationship to which the motifs belong and the exact function alloted to the pictures. We could just as easily have said that we are on the track of the eschatological problem which has constantly arisen in our analytical work although it remains for the time being without a solution. The recurring discussion about the eschatological element cannot, in our opinion, be solved by iconographical investigation. On the other hand we maintain that iconography clearly shows a tension within the motif group which cannot be removed without the loss of important sides of the iconographical expression. In our opinion, the eschatological element in the pictorial presentations captures the way in which God's work in the world has consequences for the life of man. The task of every attempt to penetrate more deeply into these questions must be to clarify more precisely how these questions are to be understood.

In order to reach greater clarity on this point we must make a considerable jump in imagery—we must leave our iconographical sources and turn to purely textual studies. The basic questions we shall put to the texts arises thus from the rudiments of interpretation revealed by the iconography as well as from the perplexity created in working with it.

PART TWO

TEXTUAL ANALYSIS

CHAPTER FIVE

BACKGROUND

In the introduction we presented our main reasons for concentrating the textual analysis on catechetical-liturgical sources (see p. XVIII). We merely wish to remark here that in our study of the sources the intention is neither to pick out particular details in the liturgical program referred to by the catecheses nor to discover distinctive features in the catechetical teaching structure. On the contrary, our interest is directed towards the way in which the sources treat the problems we have indicated briefly in our main introduction and which we have subsequently investigated in the iconographical analysis. The purpose of this introduction to the textual study is to give our work with the catecheses a general historical background. At the same time, we wish to emphasize the way in which we comprehend the eschatological problem in the 4th century.

The choice of texts comprises the catecheses of Cyril of Jerusalem, Theodore of Mopsuestia and Ambrose of Milan. These sources not only form the main bulk of known 4th century catechetical material but represent as well some of the most important liturgical material from this period.[1]

Earlier we noted that liturgical material from the period is sparse (see p. XVIII). There is reason, nevertheless, to be aware of the relative wealth of sources in this century as compared to the previous one. There is hardly a period in church history which is so meagerly supported by explicit theological sources as the last half of the 3rd century.[2] It is precisely this contrast between the conspicuously sparse material from

[1] Survey of patristic catechetical sources in Daniélou, La catéchèse. Beside the catechetical sources we employ in this study, the catecheses of John Chrysostom; Oratio catechetica magna of Gregory of Nyssa; Commentarius in symbolum apostolorum of Rufinus and De catechizandis rudibus of Augustine must be mentioned in order to include the rest of the catechetical source-material from the 4th and early 5th century. The sources mentioned here have not been used in our text analysis because none of them give an explicit interpretation of the liturgy of the Eucharist which is our final point of reference in this study. Explanatio symboli ad initiandos which probably stems from Ambrose has been left out because of its brevity which exclude the possibility of establishing a clear theological profile.

[2] "The long generation of peace between the Valerian and the Diocletian persecutions is the most poorly documented of all periods of Church history ... From this half-century no writings of a major theologian or exegete are extant. The record of the Church's growth in numbers, resources, and influence is confined largely to the generalities of Eusebius' history", Shepherd, Liturgical expressions p. 60.

the period up until 300 and the relatively abundant material from the period to follow (especially after 350), which creates difficulties in forming a reliable perspective of 4th century church life. We know far too little about the 3rd century to be able to draw up a reasonably clear background for 4th century events.

Above all, the limited material from the end of the 200's makes it difficult to convey a reasonable picture of how much is *new* in 4th century sources. One of the big problems in the interpretation of 4th century church life is maintaining continuity with earlier times while simultaneously giving the new tendencies their rightful place. Ritual as well as its interpretation obviously have deep roots in pre-Constantinian times but it is just as obvious that both undergo noticeable changes before the time of Theodosius.

1. The Catechumenate

The changes which took place in the catechumenate from the 3rd to the 4th century clearly reveal the sweeping alterations which the church's new attitude to imperial power created in the internal life and activity of the church.

Chap. 16 in Hippolytus' Apostolic Tradition gives some idea of the social consequences resulting from admission into the catechumenate in pre-Constantinian times. Here Hippolytus not only reveals the interest shown by the church in the professional background of its prospective members but he also gives clear advice as to the behaviour expected towards a number of professional groups. Brothel-keepers, actors, circus performers, gladiators, priests, high-ranking public officials, the dissolute, magicians and astrologists must abandon their former professions or be refused. Sculptors or painters must no longer create images of the gods, teachers must cease to instruct their pupils in secular wisdom, soldiers must not kill or take a military oath, Christians who have become soldiers voluntarily are to be excluded etc.[3] Although Daniélou doubts that such rigorism was practised in the 3rd century,[4] the list probably reveals the traditional ideal for the relationship of the church to certain branches of society in Antiquity. Between catechumen and society there existed a state of latent conflict which in given situations led to official persecutions.

[3] Hippolytus, Trad. apost. 16 (SC. 11. 70ff.). The same problems are discussed in Tertullian, De Idololatria.
[4] Daniélou, La catéchèse p. 142.

In post-Constantinian times participation in the catechumenate no longer involved the same social consequences and as a result it became easier to enter it. Now, indeed, to be registered as a catechumen even brought with it social advantages.[5]

Of equal importance is the fact that the period spent as a catechumen was no longer considered a direct preparation for Baptism as before. Everywhere catechumens were considered Christians and they also took their part in the Christian community and enjoyed most of the advantages of Christian fellowship. One consequence of this change was that it became rather usual to delay Baptism until just before death or at least until suffering a serious illness. A number of leading 4th century figures are amongst those who put off Baptism as long as possible. Both Constantine and his son Constantius, who was said to be "morbidly pious",[6] were not baptised until just before they died. Likewise, Theodosius, who had had a Christian upbringing, was baptised in his thirties in connection with a serious illness. Ambrose was still a catechumen when he was chosen bishop in Milan. His brother Satyrus was baptised immediately before his death.[7] And, the inscription on the Junius Bassus sarcophagus records that this city prefect, at the age of 42, died when newly baptised, NEOFITVS IIT AD DEUM.[8]

The continuous excuses for delaying Baptism indicate that this practice was looked upon deprecatingly. The Church Fathers polemicized against those who delayed Baptism in order to live freer lives in this world. In all probability, however, there were more who feared not being able to live a life free of sin and who therefore put off Baptism to be on the safe side.[9] Here we discern difficulties which lead to explicit dogmatic-theological approaches to problems. Behind the delay in Baptism is the conception that a life within the faith is hardly compatible with an everyday worldly life. Thus, Baptism is intimidated into being a purely futuristic-eschatological sacrament and a life of faith in this world is threatened.

The solution to the baptismal conflict was a consistent practice of child Baptism. Hereby, not only the problem of delayed Baptism is solved[10] but, likewise, the new arrangement leads to the abolishment of the traditional catechumenate as an institution. The achievement of child Bap-

[5] Baus, Die Reichskirche p. 304.

[6] Jones, Later Roman Empire p. 981.

[7] Source references in Jones, Later Roman Empire p. 981 note 92 (Ambrose, De excessu fratris sui Satyri I. 43ff.).

[8] See Ill. 5. For complete inscription, see Dessau, Inscriptiones I nr. 1286 p. 286.

[9] Source reference in Jones, Later Roman Empire p. 980 note 91.

[10] Postponement of Baptism is not known from the 5th century on, Jones, Later Roman Empire p. 981.

tism can be seen as the church's attempt to accentuate the relevance of faith here on earth. This theological matter is emphasized with the aid of changes in external church affairs.

Before we leave the catechumenate for the moment, it is necessary to indicate typical characteristics in its structure and content. The preparation period in itself varied somewhat from place to place but usually lasted from two to three years. It was concluded with baptismal catecheses in Lent, Baptism on Easter night possibly followed by mystagogical catecheses during the following week.[11] The texts with which we shall be dealing comprise an important part of the instruction during Lent and in the week following Easter. Daniélou divides the content of the catecheses into three: dogmatic, moral and sacramental.[12] The lines between these three parts, however, are not clearly drawn even though interpretation of baptismal symbol is a central point in Lenten instruction while instruction in the three sacraments of Baptism, Chrism and the Eucharist was usually deferred until after Easter.

B. Botte attempts to find characteristic features in the catechetical material. Actually, it is not a literary genre as the catecheses were seldom intended for publication. They could become literature and did so to a certain extent towards the end of the 4th century, but this is not in keeping with their true nature. Botte sums it up by saying that if one wishes to understand the catecheses preceding the great orators of the 4th century, these should not be studied from a literary but from a liturgical point of view.[13] Within this context the catechesis has not assumed a definite form. As liturgical prayers become "literature", the catechesis loses its viability because adult Baptism comes to an end. It has, nevertheless, the support of long oral traditions in which the main emphasis has always been on the rite of initiation. Beyond this it is extremely difficult to discover typical characteristics in this instruction. The limited number of sources makes it difficult to decide which characteristics in the extant material are peculiar to the individual source or which are to be seen as typical for the catechetical tradition in general.[14] Botte emphasizes that this does not involve just one individual problem but rather a whole complex of problems. These can only be solved if the individual themes which are utilized in the catecheses are seen in connection with both the previous exegetical tradition and the liturgical prayers as well as the various compositions of Lenten instruction.[15] A thorough examination of

[11] Bludau, Der Katechumenat p. 225-242.
[12] Daniélou, La catéchèse, has been arranged in relation to these themes.
[13] Botte, Introduction p. 38.
[14] Ibid. p. 39.
[15] Ibid.

the type Botte indicates is not only complicated methodologically owing to the nature of the available material but it would extend far beyond the limits of a study such as ours. Meanwhile, we draw attention to the fact that a comparative study of our sources offers an excellent opportunity, at least, to separate disparate theological traditions within catechetical instruction during the 300's. Differences are very clearly discernible in the various interpretations to be found in common traditional elements (for example, in the interpretation of the Lord's Prayer, Romans 6, the Sanctus) but also by comparing theological themes such as Christology, soteriology and eschatology.

On the other hand, it is impossible to give our sources a contour by comparing them to catechetical material from the same geographical area in the period before 300, indeed, hardly by comparing them to earlier catechetical material at all. Nor are previous local traditions, broadly speaking, available as far as Cyril and Ambrose are concerned and only to a limited degree for Theodore. To the extent that we attempt at all to give our sources a form in relation to the 3rd century we must be content with the more general characteristics which are indicated in this chapter. In this work, particular characteristics of 4th century catechetical instruction will be sought mainly in an attempt to correlate the theology of the catecheses and typical tendencies in 4th century church life.

It is important, nevertheless, in a study such as ours, to abide by Botte's characterization of the catechetical genre in itself and the place of the catechist in catechumen instruction. Botte feels that the catechist undoubtedly influenced the material personally but found no necessity for any profound originality in his catecheses; it shows, above all a debt to the great Christian tradition which, originating in Christ and the apostles, continues in the church.[16] The catechist works within given traditional limits where possibilities of variation are restricted. Thus, the boundaries of our search for the particular characteristics of the individual catechist are clearly set. Comparative analyses of 4th century catecheses reveal with utmost clarity that in spite of variations in traditions, the instruction in question here is largely based on a common program.

2. Celebration of Divine Service

Our sources regarding the celebration of Divine service in pre-Constantinian times are extremely modest. As a result it is difficult to perceive particular characteristics of liturgical celebration within this

[16] Ibid. p. 40.

period. On one hand, J. A. Jungmann maintains that there has been broad agreement concerning liturgical practice within Christianity in the first centuries. He maintains that the Easter controversy shows that it was considered intolerable for one church to diverge from the others in central liturgical questions.[17] G. Kretschmar, on the other hand, points out that in early times the eucharistic prayer had quite a different structure in the various districts.[18] It is the scarcity of source material which creates grounds for various interpretations on this point. From the first centuries we have only sporadic knowledge of liturgical patterns as they were primarily handed down orally which allowed a certain amount of improvisation.[19] Such being the case, it is impossible to decide how rigid the framework of the program was within the various districts.

The picture changes in the 4th century. From this period we have literary sources which enable us to recognize the existence of liturgical centres with differing liturgical traditions. So, we are aware of the Alexandrian, east and west Syrian and Roman Milanese liturgical tradition from this period. It is hardly coincidental that it is the main ecclesiastical centres which developed into liturgical focus points. Kretschmar sees this development as being connected with the growth of separate districts of jurisdiction which in turn was a cause in the widening gap between town and country.[20] As part of this restructuring, the important jurisdictional centres also became liturgical centres; these gradually came to dominate liturgical custom in entire ecclesiastical districts.

The establishment of prescribed liturgies, however, also becomes a practical necessity when Divine service must be adapted to large crowds of people.[21]

If we compare the rituals practised in the 4th century, the structural similarity existing between the various prayers within different ritual areas is striking.[22] At the same time, we must bear in mind that the basic structural similarity does allow great variation. The fundamental ritual pattern allowed for adjustments in order to comply with different theological traditions as well as new needs arising from conditions

[17] Jungmann, Liturgie p. 187f.
[18] Kretschmar, Einführung der Sanctus p. 82.
[19] Tarby, Prière eucharistique p. 26
[20] Kretschmar, Taufgottesdienst p. 265. According to Kretschmar, the consequence is: "Die Christenschar in einem Dorf galt nicht in demselben Sinne als Gemeinde wie die in der Stadt; ihr Leiter war meist ein Presbyter oder gar nur ein Diakon und damit blieb sie dem Bischof in der Stadt zugeordnet".
[21] "Die freie Textschöpfung durch den Liturgen war möglich und war natürlich, solange die Gemeinden noch etwas von einem intimen Kreis von Brüdern und Schwestern an sich hatten. Jetzt fühlte man das Bedürfnis, auch den Wortlaut der Gebete ein für allemal festzulegen", Jungmann, Liturgie p. 188.
[22] Schulz, Eucharistiegebet p. 141.

peculiar to the 4th century. Here, we shall only indicate the changes in the formulation of the anaphora prayer which are rooted in the special conditions in the theological milieu at that period.

Jungmann has shown how the struggle against Arianism was consequential in the forming of liturgical prayer formulas. In Antioch the anti-Arianistic dispute was led by Diodore of Tarsus (cf. p. 206) and Flavian, who disliked the Doxological formula: Δόξα πατρὶ δι' υἱοῦ ἐν ἁγίῳ πνεύματι. In its place they take into use the formulation: Δόξα πατρὶ καὶ υἱῷ καὶ ἁγίῳ πωεύματι. The Arian dispute also affects the liturgical work of Basilius of Caesarea which leads to praising God *with* the Son as well as praising God *through* the Son.[23] But, these changes cause the older concept of Jesus' priestly work, seen as the mediation of prayers and sacrifices to God, to become rather vague. This conception fades gradually and its place is taken by a concept of Jesus' priestly activity as being concentrated around his past acts of salvation. Thus the Divine service takes on a greater representational character in which Christ's work of salvation is the central point. This leads to a strengthening of the commemorative aspect of the Eucharist, which again involves particular emphasis on the special anamnesis.[24] A comparison between Hippolytus' anamnesis and liturgies from the 4th century creates the basis for a discussion about such a development.[25]

It is possible, moreover, to trace greater emphasis on the epiclesis in 4th century liturgies than earlier. An understanding of the consecration as an act of the Holy Spirit now comes more to the fore, not least of all after Athanasius, who, in the struggle against the Pneumatomachi, stressed that the incarnation is the work of the Spirit.[26] The distinctive features in 4th century epicleses appear again when compared to epicleses of the Hippolytus kind. Whereas the old epicleses do not speak explicitly of a direct conversion of Christ's body and blood, we see in the 4th century a steadily stronger emphasis on the consecration effect of the prayer.[27] The epicleses we find in Cyril and James are fully developed.

Such epicleses stress not only the "sacramental incarnation" which functions as an extension of the anamnesic theme but also emphasize the idea of the congregation's participation in the Epiphany.[28] This last point, meanwhile, becomes accentuated even more clearly in the 4th century utilization of the Sanctus. Once more the most influential change

[23] Jungmann, Die Stellung Christi p. 154f.
[24] Betz, Eucharistie p. 194.
[25] Schultz, Byzantinische Liturgie p. 35
[26] Ibid. p. 32.
[27] Ibid. p. 33.
[28] Ibid. p. 35.

takes place in the Syrian area. Kretschmar maintains that the use of the Sanctus in a liturgical connection can be supported by old traditions in Egypt as well as in Syria even though its function has been rather different. He considers that in Egypt the hymn was taken into use in the celebration of the Eucharist about the middle of the 3rd century where its intention was to be "Hinweis auf Christus und Geist als Mittler, die der Gemeinde den freie Zugang zu Gott auftun und durch die sie Ihm als Lobopfer bringt".[29] It is gradually introduced into a Trinitarian context, possibly in the second half of the 4th century.[30]

In Syria also there exists a strong, traditional use of the Sanctus but here its use seems to be inspired by the Jewish Qeduscha tradition in which it functions as the climax of the thanksgiving to God for creation.[31] The use of the Sanctus in this way which is reflected in the Apostolic Constitutions implies, however, that theological and Christological thanksgiving are to be separated . This creates a need for reformulation which means that thanksgiving for creation recedes and praising the Trinity comes more to the fore as an introduction to the Sanctus.[32] The need for a reformulation of the function of the Sanctus is reflected, among other places, in James' liturgy in which the Sanctus is placed in a Trinitarian context which serves as the background for the thanksgiving for creation and incarnation. In this way, the Sanctus relates the congregation to heavenly reality in another way than previously. Whereas older Antiochene tradition considered the Sanctus as the climax in creation's (eschatological?) praise of God and Alexandrians used it as an expression of the church's sacrifice of praise which was communicated through the angels to God, the Sanctus in 4th century Antiochene liturgy is comprehended as a reflection of the celestial service.[33] Shortly, we shall examine the interpretations attached to these changes in the eucharistic prayer (see p. 143). At this point we only add that changes in the anaphora prayer, which we have discussed, are mere details when compared to the changes in the *whole* framework of liturgical celebration which we find within the same period.

Although it is probable that the church, to a certain extent, adopted the plans of secular basilicas before Constantine,[34] there is no doubt that the splendid basilicas stand out as a characteristic example of 4th century imperially influenced Christian building. From this time on, church

[29] Kretschmar, Trinitätstheologie p. 180.
[30] Kretschmar, Einführung des Sanctus p. 81.
[31] Kretschmar, Trinitätstheologie p. 172ff.
[32] Ibid. p. 170.
[33] Ibid. p. 179.
[34] See note 54 in the introduction to the iconographical analysis.

buildings have a pronounced official character, [35] and are conspicuous with a grandeur and monumentality suitable for "state buildings of the highest class".[36] The sumptuous 4th century churches are part of the imperial support enjoyed by the church.[37]

The magnificent basilica is often mentioned in a positive manner in ecclesiastical writings from the 4th century,[38] but we also meet great criticism.[39] In any case it is the richly appointed church space which retains the power. Simultaneously, an increasing interest in improving the liturgical program itself is noticeable. Not only the liturgical program but vestments, furnishings, vessels and celebrations were all subject to a process of change.[40] In this same context, Divine service takes on an

[35] "Public building, of course, for centuries had been a primary responsibility of the emperors, financed and supervised by their representatives and a powerful instrument of imperial policy and propaganda. Constantine merely expands this principle to include church building", Krautheimer, Constantinian Basilica p. 128.

[36] Ibid. p. 135.

[37] Even if the church became prosperious in the 3rd century, her economy was considerably improved when the emperor transferred capital to her through great donations. The legalisation of the church's right of inheritance in 321, points in the same direction (Jones, Later Roman Empire p. 895). But, the state even undertook lasting responsibility for the economic affairs of the Church. Thus, its economy was given a firmer footing than previously when the Church had to finance its activity through offerings (Jones, Later Roman Empire p. 894). We also note that the state's economic support of the church must be regarded as an innovation without parallel in earlier practice (Jones, Later Roman Empire p. 933). State support in the 4th century contributes effectively to the enormous growth of wealth within the Church. Even if the community in Rome was prosperous by the middle of the 3rd century, this situation was changed radically through the action of Constantine. By the middle of the 4th century, one of the pagan senators in Rome, Agorius Praetextatus, said jokingly to Damasus: "Facite me Romanæ urbis episcopum, et ero protinus Christianus." Jerome, Contra Joan. Hier. 8 (PL. 23. 377).

[38] See Cyril of Jerusalem p. 149, Egeria p. 149.

[39] Jerome's statements about church building reflect a certain embarrassment. In Ep. 52 he expresses himself critically about contemporary church buildings: "Multi aedificant parietes et columnas ecclesiae subtrahunt: marmora nitent, auro splendent lacunaria, gemmis altare distinguitur et ministrorum Christi nulla electio est." (Jerome, Epist. 52. 10 (CSEL. 54. 431)). The statement is supported by Christological thinking: "nunc uero, cum paupertatem domus suae pauper dominus dedicarit, cogitemus crucem et diuitias lutum putabimus." (Jerome, Epist. 52. 10 (CSEL. 54. 432)). In his later years, Jerome is more moderate in his attitude. In a letter he advises Demetrias not to become engaged in church buildings, decorated with beautiful columns, marble, gold and precious stones. Further on he says that he will neiter criticize nor refuse Demetrias his participation in such matters. He maintains that it is better to use the money on church buildings than to hoard hidden treasures. Nevertheless, Jerome's advice is: "sed tibi aliud propositum est" (Jerome, Epist. 130. 14 (CSEL. 56. 194-195)). Here we find quite another accomodating attitude than in the letter first quoted. We find no traces of a fundamental argumentation against expensive church decorations in this context. Now Jerome even comments upon church decorations in a positive way. In Ep. 60 he praises the presbyter Nepotianus because he has decorated a church (Jerome, Epist. 60. 11f. (CSEL. 54. 563)). Through his ambiguous attitude, Jerome not only demonstrates the problems of wealth, but also brings to light his own uncertainty towards the growing wealth within the Church.

[40] Jungmann, Liturgie p. 111-139.

aspect of "fear and trembling" towards the end of the 4th century.
Kretschmar finds two reasons for this development. In the first place he
considers it a way of stopping people's contempt for the sacraments.
Secondly, he sees anti-Arian interests behind this development.[41] In our
opinion it is not unreasonable to see features of imperial ceremony also
as an influential element.

Changes in liturgical practice, of the kind in question here, possibly
correspond to a shift in the understanding of the liturgy . P. Brown main-
tains that the use of elaborate liturgical finery is one of the deciding fac-
tors in how the church has considered its relation to the hereafter. By
means of the solemn liturgy, shining light, shimmering mosaics and the
colourful curtains, valued in its full sensuality, the other world is related
to a concrete conception of paradise which is revealed in a glimpse within
the liturgical sphere. Likewise, the processions, the heavy silver, sacred
vessels and glittering Gospel books act as "visual 'triggers'" in
approaching the Divine majesty.[42] Thus, the use of liturgical furnishings
reflect—even if indirectly—a distinctive comprehension of Divinity and
its relation to the world.

3. The Eschatological Problem

A fundamentally conservative attitude marks large parts of 4th century
ecclesiological argument. The ideal is that ancient customs should act as
the guideline for new decisions.[43] This attitude is revealed, not least of
all, in the continuity which appears to have existed not only in liturgical
forms but also in catechetical tradition. There has been no difficulty,
however, in uncovering considerable changes in the 4th century Divine
service as well as in catechetical practice.

Until now we have paid little attention to the dogmatic-theological
development within the period with which we are working. Is theological
thinking affected at all by the socio-political changes taking place between
the 3rd en 4th centuries?

Kretschmar is one of the few to interest himself in such questions. The
new situation, according to him, contains a direct challenge to theological
thought: "Was dann aber christliche Existenz in der Welt—nicht von der
Welt heissen sollte, war völlig neu zu bestimmen."[44] It is hardly inciden-
tal that the 4th century is a thriving period of theological growth in stark

[41] Kretschmar, Die frühe Geschichte p. 33 note 49.
[42] Brown, Art and Society p. 24f.
[43] Jones, Later Roman Empire p. 873ff.
[44] Kretschmar, Der Weg zur Reichskirche p. 36, see also Kretschmar, Abendmahl p.
77.

contrast to the overruling passivity in the decades before the new century. Kretschmar is in no doubt whatsoever that this activity can only be understood if it is seen in the light of the theological crisis which was surmounted by precisely "die Kraft dieser Theologie".[45]

It is, meanwhile, no easy task to clarify the distinctive character of the theology now emerging. Certain dogmatic-theological problems contained in the material already referred to may serve as the first lead. When Baptism is delayed until just before death it involves, as its extreme consequence, an attempt to avoid the problems which arise by trying to live a godly life in this world. On the other hand, the precondition for the ascetic movement which also appears as a distinctive trait in the church of the 300's, is that a godly life can be led in this world but only in isolation from society.[46] Both these solutions, which cannot be judged as marginal phenomena within ecclesiastical life during the 300's, focus on the "where" and "how" of salvation as central problems. This in itself, with a certain amount of truth, can be seen as touching on problems which, in various forms, have been central in theological study throughout the entire early church. The original Christian conviction that one was living at the end of time when the new life was thought to be partly realized here on earth as an anticipation of the final and total redemption of creation,[47] has been constantly attacked from various quarters throughout the patristic period. G. W. H. Lampe points out that not only Gnosticism's view of salvation represents a break with the original early Christian eschatological conception but also points to two

[45] Kretschmar, Taufgottesdienst p. 148.

[46] Concerning the ascetic realizing a god-willed life, May says: "Traditionsgeschichtlich auf Mk. 12. 25 par. und jüdische Vorstellungen zurückzuführen ist die Anschauung, dass der Asket ein engelgleiches Leben führt: Er lebt im wiederhergestellten Paradis und nimmt zugleich die himmlische Existenz vorweg (vgl. Cyprian, De habitu virg. 22: Quod futuri sumus, iam vos esse coepistis. Vos resurrectionis gloriam in isto saeculo iam tenetis)." May, Eschatologie V p. 302. But the ascetic way of life also has a pronounced anti-social profile . Even if monastic life was organized in order to attain mystical knowledge of God, it is probable that most ascetics withdrew from ordinary social life to escape worldly temptations (Jones, Later Roman Empire p. 979). John Chrysostom demonstrates that ascetical ideals are closely related to problems in secular life. He maintains that the cities are so filled with evil that he who wants to be saved, must leave for the desert, (John Chrysostom, Adv. opp. 1.8 (PG. 47. 329)). At the same time he gives assurance that asceticism is not the only legitimate way of living a Christian life. In other contexts he polemicizes against those who say that it is impossible to realize Christian ideals within the city: Ποῦ νῦν εἰσιν οἱ λέγοντες, ὅτι οὐχ οἷόν τε ἐν μέσῃ πόλει στρεφόμενόν τινα διασῶσαι τὴν ἀρετὴν, ἀλλ᾽ ἀναχωρήσεως δεῖ, καὶ τῆς ἐν τοῖς ὄρεσι διατριβῆς, καὶ οὐ δυνατὸν τὸν οἰκίας προεστῶτα, καὶ γυναῖκα ἔχοντα, καὶ παίδων ἐπιμελούμενον καὶ οἰκετῶν, ἐνάρετον εἶναι; (John Chrysostom, Hom. In Genesim 13. 1. 1 (PG. 54. 396)).

[47] Lampe, Eschatology p. 19; see also Kelly, Early Christian Doctrines p. 459 and Introduction note 3.

tendencies which have prevailed amongst the church's orthodox theologians. In this connection, he speaks of a mysticism in which great emphasis is put on the individual soul's development to unity with the Divine.[48] In addition, he mentions a moralism inclined to think of the hope of the Kingdom of God as a hope of "heaven" where those who have performed good deeds will be rewarded for their endurance.[49]

Lampe, nevertheless, maintains that these tendencies are largerly kept in check by their ties to the historical revelation and through the apostolic tradition, Scripture and sacraments.[50] The piety of the people as well as the conceptions of the less learned theologians clearly reflect the way in which the eschatological concept—admittedly in a somewhat naive and excessively realistic form—was preserved throughout the early church. It is nevertheless, important to remember that the eschatological character of the church was challenged throughout this entire period. Concerning our study, it is of particular interest that Lampe emphasizes the importance of the social context in ideas pertaining to the eschatological problem.

It is likely that futuristic-eschatological concepts tend to be stronger in times of oppression and persecution.[51] As a result there exists a natural bond between the glorification of the martyrs and the emphasis on end-of-time expectations.[52]

We shall support Lampe's view on this point by dwelling a moment on a text which illustrates very clearly how a persecution situation can be directly connected to a perception of eschatology. It concerns the only surviving catechetical sacramental exposition from pre-Constantinian times, Tertullian's De baptismo.[53] In it Tertullian utilizes a ship as an image of the church and water to represent the world. The waves are interpreted as the trials and persecutions suffered by the faithful but which at last are overcome when Christ returns to subdue the world.[54]

[48] Lampe, Eschatology p. 19f.

[49] Ibid. p. 20f., see also Kelly, Early Christian Doctrines p. 460.

[50] Lampe, Eschatology p. 24; see also Kelly, Early Christian Doctrines p. 461.

[51] Lampe, Eschatology p. 26.

[52] "The relation between the glorification of martyrdom and eschatology can be discerned in the fact that the Gnostics depreciated the value of martyrdom and avoided it, whereas the Montanists, with their vivid if somewhat unorthodox eschatology, esteemed it very highly and regarded the record of their community under persecution as sound evidence for the truth of their claims to possess immediate inspiration", Lampe, Eschatology p. 27.

[53] Quasten, Patrology II p. 278.

[54] "ceterum navicula illa figuram ecclesiæ præferebat quod in mari, id est in sæculo, fluctibus id est persecutionibus et temptationibus iquietetur domino per patientiam velut dormiente, donec orationibus sanctorum in ultimis suscitatus compescat sæculum et tranquillitatem suis reddat", Tertullian, De bapt. 12. 7 (SC. 35.84).

The consequences of persecution to one's attitude to life here on earth is even more explicitly laid down in Tertullian's interpretation of the Lord's prayer from De oratione which is also directed towards catechumens.[55] In interpreting the part of the prayer "Thy Kingdom come", Tertullian establishes that God has always held sway over his dominion. The prayer in question, on the other hand is formulated with a view to the expectation held by the faithful towards God. With this, the theme is set. In this case it concerns the realization of the Kingdom of God governed by the will of God which also relates to the human condition. Tertullian disagrees with those who demand that the world shall endure. How is it possible to wish for such a thing when one knows that the Kingdom of God is aimed at the consummation of the world? So, it is established that Christians wish to rule, not to serve. He finds the decisive argument, however, in the infamous deeds carried out upon the faithful: "With indignation the souls of the martyrs beneath the altar cry aloud to the Lord: 'How long, O Lord, dost thou refrain from avenging our blood on those who dwell on the earth?' For, at least from the end of the world vengeance for them is ordained. Indeed, as quickly as possible, O Lord, may Thy kingdom come! This is the prayer of Christians; this shall bring shame to the heathens; this shall bring joy to the angels."[56] The blood from the persecutions simply requires the intervention of God to demand redress—understood as the Day of Judgement, an act to be carried out as soon as possible. The martyrs yearn for the day of retribution when the injustices which they have suffered will be reciprocated.[57]

If we now turn again to Lampe's theory, we see that he too is aware of the new situation which has arisen in the 4th century and its connection with the eschatological problem. Thus, he maintains that new social conditions "naturally tended to weaken the power of the idea that the sole allegiance of the Christian is to an other-worldly 'Jerusalem caelestis'."[58] A well-defined instance of such a tendency is found in Eusebius of Caesarea. In his panegryrical words on the occasion of the consecration of the church at Tyre he brings up the trials which the

[55] Quasten, Patrology II p. 296.

[56] "clamant ad dominum inuidia animae martyrum sub altari: quoniam usque non ulcisceris, domine, sanguinem nostrum de incolis terrae? nam utique ultio illorum a saeculi fine dirigitur. immo quam celeriter ueniat, domine, regnum tuum, uotum Christianorum, confusio nationum, exultatio angelorum", Tertullian, De orat. 5 (CSEL. 20.184).

[57] Emphasis on the futuristic-eschatological element at the expense of the present-time eschatological element can also be found in Tertullian's interpretations of the Sanctus, see Kretschmar, Trinitätstheologie p. 136f.; see also Kelly, Early Christian Doctrines p. 460f.

[58] Lampe, Eschatology p. 28.

church previously has had to endure. Based on a general thematic treat-
ment of the concept that it is Christ who releases mankind from darkness,
the theme is carried over into a concrete life situation. In this context
Eusebius explicitly draws attention to the definitive settlement with the
evil forces of the last persecutions, when the enemy acted like a dog
"which gnaweth with his teeth at the stones hurled at him and venteth
on the lifeless missiles his fury against those who would drive him away."
Eusebius is pointing here to the useless attacks on church buildings. This
is followed by the threats of tyrants and blasphemous ordinances by
impious rulers and finally by direct attacks on the faithful. This situation
comes to a definitive end when the emperors (Constantine and Licinius)
now spit upon the faces of the dead idols, trample on the unhallowed rites
of demons and laugh at the old deceits inherited from their fathers.
Instead, the present emperors recognize the one and only God, benefac-
tor to all and admit that Christ is "sovereign King of the universe
(παμβασιλέα τῶν ὅλων)".[59]

The acts of the emperors are, furthermore, related to the rule of
Christ.[60] With this as his point of departure, Eusebius can then tell of
how the prophecy from Isaiah 35:1-4 is realized here and now. That
which the prophet relates was recorded in the Sacred Books in words.
Now, on the other hand, these things have come down to us "no
longer by hearsay, but in actual fact" (οὐκέτ' ἀκοαῖς, ἀλλ' ἔργοις).[61] Here
it is said as clearly as is possible that the new political situation is
perceived as a salvation situation in which the present-time element in
the realization of salvation totally overshadows a futuristic-eschatological
perspective.

With this as a background it is understandable that Hernegger con-
siders Eusebius a "seismograph" for the 4th century situation.[62] In a
unique way, the important political events at the beginning of the cen-
tury are gathered together here with a clearly outlined eschatological
tendency. We maintain, nevertheless, that care must be shown in draw-

[59] Eusebius of Caesarea, Hist. Eccl. X. IV. 16 (LCL. 265. 406).
[60] Ibid. X. IV. 20 (LCL. 265. 408).
[61] Ibid. X. IV. 33 (LCL. 265. 418).
[62] See Hernegger, Macht p. 209-256. Hernegger clearly emphasizes the sharp contrast
between the biblical and the eusebian conception of eschatology: "Seiner hellenistischen
Denkstruktur entsprechend hatte er, wie noch zu zeigen ist, zur biblischen Eschatologie
keinen Zugang; darum klammerte er sich an die rational kontrollierbare Erfüllung der
Weissagungen in der Geschichte, die ihm ja der entscheidende Beweis für die Wahrheit
des Christentums war. Damit projizierte er die eschatologischen Verheissungen in die
Geschichte und sah im Reiche Konstantins das messianische Reich angebrochen",
Hernegger, Macht p. 222; see also p. 238, 240 and 243. This interpretation of Eusebius'
theology is generally accepted, see May, Eschatologie V p. 303.

ing general conclusions from studies of Eusebius' theology. Just as Tertullian cannot be considered to representative of the understanding of pre-Constantinian eschatology, neither can Eusebius, without reservation, be considered the spokesman for a leading tendency in 4th century theology.

The aim of our text analyses is precisely that of specifying the eschatological problem within the context of 4th century ritual. We have previously upheld our choice of texts from an iconographical point of view (see p. XVIII). Lampe now points out that the sacraments have played a decisive role in maintaining eschatological conceptions in the early church.[63] As a result, "some of the most striking eschatological teaching of the early Fathers" is to be found in homilies concerning the sacraments.[64] Lampe contintues: "Preaching delivered in that context is naturally the element in patristic literature to which we should go to discover the plainest exposition of eschatology. It is also the teaching which, by reason if its official and public character, can most justly be considered part of the regular tradition of the Church as a whole."[64] In this respect our sources seem to be well chosen.

As a background for our own textual studies we shall make a closer examination of the way in which certain historians of liturgy have attempted to determine more precisely the distinctive characteristics in 4th century perception of eschatology.

Such distinctive traits are usually related to changes in the liturgical structure which we indicated on p. 136. We pointed out that the anamnesis now stresses more clearly than before that the Eucharist is a commemoration of Christ with particular emphais on its connection to Christ's death and resurrection. At the same time the new outlines for the Sanctus imply that the congregation taking part in Divine service is put into a new relationship with celestial reality. Both changes can be seen as the outcome of a new perception of eschatology. G. Dix is particular interested in the anamnesis aspect: "As the church came to feel at home in the world, so she became reconciled to *time*. The eschatological emphasis in the eucharist inevitably faded. It ceased to be regarded primarily as a rite which manifested and secured the *eternal consequences* of redemption, a rite which by manifesting their true being as eternally 'redeemed' momentarily transported those who took part in it beyond the alien and hostile world of time into the Kingdom of God and the World to come. Instead, the eucharist came to be thought of primarily as the representation, the enactment before God, of the

[63] Lampe, Eschatology p. 22.
[64] Ibid. p. 23.

historical process of redemption, of the historical events of the crucifixion and resurrection of Jesus by which redemption had been achieved. And the pliable idea of *anamnesis* was there to ease the transition."[65] Dix presents the following reasoning for this interpretation: "By cataloguing, as it were, the meta-historical and eternal facts (of the resurrection, ascension, session and judgement) side by side with an historic event in time (the passion) the whole notion of the *eschaton* is brought in thought entirely *within time,* and split into two parts, the one in the historic past and the other in the historic future, instead of both in combination being regarded as a single fact of the eternal present. In the primitive conception there is but *one eschaton, one* 'coming', the 'coming *to* the Father' of redeemed mankind, which is the realisation of the Kingdom of God".[66]

H. M. Riley clearly reasons along the same lines: "By emphasizing baptism not only as the saving bath which purified from all sin and threw open the gates of heaven, but showing the relationship of this salvation to the salvific action of the life, death and resurrection of Christ ... then a major step had been taken toward providing the candidate with a spirituality for a Christian life in this world, central focus of which is the dynamic union with the humanity of Christ".[67] Riley widens the perspective by interpreting the initiation rite as "a passage into a new world of consciousness, the world of salvation history".[68]

But, also the emphasis on the place of the Sanctus in the liturgy may be seen as a result of changes in eschatological perspective. Thus, H. J. Schulz asserts that the new place alloted to the Sanctus in the anaphora contributes to the fact that "das Eschaton nicht mehr nur als Gegenstand der Erwartung, sondern schon als Anteil der Gegenwart gesehen wird".[69] This interpretation backs up M. H. Shepherd's perception of the liturgy during this same period. He, too, maintains that "the sanctification of the temporal order ... is the key to the liturgical innovations of Constantine". And, what is typical in 4th century liturgy he finds precisely in the epiphanic character of the Divine service: "There is no question that Constantine's deepest grasp of Christianity was in terms of *theophaneia* rather than of *parousia.* All the liturgical accents and emphasis that came into the church through his influence, whether directly or indirectly, tend in this direction."[70] Shepherd does not see the emphasis

[65] Dix, The Shape p. 305.
[66] Ibid. p. 265.
[67] Riley, Christian Initiation p. 222f.
[68] Ibid. p. 37.
[69] Schulz, Byzantinische Liturgie p. 35.
[70] Shepherd, Liturgical Expressions p. 78.

on the theophanic aspect as a radical change in the Christian ideological pattern but means rather that more interest is devoted to the church in this world than in its possible future: ''The temporal order was no longer a merely transitory stage of existence, but a true image and copy of the eternal glory of the communion of saints.''[71] The double dimension which time and eternity constitute continue to be utilized and this duality continues to be held together on the basis of an eschatological understanding of human existence.

In our work with the catecheses we shall try to look at aspects which the already mentioned supplementary literature considers as expressing a present-time concept of salvation, and to do this in connection with a more detailed examination of the benefits of salvation within our catechetical material. In what way are the aspects here in question related to the interpretation of a realization of the blessings of salvation? And then; does this interpretation of salvation's benefits lead to a weakening of futuristic-eschatological concepts?

[71] Ibid. p. 72.

CHAPTER SIX

CYRIL OF JERUSALEM

1. Introductory Remarks

a) The Text

The first group of texts we shall examine consists of one procatechesis, 18 catecheses, of which the last 13 are explanations of the Jerusalem Creed,[1] and 5 mystagogical catecheses which interpret Baptism, Chrism and celebration of the Eucharist. There has been much discussion as to the dating as well as authorship of these texts. A debate beginning in the 1500's has still not reached a final conclusion.[2] That the 19 Lenten catecheses must be attributed to Cyril of Jerusalem and belong to his early activity in Jerusalem (c. 350) is beyond all doubt.[3] The discussion centres on the author and the original dating of the mystagogical catecheses.

A. Piédagnel, in his introduction to the Sources Chrétiennes' edition of the mystagogical catecheses gives a fully detailed account of the authorship. In this, he refers to the discussion concerning the surviving manuscripts, the literary tradition in which the catecheses later emerge, as well as liturgical information and the basis they provide for dating.[4] He hesitates, meanwhile, to draw any unequivocal conclusion from this material.[5] The introduction, shows, nevertheless, that Piédagnel assumes Cyril to be the author—it is Cyril's life and the rest of his works which take up the remainder of his introduction.[6]

[1] For the reconstruction of the Jerusalem Creed, see Stephenson, General Introduction p. 60ff; see also p. 33f.

[2] Piédagnel, Introduction p. 18f.

[3] A certain disagreement exists concerning Cyril's status when catechizing. If he was a presbyter, the catechetical lectures were probably delivered in 347 or 348, while 350 is likely the correct date if the catecheses were delivered when he was a bishop, see Quasten, Patrology, III p. 364.

[4] Piédagnel, Introduction p. 21-33.

[5] "Nous devons constater que plusieurs explications sont possible, entre lesquelles il est difficile de faire un choix; et je souscrirais volontiers au jugement de J. Quasten, qui trouve également difficile, dans les circonstances actuelles, d'établir ou d'infirmer la paternité de Cyrille' pour les Mystagogiques", Piédagnel, Introduction p. 38.

[6] Cyril's biography is rendered in Piédagnel, Introduction p. 9-14 and in Stephenson, General Introduction p. 21-34.

Direct comparison of the textual groups leads us a step forward in the question of authorship. It is, in fact, rather easy to demonstrate a number of differences in Lenten catecheses and mystagogical catecheses. Whereas the first are stenographically recorded during catechetical teaching,[7] the mystagogical catecheses show a brevity and lack of improvised phraseology which suggests rather that they are notes made as a basis for future sermons.[8] E. J. Yarnold, moreover, points out both stylistic and theological differences which make it natural to assume a certain distance between the two text groups.[9]

The most radical solution to this problem implies an attribution of the mystagogical catecheses to Cyril's successor John (387-417).[10] But then, the idea of seeking an Origenistic tendency immediately suggests itself because John is regarded as a keen follower of Origen.[11] Kretschmar is one of those who has attempted to show that the mystagogical catecheses have Origenistic tendencies in liturgical structure as well as in content. It is, however, difficult to find his reasoning on this point convincing.[12]

Some recent contributions, on the other hand, have tried to retain Cyril's authorship of all the catecheses. C. Beukers, basing his idea on

[7] Quasten, Patrology, III p. 363; Stephenson, General Introduction p. 1 note 3.

[8] Improved sections occuring in the Lenten Catecheses in Cat. 15.33; 2.16 and 17.31 do not occur in the Mystagogical Catecheses. Yarnold's suggestion that the Mystagogical Catecheses are the preacher's notes, stands in opposition to Telfer's theory that the catecheses are complete, but short because they were followed immediately by Syriac and Latin translations, see Yarnold, Authorship p. 144f.

[9] Yarnold, Authorship p. 147-159.

[10] This solution has been predominant after W. J. Swaan's article from 1942 (Swaan, A propos) and has been advocated by, for example, Stephenson, Introduction p. 143-49 and Kretschmar, Die frühe Geschichte p. 22-27.

[11] Yarnold, Authorship p. 146.

[12] Kretschmar attempts to demonstrate that the introduction to the anaphora referred to in 5 M. Cat., maintains the same peculiarities as we find in the Origenistic exegesis of Jes.6. From this he maintains that an Origenist has introduced these elements into the Jerusalem eucharistic prayer (Kretschmar, Trinitätstheologie p. 168f.). The problem with Kretschmar's argumentation is, however, that he asserts simultaneously that these Origenistic elements are a part of the Antiochene liturgical structure (Kretschmar, Trinitätstheologie p. 169 note 1), and thus liturgically dependent upon Antioch (Kretschmar, Die frühe Geschichte p. 34). We find it more convincing to see the liturgy referred to in 5 M. Cat. in the light of an existing liturgical structure that from the Origenistic exegesis of Isaiah which has been considered questionable in the 4th century (Kretschmar, Die frühe Geschichte p. 26).
Nor do we find Kretschmar's argumentation for an Origenistic tendency in the Mystagogical Catecheses convincing. His reference to 4 M. Cat. 5 which can be seen as a further development of a tradition stemming from Clement of Alexandria (Kretschmar, Die frühe Geschichte p. 27; see also note 26), can not be used as an argument for separating the mystagogical catecheses from the others. Stephenson holds that an Alexandrian tendency is also reflected in the Lenten Catecheses, and his argumentation is similar to that found in Kretschmar, see for example Stephenson, Alexandrian Heritage p. 579f.

an analysis of the Memento prayer maintains that the 5th mystagogical catechesis should be dated between 383 and 386.[13] Yarnold rejects Beukers' argument but holds that they are the work of Cyril in his latter years. He bases this on a comparison of similarities and differences in the two text groups.[14] There are several advantages to such a solution. It satisfies liturgical objections to an early dating,[15] while at the same time, differences as well as theological continuity which actually exist in the two text groups are given a reasonable explanation. On this basis we consider the catecheses to be the result of Cyril's work in Jerusalem in the second half of the 4th century.

b) Jerusalem in the 4th Century

It is only as late as the 4th century that we find reliable sources for liturgical as well as catechetical traditions in Jerusalem.[16] Indeed, conditions in the Jerusalemite congregation are on the whole badly recorded in the period between the Bar-Cochba rebellion and the early 4th century.[17] What little source material there is from the 3rd century can reasonably be interpreted as a forewarning of the increased development to come. Already during the 200's pilgrims were attracted to the Palestinian area.[18] At the beginning of the 4th century this traffic increased enormously as the result of the Emperor Constantine's extensive building activity there.[19] The highlight of imperial interest in Palestine is without any doubt the construction of a church complex on Golgotha which according to the emperor's instructions was to be the most beautiful basilica on earth.[20] This building, called the martyrium, was consecrated in 336. Constantine's motives for such an extensive engagement in Palestine seem to vary. The visit to the Holy Land, made by his mother Helena, indicates an interest in holy places typical of the period, an interest shared by the imperial family. At the same time, the emperor consolidates his power in the eastern provinces.

[13] Beukers, For our Emperors p. 177-184.

[14] Yarnold, Authorship p. 143-161. see also note 9.

[15] See Jungman, Die Stellung Christi p. 217 note 29; Jungmann, Miss. Soll. II p. 240 note 25 and p. 578; see also Camelot, Theol. baptismale p. 724-729.

[16] Kretschmar, Die frühe Geschichte p. 22.

[17] Harnack, Mission p. 103.

[18] Ibid. p. 103, see especially note 5: "Von hier aus musste sich das Ansehen der jerusalemischen Gemeinde im Laufe des 3. Jahrh. langsam wieder heben bez. neu entstehen."

[19] Ibid. p. 103 note 5, see also Krautheimer, Early Christian Architecture p. 60ff., see also p. 77ff.

[20] Ibid. p. 62.

Jerusalem's increasing prestige in the 4th century is clearly revealed in the struggle to gain jurisdictional independence from Caesarea. A slight indication that the "power structure" at the beginning of the 4th century is somewhat unclear is revealed in the 7th canon of the Council of Niceae which establishes the precedence of Jerusalem over the other churches but allows Caesarea to retain jurisdiction over the city.[21] Even though Jerusalem is named "mother of all churches" at the first Council of Constantinople in 381, neither Cyril nor John managed to assure the city's independence of Caesarea. It is not until the time of Juvenal, bishop from 422-458, that Jerusalem becomes the seat of the Patriarch and gains jurisdiction over all of Palestine.[22]

Egeria's travel description, probably from the 380's, gives a vivid impression of religious life in Palestine at this time.[23] She herself is on a pilgrimage and the obvious purpose of her account is to encourage greater pilgrimage activity. The narrative clearly describes the ascetic ideals which characterize religious life in Jerusalem.[24] Above all, however, we are given an insight into the intense ecclesiastical activity which even marks the city scene itself.[25] The scant descriptions of the different services reveal few liturgical details but dwell rather on the splendour surrounding the celebrations.[26]

Cyril's catecheses, too, throw light on the situation in 4th century Jerusalem. In 18.27 he speaks of "every kind of excellence" (πάσης ἀρετῆς ἅπαν εἶδος) which is to be found in the Catholic church, which has existed under changing conditions at various times. Persecutions and afflictions are contrasted here to what is happening, "in times of peace, by the grace of God", when the church receives honours from kings and wealthy dignitaries and when the church has "unlimited power throughout the whole world".[27] In correspondingly positive terms he describes the Church of the Holy Sepulchre "which from his deep love of Christ was built by the Emperor Constantine of happy memory, and embellished as you see".[28] Cyril's work is carried out within a powerful church and in magnificent buildings erected by order of the emperor. Cyril finds nothing to criticize in this situation.

[21] Stephenson, General Introduction p. 13ff.
[22] Baus/Ewig, Die Reichskirche p. 247ff.
[23] For dating, see Maraval, Introduction p. 27ff. For Egeria's account from Jerusalem, see Itinerarium chap. 24-49.
[24] Egeria, Itinerarium 28 (SC. 296. 264f.).
[25] Ibid. p. 43 (SC. 296. 298f.).
[26] Ibid. p. 25. 8 (SC. 296. 252).
[27] Cat. 18. 27 (PG. 33. 1048f.).
[28] ὁ τῆς ἁγίας Ἐκκλησίας οὗτος οἶκος, ὁ τῇ φιλοχρίστῳ προαιρέσει τοῦ, ἐπὶ τῆς μακαρίας μνήμης, Κωναταντίνου τοῦ βασιλέως οἰκοδομηθείς τε καὶ, ὡς ὁρᾶς, οὕτως φαιδρυνθείς, Cat. 14. 22 (PG 33. 856), see also 14. 5 and 14. 14.

The catecheses also reveal that groups of wealthy people have had a central position in the congregation. So, as consolation, the poor are told that the Judge shows no greater preference for the learned than for the simple, for the rich than for the poor. It is emphasized, furthermore, that the landowner will not be given precedence over the workers in the fields. Nor has the slave any reason for anxiety because of his social status.[29] Statements of this kind indicate that Cyril has found it particularly necessary to argue for the weaker groups within the congregation. On the other hand the impression given is that the learned and the wealthy not only have a position within the church but that this position is indisputable.

Cyril also shows fairly unreserved support of the bounty of riches. Thus, he stresses that riches and gold and silver are not the property of the devil but that the entire world belongs to the faithful. The problem of wealth is looked upon here as a question of management: "God through the Prophet says plainly: 'Mine is the silver and mine the gold.' Only use it well and there is nothing blameworthy in silver."[30]

Now this does not imply that our catechist fails to see the problems related to the existing situation of the congregation. In Procat. 5 he discusses his members' motives for taking part in the catechumenate. He reveals a number of ulterior motives, probably familiar to him through the everyday customs of the congregation. Some attend catechetic instruction because they wish to marry, servants come to fullfil their masters' wishes and others in order to satisfy their friends. It is remarkable that Cyril does not call to account people with such motives but rather maintains that the object is to utilize the present situation to the best advantage.[31]

The catecheses, furthermore, give an excellent picture of the challenge to the faithful which paganism continues to represent. In the mystagogical catecheses, Cyril makes an example of Satan's temptations by referring to pagan cults.[32] During the following clash with pagan invocation of spirits, he describes the sacrament as the counterpart to heathen practice. While the church's ἐπίκλησις is an invocation of the adorable Trinity the pagan ἐπίκλησις is described as the invocation of evil spirits.[33] Here, the sacrament is almost perceived as a compensation for

[29] Cat. 15. 23 (PG. 33. 901).

[30] Σὺ μόνον χρῆσαι καλῶς, καὶ οὐκ ἔστι μεμπτὸν τὸ ἀργύριον, Cat. 8. 6 (PG. 33. 632), see also 8. 7. At the same time Cyril maintains traditional ideals of poverty, see 16. 19 and 5. 2.

[31] Procat. 5 (PG. 33. 342f.).

[32] 1 M. Cat. 6 (SC. 126. 92).

[33] 1 M. Cat. 7 (SC. 126. 94).

pagan custom. This attitude reflects an active and open viewpoint which obviously is meant to conquer the temptations which paganism represents to the faithful.

c) The Liturgy in Jerusalem

The liturgy known to us from 4th century Jerusalem is of great importance for the further development of the liturgy outside the boundaries of Palestine. This development takes the place because celebration of the mass in Jerusalem soon became the pattern for Divine services elsewhere as well.[34]

The liturgical organization as related by Egeria, as well as certain liturgical details expressed in the catecheses are generally accepted to be a direct result of Cyril's innovative liturgical work.[35] Although it is impossible to make a comparison with earlier liturgical sources from Jerusalem, such a hypothesis is not unreasonable. We must maintain, however, that the core of Cyril's liturgy—we refer now to celebration of the Eucharist—is certainly based on earlier liturgical traditions. Attempts to penetrate more deeply into these liturgical forms must rest on comparisons with related liturgies. In this case the somewhat later James anaphora constitutes the closest material for comparison.[36]

It has long been presumed that the two liturgies belong to the same liturgical area because nearly everything said in Cyril's liturgy emerges later in the James anaphora.[37] But, Cyril's liturgy is considerably shorter than James'. Cyril refers to the prayer of praise, Sanctus, epiclesis, intercession over the consecrated bread and wine and ends with the Lord's prayer, communion and the benediction.[38] On the other hand, (in relation to the James anaphora) the post-Sanctus prayer, the words of

[34] "Pilger begannen wohl schon im 4. Jahrhundert damit, Jerusalemer Bräuche in ihre Heimat zu verpflanzen; später übernahmen ganze Kirchengebiete offiziell Ordnungen, die hier in dieser Stadt entstanden waren, wo selbst die Steine vom Kreuz und der Auferstehung Jesu Christi zu predigen schienen. So wurden die Gottesdienste Jerusalems besonders im 5. Jahrhundert, aber auch noch später, für viele Lokal- und Provinzialriten im Osten vorbildlich, und auch den Westen haben sie stark beeinflusst. Die Frühgeschichte der Jerusalemer Liturgie gehört deshalb zu den bedeutsamsten und folgenreichsten Epochen in der Geschichte des christlichen Gottesdienstes überhaupt'', Kretschmar, Die frühe Geschichte p. 22, see also Cross, Introduction p. XIXf. and Wilkinson, Egeria's Travels p. 86f.

[35] Wilkinson, Egeria's Travels p. 86.

[36] Brightman, Liturgies p. 49ff. and p. 85ff. See also Dix, The Shape p. 187ff. giving a parallell rendering of the anaphora of James with Cyril's 5 M. Cat.

[37] Kretschmar, Die frühe Geschichte p. 27 with further references to Lietzmann, Messe p. 144f.

[38] See 5 M. Cat. 4. 22 (SC. 126. 150ff.).

institution, the anamnesis and the breaking of bread are lacking.[39] This can lead one to consider that in the liturgy commented upon in the 5. mystagogical catechesis the post-Sanctus prayer and the words of institution are missing and that these parts have been added to the liturgical structure in Jerusalem after Cyril's time.[40] Kretschmar contends, on the other hand, that the missing prayers have in fact been offered, but in silence.[41] He seeks support for this viewpoint by, among other things, comparison with the Syrian James anaphora, which evidently practices silent reading during the anaphora-prayer, but also by comparison with Theodore of Mopsuestia's catecheses.[42] In this context it also must be stressed that Cyril in fact has commented on the words of institution in 4. M. 1. The text referred to there is a compilation of Matthew's and Paul's version of the words of institution, suggesting a liturgical association.[43] If the prayers have been recited silently, it is understandable that Cyril comments upon them independently and not as a part of his treatment of the anaphora-prayer itself. F. E. Brightman also accepts the recital of institution as a part of Cyril's anaphora-prayer but finds the reason for its omission in its secondary importance in a prayer structure which links the consecration to the epiclesis.[44] It is reasonable, furthermore, to connect Cyril's reference to God's reconciliation with us who were his enemies in 5.M.5. with a liturgical section dealing with Christ's economy.[45] On this basis we assume that Cyril's anaphora has included a reference to Christ's economy as well as the words of institution.

The type of liturgy we find in Cyril and in the James anaphora are usually taken as belonging to the Syrian liturgy group.[46] The distinctive character of this liturgy is only clearly revealed when compared to the Alexandrian structure of the anaphora. In the James liturgy the thanksgiving for Christ's redemptive work leads directly into the words

[39] See Kretschmar, Die frühe Geschichte p. 27f.

[40] Dix, The Shape p. 200. Cutrone, Mystagogical Catecheses p. 57ff. also prefers this interpretation. The reference to the Eucharist in 4 M. Cat. is comprehended as a result of the need to give the Eucharist the Christological orientation missing within the anaphora itself, p. 62. Cutrone presupposes that Cyril can not change the existing structure of the anaphora.

[41] Kretschmar, Die frühe Geschichte p. 28.

[42] Ibid. p. 30 and 32.

[43] Cuming, Egyptian Elements p. 118.

[44] "He (Cyril) is only expounding the salient points of the rite and for the purposes of his exposition the whole passage between the Sanctus and the Intercession would be a single paragraph with the form of Invocation for its essential point", Brightman, Liturgies p. 469.

[45] See Reine, Eucharistic Doctrine p. 130.

[46] Cuming, Egyptian Elements p. 117.

of institution followed by the anamnesis and epiclesis, whereas, these are separated in the Alexandrian anaphora.[47] At a later point we shall look more closely at the Alexandrian anaphora prayer (cf. p. 250). Here we shall try to indicate features peculiar to the prayer structure represented by the James anaphora. Schulz emphasizes the structural similarity which is to be found between Hippolytus' anaphora and the Syrian-Byzantine prayers. He points out that the close relationship of the words of institution, anamnesis and epiclesis correspond to "die gemeinsame betont *heilsgeschichtlich orientierte Danksagung*".[48] The same interest seems to have characterized Syrian liturgy's earliest use of the Sanctus. As has been said, Kretschmar contends that the Sanctus in the Syrian area must be seen as something inspired by the Jewish Qeduscha, in which the acclamation follows as a consequence of God's work in the world (see p. 136).

These particular Antiochene liturgical characteristics are, meanwhile, not clearly reflected in Cyril's anaphora. In the first place we find no traceable connection between the words of institution, anamnesis and epiclesis because the first part is not mentioned in the fifth mystagogical catechesis. But then problems arise in Cyril's use of the Sanctus. Cyril's pre-Sanctus shows special characteristics which have no clear liturgical parallels at all.[49] His mention of the cherubim is separated from that of the seraphim by the acclamation "O magnify ye the Lord with me", so the Sanctus itself is unusually short and at the same time is only addressed to God the Father. These characteristics, according to Kretschmar, possibly suggest the influence of an Origenistic interpretation of Is. 6,[50] but may also be seen as elements of Antiochene tradition.[51] A connection with Antiochene liturgical structure also appears in the summary reference to heaven, earth, sea, sun, moon etc. which are found after Εὐχαριστήσωμεν τῷ Κυρίῳ.[52] According to F. Probst, the references are sufficiently detailed to allow the supposition that the prayer has contained a lengthier reference to the creation and the other Divine deeds of goodness as in the Apostolic Constitutions.[53] It becomes natural, thereby, to look at the Sanctus against the background of the preceding thanksgiving for God's previous work on earth. The James

[47] Tarby, Prière eucharistique p. 72ff.
[48] Schulz, Eucharistiegebet p. 146.
[49] Kretschmar, Trinitätstheologie p. 168f.
[50] Ibid. p. 169 with reference to p. 64ff.
[51] Ibid. p. 169 note 1; see also p. 170.
[52] 5 M. Cat. 5 and 6 (SC. 126. 152).
[53] Reine, Eucharistic Doctrine p. 130 with reference to Probst, "Die hierosolymitanische Messe nach den Schriften des hl. Cyrillus", Der Katholik (1884) 1 p. 154-157.

anaphora, which supplements this theme-group with a reference to the Trinity immediately following the Sanctus, is considered by Kretschmar to be a further development when compared to Cyril's prayer structure.[54] Here there is a possibility of Alexandrian influence.[55] The Trinitarian setting of the Sanctus is further developed in Theodore of Mopsuestia's anaphora prayer (cf. p. 205).

d) Cyril's Theological Position

We have maintained that Cyril's liturgy belongs to the Syriac type. It is now a question of whether we can assume any correspondence between this liturgical structure and Cyril's own theology.

In a number of articles, A. A. Stephenson has attempted to establish an Alexandrian tendency in the catecheses. The alleged influence of Clement and Origen is not supported by pronounced and indisputable Alexandrian characteristics. Stephenson is, therefore, unable to place Cyril in a theological position which could be defined as Alexandrian.[56] Nor does he find any sign of Origen's "dangerous theses". As for Origen's textual interpretation principles, scarcely a rudiment is to be found—"the scriptural exegesis is usually, as the subject demanded, literal and positive".[57] He finds his basis for associating Cyril with the Alexandrian tradition first and foremost in "a contemplative warmth and depth, a mystical élan, unmistakably in the Alexandrian tradition".[58] Stephenson defends his viewpoint by connecting a number of individual details in the catecheses with Alexandrian theology. An example is the way he distinguishes between aisthetos and noetos which plays an important part in Origen's theology.[59] Stephenson discovers the same two expressions in Cyril—although the words lack "something of their systematic character and of the fullness and precision of their content".[60] In the end, he gains no more from distinguishing between noetos and aisthetos than the conception that the unseen is made manifest to man through the visible.[61]

[54] Kretschmar, Trinitätstheologie p. 168.

[55] Ibid. p. 176.

[56] Stephenson, Alexandrian Heritage p. 577. Harnack, too regards Cyril as representative for Origenistic theology: "Die Katechesen Cyrills zeigen den Standpunkt der origenistischen äussersten Rechten; sie ruhen allerdings auf Orig. de princip., aber sie drücken ehrlich den christologischen Standpunkt der formula macrostichos aus; nur das ὁμοούσιος fehlt, in der Sache ist Cyrill orthodox", Harnack, Lehrbuch II p. 249 note 3.

[57] Ibid. p. 581, see also p. 578 where Stephenson speaks of "generally Antiochene treatment of Scripture" in the catecheses.

[58] Ibid. p. 573.

[59] Ibid. p. 580.

[60] Ibid.

[61] Stephenson, Alexandrian Heritage: "In the Sermon the words hardly occur at all,

But, now we approach features which are typical of early Christian theology in general rather than Alexandrian theology in particular. Thus, the mystical character of the catechesis is not be understood as a distinctive Alexandrian element. There is, for example, no difficulty in finding examples of interest in "a higher knowledge of God" in the catecheses of the Antiochene, Theodore of Mopsuestia (cf. p. 208). The fear element, which appears for first time in a sacramental context in Cyril's catecheses, plays its part in giving Divine service an air of mystery.[62] This, however, is usually thought to have an Antiochene origin, which further confirms the idea that the mystical-contemplative component cannot be a specifically Alexandrian characteristic.[63]

Just as Stephenson tries to establish a connection with Alexandrian tradition, attempts have been made to trace typical Antiochene characteristics in the catecheses. We have already mentioned that even Stephenson finds Cyril's exegeses marked by the Antiochene interpretive principles. Indeed, there are even those who, from a study of exegetical principles, would place him among the theologians from the Antiochene school.[64] It is rare, however, to find a proper argumentation in support of such a viewpoint. W. R. Jenkinson makes a slight attempt in this direction. He maintains that Cyril's emphasis on free-will and the importance this concept has for "human moral effort" must be considered as typically Antiochene.[65]

A. Paulin, on the other hand, contends that Cyril is to be understood as "un incomparable témoin de la tradition commune de l'Église de son temps".[66] Furthermore, he maintains that the differences which exist between the various schools would have but slight influence on elemen-

but the substance of the distinction they express is kept constantly before the audience or the reader by the recurring contrast between the visible and invisible, body and soul", p. 580.

[62] Quasten, Patrology III p. 376; Dix, The Shape p. 200.

[63] Ibid. p. 376, see also Yarnold, Authorship p. 149f. and Yarnold, Baptism p. 247-267.

[64] "Cyrill ist in der Exegese jedenfalls Schüler der Antiochener", Niederberger, Logoslehre p. 25. In note 25 this is elaborated upon as follows: "In der 17. Katechese behandelt er (c. 12f.) die ersten 18 Verse des zweiten Kapitels der Apostelgeschichte ganz nach Art der Exegeten damaliger Zeit, und zwar folgt er den Prinzipien der Antiochenischen Schule. Seine Auslegungen sind im allgemeinen nüchterne Literalinterpretationen und in allegorischen Erklärungen sieht er eine Gefahr (jfr. 6. 17). Völlig frei zu bleiben von jeglicher Allegorie ist indes auch Cyrill nicht gelungen (13. 8, 21; 14. 11; 17. 10), aber seine eigentlich dogmatischen Beweise stellt er nicht auf diese Art des Auslegung ab."

[65] Jenkinson, The Image of God p. 55.

[66] Paulin, Cyrill. Catechete p. 20. Chadwick, too, underlines that Cyril represents "ordinary church life". This statement is supported by the nonpolemic attitude of the catecheses "whose pastoral instruction is almost wholly untouched by the factious slogans of the rival parties of the age", Chadwick, Early Church p. 288.

tary teaching of the faith. This is, of course, correct if by differences one thinks first and foremost of the subtleties which were to mark the Christological dispute in times to come. Another thing is whether the direction of the various schools actually reflects differences in theological interest and orientation. On this basis, it seems reasonable to renew the question of whether it is possible to find a distinctive theological profile in Cyril. By this we do not mean individual features which agree with the great schools of theologians but a unified theological tendency.

In the first place we shall pause to note certain characteristic information we find in the catecheses themselves. As might be expected, Cyril wishes to appear as a Scriptural theologian. It is the holy Scriptures which are the primary source of any knowledge of God.[67] In this connection it is important to note that this information is accompanied by a pronounced dislike of speculative theological study. Thus, interest in the holy Scriptures can be opposed to "human reasoning",[68] just as we find disdain for what is called "artificial arguments",[69] "ingenious reasonings",[70] and "sophistical artifices".[71] It is justifiable to understand Cyril's reservations concerning ἐξήγησιν θεωρητικήν in connection with this clear dislike of any thinking which exceeds the words of the Scriptures.[72] The adjective, θεωρητικός can mean contemplative as well as speculative,[73] and in his interpretation Stephenson emphasises the contemplative aspect. As a result, he underlines the non-contemplative character of the catecheses in contrast to, for example, the sermons.[74] We contend, on the other hand, that the catecheses allow for a contemplation of God (cf. p. 208 for an example). Nevertheless, catechetical instruction gives evidence that Cyril maintains a reserved attitude towards the type of contemplation which exceeds scriptural bounds.[75] It seems, therefore, that the statement refers to Cyril's mistrust of speculative treatment of any part of the faith not based on the words of the Scriptures. Against this background the matter-of-fact nature of Cyril's scriptural inter-

[67] Cat. 4. 17 (PG. 33. 476f) and 16. 11 (PG. 33. 932).

[68] Cat. 17. 1 (PG. 33. 968).

[69] Cat. 4. 17 (PG. 33. 477).

[70] Ibid.

[71] Cat. 13. 8 (PG. 33. 784).

[72] Cat. 13. 9 (PG. 33. 784). The "speculative" exegesis in 13. 9 is contrasted to the engagement in convincing (πιστοποιεῖν) of what is already believed. In 13. 8 this is related to the preaching of the crucified Christ proclaimed beforehand by the prophets.

[73] Lampe, Lexicon p. 647. The term can also refer specifically to the allegorical interpretation.

[74] Stephenson, General Introduction p. 6f. According to Stephenson 13. 9 implies that Cyril makes use of "two kinds of scriptural exegesis", p. 6.

[75] Cat. 13. 8f. (PG. 33. 784f.) and Cat. 11. 12 (PG. 33. 705).

pretation may be considered a safeguard against the speculation permitted by Alexandrian principles of scriptural interpretation.

This does not necessarily imply that Cyril is to be seen as a theologian of the Antiochene school. He considers himself as belonging to the broad stream of orthodox tradition, the outlines of which are best seen in polemical attacks on various forms of heresy. Without specification he is able to refer to οἱ ἐξηγηταὶ Πατέρες ἡμῶν.[76] We find references to only two previous theologians. As the source for his rendition of the story of the phoenix (cf. p. 75) he uses Clement of Rome who relates the same story.[77] Of greater interest is his reference to Irenaeus' Adversus Haereses with which he is obviously familiar.[78] In this context, Irenaeus is characterized merely as ὁ ἐξηγητής. With this in mind, it is not unreasonable to assume a certain positive dependence upon Irenaeus' theology.[79]

When Jenkinson considers Cyril's theology to be influenced by Irenaeus, his observation stems from a comparison of the basic theological structures of the two authors. The point of departure is the understanding of the imago concept. Jenkinson contends that Cyril's way of differentiating between imago and similitudo has its premisses in Irenaeus' theology as opposed to Alexandrian theology.[80] He finds, nevertheless, that Irenaeus' views have been modified in Cyril, possibly the result of a certain influence from Alexandrian theology.[81]

Jenkinson, meanwhile, pays no attention to Cyril's utilization of eschatological conceptions. Kretschmar, on the contrary, pauses at precisely this aspect of Cyril's theology. He finds a fully developed history of salvation missing in Cyril's catecheses. In any case, in a comparison with Theodore of Mopsuestia, he maintains that "in Jerusalem ... fehlt ... die eschatologische Klammer, in der für Theodor das vergangene Heilgeschehen und die Taufe heute stehen ... das Heil ist für den Jerusalemer Theologen einfach 'Wahrheit', für Theodor Wahrheit als Angeld für die künftige, himmlische Wirklichkeit."[82]

Neither Jenkinson nor Kretschmar pursue any further attempt to clarify how the restoration brought about by Christ is to be understood in any detail. On this point, meanwhile, we find some interesting viewpoints in H. Lietzmann's characterization of our theologian. Lietzmann

[76] Cat. 13. 21 (PG. 33. 797).
[77] Cat. 18. 8 (PG. 33. 1025).
[78] Cat. 16. 6 (PG. 33. 925),
[79] Jenkinson, The Image of God p. 69f.
[80] Ibid. p. 66-70.
[81] Ibid. p. 71.
[82] Kretschmar, Taufgottesdienst p. 177.

gives a lucid presentation of Cyril. He finds two characteristic features in the catecheses. In part his attention is drawn to their moralizing aspect and in part to the sacraments' "naturreligiösen Symbolik". This sacramental symbolism which is also called "Ritualismus", implies "eine naturreligiöse Verdinglichung" which is appraised in a rather negative way.[83] His attitude towards the ethical teaching is equally disparaging. In this context, Lietzmann stresses that the sacraments open the way for ethical "Höchstleistung" leading to the divinization of man."[84] We shall take leave of Lietzmann's evaluation of Cyril's theology as it reveals almost more of Lietzmann's own theological profile than of Cyril's. On the other hand we note with interest that Lietzmann focuses on the importance of natural symbols and the concept of man's divinization in Cyril's understanding of soteriology. Both these themes will play central parts in our analysis.

When we embark upon the textual analysis itself, our task will be to relate our interpretation of the theological problems, set forth here, to the iconographical material previously treated. We have chosen to take our point of departure in the problems to which the iconographical analysis led. As the study proceeds we shall attempt to show how this iconographical dilemma is connected with the theological problems presented here.

2. The Dogmatic Framework

a) The Conception of Paradise

In the course of our work with iconographical analysis we returned repeatedly to the problems which specific settings created in the overall interpretation of the pictures. Time and again we were brought to a halt by the diffuse character which these pictorial elements seemed to have. In our work with Paulinus' tituli we found clear evidence that the diffuse setting sprang from the endeavor to refer to heaven and earth at one and the same time (see p. 92 and 93). Precisely this aspect of the pictorial pro-

[83] "Wir sehen den Weg offen, auf dem die naturreligiöse Verdinglichung in das Christentum einzieht und die primitiven Bedürfnisse des natürlichen Menschen befriedigend an die Stelle der verdrängten heidnischen Vorstellungen tritt", Lietzmann, Alte Kirche p. 101.

[84] "Hier in der Wunderwirkung des eucharistischen Sakraments entspringen die Lebensquellen dieses Christentums, das in voller Unbekümmertheit um logische Schranken die unbedingte Selbstherrlichkeit des freien menschlichen Willens zu sittlicher Höchstleistung aufruft und sich zugleich dessen klar bewusst ist, dass die Erfüllung dieser Forderung nur durch die sakramentale Vergottung der menschlichen Natur bewirkt werden kann", Ibid. p. 101f.

gram seems to present one of the main difficulties in interpretation which requires a solution. When we now turn to Cyril's catecheses, we find that neither a mountain nor urban setting takes a prominent place in catechetical teaching. On the other hand, there is constant reference to paradise which is the third recurring setting in our apses. It is with a closer examination of precisely this motif we choose to open our catechetical analysis.

Initially, Cyril maintains that paradise refers to the abode of Adam before the expulsion. Cyril gives no detailed description of conditions in paradise. We learn, however, that all created things were good although man alone was created in God's image. Likeness to God is supported by reference to Genesis 1:26 and is interpreted as εἰκὼν λογικὴ θεοῦ. This rational image is closer to God than a physical, pictorial reproduction is to its object. Cyril's main point, meanwhile, is that there is no place in paradise for envy, which was brought into paradise by the devil. The consequence of this act of the devil is that man can no longer take his place there.[85]

This does not imply that existence in paradise is primarily understood as an episode in the history of man belonging to the beginning of time. Paradise can also refer to a condition of life in contrast to ordinary earthly existence. Thus, Cyril is able to say that the expulsion of Adam causes Paradise, which is filled with the most magnificent fruits, to be exchanged—ἀντικατηλλάξατο—with the earth which bears thorns.[86] Here earth is put in contrast to paradise. The concept of paradise as a prehistoric state as well as the idea of paradise as a contrast to earth seems to assume that a paradisical condition is beyond reach after the fall.

Cyril, nevertheless, is able to emphasize that the concept of paradise continues to be relevant for mankind. In 2.7 we find an explanation of how this paradise is thought to function after man has been obliged to live on the thorny earth. Cyril points out that after the fall God put man in the face of (κατέναντι) paradise, which in this context is seen as a basic point of orientation in life. Paradise, here, means not only the place which man had to leave but also the place to which he will return. Recognition of the connection between the lost paradise and the coming paradise creates the basis for salvation.[87] The text assumes that the connection between the lost and future paradise is familiar, which is to say

[85] Cat. 12. 5 (PG. 33. 732). In 1 M. Cat. 9 paradise is described as a place located in the east.

[86] Cat. 2. 4 (PG. 33. 389).

[87] 'Εκβάλλει μὲν αὐτὸν τοῦ παραδείσου ..., κατοικίζει δὲ τοῦ παραδείσου κατέναντι· ἵνα βλέπων ὅθεν ἐξέπεσε, καὶ ἐξ οἵων εἰς οἷα κατηνέχθη, λοιπὸν ἐκ μετανοίας σωθῇ, Cat. 2. 7 (PG. 33. 392).

that it takes for granted a knowledge of the relationship between Christology and paradise which is stressed elsewhere in the catecheses. Thus, in 13.18 Cyril contends that Christ bore the crown of thorns to wipe out the condemnation of the earth.[88] He points out, furthermore, referring directly to the description of paradise, that Christ brought about salvation in a garden.[89] The salvation brought about by Christ is passed on to the faithful. For that reason, we read also that man who once was driven out of paradise, διὰ τὸ ξύλον 'Ιησοῦ will be allowed to return.[90] Cyril usually emphasizes that the faithful may enter paradise *immediately*. According to 14.10, entry into paradise is made possible through Baptism.[91] Cyril cannot, in fact, direct the faithful to an actual earthly paradise. So, he also says that the faithful shall be planted in τὸν νοητὸν παράδεισον.[92] To begin with it is important that this spiritual paradise be emphasized as belonging to the present. Nevertheless, if this statement remains isolated, it becomes misleading as Cyril also uses paradise as a synonym for heaven.[93] This is clearly expressed when the thief on the cross is promised immediate entry into paradise. That the ungodly thief should be the first allowed to enter heaven is explicitly stressed by Cyril.[94] Here it is death which marks the entry to the pleasures of paradise, not participation in the faith through Baptism.

The relationship between the fulfilment of salvation in the world and in the hereafter is best interpreted as a state of tension. This is clearly seen if we once again use paradise as our centre of orientation. Cyril speaks of the suffering endured by the martyrs here on earth. In this context, suffering is considered as nothing when compared to celestial glory and "the Paradise of pleasure". But, Cyril has more to say. The reality of heaven is already present during their suffering because it is said of the martyrs that they already τῇ δυνάμει are in paradise.[95] The heavenly reality which the martyrs will soon be a part of is already present during their sufferings on earth.

With this background we are able to maintain that the concept of paradise embraces quite a range of meanings in Cyril's catecheses. The many layers found here are directly connected with the complex under-

[88] Cat. 13. 18 (PG. 33. 793).
[89] Cat. 13. 19 (PG. 33. 796).
[90] Cat. 13. 2 (PG. 33. 773).
[91] See p. 185, see also 1 M. Cat. 9 and 2 M. Cat. 2.
[92] Cat. 1. 4 (PG. 33. 373).
[93] Cat. 14. 26 (PG. 33. 860). Cyril refers to 2 Cor. 12. 4 and says that Paul was taken up εἰς οὐρανὸν, καὶ εἰς παράδεισον.
[94] Cat. 13. 31 (PG. 33. 810). Cyril underlines that the thief enters paradise before Abraham, Moses and the prophets.
[95] Cat. 16. 20 (PG. 33. 948).

standing of the concept of salvation given in the catecheses. The catecheses, in fact, describe salvation by comparing references to this world with references to heaven. In this textual analysis our task is to clarify more fully the connecting lines between these aspects. We maintain that only a study of this problem within a wider textual context (in our case the catecheses) will throw light on the corresponding tensions we have recorded within the iconographical material.

b) Christology and the Ruler Theme

The iconographical sources may be of advantage in indicating the further direction to be taken in working with the problem raised by the paradise theme. In the course of the analysis we saw that the meadows and mount of paradise always served as a background for a central Christological motif. Thus, it seems sensible that further work be given a Christological orientation.

We recall from the iconographical analysis that Christ on the mount was interpreted as a theophanic motif. In the traditio-legis group, the ruling representative of the Godhead stands before the congregation of the faithful with the characteristic arm gesture of the sun god (cf. p. 73). Even catecheses are marked by a ruler theme which has its roots in Christ's Divine dignity.

We find a typical example of Cyril's utilization of the ruler theme in his interpretation of Zach. 9.9. The exegetical problem is to solve the question of which king is in question here. In this context it is useless to refer to things which all kings have in common, such as, the dignity of purple, military guards and gilded carriages. Instead, the king spoken of in Zach. 9.9 must be distinguished from other kings by finding out what is specific for this king alone. Cyril finds a special characteristic when it is said that the king rides upon a foal.[96] To begin with, let us examine the type of emphasis on royal dignity which we find here. We see that Christ is looked upon as true king but yet in another sense than to other kings. The connection with ordinary earthly power is preserved while at the same time a distinct wish to define the dignity of Christ's kingship as something other than that of worldly rules is present. It is obvious that the main interest here centres on what is distinctive in Christ's kingship.

The use of a royal terminology is somewhat more explicit in 13.17. Here, too, attention is centred on set conventions of the usual concept of kings. Cyril stresses that Christ is dressed in a purple garment and that he is crowned by soldiers who fall to their knees, acclaiming and pro-

[96] Cat. 12. 10 (PG. 33. 735).

claiming him king. We find here, as well, distinctive features which distinguish Christ from other kings. The crown placed upon his head by the soldiers is of thorns and his proclamation as king is met with cries and mockery and demands that he be crucified. The organization of the relationship between ordinary royal dignity and that of Christ merits our attention. Cyril says that despite the distinctive features of Christ's dignity, τύπος of royal dignity is, nevertheless present in that which takes place. His coronation, likewise, is described as τυπικῶς, which once again is supported by a quotation from the Old Testament.[97] The connection between Christ's royal dignity and a worldly understanding of kingship is established by means of the typological terminology while at the same time the distance from an ordinary understanding of kingship is maintained.

A more significant opinion concerning the terminology of kingship is to be found in the discourse on Christ as Lord. Cyril says, "He is called Lord; not improperly, as those among men are so called".[98] Here, the ordinary everyday use of κύριος is characterized as καταχρηστικῶς, which is to say inexactly or unnaturally.[99] The explanation which follows elucidates what this means; Lord, strictly speaking, is one whose kingship is eternal. Christ's kingship, therefore, proves to be the true one in contrast to ordinary worldly power.

The imagery we meet here seems to have quite another character than that which marked the paradise theme. We mean that the understanding of Christ as king is aimed at the least possible ambiguity in interpretation. This emerges clearly in the limits Cyril sets for himself as compared to usual political usage of corresponding terminology. In this connection it is of particular interest that Christ's kingship can be perceived as the basis for all other usage of the same terminology. In this way Cyril tries to solve the problems which inevitably are tied to the use of political terminology in a theological context. Previously we have seen that iconography faces the same problems. There too, the solution is approached by keeping a certain distance from existing political imagery.

At the same time, the need for a precise use of language reveals an endeavor to stress certain Christological characteristics. We recall that in 10.4 Christ's kingship is described as ἀΐδιον κυριείαν. In 10.5 we find a more detailed description of this ruling power. It is pointed out, here also, that this dignity is not καταχρηστικῶς as with mankind but that Christ is Lord τῇ ἀληθείᾳ. In the following, the true dignity of kingship

[97] Cat. 13. 17 (PG. 33. 793) with reference to Cant. 3. 11.

[98] Κύριος καλεῖται, οὐ καταχρηστικῶς ὡς οἱ ἐν ἀνθρώποις, ἀλλὰ ὡς φυσικὴν καὶ ἀΐδιον ἔχων κυριείαν. Cat. 10. 4 (PG. 33. 664f.).

[99] Lampe, Lexicon p. 727.

is interpreted as Christ's Lordship over his own work. Christ's kingship reflects the Creator's rule over his creation, a power in which the stress is on the greatness of the ruler in relation to that over which he rules. The role of king can be summarized as follows: "First He is Maker, then Lord; first, by the will of the Father, He made all things; then he assumed the Lordship over the things made."[100]

The emphasis on Christ's kingship which we found in 12.10 belongs in a related context. Here, too, kingship is used to specify the relationship between Christ and mankind but in this case Cyril makes use of soteriological categories. In his interpretation of Zach. 9.9, Cyril is not content to stop at the peculiarity of Christ's royal dignity which the foal signals but rather seeks other signs (σημεῖον) in order to make certain which king is referred to here. He dwells upon the prophet's assertion, "Here is your God" which is followed by, "he comes to save you".[101] The king is to be understood as the God of man who brings him salvation. Thus, speaking of Christ as the manifestation of God turns in a soteriological direction.

In both these texts kingship dignity points to Christ's Divine power as it is practised toward mankind. This interpretation is established definitively in 12.1 in which Cyril speaks of the necessity of Christ being God as well as man. In this context βασιλεύς points to his Divinity, whereas ἰατρός represents his humanity. The coming of Christ means, therefore, that the king, "girded Himself with the linen towel of humanity".[102]

These conceptions assume that Christ in representing God, makes him known to man. First, let us look more closely at how Cyril perceives the relationship between Christ and God the Father.

With reference to John 10:9, Cyril established that Christ is the door to ἡ πρὸς τὸν Πατέρα γνῶσις.[103] But, Christ also appears as the representative of the Godhead. Thus, his coming can be a parallel to the Lord's arrival in his temple, the Lord who comes in strength, the Lord who comes and lives among people, the rightful and redemptive king—indeed it is ὁ θεὸς ὑμῶν who comes to save.[104]

[100] πρῶτον ποιητὴς, εἶτα Κύριος· πρῶτον ἐποίησε θελήματι Πατρὸς τὰ πάντα, εἶτα κυριεύει τῶν ὑπ᾽ αὐτοῦ γενομένων, Cat. 10. 5 (PG. 33. 668). It is the distance and supremity which Christ has in relation to the created world which distinguishes his rulership from that of ordinary human beings.

[101] Cat. 12. 12 (PG. 33. 737) with reference to Is. 35. 4.

[102] Cat. 12. 1 (PG. 33. 728).

[103] Cat. 10. 1 (PG. 33. 661).

[104] Cat. 12. 12 (PG. 33. 737) with preceding scriptural references in Cat. 12. 8.

The conception that Christ is God made manifest implies that he be given the same ontological position which God himself holds. Thus, Cyril comments on John 14:9 by saying, "the Son is like in all things to Him who begot Him."[105] The meaning of the statement unfolds further by Christ being called Life of Life, Light of Light, Power of Power, God of God, while simultaneously it is maintained that unchangeable divine characteristics (ἀπαράλλακτοι τῆς θεότητος οἱ χαρακτῆρες) are in the Son.[106] We note that in this context Cyril makes use of the term ὅμοιος and not ὁμοούσιος which is the hallmark of orthodoxy in the 4th century. Ὁμοούσιος is not to be found anywhere in Cyril's catecheses but ὅμοιος is also used two other places.[107]

Several explanations for Cyril's obvious dislike of the term ὁμοούσιος have been sought. In this connection, the restraint practised in the use of philosophically determined terminology in the catecheses is usually cited. The repeated references to the Scriptures as the source of belief may suggest that Cyril has tried to avoid new and unusual theological terminology.[108] It has been pointed out, furthermore, that the expression has been discredited since its rejection by a synod in Antioch in 268 as a reaction to its use by Paul of Samosata.[109] Quasten, for his part, contends that the ὁμοούσιος term has also been used in connection with Sabellian conceptions.[110]

Nevertheless, it is first and foremost the attitude towards Arianism which has been discussed in connection with Cyril's terminology on this point. Historical facts as well as theological tendencies suggest a closer examination of Cyril's attitude towards Arianism. We know that Cyril was appointed bishop by the Arian Acacius.[111] Although their relationship became strained after a short time,[112] we may assume that Acacius has considered Cyril a sympathizer at the time of his consecration as bishop. Sources from the 4th century also like to designate Cyril an Arian.[113] It is possible, furthermore, to read an Arianistic tendency in the statements of subordinationism found in the catecheses.[114]

Even so it is not to be taken for granted that the subordinationist tendencies are meant as an association with an Arian inclined Christology. In their attempts to establish Cyril's orthodoxy, several scholars have concentrated on precisely these statements. J. Lebon links Cyril's Christology to a later day orthodox distinction between Person and Essence by maintaining that Cyril's real meaning is expressed in just a few passages[115] and that other Christological

[105] Ὅμοιος γὰρ ἐν πᾶσιν ὁ Υἱὸς τῷ γεγεννηκότι, Cat. 11. 18 (PG. 33. 713).
[106] Cat. 11. 18 (PG. 33. 713).
[107] See Cat. 4. 7 (PG. 33. 461) and Cat. 11. 4 (PG. 33. 696). The usage of ὁμοούσιος in Cat. 17. 32 (PG. 33. 1005) is secondary, see PG. 33. 1005 note 4.
[108] Niederberger, Logoslehre p. 61.
[109] Ibid. p. 62. Stephenson, General Introduction p. 56.
[110] Quasten, Patrology, III p. 371.
[111] Ibid. p. 362.
[112] Ibid.; see also Stephenson, General Introduction p. 22
[113] Ibid.; see also Stephenson, General Introduction p. 21f.
[114] Perler, Kyrillos col. 710 mentions a number of texts implying a tendency towards subordination: Cat. 10. 5; 11. 11; 10. 9; 15. 30; 7. 5; 10. 7f.; 11. 23; 12. 16; 14. 27.
[115] Most important is Cat. 11. 16, see Lebon, Position de saint Cyrille p. 376ff.

formulations must not block this meaning.[116] Stephenson, on the other hand, contends that the parts of the puzzle fall into place if Cyril's passage is seen in the light of Aristotelian determined traditions in which the divinity is perceived as a single genus incorporating three individual species.[117] An organization of this kind allows for a certain subordinationist thinking.[118]

We are sceptical towards both these attempts to save Cyril's Christology. Instead of searching for a philosophically fixed model behind the catechetical passages, we are more inclined to believe that Cyril's Christology is not formulated in a way fully satisfactory to future demands. P. B. Niederberger points out that 4th century Christology is marked by "mangelhaften Terminologie".[119] The problem of terminology becomes particularly urgent for a theologian who hesitates to utilize new and unconventional expressions in trying to express the relationship between the Father and the Son clearly. This hesitation, however, is not a characteristic peculiar to Cyril. It is, for example, indicative that Athanasius too has not utilized ὁμοούσιος until c. 357-58.[120] It follows that we find it reasonable to describe Cyril's Christology as lacking in precision which does not mean that it is marked by an Arian tendency.

That Cyril does not entertain an Arianistic determination of the relationship between the Father and Son is revealed by a number of anti-Arianistic phrases in the catecheses.[121] At the same time Cyril is occupied in keeping the two Persons apart.[122] The limitations he puts upon himself both to the right and to the left indicate a deliberate attempt to avoid both heretical extremes.[123]

Cyril's subsequent life as a theologian supports this understanding of him. Little by little he accepts the ὁμοούσιος terminology. Just when this occurs is not clearly recorded,[124] but it is beyond doubt that he is a stout defender of orthodoxy at the second Ecumenical Council in Constantinople in 381 and even seems to have played an important role there.[125]

Endeavors to decide the relationship between the Father and Son must not be seen as an attempt to penetrate the innermost being of the Divinity. In the theological explanation of the ontological position of the Son, Cyril considers it important to adhere to the restrictions which should mark man's investigation into the Divinity. This is formulated

[116] Lebon, Position de saint Cyrille p. 376.

[117] Stephenson, Trinitarian Theology p. 238f.

[118] "The genus-individual species logic explains how the Catecheses can combine a strong doctrine of the true and proper divinity of the Son with decidedly 'subordinationist' passages. For there can be inequality between species of the same genus, and in the Trinity the generation of the Son in fact establishes a hierarchy", Stephenson, Trinitarian Theology p. 238f.

[119] Niederberger, Logoslehre p. 71.

[120] Stephenson, General Introduction p. 40, see also p. 49.

[121] Niederberger refers to Cat. 7. 7; 11. 19; 11. 4; 3. 14; 11. 9; 11. 4, Niederberger, Logoslehre p. 69.

[122] Quasten finds anti-Sabellian statements in Cat. 4. 8; 11. 13; 11. 16f.; 15. 9; 16. 4, Quasten, Patrology III p. 371.

[123] See Cat. 11. 17f. (PG. 33. 712f.).

[124] Stephenson, General Introduction p. 30ff.

[125] Ibid. p. 32f.

with emphasis in 11.19: "That God has a Son believe, but how, do not eagerly search out; for seeking you will not find. Do not exalt yourself, that you may not fall; 'what is committed to you, attend to'."[126] For Cyril it is an expression of human hubris for man to actually think he is able to understand the internal relationship between the Father and Son. Thus, man is to control his curiosity so that it does not lead to ungodliness. The danger is that man, with imagined humility, is misled into trying to fathom the Creator.[127] Attempts at precise definition of the Son's position in relation to the Father are not meant to draw out the innermost secrets of God. In the clarification of terminology there is a limit to the knowledge obtainable by man. The object of Cyril's passages in connection with the term Son, is to show that Christ, from an ontological point of view, is equal to the Father,[128] and that this equality has always existed. What otherwise lies hidden in the term Son is hidden from man and will continue to be so. How Christ was begotten from the Father is among those things known only to God.[129] All that mankind can say of these things is that it has happened in a manner no man can understand.[130] From the Scriptures we know that Christ is called Son. The theologian has enough to do in finding out what this means without also trying to find the answer to the Son's birth from the Father.[131] Cyril ascertains, "It is enough to know that God begot One Only Son".[132]

Thus, it is established that Christ represents God. But, we have also indicated that God made himself known to man through Christ's humanity because man would not be able to understand him or see him in any other way.[133]

Behind this statement is the concept of an insurmountable barrier between the Divine and the human. Cyril can even claim that man would cease to live were he to try to see God. Thus, through love of mankind,

[126] Καὶ ὅτι μὲν ὁ Θεὸς Υἱὸν ἔχει, τοῦτο πίστευε· τὸ δὲ πῶς, μὴ πολυπραγμόνει· ζητῶν γὰρ οὐχ εὑρήσεις. Μὴ ἐξυνψοῦ σεαυτὸν ἵνα μὴ πέσῃς· Ἃ προσετάγη σοι, ταῦτα διανοοῦ, Cat. 11. 19 (PG. 33. 713f.).

[127] Cat. 11. 12 (PG. 33. 705).

[128] Cat. 11. 7 (PG. 33. 693). Cyril stresses that Christ is the Son of God φύσει, καὶ οὐ θέσει. Afterwards he maintains that the Son is begotten ἐξ ἀρχῆς and ἀνάρχως.

[129] Cat. 11. 8 (PG. 33. 700) The Son is begotten as Very God before all ages in a way God alone knows.

[130] Cat. 11. 11 (PG. 33. 702f.). Man cannot understand how the Father begot the Son.

[131] Cat. 11. 12 (PG. 33. 705)). As long as the Scripture says nothing of the generation of the Son from the Father, it is meaningless to enquire into such things.

[132] Αὔταρκες ἡμίν εἰδέναι, ὅτι Θεὸς ἐγέννησεν Υἱὸν ἕνα μόνον, Cat. 11. 12 (PG. 33. 705).

[133] Cat. 12. 13 (PG. 33. 737). Cyril comments "We believe in Jesus Christ, who came in the flesh and was made man" as follows: ἐπειδὴ ἄλλως οὐκ ἐχωροῦμεν. Thereafter he says that since we could not behold or enjoy him as he is, he became what we are, that we may be allowed to enjoy him.

heaven is spread as a cover over the earth so that man shall not perish.[134] As a result, the chances of approaching the Godhead in this world are rather limited. Nevertheless, man is able to form a φαντασία of God's δύναμις by means of God's work in the world. But, when Cyril attempts to find support for this thought by referring to Solomon, he stresses that ἐκ τῶν κτισμάτων ὁ γενεσιουργὸς θεωρεῖται only with the limitations which ἀναλόγως set for an approach.[135] The analogous situation which exists between the Creator and created makes it impossible to build a bridge leading directly from creation to the Creator. The meaning behind the formulation is rather related to the contrast which the act of creation shows between God's greatness and man's limitations. In 6.4 Cyril elaborates on how this is to be understood. He speaks of a violent rainstorm which has just passed over Jerusalem. Try, he says, to count the drops, not those which have fallen on the whole city but those which fell upon the roof above us in the course of one hour! As this is impossible, the example is to be used to reach acknowledgement of one's own frailty as well as God's δύναμις.[136] The conclusion in 9.2 must be read on the basis of such a viewpoint: "For so much the greater does God seem to each man, as the man achieves a loftier concept of creatures."[137] A study of the created structure reveals the distance between God and man.

Nevertheless, this concept that God is incomprehensible, does not imply that he is completely unapproachable for man, for as Cyril says, shall one go hungry from a vast orchard even if one is unable to eat all the fruit?[138] The object of this text is first and foremost to maintain the limitations which characterize man's encounter with God. Basically one should be aware that exact knowledge of God lies beyond the horizon of man.[139] One acquires only the knowledge of God which one needs.[140] In keeping with such thinking the task of the theologian is also limited to what human nature is able to comprehend.[141] As a result, God must take

[134] Cat. 9. 1 (PG. 33. 637). Cyril maintains that the heavens are spread as a veil before the Godhead (παραπέτασμα τῆς οἰκείας θεότητος). The statement is a comment on John 1. 18.

[135] Cat. 9. 2 (PG. 33. 640) with reference to Sap. 13:5.

[136] Cat. 6. 4 (PG. 33. 544).

[137] Τοσούτῳ γὰρ μείζων ἑκάστῳ φαίνεται Θεός, ὅσῳ ἂν μείζονος θεωρίας τῶν κτισμάτων ἐπιλάβηται ὁ ἄνθρωπος, Cat. 9. 2 (PG. 33. 640).

[138] Cat. 6. 5 (PG. 33. 545).

[139] Cat. 6. 2 (PG. 33. 540). This lack of the possibility of gaining knowledge concerning God stresses the importance of confessing ignorance about these things: Ἐν τοῖς γὰρ περὶ Θεοῦ, μεγάλη γνῶσις τὸ τὴν ἀγνωσίαν ὁμολογεῖν.

[140] Cat. 6. 5 (PG. 33. 545). Cyril says that even if you cannot drink the whole stream, you are allowed to take in proportion to your need. And even if you cannot behold all the sunlight, you are allowed to gaze upon the sun.

[141] Cat. 6. 2 (PG. 33. 540).

into consideration the limitations which govern man's encounter with him. That God does take such consideration is foreshadowed in the organization of Ezekiel's vision. Here it is emphasized that Ezekiel did not see God in his vision but ὁμοίωμα δόξης Κυρίου.[142] Man is not allowed to see the Divinity himself but merely his likeness. Even the sight of this likeness caused Ezekiel to fall to the ground in fear.

The need to consider human weakness is most apparent in the interpretation of the incarnation. This is illustrated by making Christ's coming and God's appearance on Mount Sinai parallels. When God manifested himself in fire, the people begged Moses to talk with him so that they themselves should not die. Cyril emphasizes that as the people dared not even hear God's voice they would surely die if they were to see him.[143] Furthermore, a reference is made to Daniel who dared not look at the angel's face but instead fell upon his face and trembled.[144] Not until the one who revealed himself had changed himself—μετεβλήθη—and assumed human form (ὀπτασίαν ἀνθρώπου), did Daniel regain the power of speech. It is because of the frailty of man that Christ assumed (ἀνέλαβε) τὸ ὁμοιοπαθές.[145] Cyril perceives Daniel's vision of the angel as πεῖρα of the way in which God may reveal himself to man adapting himself to it by incarnation.

At the same time Christ is understood as the shape in which God appears at all times, also prior to the incarnation. With references to I Corinthians 10:4 and Hebrews 11:26f. he ascertains that the prophets saw Christ καθὸ ἐχώρουν ἕκαστος.[146] Of particular interest is the interpretation of Moses' longing to see God. Cyril interprets God's answer to Moses, that no one may see God's face and live, as support for the idea that God must assume the face of human nature (τὸ τῆς ἀνθρωπότητος πρόσωπον).[147] From there the association is carried further to the account of the transfiguration in which it is said that Christ's face shone as the sun. This is seen as a manifestation of ὀλίγης ἀξίας, because the face only shone "in the measure the disciples could bear", not according to the "full power of Him who wrought". Not even the transfiguration can inform us about the Godhead itself.

Isaiah 6 is also utilized to show that Christ makes God known at all times. For Isaiah saw the Son upon the throne "before the coming of the Saviour in the flesh" because the son has a throne in heaven "from the

[142] Cat. 9. 1 (PG. 33. 637).
[143] Cat. 12. 13 (PG. 33. 740) with reference to Ex. 20:19. Even in this context the aspect of fear is maintained.
[144] Cat. 12. 14 (PG. 33. 740) with reference to Dan. 10:12.
[145] Cat. 12. 14 (PG. 33. 741).
[146] Cat. 10. 7 (PG. 33. 669).
[147] Ibid.

time He is''.[148] Christ sits upon this throne before as well as after the incarnation.

That Christ is in heaven also after the incarnation does not mean that he is far away from man on earth: He "who sits on high" is indeed also "present here with us".[149] Thus, Cyril says of the celestial Christ, "He is here in the midst of us". This proximity is thereupon associated with Christ's soteriological task for mankind. The role of the enthroned Christ is to guard man's soul and to preserve the unshaken and unchangeable hope of the resurrected one. What is said about Christ in heaven leads, thus, to words about Christ's significance for man which is again focused on ὁ καταβὰς καὶ ἀναβάς.[150] Interest in the celestial Christ leads to interest in the Christ who descended and worked on earth.

In several ways, the observations made here are of iconographical interest. In the first place, the visual character of the way in which the Divine is made known to man is significant. The encounter with God, which always has a Christological character, is described with the aid of visions. That Christ reveals himself to man in this way presupposes that he is far above, he is their ruler. At the same time, however, the use of royal terminology maintains the proximity of Christ and man. The driving force behind God's appearance in the world is the Creator's will to preserve his own creation. Thus, an analysis of the ruler theme leads naturally to an investigation into soteriology.

c. The Cross as the Tree of Life

We recall from the iconographical analysis that the cross contained many layers of meaning reflecting various aspects of Christology. We remember too, that the cross was directly associated with the paradise theme either by its position on the mount of paradise or its similarity of shape to the tree of life. It is, therefore, reasonable to assume that an examination of the cross will throw light on the soteriological question which the paradise theme suggested.

It is quite justifiable to link an examination of Cyril's Christology to his use of the cross. Cyril perceive the cross as the foundation upon which everything concerning the faith may be built.[151]

The basis for an interpretation of the meaning of the cross lies in the actual fact of its existence. Christ's suffering is ἀληθές and Christ is

[148] Cat. 14. 27 (PG. 33. 861).
[149] Cat. 14. 30 (PG. 33. 865).
[150] Cat. 14. 30 (PG. 33. 864).
[151] Λάμβανε οὖν πρῶτον ἀρραγὲς θεμέλιον τὸν σταυρὸν, καὶ ἐποικοδόμει τὰ λοιπὰ τῆς πίστεως, Cat. 13. 38 (PG. 33. 817).

ἀληθῶς crucified. It follows that the cross cannot be considered an illusion. If it was, redemption, too, would be an illusion (δόκησις).[152] The reality of the cross is understood as supporting the reality of salvation.

Our catechist, furthermore, emphasizes that the resurrection following the crucifixion is an organic part of this act of salvation. It is the resurrection which prevents the cross from becoming an embarrassment to the faithful: "I confess the Cross, because I know of the Resurrection".[153] The light cast on the crucifixion by the resurrection marks the way in which the crucifixion itself is understood. It is the two events seen together which makes it possible to speak of the cross as τὸ τρόπαιον Ἰησοῦ τὸ σωτέριον.[154] Together the crucifixion and resurrection comprise the decisive act of salvation.

If we are to reach an understanding of the character of this salvation, we find that the reference to τὸ ξύλον τῆς ζωῆς opens a way of putting it into perspective. An emphasized passage is to be found in 13.35: "The Tree of Life, then, was planted in the earth, to bring blessing for the earth, which had been cursed, and to bring release for the dead."[155] In the first place we shall take a closer look at what the lifting of the curse upon the earth involves. The expression refers to the condition of the earth as a whole which was created by the fall. The reference to Genesis 3:17-18 in 13.18 and 14.11 indicates the consequences of the curse by speaking of the earth as filled with thorns. This curse brought to the earth by Adam was, however, removed (ἐξεριζώθη) by Christ. The thorns can thus be put in contrast to the Christological image of the vine which is planted in the earth.[156] In 13.18, on the other hand, the thorns are pitted against Christ's crown of thorns which removes the curse. In this context too, the close connection to the doctrine of creation is emphasized when it is said that Christ was buried in the ground—"to have the earth which had been cursed receive a blessing instead of the curse".[157] The earth is blessed through the death of Christ.

That the crucifixion creates new possibilities of life on an earth damaged by the fall is a recurring theme. Thus, the serpent which Moses

[152] Cat. 13. 4 (PG. 33. 776). Cyril also says that the cross is not δόκησις.

[153] Ὁμολογῶ τὸν σταυρόν, ἐπειδὴ οἶδα τὴν ἀνάστασιν, Cat. 13. 4 (PG. 33. 776f.).

[154] Cat. 13. 40 (PG. 33. 821), see also 13. 20. Another way of relating the death of Christ to his resurrection, takes the crown of thorns as its point of departure. Christ wears the crown of thorns κατὰ ἀτιμίαν δι' ὑπομονῆς, but in the resurrection he gets τὸ διάδημα τῆς κατὰ τοῦ θανάτου νίκης, Cat. 14. 1 (PG. 33. 825).

[155] Ἐνεφυτεύθη τοίνυν τὸ ξύλον τῆς ζωῆς ἐν τῇ γῇ, ἵνα ἀπολαύσῃ τῆς εὐλογίας ἡ καταραθεῖσα γῆ, καὶ ἵνα λυθῶσιν οἱ νεκροί, Cat. 13. 35 (PG. 33. 816).

[156] Cat. 14. 11 (PG. 33. 837). The vine was planted to root out the curse that came from Adam.

[157] Cat. 13. 18 (PG. 33. 793).

placed upon a pole in order to save those bitten by a living serpent (cf. Numbers 21:9), may also serve as τύπος for Christ's act of salvation upon the cross. The cross is interpreted as a life-giving symbol which removes the damage to which man has been subjected.[158] The consequences of the crucifixion for the creation is most clearly expressed when it is said that Christ spread out his arms upon the cross to encompass the ends of the world (τῆς οἰκουμένης τὰ πέρατα).[159] The significance of the doctrine of creation in this context is underlined by Cyril when he emphasizes that in the same manner God also established the heavens with his "spiritual hands".

In 13.35 we saw that the blessing of the earth brought by the tree is placed side by side with the deliverance of the dead. The cross, in other words, not only removes the curse laid upon the earth but also leads to the destruction of the power of death. This is related to theme-groups other than those centred around the curse theme.

In 13.2 Cyril stresses that Adam's sin brought death into the world with the result that the power of death ruled (ἐβασίλευσεν) over the world.[160] It is difficult to fathom the precise meaning of this statement. The problem takes on a paradoxical character when Cyril contends that people are dead although this death differs from that of Lazarus.[161] Death appears here as an unavoidable aspect of life which, nevertheless, implies a form of life. Death's place in life becomes somewhat clearer when Cyril says that God in his goodness lets Adam avoid dying immediately after the expulsion. Instead, man is placed on earth.[162] Death is seen here as the complete opposite of life in paradise and life on earth is perceived as life marked by death. Life on earth represents merely a postponement of death's encroachment upon mankind.

This death-determined life is in total contrast to the life God willed. Through sin man has become the enemy of God, and the result of sin is death. When God allows Christ to die on the cross, he retains the death judgement over man while simultaneously revealing his mercy. This takes place when "Christ took our sins 'in his body upon the tree' ".[163] In 13.28 Cyril emphasizes more explicitly that sin died when Christ's

[158] Cat. 13. 20 (PG. 33. 797). We note that the salvation which came from the serpent fixed on a pole, restored anyone bitten by living serpents to health. This salvation is interpreted as a prefiguration of the crucifixion. With reference to other life giving events from O.T., Cyril points out: πάντοτε διὰ ξύλου ἡ ζωή.

[159] Cat. 13. 28 (PG. 33. 805). For the cosmic aspect, see p. 113.

[160] Cat. 13. 2 (PG. 33. 773).

[161] Cat. 2. 5 (PG. 33. 389).

[162] Cat. 2. 7 (PG. 33. 394).

[163] Cat. 13. 33 (PG. 33. 813); quotation from 2 Petr. 2:24. The consequence is that through this death the faithful dies to sin.

humanity was nailed to the tree.[164] Through one person came death, through one person came life, just as man was driven out of paradise through one tree and the faithful were again led into paradise by one tree.[165] Such a formulation assumes that the tree of paradise and·the tree of the cross create fundamentally different conditions of life. Thus, it may be said that Eve brought death and Mary life into the world.[166]

Our examination of the tree of the cross suggests, thus, the co-existence of two different interpretations of the crucifixion. Restituated, created life is not to be placed, without reservation, on the same footing as life in which the threatening power of death is removed. Let us now look more closely at Cyril's further treatment of these questions in his interpretation of the resurrection.

d) The Resurrection of Christ

In our study of the resurrection we draw no sharp distinctions between passages concerning Christ's resurrection and those concerning the resurrection of man; both reflect the same structures and descriptions of them are generally interwoven.

In 14.10 Cyril's interest lies in the time of the resurrection. He leads the listeners' attention towards the time of the catecheses, which is to say spring, when the earth is covered with flowers and the grapevines are pruned. With reference to Genesis 1:11 (LXX), it is declared, further-more, that this is also the time of the world's creation. The purpose of connecting Christ's resurrection and the creation is, in the first place, to establish that the resurrection conforms with a structure which is imbedded in the act of creation. The imagery assumes that the changing seasons are a God-willed structure not affected by the fall. Between this structure and the resurrection exists a fundamental similarity which sheds light on the meaning of the resurrection.[167]

The same subject is treated in greater detail in the exposition concerning the resurrection of the dead at the end of time. In support of the idea of man's resurrection, Cyril also refers here to the seasonal cycle. In winter the trees stand as though dead (ὡς νεκρά). But, these apparently dead trees receive again in the spring a sort of resurrection from the dead (ἡ ζωοποίησις ... ὥσπερ ἀπὸ νεκρώσεως). Indeed, Cyril finds it possible to

[164] Cat. 13. 28 (PG. 33. 805). The presupposition is that the sin which Christ bore, was born by his humanity.
[165] Cat. 13. 2 (PG. 33. 773).
[166] Cat. 12. 15 (PG. 33. 741).
[167] Cat. 14. 10 (PG. 33. 836).

speak of an annual ἀνάστασις among visible things.[168] In nature Cyril finds a parallel to the transition from death to life which is brought about by the resurrection.

The problem in imagery of this kind is that there is no reference to a hiatus which is fully comparable with the cleft between death and resurrection. The object of such a comparison, however, is to maintain the continuity in God's act of creation as clearly as possible. The condition brought about by the resurrection is to be understood as an act of creation on a level with God's creation in nature.

In the same breath Cyril carries the thought further and links this act of creation to God's first creation. He speaks of God who has created man from nothing and who once again will be able to raise him up when he has perished. This time he compares man's condition to a statue which has been broken but put together again in its original form.[169]

This interpretation of Christology in the light of the doctrine of creation determines Cyril's further exegesis in 14.10. In God's act of creation in the springtime, man appeared κατ' εἰκόνα, καθ' ὁμοιότητα. According to Cyril κατ' εἰκόνα is not disturbed by the fall. On the other hand καθ' ὁμοιότητα becomes obscure (ἡμαύρωσε). Next it is said that man lost (ἀπώλεσε) this condition. Here we find a double frame of reference to which ὁμοιότης is related. Is this condition to be understood as lost or obscure? Cyril's immediate emphasis underlines loss because the following discourse concerning restoration (διόρθωσις) is related to the discourse on the lost condition.[170]

But, Cyril also finds himself able to speak of Christ's act of salvation in a way which rather assumes that the ὁμοιότης condition is understood as obscure rather than lost. In 12.5 Cyril, introducing an account of the reason for Christ's coming, refers to the story of creation. He stresses that the world is created for the sake of man and that everything within creation is there to serve man. This situation, meanwhile, is upset by the fall which introduces a process of decay which even continues after Israel becomes the chosen people. Here we shall take note of the categories used to describe the decay. Cyril says that the chosen people have been hurt (ἐτραυματίσθη). To repair this damage God sends his prophets to heal (θεραπεῦσαι) Israel.[171] The prophets, however, are unsuccessful in their

[168] Cat. 18. 7 (PG. 33. 1023). Cyril stresses that the annual resurrection of visual things is effected in order to defeat the disbelief concerning the resurrection from the death. Chapter 18 gives a lot of examples from nature reflecting the same structure. It is in this connection Cyril refers to the phoenix (18.9).

[169] Cat. 18. 6 (PG. 33. 1024).

[170] Cat. 14. 10 (PG. 33. 836), see also Jenkinson, The Image of God p. 52.

[171] Cat. 12. 6 (PG. 33. 732).

efforts to do this. Man's misery is described as a τραῦμα which strikes the entire body—from head to foot. The most terrible thing about this condition is that man has no remedy for his own illness. The description of man's condition concludes with a plea to God for help in overcoming the evil.[172] And the Lord hears the prayers of the prophets and sends his son as doctor (ἰατρόν).[173] In 12.1 Christ's healing activity is described in greater detail: "For Jesus the King, when about to become our Physician, girded Himself with the linen towel of humanity, and cared for that which was sick."[174] Here, the acts of Christ are related to man's condition on earth in such a way that Christ appears as the one who suffers for man's ills. Man's ills, which is to say his sins, are removed and he stands forth free of sin. In 10.13 we are given a more explicit explanation of how Cyril perceives man's ills. Christ is presented here as "both healer of bodies and physician of spirits ...". The examples of healing are significant. Christ heals not only ordinary blindness but also brings light to minds. Cyril then refers to Matthew 9:6, saying that Christ healed the soul when he caused sinners to be converted because, thereby, he could heal the body. Through the healing of his soul the whole person becomes healthy.[175]

The idea that God in Christ renews the act of creation presumes a nearness between God and his work. Cyril considers it unreasonable that the God of creation should be far away from his world.[176] In a precise theological formulation the creator's relation to his creation is maintained in the following words: οὗτος ἐν πᾶσίν ἐστι, καὶ πάντων ἐκτός.[177]

In a remarkable way Cyril takes God's presence in creation seriously. For him nature, in a way, becomes transparent for the Divinity in quite a different way than man. In connection with the crucifixion Cyril emphasizes the contrast between the behaviour of man and nature at the decisive moment. Whereas the people mocked and smote Christ, seeing him merely as a person, creation acknowledged him as God. This was shown by the darkening and trembling of the sun, unable to endure the sight of its master so disgraced.[178] At the moment of Christ's death creation immediately realized what had taken place.

[172] Cat. 12. 7 (PG. 33. 733).
[173] Cat. 12. 8 (PG. 33. 733). The Father decided to send his Son, because ἡμῶν τὸ γένος should not be despised by God.
[174] Ὁ γὰρ βασιλεὺς Ἰησοῦς ἰατρεύειν μέλλων, λέντιον ἀνθρωπότητος περιζωσάμενος, ἐθεράπευσε τὸ νοσοῦν, Cat. 12. 1 (PG. 33. 728).
[175] Cat. 10. 13 (PG. 33. 677).
[176] Cat. 18. 3 (PG. 33. 1020). Things being far away for man, are near to God because he holds πᾶσαν τὴν γῆν ἐν δρακί.
[177] Cat. 4. 5 (PG. 33. 460).
[178] Cat. 4. 10 (PG. 33. 469).

This nearness between God and creation also applies to God's relationship to man. As a result of the positive relationship between God and creation, Cyril stresses that the incarnation must not be looked upon as a degrading act on the part of God: "He is not ashamed to take flesh from such members, when He framed these very members."[179] To hold the body in contempt implies, in the final analysis, a contempt for the Creator.

The emphasis upon the excellence of creation is obviously connected with the polemical situation in which Cyril found himself. The satirically inclined attack on the Manichaeans in 6.32 shows a rare vehemence. Here it is precisely the understanding of creation and the Creator which lies behind Cyril's engagement. Cyril contends that the Manichaeans scorn and withdraw themselves not only from those who give them food but, likewise, from the food itself and the God who is responsible. He goes on to point out the absurdity of the Manichaeans' attitude; if one is dependent upon food, it is illogical to scorn it. For Cyril the Manichaeans are the children of sloth who refuse to work but live off those who labour for their food.[180]

This tendency to base Christology and soteriology on the doctrine of creation finds its most pregnant expression in the comparison of the resurrection and the Old Testament account of Moses' rod. This theme is already touched upon in 4.30 and is developed more fully in 18.12. In 4.30 Cyril bases his exposition on the analogy of the blossoming of spring and the resurrection, maintaining that it is more natural that man be given new life than nature. He follows this with a reference to Moses' rod which by the will of God is transformed into a serpent which, indeed, has quite another nature than that of the rod. Seen in this way, it is unreasonable that man after death should not receive his own nature again.[181]

The same argument is repeated in 18.12, but here, the contrast between the transformation of Moses' rod and that which happens to the righteous in the resurrection is emphasized as follows: "The transformation of the rod was above nature: will not the just be restored according to nature?".[182] Here the resurrection is given a κατὰ φύσιν—character and reflects an act precisely corresponding to the other acts of God in his creation.

[179] Οὐκ ἐπαισχύνεται δὲ ἐκ μελῶν τοιούτων ἀναλαμβάνειν σάρκα, ὁ τῶν μελῶν αὐτῶν πλάστης, Cat. 12. 26 (PG. 33. 757). In this context the body of Christ is referred to as a holy body which is regarded as τὸ καταπέτασμα τῆς θεότητος.

[180] Cat. 6. 32 (PG. 33. 595f.).

[181] Cat. 4. 30 (PG. 33. 493).

[182] Cat. 18. 12 (PG. 33. 1029).

The interpretation of the resurrection, as we have sketched it here, does not reign supreme in the catecheses. In 14.17f. Cyril once again attempts to make the resurrection credible. In this case it is the fact that Jesus has been dead for three days and buried as well which is the stumbling block. As an approach to the interpretation, the typological utilization of the Jonah episode in Matthew 12:40 is used. According to Cyril, the heat in the whale's belly was so intense that even the legs of the one devoured melted. This event is used to show that it is no more difficult to rise from the earth than to survive in the belly of such a fish. The point, in the first instance, is that these phenomena are comparable: "If one is credible, the other is credible; if one is incredible, the other also is incredible; to me both are equally credible."[183] Here it is no longer a matter of comparison of natural phenomena. The ultimate basis lies in God's almighty power: Πάντα γὰρ δυνατὰ παρὰ τῷ θεῷ.[184]

A rather similar argumentation is to be found in the disposition of the Virgin birth. In this case the story of Sarah is compared to that of Mary. In the beginning it is made clear that the barren Sarah gives birth. Is it then so unreasonable that a virgin should give birth? Just as in 14.18 the two events are made analogous; both must be rejected or both accepted. Here, too, our catechist insists that God is behind both events. His rendition of the character of the events attracts attention: "It is contrary to nature for a barren woman to bear, and for a virgin to bear."[185] The incarnation is described here as a παρὰ φύσιν—act and the similarity with the aforementioned interpretation of the resurrection makes it reasonable to understand it in the same way.

If we look back to the Jonah story again, we see that the interpretation focuses upon the problem of death. We recall that it was Jonah's legs which disintegrated in the whale's belly. Of Jesus, it is said, that he descended into the underworld in order that death should deliver up those who had been swallowed.[186] It is pointed out, furthermore, that death was terrified at the arrival in the underworld of a new visitant, one not subject to the bonds of the place. The righteous, therefore, could say with Paul: "O Death, where is thy sting?" because it is the Conquerer (ὁ νικοποιός) which has set them free.[187]

It is hardly coincidental that Cyril uses the stories of Sarah and Jonah to support the interpretation of the resurrection as a παρὰ φύσιν—

[183] Εἰ πιστὸν ἐκεῖνο, καὶ τοῦτο πιστόν· εἰ τοῦτο ἄπιστον, κἀκεῖνο ἄπιστον· ἐμοὶ μὲν γὰρ ἀμφότερα ὁμοίως πιστά, Cat. 14. 18 (PG. 33. 848).

[184] Cat. 14. 18 (PG. 33. 848); quotation from Matthew 19:26.

[185] Οὐκοῦν εἰ τὸ στεῖραν γεννῆσαι παρὰ φύσιν· καὶ τὸ παρθένον γεννῆσαι, Cat. 12. 28 (PG. 33. 760).

[186] Cat. 14. 17 (PG. 33. 845).

[187] Cat. 14. 19 (PG. 33. 848f.).

occurrence. Both events are the expression of God's relationship with his people as the Scriptures testify and may, therefore, serve as τύποι for that which happens to Jesus. Events with παρὰ φύσιν character aid in clarifying the relation between the coming of Christ and God's previous relationship to his people.

Various Old Testament events serve as fixed points in the interpretation of the coming of Christ. This is explicitly stressed in 13.8 where prophetic testimony is a direct support for the deliverence of Christ: "For everything that concerns Christ has been written; there is nothing doubtful, since nothing is unattested."[188] This firm belief that patterns concerning the life of Christ are recorded in the Old Testament leads to Cyril's constant insistance upon συμφωνία between the New Testament and Old Testament.[189]

The way in which the prophecies and the life of Christ are related may be described in a number of different ways. 13.11 vaguely intimates that the prophets speak enigmatically (αἰνιγματωδῶς) about Christ.[190] Elsewhere the prediction is described as τὸ μυστήριον awaiting fulfilment.[191] Such statements really mean that the prophecy was only made clear in the light of the Christological fulfillment.

At the same time Christ represents something more than was present in the old covenant. In 17.18 the grace of the New Testament is compared to a new wine. It is true enough that the vine bore fruit in the time of the prophets but only now does it bear richly. Likewise, the participation of the fathers in the Holy Spirit may be spoken of but only now is man completely filled with the gifts of the Spirit. Through such formulations, continuity as well as change is maintained in relation to the past. Continuity is linked to the understanding of God and difference to the degree of participation in Divine grace.[192] In a Trinitarian formulation Cyril presents a condensed interpretation of God's actions regarding his people within the Old and the New Testament: "There is One God, the Father, Lord of the Old and the New Testament, and One Lord Jesus Christ, who was prophesied in the Old, and came in the New Testament, and One Holy Spirit, who heralded Christ through the Prophets, and when Christ came, descended and showed him forth."[193] Here too, unity

[188] Cat. 13. 8 (PG. 33. 781).

[189] Cat. 2. 4 (PG. 33. 388) uses this terminology.

[190] Cat. 13. 11 (PG. 33. 788).

[191] Cat. 13. 32 (PG. 33. 812). As a commentary on John 19:30 it is said: Πεπλήρωται γὰρ τὸ μυστήριον· πεπλήρωται τὰ γεγραμμένα· ἐλύθησαν αἱ ἁμαρτίαι.

[192] Cat. 17. 18 (PG. 33. 989).

[193] Εἷς Θεὸς, ὁ Πατὴρ, Παλαιᾶς καὶ Καινῆς Διαθήκης Δεσπότης· καὶ εἷς Κύριος, Ἰησοῦς Χριστὸς, ὁ ἐν Παλαιᾷ προφητευθεὶς καὶ ἐν Καινῇ παραγενόμενος· καὶ ἓν Πνεῦμα ἅγιον, διὰ προφητῶν μὲν περὶ τοῦ Χριστοῦ κηρύξαν· ἐλθόντος δὲ τοῦ Χριστοῦ καταβὰν, καὶ ἐπιδείξαν αὐτόν, Cat. 16. 3 (PG. 33. 920).

is primarily maintained by emphasizing that the same God has acted in both cases. But the works are different; prophecy is replaced by the actual presence of Christ and the Holy Spirit in the world. In keeping with such thinking the Hebrew Easter celebration is characterized as τυπικός when compared to the celebration which now is ἀληθινός.[194]

In our analysis we have shown that Cyril elucidates the meaning of the resurrection by resorting to two different explanatory models. He does this partly in the light of the doctrine of creation and partly against a background of God's previous acts for his people. The catechist himself is not particularly bothered by the tension between these different explanations. In general, he is content to use completely pragmatic grounds for his two different methods of argumentation. Creation is the frame of reference used in apologetics aimed at heathens. Towards those who do not recognize the Scriptures, one must contend with rational arguments ἐκ λογισμῶν ... καὶ ἀποδείξεων.[195] For Jews and Samaritans the Scriptures, on the contrary, contain a certain argumentative value which in the case of the Jews is based on the Old Testament and for Samaritans on the law.[196]

Beyond this we find the beginnings of a comprehensive theological perspective in 12.28 in which Cyril accounts for the παρὰ φύσιν character of the Virgin giving birth. The ultimate argument in support of God's παρὰ φύσιν acts is sought after by Cyril in God's creative power. The Creator of nature who has no need to heed the nature of trees but who causes dry rods to put forth branches can also give the Virgin the ability to bear. The birth of Jesus by the Virgin is to be understood as a creative act of God and thus leads back to the Creator's omnipotence. The κατὰ φύσιν—as well as παρὰ φύσιν—acts are thus ultimately combined in God's creative power even though the acts in question are different in character.

e) The Parousia

In the previous section, particular attention was given to the understanding of the character of redemptive work as described in the catecheses. But, not much interest was shown in deciding where and when this salvation was to take place. It is clear, however, that the crucifixion and resurrection constitute crucial points in Cyril's Christology. It is Christ's death and resurrection which is the determining feature in the

[194] Cat. 14. 10 (PG. 33. 836).
[195] Cat. 18. 10 (PG. 33. 1029).
[196] Cat. 18. 11 (PG. 33. 1029).

new relationship of God and the world. Thus Cyril can say that the glory of the cross has redeemed all mankind (κόσμον ὅλον ἀνθρώπων).[197] And in continuing he can emphasize: "Do not wonder that the whole world was redeemed."[198] The crucifixion has consequences for mankind as a whole.

Cyril stresses, likewise, that everlasting life (ζωὴ αἰώνιος), which is understood as a life which stands in contrast to the life ending in death, is brought into the world at the tree of life.[199] Through Christ's death the power of death over man is vanquished.

There is an aspect of tension between this interpretation of the incarnation and concepts of Christ's coming at the end of time. We shall look more closely at the part played by end-of-time concepts in Cyril's catechetical work. In this connection we shall not emphasize questions concerning when the parousia is to take place. It is evident that Cyril considers Christ's coming as being in the near future without this having any direct consequences on his theology.[200] Our interest will be mainly centred around the meaning of the parousia seen in relation to the incarnation and the consequences of the parousia for the interpretation of soteriology.

As we have attempted previously to examine Cyril's understanding of salvation by means of cross terminology, we shall, in this context, take our point of departure in the futuristic-eschatological meaning alloted the cross in the catecheses. Cyril says that the cross πάλιν will reveal Jesus from heaven. The reason that τοῦ βασιλέως τὸ τρόπαιον will go before him is that the Jews, who were responsible for the execution, will recognize him by the cross and pour out their troubles whereas the faithful will be able to acclaim him at that same cross.[201] By means of the cross, the events taking place at the end of time are connected to Jesus' life on earth as well as to the lives of the faithful. The cross, as the sign of the parousia, points out that the consequences of Christ's saving work will only appear at the end of time.

This question is given a broader perspective in Chap. 15 of the catecheses which is particularly devoted to the theme of parousia. Already in the beginning of the chapter we notice that Cyril relates the incarnation and the parousia. Cyril speaks of the double coming of Christ. Typical of the first coming—the incarnation—is its conceal-

[197] Cat. 13. 1 (PG. 33. 772).
[198] Cat. 13. 2 (PG. 33. 773).
[199] Ibid.
[200] Cyril refers in Cat. 15. 5ff. to many eschatological events which have taken place already. It is surprising that the Roman Empire should be connected to the activity of Antichrist, see Cat. 15. 12f. Such statements are not brought into conflict with the positive evaluation he gives of Emperor Constantine.
[201] Cat. 13. 41 (PG. 33. 821).

ment, in contrast to the conspicuousness of the parousia. The secrecy consists, first and foremost, of the fact that his Divinity was not made unmistakable at the incarnation. The manger, cross, ignominy, the people's judgement, silence and meek words will give way at the end of time to shining light, hosts of angels, judgement and the display of power.[202] Not until then will complete triumph be realized. A more precise account of what this triumph involves is to be found in the following. So it is said in 15.3 that the parousia of Jesus will lead to the end of this world and that the created world will be made new again (ἀνακαινοποιεῖται).[203] In continuing we shall see what this renewal of the creative act comprises. The end of the world implies that an ultimate and definitive stop will be put to all the world's misery. Corruption, thievery, adultery and all manner of sin shed upon the earth, all blood which has flowed in the world shall be removed from this wondrous building which is the world. This will come to pass because this world will come to an end and one more beautiful will appear. In this way Cyril maintains that the events of the parousia have direct consequences for the created world. It is the present world which will be restituated at the end of time. In this way the continuity of God's act of creation and parousia is maintained.

At the same time, however, Cyril emphasizes that the renewal in question here has a far-reaching effect which is not complete until the stars die and rise again. Cyril says, in fact, that the work of creation faces a future which can only be described as the resurrection of the heavens (ἀνάστασιν ὥσπερ ... τῶν οὐρανῶν).[204]

In Cyril's account of the consequences of the parousia for mankind, we are given further particulars as to how the work of creation changes at the end of time.

Previously we have pointed out that Cyril perceives Christ's victory over death as an act which is essentially different from God's other acts pertaining to his creation. In keeping with this reasoning, Cyril stresses that the resurrected body is not a frail body but is still the same as the earthly body, merely transformed (cf. μεταποιεῖται). As an example to illustrate this transformation he uses iron which, when fired sufficiently, itself becomes fire. The conclusion is as follows: "This body, therefore, shall rise, but it will not abide in its present condition, but as an eternal body."[205] The key to the interpretation of the consequences of resurrection lies without any doubt in the eternity in which the body participates.

[202] Cat. 15. 1 (PG. 33. 869).
[203] Cat. 15. 3 (PG. 33. 873).
[204] Ibid.
[205] Ἐγείρεται μὲν οὖν τοῦτο τὸ σῶμα· ἀλλ' οὐ μένει τοιοῦτον, ἀλλὰ μένει αἰώνιον, Cat. 18. 18 (PG. 33. 1040). The point of departure is 1 Cor. 15:53.

The limiting power of death is destroyed. In this context, the connection with created order is still maintained, but at the same time the contrast to created life is emphasized more clearly than in the passage on the renewal of the world. For here it is no longer a question of the elimination of aspects in this world, such as was the case with theft, adultery etc., but rather one of a structural change in relation to the present world. Thus Cyril too, can posit that the body in the resurrection will flower, no longer as the flowers of the field, but as ἐπουράνιον ἄνθος.[206] Cyril also feels entitled to speak of the faithful who will be honoured τὸ ὑπὲρ ἄνθρωπον when they are taken up in the clouds and will be with the Lord eternally.[207] At the parousia man will take part in the celestial life. Here it is no longer necessary to understand God's acts either as κατὰ or παρὰ φύσιν, but the created world is led ὑπὲρ φύσιν.

In this way the parousia is given a double function. At the end of time creation is restored in its entirety while at the same time eternal life will definitively destroy death's threatening power. As compared to the incarnation the parousia brings no new benefits of salvation but it underlines the final realization of them.

This emphasis on the parousia results in Christology comprising a structure stretching from Christ's past activity to his actions at the end of time. This does not necessarily imply that Cyril's catechetical instruction is determined by an unequivocal futuristic perspective. The Christology is not only directed forward to the parousia but also to a realization of the salvation taking place in the congregation here and now. This point may, once again, be illustrated with the aid of the cross. Cyril speaks of the many small pieces of Christ's true cross which are spread all over the world, and as such bear witness to the reality of the cross.[208] The purpose of this cross is to substantiate the concept that Christ was crucified for our sins.[209] Christ's redemptive work can be made a reality for the faithful here and now, and this implies that the state of tension between Christ's crucifixion and the parousia is perceived by the faithful as a tension between salvation now and at the end of time.

As we continue, we shall concentrate on the realization of salvation as Cyril describes it in the rites and then put special emphasis on an understanding of the way in which the ritual brings about Christ's presence. Does the ritual imply that the present-day aspect of salvation is paramount or is it primarily directed toward a futuristic, definitive realization of salvation?

[206] Cat. 15. 20 (PG. 33. 897).
[207] Cat. 15. 19 (PG. 33. 896).
[208] Cat. 13. 4 (PG. 33. 776).
[209] Cat. 4. 10 (PG. 33. 468). The cross can persuade us that Οὗτος ἐσταυρώθη ὑπὲρ τῶν ἁμαρτιῶν ἡμῶν ἀληθῶς.

3. The Ritual Representation

a) The Ritual

Already in an initial approach to Cyril's understanding of the ritual we see that figurative forms of expression are utilized extensively. Characteristically, it is said in connection with Chrism: "Everything has been wrought in you 'likewise' (εἰκονικῶς) because you are likenesses of Christ."[210] This relationship between Christ and man also determines how contact between the two is to be established. As our study progresses, we shall see that such figurative relations play a dominant role within ritual acts. A typical example is to be found in the introductory phase of the baptismal ceremony in which the devil is renounced. In this connection the figurative sphere is the west. The reason given is that the west which is "the region of visible darkness" (τοῦ φαινομένου σκότους τόπος), has a fundamental likeness to the devil who is himself darkness (σκότος). Because of this similarity, the visible area serves as the figurative sphere for the invisible devil. Acts aimed at the devil are therefore συμβολικῶς carried out towards the west where the devil, in a way (ὡς), is present.[211]

In the mystagogical catecheses Cyril reserves the σύμβολον-terminology for actualization which is connected to ritual forms of expression.[212] Thus it is only from the context of the ritual that the hands in 5.M.2 are described as σύμβολον for the action. It is the ritual washing which underlies the usage of the symbolic expression in this connection.[213] The hands, here too, become a symbol and it is in relation to this symbol that the act is carried out.

In continuing this study we shall make a closer examination of how this figurative way of thinking influences the understanding of the two main sacraments.

In Baptism it is the water which constitutes the figurative sphere. The correspondence between this water and Jesus' sepulchre makes it possible to establish a connection between the baptismal candidate and Christ's death. Cyril makes it clear that immersion corresponds to night as it is impossible to see beneath the surface of water; and that emergence corresponds to day. The three immersions, thereby, correspond to the three

[210] πάντα εἰκονικῶς ἐφ' ὑμῶν γεγένηται, ἐπειδὴ εἰκόνες ἐστὲ Χριστοῦ, 3 M. Cat. 1 (SC. 126.120).

[211] 1 M. Cat. 4 (SC. 126. 88).

[212] We shall investigate the meaning of the symbol terminology in the analysis of Theodore of Mopsuestia, see p. 239.

[213] 5 M. Cat. 2 (SC. 126. 149).

days spent in the tomb. By means of the events taking place in this water, the baptizand is put into contact with the decisive events in the life of Jesus. The baptismal act becomes σύμβολον for Christ's stay in the tomb.[214]

The aim of these events is to effect participation in the act of salvation which Jesus' death and resurrection represent: "In the same moment you were dying and being born, and that saving water was at once your grave and your mother."[215] Here we detect a shift in imagery. The water is no longer the grave and the three immersions no longer correspond to the three days and three nights. On the contrary, immersion and the succeeding emergence from the water are now interpreted as the baptizand's own death and rebirth.

An important point in the exposition on Baptism is associated with the relation between the figurative sphere and the underlying reality. In 2.M.5 the very real contrast existing between true, historical events and their symbolic enactment is clearly emphasized.[216] The actual crucifixion, burial and resurrection are emphasized as clearly as possible in obvious contrast to the ritual's ἐν εἰκόνι ἡ μίμησις. It is essential, nevertheless, to stress that the figurative event establishes a genuine participation in the Christological events. Through imitation, true salvation is brought about.[217] The baptismal act emerges as the direct mediator between Jesus and his passion on one hand and the baptizand and his participation in salvation on the other.

If we turn now to the celebration of the Eucharist, we find a somewhat different organization than that of the baptismal rite. In this case, it is the bread and the wine which constitute the figurative sphere and which therefore are expected to resemble Christ's body and blood. This similarity is not specifically explained but references to John 6:53 and Psalm 23:5 suggest that the life-giving qualities of bread and wine play a certain role. The faithful participate in the body and blood of Christ "in the figure of bread" and "in the figure of wine" (ἐν τύπῳ ἄρτου ... καὶ ἐν τύπῳ οἴνου), with the result that the believer becomes a Christ-bearer (χριστοφόρος).[218] The bread and wine render participation in ζωή.[219]

[214] 2 M. Cat. 4 (SC. 126. 110).

[215] Καὶ ἐν τῷ αὐτῷ ἀπεθνήσκετε καὶ ἐγεννᾶσθε, καὶ τὸ σωτήριον ἐκεῖνο ὕδωρ καὶ τάφος ὑμῖν ἐγίνετο καὶ μήτηρ, 2 M. Cat. 4 (SC. 126. 112).

[216] About the believers it is said: οὐκ ἀληθῶς ἀπεθάνομεν, οὐδ' ἀληθῶς ἐτάφημεν, οὐδ' ἀληθῶς σταυρωθέντες ἀνέστημεν. About Christ it is said: Χριστὸς ὄντως ἐσταυρώθη καὶ ὄντως ἐτάφη καὶ ἀληθῶς ἀνέστη, 2 M. Cat. 5 (SC. 126. 112f.).

[217] 2 M. Cat. 5 (SC. 126. 114).

[218] 4 M. Cat. 3 (SC. 126. 136).

[219] 4 M. Cat. 4 (SC. 126. 138) quotes John 6:53: Ἐὰν μὴ φάγητέ μου τὴν σάρκα καὶ πίητέ μου τὸ αἷμα, οὐκ ἔχετε ζωὴν ἐν ἑαυτοῖς.

We must, nevertheless, stress that the figurative action no longer functions merely as a connecting link in the communion between Christ and the faithful (cf. Baptism) but bread and wine are themselves assigned the qualities belonging to the body and blood of Christ: "Do not then think of the elements as bare bread and wine; they are, according to the Lord's declaration, the Body and Blood of Christ."[220] As in Baptism, concrete symbols mediate between Christ and the faithful but now the bread actually contains the body.[221] This emerges most clearly in 4.M.2 in which Cyril says that Christ changed (μεταβαλών) wine into blood.[222] What is apparently bread is no longer bread even though it tastes as such; it has become the body of Christ.[223] At the same time, Cyril stresses that the bread also remains bread—there is no question of eating meat when receiving bread in the celebration of the Eucharist. When Jesus, in John 6:53 speaks of eating his flesh, it must be understood spiritually (πνευματικῶς).[224] It is, however, more important than before to stress that it is a case of true mediation with clear emphasis on its physical character. The faithful will partake physically in Christ—his body and blood are thus transmitted through the sacrament to the faithful's own body.[225] In this way the ritual establishes a direct line of communication between the faithful and Christ. And, it is by way of this communion between Christ and catechumen, established with the help of physical realities, that salvation itself is brought about. The baptismal water can, accordingly, be characterized as "that saving water" (τὸ σωτήριον ἐκεῖνο ὕδωρ).[226] The baptismal rite becomes the act of God which leads the catechumen into communion with Christ.

The relationship between catechumen and Christ is, however, more complicated than a first impression indicates. This complexity springs from the wealth of meaning ascribed to Christology. We shall look more closely at just what is mediated to the faithful within the ritual.

Previously we have indicated that Christ's resurrection establishes the possibility for the catechumens to become part of restituated created life

[220] Μὴ πρόσεχε οὖν ὡς ψιλοῖς τῷ ἄρτῳ καὶ τῷ οἴνῳ· σῶμα γὰρ καὶ αἷμα κατὰ τὴν δεσποτικὴν τυγχάνει ἀπόφασιν, 4 M. Cat. 6 (SC. 126. 138).

[221] See formulations such as Ἐν τύπῳ γὰρ ἄρτου δίδοταί σοι τὸ σῶμα ..., 4 M. Cat. 3 (SC. 126. 136).

[222] 4 M. Cat. 2 (SC. 126. 136); see also 5 M. Cat. 7 connecting the consideration to the epiclesis.

[223] See 4 M. Cat. 9 (SC. 126. 144).

[224] 4 M. Cat. 4 (SC. 126. 138). Otherwise it would have been σαρκοφαγία.

[225] Quasten says that Cyril is less diffuse here than his predecessors: "It is in his Eucharistic doctrine that Cyril makes a more definite advance on his predecessors. He expresses himself more clearly regarding the Real Presence than all the earlier writers", Quasten, Patrology III p. 375.

[226] 2 M. Cat. 4 (SC. 126. 112).

(cf. p. 172). In 14.10, attention is drawn not only to the relation between creation and Christology, which we have touched on previously, but also to the relation between these themes and the rite. We recall that Cyril emphasizes that Christ rose up in the spring when earth was covered in flowers (cf. p. 172). But, Christ's resurrection was also linked to the Easter celebration which previously had a figurative character but which now had become a reality. Creation—considered a past event—is associated here with Jesus' resurrection, aided by the seasonal rebirth to which the ritual cycle is in turn adapted. Creation occurs time after time, just as does Easter and that they coincide allows us to see Christ's resurrection as well as the baptismal rite in the light of the doctrine of creation.

In Baptism, the catechumen is placed in a context focusing on creation. With particular emphasis the present-time meaning of the resurrection is maintained in Procat. 5. Cyril states that Christ will make the faithful to live again (ζωοποιήσῃ) after allowing them to die. This assertion is corroborated by reference to Romans 6:11 which is interpreted thus: "Die, then, to sin, and live to righteousness; from today be alive."[227]

The content of the forthcoming rebirth is recounted in 2.5, where the resurrection of the baptised is compared to the awakening of Lazarus, who, when he arose had been buried for four days and had already begun to smell. Is it not easier to believe in the resurrection taking place in the baptismal rite where one who is alive rises up than that which happened to Lazarus? The resurrection of the baptized is not perceived here primarily as a parallel to resurrection from death. It is rather a parallel to rising after having fallen, to the regaining of sight, the possibility of walking properly again after having been lame. Here resurrection is restituated, created life.[228]

Such an interpretation is further sustained when Cyril, in the following, maintains: "Nature, then, admits of salvation."[229] As an example of what this involves, Cyril refers to the thorny ground which will be transformed into fertile soil. When earth can become fertile, man must be part of salvation. Here, too, salvation is interpreted as the restituation of creation which can be consummated in this world.

In Baptism, participation in created life is transmitted to the faithful. This implies that sin has lost its power. In 18.20 the remission of sins which underlies the assertion is elaborated upon. Here Cyril says that people should take care of their bodies to protect them from the marks

[227] Ἀπόθανε τοῖς ἁμαρτήμασιν, καὶ ζῆσον τῇ δικαιοσύνῃ· ἀπὸ τῆς σήμερον ζῆσον, Procat. 5 (PG. 33. 344).
[228] Cat. 2. 5 (PG. 33. 389).
[229] Ἡ μὲν οὖν φύσις ἐπιδέχεται τὴν σωτηρίαν, Ibid.

of sin—(οἱ σπίλοι τῶν ἁμαρτιῶν). Just as a sore leaves a scar so does sin leave traces of the scars. In Baptism, however, God heals (θεραπεύει) previously incurred sins and after Baptism the baptized one emerges restored to health. Thereafter, the faithful must take good care so that the vesture of the body remains pure.[230]

This new, clean and pure life can be realized in this world. For even though the nature of sin is terrible, sin is not incurable (ἀθεράπευτος), but "easy of cure for him who puts it away by repentance (εὔιατος δὲ τῷ διὰ μετανοίας ἀποτιθεμένῳ).[231] Once again, an example will illustrate what Cyril means. If a hot coal is held in one's hand the result is a burn. But, the burn is driven away as soon as the coal is thrown away. The interpretation is based on the doctrine of creation: "The Creator, being good, created unto good works."[232]

This interpretation of salvation swings in a moralizing direction where cleanliness becomes analogous with moral purity which can be maintained by directing free will away from sin.[233] In this sense, sin can be conquered and purity restored after Baptism. In this context, according to Cyril, there is no need for a futuristic-eschatological supplement in which this condition is accomplished. Purity is established at the time of Baptism; the difficulty thereafter is to maintain this condition.

We have maintained earlier that man's restitution through Baptism may anticipate the cosmic restitution which will be brought about by the parousia (cf. p. 180). This cosmic aspect is not brought out in the ritual itself. Here the redemption of *the faithful*'s sins is stressed without any suggestion if its being a partial settlement of sins. Cosmic notes sounding in the eucharistic celebration refer solely to nature and its relation to the Godhead. In directing all attention towards God it is said that man's glorification shall be like creation's glorification of God. Here it is not the created world which shares in restitution thereafter, but it is the cosmos which serves as the model for a restituated mankind's glorification. The anaphora prayer appears to assume a harmony between creation and a restituated mankind which does not depend upon a further realization of salvation.[234]

On the basis of our treatment of Christology, we also expect an organization of the rite in which death is the central point. Such an inter-

[230] Cat. 18. 20 (PG. 33. 1041).

[231] Cat. 2. 1 (PG. 33. 384).

[232] Ὁ μὲν οὖν κτίστης, ἀγαθὸς ὤν, ἐπὶ ἔργοις ἀγαθοῖς ἔκτισεν, Ibid., with reference to Eph. 2:10.

[233] In Cat. 2. 1 it is said that the sin stems from one's own free will, see also Cat. 4. 19ff,

[234] See 5 M. Cat. 6 (SC. 126. 154), see also p. 174.

pretation is expressed in 3.11 where it is said that Baptism "draws death's sting" (λύεται τοῦ θανάτου τὸ κέντρον).[235] The context shows us that here, death is understood as an enemy who keeps man bound but is destroyed when Christ is baptised. The result of this act is that life thereafter awaits that death will be silent through Baptism of the faithful.

Such an understanding presumably underlies 2 M.6 where it is said that it must not be thought that Baptism consists only of the remission of sins and the grace of adoption. The statement can almost be taken as a polemical correction of the interpretation around which we have built our baptismal interpretation so far. As a supplement, Cyril maintains that Baptism must be understood as "the antitype of the Passion of Christ" (τῶν τοῦ Χριστοῦ παθημάτων ἀντίτυπον).[236] In support of this statement he uses Romans 6:3-5 which stresses that one who is baptized into Jesus' death, is buried with him, and ἐν μιμήσει has taken part in Jesus' passion. Cyril dwells upon the participation of the baptizand in Jesus' death. Through Baptism the faithful become united (σύμφυτοι) with the death of Christ,[237] even though thereafter it must be emphasized that it is a question of a ὁμοίωμα with death.

Cyril, meanwhile, does not isolate this connection with the passion. In 2 M.8 he says that God who has presented (παραστήσας) the catechumens "as those who have come alive from the dead" (ὡς ἐκ νεκρῶν ζῶντας), will also give them the opportunity to walk "in newness of life" (ἐν καινότητι ζωῆς).[238] It is not made clear just what this new life consists of, but in 3 M.1 it is pointed out that God conformed us "to the body of the glory of Christ" (τοῦ σώματος τῆς δόξης τοῦ Χριστοῦ).[239] Through participation in Christ's passion, participation in his glory is brought about. Here we approach what is rendered by Baptism besides the remission of sins. We are taken a step further by 3 M.6. Referring to Jesus it says that he is "the beginning of your salvation, since He is truly the 'first handful' of dough and you 'the whole lump': and if the first handful be holy, plainly its holiness will permeate the lump."[240] The same point is also established in connection with interpretation of the eucharistic elements; Cyril asserts that one who is given the bread and wine, receives Christ's body and blood and thus becomes one with him. In consequence "when His Body and Blood become the tissue of our members, we become

[235] Cat. 3. 11 (PG. 33. 441).
[236] 2 M. Cat. 6 (SC. 126. 114).
[237] 2 M. Cat. 7 (SC. 126. 116) with reference to Rom. 6:5.
[238] 2 M. Cat. 8 (SC. 126. 118).
[239] 3 M. Cat. 1 (SC. 126. 120).
[240] Cyril says that Christ is ἡ ἀρχὴ τῆς ὑμετέρας σωτηρίας· ἐκεῖνος γὰρ ἀληθῶς ἀπαρχή, καὶ ὑμεῖς τὸ φύραμα· εἰ δὲ ἡ ἀπαρχὴ ἁγία, δηλονότι μεταβήσεται ἐπὶ τὸ φύραμα ἡ ἁγιότης, 3 M. Cat. 6 (SC. 126. 130).

Christ-bearers and as the blessed Peter said, 'partakers of the divine nature'."[241] Here we meet a scrutiny which lies on quite a different level to that found in the discussion about salvation's relation to sin. Now it is no longer a question of returning to a lost, created condition but rather, through suffering, a bursting of the bounds of creation to allow space for another element of reality, i.e. the holy, the Divine nature. Participation in Divine nature must be understood as an answer to the problem which death represents for catechumens. This participation is not restricted by futuristic-eschatological reservations. So, in this way, the restitution motif as well as the death theme are given a present-time accent which to a certain extent moderates the importance of the futuristic-eschatological concept.

b) Ritual and Vision

We have seen that, for the faithful, the ritual turns the benefits of salvation into reality in a way which threatens to weaken the futuristic-eschatological tendency found within the Christological program. The rite links Christ's passion and resurrection to the life of the faithful in such a way that the ritual representation detracts from a futuristic perspective.

The interpretation of the ritual, however, as we have presented it hitherto, does not convey a satisfactory picture of how Cyril understood the rite. Until now our concern has been centred, first and foremost, on the sacramental act itself. We have paid little heed to the spoken part of the rite. Nor have we looked closely at just how Cyril imagines that the sacramental act can be apprehended by the faithful. In these contexts the vision plays an important role. Not only does the anaphora prayer itself point towards the visionary aspect but, in other ways as well, visions tend to emerge within the ritual context. Vision, in this context, means the visual mental processes through which the mind perceives both the invisible things and things belonging to the future and the past. As Cyril, through these visions focuses interest on the problem of comprehension, whereas at the same time the ritual act is given a wider perspective compared to the interpretation given hitherto, it becomes important to take a closer look at Cyril's use of visions.

The immediate connection between rite and vision is expressed in 4 M.9. Cyril's indication that the wine and bread also entail participation

[241] Οὕτω γὰρ καὶ χριστοφόροι γινόμεθα, τοῦ σώματος αὐτοῦ καὶ τοῦ αἵματος εἰς τὰ ἡμέτερα ἀναδιδομένου μέλη. Οὕτω κατὰ τὸν μακάριον Πέτρον θείας "κοινωνοὶ γινόμεθα φύσεως", 4 M. Cat. 3 (SC. 126. 136) with reference to 2 Petr. 1:4.

in Christ's passion and death leads to a quotation from Psalm 104 which, when interpreted in a sacramental context, dwells upon the effects of the Eucharist. The bread strengthens the heart and makes the face of the soul shine. The gladness which occurs, implies that the soul "reflecting as in a glass the glory of the Lord" (τὴν δόξαν Κυρίου κατοπτριζόμενον), can be led "from glory to glory" (ἀπὸ δόξης εἰς δόξαν). Here the meaning of the sacrament is concentrated on an approach to Christ's δόξα. The sacrament opens the way to a contemplation of the Godhead.[242]

Before taking a closer look at what the faithful contemplate, it might be useful to turn our attention to the esoteric character of this contemplation. Already in 4 M.9 it is stressed that the prerequisite for approaching Christ's δόξα is a clean conscience. The contemplation is restricted to the pure and therefore is not a possibility open to one and all. When Cyril describes the effects of being possessed by the devil, he says that man becomes "darkened" and that the soul no longer sees.[243] And, when he gives an account of the devil's temptations, he confronts these temptations in the following way: "We have need therefore of divine grace, and a sober mind, and eyes that see clearly."[244] Here, the ability to see is linked to Divine grace. Indeed, the eye which sees the whole instead of merely the parts, can even appear as a Divine attribute: "being all eye and all ear and all mind" it is said in speaking of God.[245] At the same time we are given the impression that this seeing is to be understood as a rational act.

Ability to see God, as has been said before, is to be understood as a benefit which only the faithful may share. The precondition for such seeing is the enlightenment which only faith can impart to the soul. Of the soul it is said, thus: "For when it is enlightened by faith, the soul has visions of God, and contemplates God, as far as it may."[246] Through the soul the faithful are given the chance to contemplate God—although with the limitations καθ' ὅ ἐὰν ἐγχωρῇ represent.

The contemplation of God which takes place in the soul, is of decisive importance in acquiring the benefits of faith. Moving from a superficial

[242] 4 M. Cat. 9 (SC. 126. 144) with reference to Ps. 104:15. Harl, From Glory to Glory, stresses that the terminology functions as a reference to the effect of Baptism understood as participation in the divine glory, but at the same time serves as "l'exhortations au progres", see p. 734f.

[243] σκοτοῦται ὁ ἄνθρωπος, ἤνοικται ὁ ὀφθαλμὸς, καὶ δι' αὐτοῦ οὐ βλέπει ἡ ψυχή, Cat. 16. 15 (PG. 33. 940).

[244] Χρεία τοίνυν θείας ἡμῖν χάριτος, καὶ νηφαλίου διανοίας, καὶ βλεπόντων ὀφθαλμῶν, Cat. 4. 1 (PG. 33. 456).

[245] Cat. 6. 7 (PG. 33. 549).

[246] Περὶ Θεοῦ μὲν γὰρ φαντάζεται, καὶ Θεὸν κατοπτεύει καθ' ὅ ἐὰν ἐγχωρῇ, τῇ πίστει φωτισθεῖσα, Cat. 5. 11 (PG. 33. 520).

relationship to a true meeting with God corresponds to a journey from external, sensed phenomena to internal experiences: "You used to be called a catechumen, when the truth was being dinned into you from without: hearing about the Christian hope without understanding it; hearing about the Mysteries without having a spiritual perception of them; hearing the Scriptures but not sounding their depths. No longer in your ears now but in your heart is that ringing: for the indwelling Spirit henceforth makes your soul the house of God."[247] From speaking of hope man is led to seeing hope, from knowledge of the mysteries to grasping them, from instruction in the Scriptures to a perception of their depths, from the senses to the mental activity of the mind. The full and complete acquisition of the content of faith only takes place when man grasps it in his mind. In this way, Cyril finds a way to explain that external concrete occurrances are worthless if they only remain superficial, by which he means that they are not acquired with sincerity.[248]

This directive as to the realization of God's relationship to the inner man is natural as it is precisely the soul which is characterized as that part of man closest to God; the soul is God's highest creation, it is created in his image and capable of doing what it desires.[249]

This does not imply that Cyril perceives the inner man as the point of contact between man and God which is unaffected by man's fate in this world. Sin has, indeed, entered here also: "Sin burns, it cuts the sinews of the soul" (καίει γὰρ ἡ ἁμαρτία τὰ νεῦρα τῆς ψυχῆς).[250]

It is, therefore, within the inner man that the faithful are given the chance of contemplating God. The vision of God brings with it a deeper understanding of the mystery of the faith. We shall now look more closely at the content of these visions which Cyril recounts and thus try to describe the hope which can be seen, the mysteries which are revealed.

In connection with Chrism, we read that the catechumen was anointed on the forehead in order that he be freed from the shame borne by the first of mankind after the fall and that with uncovered face, as in a mirror, he could see the glory of God.[251] Here anointment is given a double purpose; it is interpreted with a view to God's act towards man while simultaneously mediating a vision of the Divinity. These two aspects

[247] Κατηχούμενος ἐλέγου, ἔξωθεν περιηχούμενος· ἀκούων ἐλπίδα, καὶ μὴ εἰδώς· ἀκούων μυστήρια, καὶ μὴ νοῶν· ἀκούων Γραφάς, καὶ μὴ εἰδὼς τὸ βάθος. Οὐκ ἔτι περιηχῇ, ἀλλ' ἐνηχῇ· τὸ γὰρ ἔνοικον Πνεῦμα, λοιπὸν οἶκον θεῖον τὴν διάνοιάν σου ἐργάζεται, Procat. 6 (PG. 33. 344).

[248] See Procat. 1 and 2, in which Cyril maintains that the baptismal act itself is not necessarily accompanied by an inner acquisition of what happens.

[249] Cat. 4. 18 (PG. 33. 477).

[250] Cat. 2. 1 (PG. 33. 384).

[251] 3 M. Cat. 4 (SC. 126. 126).

which we have treated previously in a Christological context, are arranged one after the other as supplements in an ecclesiological context. The vision of God appears as a benefit side by side with God's acts toward mankind. We shall now see how Cyril attempts to draw these aspects closer together.

The prerequisite for such an approach is that the Divinity is not only perceived as a reality beyond the world of man but that God, through the creation of the world and the incarnation is in fact present in the historical process. In a remarkable way, the linking of these factors mark Cyril's use of visions. We have already shown that a vision allows room for the Godhead. But, this is usually supplemented by motifs referring, first and foremost, to God's work on earth. A clear-cut example of the place alloted to Christ's historical acts within a visionary framework is to be found in 15.4 where it is said of Christ: "He, opening His divine and blessed lips, says: 'Take care that no one leads you astray'. You also, my hearers, seeing Him now with the eyes of the mind, listen to Him repeating the same words to you: 'Take care that no one leads you astray'."[252] The prediction of being led astray becomes a reality to the faithful because Christ becomes present in their minds and repeats the same words which he expressed when he was physically present on earth. The Christ "seen" by the mind is the same as the one who once carried out his works on earth but he is also the same as the one who has always been with the Father in heaven. He, who is seen by man, is the pre-existent and the incarnated one who once again takes his place on the right hand of the Father. We sense a certain tension between an earthly and heavenly aspect in this text, where a mental vision is utilized to associate the Divinity and Christ's previous activities in the mind's eye of the faithful.

We have seen earlier that Cyril's interpretation of God's work on earth unfolds in a composite pattern of actions. It is precisely in order to retain coherence in this complicated structure that the vision proves a valuable support. Cyril points out that when it is a question of retaining composite thought patterns, language reveals its greatest weaknesses. For example, the relationship between the Father and the Son requires so many words in order to explain it that one is led to believe that it is equally difficult to understand. The mind, however, is able to retain complex thoughts which take a great deal of time to explain in words: "Now while the mind's thought is very swift, the tongue needs words and much

[252] Ὁ δὲ τὸ θεῖον αὐτοῦ καὶ μακάριον ἀνοίξας στόμα, λέγει· Βλέπετε μή τις ὑμᾶς πλανήσῃ. Καὶ ὑμεῖς, οἱ ἀκροαταί, νῦν τοῖς τῆς διανοίας ὀφθαλμοῖς ὡς ἐκεῖνον ὁρῶντες, τὰ αὐτὰ καὶ πρὸς ὑμᾶς ἀκούετε λέγοντες· Βλέπετε μή τις ..., Cat. 15. 4 (PG. 33. 876).

intermediary discourse."[253] In this case, Cyril finds a parallel to the mind's capability in that of the eye which is capable of grasping something in full in a single moment. On this point the eye's ability corresponds with a specific adaptation in the mind.

It appears now that Cyril utilizes the vision precisely in order to retain particular types of complex thought patterns. We find a typical example in 16.16 where Cyril gives an account of what the soul can see with the help of the Spirit. The whole culminates in his passage about enlightenment of the soul: "As a man previously in darkness and suddenly seeing the sun gets the faculty of sight and sees clearly what he did not see before, so the man deemed worthy of the Holy Spirit is enlightened in soul, and sees beyond human sight what he did not know. Though his body is upon the earth his soul beholds the heavens as in a mirror. He sees, like Isaiah, 'the Lord seated on a high and lofty throne'; he sees like Ezekiel, 'him who is above the cherubim'; he sees, like Daniel, 'thousands upon thousands and myriads upon myriads'; and little man sees the beginning and the end of the world, the times in between, the successions of kings; in short, things he had not learned, for the True Enlightener is at hand. The man is confined within walls; yet his power of knowledge ranges far and wide, and he perceives even the actions of others."[254]

Cyril stresses that the soul is able to acquire other experiences than those obtainable by the body. In the first place, it is a matter of seeing a likeness of heaven as the prophets have seen it. What is striking about his words concerning the prophets' vision which allowed a glimpse of God in the fact that Cyril goes beyond what the prophets have told in order to describe what the soul can see in *this* world. By the context it is seen that the main emphasis is on this last aspect. Cyril presents a great number of examples in which the soul, with the help of the Spirit, can see happenings when the body has not been present. He limits himself to the beginning and the end of the world, but actually covers the entire historical process, exemplified by the succession of kings. The concern

[253] ἀλλ' ὅπερ ἐν ἀκαριαίῳ νοεῖ, τοῦτο ἐν ῥήμασι πολλοῖς διηγεῖται, Cat. 6. 2 (PG. 33. 540). As an example Cyril refers to the many words needed to explain about all the stars which the mind perceives in an instant.

[254] Καὶ ὥσπερ ἐν σκότει πρότερον τις ὤν, εἶτα ἐξαίφνης ἥλιον ἰδών, φωτίζεται τοῦ σώματος τὸ βλέμμα, καὶ βλέπει, ἃ μὴ ἔβλεπε, φανερῶς· οὕτω καὶ ὁ τοῦ ἁγίου Πνεύματος καταξιωθείς, φωτίζεται τὴν ψυχήν, καὶ ὑπὲρ ἄνθρωπον βλέπει ἃ μὴ ᾔδει. Ἐπὶ γῆς τὸ σῶμα, καὶ ἡ ψυχὴ κατοπτρίζεται τοὺς οὐρανούς. Βλέπει, ὡς Ἡσαΐας, τὸν Κύριον καθήμενον ἐπὶ θρόνου ὑψηλοῦ καὶ ἐπηρμένου· καὶ βλέπει, ὡς Ἰεζεκιήλ, τὸν ἐπὶ τῶν χερουβίμ· βλέπει, ὡς Δανιήλ, μυριάδας μυριάδων καὶ χιλιάδας χιλιάδων· καὶ ὁ μικρὸς ἄνθρωπος ἀρχὴν κόσμου βλέπει, καὶ τέλος κόσμου, καὶ μεσότητα χρόνων, καὶ βασιλέων διαδοχὰς οἶδεν· ἃ μὴ ἔμαθε· πάρεστι γὰρ ὁ ἀληθινὸς φωταγωγός. Ἔσω τοίχων ὁ ἄνθρωπος, καὶ ἡ δύναμις τῆς γνώσεως ἐκπέμπεται μακράν, καὶ βλέπει καὶ τὰ ὑπὸ ἄλλων γινόμενα, Cat. 16. 16 (PG. 33. 941).

throughout is to become familiar with the acts of the Spirit in the world: "You have seen His power, exercised throughout the world."[255] It is not profane history but God's activities in the world which comes within the category of what the soul can see.

Further, Cyril stresses that the knowledge transmitted in this way through the Spirit is of quite a different sort than the knowledge spread by people to each other. He not only maintains that the wisest men of Greece were not familiar with it but he also emphasizes that it is a question of something which *cannot* be learned.[256] The point is that the limits set by the body and worldly wisdom for the kind of knowledge man can acquire are abolished by the Spirit: "It was here shut up in the body, but the spirit given to me by God saw even things far away, and showed me what was happening elsewhere."[257] Aided by the Spirit, man is lifted up from an actual, everyday situation and given admission to experiences from elsewhere. As we have seen, this concerns in part the experience of heaven—the sight of heaven—in part the experience of God's activity in the world. The vision, in this case, becomes a sort of magnetic field where an attempt is made to combine the Divine Being with God's acts in the world. The soul is informed about the Divinity and God's work in the world, both combined in one vision. That this involves an expansion of the visionary form which threatens to shatter it, is sensed in 16.23 where Cyril, after summing up what the soul can see of the Spirit's worldly work, repeats the instruction in 16.16 by saying "Tarry no longer on the earth, but mount on high."[258]

We find exactly the same juxtaposition in 5.11 to which we have referred earlier (cf. p. 189). After discussing the soul which beholds God, the interest swing towards its ability to see conditions within the structure of this world: "It ranges over the bounds of the universe, and before the consummation of this world, beholds the judgment and the payment of the promised rewards."[259] Here, in the first place, there is clear emphasis on the two elements comprising the vision, the Divine Being and God's activities. In connection with the treatment of God's work, the soul's synthetical ability is emphasized, as mentioned earlier—it wanders beyond the boundaries of the world. At the same time, stress is laid on the hermeneutic function which can be extracted from this wandering: the soul beholds the judgment before the end of present time. This entails,

[255] Εἶδες αὐτοῦ τὴν δύναμιν, τὴν ἐν παντὶ τῷ κόσμῳ, Cat. 16. 23 (PG. 33. 949).
[256] Cat. 16. 17 (PG. 33. 941).
[257] ὧδε ἤμην ἐγὼ περικεκλεισμένος τῷ σώματι· ἀλλὰ τὸ πνεῦμα, τὸ ὑπὸ τοῦ Θεοῦ μοι δοθέν, ἔβλεπε καὶ τὰ μακρὰν, καὶ τὰ ἀλλαχοῦ γινόμενα σαφῶς ἐδείκνυέ μοι, Cat. 16. 17 (PG. 33. 944).
[258] Cat. 16. 23 (PG. 33. 949).

however, that the soul in seeing the whole expanse of God's acts, is thus prepared to apply these acts to itself. In beholding the judgement, the promised reward thus becomes the motivation for life here in this world. So the reference to the judgement serves first and foremost as the motive for behaviour here on earth. We sense here an accentuation in Cyril's method of utilizing the vision which corresponds to the interpretation of the ritual which we have reached earlier. The vision is not to be understood as a step on the way to a futuristic-eschatological consummation of salvation but rather as a help in maintaining the realization of salvation here and now.

The relationship between the futuristic and the present-time aspect in the vision theme is particularly well elucidated in Procat. 15. It is built upon God's exhortation to the soul to be pious. Almost as a reward for this piety, it is said that God will at one time show the catechumen his night, the darkness which is as light as the day. In the future man shall see God. That this meeting belongs to the end of time is further emphasized, as it continues, where it is maintained that the gates of paradise will be opened for the faithful. In the next moment, however, these future happenings are linked to the salvation bestowed through the baptismal water. At the end of time the faithful will rejoice that their contact with Christ was made in the baptismal water. In this way the futuristic aspect is connected with both the present-time aspect and the original event of Christ. From here on, attention mainly turns on the actual, present-time aspect. Cyril says: "Even now, I beseech you, in spirit lift up your eyes; behold the angelic choirs, and the Lord of all, God, on His throne, with the Son, the Only-begotten, sitting on His right hand, and the Spirit, too, and the Thrones and Dominations ministering, and every man of you and every woman receiving salvation. Even now let there ring in your ears that excellent sound which you shall hear when the Angels, celebrating your salvation, chant: 'Blessed are they whose iniquities are forgiven', on the day when, like new stars of the Church, you will enter, your bodies bright, your souls shining."[260] That God who, a short time ago, could only be seen in the future can now sud-

[259] κόσμου τε τὰ πέρατα περιπολεῖ, καὶ πρὸ τῆς συντελείας τοῦ αἰῶνος τούτου τὴν κρίσιν ἤδη βλέπει, καὶ τὴν μισθαποδοσίαν τῶν ἐπαγγελιῶν, Cat. 5. 11 (PG. 33. 520).

[260] Ἤδη μοι τῆς διανοίας τὸ ὄμμα ἀναβλέψατε· ἤδη μοι χοροὺς ἀγγελικοὺς ἐννοήσατε, καὶ δεσπότην τῶν ὅλων Θεὸν καθεζόμενον, Υἱὸν δὲ μονογενῆ ἐν δεξιᾷ συγκαθήμενον, καὶ Πνεῦμα συμπαρόν· θρόνους δὲ καὶ κυριότητας λειτουργοῦντας· καὶ ὑμῶν δὲ ἕκαστον καὶ ἑκάστην, σωζόμενον καὶ σωζομένην. Ἤδη ὑμῶν τὰ ὦτα ὥσπερ κατηχείσθω· ποθήσατε ἐκείνην τὴν καλὴν ἠχήν, ὅτε ὑμῶν σωθέντων οἱ ἄγγελοι ἐπιφωνήσουσι· Μακάριοι ὧν ἀφέθησαν αἱ ἀνομίαι, καὶ ὧν ἐπεκαλύφθησαν αἱ ἁμαρτίαι· ὅτε, ὥσπερ ἀστέρες τῆς Ἐκκλησίας, εἰσέλθητε φαιδροὶ τῷ σώματι καὶ φωτεινοὶ τῇ ψυχῇ, Procat. 15 (PG. 33. 357f.).

denly be beheld by the inner eye as can the whole Trinity. To this
Trinitarian vision, however, is added "every man of you and every
woman" (ὑμῶν ἕκαστος καὶ ἑκάστη). Procat. 15 shows why the faithful are
added to this vision; it is people who are included in God's earthly work
who are seen here with the Trinity. The change in perspective is carried
further through the identification of the futuristic vision with a vision of
the celestial. In Procat. 15, this change in orientation is directly linked
to the interpretation of salvation. The purpose of the sight of the Trinity
accompanied by the faithful is that now the angels will be able to cry out
to the faithful on earth: Μακάριοι, something which implies that they may
be considered "like new stars of the Church" (ὥσπερ ἀστέρες τῆς
Ἐκκλησίας). The perspective is moved from the future to the present in
order to emphasize, in this way, the present-day character of salvation.

Even the celebration of the Eucharist is influenced by visionary
themes. The celebration opens in traditional manner with Ἄνω τὰς
καρδίας, which instructs the mind to turn away from all wordly sorrows
and mundane troubles and instead direct itself towards God—*up* towards
God.[261] This lifting-up of hearts serves here as an exclusive concentration
on God. The entire beginning of the anaphora prayer is, therefore, con-
centrated on the glorification of this God, in which the congregation
stimulated by the cosmos' song of praise, praise the Lord. This praise
reaches its zenith when the congregation joins the heavenly song in its
concerted praise: Ἅγιος, ἅγιος, ἅγιος Κύριος Σαβαώθ. The congregation's
praise, joined with the Seraphim's, presumes that they visualize what
Isaiah beheld in his vision of heaven.[262] The vision, meanwhile, is not to
be understood as exclusive concentration on the Divine Being. This is
explicitly expressed in the first part of the eucharistic prayer in which the
reference to creation serves as the motivation for the thanksgiving offered
to God. Cyril then remarks that the God in heaven, who is to be thanked
here, is also τὸν φιλάνθρωπον θεόν.[263] It is likewise intimated in 5 M.5 that
the eucharistic prayer gives thanks for restitution through Christ. As
mentioned earlier (cf. p. 151) Cyril, unfortunately, does not discuss the
Post-Sanctus prayer in which thanksgiving for creation and incarnation
are probably to be found. Even so, it remains that the Sanctus hymn is
placed in a context where both the Divine Being and Divine act carried
out in the world are the motivation behind the congregation's participa-
tion in the Seraphim's songs of praise.

[261] 5 M. Cat. 4 (SC. 126. 150). For "sursum-corda", see Dölger, Sol Salutis p.
301-320.
[262] 5 M. Cat. 6 (SC. 126. 154).
[263] 5 M. Cat. 4 (SC. 126. 152).

This homage involves a genuine participation in that to which the thanksgiving applies. The faithful are simply drawn in and become a part of God's acts. This is brought out for the first time in the opening to the Sanctus where the Seraphim's song of praise and that of the faithful appear in unison.²⁶⁴ This aspect is then emphasized in the reception of the elements when the holy receive the holy. In the interpretation of the passage Τὰ ἅγια τοῖς ἁγίοις it is emphasized that the close relationship be established "by participation, training and prayer" (μετοχῇ καὶ ἀσκήσει καὶ εὐχῇ).²⁶⁵

Our study of the eucharistic prayer, because of the missing Post-Sanctus link, has not given any impression of the character of God's acts in this context. Nevertheless, Cyril's interpretation of the Lord's prayer conveys an impression of the position of futuristic-eschatological concepts within the celebration of the Eucharist. Particular interest is summoned by the interpretation of Ἐλθέτω ἡ βασιλεία σου. Here we find a completely moralizing interpretation focusing attention on the pure soul: "It is the man who ... has purified himself in action, thought and word, who will say to God: 'Thy kingdom come'."²⁶⁶ The passage can only imply that the kingdom of God is understood to be present in those here on earth possessing a pure soul.

Examination of the visions has, thus, shown them to be a complement to the interpretation we have given the ritual itself as an act. The rite concentrates on the association of Christ and the faithful and gives precise characteristics of the benefits of salvation which are mediated in this way. The visions which belong exclusively within the sphere of the faithful and which are usually linked to the celebration of the rite, fill out this framework. In the first place, the visions insure that what takes place in the ritual is not approached superficially. Then, the vision makes sure that the boundaries of interpretation allow space for all God's deeds in the world. In this way it becomes possible to regard the ritual not only in the light of Christ's past deeds but also in the light of God's acts at the end of time. It is just such an expansion we find in Cyril's visions even if it does not entail a dominating place for futuristic-eschatological concepts in the interpretation of ritual. Finally, the vision accompanied by the anaphora prayer extends the limits of the ritual act so that the soteriological aspect is organized under an all-encompassing perspective the object of which is to keep God and all God's work together as an entity.

²⁶⁴ 5 M. Cat. 6 (SC. 126. 154). Cyril maintains that when the congregation says Sanctus, this leads to κοινωνοὶ τῆς ὑμνῳδίας ταῖς ὑπερκοσμίοις γενώμεθα στρατιαῖς.
²⁶⁵ 5 M. Cat. 19 (SC. 126. 168).
²⁶⁶ 5 M. Cat. 13 (SC. 126. 162) with reference to Rom. 6:12.

4) Summary

Our analysis of Cyril's catecheses has been, to a great extent, concentrated on soteriological questions. In this connection, the rituals are of decisive importance because it is here the connection between the faithful and the benefits of salvation are established. A more precise understanding of what takes place in the ritual is linked to the interpretation of salvation itself. The analysis has shown that Cyril stresses the restoration theme in his interpretation of salvation, as does Jenkinson (cf. p. 157) but our study gives a more precise description of this restoration than we find in Jenkinson. We have stressed, in this context, the importance of the themes of healing and regeneration found in the catecheses. To what extent Cyril's interpretation of death can be connected with a restitutive theological perspective is difficult to decide. On one hand death belongs within a theme of life context. On the other hand it has a tendency to lead into a discourse on divinization. Here, however, we must point out that divinization does not primarily serve as the expression of meaningless self-glorification of free-will, just as the use of natural symbols cannot be considered the result of primitive need in the natural man as Lietzmann maintains (cf. p. 158). Both these aspects, however, are based on an understanding of salvation focused on its realization in the ritual.

To continue, we see a connection between this soteriology and Cyril's attitude towards the social situation affecting the Jerusalem congregation in the last half of the 4th century. Cyril's theology, which presumes a positive view of the created world, as it actually is, seems well suited to the contemporary situation.

Concentration on the present-time aspect of salvation does not imply a lack of interest in futuristic-eschatological concepts. Our study of visionary representations of God's acts clearly demonstrates that a present-time salvation is not only related to Christ's past acts of salvation but must be seen in the light of futuristic-eschatological concepts. Through visions, a particularly clear tension is maintained between the here and now and a futuristic realization of salvation. We have seen, nevertheless, that in Cyril's visions, interest in futuristic aspects of salvation swings around to concentration on present-time realization of salvation, thus supporting elements to which we have drawn attention in the interpretation of the ritual acts themselves. Even though Cyril's understanding of salvation implies a futuristic-eschatological dimension, the catecheses are not clearly directed towards the parousia. In that respect we consider our work a more distinct specification in relation to Kretschmar's hypotheses (cf. p. 157). The eschatological framework is not lacking, as Kretschmar claims, but it is not *emphasized*.

In addition, our study of visions has shown that tension between present-time and futuristic views of salvation form part of the vision's wider scope. This interpretation of the visions, moreover, presupposes that the theological field of interest covers more than soteriological questions. For here, Christ's deeds are not a matter of interest merely because of the new dimensions they offer for human existence but the horizon is also extended towards specific theo-logical perspectives. The foundation for everything said about soteriological problems lies in the Divine Being itself. The God who is not only important for man's existence but for the entire created world must be approached with the greatest meekness.

We find clear-cut connections between our interpretation of Cyril's catecheses and our iconographical pictures. The analysis has not only clarified how individual elements in the ambiguous paradise theme can be linked together but also has suggested a close relationship between the catecheses' visions and the theophanically inspired apsidal presentation. In the same way as in the apsidal mosaics, Cyril's visions help us to clarify the connection between the ritual act and the God who works in the world. In the ritual vision, God is present in the liturgical space in the way that Christology's past and future acts are in a way gathered into the actual ritual in question. In the analysis of Theodore we shall obtain a more precise understanding of the vision's place in the ritual context. At this point we shall merely underline the fact that Cyril's catecheses do not supply the only possible solution to the eschatological problem such as it is expressed in our apses. On the other hand, we maintain that this catechetical organization of the theme group, God and God's acts, reveals *one* possible way of interpreting the pictorial material. Only after examining a number of catecheses will we be able to decide whether or not this organization can be considered typical for the 4th century. The purpose of our further study will be a matter of finding a corresponding organization in the other textual groups.

THEODORE OF MOPSUESTIA

1. Introductory Remarks

a) The Text

The catecheses of Theodore of Mopsuestia have attracted a far greater amount of research than those of Cyril. The attention devoted to Theodore's baptismal instruction is undoubtedly a consequence of the clearly defined theology expressed here. In a rather different way to that of Cyril, Theodore joins the individual concepts of faith together into a distinctive structure. His work takes place within a milieu representing one of the most important traditions in early Christian theology. Theodore is considered one of the most outstanding representatives of Antiochene theology.[1] In him one can thus "hope to recover both the classical form and the original context of one of the two principal eastern traditions in patristic teaching about the Person of Christ".[2]

It is precisely his connection with this milieu which has led to Theodore's decidedly controversial posthumous reputation. When he died in 428, his theological work was looked upon with great approval.[3] Shortly after the Council of Ephesus (431), however, this theology is attacked for the first time and at this point the first collections of extracts from his writings appear.[4] Cyril of Alexandria furthers the attack on Theodore, who with his teacher Diodore of Tarsus is now put in the same category as Nestorius.[5] Opposition to Theodore's theology results in the repudiation of his entire theology by the 5th Ecumenical Council in Constantinople (553).[6]

[1] "It was he who first developed and systematized the theological outlook of the so-called 'Antiochene School' ", Norris, Manhood p. XI.

[2] Ibid. p. XII.

[3] Quasten, Patrology III p. 401.

[4] Ibid. p. 414.

[5] For Diodor of Tarsus, see Sullivan, Christology p. 181-196 and Koch, Heilsverwirklichung p. 236-242. Koch maintains that it is hardly possible to relate Diodore to Theodore in order to establish theological dependence: "Ein solches Unterfangen muss scheitern, weil von dem Werk Diodors noch ungleich weniger erhalten ist als von den ja auch nur zum geringsten Teil überlieferten Schriften Theodors", Koch, Heilsverwirklichung p. 236.

[6] Quasten, Patrology III p. 414.

One of the disputed questions in more recent Theodore research focuses precisely on this council's resolution of 553. Do collected extracta used by the opposition (in their case against Theodore) and which formed the basis of the synodal decision convey a correct picture of his theology? In this debate, Theodore's catecheses play an important role.

The catecheses, which became available through A. Minganas' publication of 1932/33,[7] provide a completely new type of source material for the study of Theodore's theology. For the first time in modern times there is now access to a comprehensive collection of texts from his own hand. This opens the way to a re-evaluation of his theology in its entirety.

The catecheses themselves divide quite naturally into two main groups; the first ten are commentaries on the baptismal symbol, which is a local variation of the Niceno-Constantinopolitan Creed,[8] while the last six interpret the Lord's prayer, Baptism and the Eucharist. The first group has been used during Lent but it is uncertain whether the last six have been used before or after the baptismal act.[9] Thus, we face catechumen instruction which, at least in its outer structure, is very similar to that of Cyril.

The publication of these texts caused the controversy over the reliability of earlier sources for Theodore's theology to flare up again. R. Devreesse maintains that the quotations from Theodore's texts known to us from the documents of the 5th Ecumenical Council cannot be considered reliable. On the other hand, in his opinion, the Syriac translations of Theodore's work are dependable.[10] M. Richard has endeavored to support this view by translating from Syriac to Greek texts which also have been recorded by Leontius of Byzantium (543 +) in Greek and by then comparing them. But, while Richard maintains that Leontius' text "was modified by a theologian well aware of what he was doing",[11] Sullivan contends that changes in an orthodox direction have been made in the Syriac text about the middle of the 5th century.[12] J. McKenzie has evaluated the two interpretations, one against the other, and arrived at the following result: "It has been proved, and Sullivan has accepted the

[7] Mingana V and VI contain Cod. Mingana Syr. 561 with English translation. For text criticism see Mingana V p. 1-18.

[8] Quasten, Patrology III p. 409.

[9] Ibid. p. 408-409 means that the mystagogical catecheses are addressed to the neophytes in the course of the week following Baptism. Janeras, on the other hand, maintains that only the last catechesis was delivered in the week following Easter, Janeras, En quels jours p. 121-133.

[10] Devreesse, Essai.

[11] Richard, Tradition p. 66 (reference from McKenzie, Annotations p. 348).

[12] Sullivan, Christology p. 80-82.

proof, that the compilations exhibit in some instances the compiler's way of putting a thought rather than that of the author; and it has certainly been shown that the compilers did not feel themselves bound to reproduce every phrase, every last word of their prototype. Until the dishonesty and bad faith of the Syriac translators have been equally well demonstrated, it is difficult to see how we can treat the two sources as of equal value.''[13] We consider, as does McKenzie, the Syriac translation of Theodore's text as a reliable source for Theodore's theology.

This debate has also led to renewed interest in the premises for the synodal decision in 553. Evaluation then, as evaluation for researchers who stress Theodore's heterodoxy, has been governed, to a great extent, by dogma developed after Theodore's death. Thus, the discussion about the role played by the expressions nature and person in his theology is frequently influenced by dogmas long after his time. It is, of course, quite legitimate to examine Theodore's use of these terms. On the other hand we are sceptical of attempts to repudiate his theology on the basis of comparison with posterity's demands for orthodoxy. We find McKenzie's approach engaging: ''I suggest that Theodore's Christology is no more and no less than what we should expect it to be in a man who lived in his time and his theological milieu. The Christology of Theodore is not the Christology of Ephesus and Chalcedon; nor do I think we should expect it to be. Neither is his terminology that which was elaborated in these Councils and in the theological discussions which took place before, during, and after them.''[14] In associating ourselves with such an evaluation we become somewhat removed from the debate concerning Theodore's relation to codified ecclesiastical instruction. From a methodological viewpoint this is an advantage, for such a discussion is apt to acquire an anachronistic character, while at the same time attention is deflected from interesting sides of Theodore's theology.

b) Catecheses and the Historial Milieu

Before making a closer examination of the more recent debate concerning Theodore's theology we shall attempt briefly to place the catecheses in an historical perspective. To place them within an exact historical time span is, however, rather a problem. Indeed, it is just as difficult to give a conclusive time for the catecheses as it is to place their origins geographically. We know that Theodore was ordained by the Bishop of Antioch c.383 and that he became Bishop of Mopsuestia in Cilicia in

[13] McKenzie, Annotations p. 354.
[14] Ibid. p. 370.

392.[15] It is, meanwhile, uncertain whether he held his catecheses before or after he became bishop. J. Quasten assumes that they were held in Antioch,[16] whereas Lietzmann believes them to be from his period as bishop.[17] It is, nevertheless, obvious that even if they were held while he was bishop, the region was still within the area influenced by Antioch: "Mopsuestia belonged to the Patriarchate of Antioch, being a suffragan of the metropolitan see of Anazarbus, which in turn was a suffragan of Antioch."[18]

The catecheses provide a very flimsy base on which to form an opinion of the social status of the audience. The impression is, however, that they have been aimed at a reasonably well-educated group of members. The abstract, philosophical way of expression points in this direction even though these characteristics convey, first and foremost, an impression of Theodore's own cultural background.[19]

From the catechetical material it is, likewise, difficult to form a clear impression of Theodore's attitude towards the social environment in which he lived. In scattered glimpses he indicates, however, a markedly detached view of large parts of the community life surrounding him and his catechumens. This is clearly reflected in his interpretation of the baptismal renunciation of the devil. It is said here that all who are preoccupied with "outside wisdom", and bring the mistakes of the heathen into the world, belong among the angels of Satan.[20] The attack is aimed at "poets who maintained idolatry by their vain stories" as well as "those men who under the name of philosophy established devastating doctrines among pagans, and corrupted them to such an extent that they do not acquiesce in the words of the true religion".[21] It is evident that the connection to paganism forms the basis for his disapproval of both poetry and philosophy. The framework of Theodore's thinking is explicitly expressed in the following quotation: "Service of Satan is everything dealing with paganism, not only the sacrifices and the worship of idols and all the ceremonies involved in their service, according to the ancient custom, but also the things that have their beginning in it."[22] Working from this, Theodore is able to direct his attack against aspects

[15] Quasten, Patrology III p. 401. For biography see Carter, Early chronology p. 87-101.

[16] Ibid. p. 409.

[17] Lietzmann, Liturgie p. 72.

[18] Reine, Eucharistic Doctrine p. 3f.

[19] Theodore studied rhetoric and literature under Libanius, Quasten, Patrology III p. 401; see also Dewart, Theology of Grace p. 3ff.

[20] Mingana VI. 39.

[21] Ibid. VI. 39f.

[22] Ibid. VI. 41.

of the ancient culture where the connection to paganism probably has been relatively vague towards the end of the 4th century.[23] Thus, he rages against "the theatre, the circus, the racecourse, the contests of the athletes, the profane songs, the waterorgans and the dances, which the Devil introduced into this world under the pretext of amusement, and through which he leads the souls of man to perdition".[24] This disapproval of the culture of Antiquity, in a rather wide sense, can be seen as a further development of early Christian traditions. But, on the basis of 4th century political development and Cyril's attitude towards it (cf. p. 149), Theodore's vehement diatribe seems at first glance somewhat surprising. In Antioch, however, which is Theodore's background, the social situation is rather different from that of Jerusalem. Even though Antioch is considered largely Christianized by the middle of the 4th century, it must be remembered that the city was an ancient centre of Hellenistic culture with famous temples and local Olympic games.[25] It is probably because of its close association with Hellenistic cultural life that Julian chose Antioch in preference to Constantinople as the centre for his reform movement.[26] It was here, too, that Julian's friend, the rhetor Libanius settled in 354 and remained at least until 393.[27] Libanius' writings convey an excellent impression of the cultural climate in the city.[28] Although he had both pupils and friends who were Christians,[29] he represented a decidedly anti-Christian attitude. The Christian faith was to him a declared enemy of Hellenistic tradition.[30] Other sources reveal that this conflict was not limited to a small cultural élite around Libanius.[31]

[23] Downey, Antioch p. 440f.

[24] Mingana VI. 43.

[25] Downey, Antioch p. 382.

[26] Ibid. p. 381f.

[27] Ibid. p. 373.

[28] "One of the most important services of Libanius is to allow us to see the cultural life of the *polis* as this had maintained itself at Antioch. We get a very strong sense of the vigorous educational and cultural activity of the city, supported as they were by the economic prosperity and political prestige which Antioch enjoyed", Downey, Antioch p. 375.

[29] Ibid. p. 379.

[30] "Public festivals and athletic contests ... represented an essential part of the life of the Greek city. In this framework there was no room for Christianity, which, to Libanius and his friends, not only played no part in the traditional life of the *polis*, but was an avowed enemy of the tradition itself. It was the Greek heritage, not the new religion, that was the living reality", Downey, Antioch p. 375.

[31] Downey, Antioch p. 387f. gives examples of cultural confrontation during the reign of Julian. See, however, Liebeschuetz, Antioch, who moderates the significance of the conflicts between Christianity and paganism in Antioch in the last part of the 4th century, p. 224ff.

John Chrysostom's ideal picture of Christians corresponds well with the contrasting pattern drawn by Libanius between Christian and Hellenistic culture. Chrysostom carried on a continuous struggle to hinder the faithful from participating in any form of entertainment having roots in Hellenistic culture.[32] This is probably also the background for Theodore's outspoken attacks on Hellenistic culture. It is of particular interest, in our context, that this state of conflict should still exist at the end of the century. The political events at the beginning of the century paved the way for a cultural struggle which, as far as Antioch is concerned, lasted throughout the entire 4th century. In analysing Theodore's theology we shall endeavor to find the connection between this cultural milieu and Theodore's perception of eschatology. Our main interest, however, is to be found in Theodore's treatment of the eschatological problem within the liturgical context. We shall draw particular attention to the way in which Theodore treats visual motifs within the ritual and the connections which may exist between Theodore's use of visions and the iconography previously treated. As a background for our interest in Theodore's ritual we must look more closely at the structure of the rite found in the catecheses.

c) The Antiochene Liturgy

As has been said earlier, Theodore's rite belongs to the Syriac liturgical family and is thus related to the structure of Cyril's and James' ritual (cf. p. 152). Lietzmann has extracted the liturgical information from the catecheses in order to find Theodore's liturgical structure,[33] and he also proves similarities with the other Antiochene liturgies such as the Clementine liturgy from the 8th book in the Apostolic Constitutions,[34] the liturgy in Chrysostom's Homilies[35] and later Byzantine rites.[36]

We limit ourselves to a closer examination of Theodore's formulation of the anaphora prayer itself because what we are searching for is the direct connection between the apsidal presentation and the liturgy related to the celebration of the Eucharist. In content the pre-Sanctus differs from the Apostolic Constitutions in which the Sanctus is the climax of the thanksgiving for God's good deeds for mankind from creation until the entry of the people of Israel into the promised land. Although Theodore

[32] Downey, Antioch p. 439ff.
[33] Lietzmann, Liturgie p. 71-97, see also Rücker, Ritus and Reine, Eucharistic Doctrine.
[34] Brightman, Liturgies p. 3ff. with the anaphora on p. 14.
[35] Ibid. p. 470ff. with the anaphora on p. 473.
[36] Ibid. p. 309ff.

gives no detailed information about the content in this section, we note that the interpretation of the Sanctus is centred around Trinitarian concepts—indeed, the prayer is offered to the Trinity. We recall that Trinitarian themes also played a certain part in the James anaphora but there they first appear after the Sanctus (cf. p. 154). Lietzmann considers Theodore's formulation as a further development in relation to the James anaphora.[37] In this way the Sanctus is given another function than in the Apostolic Constitutions as it no longer acts as the climax in a thanksgiving for God's acts but rather as the crowning point in a cosmic glorification of the Trinitarian Divine Being. Concentration on the Divine Being functions simultaneously as a background for the post-Sanctus where the prayer (as distinct from the Alexandrian prayer structure) continues as a thanksgiving for Christ's economy. And, the post-Sanctus, as in the James anaphora leads directly into the words of institution, anamnesis and epiclesis. The words of institution are merely implied through the formulation "when our Lord was about to draw nigh unto His Passion, He instructed His disciples ..."[38] The anamnesis, too, is suggested merely as a liturgical element.[39] In addition, the epiclesis with the prayer of consecration is short and to the point in style, reminiscent of Cyril's formulation: "It is with great justice, therefore, that the priest offers, according to the rules of priesthood, prayer and supplication to God that the Holy Spirit may descend ..."[40]

Thus, Theodore's prayer appears to be a further development of the liturgical structure we recognize from Cyril's catecheses. The most important difference is without any doubt the clarified function of the Sanctus as an interpretive link between the praise offered to the Divine Being and the thanksgiving for God's work throughout history.

d) The Theological Milieu in Antioch

Antioch came to play an important liturgical role in early Christian times. All surviving eastern rites, apart from those few stemming from

[37] "Wir befinden uns vielmehr deutlich auf dem Wege zu den kurzen Anaphoren der späteren Zeit, die nur allgemein Lobesformeln enthalten, und von denen Ja. 50, syr. 10f. eine gute Vorstellung gibt. Die Entwicklung ist bei Theodor aber bereits insofern über Ja. hinausgeschritten, als er auch diesen Gebetsteil trinitarisch formuliert, wie Ba. Chr. 322f. und Nest. 283f. der Fall ist", Lietzmann, Liturgie p. 92.

[38] Mingana VI. 103. While Lietzmann maintains that the words of institution are not mentioned because of "die mysteriöse Scheu vor dem Aussprechen der heiligen Worte ausserhalb der sakramentalen Anwendung", Lietzmann, Liturgie p. 93, Reine says with support from Brightman, that the main reason for the omission is Theodore's emphasis on the epiclesis. About the words of institution he says: "Theodor clearly does not consider them the 'form' of consecration", Reine, Eucharistic Doctrine p. 137.

[39] Mingana VI. 103. See Reine's discussion with Lietzmann in Reine, Eucharistic Doctrine p. 137ff.

[40] Mingana VI. 104; see Reine, Eucharistic Doctrine p. 141ff.

Alexandria, are closely related to the Antiochene ritual pattern.[41] There is a certain conflict between the powerful liturgical influence emanating from Antioch and the disordered theological milieu marking the city throughout the greater part of the early Christian period. Agreeing with W. Bauer, Shepherd maintains that Antioch was pervaded by Gnosticism throughout most of the 2nd century.[42] Thereafter, problems followed in quick succession: "In the third century, it was rocked by the respective partisans of Monarchianism and Origenistic trinitarianism. The most unhappy period was the fourth century. From the Council of Nicaea to the end of the century, Antioch was rent by schism, sometimes of two, sometimes of three factions. It was incapable of exerting influence at a time when it might have counted for much. The see had hardly recovered its unity and strength when it was humiliated by the Christological controversies set going by Nestorius. From that time onwards, its precarious unity was doomed."[43] Of particular interest in our context are naturally the conflicts which took place in the 4th century. Theologically these were brought about by the schism between Arians and the orthodox,[44] but many other factors played their part in making the fight irreconcilable.[45] As a result of the hefty conflicts which marked Antioch throughout the 4th century, the theological scene was never dominated by one particular school—Apollinaris taught in the city c.375 and Cyrillus and Eutyches had followers there.[46]

It is possible, nevertheless, to trace a coherent theological tradition in Antioch also through this century. At just this time, with its roots in earlier local traditions, a distinctive Antiochene theology develops.[47] We shall recount some of the main characteristics from a typical interpretation of this theology as a frame of reference for our own study of Theodore's theology. According to B. Drewery, the emphasis on the difference between God and man is of great importance in Antiochene theology.[48] Antiochene Christology in its entirety is seen as derived from this problem. Correspondingly, W. Elert interprets the concept of *finitum non capax infiniti* as the essential mark of Antiochene Christology.[49]

[41] Shepherd, Formation p. 30.

[42] Ibid. p. 29 with reference to Bauer, Rechtglaubigkeit p. 67-70.

[43] Ibid. p. 29; for further reading see Shepherd p. 28 note 18 and p. 29 note 21 and 22.

[44] See Downey, Antioch p. 359f.; p. 396ff.; p. 410ff.; and p. 414ff.

[45] Drewery, Antiochien p. 110 mentions in this context "persönliche Antipathien, Rivalität zwischen den grossen Bischofssitzen, wachsender Gegensatz zwischen Ost und West, kaiserliche Intervention und Spannungen zwischen Kirche und Staat".

[46] Ibid. p. 112.

[47] Ibid. p. 106.

[48] "Der 'Abgrund' zwischen Gott, dem Ungeschaffenen, Ewigen, Unvergänglichen, Leidlosen, und dem geschaffenen, sterblichen, vergänglichen und dem Leiden ausgelieferten Menschen ist unaussprechlich und unüberbrückbar", Ibid. p. 107.

[49] Abramowski, Zur Theologie, with reference to Elert in note 130.

Drewery finds another central Christological point in the Antiochene view of redemption in which sin and the fall of man are emphasized at the expense of the incarnation. This led to an accentuation of the anthropological pattern: man in creation—man after the fall—man after redemption, which in turn presumes a Christology centred around the history of salvation.[50] In keeping with this thought, Drewery sees the redeemed man as "der wiederhergestellte Mensch der Schöpfung und niemals der gottgewordene Mensch",[51] which is considered to be a typically Origenistic idea.

Drewery's latest contention agrees with one of the interpretations which has been forwarded in discussing Theodore's theology. W. de Vries' principal accusation against Theodore's Christology is aimed at presisely the point that as a result of the sharp division in the two natures of Christ, he is not able to emphasize man's divinization. According to De Vries, man in this world is given merely a widened knowledge of religious truth and the possibility of a life corresponding to this knowledge.[52] Salvation here and now becomes in the end solely a moral aid in avoiding sin.[53] The strong accent on eschatology in Theodore's reasoning is understood to be a consequence of this perception of salvation: "Das Heil ist also nach allem bei Theodor eschatologisch gefasst und es bedeutet für den Menschen kaum eine wahre Vergöttlichung."[54] In De Vries' opinion, the eschatological emphasis is a result of an unsatisfactory realization of salvation here on earth. What cannot be realized on earth must be pushed into the future.[55] On this basis De Vries contends that Theodore is a Nestorian before Nestorius.[56] This conception of Theodore as a heterodox theologian finds support in a great number of important studies of Theodore.[57]

As we have already intimated, interpretations of this sort have not been unaffected by research into Theodore's catecheses. Although everyone agrees that Theodore puts great emphasis on the separation of Christ's two natures, this does not necesarily lead to the kind of results stressed by De Vries. Thus, I.Oñatibia for example, maintains that the reality of salvation according to Theodore is experienced in this life, while simultaneously he emphasizes that it is first and foremost the

[50] Drewery p. 108.
[51] Ibid. p. 109.
[52] De Vries, Das eschatologische Heil p. 324.
[53] Ibid. p. 309.
[54] Ibid. p. 325.
[55] Ibid. p. 309.
[56] De Vries, Nestorianismus p. 146ff.
[57] For further study, see Koch, Heilsverwirklichung p. 16-22.

celestial reality which forms the frame of reference for this actualization.[58]

This glimpse of the discussion concerning Theodore's theology shows that his perception of eschatology has played a central part in the debate. On that score, there is a close correspondence between our own field of problems and other contributions to an interpretation of Theodore's theology.

2. The Dogmatic Framework

a) Our Approach to the Study of Theodore's Catecheses

We pursued the study of Cyril's catecheses as far as to an analysis of the subject of visions. We found that such visions are usually related to the interpretation of the ritual and that their task is to supplement the understanding of it. We have also stressed that Cyril's visions are primarily centred around God's work in the world; at the same time it is underlined that this work originates in God himself. We noted, furthermore, that Cyril's interpretation of God's work tended to accentuate a present-time perception of salvation which in a way led to a reduced interest in the futuristic-eschatological perspective. We found remarkable agreement between the subjects of the ritual's visions and the apsidal pictures; the visionary subjects in the rite seemed to correspond with the visions familiar to us from our iconographical analysis. In studying Theodore's catecheses we shall endeavor to determine the relation between the ritual vision and the apsidal vision more closely. At the same time we shall attempt to clarify the theological profile which is characteristic of Theodore's interpretation of ritual.

In Theodore's catecheses, too, we find a remarkable interest in visual themes.[59] In the introduction to his interpretation of the Creed, he draws attention to the question of religion which is just as invisible as it is ineffable. This implies that to see the Divine nature with the help of one's eyes is impossible. This does not entail, however, that an approach to the

[58] Oñatibia, La vida cristiana p. 100-133.

[59] Koch, Heilsverwirklichung maintains on the other hand that themes connected to visions of God, do not play an important part in Theodore's writings: "Diese (die Gemeinschaft mit Gott) bleibt überhaupt blass und wenig hervorgehoben. So auch fehlt die Anschauung Gottes als essentielles Moment der Beseligung fast völlig, der Gedanke einer Teilnahme an der göttlichen Natur, der Vergöttlichung ist nahezu gänzlich zurückgedrängt", p. 157. In our analysis, we do not take our point of departure in visual themes alone, but we wish to demonstrate that they play an important role in Theodore's treatment of "the question of religion".

Divine nature becomes completely beyond reach. On the contrary, Theodore maintains that it is precisely this invisibility which allows faith to make it possible for the mind to see God.[60] Anything concerning God is approached with faith aided by the mind.[61] Like Cyril, Theodore adheres to an exclusive element in this approach. The invisible thing which is confined within "the question of religion", can only be beheld by a faith which is healthy and pure.[62]

In this same matter Theodore, too, dwells upon the content of what the mind beholds: "The question of religion consists in two things: confession concerning God and concerning all the various and numerous things that were and will be made by Him."[63] As with Cyril we see that the vision encompasses God and his work.[64] Again as with Cyril, God's acts are primarily linked to Christ's "economy". Thus in VI. 44, the Divine nature and benefits of salvation which spring from Jesus' economy are invisible and must therefore be approached through faith.[65]

Similarity to Cyril extends even further; also Theodore's presentation of the subject of visions tends to take place within a ritual context. In his commentory on the introduction to the eucharistic prayer "lift up your minds", which Theodore considers a necessary preparation for the Eucharist as a whole, we find a short recapitulation of the vision's place within the ritual context: "Although we are supposed to perform this awe-inspiring and ineffable service on earth, we, nevertheless, ought to look upwards towards heaven and to extend the sight of our soul to God,

[60] "Because the question of religion lies in the belief in things that are invisible and indescribable, it is in need of faith, which causes mind to see a thing that is invisible." (Mingana V. 22). Further on we find statements in clear contrast to Koch's interpretation (see note 59): "We are enabled by faith to be worthy of seeing the nature of God 'who is the sole invisible and incorruptible, who dwelleth in the bright light which has no equal, and whom no man hath seen nor can see'." Mingana V. 22.

[61] Norris, Manhood, rejects the idea that this plays an important part in Theodore's theology at all. According to Norris, the soul has no possibility of transcending the visible world: "As he relinquishes the Neo-Platonic emphasis on the contemplative activity of reason, so also he ignores the idea of the soul's transcendence of the visible world—its interior exemption from the forms of temporal existence", p. 130. According to Norris the mental possibilities are solely moral: "As Theodore sees it, reason is a capacity for moral judgement and moral choice", p. 132.

[62] Mingana V. 25: see also Mingana V. 81.

[63] Ibid. V. 22.

[64] The thematic connection between "Anschauung Gottes", "Beseligung" and "Vergöttlichung" suggested by Koch (see note 59), is misleading.

[65] "As Divine nature is invisible, faith is called to the help of the person who draws nigh unto it, and who promises to be constantly in its household. The good things that (God) prepared for us, through the Economy of Christ our Lord, are likewise invisible and unspeakable, and since it is in their hope that we draw nigh unto Him and receive the sacrament of baptism, faith is required so that we may possess a strong belief without doubt concerning these good things which are prepared for us and which are now invisible", Mingana VI. 44.

as we are performing the remembrance of the sacrifice and death of Christ our Lord, who for us suffered and rose, is united to Divine nature, is sitting at the right hand of God, and is in heaven, to which we must extend the sight of our soul and transfer our thoughts by means of the present remembrances. And the people answer: 'To Thee, O Lord' and in this they confess with their voices that they are anxious to do so.''[66] Here Theodore describes the contemplation as directly connected to the sacramental act. Then we find the same orientation of the subject which we have met earlier. In the ritual program declared here, the mind's eye is directed towards God.[67] At the same time, however, Christ who is also in heaven after his passion and resurrection, is beheld.

When we now set ourselves the task of attempting to penetrate into the more exact content of Theodore's visions of this kind, it is natural to take our point of departure in his Christology which in this connection appears to be the most problematical. Immediately, we are faced with the Christological tensions disclosed in VI.99. The mention of Jesus is based on his suffering and death for the sake of man but then attention is directed to Christ's celestial life where nearness to the Divine nature becomes the object of interest. Reference to heaven is not to be understood here as an indication of place but is intended rather to connect Christ with the Divinity and in this way functions as an ontological determination.

The state of tension in the Christology is even more clearly expressed in Theodore's account of Christ's incarnation. Theodore says: ''We are not to think that Divine nature which is everywhere moves from place to place, because this Divine nature has no body, it cannot be circumscribed in a place. He who is not circumscribed is everywhere, and He who is everywhere it is not possible for us to think of Him that He moves from place to place.''[68] In a more detailed account, Theodore refers to John 1:10-11 where ''He was in the world'' is interpreted as expressing that God is omnipresent, but ''He came unto His own'' denotes his economy. Even though the Divine nature is described here as omnipresent, this does not prevent Theodore from maintaining, at the same time, that the Logos is ''above all'', because he is the origin of everything.[69] The omnipresent and heavenly Logos points to the Divinity

[66] Mingana VI. 99.

[67] For further reading about the imagery, see Bjerre-Aspengren, Bräutigam p. 121ff.; see also Wilpert, Auge p. 964.

[68] Mingana V. 52.

[69] ''He is eternally from His Father, is always with Him, and is above all as He is the cause of everything'', Mingana V. 53.

of Christ, the descent from heaven to earth describes his economy. For
Theodore, these ideas are inseparably linked.

In the first place we shall attempt to delve more deeply into Theodore's
utilization of visions by taking a closer look at the profile of his
Christology and the role it plays within his interpretation of life. We
follow this with a study of Theodore's association of Christology with
visions as well as the actualization to which this subject belongs.

b) The Ontology

Theodore's understanding of Christ's works can only be interpreted in
a satisfactory way if seen against the background of his interpretation of
the relation between God and the world. It is Theodore's reflections con-
cerning ontology and the theology of creation which form the founda-
tion for the organization of the Christology. The main intention of
Theodore's ontology is to place God and man in the right relation to one
another. The point of departure is Exodus 3:14-15: "When He says: '*I
am that I am*', this is my name for ever and this is my memorial unto
generations', we understand that God is called by this name, because He
is truly '*I am that I am*', while all the created beings are not truly '*I am
that I am*', because they were created from nothing according to the will
of their Maker. Because He is the true being, He is called '*I am that I am*',
and He is not made by another.''[70] We see at once that Theodore's main
purpose in utilizing Exodus 3 is to draw up the boundaries between God
and created beings. This demarcation does not mean that created beings
are denied ontological status. Theodore elaborates upon this by main-
taining that many beings bear the name "I am", simply because they
"are". And, these beings who lay claim to existence *do* in fact exist. The
point is, on the other hand, that to exist—or the name "I am"—belongs
to God in a special way because he has existed forever and eternally.[71]
Just as God is the only true father, only God can be granted true being:
"In truth He is 'I am' alone.''[72] This true being stands in an insoluble
relation to truth. In the Scriptures, a falsehood is called something tran-
sitory in contrast to truth which is intransitory and lasts forever.
Theodore supports the thought by using an illustration: The correlation
between truth and being is shown in the way that one who affirms some-
thing which exists, tells the truth.[73] Thus, truth conveys meaning only

[70] Mingana V. 30.
[71] Ibid. V. 98.
[72] Ibid. V. 99.
[73] "(The Book) calls falsehood a perishable thing that is not permanent, and truth an
imperishable thing that is permanent. Because the one who affirms a thing which does

when it is associated with being. So, adherence to being in an object expresses truth. It becomes obvious that truth cannot be fully expressed in an object having merely transitory existence. Only "a thing which lasts and exists permanently", expresses truth (cf. note 73).

Theodore carries the matter further and ties this idea of truth to man's experience in the world. These experiences reveal that that which concerns man is considered as nothing and must, therefore, be regarded as an expression of falseness. Here he mentions wealth, power and might which are usually considered things which count amongst people. All of this is an expression of falseness in that it is limited to a life span. The conclusion is that even our existence must be considered false since it is cut off at death, which definitively confirms that we are nothing.[74] Being can never be fully expressed in the human sphere. It is the lack of recognition of this which leads to the false concepts man creates about himself. On the other hand, it is in the question of death that the key to a relevant understanding of human existence is to be found. That again is to say; because human existence is limited, it is not the expression of true being.

Theodore, however, has more to say about this limitation of existence. He wants to make it clear that only when man subjectively experiences the change from pride in existence to the feeling that "I was nothing", does the awareness of derivative, dependent existence occur: "I was about to perish, if Thy wonderful help had not assisted me."[75] The experience of existential nothingness creates a metaphysical "experience"—false being is felt to be dependent upon true being. Derived existence thus becomes the distinguishing mark of human existence in contrast to that of the Divine.[76]

Derived existence is then related to the created sphere. In created beings there is nothing which can endure by its own means, but everything created receives its being through something else. Nor can created things mediate anything lasting to others since their own existence is dependent upon the Creator.[77] The created being is thus in

not exist lies, and the one who affirms a thing which exists, tells the truth, it (the Book) calls falsehood a thing which does not last because it becomes like a thing which does not exist, while it calls truth a thing which lasts and exists permanently", Mingana V. 106.

[74] "I found by experience that human things are nothing and that in truth they are all false: wealth, power, might, and all things which are considered by men to be great and wonderful. All these things, nay, even the fact of our existence are also false, because we make show of this fact of our existence to deceive those who see us, while eventually we are cut off by death and reminded that we are nothing, and all the great things that we are supposed to possess leave us at the end of our life", Mingana V. 106.

[75] Mingana V. 106.

[76] "In created things there is nothing that can last by itself; the one who may be so constituted is so through another", Mingana V. 107.

[77] Ibid. V. 107.

an uninterrupted state of dependence which must not be broken in order
that the created one shall remain a created being. In this way, the created
one is in a state of tension between his own nothingness and God's ''let
there be''. Only through participation in God's being, understood as the
will to create, does man maintain his ontological status.

If we now return to Theodore's understanding of God, we find here
too an ontological connection to the subject of creation: ''God is one,
who is from eternity and is the cause of everything ... It was in no need
to be made by another, because it is the cause of everything. This is the
reason why He is God alone, and anything that is made cannot by nature
be God, as it is made by another. All the created things rightly attribute
their existence to their Creator who is God, to whom they owe their
being, and for this they are under an obligation of gratitude to Him who
by His own good will and power vouchsafed to them to be what they
are.''[78] We see that the contrast between God and the created being
emerges as an ontological contrast. That which is characteristic of God
by nature, will never be man's by nature. Thus, man's ontological status is
not changed by man's becoming involved in sin. The fall is, thereby, to be
understood as a result of man's ontological state. According to Theodore,
man would never have come into contact with evil if he had been a god
by nature.[79] Not even after man, through salvation, participates in
Divine qualities is there any change in ontological status, because these
qualities are not something which man has by nature but, on the con-
trary, it is a question of received qualities.[80]

Thus, Theodore's ontology comes to indicate the pattern for his entire
teaching of mankind's relation to God. The problem is, meanwhile, that
man's attitude towards God is not unequivocally clarified in the descrip-
tion we have set forth hitherto. When man's ontological situation is
perceived as a state of dependence upon God, it involves the possibility
of a change in the relationship between God and mankind. Above all, the
course of history brings about a shift in man's relation to God.

Theodore, in fact, assumes that the basic positive, ontological connec-
tion between man and God is not to be fully realized within the bounds
of this world. That the created world has become such a mess, Theodore
blames on man himself. This is most clearly expressed by the change
already met by the imago concept at the creation of man: ''Our Lord
God made man from dust in His image and honoured him with many

[78] Ibid. V. 26.
[79] Ibid. V. 46.
[80] See formulations such as ''we expect to receive immortality ... we shall become
incorruptible ... incorruptible ...'', Mingana VI. 115.

other things. He especially honoured him by calling him His image, from which man alone became worthy to be called God and Son of God; and if he had been wise he would have remained with the One who was to him the source of all good things, which he truly possessed, but he accepted and completed the image of the Devil, who like a rebel had risen against God and wished to usurp for himself the glory that was due to Him, and had striven to detach man from God by all sorts of stratagems and appropriate God's honour, so that he might insult Him by rivalry. He (the Rebel) assumed, therefore, the attributes and the glory of a helper, and because man yielded to his words ... and followed the Rebel as his true helper, God inflicted upon him the punishment of reverting to the dust from which he had been taken. And from the above sin death entered, and this death weakened (human) nature and generated in it a great inclination towards sin.''[81]

We recognize the original structure for the relation between God and man. Man is dependent upon God who is the source of all good things. This dependency is also maintained by emphasizing that man is imago Dei which gives him the right to be called God and God's Son. The text conveys the impression that originally man participated in the blessings bestowed upon him by creation. In the meantime, man joined the devil's rebellion against God, and man's likeness to God is replaced by a likeness to the devil. God's answer to these deeds is to make man mortal, something which again removes man even farther from God.

To a certain degree, this account stands in contrast to other conceptions which Theodore makes use of in interpretating the human "first state". This contrast emerges clearly if we compare the passage taken from VI.21 with the following statement: "It is indeed known that the One who at the beginning willed and made us mortal, is the One who is now pleased to make us immortal, and the One who at the beginning made us corruptible is the One who now makes us incorruptible. He willed at the beginning and made us passible and changeable, and at the end He will make us impassible and unchangeable. He is the Lord, and has the power to accomplish both. He rightly and justly leads us from low to high things, so that by this transference from small to great things we may perceptibly feel that our Maker and the cause of all our good things, who at the beginning made us as He wished and willed, and who at the end brought us to perfection, did so in order to teach us to consider Him as the cause also of our first state, and thus to think that since we were in need to be transferred to perfection, we could not have existed at the beginning if He had not brought us into existence.''[82]

[81] Mingana VI. 21.
[82] Ibid. VI. 59.

In these quotations, the interpretations of God's work are of a different type. In VI. 21 Theodore perceives man's mortal existence on the earth as a fall from an original imago state. In VI.59, on the other hand, God-created human life on earth is framed in such a way as to include a futuristic perspective. The contrast ascertained here has given rise to conflicting interpretations of the anthropological element in Theodore's theology. The most distinctive interpretation is expressed in an article by J. Gross in which it is asserted that texts which uphold the so-called katastase teaching (of the type VI.59), presume that from the beginning Adam belonged to the first katastase and thus was created mortal.[83] With such a point of departure the way lies open for a Pelagianistic inclined theology.[84] Devreesse, however is in distinct opposition to contentions of Pelagianistic characteristics in Theodore's theology,[85] and maintains that Theodore considers Adam immortal when he was created.[86] G. Koch rightly asserts that attempts at harmonizing which play down one aspect in favour of the other are unacceptable.[87] This does not mean, however, that Theodore's theology on this point contains two tendencies each pointing in its own direction. With reference to De Vries, Koch contends that the created condition which points forwards towards a new creation, is easily perceived as a condition rooted in the disturbance of creation brought about by sin.[88] We add that, in our opinion, the two texts quoted as a basis for discussion about this field of problems are determined by an underlying fundamental idea which ties them together. In VI.59 it is strongly emphasized that mortal life is to be perceived as created by God. The remarkable thing about this interpretation is that mortal, created life appears to be a life in line with God's actual intentions. The forward perspective serves precisely to stress that this world is the work of God. The concept of a future life only has meaning if seen on the basis of existence here on earth. Indeed, the purpose of God's furtherance of

[83] "Alles in allem genommen war für Theodor von Mopsuestia der Fall Adams kein Abfall von einem höheren, über- oder aussernatürlichen Zustand zu einem niedrigeren, etwa bloss natürlichen, geschweige denn eine eigentliche Verderbnis der menschlichen Natur. Er war auch kein Bruch in der Heilsgeschichte, vielmehr ein Anfang, die erste Episode der gegenwärtigen Weltphase, in welcher Tod und Sünde dominieren", Gross, Theodor p. 9.

[84] "Nun ist aber ohne weiteres klar, dass auf dem Boden einer solchen Weltanschauung und Theologie eine Natur- oder Erbsündenlehre niemals wachsen oder darin auch nur Wurzel fassen konnte. Eine Begegnung Theodors mit der augustinischen Erbsündenneuerung musste daher bei ihm zwangsläufig eine Reaktion entschiedenster Ablehnung auslösen. So war es in der Tat", Gross, Theodor p. 10.

[85] "La doctrine pélagienne de Théodore est un mythe", Devreesse, Essai p. 164.

[86] "Créé immortel, Adam est devenu mortel par suite de son péché", Devreesse, Essai p. 98.

[87] Koch, Heilsverwirklichung p. 71.

[88] Ibid. p. 67.

existence towards a higher level is to make it quite clear that earthly existence is God's work. Man's mortal existence in the world would not have been existence if God had not been behind it.

It is, as a result, a sign of misunderstanding when the created world is interpreted as the work of Satan. According to Theodore, Satan attempts just such an interpretation by urging that man has belonged to him from the creation of Adam, who is perceived here as the representative of mankind.[89]

The discord between Satan's interpretation of man's condition and the understanding which Theodore means should form the basis of the interpretation of man's condition is occasionally depicted as a lawsuit. Faith's interpretation of human life, in this context, is related to God's act of creation. Theodore maintains that man did not belong to Satan from the beginning but belonged to God who created him from nothing in his own image. Only after the Tyrant had shown his wickedness and man had been negligent was he driven towards evil and lost his likeness to God which was part of creation.[90] But, this twist makes it again necessary to refer to the pure existence *before* the fall. That this world is created by God is thus outlined, aided by thoughts of a future world as well as by the concept of a God-willed existence prior to the fall. At the same time Theodore insists that this world does not allow for a total consummation of existence.[91] So, life on earth is contrasted with a celestial imago existence as well as with a future existence in which mortal life is brought to perfection.

It is precisely on the basis of this enlarged perspective of human existence that life in this world can be described mainly with the help of a negative terminology. For, Satan's disturbance is just as real as God creating from nothing: "Did you realise the extent to which Adam, our common father, who had listened to him, had been injured, and into how

[89] Mingana VI. 27.

[90] Ibid. VI. 28.

[91] This interpretation stands not only in constrast to the interpretations given by Gross and Devreesse, but also to Norris' attempt to understand the conception of Adam's creation as an immortal being as a part of the theory of the two katastases; "Since, however, death was the appropriate punishment of man's sin, and since God knew beforehand that Adam would yield to Satan's wiles, God created man mortal from the start, in order that after man's defection the due penalty—death—might properly and consistently supervene. Thus death turns out to be both punishment for sin, and a part of the constitution of human nature", Norris, Manhood p. 182. Norris sums up his interpretation as follows: "Mortality is chronologically prior to sin; but sin is logically prior to mortality: and this is true, not merely in the case of Adam, but also in the case of his posterity", p. 184. While Norris focuses solely upon problems connected to the relation between mortality and sin, we maintain that Theodore is more interested in the greater body of which the mortal existence is a part.

many calamities he has fallen? or the extent to which his descendants have given themselves up to Satan? or the gravity of the calamities which were borne by men, who later chose to become his servants?''[92]

The problem of a disrupted creation is the problem of sin. And, sin originated when man yielded to the pressure of Satan's evil.[93] This possibility of sinning is further tied to a particular characteristic of the constitution of human nature in this world. Sin originates in the will of the soul which first accepted the fatal advice of Satan. For Theodore it is important to establish that it is the soul and not the body which yields to the devil's temptations.[94] The soul's inclination towards sin springs from its mutability, its instability. It is the mutable soul which is driven to "passions of sin".[95] Furthermore, Theodore sees man's mortality as the result of its sinfulness,[96] while at the same time mortality weakens man's nature and increases its tendency towards sin.[97] Death, for its part, exposes the body to "dissolution and corruption".[98] That which takes place within the soul when its will turns towards sin is thus consequential for man as a whole. The soul's mutability and its abandonment to "passions", as well as the body's mortality and opportunity of destruction are related to the sphere of sin. Theodore has no problem with the concretization of these sinful deeds.[99] It is, nevertheless, the terminology which we have used here which is preferred and characterizes his description of man's worldly condition. In the catecheses, also, we note a clear tendency towards relating the concepts in question. By means of these concepts he gives a unified characterization of man's existence in a world of sin: "he who is born of the flesh is flesh by nature, and is mortal, passible, corruptible, and changeable in everything."[100]

The disruption of creation is comprehended as a consequence of sin. If destruction is to be conquered, something must be done about sin. As sin arrived in the world through one person and death again through sin, sin which is the cause of death must be destroyed. Only when sin is vanquished will death be wiped out as a necessary consequence. On the other hand, without the destruction of sin man will continue in a lasting state

[92] Mingana VI. 38.

[93] Ibid. VI. 21.

[94] Ibid. V. 56f. Emphasis of this aspect by Theodore is an explicitly anti-Apollinarian characteristic, see Norris, Manhood p. 202-207.

[95] Mingana V. 57. For the soul's mutability, see Norris, Manhood p. 133; for the soul's participation in "passions", see Norris, Manhood p. 133.

[96] "Sin ... was the cause of death", Mingana V. 56.

[97] "This death weakened (human) nature and generated in it a great inclination towards sin", Mingana VI. 21.

[98] Mingana V. 57.

[99] Ibid. V. 57f.; see also VI. 27.

[100] Ibid. VI. 50.

of mortality.[101] It is, in fact, sin—understood here as the cause of certain structures in existence—which is the problem of the present world. It follows that Christology in the first place is tied to the subject of sin and then to structures caused by sin. The special thing about Christ is that through the grace of God he has avoided sin. When, in spite of this, Satan, by stirring up the Jews, causes his death, a disparity arises; it is sin which is to deliver man up to death. When this injustice is put before God, he easily abolishes the damnation and raises Christ from the dead.[102]

When sin is overcome the way lies open for a life in contrast to a life of sin and the four characteristics of humanity in the world of sin. This new life is realized in Christ's life. Christ assumes the soul in order that it be delivered from sin and participate in an immutability which leads to the conquest of bodily passions. And, when sin is totally vanquished, immortality will replace mortality.[103] Thus we see that Christ brings about the restitution of man. We note, however, that this restitution leads, in a way, beyond the structures of this world. In order to elucidate Christ's place within redemptive work more exactly, we must take a closer look at the Christology in the catecheses.

c) *Christology*

Theodore's Christological reasoning differs to that of Cyril. Cyril emphasizes that God adapts himself to human conditions and shows himself to man as a person. Theodore, however, maintains that the man, Jesus, is put into a unique relationship with the Divinity through being assumed by the Logos: "He is not God alone nor man alone, but He is truly both by nature, that is to say God and man: God the Word who assumed, and man who was assumed. It is the one who was in the form of God that took upon Him the form of a servant, and it is not the form of a servant that took upon it the form of God. The one who is in the form of God is God by nature, who assumed the form of a servant, while the one who is in the form of a servant is the one who is man by nature and who was assumed for our salvation. The one who assumed is not the same as the one who was assumed nor is the one who was assumed the

[101] Ibid. V. 56.

[102] Ibid. V. 60.

[103] "It is with justice, therefore, that our Lord assumed the soul so that it should be first delivered from sin and be transferred to immutability by the grace of God through which it overcomes also the passions of the body. When sin is abolished from every place and has no more entry into the soul which has become immutable, every kind of condemnation will rightly be abolished and death also will perish. The body will thus remain immune from death because it has received participation in immortality", Mingana V. 58.

same as the one who assumed, but the one who assumed is God while the one who was assumed is a man.''[104]

The formulations here clearly show the difference between Theodore's and Cyril's Christology. Theodore does not allow for the conception that Christ is God made man, as we are familiar with in Cyril's catecheses.[105] Thus, the meeting between the Divine and the human in Christ must be dealt with in another way.

Theodore's Christology has been made the subject of extensive discussion. We shall not go into all the nuances and details in this debate but be content to draw up certain main lines.

On one hand, De Vries contends that Theodore's clear division of Divinity and humanity in Christ implies that his Divinity will never actually enter into this world: ''Dem Menschen Christus kommt nur eine Adoptivsohnschaft wirklich zu. ... Es dürfte mit den bisherigen Ausführungen für unseren Zweck genügend dargetan sein, dass Theodor tatsächlich die wahre Menschwerdung des Sohnes Gottes leugnet.''[106] De Vries maintains that Theodore's explicit separation of the one who assumes and the one who is assumed entails that God and man in Christ are not one and the same person.[107] The union between the one who assumes and the one who is assumed is, therefore, not to be understood as a physical union and for this reason it is impossible that Divine life can be transferred to man.[108] De Vries finds the grounds for his evaluation in the communicatio idiomatum concept. In his opinion, there is no place in Theodore's theology for communicatio idiomatum as he draws no clear distinction between the person of Christ and the nature of Christ.[109]

On the other hand, E. Amann interprets Theodore as being in agreement with traditional theology: ''Ainsi les textes scripturaires, tels que les commente Théodore, font clairement allusion tant à la différence des natures qu'à l'ineffable union qui existe entre elles. Cette union, ils nous l'enseignent, non seulement quand ils nous donnent la connaissance de chaque nature, mais aussi quand ils affirment que ce qui est dû à l'une est également dû à l'autre, de sorte que nous puissions entendre le caractère admirable et la sublimité de l'union qui les joint.''[110] Typically enough Amann, too, uses the communicatio concept as the basis for his evaluation. But, in contrast to De Vries, he holds that this concept is to be found in Theodore's writings.[111] In this connection, De Vries argu-

[104] Mingana V. 82.
[105] Cf. Cyril of Jerusalem, Cat. 12. 3.
[106] De Vries, Nestorianismus p. 96.
[107] The interpretation is supported by sayings like this: ''The one who assumed is not the same as the one who was assumed nor is the one who was assumed the same as the one who assumed, but the one who assumed is God while the one who was assumed is a man'', Mingana V. 82.
[108] De Vries, Nestorianismus p. 106.
[109] Ibid. p. 94.
[110] Amann, La doctrine christologique p. 181.
[111] Amann refers to Mingana V. 87-89 where, among other things, we read: ''The Sacred Books also teach us this union, not only when they impart to us the knowledge of each nature but also when they affirm that what is due to one is also due to the other, so that we should understand the wonderfulness and the sublimity of the union that took place (between them)'', Mingana V. 87f.

ment for rejecting Amann's interpretation has a certain interest. De Vries contends that the salient points in the text which serve as grounds in Amann's argument can only be perceived as "nicht mehr als eine Redensart".[112]

This debate has become more complex as a result of recent research contributions. The conclusions in F. A. Sullivan's scholarly examination of Theodore's Christology, however, are close to those of De Vries but they are based on a far more thorough treatment of Theodore's Christological terminology than in De Vries' case. Sullivan contends that Theodore upholds the distinction between the two natures (φύσις) of Christ as well as the union in one prosopon (πρόσωπον).[113] But, to get at the exact meaning of such expressions is only to be accomplished by looking for the intentions behind this use of language. Sullivan, means here that Theodore was unsuccessful in explaining the union in a satisfactory way. Primarily, this is due to his over-simplified use of the Logos conception. Theodore does not distinguish clearly between the Divine Logos as a person and his Divine nature as such.[114] Only through such a distinction is it possible, according to Sullivan, to refer birth, suffering etc. to the Logos "as the subject to whom they ultimately belonged", while at the same time avoiding the reference of these qualities to the Logos "in His divine nature".[115] His failure in making distinctions in his understanding of the Logos also has consequences for the way in which Theodore perceives the union in the prosopon. For, because of the lack of terminological identity between the Logos and "the One who assumed" it is impossible for Theodore to understand the prosopon as "the eternal Person of the Word".[116] The prosopon becomes, therefore, " 'a common person', a person who results from the union of the two natures".[117] Sullivan contrasts Theodore's interpretation with an interpretation which implies that "God the Word is the subject of whom one rightly predicates not only the attributes of his divinity, but also the actions and passions of that humanity which He has 'made His own' ".[118]

While Sullivan's own position leaves room for a substantial union between the two natures, he means that Theodore's Christology allows solely for "an extraordinary presence of God the Word in a man",[119] where the "inhabitation" in question is perceived as "a unity of operation between the Word and the man assumed".[120]

Sullivan's appraisal of Theodore's theology is determined by its diametrical difference to Alexandrian theology, as primarily expounded by Athanasius and then Cyril of Alexandria.[121] We contend that in basing his opinion on such criteria of assessment, the result is almost a foregone conclusion. Theodore's theology has no possibility of being understood on its own premises because distinctions in expressions which are foreign to him are used as the standard in

[112] De Vries, Nestorianismus p. 95.
[113] Sullivan, Christology p. 201.
[114] Ibid. p. 206f.
[115] Ibid. p. 206.
[116] Ibid. p. 260.
[117] Ibid. p. 281.
[118] Ibid. p. 283.
[119] Ibid. p. 239.
[120] Ibid. p. 254.
[121] Ibid. p. 209, 214, 283, 160, 165.

assessing his theology. It is, therefore, not surprising that other analyses of the Christological terminology used by Theodore, have led to other results.

A typical contribution in this respect is to be found in G. Koch's treatment of Theodore's perception of salvation. Koch, too, points out that we do not find a distinct division between the Logos as prosopon and the Divine nature in the Logos. As a result, it is not made sufficiently clear that Christ's prosopon is identical with the Logos' prosopon.[122] These observations, however, do not necessarily imply that Theodore represents an adoptive Christology. Koch studies these questions in constant confrontation with Sullivan. We limit ourselves to indicating one of the controversial issues, namely, the interpretation of communicatio idiomatum. Koch establishes that there is agreement on the fact that Theodore considers such an exchange in the one direction; the assumed person can be alloted Divine attributes because of union with the Logos.[123] The question is whether it is possible to state anything human about the Logos. Although Theodore is extremely reserved on this point, Koch professes to find proof of "die seinmässige Begründetheit des Aussagenaustausches in dieser Richtung".[124] The crucial text is Theodore's interpretation of John 3:16,[125] in which "he gave his only begotten Son" provides the opportunity to contend that even if it is impossible to say that God suffered, it can be established, concerning the passion, that "totum divinitati tribuitur".

Sullivan points out that the text shows clearly that Theodore does not differentiate between what can be said about the only begotten Son and that which refers to the Divinity. But how does Sullivan think that Theodore understands the suffering which is attributed to the Divinity? The answer is: "It can be nothing more than a way of speaking: of alluding to the divinity with which the *homo assumptus* is united."[126] It is here that Koch expresses his criticism. With support from McKenzie, he maintains that "totum divinitati tribuitur" must reflect a Greek construction which does not mean that the whole can be ascribed to the Divinity, but "that the whole thing is assumed by the divinity".[127] Based on such an interpretation, Koch contends that the text "ist ein Beweis Theodors für die seinmässige Begründetheit dieser Sprechweise".[128] We find Koch's interpretation of the text in question more convincing than that of Sullivan who actually avoids the problem by taking the disputed passage to mean "nothing more than a way of speaking".[129] We must, nevertheless, emphasize that Koch, too, fails to find a clearly expressed substantial union within Christological organization. Theodore, in fact, does not stress that union in the one prosopon is of a hypostatic, personal kind.[130] Based on this, Koch says that in Theodore we find an intentional, substantial union.[131]

[122] Koch, Heilsverwirklichung p. 50.

[123] Ibid. p. 49.

[124] Ibid.

[125] "Quomodo ergo dixit: *Filium suum Unigenitum dedit?* Quamvis sit evidens, divinitatem pati non posse; propter coniunctionem tamen unum sunt; quare etsi alius pateretur, attamen totum divinitati tribuitur", see Sullivan, Christology p. 208.

[126] Sullivan, Christology p. 209.

[127] Koch, Heilsverwirklichung p. 50 with reference to McKenzie, Annotations p. 358.

[128] Ibid. p. 50.

[129] We saw the very same tendency in De Vries's interpretation of problematical texts, see p. 220.

[130] Koch, Heilsverwirklichung p. 45.

[131] Koch sums up as follows: "Diese Einung wird als Ganzeinung, als von Anfang an

This discussion provides the necessary assumptions for a relevant interpretation of those aspects of Theodore's Christology which are of particular interest to us in the present study. Our aim is to clarify whether or not Theodore, in his Christology, allows for the concept of Christ revealing the Godhead to man. At the same time we aim to map the way in which Theodore treats the soteriological questions on the basis of his Christology.

Light has been shed on the first problem in a text where Theodore gives an account of Christ's resurrection. We have previously seen that he imagines that "the man who was assumed" and descended into death, rose up again and ascended to heaven to sit on the right hand of God (see p. 210). Theodore maintains, furthermore, that this person is to be worshipped by all. Here he encounters the problem of the clear distinction drawn between Christ's two natures. For man, by his very nature is not entitled to be worshipped. Theodore is thus forced to break down the barrier between Christ's human and Divine nature which he otherwise so frequently stresses: "While all these things are clearly and obviously said of human nature he referred them successively to Divine nature so that his sentence might be strengthened and be acceptable to hearers. Indeed, since it is above human nature that it should be worshipped by all, it is with justice that all this has been said as of one, so that the belief in a close union between the natures might be strengthened, because he clearly showed that the one who was assumed did not receive all this great honour except from the Divine nature which assumed Him and dwelt in Him."[132] The assumed one receives from the Divine nature the honour which is necessary in order that the worship be meaningful. In worship the natures are treated "as one"—something, however, which does not lead to the fact that God "in his nature" is affected by human behaviour.[133] Here Theodore withholds an aspect of the Godhead while

bestehend, unauflöslich und unaussagbar, von allen anderen moralisch-dynamisch-akzidentellen Einungen abgehoben, ihr substantialer Character ist fast unausweichlich nahegelegt, zumindest intendiert; doch die Union wird nicht in Klarheit als hypostatische erkannt", Koch, Heilsverwirklichung p. 56. The results achieved by Koch are supported by Abramowski's analysis of the prosopon-term. With reference in a text in Contra Eunomium (Abramowski, Zur Theologie p. 263) she maintains that this term does not have an ontological meaning in the Christological context. Nor does it support that the union in Christ is moral. Abramowski says: "Die Schwierigkeit in der Interpretation der Christologie Theodors, die sich an den unaufhörlichen neuen Versuchen zu diesem Thema zeigt, liegt darin, dass die Christologie selber auf zwei Ebenen abgehandelt wird: von den zwei Naturen Christi und ihren Unterschieden wird ontologisch gesprochen, die Einheit der Person Christi wird dagegen wohl ontisch vorausgesetzt, während eine ontologische Beschreibung oder gar Definition mit den Theodor zur Verfügung stehenden Begriffen nicht möglich ist", Abramowski, Zur Theologie p. 265.

[132] Mingana V. 66.
[133] Ibid. V. 67.

simultaneously maintaining that Christ's human nature after the resurrection receives an honour which, strictly speaking, belongs to the Divine nature. Even as the two natures are kept separate, it is possible to speak of a transference of qualities from the Divine nature to the human nature. McKenzie remarks that here it is a question of a communicatio downwards from above. He maintains, nevertheless, that it is a question of a particulary important communicatio statement because it concerns "one subject of adoration".[134] L. Abramowski, too, draws attention to the union which is forthcoming in the act of worship: "Dass die gemeinsame Anbetung für die Verbindung der Naturen in Christus wesentlich ist, ist ein durchaus geläufiger Gedanke bei ihm, es ist daher nur konsequent, wenn das Ergebnis der Vereinigung, das Prosopon, mit Hilfe der Anbetung beschrieben wird."[135]

A similar way of thinking is to be found in Theodore's description of the parousia. It is, indeed, "the prosopon of the man who was assumed"[136] who shall judge the quick and the dead. Theodore must, however, clear up the misunderstanding that in this case it should concern an ordinary person. For this reason it is said in the Creed: "And He shall come again to judge". Here the purpose of "again" is to point to Christ's Divinity: "Because they (our blessed Fathers) were referring in their words to the Divine nature they counted His coming twice, first when He came down through that man, and secondly when He will come *again* through the same man who has been assumed, because of the ineffable union that that man had with God."[137]

Thus, we see that Theodore clearly wishes to keep Christ's two natures so closely connected that in speaking of the resurrected as well as in speaking of the incarnation and parousia he can establish for mankind that the human Christ truly reflects the Divinity.

But, what are the consequences of Theodore's Christological thinking for questions of soteriology? We shall attempt to reach an answer by looking more closely at his reason for so clearly stressing Christ's humanity. On one hand, Christ's humanity is particularly important in tying Christology to themes of creation and the fall. It is, in fact, the fall which makes it necessary for God "to make manifest a providence consonant

[134] McKenzie, Annotations p. 366.

[135] Abramowski, Zur Theologie p. 266, see also Norris, Manhood p. 231f. who interprets accounts about the great honour paid to the humanity of Christ, as follows: "this unity of prosopon is by no means a mere habit of speech by which two things are fictitiously treated as one. On the contrary there is, by the fact of the union, a relationship established which creates a basis in reality for the one prosopon."

[136] Mingana V. 80.

[137] Ibid. V. 81.

with the works which He himself had made''. Here Theodore refers to
God's act of creation when man was created from nothing and received
a body formed of nothing and in him was instilled a soul which had not
existed before. To emphasize Christology's relevance for the created but
fallen man, God took one of us and allowed the beginning of all good
things to be consummated in him.[138] Norris points out, quite rightly, that
here we find an emphasis on Christ's work as a man which exceeds the
thought that the Divine Son yields to the terms of human nature. Christ
is not perceived here merely as locus for Divine intervention but he also
becomes the locus for man's conquest of sin.[139] The undoubted purpose
of this accentuation of man's role in Christology is to give Christological
relevance to actual life in a world of sin.

It is evident, however, that Theodore also wishes Christology to open
up perspectives which stretch beyong the created sphere. In this way he
can stress that Christ's union with God also has consequences for the
faithful. The purpose of Christ's union with the Divinity is to give man
''the honour of relationship with the Divine nature''.[140] In VI.75
Theodore shows that Christ's union with God implies that he participates
in Divine immortality which, later, he will be able to confer upon the
faithful.[141] Here immortality stands in contrast to that which is due to
human nature. When man participates in immortality he also has ''rela-
tionship with Divine nature'' in a way which is beyond the scope of this
world. Nevertheless, there is no question here of man becoming like God
and exceeding the bounds between Creator and created. Thus, in
another passage, Theodore is able to postulate the the union of the
faithful with Christ leads to communion with the Divine nature,[142] yet
without entailing any likeness of man to God.[143] Our interpretation
stands in contrast to that of Norris who emphasizes exclusively that man
is limited to likeness with Christ's human nature, not his Divine
nature.[144] Norris' accentuation is, for that matter, correct. We believe,
nevertheless, that the immortality in question here, does not belong to

[138] Ibid. VI. 29. In this connection it is said of man: ''We have rightly reverted to our
Lord to whom we belonged before the wickedness of Satan, and we are, as we were at
the beginning, in the image of God'', Mingana VI. 30.

[139] Norris, Manhood p. 194.

[140] Mingana V. 113.

[141] ''Indeed, even the body of our Lord does not possess immortality and the power of
bestowing immortality in its own nature, as this was given to it by the Holy Spirit; and
at its resurrection from the dead it received close union with Divine nature and became
immortal and instrumental for conferring immortality on others'', Mingana VI. 75.

[142] Mingana VI. 105.

[143] Ibid. V. 46.

[144] ''It is not likeness to God, or to the divine Son, of which Theodore writes, but
likeness to the resurrected humanity of the Lord'', Norris, Manhood p. 170.

Christ's human nature as such. Immortality is and will remain a Divine quality which is not understood correctly if only seen in connection with Christ's human nature.[145] The consequence of our interpretation, however, is not that man, through Christ's redemptive work ceases to be created. In rejecting Norris' interpretation, our purpose, first and foremost, is to dispute the conclusion he draws from, among others, VI.75 in which salvation is perceived solely as a restitution of the present created world.[146]

Here, we recognize Christological elements we have met in Cyril. There, however, we were left with an unsolved state of tension between that in which the restituated creation participates and the divinization which Christology opens for (see p. 178). Theodore's efforts to combine Christ's two natures already indicates that this, in another way, presents a problem. The question is simply: How does he try to solve the factual problem which is inherent in Christology itself beyond attempting to identify the relationship between Christ's two natures?

In a description of Christ's passion where the power of sin is vanquished, we find the rudiments of a solution. When Christ's human nature is subjected to suffering, Christ's Divine nature comes to the rescue and suffering is overcome. In order that this may be realized, the nature subjected to suffering must be changed. This change is completed in precisely this suffering where the nature is made perfect.[147] Deliverance from the characteristics of life takes place because human nature changes. God delivers man from the power of Satan by making him unassailable for Satan. God is not changed in the incarnation but man is transformed in his encounter with God.

This renewed man retains a connection with created life while at the same time he appears to be raised up above this world: " 'The first-born of all creatures' means that He was the first to be renewed by His resurrection from the dead; and He changed into a new and wonderful life,

[145] The nature of God is characterized by contrasting it to mortal nature: "you are mortal men by nature, which is very different from Divine nature", Mingana V. 46; see also Koch, Heilsverwirklichung p. 143.

[146] "His (goal of redemption) is not, we have seen, a theory which finds the substance of salvation in any 'divinization' of man. Consistently with this understanding of the image theme, he is interested in the redemption of man as a creature implicated in the life of the created world. The restoration of man to this ideal state ... depends primarily upon humanity's return to a state of perfect obedience to God and to the fellowship with God which such obedience effects", Norris, Manhood p. 191.

[147] "He (who was assumed) was in need of the One who was to deliver him from passion, the One who changed His nature and made Him impassible and crowned Him with sufferings. As to Himself He dwelt in Him, and He is by nature impassible, and has the power to make Him impassible also although (by nature) passible. In this way He perfected through sufferings and made immortal and immutable in everything the form of a servant", Mingana V. 86.

and He renewed also all the creatures and brought them to a new and a higher creation ... He moved to a new life and ascended high above all creatures''.[148] On one hand, creation's first-born is given a new life; on the other hand the new life is of higher quality than life on earth.

Theodore also uses a description of a potter to illustrate that the one renewed exceeds the bounds of this world. As it is the potter's custom to give new form to broken pots with the help of water, which is to say, to give them the desired form by creating them anew, so too did the Lord and Creator of man renew him after he had fallen and been destroyed by sin. This took place when God destroyed death through Christ's resurrection and gave man hope of resurrection after death and hope of a world "higher than the present''.[149]

This new life, unlike the life on earth is described by referring both to the doctrine of creation and to Divine life. It seems to concern a form of *transfigured world* which, strictly speaking, shows no conformity to this world, while simultaneously having clear elements connecting it with this same world. In this respect, the dominant use of concepts by Theodore is characteristic. The contrast to that group of concepts which are normally used to describe this world is used as a collective group to identify the characteristics of Christ's work: "He (Christ) abolished all old things and showed new things in their place. Every man who is in Christ is a new creature; old things are passed away and all things are become new. Death and corruption have ceased, passions and mutability have passed away.''[150] On one hand, such a way of expressing himself entails an understanding of the new situation on the basis of the created world. Immortality is perceived as life not limited such as life in this world. A life of greater quality has the same source as all created life in this world: "to Him who is able to create something from nothing belongs the act of giving life, that is to say, to make us immortal so that we should always live.''[151] On the other hand the same expressions allow for closer ties with the new life and Divinity than is the case with life in this world. Christ, through his resurrection, will change people and give them a part in his body and take them with him up to heaven where they will be with him forever.[152] This condition is considered as immortal and is, thereby,

[148] Mingana V. 39.
[149] Ibid. VI. 57.
[150] Ibid. V. 19.
[151] Ibid. V. 110, see also V. 24 and V. 68.
[152] "As long as we are in this mortal body we are as it were absent and remote from the Lord ... we are looking with great eagerness to the time when we will divest ourselves of this mortal body and cast it away from us and become immortal and immutable at the resurrection from the dead, and then we will be with our Lord like men who for long time and for the duration of this world were absent and expecting to be present with Him'', Mingana V, 77.

closely knit to God's own nature which, among other things is character-
ized by its contrast to mortality (cf. note 145).

On this basis, we can establish two elements within Theodore's
Christology. First, it is Christ's task to show God to man; secondly, he
will provide man with the benefits of salvation which are not only to be
found above the visible and created but, which in addition, are associated
with the Divine.

After describing Theodore's perception of the benefits of salvation we
shall be able to make a closer examination of just how Theodore thinks
that these redemptive blessings are to be realized in relation to this world.

d) The Definitive Realization of Salvation

We have seen earlier that the mediation of redemptive benefits in Cyril's
work is interpreted partly as a transfer of heavenly, eternal life into ear-
thly existence and partly as a renewal of created life. Here, without
doubt, lay inherent perspectives which led to the beyond. We main-
tained, nevertheless, that Cyril paid great attention to the realization of
redemptive benefits within this world.

Now we have seen that Theodore works in quite a different way to
Cyril in his organization of the state of tension existing in the perception
of salvation itself and that this is brought about with the help of the
expressions mortality/immortality etc. In doing this, certain problems
become more urgent for Theodore than for Cyril. We recall that with
comparative ease Cyril could allow the realization of salvation in this
world, partly by seeing it as the restoration of created order and partly
by believing that man changes and by doing so, participates in the
Godhead. But, how can Theodore's immortality be realized in this life?

When we now look more closely at how Theodore thinks that man par-
ticipates in the benefits of salvation which Christology represents, we
notice immediately a distinct withdrawal from the world in his organiza-
tion of soteriological questions. A single passage shows very clearly
Theodore's interest in the progress from this life to life in the hereafter:
"If Christ our Lord had immediately after His rising from the dead,
raised also all men who had previously died, and had bestowed upon
them new life fully and immediately, we should have been in no need of
doing anything; as, however, He actually performed only on Himself the
renewal which is to come and through which He rose from the dead and
His body became immortal and His soul immutable, it became necessary
that this decrepit and mortal world should last further in order that
mankind might believe in Him and receive the hope of communion (with

Him) and future life.''[153] Here, the world is seen rather as a waiting place for that immortality which for the present is Christ's alone and into which man hopes to be drawn. Many textual sources support this view.[154] This other-worldliness corresponds with definite characteristics in Theodore's anthropology. In the same way that Theodore makes the importance of earthly life relative by outlining it against a heavenly and future existence, we discover in the soteriology an emphasis on a futuristic-eschatological element and a heavenly aspect. This pull towards the future is clearly seen in certain texts which take the creation as their subject. Here, the renewal can appear as something which will only be consummated "in the next world".[155] This futuristic aspect is typical of Theodore's theology, and here we find the reason for speaking of his instruction in the two katastases: "Probably the most characteristic conception embodied in Theodore's theological doctrine of man is the so-called doctrine of the 'Two Ages', which governs and influences every aspect of his thought."[156] Norris points out, furthermore, that this teaching means that Theodore primarily works "in terms of a 'horizontal' contrast between two successive states of a single, created human existence".[157] In support of such an interpretation, a passage from Theodore is usually cited. In this it is clearly stated that creation is divided into epochs, one of present time and one of the future. A mutable condition exists at present but in the future God will renew all things so that they become immutable.[158] As we have pointed out before, Theodore imagines this future condition as a continuation of existence here on earth—the created sphere includes them both. We feel, meanwhile, that this aspect of interpretation must not be isolated as Norris does.[159] Theodore's perspective is, indeed, not solely directed towards a futuristic consummation of salvation. Our interpretation of this point corresponds closely with the views expounded in our approach to the Adam problem (see p. 215). There we pointed out that the concept of a fall from a heavenly existence was of decisive importance in

[153] Mingana V. 70.

[154] Ibid. V. 19, 61, 68, 77.

[155] Ibid. V. 19.

[156] Norris, Manhood p. 160.

[157] Ibid. p. 160.

[158] "Quod quidem placuit Deo, hoc erat, in duos status dividere creaturam: unum quidem, qui praesens est, in quo mutabilia omnia fecit; alterum autem, qui futurus est, cum renovans omnia ad immutabilitatem transferet", De Vries, Das eschatologische Heil p. 310.

[159] The emphasis of the "horizontal" way of thinking is clearly set forth in the following passage: "the historical dualism of the Ages becomes, in effect, Theodore's alternative for the metaphysical dualism of the Platonic tradition", Norris, Manhood p. 160.

anthropological thinking. In concurrence with this concept Theodore, too, is able to maintain that man's salvation is consummated in heaven. Such an understanding is explicitly expressed in the following quotation: "And it is *one* Church, which embraces all, on account of those who believe in all countries and expect to receive heavenly life, as the blessed Paul said: 'The heavenly Church in which are written the firstborn of God' ... He called them also 'written in heaven', because it is there that they will dwell."[160] As far as we can see, this point of view dominates Oñatibias' interpretation of Theodore's theology. Thus, he says that the Christianity presented by Theodore to his catechumens is first and foremost directed towards heaven.[161] This does not mean that Oñatibia overlooks historical progression. It is clear, nevertheless, that he understands immortality etc. primarily as a heaven-sent gift. As a synthesis of redemptive blessings in which people expect to participate in heaven, immortality is to be understood not only as a prenatural gift but as a form of life implying participation in a Divine quality.[162]

The problem arising from our interpretation is determined by the linking of the two elements. Here it is not sufficient to point out that salvation renews created order here and now; nor is it adequate to refer to the Divine entry into the world. No, salvation is certainly brought to the world but its aim also is to lead man beyond created order. It is only in the life hereafter that man will receive the renewal which looses his bonds to this burdensome world. As we have seen earlier, Theodore organizes this through the combination of two sets of terminology. We contend that the combination plays a greater part in Theodore's theology than in Cyril's. The future and the heavenly are categories which Theodore *must* combine in order to bring out what is characteristic in salvation—the future becomes the heavenly at the same time. This connection between that which is above and that which is to come always seems to be the underlying factor when expressions such as "immortality" etc. are used about man. Next we notice that the hereafter which comes forth in this

[160] Mingana V. 114.

[161] "El Cristianismo que Teodoro presenta a sus catecúmenos es un Cristianismo esencialmente proyectado hacia el cielo. Todas las realidades cristianas (Recención, Sacramentos, vida cristiana) las explica en función de los bienes imperecederos del cielo", Oñatibia, La vida cristiana p. 101.

[162] "Este don de la immortalidad, que en las descripciones del Mopsuesteno va muchas veces en compañia de los dones de incorruptibilidad, impasibilidad e inmutabilidad, no es un don meramente preternatural, como pretende De Vries. Se dice expresamente que'es un cierto modo de vida divino' (Hom. 12. 5). En efecto, siempre que Teodoro trata de caracterizar la naturaleza intima de Dios, recurre a los conceptos de inmortalidad e inmutabilidad; cfr. por ejemplo, Hom. 4. 10 (87); 10. 6 (253); 9. 13 (233). Participar de la inmortalidad es, para Teodoro, participar de una propiedad divina", Oñatibia, La vida cristiana p. 102 note 8.

way has quite another emphasis in Theodore's theology than in Cyril's. Theodore's understanding of salvation simply requires strong emphasis on a hereafter-soteriological aspect.

The difference between Cyril and Theodore may be clearly observed in their interpretation of the prayer "Thy Kingdom come" in the Lord's prayer. While Cyril postulates that the kingdom of God is at hand in the pure soul (see p. 196), we find quite another directive towards the hereafter in Theodore's interpretation. He maintains that it is fitting for those who are called to the heavenly kingdom "to think of things which are worthy of that Kingdom, to do the things that are congruous to the heavenly citizenship, to consider the earthly things small and believe them to be below their dignity to speak and think of them".[163] The following example given by Theodore stresses that an orientation towards the kingdom of heaven contrasts with "commerce of this world", which is understood literally here, meaning ordinary business activity.[164]

If we turn our attention to Theodore's attempt to combine the two aspects referred to above, we find a very informative presentation in the explanation of the Old Testament's tabernacle which consisted of the holy and the holy of holies. These two parts of the temple are tied to the concept of this life's relation to the future/heavenly: "The first was the likeness of the life and sojourn on the earth on which we now dwell, and the second, which they called holy of holies, was the likeness of the regions which are above the visible heaven, to which our Lord Christ, who was assumed for our salvation, ascended, in which He now is, and to which He granted us to go in order to be there and dwell with Him, as the blessed Paul said: 'Whither the forerunner is for us entered, Christ, who became a high priest for ever after the order of Melchizedec' ... The work of a high priest is indeed that he should draw nigh unto God first, and then after him and through him the rest should draw nigh.''[165] Just as the tabernacle consists of two rooms so can life be divided into two consecutive epochs. In addition to being consecutive, these two parts are characterized as being at different levels; the first epoch is likened to life on earth, the other to a heavenly life. But, the text also conveys an impression of how these two spheres of life are linked to each other; it is Christ who through his ascent to heaven prepares the transition from one epoch to the other. There is, however, a time lapse between the

[163] Mingana VI. 9.

[164] Theodore speaks in this context about to "go and wander in the bazaars and inns and such like". At the same time the speaks of the "evil trading and unholy work" of this world, Mingana VI. 9.

[165] Mingana VI. 18.

establishment of this bridge from one epoch to the other and to the time when man shall participate in that which belongs to the new epoch. In this way, Theodore's interpretation of the tabernacle's two separate rooms clearly expresses the importance of spatial symbolism as well as progression of time in the interpretation of soteriology.

3. The Ritual Representation

a) The Ritual Representation of Salvation

Emphasis upon a futuristic-eschatological consummation of salvation in no way implies a lack of interest on Theodore's part in the realization of salvation in the lives of the faithful here on earth. It is in order to realize salvation that both the vision and the rite, which form the basis of our analysis, find their rightful place in the catecheses. Through an analysis of Theodore's theology we have acquired greater insight into his understanding of God's redemptive acts in the world. The result is a firmer foundation for a better understanding of his structuring in approaching the problem of representation.

Our introduction to this chapter gave a clear impression of the crucial role played by the sacraments in the mediation of salvation here and now. Theodore makes a direct connection between future redemptive benefits and present life conditions thus: "We are ordered to perform in this world the symbols and signs of the future things."[166] The context makes it clear that symbols and signs refer to the eucharistic sacrament which, in this way, is explicitly related to the act of salvation and its benefits of which we have given an account previously. At a later point we shall discuss the importance of signs and symbols in Theodore's understanding of the sacraments. Here, to begin with, we shall concentrate on the visual character of the rite and its importance in lending actuality to salvation.

In Theodore's interpretation of the Eucharist, decisive importance is bestowed upon the officiating priest because he is seen as an image of the true high-priest Christ and his sacrifice.[167] Theodore, in fact, encourages his congregation to imagine Christ by regarding the priest—"as through him we see One who saved us and delivered us by the sacrifice of Himself".[168] In the sacramental act attention is led back to Christ's

[166] Mingana VI. 82.
[167] For Theodore's understanding of the Jewish priesthood in relation to the priesthood of Christ, see Lécuyer, Le sacerdoce chrétien p. 481-516 and Betz, Eucharistie p. 132ff.
[168] Mingana VI. 85.

redemptive acts while at the same time these acts appear to be present through the priest's physical presence. It is, therefore, the task of the mental image which emerges from the ritual act to maintain the connection between the ritual and Christ's redemptive acts: "In contemplating with our eyes, through faith, the facts that are now being re-enacted: that He is again dying, rising and ascending into heaven, we shall be led to the vision of the things that had taken place beforehand on our behalf.[169] The vision of Christ's past redemptive work anchors the ritual firmly to past events. Things which have happened earlier to Christ will also happen to the faithful.[170]

In order to maintain this belief, however, it is not enough for Theodore to refer the faithful to an imagined picture of Christ's sacrificial act. The priest also represents "dimly ... the image of the unspeakable heavenly things".[171] Our previous treatment of the Christological question makes this shift in perspective understandable. Because Christ's resurrection plays such a decisive role in Theodore's Christological thinking, it becomes vital to ensure a place for this element in interpreting the ritual. Visually, this is maintained by directing the mind's eye towards the resurrected Christ in heaven. The same point is emphasized verbally in the eucharistic prayer's Christological part (Post-Sanctus) which is rendered in the catechesis as follows: "He made manifest the Economy which took place in Christ, and by which the One who was in the form of God was pleased to take upon Him the form of a servant, so that He might assume a perfect and complete man for the salvation of all the human race; and He abolished the old and harsh observances which were formerly enjoined upon us through the deadweight of the law, and also the dominion of death which was dating from ancient times; and He granted us ineffable benefits which are higher than all human intelligence and for which He agreed to suffer, so that through His resurrection He might effect a complete abolition of death."[172] Here, the interpretation is directed towards the triumph over the power of death which is brought about by the resurrection. It is this aspect which makes it necessary to allow room for heaven in the mental image which accompanies the rite. Because the sacrifice is "the likeness of heavenly things", it becomes

[169] Ibid. VI. 83.

[170] "As we have a firm belief that things that have already happened will happen to us, so (the things that happened at the resurrection of our Lord) we believe that they will happen to us. We perform, therefore, this ineffable sacrament which contains the incomprehensible signs of the Economy of Christ our Lord, as we believe that the things implied in it will happen to us", Mingana VI. 20.

[171] Mingana VI. 83.

[172] Ibid. VI. 102f.

necessary for the mind to imagine "that we are dimly in heaven, and, through faith, draw in our imagination the image of heavenly things".[173]

Theodore, however, gives not thorough description of how the mind is to imagine heaven. Interest centres primarily on the priest as the point of departure in the imaginative process. We must, meanwhile, note that the deacons play a certain role in this context by leading the mind towards the invisible hosts who serve in heaven. In speaking of the deacons, emphasis is on the same point on which we have concentrated in analyzing the priest's image-creating function. As might be expected, the deacons, by directing attention to the invisible hosts, stress that the rite refers to heavenly reality,[174] but Theodore also points out that the invisible hosts served at Christ's sacrificial death.[175] It is explicitly emphasized that the hosts of ministry were present when the Saviour's suffering was consummated.[176] The creation of this double image is the direct result of the wish to keep Christ's death and resurrection together. Christ's death and resurrection are indivisible but demand a double mental image.[177]

Until now we have concentrated on attempts to maintain Christ's death and resurrection in the ritual by means of an image brought by the sight of the priest. This theme is supplemented through the interpretation of the ritual which we find within the anaphora prayer. The priest delivers the prayer immediately after the deacon has called upon the congregation to behold the sacrifice. Despite the fact that visual attention is concen-

[173] Ibid. VI. 83.

[174] Ibid. VI. 83f.

[175] Ibid. VI. 85.

[176] "And when the offering which is about to be placed (on the altar) is brought out in the sacred vessels of the paten and the chalice, we must think that Christ our Lord is being led and brought to His passion, not, however, by the Jews—as it is incongruous and impermissible that an iniquitous image be found in the symbols of our deliverance and our salvation—but by the invisible hosts of ministry, who are sent to us and who were also present when the Passion of our Salvation was being accomplished, and were doing their service", Mingana VI. 85f.

[177] Lecuyer totally subordinates the historical aspect to the heavenly theme: "A l'Eucharistie s'applique donc ce que nous disions plus haut en général des sacrements: c'est une *image* d'une réalité céleste", Lécuyer, Le sacerdoce chrétien p. 506. This interpretation is based on a Christology solely stressing the heavenly Christ: "On peut même dire que c'est seulement au ciel que le Christ est véritablement grand prêtre, selon toute la plénitude du mot, puisque la Passion elle-même n'était que le prélude et, pour ainsi dire, la condition préalable nécessaire pour la Résurrection et l'Ascension", Lécuyer, Le sacerdoce chrétien p. 490. The same tendency is found in Betz: "Theodors Blick ist bei der Betrachtung des Hohepriestertums Jesu ganz auf dessen himmlische Stellung gerichtet", Betz, Eucharistie p. 132. Even if it is right, as Betz maintains, that the main interest in Theodore's Christology is related to the effect of the death and resurrection of Christ (Betz, Eucharistie p. 133), this does not mean that the historical aspect is lost, as Betz indicates.

trated on the sacrifice, the preparatory greeting "Lift up your minds" is interpreted as a request to look "upwards towards heaven and to extend the sight of our soul to God".[178] The purpose this time is not only to allow space for Christ's "economy", but also to draw the Divine Being into the sphere of the mental image. The faithful are encouraged to turn their eyes physically upwards and in this way lead the mind's eye to God. The reason for this last broadening of perspective lies in the anaphora prayer's superior perspective itself. The character of the anaphora prayer is one of thanksgiving "for all these things which were accomplished for us", and these thanks must be directed to God who is "the cause of all these benefits".[179] Indeed, the entire ritual act belongs in a context of praise because the rite itself represents a commemoration of the grace in which man has participated and which later gives occasion for praise.[180] This praise is not exclusively linked to the ritual but is connected with the glorification which all visible creatures and the invisible hosts practise. The ritual is given a cosmic and celestial aspect which is based on an all-embracing praise of the eternal and Divine nature. This broadening of perspective allows for a meaningful interpretation of the Hagios cries. Theodore's point is, in fact, that the praises of the congregation are to be organized in the broad context which we have just indicated. When the congregation sings with loud voices, Hagios, Hagios, Hagios, it is in imitation of the song sung by the invisible creatures and thereby exceeds the bounds of the ritual celebration. For, the imitated song opens up the perspective towards the song which eternally and at all times is carried on around God's throne.[181] This expansion which is opened up by the anaphora prayer, thus fills in and supplements the previously discussed concentration on Christ's economy. By drawing the Divine Being into the field of vision, the all-inclusive character of the ritual is emphasized. Christ's economy is now seen in the light of the cosmic praise of the Divine Being.

In the interpretation of Isaiah's vision, which forms the first climax in the anaphora prayer, we find once again the same group of themes dis-

[178] Mingana VI. 99.
[179] Ibid.
[180] "The right praises of God consist in professing that all praises and all glorifications are due to Him, inasmuch as adoration and service are due to Him from all of us; and of all other services the present one, which consists in the commemoration of the grace which came to us and which cannot be described by the creatures, takes precedence", Mingana VI. 100.
[181] "He makes also mention of the Seraphim, as they are found in the Divine Book singing the praise which all of us who are present sing loudly in the Divine song which we recite, along with the invisible hosts, in order to serve God. We ought to think of them and to offer a thanksgiving that is equal to theirs", Mingana VI. 101.

cussed here (God, economy and glorifying creatures). Theodore points out that the Hagios cries of the Seraphim sounded at the same moment Isaiah foresaw the benefits to be granted to mankind. Thus, the vision becomes a reference to Christ's economy, while at the same time, the three shouts of Hagios maintain the reference to the Godhead as well as the praise of the congregation.[182] In VI.118, Theodore elaborates upon his interpretation of the vision. Here it is said that Isaiah saw "a sign of the Economy of Christ our Lord, from which all the earth was about to be filled with Divine glory".[183] The vision contains Christ's economy and its consequences for creation . Next, the three cries of Hagios refer to the three persons of the Trinity, while the Lord Sabaoth refers to the one almighty Divinity. Finally, the cries indicate the distance existing between the one true and impassable Divinity and the creation one who has become sacred by an act of grace. The interesting thing in VI.118 is that these three elements are directly related to one another.[184] We mentioned the explicit reference to Christ's salvation economy. But from here, not only would heaven and earth be filled with Divine glory but the mystery of the Trinity would be made known through the economy just as "evangelization, faith and baptism" have their roots here. In this way the anaphora prayer leads up to a thematic climax with a visionary character and which as far as the content is concerned, refers to the economy's source in God, the economy itself and its consequences for man.

Our examination of the eucharistic prayer reveals, in this way, a vision-directed prayer structure corresponding directly with the actual ritual act and its visionary character. The interaction between ritual and prayer is clearly reflected in the text cited in our introduction to this analysis of Theodore (see p. 209). After examining Theodore's Christology, the reference to the two ontological levels no longer presents a problem because the Christology's distinctive character is found in

[182] "Indeed, while the blessed Isaiah foresaw, by the working of the Spirit, the benefits that were to be granted to the human race, he heard in vision the Seraphim uttering these words", Mingana VI. 100. Having emphasized the contrast between what is seen from those who see, Theodore gives an interpretation of the Hagios-shouts: "The doctrine of the Trinity was also revealed at that time when one Godhead was proclaimed in three persons", Mingana VI. 100f.

[183] Mingana VI. 118.

[184] "This may also be learnt from the words of the blessed Isaiah, because the awe-inspiring vision which he saw was a sign of the Economy of Christ our Lord, from which all the earth was about to be filled with Divine glory, was to learn also the mystery of the Trinity, and receive evangelisation, faith and baptism in the name of the Father, the Son, and the Holy Spirit. To make this manifest, the Seraphim shouted in a loud voice the canticle: 'Holy, holy, holy the Lord of Sabaoth, the heaven and the earth are full of His praises'", Mingana VI. 118.

precisely this double reference. On the other hand, there is cause to look more closely at the text's utilization of visions. We note that the ritual act is seen here as the basis for the mind's vision imagery.[185] Next, interest is drawn to Christ who through his participation in the Divine nature may be beheld by lifting one's gaze upwards to God. It is this very participation of Christ in the Divine nature which makes it possible to realize bygone redemptive acts by means of visions. Thus, it is reference to the Divine as well as to the economy which accords the vision a distinctive hermeneutical function; not only does it open the way for Divine presence in the ritual context but it can, simultaneously, interpret this Divine presence through reference to Christ's past work of salvation.

Thus, the point behind the visionary character of the ritual as well as the anaphora prayer is to structure the ritual in such a way that the meaning behind it becomes as easily understood as possible. Here, the mind's eye plays a decisive role. For Theodore, it is the inner mental processes which make a reasonable interpretation of the ritual act possible. We have seen that it is the inner eye which ties the rite to heavenly themes. But, it is also the inner mental process which makes it comprehensible for the faith that the liturgical act is directly connected to Jesus' death. Both of these difficult hermeneutic leaps, which are the premises for giving the ritual a theological meaning, require an inner interpretative process.

At the same time it is absolutely necessary to emphasize that this inner process is directly dependent upon the exterior ritual act. The rite itself, by means of its visual character, creates the basis for the eyes' contemplation which opens the way for an interpretive image of the events reproduced by the ritual. The rite provides the external condition for outer as well as inner visual processes in those participating in it. When the liturgy, by means of the exhortation "Lift your minds" has prepared the congregation for the ritual act, the function of the physical eye and the mind's eye is parallel. A concrete, ritual act is seen by the physical eyes while the mind sees a vision which supplements the rite. It is only when these two processes function together that the meaning of the rite is clearly divulged.

This interplay of inner and outer phenomena is also expressed in Theodore's interpretation of what takes place when the Eucharist is received by the faithful. When the priest says "the Body of Christ", it does not imply that the faithful shall "look at that which is visible", but

[185] Cf. "although we are supposed to perform this awe-inspiring and ineffable service on earth, we, nevertheless, ought to look upwards towards heaven", Mingana VI. 99.

that he shall imagine in his mind "the nature of this oblation (lit. the thing which is placed), which, by the coming of the Holy Spirit, is the body of Christ."[186] This visible object is necessary and unavoidable but its true nature is only accessible to the mind. The mental images give an interpretation of the outer, ritual acts. Thus, they have a very central epistemological importance as it is precisely by means of the visual process that the specific value of the ceremony is made accessible.

This vision which is such a theologically important part of the ritual celebration is in danger of becoming diffuse. It is hardly accidental that Theodore, in his catechetical instruction repeatedly returns, not only to the vision's importance for the ritual, but to the vision's actual content. Theodore's catecheses reveal a direct need of a visual element in the Divine service; one which can supplement the ritual act more explicitly than the short reference to Isaiah's vision found in the Hagios cry. The existing apsidal decorations which we have analyzed earlier, offer such a supplement. Here we find a vision presenting exactly the same group of themes which Theodore considers important (compare, for example, our theme division in Paulinus of Nola's tituli (cf. p. 91) with Theodore's interpretation of Isaiah's vision). In the world of Theodore's liturgy, the visionary image directly supports the rest of the ritual ceremony. Admittedly we find no references to pictorial decorations in Theodore's catecheses. Thus, we cannot with certainty assert that apsidal iconography has had such a function in Theodore's congregation. We believe, nevertheless, that we have sufficient grounds to contend that there is a natural place in Theodore's liturgical understanding for the type of iconography which we have analyzed.

Having now examined Theodore's interpretation of the ritual ceremony's pattern, we shall look more closely at the distinctive outline he gives to the soteriological themes within these bounds. Earlier, we referred to the singing of the Seraphim which the faithful are to imitate (cf. p. 234). Seraphim appear simply as prototypes of the created beings' conduct in relation to the Creator. Thus, Theodore too, can say that the economy makes it possible for man to serve God just as the Seraphim. Here, however, the futuristic-eschatological perspective which permeates the catecheses is brought in as a sort of reservation as to what can be realized in the rite: "the Economy of our Lord granted us to become immortal and incorruptible, and to serve God with the invisible hosts 'when we are caught up in the clouds to meet the Lord in the air, and so shall we ever be with the Lord', according to the saying of the Apos-

[186] Mingana VI. 113.

tle.''[187] Not only is the praise of the faithful based on the economy's mediation of immortality but, simultaneously, a futuristic aspect is introduced. Man's total praise of God actually belongs in the future. This interpretation is supported by a further explanation of the vision given by Theodore. He carries the heavenly theme disclosed by the Seraphim no further, but, rather contrasts it with his interpretation of Isaiah's cry of woe, where the distance between unclean people and the vision's king, Lord Sabaoth is maintained. It is the fallen man who is in need of God's unlimited mercy which is the actual framework of the rite.

It is impossible, therefore, for the vision to distribute the heavenly benefits adequately in a ritual context. According to Theodore, the vision is only beheld "dimly" through faith and this sight stands, to a certain extent, in contrast to what will be seen when one comes to participate in the heavenly benefits: "We wait here in faith until we ascend into heaven and set out on our journey to our Lord, where we shall not see through a glass and in a riddle but shall look face to face."[188] The true sight of God and true participation in the Seraphim's praise is not to be achieved by man here on earth.

The distance between that which is mediated in the ritual and that in which one participates at the end of time, also marks the understanding of the sacrament itself. Thus, the sacrament is perceived as symbol and sign of future things which create the possibility of achieving "a sense of possession and a strong hope of the things for which we look".[189] This desire to accentuate the temporary character of the sacrament is emphasized most clearly when Theodore contends that the future bestowal of grace will happen without sign and symbol.[190] Such assertions must be seen against the background of Theodore's basic understanding of the sacraments in general. The sacrament conveys, indeed, "the representation of unseen and unspeakable things through signs and emblems".[191] The sacrament belongs within the sphere of faith on earth where the object of religion is invisible (cf. p. 209).

We shall now attempt to give a more exact explanation of how Theodore perceives man's participation in the invisible benefits of salvation. Such an explanation will be linked primarily to his interpretation of the sacramental symbolic acts.

[187] Ibid. VI. 101.

[188] Ibid. VI. 82.

[189] Ibid.

[190] "He shows that when our Lord shall come from heaven, and make manifest the future life, and effect the resurrection of all of us—from which we shall become immortal in our bodies and immutable in our souls—the use of sacraments and symbols shall by necessity cease", Mingana VI. 72, see also VI. 112.

[191] Mingana VI. 17.

b) The Character of Ritual Representation

The debate concerning Theodore's understanding of the sacrament shows that it is not easy to decide the exact character of ritual representation in the catecheses. The discussion about the character of the reality of benefits to the faithful within a sacramental context has usually been linked to an interpretation of expressions such as τύπος, ἀντίτυπος and σύμβολον. We met precisely the same use of terms in the analysis of Cyril's understanding of the sacraments. There, we pointed out that the ritual, through its symbolism, transmitted a genuine participation in salvation to the faithful (see p. 183). This interpretation conforms with traditional interpretation of symbol and typos within this period. In more general characterizations of patristic usage of symbol and typos terminology, it is usual to underline that the purpose of such expressions is to emphasize a genuine participation in the benefits of salvation.[192] In studies of Theodore's work, meanwhile, we find various nuances in this terminology. The background for the discussion concerning Theodore's perception of symbols is to be found in the somewhat peculiar passage in VI.75: "It is with justice, therefore, that when He gave the bread He did not say: 'This is the symbol of my body,' but: 'This is my body', ... because He wished us to look upon these (elements) after their reception of grace and the coming of the Spirit, not according to their nature, but to receive them as if they were the body and blood of our Lord."[193] This statement has been thought to express the disrepute into which symbolic terminology fell towards the end of the 4th century because of its ambiguity.[194] The statement, however, is not definitively explained by

[192] Battifol writes: "Il suit de là que, en Syrie, dans la seconde moitié du IVe siècle, on acceptait que l'eucharistie fût appelée ἀντίτυπον du corps et du sang du Christ. Le sens du mot ἀντίτυπον est, croyons-nous, celui que donne la *Secunda Clementis*, quand, distinguant dans le Christ la chair et l'esprit, elle écrit: 'Cette chair est l'antitype de l'Esprit: nul qui outrage l'antitype ne recevra l'original'. Autrement dit, l'antitype est une représentation de l'original", Battifol, Études d'histoire p. 386f. Likewise in Woolcombe: "la théologie de l'Eucharistie au IVe siècle était telle que τύπος ne pouvait pas simplement signifier une *rprésentation*: comme Harnack l'a bien vu, τύπος, *symbolum*, et autres mots semblables, comportaient absolument le sens de la Présence réelle de Notre Seigneur dans le Sacrement ... Un signe ou ... un symbole *fût* actuellement, en quelque sens, ce qu'il représentait", Woolcombe, Le sens de 'type' p. 96.

[193] Mingana VI. 75. The Syriac formulation translated by Mingana with "as if" is disputed. Rücker translated with ut: "sed ita suscipere ut sunt (scilicet) corpus et sanguinem Domini", Rücker, Ritus p. 31. Both translations are possible. De Vries follows Mingana, see De Vries, Nestorianismus p. 136 note 4; Reine prefers Rücker's interpretation, Reine, Eucharistic Doctrine p. 9f.

[194] Battifol comments on a parallel to the text referred to: "Le premier symtôme formel de réaction contre l'emploi du mot 'symbol' cher à Eusèbe, est fourni par un antiochien, Théodore de Mopsueste", Battifol, Études d'histoire p. 390. Objection to this terminology has been regarded as a reaction against tendencies within Alexandrian theology, Woolcombe, Le sens de 'type' p. 99f., see also Koch, Heilsverwirklichung p. 168f.

such an interpretation. Theodore, in fact, makes extensive use of symbolic terminology in his catecheses. In the light of other statements in the catecheses, the meaning in the text referred to here is obscure.

De Vries' explanation is extreme. He considers the text problematical: "Es soll betont werden, dass wir in der Eucharistie nicht bloss ein *leeres* Symbol haben, sondern ein Symbol, das uns eine wirkliche Garantie der künftigen Unsterblichkeit gibt."[195] This statement, however, must correspond with the understanding of the sacrament which De Vries considers Theodore to advocate. With VI.77 as his reference,[196] he maintains that the bread is merely a symbol of the body of Christ and is not the reality it represents.[197] It is worthwhile to examine De Vries' viewpoint more closely. Using textual material as reference, he attempts to show that Theodore considers symbol and reality to be in contrast. He finds an example in VI.49: "You should now proceed towards baptism in which the symbols of this second birth are performed, because you will in reality receive the true second birth only after you have risen from the dead."[198] With the support of a number of similar texts[199] De Vries draws the following conclusion: "Das Symbol enthält also nicht die Wirklichkeit selbst ... Eine ... realistische Auffassung würde ganz aus dem Rahmen des minimistischen Systems Theodors herausfallen."[200]

As could be expected, Oñatibia has quite another interpretation. In his opinion, the text gives unequivocal proof that symbols in a sacramental context embody the reality they symbolize and thus confirm the thought that Christ is present in the Eucharist.[201] L. Abramowski supports this interpretation: "Doch bedarf sein Kernsatz, der Typus enthalte die Wirklichkeit, die er abbildet, noch einer Ergänzung: der Typus enthält die Wirklichkeit, die er abbildet, *in dem er an ihr teil hat.*"[202]

Between these two extremes we find two other opinions. Koch maintains: "Typussein, Symbolsein bedeutet nicht schon an und für sich seinshafte Gegenwärtigkeit, seinshaftes 'in Erscheinung kommen' des Typisierten, Symbolisierten, sondern es bedarf, soll das Abbild nicht ontologisch leer, ein bloss gnoseologisch wirksames Zeichen sein, einer besonderen Wirklichkeitsmittlung, die wir bei Theodor in der ἐνέργεια, der 'Gnade des Geistes' erkennen werden."[203] Basically, Koch is close to De Vries' interpretation; he holds that

[195] De Vries, Nestorianismus p. 136f.

[196] "It does not do this (assist in attaining immortality) by its own nature but by the Spirit who is dwelling in it, as the body of our Lord, of which this one is the symbol, received immortality by the power of the Spirit, and imparted this immortality to others, while in no way possessing it by nature", Mingana VI. 77.

[197] De Vries, Nestorianismus p. 137.

[198] Mingana VI. 49.

[199] Ibid. VI. 52; VI. 79.

[200] De Vries, Nestorianismus p. 118 and 120; see also De Vries, Das eschatologische Heil p. 318.

[201] "Es ésta una prueba evidente de que, para Teodoro, lo mismo que para los demás Padres de la Escuela antioquena, el τύπος *contiene* la realidad que simboliza, puez está fuera de toda duda que nuestro autor afirmó enfáticamente el dogma de la Precencia Real. Toda su doctrina eucarística descansa sobre la afirmación categórica de la presencia de Cristo en la Eucaristía", Oñatibia, La vida cristiana p. 119f.

[202] Abramowski, Zur Theologie p. 274.

[203] Koch, Heilsverwirklichung p. 168.

the symbol in itself does not bring about actual presence.[204] The symbol in itself has solely gnosiological value.[205] This understanding must prevail when it is a question of the symbol referring to Christ's historical redemptive work.[206] On the other hand, Koch, in contrast to De Vries, contends that when the symbol is utilized to maintain the connection to eschatological redemptive benefits we find "eine gewisse seinshafte Erfülltheit".[207] In this context it is imperative to maintain that the ontological connection be established through the Holy Spirit. It is still merely a question of salvation being "ontisch schwach" present in the church.[208]

The salient point in Koch's understanding is the interpretation of the representative nature of symbols in connection with Christ's redemptive work. As has been said, Koch maintains that, in this context, the symbol is solely to be taken as a sign. It is through this sign, nevertheless, that the work of the Holy Spirit is to be seen and in speaking about the benefits of salvation, the sign is "seinshaft erfüllt".[209] Koch barely argues for this interpretation but contrasts it provisionally to Casel's theology.

J. Betz also wishes to keep a certain distance from Casel in his interpretation but here, however, it is only a question of slight modification. He establishes the main part of his opinion against interpretations of Koch's type: "Das Urmysterium entfaltet ... seine Wirkung im Kultmysterium. Man würde aber Theodor missverstehen, wollte man die Aussage im Sinne der modernen Effectustheorie verstehen, nach der im Sakrament nur die Wirkung, die Frucht des Kreuzestodes, nicht aber der Kreuzestod selbst gegenwärtig wird."[210] Betz also disagrees with Casel's doctrines.[211] He prefers, on the other hand, to speak of commemorative actual presence (kommemorative Aktualpräsenz). The purpose of the designation is to hinder interpretations of Casel's type in which past acts of salvation "steht ... in sich selbst wieder auf".[212] The presence in question here is not absolute but relative—it is symbolic. Even so, it concerns an objective commemoration. As the actual presence and anamnesis come to denote the same, Betz finds it natural to speak of a commemorative actual presence. The presupposition for such a viewpoint is that the sacrament conveys the presence of Christ's past act of salvation: "Das Sakrament kann nicht anders Typos *unserer* kommenden Herrlichkeit sein, als dass es Typos der schon verwirklichten Herrlichkeit *Christi* ist. Es kann nicht Typos der *Herrlichkeit* Christi sein, ohne

[204] "Die Typen, Bilder und Symbole vergegenwärtigen nicht schon als solche in seinshafter Weise", Koch, Heilsverwirklichung p. 197.

[205] "Wir haben dargelegt, dass die Begriffe des Typus und des Symbols zunächst nur Zeichen, Anzeige einer unsichtbaren, unaussprechlichen Wirklichkeit bedeuten, einer Wirklichkeit, die ebensowohl gleichsam in Zeichen verhüllt gegenwärtig, wie auch 'ausserhalb seiner' sein kann, so dass nur für die Erkenntnis auf sie hergewiesen wird", Koch, Heilsverwirklichung p. 198.

[206] "Nach 'rückwärts', in Beziehung zu dem historischen Heilswerk Christi, ist die Trias Typus, Symbol, Bild nur Darstellung, Gedächtnis und Erinnerung im Zeichen, nicht ontisch erfüllte Repräsentation", Koch, Heilsverwirklichung p. 170.

[207] Koch, Heilsverwirklichung p. 171.

[208] Ibid. p. 180.

[209] Ibid. p. 185f.

[210] Betz, Eucharistie p. 221.

[211] Ibid. p. 243.

[212] Ibid. p. 241f.

dass es gleichzeitig Typos seines *Leidens* und seines *Todes* wäre, weil Leiden und Tod die Ursache seiner und unserer Verherrlichung sind.''[213].

The focal point in this lack of agreement between Koch and Betz is tied to the understanding of the relation between symbol and Christ's redemptive work. We shall establish our own position regarding the existing disagreement by examining certain texts.

Our point of departure is found in the account concerning the sacraments in VI.17: ''Every sacrament consists in the representation of unseen and unspeakable things through signs and emblems. Such things require explanation and interpretation, for the sake of the person who draws nigh unto the sacrament, so that he might know its power. If it only consisted of the (visible) elements themselves, words would have been useless, as sight itself would have been able to show us one by one all the happenings that take place, but since a sacrament contains the signs of things that take place or have already taken place, words are needed to explain the power of signs and mysteries.''[214] Thus, the performance of the sacrament in itself holds limited interest; the importance lies in its possibility of representing something other than the performance suggests.

In a continuation of the above quotation, Theodore emphasizes his view of the sacrament by contrasting it to the Jewish religious service: ''The Jews performed their service for the heavenly things as in signs and shadows, because the law only contained the shadow of good things to come, and not the very image of the things, as the blessed Paul said. A shadow implies the proximity of a body, as it cannot exist without a body, but it does not represent the body which it reflects in the same way as it happens in an image. When we look at an image we recognise the person who is represented in it—if we knew that person beforehand—on account of the accurately drawn picture, but we are never able to recognise a man represented only by his shadow, as this shadow has no likeness whatever to the real body from which it emanates. All things of the law were similar to this.''[215] Here, Theodore employs two different ways of understanding the ritual act. It has either the shadow's proximity to its object or it represents the object in such a way that it becomes

[213] Ibid. p. 230. As his main textual source Betz refers to Mingana VI. 83: ''Aus diesem Text ersehen wir, dass die Eucharistie Gedächtnis des Todes Christi ist, dieses Gedächtnis aber selbst die Form eines Opfers hat. In ihm wird das vergangene Heilswerk Christi gegenwärtig, und zwar nicht in sich selbst, in seinem historischen Daseinsakt, sondern im und am Typos oder Bild. Wenn wir die jetzt vollzogenen Gedächtnismittel betrachten, sehen wir nach Theodor, wie Christus jetzt wieder stirbt und aufersteht, was er einst getan'', Betz, Eucharistie p. 231.

[214] Mingana VI. 17.

[215] Ibid. VI. 17f.

actually recognizable. Distance is maintained because the sacrament as an image is *not* the object itself. Proximity is maintained by tying object and sacrament together in the same way as the image is tied to the thing depicted. But, is not proximity still such that one can say that the heavenly beyond truly *is* not in the image?

Theodore's further emphasis is not related to a comparison with the pictorial image. On the contrary, he returns to the above cited comparison of the Jewish and the Christian Divine service. The Jewish service is perceived as a shadow of heavenly things. Christians, on the other hand, see heavenly reality *because Jesus has showed it to them through his resurrection* and promised participation in it at the end of time.[216] Thus, the key to Theodore's understanding of the sacrament is found in Christ's work of salvation. The new reality has entered the world through Christ rising from the dead and because of his human nature man can participate in that which Christ brought. Grounds for talk of the benefits of salvation are here, as otherwise in Theodore's works, Christ's redemptive work. By referring to Christ's economy, a way is opened to salvation for the faithful. Christology and redemptive benefits are tied together in such a way as to make it impossible to refer to one without bringing in the other. The key to any talk of participation in salvation by the faithful has its roots in Christology.

In Baptism a direct connection is made between Christ and the one baptised: "when at my baptism I plunge my head I receive the death of Christ our Lord, and desire to have His burial, and because of this I firmly believe in the resurrection of our Lord; and when I rise from the water I think that I have symbolically risen a long time ago."[217] Baptism conveys true participation in the death of Jesus and thereby the baptised one is related to his resurrection. At the same time, however, Christ's resurrection and our resurrection are kept apart. The state of tension thus arising between participation in Jesus' death and resurrection is explained in the interpretation of Romans 6:5 which makes use of a corresponding tension: "In using the future tense he confirms the present event by the future reality, and from the greatness of the coming reality

[216] "In this way they (the Jews) only performed their service as a sign and a shadow of the heavenly things, because that service gave, by means of the tabernacle and the things that took place in it, a kind of revelation, in figure, of the life which is going to be in heaven, and which our Lord Christ showed to us by His ascension into it, while He granted all of us to participate in an event which was so much hidden from those who lived in that time that the Jews, in their expectation of the resurrection, had only a base conception of it", Mingana VI. 19. See also the following statement: "The things that the ancient held as figures and shadows came now into reality when our Lord ... became immortal ... as by His union with our nature He became to us an earnest of our own participation in the event", Mingana VI. 19f.

[217] Mingana VI. 52.

he demonstrates the credibility of the greatness of its symbols, and the symbol of the coming realities is baptism."[218] Theodore stands firm in his belief that Baptism conveys participation in Jesus' death and in his resurrection at the end of time. These are indisputable realities and the faithful must organize their lives accordingly. Man is linked to this entire reality in the sacrament. Precisely the incontestability of resurrection shows the meaning contained in the sacrament. For, resurrection appears so certain that in it we find the anchorage allowing the mediation of this reality to be brought validly into this life. For Theodore, the greatness of the sacrament lies in the possibility of making the economy and our future participation in salvation a reality here and now.

Making the genuine connection between the faithful and Christ in the sacrament his basis, Theodore is also able to speak of genuine participation in the benefits of salvation here on earth. This participation in redemptive benefits conveyed by the sacrament is described by Theodore as a potential participation in redemption. Just as a child has the potential ability to talk, hear, walk and work which is only fully developed at a later stage, so are the conditions for the baptised. Indeed, all possibilities for an immortal and immutable nature are potentially present, but, these possibilities cannot be utilized for the time being in order to lead to "a complete and perfect act of incorruptibility, immortality, impassibility and immutability".[219]

Through interpretation of the sacrament itself also, Theodore is able to emphasize the actual participation which it conveys. Thus, he points out that through the sacrament, the faithful "sometime beforehand" participate in "the realities themselves".[220] This participation, although not complete, is usually spoken of as a participation in salvation.[221] In this way Theodore is enabled to maintain that salvation is not completely effected in this life while at the same time maintaining the idea that the sacrament conveys a true participation in future benefits of salvation.

This understanding of how salvation enters into this world also marks Theodore's comprehension of what is mediated through bread and wine in the celebration of the Eucharist. The true presence is expressed by considering the element as "immortal, incorruptible, impassible, and

[218] Ibid.

[219] Ibid. VI. 56.

[220] Ibid. VI. 115; see also VI. 52: "all this is done in symbols and in signs, in order to show that we do not make use of vain signs only, but of realities in which we believe and which we ardently desire".

[221] "As long as we are on the earth, however, because we only receive them by hope through our participation in these mysteries, it is possible to fall away from them, as we have a changeable nature", Mingana V. 21; see also VI. 50. See also Abramowski, Zur Theologie p. 274f.

immutable by nature, as the body of our Lord was after the resurrection".[222] At the same time the future perspective is maintained. Theodore contends, indeed, that the purpose of the sacrament which announces "the gift of immortality through an immortal nourishment", is to create an assurance concerning the future benefits "for the sake of which we draw nigh unto the holy Sacrament".[223]

Participation in the salvation granted by the sacrament leads to death's loss of its actual hold over those baptised. As a consequence, Theodore is able to maintain that the faithful in the future will be "completely immortal etc. ... by nature".[224] The statement presumes a form of participation in immortality already here on earth. Again we find the background in Christ's death and resurrection where the all-encompassing Divine decree establishing the power of death over mankind was abolished. Using I Corinthians 15:20 as reference, Theodore explains that death resembles a long sleep for those believing in Christ, "because they will rise and divest themselves of death through the resurrection".[225]

Since immortal life is a result of Christ's destruction of the power of sin by the sinless life he lived, this life here on earth can also be seen in the light of an immortal life. In consequence, Theodore, emphasizes that life here on earth should be organized as far a possible on the basis of the hope of a future life. In this respect, Christ is the model for man.[226] In this life, one should behave "as if you had been for a long time in the next world".[227] If life is planned around good deeds, sin which involuntarily finds its way to the faithful because of weakness, will cause no injury. It is here that the sacrament is a support by supplying the strength to carry out good deeds.[228] A life free of sin is impossible in this world, but it can be imitated and through imitation take on the character of life in the hereafter. The future puts its stamp upon the present.

4. Summary

In the introduction to this chapter, we pointed out that Theodore's theology was developed in a milieu marked by the confrontation of Hellenistic culture and Christian faith. Our analysis of Theodore's theology has revealed a theological profile showing an equally clear divi-

[222] Mingana VI. 104.
[223] Ibid. VI. 108.
[224] Ibid. VI. 112.
[225] Ibid. VI. 52.
[226] Ibid. V. 69.
[227] Ibid. VI. 11.
[228] Ibid. VI. 117.

sion between the existing, created world and the sphere of the hereafter, which stands in a certain contrast to this world. Theology of this type is closely related to Theodore's one-sided concentration on death as a theological problem. When salvation is seen as the conquest of death, the perspective is naturally beyond the present, death-ridden world. In a remarkable way, Theodore combines such an understanding of salvation with great attention on Christ's human nature and God's care for the created world. Thus, Theodore's entire catechetical work shows a clearly outlined creation theology. But, the introduction of the other katastase implies that interest in the existing world almost disappears of its own accord. Why should one be wrapped up in the first katastase when God has created a new epoch for his world, one in which death is vanquished?

It is striking that this theological doctrine is so strongly set forth at the end of the 4th and the beginning of the 5th centuries. It is interesting, therefore, to note that Theodore emphasizes this perspective more intensely than does Cyril, but also more strongly than his teacher Diodor.[229] It is not easy to find Theodore's grounds for such strong emphasis on salvation's futuristic character and the corresponding distance from "this decrepit and mortal world".[230] We shall merely state that Theodore's theological profile seems to be the result of theological tradition, social position and his own personality.[231]

Even though Theodore's theology is markedly drawn towards the next world, there is no doubt as to the importance which the ritual retains in Theodore's catechetical instruction. It is in the ritual that man is put into contact with the new creative act which God applies in this world but

[229] About Theodore Koch says: "Das Heil, das in der Kirche, durch die Kirche gegeben ist, scheint gegenwärtiger gefasst und auch weniger stark durch die Güter der Unsterblichkeit und Unveränderlichkeit bestimmt zu sein ... So scheint die Kluft der 'eschatologischen Differenz' bei Diodor weniger weit aufgerissen zu sein als bei Theodor, wenngleich auch hier eine starke 'Endheilsspannung' erkennbar wird", Koch, Heilsverwirklichung p. 241f.

[230] The reasons that the world will endure is that "mankind might believe in Him and receive the hope of communion (with Him) and future life", Mingana V. 70.

[231] Theodore contrasts Hellenistic culture with the heavenly and the futuristic aspect toward which the Christian is orientated. Having described pagan cults as the devil's pleasure, he says: "It is not difficult to know the great injury caused by these things to the souls of men, and we ought to remove from all of them the son of the Sacrament of the New Testament, who is being enrolled in the citizenship of heaven, who is the heir of the future benefits", Mingana VI. 43. The negative attitude towards the world itself seems to be connected to a specific experience of life on earth: "We do everything in labour, and our nature itself emanates and suffers from it. As to God, He is above all these. Even when we reign, when we become governors, when we judge, when we work, when we speak, when we look, and do any other thing, we do all with labour, and when fatigue is protracted, it is followed by sweat; and because our nature is mortal and corruptible, it will perish through labour", Mingana V. 34. Life on earth will forever be full of hard work and burdens.

which is only made complete at the end of time. This interpretation conveys insights which supplement the knowledge gained in studying Cyril. Cyril has already shown us the importance of inner mental processes in man's encounter with God and God's works. Theodore explains, in addition, how the ritual's organization helps to create an inner image, the purpose of which is to maintain the connection between all the meaning levels referred to in the ritual. According to Theodore, the ritual grants an inner view of the Divine Being and Christ's previous and future redemptive works into which the faithful will be drawn. Between the mental imagery encouraged by Theodore and the pictorial imagery which we know from our iconographical analyses there exists close communication. Based on the similar thematic relationship to be found in the two types of ''pictorial programs'', we venture to suggest the function of the apsidal imagery by means of a comparison with Theodore's mental visions. We think it probable that the purpose of the apsidal imagery is to support the mental process which is a condition for comprehension of the ritual's meaning.

CHAPTER EIGHT

AMBROSE OF MILAN

1. Introductory Remarks

a) The Text

The last text group with which we shall be dealing in this study differs in several ways from the previously analyzed texts. To begin with, the term text group requires some nuances in definition because, in fact, it concerns two different textual units. De mysteriis and De sacramentis are both instructional texts aimed at the newly baptised but it is a question of two separate accounts concerning the sacramental program. If we compare these texts with Cyril's and Theodore's catecheses, we notice immediately that any explanation of the baptismal symbol, which plays such a large role in the other catecheses, is lacking. Here we have only access to the mystagogical parts of catechumenical instruction and these are in some ways a duplicate. This means that we are not only faced with a much shorter text than with the other two but that the content also is more limited. Thus, it becomes impossible to treat the Christological theme at any length on the basis of these texts because the material simply does not treat Christology thematically in the same manner as in an interpretation of the baptismal symbol.

These texts, furthermore, differ from those already analyzed in being of western origin. Disagreement has arisen as to the author. This is not so great in the case of De mysteriis as in De sacramentis. Whereas it has been usual to attribute the first to Ambrose, a considerable number of attempts have been made to deprive De sacr. of its traditional Ambrosian origin.[1] Discussion concerning the connection between the two texts has centred around the evaluation of similarities and dissimilarities in the two text groups. On one hand the similarities are striking. In both cases, as has been said already, concern is with instruction of the newly baptised. Further, the rituals referred to are practically identical and the theological terminology is principally the same.[2] This similarity cannot be incidental. It must be either a case of two works by the same author or one being directly contingent upon the other.

[1] Botte, Introduction p. 8ff.
[2] Ibid. p. 7.

The problem is to decide upon the closer relationship between them and so an evaluation of the dissimilarities comes to the foreground. Whereas De sacr. is in the form of a series of sermons, De myst. appears to be work in which the sermon form has developed into literary fiction. In addition, a large part of the material from De sacr. is not included in De myst.[3] Not least of all, differences in style can be demonstrated.[4] The discussion caused by the dissimilarities is thoroughly covered by Botte.[5] His own appraisal is built on analyses which deal with three aspects of the source material: their historical information, their reference to liturgical usage and their use of Biblical texts. Botte's treatment of these themes, in which, moreover, he supports the work of P. Faller and R. H. Connolly,[6] points to Ambrose as the author of both texts.

How then does Botte take the striking stylistic differences in the two texts into consideration? In the first place he points out that a difference in literary genre justifies a difference in style. He goes on to say that there is no genuine Ambrosian sermon material which can be utilized to carry out an adequate stylistic study. But, the most important reason for a number of irregularities in De sacr. can be explained on the basis of the theory already launched by F. Probst[7]; De sacr. was never published by Ambrose but consists of sermons recorded by a stenographer.

Botte's argument is not considered to be the final word in the debate. K. Gamber's attempt to deny Ambrose' authorship of De sacr.[8] has been challenged by, among others, J. Schmitz.[9] We find Botte's argumentation convincing and consider De sacr. to be the work of Ambrose on an equal footing with De myst.

Thus, we consider Ambrose to be the author of both texts and consequently Milan as their place of origin. They are usually dated 380/1.[10]

b) The Liturgy in Milan

Source records of religious life in Milan in the 3rd century are extremely sparse.[11] Our first information about the 4th century Milanese liturgy is,

[3] Ibid. p. 8.
[4] Botte says: "Le *De sacramentis* est assurément inférieur au *De mysteriis* et aux autres oeuvres certainement authentiques d'Ambroise. Le style en est négligé; il est coupé de fréquentes interrogations, qu'on a qualifiées souvent de froides et de puériles'', Ibid. p. 8.
[5] Ibid. p. 8f.
[6] Ibid. p. 11 note 3 and 4.
[7] Ibid. p. 10 note 1.
[8] Gamber, Autorschaft and Gamber, Sakramentarstudien p. 120-144.
[9] Schmitz, Gottesdienst p. XXV note 12; see also Schmitz, Zum Autor p. 59-69.
[10] Schmitz, Gottesdienst p. 384; Daniélou, La catéchèse p. 32.
[11] "Although the ecclesiastical history of Milan appears to date from the beginning of the third century, hardly anything is known of it during the first hundred years'', Dudden, Life and Times p. 63.

in fact, connected to renderings of those parts of the eucharistic prayer
which we find in De sacr.[12] It is generally accepted that Greek was used
as the language of liturgy in the west until the middle of the 4th century.[13]
We know, likewise, that Ambrose' predecessor in the episcopal seat, the
Arian Auxentius, came from Cappadocia and had no command of
Latin.[14] As a result it is very likely that the Milan liturgy was celebrated
in Greek right up to Ambrose' time. If this is the case, it is natural to
consider Ambrose himself as the one to introduce the Latin canon which
we find preserved in De sacr.

But, is Ambrose himself the author or has he adopted it from some
other place? Here, we are faced with a controversial problem. Schmitz
gives a detailed account of various research viewpoints while at the same
time pointing out weaknesses in the various arguments. His attention is
clearly directed towards Milanese dependence on Roman liturgy.[15]
Although his conclusion is extremely cautious, there is, however, little to
indicate that here we are faced with a new creation which holds a rather
free position in comparison to the previous liturgical tradition. I.
Schuster points out that in Milan there had been small leeway for
liturgical innovation. For him, the Milan ritual stands "come un com-
promesso tra Oriente ed Occidente".[16]

The characteristic structure of the eucharistic celebration as we know
it from Ambrosian catecheses, displays a certain relationship to the Alex-
andrian ritual which is rather different to the Antiochene rite with which
we have been occupied.[17] The Alexandrian rite has the following basic
structure: praise, reference to the story of salvation, intercession, intro-

[12] For the scanty information concerning church life in Milan before the time of
Ambrose, see Dudden, Life and Times p. 64; see also p. 64 note 7.

[13] Schmitz, Gottesdienst p. 391; Lavorel, La doctrine eucharistique p. 15. See, how-
ever, Kretschmar's reservations in Abendmahlfeier p. 266ff. For the change from Greek
to Latin as the liturgical language in Rome, see also Kretschmar, Trinitätstheologie p.
146f.; Klauser, Übergang and Mohrmann, Origines.

[14] Schmitz, Gottesdienst p. 390.

[15] "Die schlechte Quellenlage macht es unmöglich, den Autor oder wenigstens den
Entstehungsort des in Sacr. zitierten Hochgebets zu ermitteln. Fest steht nur, dass es im
Bereich der lateinischen Liturgie verfasst worden ist, und zwar von einem Autor, der in
Rom beheimatet war oder zumindest eine römische geprägte Schule besucht hat. Es
könnte deshalb durchaus sein, dass Ambrosius den Text geschaffen hat. Aufgrund seiner
Ausbildung war er mit der Juristensprache vertraut und dürfte auch den heidnisch-
römischen Gebetsstil beherrscht haben. Es ist jedoch nicht ausgeschlossen, dass er das
Hochgebet aus Sacr. in einer anderen Kirche—zum Beispiel Rom—vorgefunden und von
dort übernommen hat", Ibid. p. 398.

[16] Schuster, Sant' Ambrogio p. 49; see also Dudden, Life and Times p. 65 who main-
tains that Orientalizing elements within the Milanese liturgy may stem from the period
when Auxentius was bishop.

[17] Kretschmar, Trinitätstheologie p. 147 with text support in note 2.

duction of Sanctus, Sanctus, 1. epiclesis, words of institution, anamnesis, epiclesis and doxology.[18] Here the succession of prayers does not underline the history of salvation as the dominant theological perspective of prayers as we are familiar with in the Antiochene rite (cf. p. 204). Rather, it is significant that texts characterized by praise and anamnesis lead into prayers. In this way, the first epiklesis connects the Sanctus with the words of institution, which means that the word of the Lord appears as the basis for the epiclesical prayer.[19] Thus, this prayer is connected to an oblation theme in which the gifts are perceived as a likeness of Christ's body.[20] Even though the origin of this liturgy appears to be extremely diffuse, there is much to suggest that precisely the connection of the Lord's words and the epiclesis reveal characteristics distinctive to the Alexandrian ritual.[21] Between this ritual structure and that of De sacr., Schulz claims to be able to establish conformity on decisive points.[22]

The prayers cited in De sacr., moreover, are of great importance in the history of liturgy as they represent the most exhaustive western liturgical source after Hippolytus as well as the earliest source revealing details within a Latin liturgical text.[23] De sacr. IV. 21, 22 and 26, which probably give direct quotations from the liturgy,[24] comprise prayers for blessing of the gifts, words of institution, anamnesis and anamnesis prayer.[25] Ambrose, however, gives little information about the other parts of the eucharistic prayer. The exceptionally scanty information about the preceding section reads: "Laus deo defertur oratio petitur pro populo pro regibus pro ceteris".[26] Whereas, Migne as well as Botte, in

[18] Tarby, Prière eucharistique p. 73f.
[19] Schulz, Das frühchristliche Eucharistiegebet p. 148.
[20] Ibid. p. 148f.
[21] Schulz says: "Die Tatsache jedoch, dass in der alexandrinischen Liturgie die heilsgeschichtlich orientierte Danksagung (als eigenes Textstück) von alters her weniger stark die Gesamtanaphora bestimmt und deshalb auch wenig geeignet ist, das Abendmahl Jesu in den Dank miteinzubeziehen, vielmehr der Aufblick zur Herrlichkeit Gottes bei Beginn der Danksagung und beim *Sanctus* schnell zu Interzession und Segensbitte führt, bedingt konkret die Ausbildung einer ersten Epikleses. Diese jedoch ist nicht eigentlich auf die Herrenworte ausgerichtet; sondern letzere erscheinen in ihrem Stiftungscharakter als gewissermassen konkretisierende Begründung für die Bitte um Segen (und für das Oblationsgeschehen als dessen Verwicklichungsmedium)", Ibid. p. 150.
[22] "Betrachtet man von der alexandrinischen Anaphorastruktur her den römischen Kanon, und zwar zunächst in der von *De Sacramentis* gebotenen Textform, so wird sehr schnell klar, dass die dem Einsetzungsbericht hier vorausgehende Bitte in ihrer Funktion der ersten alexandrinischen Epiklese entspricht", Schulz, Das frühchristliche Eucharistiegebet p. 150.
[23] Schmitz, Gottesdienst p. 381.
[24] Ibid. p. 386.
[25] Schmitz refers the text in Gottesdienst p. 384f.
[26] De sacr. IV. 14 (SC. 25.108).

his edition in Sources Chrétiennes from 1950, interjects the following punctuation: laus deo defertur / oratio petitur pro populo,[27] we find in Cod. 188 from St. Gallen: laus deo defertur oratio / petitur pro populo.[28] O. Faller, on the other hand, divides the text into three in his version in CSEL: laus deo / defertur oratio / petitur pro populo which Botte, too, has adopted in his second textual version from 1961.[29] Schmitz argues in favour of choosing the last variant which results in the following structure:

> laus deo (dicitur),
> defertur oratio,
> petitur pro populo,
> pro regibus,
> pro ceteris.[30]

But, even if this variation is chosen, uncertainty prevails as to whether the intercessions referred to here are to be understood as the content of the oratio in question or whether the oratio refers to a prayer in which the content is not disclosed. In any case, it seems obvious that the praise must refer to the preface. No further mention of this part of the eucharistic prayer is made by Ambrose. The earliest preserved preface from Milan dates from the middle of the 5th century and therefore hardly of use to us.[31]

An important question in our context is whether or not Ambrose' preface has led into the Sanctus. Ambrose makes no reference to Sanctus in his catecheses. It is striking, nevertheless, that in several contexts he cites a Sanctus formula which clearly differs from Isaiah 6:3 and which, therefore, could be taken from the liturgy. It read as follows: "Cherubin et Serafin indefessis uocibus clamant: Sanctus, sanctus, sanctus",[32] or "Cherubin et seraphin indefessis vocibus laudant et dicunt: Sanctus, sanctus, sanctus".[33] On the other hand, Ambrose cites Isaiah 6:3 in the following way: "Et clamabant (sc. seraphin) alter ad alterum et dicebant: Sanctus, sanctus, sanctus".[34] The most remarkable difference between these formulas is that the first two use the present tense, as in the Roman

[27] Migne renders the text as follows: "laudes Deo deferuntur, oratio petitur pro populo" (PL. 16.459); see also Des sacrements, Des mystères, ed. by B. Botte (SC. 25.82), Paris 1950.

[28] Schmitz, Gottesdienst p. 399.

[29] De sacr. IV. 14 (CSEL. 73.52).

[30] Schmitz, Gottesdienst p. 399.

[31] Ibid. p. 400.

[32] Ambrose, Expositio 7.120 (CSEL. 32.4.333).

[33] Ambrose, Spir. sanct. 3.16.110 (CSEL. 79.197).

[34] Ibid. 3.21.160 (CSEL. 79.217).

liturgy, instead of the imperfect tense used in the Isaiah quotation. No
certain conclusion can be drawn from these considerations.[35]

With this as his background, Schmitz presumes the structure of the
eucharistic prayer in Milan to comprise: praise (preface), (prayer),
intercessions, epiclesis, words of institution, anamnesis and oblatio-
prayer—thus leaving it open as to whether Sanctus has been integrated.[36]

c) Milan in the 4th Century

Milan's flowering as a city of importance within the Roman Empire is
short lived. It is only at the turn of the 3rd to 4th centuries that Milan
builds up a sufficiently important position that she, in fact, competes
with Rome herself.[37] Diocletian as well as Maximian make it their
administrative centre. The Emperor Constantius completes the separa-
tion from Rome by dividing Italy into administrative parts with Milan
as the centre for the northern part. Throughout the 4th century the city
is used frequently as an imperial resort. From it Constantius issues a
series of decrees and Julian is proclaimed emperor here. Valentinian
makes the city his residence and Theodosius spends long periods in the
city and is buried here. Finally, Honorius governs the Western Empire
from the palace in Milan until he is forced to withdraw by the Goths. The
4th century is Milan's greatest period. During this flourishing period the
city also developed into an important commercial centre. The population
is estimated at between 130 to 150 thousand.[38]

As bishop of Milan from 373-397, Ambrose played an important role
in contemporary religious-political matters. Not only did he strengthen
the power of the Milan episcopacy in its struggle with Rome,[39] but by
his involvement in the Arian dispute helped to consolidate the diocese
internally.[40]

The controversies which arose between Ambrose and the emperors
toward the end of the century are of particular interest. In this context
we shall only examine his participation, at the highest political level, in
the fight against paganism.

Ambrose himself belonged to a family of the Roman nobility, was a
relative of Symmachus[41] and had a promising civil career behind him

[35] See Kretschmar, Einführung des Sanctus p. 79-86 for the problems connected with
the interpretation of Sanctus in western sources.
[36] Schmitz, Gottesdienst p. 406f.
[37] Noyes, The Story of Milan p. 5f.; see also Dudden, Life and Times p. 62.
[38] Schmitz, Gottesdienst p. 277.
[39] Campenhausen, Ambrosius als Kirchenpolitiker p. 20f.
[40] Ibid. p. 98-125.
[41] Ibid. p. 170.

before becoming bishop in 373.[42] This did not prevent him from throwing himself uncompromisingly and with rare vigour into the fight against paganism. His attitude is particularly clearly seen in the dispute of the Altar of Victory. This altar had been removed from the Roman senate under Constantius in 357 but returned to its place there under Julian. New and drastic steps were taken during Gratian's rule against Roman paganism and these affected the altar which once again was removed. It seems that already at this time Ambrose was active in the anti-pagan struggle. On the occasion of the senate's first approach to the emperor on the subject in 382, the co-operation between Christian senators, Damasus and Ambrose prevented any change. Some years later the next thrust is made by the senate, led by Symmachus.[43] Here we shall merely state the results of this uncompromising controversy. Ambrose wins the support of the emperor Valentinian II but, only after threatening him with excommunication.[44] For the first time this method was used with success against an emperor.[45] Despite attempts by H. F. von

[42] Ibid. p. 24-26. It caused a sensation when Ambrose, son of a praefectus praetorio and himself a consular in Aemilia was elected bishop of Milan (Jones, Later Roman Empire p. 923). There is no doubt that in the 4th century the upper social classes were incorporated into the church to a greater extent than before. Sources from the 4th century show a certain degree of embarrassment. Pope Siricius' attitude is hostile towards consecration of "qui cingulo militiae saecularis adstricti olim gloriati sunt" or "qui posteaquam pompa saeculari exultaverunt aut negotiis rei publicae optaverunt militare aut mundi curam tractare" (Siricius, Ep. 6. 1, quotation from Jones, Later Roman Empire p. 923 note 135).

Towards those holding important official positions after becoming Christians we find a distinct attitude of suspicion and watchfulness. In the seventh canon set forth at the synod in Arles (314) it is stated that imperial officials holding leading positions in the church must accept the ruling that the bishop reserves the right to hold them under supervision and if necessary exclude them from the church if they act "contra disciplinam" (C. Arel. I can. 7, see Jones, Later Roman Empire p. 979 note 96). The resolution assumes a cleft between the ethics of the church and those leading society.

No solution to the problem had been reached by the end of the century. When Ambrose is asked about a death sentence signed by a Christian judge, he answers: "Excusationem ... feceris". Following this, Ambrose points to heathens who congratulate themselves because they have refrained from soiling their axes with blood while governing the provinces. Ambrose asks: "Si hoc gentiles, quid Christiani facere debent?" (Ambrose, Ep. 253 (PL. 16.1084)). For the election of Ambrose as bishop see Fischer, Ambrosius p. 527-531.

[43] For details concerning the controversy of the Altar of Victory, in addition to the account in Campenhausen, Ambrosius als Kirchenpolitiker p. 166ff., see Dudden, Life and Times p. 256ff. and Kötting, Christentum und heidnische Opposition p. 16ff.

[44] Campenhausen, Ambrosius als Kirchenpolitiker p. 176.

[45] Campenhausen gives the following evaluation of Ambrose' threat of excommunication: "Der Gedanke, dass so etwas möglich sei, war an und für sich schlechthin unerhört. Aber wo hatte man seine Durchführung in der herrschenden Kirche auch so ernsthaft in Erwägung gezogen? Nur einige mutige Sonderlinge hatten es während der arianischen Kämpfe gewagt, ihrem Kaiser die Kirchengemeinschaft zu verweigern, und die Bestrafung war dem Versuche stets sofort gefolgt. Ambrosius behauptete jetzt mit seiner

Campenhausen to give a more faceted picture of Ambrose' standpoint towards paganism,[46] it is his aggressive, uncomprising attitude towards contemporary paganism which remains the most characteristic. We recall that Theodore, too, represented an implacable attitude towards pagan cults, but Ambrose seems to draw rather different consequences of such an attitude than our eastern catechist. Theodore is satisfied to ask that Christians avoid paganism. In accordance with this, he constructs a theological interpretation which implies that the present world, understood as the first katastase, is to get along as best it can after Christ's introduction of God's newly created world. Ambrose, however, demands that the bastions of paganism in this world are to be stormed and conquered now. It is a corresponding endeavor to promote Christian interests within the socio-political reality which leads to clashes with the Emperor Theodosius over the burning of the synagogue in Callinicum and the Salonica massacre.[47]

For Ambrose, too, it is important to relate active participation in anti-paganism with the interpretation of life in the world as found in the catecheses, even if it does not provide a clearly drawn connection between Ambrose the politician and Ambrose the catechist. The most striking characteristic of Ambrose' catecheses on that score is, indeed, the total lack of reference to the kind of life he himself and the catechumens live. If a tentative suggestion as to Ambrose' interpretation of the position of Christians in the world is to be made, it must be done through his comparison of Christians to fish in the sea. Ambrose says: "Imitate the fish ... It is in the sea and is upon the waters ... A tempest rages in the sea, storms shriek, but the fish swims ... So even for you this world is a sea ... And do you be a fish, that the water of the world may not submerge you."[48] We shall return to the passage later and examine it in a wider theological perspective. Here we take note of the permanent condition which is the assumption behind the imagery. Man's condition in the world is depicted as one which is not aimed at his destruction because he is created for the world just as fish are for water. That life in the world can be burdensome is emphasized by reference to storms etc.

Drohung das Feld. Aber noch in anderer Hinsicht tritt bei seinem Schritte ein Neues in Erscheinung. Durch Ambrosius wird das alte kirchliche Zuchtmittel des Bannes zum erstenmahl planmässig für einen Zweck in Anwendung gebracht, der zwar die Kirche kirchenpolitisch in hohem Masse angeht, mit dem Glauben und der Sittlichkeit der Christen aber nicht das geringste mehr zu tun hat", Campenhausen, Ambrosius als Kirchenpolitiker p. 180f.

[46] Ibid. p. 186-188.
[47] Ibid. p. 230-245.
[48] "Imitare illum piscem ... In mari est et super undas est ... In mari tempestas furit, stridunt procellae, sed piscis natat ... Ergo et tibi saeculum hoc mare est ... Et tu esto piscis ut saeculi te unda non mergat", De sacr. III. 3 (SC. 25.92).

Here is a signal that Ambrose interprets life on earth differently than, for example, Theodore. But, does this mean that Ambrose emphasizes other dogmatic elements than does Theodore? Does eschatology play a lesser role in Ambrose' total theological conception than in Theodores?

d) The Theological Position of Ambrose

Important research contributions underline the clearly futuristic-eschatological profile of Ambrose' theology. J. E. Niederhuber's extensive work, "Die Eschatologie des heiligen Ambrosius", shows very distinctly that Ambrose utilized the end-of-time conception widely; to such an extent, in fact, that it becomes possible to organize an eschatological system in which all details concerning last things are given their definite place. Here we shall only take note of a single aspect of this discourse. Niederhuber's book gives the impression that the author, in studying Ambrose' work, has extracted all themes concerning the end of time and systematized them. The underlying interest seems but slightly influenced by a wish to uncover the importance of eschatology within Ambrose' theology as a whole. On the contrary, eschatology is put forward as a single, separable point of instruction and Niederhuber's interest is largely to show that Ambrose teaching is in accordance with codified church law.[49]

V. Hahn, on the contrary, in "Das wahre Gesetz" treats the eschatological problem as an integrated part of Ambrose' theology as a whole. Hahn stresses with great emphasis that Ambrose' stands "in der heilsgeschichtlichen Tradition".[50] Hahn then elaborates upon what he means by history of salvation. He emphasizes that the expression implies that salvation takes place in the actual course of history but also that it is realized in different ways within the history. Hahn speaks about "Vorbereitung, Hinführung und Erfüllung".[51] This tripartite division is most characteristically expressed by Ambrose in his grouping of the

[49] In the introduction he says: "Zur allgemeinen Charakteristik der ambrosiaischen Eschatologie mag noch zum voraus hervorgehoben werden, dass des Kirchenvaters Grundvorstellungen von den endgeschichtlichen Vorgängen und Zuständen im allgemeinen mit der Offenbarungslehre durchaus übereinstimmen", Niederhuber, Eschatologie p. VIII.

[50] "Ambrosius steht ganz in der heilsgeschichtlichen Tradition, seine Predigt ruht auf heilsgeschichtlichen Konzeptionen, die nicht immer direkt ausgesprochen, aber in ihrer tragenden Funktion erkennbar werden. Daran kann alle philonische Allegorese nichts ändern. Der Mailänder Bischof ist heilsgeschichtlicher Theologe aus 'christlichem Instinkt'. In dem Bewusstsein von dem sich in der Geschichte verwirklichenden Heil, das sich unter dem Walten Gottes durchsetzt, liegt die Überwindung des prophanen philosophischen Denkens", Hahn, Das wahre Gesetz p. 196f.

[51] Ibid. p. 197.

terms umbra—imago—veritas; meaning "drei Zustände der Ver-
wirklichung des Heiles".[52] Hahn is obviously aware that this interpreta-
tion is not without problems. Thus, in a lengthy discourse,[53] he stresses
that the pattern of thinking has Platonic origins.[54] He maintains, never-
theless, that this pattern is gradually given a clearer orientation towards
the history of salvation—rather carefully in Origen, and clearly
expressed by Methodius of Olympus who utilizes it in the same way as
Ambrose.[55]

Hahn's work stands in marked contrast to the anthropologically
inclined interpretation of Ambrose' theology given by W. Seibel. In his
analysis, the utilization of the imago theme plays a central role. He finds
a characteristic instance of Ambrose' imago thinking in the interpreta-
tion of the two accounts of creation which are perceived as two con-
secutive creative acts. The first created man who is described in Genesis
1:26 is distinguishable by his likeness to God (Gottenbenbildlichkeit) and
as such incorporeal, immaterial and invisible.[56] Man, as spoken of in
Genesis 2:7 is, on the contrary, visible and material. These two beings
relate to one another in that the first man can be present in the other
man's soul without being identical with the soul. Here we note that the
soul is not seen as the image of God, but is created "ad imaginem
Dei".[57] Within these boundaries Christ's saving work is associated with
those who were created "ad imaginem", but had lost this likeness
through sin.[58] The consequence of salvation, however, refers to the man
who is spoken of in Genesis 1:26 and who functions within Ambrose'
theology as a supernatural principle of perfection.[59] This structuring of

[52] Hahn continues: "Gesetz, Evangelium und Wahrheit—*umbra, imago* und *veritas*
erscheinen so als drei Zustände der Verwirklichung des Heiles, als drei hintereinander
liegende Etappen der einen Heilsgeschichte. Dabei ist wichtig festzuhalten, dass
Dreigliederung der Heilsgeschichte in Umbra—Imago—Veritas nicht in erster Linie
heilsgeschichtlich intendiert ist, sondern aus einem moralischen Interesse angesprochen,
dann aber heilsgeschichtlich verstanden wird. Dem entspricht auch die Tatsache, dass
Umbra—Imago—Veritas in erster Linie Zuständlichkeiten sind, Grade des Heilsver-
wirklichung, denen dann allerdings bestimmte Heilsabschnitte entsprechen", Ibid. p.
213.
[53] Ibid. p. 251-291.
[54] Ibid. p. 291.
[55] Hahn sees thus a clear tendency in the development of the use of the scheme: "An
sich Begriffe für Seinsstufen, werden sie im Bereich der christlichen Theologie zu
Bezeichnungen von Heilszuständlichkeiten, die dann bei Ambrosius ... stärker als bei
anderen Vätern auf konkrete heilsgeschichtliche Bereiche angewendet werden, so dass sie
nicht nur Zuständlichkeiten, sondern auch Heilszeiten bezeichnen, Ibid. p. 221.
[56] Seibel, Fleisch und Geist p. 12.
[57] Ibid. p. 13.
[58] Ibid. p. 60.
[59] Ibid.

imago thinking, which is clearly rooted in Alexandrian theology,[60] has quite another orientation than Cyril's. In contrast to an Irenaeistic influenced way of thinking, we are faced here with a framework in which the actually created man constitutes "das unterste Stockwerk im vertikal nach oben aufgebauten ambrosianischen Weltsystem".[61]

Hahn as well as Seibel link Ambrose' theology to Origenistic theology. But, whereas Hahn stresses the moderating effect of Origen on the further development of platonic ideas and that this same tendency applies to Ambrose, Seibel prefers to emphasize the importance of Origen in bringing a platonic conception of the world into Christian theology.

There seems to be little disagreement as to the Alexandrian influence on Ambrosian theology.[62] Botte points out, meanwhile, that the influence of Plato and Origen should not be exaggerated in a catechetical context.[63] He underlines that we cannot expect to find particular Ambrosian catechetical characteristics in either the structure, choice of subject or imagery in a narrow sense. On the other hand, we maintain that it is possible to find an Ambrosian tendency in his interpretation of individual traditional elements. In the following we shall concentrate our attention on the Ambrosian utilization of traditional elements.

Before we embark upon these questions we shall pause a moment to consider the alleged literary similarity of Cyril's catecheses and Ambrose' catechetical instruction. This thought was expounded by F. Kattenbusch in 1894,[64] and has been re-introduced by Yarnold in 1971.[65] Botte vigorously rejects the idea of direct connection between the two authors.[66] He maintains considerable differences between the two catecheses[67] and concludes by saying: "Il serait puéril, à mon avis, de vouloir expliquer les ressemblances par un emprunt".[68]

[60] Ibid. p. 11.
[61] Ibid. p. 15.
[62] Rinna, Die Kirche p. 166; Botte, Introduction p. 39.
[63] Botte, Introduction p. 40.
[64] Ibid. p. 37 note 1.
[65] Yarnold, Did St. Ambrose know p. 184-189.
[66] "On semble croire que c'est Cyrille qui a créé la catéchèse mystagogique et qu'un rapprochement avec Ambroise signifierait pratiquement un emprunt direct de la part de celui-ci. On fait ainsi abstraction de la possibilité d'une source commune, alors que la catéchèse baptismale représente peut-être un des genres littéraires les plus anciens dans l'Église", Botte, Introduction p. 37.
[67] "Ni le plan général, ni l'allure du style ne trahissent une dépendance. Quant aux explications, il arrive qu'elles coïncident ... Mais elles sont parfois aussi toutes différentes", Ibid. p. 37.
[68] Ibid.

2. The Ritual Representation

a) The Purpose of a Visually Inclined Rite

In our analyses of both Cyril's and Theodore's catecheses, we have surveyed their utilization of visual themes. Our interest in approaching this question stems from our earlier iconographical analyses. By following this path we have attempted to establish a correlation between the rite and apsidal iconography.

In this way we have focused attention on a decisive aspect of the wider framework within which ritual and apsidal imagery belong. In studying the Fathers' utilization of visual means, we are not only given rich opportunities of penetrating into their way of approaching the problem of actualization but also of gaining insight into their efforts to connect dogma and ritual.

But, the interpretation of dogma and rite interacts with a certain attitude towards life in the world. The dogma, ritual actualization and attitude towards life are, thus, three factors which mutually affect each other. Our comparative material from approximately the same period shows, meanwhile, that connecting these three factors may take place in different ways.

We approach Ambrose' distinctive position regarding these questions by using De myst. 2 as our basis. Here Ambrose relates the reason why the mystagogical catecheses are to be held after Baptism itself. Ambrose says: "Then there is the consideration that the light of the mysteries will infuse itself better in the unsuspecting than if some sermon had preceded them."[69] Ambrose wishes to emphasize that in speaking of the sacraments before the baptismal ceremony the candidate will be prepared in such a way that the effect of the meeting with the unexpected will be reduced. For him, the spontaneity of the act is essential. It is, therefore, hardly accidental that the ritual is spoken of as a "lux mysteriorum". For Ambrose the visual character of the ceremony comes into its own.

The visual character of the mystery is elaborated upon in De sacr. III. 11f. Ambrose says that he who approaches the altar sees something he has not seen before. To explain what this involves, he refers to a particular prefiguration of the baptismal act—the apostle John's account of the healing of the blind man (John 9:1-12). In all the evangelistic accounts of this miracle, Jesus causes "lumen oculorum" to return to the blind man. In John's version, however, we find an important addition.

[69] "Deinde quod inopinantibus melius se ipsa lux mysteriorum infuderit quam si ea sermo aliqui praecucurrisset", De myst. 2 (SC. 25.156).

Ambrose points out that whereas the other evangelists were content merely to relate that the miracle took place, John adds that Jesus made a lump of clay which he placed on the man's eyes. The man was then told to wash himself in the pool of Siloam. Only after this was done, could he see again. It is this addition which makes the scene a prefiguration of Baptism because it is maintained that the blind man regained his sight by means of water.

Ambrose, furthermore, stresses that the act in itself is vital in the transition from blindness to seeing. He speaks almost disparagingly of the other apostles' accounts of the healing which occurs merely with the help of words. The content of the mystery lies hidden in the ritual act itself.

The account is used to illustrate the conception that the depths of the mysteries can only be plumbed after the eyes have been opened. As this occurs in the baptismal act itself, we find here an elaborate basis for delaying introduction into the mysteries until afterwards. It is not only a matter of utilizing the surprise effect (cf. De myst. 2.), but equally of delaying instruction until the possibilities of understanding the content are widened. Baptism provides the probability of new comprehension. It is only after Baptism one truly sees.

We are faced here with the same dualism we have met in our earlier textual analyses. On one hand the decisive importance of the rite itself is emphasized. On the other, the connection is maintained between this act and its epistemological consequences which are primarily expressed in speaking of a new ability to see. First of all, let us examine the epistemological aspects of the ritual more closely.

If we return for a moment to De myst. 2, we see right away that the terminology used there paves the way for the establishment of a close connection between outer and inner visual processes; "Lux mysteriorum" points so obviously to outer and inner phenomena simultaneously. The correlation between outer and inner visions is thematically organized in Ambrose' further analysis of John just mentioned. Here it is pointed out that what is said about the actual ritual leads naturally to the question of *inner mental* processes. First, Ambrose calls attention to the fact that the ability to see with the eyes of the heart is not just a matter of course: "You saw the things that are corporeal with corporeal eyes, but the things that are of the sacraments you were not yet able to see with the eyes of the heart."[70] He continues by pointing out that ability to see with the mind is established in the sacramental act which makes it possible to intercept "lumen sacramentorum".[71]

[70] "Videbas quae corporalia sunt corporalibus oculis, sed quae sacramentorum sunt cordis oculis adhuc uidere non poteras", De sacr. III. 12 (SC. 25.98).
[71] Ibid. III. 15 (SC. 25.100).

Ambrose defines the message mediated by the sacrament more precisely in De myst. 15: "Therefore, you should not trust only in the eyes of your body. Rather is that seen which is not seen, for the one is temporal, the other eternal. Rather is that seen which is not comprehended by the eyes, but is discerned by the spirit and the mind."[72] Indeed, what is seen in the unfolding of the mysteries is of interest but, the meaning in the visible act is that it leads to the contemplation of the invisible which is not received with the help of the eye but that of the mind. The text, thus far, parallels De sacr. III. 12. In this text, however, we find a more detailed account of what the invisible is. The contrast visible/invisible corresponds to the contrast temporal/eternal.

The theme is elaborated upon in De myst. 8, where, in speaking of the baptismal water it is said: "What have you seen? Water, certainly, but not this alone."[73] The point of departure is without any doubt water, but at the same time only a limited interest is shown in the water as such. To explain the meaning of the water within a ritual context, Ambrose uses two N.T. references, II Corinthians 4:18 and Romans 1:20. The first reference is a variation of the same opposites we have already touched upon; the contrast between visible and invisible which corresponds to the contrast temporal/eternal. Here it is quite evident that this contrast is meant to apply to the baptismal water; the visible water includes an invisible component which corresponds to the eternity perspective. Then Romans 1:20 is cited. In this case the contrast visible/invisible is tied to the relationship creature/Creator. Ambrose' interest in these contrasting terms in connection with his treatment of the baptismal water only becomes clear when Romans 1:20 is combined with John 10:38. Ambrose wishes to show that a connection exists between the visible and the invisible and he manages this by relating it to creation. God's work and God himself belong together. But, hereby, also exists the fundamental start for a reasonable interpretation of the baptismal water; the visible water contains an invisible component which is God himself who is present in his creation: "Believe, therefore, that the presence of Divinity is at hand there. Do you believe the operation? Do you not believe the presence? Whence would the operation follow, unless the presence went before?"[74] That is precisely Ambrose' point—to maintain

[72] Non ergo solis corporis tui credas oculis: magis uidetur quod non uidetur, quia istud temporale, illud aeternum. Magis adspicitur quod oculis non conprehenditur, animo autem ac mente cernitur", De myst. 15 (SC. 25.162).

[73] "Quid uidisti? Aquas utique sed non solas", Ibid. 8 (SC. 25.158).

[74] "Crede ergo diuinitatis illic adesse praesentiam. Operationem credis, non credis praesentiam? Vnde sequeretur operatio nisi praecederet ante praesentia?", Ibid. 8 (SC. 25.160).

that God's role in the sacrament becomes understandable on the basis of God's presence which is found here. Hereby we have arrived at an important decision; interest in the invisible is inextricably bound to perceiving the connection between God and God's work within the ritual context. An act of God is accompanied by his presence. This Divine work is made known to man through the interaction of ritual and visions.

Just as in our work with Cyril's and Theodore's catecheses, an elucidation of how such visions supplement the ritual ceremony would be welcome here as well. But, to approach this question in such a way presumes a description of the content of ritual visions. Ambrose, however, renders no such visions in his catecheses. We lack especially an interpretation of the Sanctus, which has been important in both textual groups dealt with earlier. As far as Ambrose is concerned, we do not even know with certainty whether this part belonged to his eucharistic prayer. This does not mean, however, that the vision theme was not a matter of concern to Ambrose.[75] But, lacking an exhaustive study of such themes within catechetical instruction, our analysis of Ambrose' catechetical teaching takes a rather different form than the analyses of the other two catecheses. It is impossible for us to find out how Ambrose perceived these visions within a ritual context. We see clearly, nevertheless, that concern with visions is directly linked to the desire to produce a satisfactory interpretation of the rite. We shall, therefore, look more closely at how Ambrose perceives God's part in the ritual. It is only by approaching the matter in this way that it becomes possible to penetrate more deeply into the soteriological themes which are of such importance within this context.

b) God's Part in the Rite

In De sacr. I. 13f. the story of Naamen is repeated and directly related to the baptismal theme. Naamen is told by Elisha to bathe in the Jordan and he will be restored to health. Naamen's reaction is important to Ambrose. Naamen is surprised that this alone is sufficient. Why should he travel such a distance to bathe in the Jordan—was not the water in his own country good enough? In the end, however, he does what the profet has instructed and is healed. For Ambrose, this is directly connected with Baptism. What happened to Naamen is to be seen as an anticipation of what takes place in Baptism: "You have seen water: not all water cures, but the water which has the grace of Christ cures. One is an element, the other a consecration; one an opus, the other an opera-

[75] See Studer, Theophanie-Exegese p. 37-53. Studer regards the application of visions as a part of an anti-Arian argumentation.

tion. Opus belongs to water; operation belongs to the Holy Spirit. Water does not cure unless the Holy Spirit descends and consecrates that water.''[76] The story of Naamen is used to bring out the distinctiveness of the specially chosen water. In the Jordan Naamen could be cured; in the baptismal water a corresponding cure is found. Ambrose continues by stressing how the cure takes place in the baptismal water; the Holy Spirit descends and consecrates the water. Only when the element is consecrated does God's divine act take place.

Thus, a clear tension arises between the element and that which is mediated through this element after its consecration. It is important here to point out that what is ''added'' by consecration does not imply that the element in itself is of no consequence. It is ''aqua quae habet gratiam'' which mediates God's presence. Nor is the choice of element arbitrary. This is particularly emphasized in speaking of the eucharistic element where Ambrose stresses that there is a ''similitudo'' between the wine and Christ's blood. Wine has a ''similitudinem sanguinis'' which corresponds to the ''mortis similitudinem'' into which the faithful enter.[77] Life within the faith is a life in ''similitudo''. In the canonical prayer, on the contrary, the term ''figura'' is used to indicate the relationship between the elements and Christ's body and blood.[78] In this way Ambrose stresses that the sacramental act joins the faithful to Christ's fate on earth. Just as in Cyril and Theodore, God's work in the world is anchored in Christology.

At the same time, however, consecration implies that something wondrous has happened to the element. The acts of the Holy Spirit have a miraculous character. This is further emphasized in De sacr. II. 3ff. Here, too, the account of a miracle is used to elucidate the act of Baptism. In this case it concerns the healing at the pool of Bethesda.[79] The angel who descends from heaven to stir the water ''significat figuram uenturi domini nostri Iesu Christi''.[80] Ambrose does not think that it is the Holy Spirit who comes down to the water but Christ himself. In the celebration of the sacraments, Christ is present.[81] The text proceeds to divulge how

[76] ''Vidisti aquam, sed non aqua omnis sanat, sed aqua sanat quae habet gratiam Christi. Aliud est elementum, aliud consecratio, aliud opus, aliud operatio. Aquae opus est, operatio spiritus sancti est. Non sanat aqua nisi spiritus sanctus descenderit et aquam illam consecrauerit'', De sacr. I. 15 (SC. 25.68).

[77] Ibid. IV. 20 (SC. 25.112).

[78] Ibid. IV. 21 (SC. 25.114).

[79] Cf. John 5:1ff.

[80] De sacr. II. 3 (SC. 25.74).

[81] The presence of Christ in the liturgy is clearly expressed in De myst. 27: ''Credo ergo adesse dominum Iesum inuocatum precibus sacerdotum qui ait: Vbicumque fuerint duo uel tres ibi et ego sum. Quanto magis ubi ecclesia est, ubi mysteria sunt, ibi dignatur suam inpertire praesentiam.'' (SC. 25.170).

Ambrose perceives God's miraculous act and his presence through Christ within the ritual context.

Ambrose remarks himself that the text is read in connection with the baptismal ceremony; it is a baptismal text.[82] With this, everything lends itself to a parallelization of this event and the baptismal ceremony: "Perchance you say: 'Why now is it not moved?' Give heed why: 'Signs for the incredulous, faith for those who believe'."[83] The question presupposes that a miracle takes place in both cases. The problem, however, is that only in the first case is the miracle so undisguised that all could see what happened. Ambrose maintains, on the contrary, that the miraculous character of Baptism is invisible because it must be accepted through faith. The non-believer requires visible signs, the believer does not. Even so, both are seen as miracles.

We shall now attempt a more thorough investigation into Ambrose perception of the sacraments' miraculous character and then examine a eucharistic text more closely. Here we find the same problem which arose in the discussion about Baptism; to decide the relationship between the visible element and that which is mediated through this element: "Perhaps you may say: 'I see something else; how do you tell me that I receive the Body of Christ?'"[84] The problem is, once again, how to amalgamate the visible, the existing material and the content of the element after consecration. In order to organize a valid interpretation of what happens to the element, Ambrose uses a great number of examples from the O.T. These illustrate that God has made known the manner of his work in the holy Scriptures; herein lies a pattern, one which can be utilized to understand subsequent acts of that same God. We note, however, that on this point Ambrose differs from Cyril, who also found a structural similarity between God's act and the created, existing world. Ambrose, on the other hand, chooses his analogies solely from accounts of God's miraculous deeds among his people. Indeed, Ambrose *must* use biblical accounts alone as he proceeds to utilize them in a different way to Cyril. Ambrose is not concerned with seeing God's act in the eucharistic element as one which takes place on the existing creative act's own premises. Thus, the examples to be used in interpreting the Eucharist are of a different kind than Cyril's. Ambrose refers to the story of Moses' staff which becomes a serpent, Egypt's wells which are filled with blood instead of water, the crossing of the Red Sea by the Israelites,

[82] De sacr. II. 3 (SC. 25.74).

[83] "Dicis forte: Quare modo non mouetur? Audi quare: signa incredulis, fides credentibus", Ibid. II. 4 (SC. 25.76).

[84] "Forte dicas: Aliud uideo, quomodo tu mihi adseris quod Christi corpus accipiam?", De myst. 50 (SC. 25.184).

Moses who strikes water from the rock, the bitter water in the well at
Mara which becomes sweet and the axe head which falls into the water
but is made to surface again by Elisha. Two points are made in the use
of these references. First, Ambrose emphasizes that all these miracles are
performed by a prophet—prophetic grace, prophetic prayer etc. are con-
stantly mentioned. Secondly, he establishes that the miracles are always
"contra naturam". Both these aspects are important in interpreting the
sacrament. Ambrose utilizes the prophetic aspect to bring out the very
magnitude of the sacramental act: "But if the benediction of man had
such power as to change nature, what do we say of divine consecration
itself, in which the very words of our Lord and Saviour function?"[85] For
Ambrose, that which occurs during the Eucharist far exceeds the
Israelites' crossing of the Red Sea! The miracle at the Red Sea takes
place on a basis of "humana benedictio", whereas what takes place in
the Eucharist is the result of Divine consecration.

This is followed by an elaboration on the exact character of "contra
naturam". In Ambrose' view, what takes place is not opposed to nature.
It is not an act in which God breaks the laws of nature but rather one
in which the organization of nature itself is changed.[86] This is
investigated more thoroughly in De myst. 50: "Therefore, we make use
of examples great enough to prove that this is not what nature formed
but what benediction consecrated, and that the power of benediction is
greater than that of nature, because even nature itself is changed by
benediction."[87] There is no discrepancy between the consecrated
elements and the elements in their natural substance but they are raised
above the sphere of the natural world. Ambrose believes that God's
intervention into the world leads to a change in the character of the
world; if God is fully present in the created, it is no longer the same as
before. God's presence changes nature.

Ambrose uses two different terms to characterize the elements before
consecration, "natura" and "specie". While "natura" is the most usual
expression, "specie" is used in three contexts.[88] L. Lavorel has
examined this terminology more closely in order to discover whether or

[85] "Quod si tantum ualuit humana benedictio ut naturam conuerteret, quid dicimus
et ipsa consecratione diuina ubi uerba ipsa domini saluatoris operantur", Ibid. 52 (SC.
25.186).

[86] See De Myst. 52: "Sermo ergo Christi, qui potuit ex nihilo facere quod non erat,
non potest ea quae sunt in id mutare quod non erant? Non enim minus est nouas rebus
dare quam mutare naturas." (SC. 25. 186).

[87] "Quantis igitur utimur exemplis, ut probemus non hoc esse quod natura formauit,
sed quod benedictio consecrauit maioremque uim esse benedictionis quam naturae, quia
benedictione etiam natura ipsa mutatur", De myst. 50 (SC. 25.184).

[88] Ibid. 52, 54 and De sacr. IV. 20.

not the two expressions cover the same thing. As far as nature is con-
cerned the case is straightforward enough; it signifies "ce qu'est cet être
par sa naissance ou son origine". [89] "Specie", however, appears to be
somewhat different. In Lavorel's conclusion, meanwhile, the term is
interpreted along the same lines as "natura".[90] It is particularly
emphasized in De sacr. IV. 19 that the transition from natural to con-
secrated bread is understood as a physical alteration: "Then you have
learned that from bread the body of Christ is made. And what is vine,
water? It is put in the cup, but it becomes blood by heavenly consecra-
tion."[91] In his commentary, Lavorel stresses that the verb "fieri"
expresses the thought that Christ's body and blood replace the bread and
wine through the completion of a change in the elements.[92]

Here we touch upon an important feature of Ambrose' understanding
of the sacraments. It is his firm belief that through the sacraments the
faithful are faced with Christ's presence and Christ's work with
mankind. At the same time, it is important to maintain that this act has
a special character. As a continuation of God's previous dealings with his
people it has the nature of a miracle which causes a transformation in the
structures otherwise determining existence on earth.

c) A Short Survey of Christological Research

That Ambrose perceives the sacrament as a miracle is closely related to
his Christology. A direct connection between the interpretation of the
mysteries and incarnation is established by Ambrose in De myst. 53. The
truth about the mysteries springs, indeed, from the mystery of the incar-
nation itself.[93] Ambrose finds the same miraculous character in the story
of the birth of Christ as we have seen in his interpretation of the
sacraments. As the basis for his interpretations of the Virgin birth he
refers to natural birth. From this perspective, the Virgin birth becomes
"praeter naturae ordinem". It is this disruption in nature's order which
makes it unreasonable to expect conformity with nature's order also in
the sacraments: "Why do you seek here the course of nature in the body
of Christ, when the Lord Jesus himself was born of the Virgin contrary
to nature?"[94] Nevertheless, the scanty Christological information in the

[89] Lavorel, La doctrine eucharistique p. 94.

[90] Ibid. p. 95.

[91] "Ergo didicisti quod ex pane corpus fiat Christi et quod uinum, quod aqua in
calicem mittitur, sed fit sanguis consecratione caelesti", De sacr. IV. 19 (SC. 25.112).

[92] Lavorel, La doctrine eucharistique p. 92.

[93] Cf. De myst. 53: "Suis utamur exemplis incarnationisque mysteriis adstruamus
mysterii ueritatem." (SC. 25.186).

[94] "Quid hic quaeris naturae ordinem in Christi corpore, cum praeter naturam sit ipse
dominus Iesus partus ex uirgine", De myst. 53 (SC. 25.188).

catecheses makes it impossible to form a picture of Ambrose theology on this question. It is not our intention, however, to include other Ambrosian sources in the analysis in order to supplement the catecheses on this point. On the other hand, we draw attention to focal research contributions of Christological questions as background material in our work with catechetical organization of soteriological questions.

It seems to be without doubt that in Christology Ambrose differentiates between nature and person in such a way as to avoid the problems which arose in Theodore. F. H. Dudden points out that Ambrose draws a clear distinction between Christ's natures in which only what is suitable is alloted to each of them.[95] At the same time Ambrose emphasizes that this does not mean that Christ has two persons. It is only a matter of one person to whom, both acts performed by Divine nature and by human nature, can be ascribed.[96] Such an organization also allows space for communicatio idiomatum.[97] The results of this Christology are clearly reflected in Ambrose utilization of imago terminology. The imago term itself is reserved for Christ and renders an ontological equality between the Father and Son.[98] Consequently, the Godhead can be seen in Christ. Further adaption of imago terminology reveals important aspects of Ambrose' perception of redemptive benefits. The discourse on man's "ad imaginem" reveals that salvation brings about a nearness to Divinity, despite the fact that man, because of his nature, will never possess holiness.[99]

It is obvious that Ambrose describes benefits of salvation as a supernatural blessing. F. Szabó, whose primary concern is with the doctrine of creation in Ambrose' Christology, stresses the coherence between creation and renewal. Here, unity is upheld by means of the common subject for the two acts. On the other hand, the character of the benefits

[95] "In Him the two Natures are preserved in their integrity. They are not so intermingled that one annihilates the other or that a single Divine-Human Nature—neither wholly Divine nor wholly human, but a combination of both—results. They coexist, each discharging its appropriate functions", Dudden, Life and Times p. 597.

[96] "But, if Christ is one Person, it follows that, while the Divine acts are in the Divine Nature and the human acts are in the human Nature, both the Divine and the human acts can properly be predicated of the one Person in whom the two Natures are united", Dudden, Life and Times p. 598.

[97] Szabó, Christ Createur p. 81.

[98] "Ambrosius unterscheidet streng 'imago' und 'ad imaginem': 'imago', wesensgleiches Bild Gottes, ist nur Christus selbst, der wesensgleiche Sohn des Vaters ... Das Bild ist Gott gleich, das Abbild ihm nur ähnlich", Seibel, Fleisch unde Geist p. 173.

[99] "Wir sind nicht heilig wie Gott in der Ewigkeit seiner Natur, sondern sollen erst heilig werden. Wir besitzen die Heiligkeit nicht von Natur aus, sondern in der Nachahmung Gottes, der uns in seiner freien Güte schenkt, was wir noch nicht sind", Seibel, Fleisch und Geist p. 173.

is perceived as being on different levels.[100] The distinctive character of Christ's saving work is tied to the divinization it makes possible,[101] which again presumes that man's nature is changed.[102]

It is more difficult to agree upon the "where" of redemptive benefits as Ambrose sees it, a subject interpreted in different ways by Seibel and Hahn. Seibel does not thematicize the problem explicitly but, nevertheless, it is not difficult to see a definite profile in his interpretation. In his account of Baptism he makes De sacr. II. 17-19 his point of departure. He interprets it as expressing Baptism as the decisive break with death and the devil's sway.[103] Here, the interpretation of man's rebirth in Christ centres around the realization of the similitudo condition.[104]

Hahn's perspective is in the opposite direction. Based on a strongly emphasized historical salvation program (cf. p. 256), he stresses that the lifetime of the church is between the birth of Christ and his reappearance on the day of judgement.[105] Nevertheless, he cannot avoid facing the contrast between a strictly progressive interpretation of the history of salvation and the ambiguous understanding of salvation within both the New Testament and Ambrose.[106] Hahn attempts to surmount the problems arising from this ambiguity by separating stories of individuals from the history of salvation itself. Thus, in Expositio X. 7, when Ambrose leads the question of Christ's arrival to judge into a question of his arrival into peoples' hearts, it is not seen as an attempt to connect futuristic-eschatological conceptions with a present-time eschatological viewpoint, with particular emphasis on the latter but rather as an example of the

[100] Szabó, Christ Createur p. 86.

[101] "Le Fils = Verbe par qui tout a été fait est le seul capable de sauver la créature déchue et il peut, seul, la diviniser", Szabó, Christ Créateur p. 87.

[102] Szabó, Christ Créateur p. 111f., se especially the reference to Ep. 76. 7 (PL. 17.1261).

[103] "So ist der Tod in der Taufe *eine Vorausnahme des leiblichen Todes*. Gewiss vollendet sich auch der Tod der Taufe erst im Tod des Leibes. Aber in ihm wird nur im leib-seelischen Ganzen des Menschen sichtbar, was in der Taufe geschehen ist", Seibel, Fleisch und Geist p. 163.

[104] "Dennoch ist das Fleisch *noch nicht völlig unterworfen.* Die Einheit zwischen Leib und Seele wird erst in der Glorie des Himmels vollkommen sein. Der Leib muss sterben, um zum Leib der Herrlichkeit verwandelt zu werden. Bis dahin beschwert er die Seele (2. Kor. 5. 4), und der Mensch muss in der täglichen Aszese dem leiblichen Tod entgegenleben", Seibel, Fleisch und Geist p. 188. See also p. 189.

[105] Hahn, Das wahre Gesetz p. 498.

[106] This duality is regarded by Hahn as a tension between "Heilszeit" and "Heilszustand" in the N.T.: "Mit Christus ist der Zugang zum Paradies erschlossen, doch muss dieser Zugang von den Menschen erst erkämpft werden. So wird dann das NT einerseits eindeutig als der neue Tag und die neue Heilszeit angesprochen, andererseits aber auch ganz auf die Linie der irdischen Zeit gestellt, als deren letzte Etappe es erscheint", Hahn, Das wahre Gesetz p. 498.

merging of salvation's story and the individual's story.[107] This sort of organization, in fact, does not allow for eschatological tension in a soteriological context such as we have in this study.

With this research survey in mind, we shall examine in greater detail the wide boundaries within which Ambrose places the benefits of salvation.

d) Benefits of Salvation

In De sacr. I. 11f. Ambrose considers it appropriate to link interpretation of the sacraments with the Jewish mysteries.[108] In the first place, he attempts to ascertain that Christian sacraments are older than those of the Jews. His concern with this question is purely polemical. Ambrose must establish that God's dealings with Christians surpasses his earlier works so that it becomes credible as a new Divine act. He does this by referring to the age of the sacraments. The Eucharist is older than the Jewish fall of manna because Melchizedec is "auctor sacramentorum".[109] So, Melchizedec—"rex iustitiae, rex pacis"—appears in a way as the Christians' progenitor, whereas the Jews can only trace their heritage as far back as Judah. Based on this, Ambrose can say: "So first understand ... that the Christian people began before the people of the Jews began, but we in predestination, they in name."[110] God has founded the church in the form of predestination before the origin of the Jews. As far as we can see, such an interpretation of the relation between Jews and Christians must cause difficulties in a strictly progressive interpretation of salvation's history such as Hahn sees it.[111] For, here we have a combination of two perspectives, one of development and one of static order which seems to weaken Hahn's interpretation.

Ambrose, however, attempts to show that the Christian sacraments surpass those of the Jews by emphasizing that the effect of Baptism and

[107] "In Christus, der ohne Zeit ist, aber in der Geschichte wirkt, ist der Ort, wo die Geschichte des Heiles und die Geschichte des Einzelnen einander begegnen. Hier greift die Überzeitlichkeit der Testamente auf den Bereich des einzelnen Menschen über. Sie äussert sich vor allem in zwei Eigenarten der theologischen Aussage", Hahn, Das wahre Gesetz p. 500.

[108] "Illud promitto quod diuiniora et priora sacramenta sunt Christianorum quam Iudaeorum", De sacr. I. 11 (SC. 25.66).

[109] De sacr. IV. 10 (SC. 25.106).

[110] "Ergo primum intellege ... prius coepisse populum Christianum quam coepisse populum Iudaeorum, sed nos in praedestinatione, illum in nomine", Ibid. IV. 11 (SC. 25.106f.).

[111] Characteristically, Hahn focuses solely on the increase of participation in salvation, and not on the problem concerning the age imbedded in this theme, see Hahn, Das wahre Gesetz p. 393ff.

the Eucharist surpasses what is called the Jewish mysteries by far. The reference here is to miraculous events in Jewish history such as the crossing of the Red Sea. Ambrose' aim is to convince the congregation that the effect of this happening cannot be compared to that of Baptism. The Jewish sacrament did not prevent the participants from dying. Indeed, the Jews died even though they had been saved by a mystery. Baptism, on the contrary leads to a transition ''a terrenis ad caelestia'', which in turn is interpreted as ''the passage from sin to life, from fault to grace, from defilement to santification—he who passes through this font does not die but rises''.[112] In contrast to the Jewish mysteries, Christian mysteries render victory over death and as a result rank far above those of the Jews.

The condition of mankind and of the Jews before Christ have certain common characteristics; the certainty of death is paramount for both. Ambrose gives an account of his interpretation of the fall in De sacr. II. 17. Here he states that death became man's fate after he had sinned. Death, nevertheless, is not to be considered a punishment inflicted upon man by God but rather a benefit. If God had not introduced death into the world, the power of evil would be even greater than it is. Nor is the situation in which sin exists described as totally forsaken by God. God has always ensured his control over his creation which again implies the ever present possibility of benefits.

Thus, the limitation set by death on the power of evil is not considered a sufficient intervention by God into the ravages of death. God wishes the world to be freed from damnation and rather to become a blessed place.[113] Christ died and rose again that this might be. The interruption in Satan's power brought by Christ is transmitted to the faithful through Baptism as they are baptised into Jesus' death.[114] When the effect of this act is elaborated upon, interest is centred first of all on the closeness established between Christ's suffering and death and the faithful. Ambrose' explanation here is based on an interpretation of Romans 6, which evidently has served as part of the instruction in preparation for Baptism. That Baptism takes place ''in morte Jesu'', requires closer definition: ''That, just as Christ died, so you also taste of death; just as Christ died to sin and lives unto God, so you, too, died to the former allurements of sins through the sacrament of baptism and rose again

[112] ''transitus a peccato ad uitam, a culpa ad gratiam, ab inquinamento ad sanctificationem—qui per hunc fontem transit, non moritur sed resurgit'', De sacr. I. 12 (SC. 25.66).

[113] ''Remedium datum est ut homo moreretur et resurgeret. Quare? Vt et illud quod ante damnationis loco cesserat loco cederet beneficii'', De sacr. II. 17 (SC. 25.82).

[114] See also De sacr. III. 2 (SC. 25.90).

through the grace of Christ. So, death is, but not in the reality of corporal death but in likeness."[115] Ambrose continues by describing the meaning of likeness with death, which implies being crucified with Jesus—he speaks of holding fast to (adhaerere) Christ. This again is explained as clinging to Jesus' nails to prevent the faithful from being torn from Jesus by the devil. By means of the nails, i.e. suffering, participation in Jesus is maintained.[116] Thus, the faithful die "in similitudine", and this death means that they are no longer subject to the temptations of the devil.

Ambrose, however, does not describe the baptismal ceremony solely as participation in Christ's passion. The sacrament also gives the faithful a share in abundance which implies that need no longer exists. Meanwhile, little use is made of the imagery of creation to describe these riches. It is true that Ambrose, with reference to Cant. 5.1, relates that the faithful will bloom just as apple trees but, characteristically enough, he confronts this flowering with the period between Adam and Christ when people were like dry trees.[117] Even here it is primarily a matter of interpreting imagery taken from the Scriptures. But, the meaning of scriptural imagery is only discovered when the Scriptures are read in a sacramental context even though the meaning has always been latent in the texts. Thus, it can be said that David foresaw the mystery already when Psalm 23 was formulated: "And he in spirit foresaw these mysteries and rejoiced and said that nothing was lacking to him. Why? Because he who shall receive the body of Christ shall never thirst (non esuriet in aeternum)."[118]

We note that in Ambrose' interpretation of the psalm quoted, it is said that Christ's body satisfies hunger "in aeternum". The plenty supplied through the sacrament is here endowed with an eternal value which bursts the bounds of the sphere of creation. Faith opens the way to a life unlimited by the boundaries of this world. We recall that death was a central point in Ambrose' theology. Before Christ it was death which decided man's fate and therefore Christ's death is primarily interpreted as a victory over death. Through the sacraments the faithful are renewed. Typical of this renewed life is that death holds no power over it. This is stressed explicitly in De sacr. IV. 24, where the importance of the

[115] "Vt quomodo Christus mortuus est, sic et tu mortem degustes, quomodo Christus mortuus est peccato et deo uiuit, ita et tu superioribus inlecebris peccatorum mortuus sis per baptismatis sacramentum et resurrexeris per gratiam Christi. Mors ergo est, sed non in mortis corporalis ueritate, sed in similitudine", Ibid. II. 23 (SC. 25.86).

[116] See ibid. V. 29 (SC. 25.136).

[117] Ibid. V. 14 (SC. 25.126); see also IV. 2.

[118] "Et ille in spiritu haec mysteria praeuidebat et laetabatur et nihil sibi abesse dicebat. Quare? Quia qui acceperit corpus Christi non esuriet in aeternum", Ibid. V. 12 (SC. 25.124) with reference to Ps. 23:1ff.

sacraments is compared to the importance of the manna: "Then, he who ate the manna died; he who has eaten this body will effect for himself remission of sins and 'shall not die forever'."[119] The problem of death is considered here in connection with the problem of finiteness. The benefit of salvation comes forth as the victory of precisely life's finiteness. It becomes important, therefore, to emphasize the difference in benefits bestowed by the manna and the Eucharist. The manna is a benefit which belongs within wordly bounds; the Eucharist, on the contrary, bestows benefits which reach beyond the finite structure of this world.

The same interpretation is used by Ambrose in his exegesis of Psalm 51:9. Here he stresses that David perceived grace "in figuram". This grace he imagines by speaking of being washed and made whiter than snow. Ambrose points out that snow can easily become dirty and spoiled (corrumpitur). This distinguished it from the grace which it prefigures: "That grace which you have received, if you hold fast what you have received, will be lasting and perpetual."[120] Again wordly corruptibility is contrasted with the eternal character of grace.

The sacramental benefits received by the faithful are such that they defy the characteristics of the worldly structure in which everything is subject to the finality. Thus, it is said that the manna was subjected to "corruptio". This does not apply to the sacrament: "This is foreign to every corruption, because whosoever shall taste in a holy manner shall not be able to feel corruption."[121] The nature of the sacrament is one of intransience which it bestows upon those participating in it.

Ambrose' interest in the all-surpassing nature of redemptive benefits is brought to a climax in De sacr. VI. 4, where he interprets John 6: "I am the living bread which came down from heaven". This passage can only be understood when seen in the context of Christ as "sharer of both divinity and body", and thus able to bestow upon them who receive the body participation in "that nourishment of His divine substance".[122]

e) The "Where" of Salvation

As we now intend to concentrate on where salvation takes place, it seems reasonable to examine one more textual description of the sacrament

[119] "Deinde manna qui manducauit mortuus est, qui manducauerit hoc corpus, fiet ei remissio peccatorum et non morietur in aeternum". Ibid. IV. 24 (SC. 25.116).

[120] "ista gratia quam accepisti, si teneas quod accepisti, erit diuturna atque perpetua", Ibid. IV. 6 (SC. 25.104).

[121] "hoc ab omni alienum corruptione, quod quicumque religiose gustauerit corruptionem sentire non poterit", De myst. 48. (SC. 25.182).

[122] De sacr. VI. 4 (SC. 25.138f.).

which relates it to the Old Testament. In De sacr. I. 20 it is stated that the Red Sea is to be understood as "figuram istius baptismatis", in contrast to Baptism which is characterized as "ueritas".[123] As for the water which flowed from the rock in the desert, it states that this took place "in umbra" as opposed to that which takes place "in ueritate".[124] Here it is presumed that truth actually exists in the sacrament, making it unnecessary to keep an open place for that which will only be realized in the hereafter. Such an interpretation is directly related to an interpretation of that regeneration experienced in the sacrament. Thus, it may also be said in the ritual: "God the Father Almighty, who regenerated you by water and the Holy Spirit and forgave you your sins, Himself will anoint you unto life everlasting."[125] Regeneration through water brings eternal life. But, what is eternal life? Ambrose emphasizes: "Do not prefer this life to that life."[126] He gives the impression here that eternal life is being contrasted with worldly life. But, the example used as an interpretation presents shades of meaning. Ambrose warns that one must guard against those who would deprive one of faith. Likewise, one must be careful not to wander from the path of righteousness even though threatened with death. If one chooses to keep the faith, despite great temptations from without, then one has chosen eternal life instead of this life.

The impression that eternal life may be realized in this world is strengthened by Ambrose' further interpretation of "regeneratio". Here, the regenerative theme and the resurrection theme are directly connected. Just as immersion means participation in Jesus' death, emergence from the water conveys a share in his resurrection: "Thus, then, even in baptism, since it is a likeness of death, undoubtedly, when you dip and rise again, it becomes a likeness of resurrection."[127] This resurrection is further interpreted as "regeneratio". Water plays a dominant role in the following clarification. Ambrose refers to Genesis 1:20f, as the basis for his interpretation. Obviously, the point is that right from creation, water has made life possible. Water "generauit" then "ad uitam". On the other hand, water now "regeneraret ad gratiam". Again regeneration appears as a contrast to life, while at the same time association with the phenomenon of creation is assured by means of a common

[123] Ibid. I. 20 (SC. 25.70).

[124] De myst. 48 (SC. 25.182).

[125] "Deus ... Pater Omnipotens, qui te regenerauit ex aqua et Spiritu concessitque tibi peccata tua, ipse te unguet in uitam aeternam", De sacr. II. 24 (SC. 25.88).

[126] "Noli hanc uitam illi uitae anteferre", Ibid.

[127] "Sic ergo et in baptismate, quoniam similitudo mortis est, sine dubio dum mergis et resurgis similitudo fit resurrectionis". Ibid. III. 2 (SC. 25.90), see also De sacr. II. 23.

water theme. Ambrose uses an illustration to stress what he reads into this "regeneratio". Here too, the subject is water in which man is encouraged to behave as fish who manage even when storms rage. Water is a picture of the world as it appears to the faithful: "And do you be a fish, that the water of the world may not submerge you."[128] Here, the world's water must express the trials which beset the faithful in this world but which he is able to resist just as fish withstand the storms of the sea. Again "regeneratio" and "resurrectio" represent characteristics of the life led on earth by the faithful. It is a direct statement of the faithful's condition in a world full of trials. We emphasize, as earlier, that it is not a question here of a temporary condition which is expected to pass shortly (cf. p. 255). It is rather that Ambrose envisages the lives of the faithful on earth as like that of fish in the ocean where many troubles abound.

In order to sustain life on earth, the need of aid and protection is a dominant thought with Ambrose. The devil, accustomed to causing guilt, is a threat, ever ready with his cunning attacks. Against this threat, only God can help: "But he who commits himself to God does not fear the Devil."[129]

The interpretation of Ambrose' understanding of "resurrectio" given here, is somewhat more complex in De sacr. II. 17ff., as has been noted above. We have said that God brought about man's death in order to stop the spread of evil. But, the purpose of God's action is not alone to limit the possibilities of evil. Christ's resurrection brings about "naturae reformatio". The context suggests that the intention here is to place this "reformatio" in a futuristic-eschatological context. We see, however, that Ambrose immediately attempts to steer away from such an orientation. We find a forewarning of this already in De sacr. II. 17, in which the world is spoken of as a place which could once again become a blessed place. This thought is developed further in De sacr. II. 18, in which Baptism is considered the act which limits the devil's further mastery of the world. In this connection, the baptismal ceremony is seen as "quasi sepultura" which opens the way for a new life already here on earth.[130]

The same tendency is to be found time and again in the catecheses. We shall pause a moment to include a few examples to supplement what has already been said. In connection with the Chrism, it is said that the believer is anointed "as an athlete of Christ, as if to contend in the contest of this world".[131] To this picture of the faithful's struggle on earth

[128] Ibid. III. 3 (SC. 25.92).

[129] "Sed qui deo se committit diabolum non timet", Ibid. V. 30 (SC. 25.136), see also De sacr. I. 4.

[130] Ibid. II. 19 (SC. 25.84).

[131] "quasi athleta Christi, quasi luctam huius saeculi luctaturus", Ibid. I. 4 (SC. 25.62).

belongs the promise of a prize: "He who contends has what he hopes for; where there is a struggle, there is a crown."[132] When Ambrose is to recount *where* the prize is to be given, we are met by the following cryptic passage: "Although the reward is in heaven, the merit for the reward is established here."[133] The reward is not understood as something which primarily belongs to the world beyond that in which the faithful already are.

Nowhere else is Ambrose' interest in seeing the new life as something to be realized *in* this world shown more clearly than in his interpretation of Pater Noster. It is, first of all, in the part of the prayer "thy kingdom come" that he makes an attempt to avoid any chance of misunderstanding: "As if the kingdom of God were not eternal."[134] The kingdom of God is eternal so therefore cannot be alloted an existence it already has. Ambrose follows this by linking the kingdom to Christ who himself said: "For this I was born."[135] But in this context as well, "thy kingdom come" is difficult. Organized with a view to Christological interpretation, the passage implies that the kingdom *has* come to the world through Christ. And, the kingdom brought by Christ is further mediated to the faithful: "For He Himself says: 'The kingdom of God is within you'."[136] Thus, the kingdom of God is not to come—it is here already: "But then the kingdom of God has come, since you have obtained His grace."[137]

With this as the background, it is clearly to be seen why Ambrose is so interested in drawing attention to the miraculous character of the sacraments. For, miracle, in the sense of a change in nature's order becomes necessary if salvation with such a content is to be brought into this world. In the sacraments things happen which are analogous to God's creation at the beginning of time: "He Himself spoke and it was made; He Himself commanded and it was created. You yourself were, but you were an old creature; after you were consecrated, you began to be a new creature. Do you wish to know how a new creature? It says: 'Every creature is new in Christ'."[138] Here on earth the faithful participate in the changes in God's creation, changes which destroy the power of evil. Man has been endowed with a nature containing eternal qualities already here. We see that the regeneration which Theodore

[132] "Qui luctatur habet quod speret: ubi certamen, ibi corona", Ibid.
[133] "Nam etsi in caelo praemium, hic tamen meritum praemii conlocatur", Ibid.
[134] Ibid. V. 22 (SC. 25.130).
[135] John 18:37.
[136] De sacr. V. 22 with reference to Luke 17:21.
[137] "Sed tunc uenit regnum Dei quando eius estis gratiam consecuti", Ibid.
[138] "Ipse dixit et factum est, ipse mandauit et creatum est. Tu ipse eras, sed eras uetus creatura; posteaquam consecratus es, noua creatura esse coepisti. Vis scire quam noua creatura? Omnis, inquit, in Christo noua creatura", Ibid. IV. 16 (SC. 25.110).

reserves for the resurrection at the end of time, is drawn into the world by Ambrose and realized here and now. Ambrose is, therefore, able to speak of an eternal life which unfolds here on earth. This eternal life stands in contrast to mortal life. Thus, it may also be said: "Heaven is there where fault has ceased; heaven is there where shameful deeds are idle; heaven is there where there is no wound of death."[139] This emphasis on the possible realization of eternity on earth, does not, of course, imply the elimination of a future salvation. It does mean, however, that in his catecheses Ambrose is primarily concerned with the possibilities of salvation in this world.

This emphasis on salvation's realization here on earth is not so much associated with a futuristic redemption as it is directed towards an ontological level to be found *above* mankind. We use Ambrose' canonical prayer to explain this in greater detail. Here we read: "On the day before He suffered He took bread in His holy hands, looked toward heaven, toward you, holy Father omnipotent, eternal God, giving thanks ..."[140] The same linguistic style is used about the chalice where, however, "in sanctis manibus suis" is left out. Clearly, one's gaze is directed towards heaven as a reference to greatfulness to God. But, at the same time, this upward direction functions as a key to the interpretation of the sacrament's content itself. Ambrose comments: "Before it is consecrated, it is bread; but when Christ's words have been added, it is the body of Christ."[141] In addition, "corpus Christi" is meant to be interpreted as analogous to the manna which fell from heaven. In this context, Ambrose stresses that Christ is "auctor caeli".[142] God is in heaven, Christ and the sacraments come from heaven. But, the priest's presentation of the sacraments is placed within the same context. Thus, we read in the canonical prayer: "Therefore, mindful of His most glorious passion and resurrection from the dead and ascension into heaven, we offer you this immaculate victim, a reasonable sacrifice, an unbloody victim, this holy bread, and chalice of eternal life. And we ask and pray that you accept this offering upon your sublime altar through the hands of your angels, just as you deigned to accept the gifts of your just son Abel ..."[143] The

[139] "Caelum est ibi ubi culpa cessauit, caelum est ibi ubi flagitia feriantur, caelum est ibi ubi nullum mortis est uulnus", Ibid. V. 20 (SC. 25.130).

[140] "Qui pridie quam pateretur, in sanctis manibus suis accepit panem, respexit ad caelum, ad te, Sancte Pater Omnipotens Aeterne Deus, gratias agens ...", Ibid. IV. 21 (SC. 25.114).

[141] "Antequam consecretur panis est; ubi autem uerba Christi accesserint, corpus est Christi", Ibid. IV. 23 (SC. 25.114).

[142] Ibid. IV. 24 (SC. 25.116).

[143] "Ergo memores gloriosissimae eius passionis et ab inferis resurrectionis et in caelum ascensionis, offerimus tibi hanc immaculatam hostiam, rationabilem hostiam, incruentam hostiam, hunc panem sanctum et calicem vitae aeternae, et petimus et

similarity between the Christological events and the interpretation of the bread is striking: Christ dies, is resurrected and ascends to heaven; the bread and wine will follow the same process, true enough in an unbloody way. The elements *are* the victim which is sacrificed; they become holy, just as Christ in his resurrection became holy,—they are the vessels of life everlasting. It is said also, therefore, that this offering is brought forth "per manus angelorum tuorum". Here, it is the priest who is represented as the angel. In De myst. 6 Ambrose comments upon the meaning of this: "He is an angel, who announces the kingdom of Christ, who announces life eternal."[144] Attention is focused on the priest's role, we must not perceive him from what we see but in accordance with the task he discharges. It is here the angel enters the scene: the priest is God's messenger, the medium of Divine benefits to the world—in this case exemplified as Christ's kingdom and eternal life. This, however, again implies that these benefits are always perceived as supernatural. Even when Ambrose describes the consequences of faith in this world, they are called heavenly, in contrast to worldly.

This conception involves a lasting balance between that which the faithful have here on earth and that which is in heaven. In a Christological context, this point is maintained by Christ's presence in the world and his present abode in heaven. In a sacramental context, this same thought is expressed through the sacrament as the carrier of the Divinity "in figura". As far as the participants are concerned, it means that in a ritual context, they are to turn towards the sacrament itself— being aware, at the same time, that this same sacrament is only man's way of approaching the Divinity. With this as a background, it is under- standable that Ambrose, possibly in a more one-sided way than both Cyril and Theodore, maintains that a mental attitude directed towards the world above should accompany the sacramental act.

This double orientation is expressed clearly and explicitly in De sacr. I. 6: "Consider where you receive the heavenly sacraments. If the body of Christ is here, here, too, are the angels established. 'Wheresoever the body shall be, there shall the eagles also be', you have read in the Gospel. Wheresoever the body shall be, there shall the eagles also be, who are accustomed to fly so as to escape the earthly and to seek the heavenly."[145]

precamur uti hanc oblationem suscipias in sublime altare tuum per manus angelorum tuorum, sicut suscipere dignatus es munera pueri tui iusti Abel ...", Ibid. IV. 27 (SC. 25.116).

[144] "angelus est qui regnum Christi, qui uitam aeternam adnuntiat", De myst. 6 (SC. 25.158).

[145] "Considera ubi capias sacramenta caelestia. Si hic corpus est Christi, hic et angeli constituti sunt: ubi corpus ibi est aquilae, legisti in euangelio. Vbi corpus Christi ibi et aquilae quae uolare consuerunt ut terrena fugiant, caelestia petant", De sacr. I. 6 (SC. 25.64) with reference to Matthew 24:28.

On one hand, Ambrose emphasizes that "corpus Christi" is here; on the other, he stresses that the body of Christ is sought after by eagles who are seeking the celestial.[146]

This analysis of the sacrament, to a certain extent, stands in contrast to R. Johanny's understanding of it as expressed in his work on Ambrose' perception of the sacrament. Johanny, as Hahn, accentuates the story of salvation as the interpretive framework and focuses attention on the importance of the story of salvation for the faithful in the Eucharist.[147] Interest in the sacrament, however, leads to another utilization of the umbra-imago-veritas theme than that found in Hahn. For Johanny the sacrament is considered to be an anticipation of future redemptive benefits, almost as in Theodore's catecheses.[148] We find very weak support for such an interpretation in our sources. It is true enough that in De sacr. IV. 26, through reference to I Corinthians 11:26, it is intimated that the period of the sacrament unfolds between Christ's suffering and death and Christ's return, but the prayer rendered in De sacr. IV. 27 makes no reference to the parousia.[149] On this basis, Johanny's analysis appears to be simply an over-interpretation: "Dans le mémorial se trouvent regroupés deux aspects: la mémoire qui porte sur un fait du passé, et l'attente du retour du Christ qui est l'aspect eschatologique de l'eucharistie. Memoire et eschatologie se recoupent dans le Sacrement."[150] We do not deny that Ambrose' thinking encompasses eschatological concepts, but we do dispute that these, in De myst. and De sacr., play an equally important part as the recollection of Jesus' suffering, death and resurrection. We maintain that in the catecheses, heaven as a spatial category plays a far more important role than do futuristic-eschatological conceptions.

[146] See ibid. IV. 7.

[147] "L'eucharistie nous apparait alors dans toute sa dimension, en relation avec un fait passé et une réalité à venir. Elle est le lieu présent du Christ en acte de salut, où se recoupent le passé et le futur par actualisation (aspect mémorial) et par anticipation (aspect eschatologique)", Johanny, L'eucharistie p. 166.

[148] "Ces trois termes, liés ensemble, caractérisent l'ensemble de l'histoire du salut et permettent de passer de l'umbra à la veritas par l'imago avec complexité ou réduplication sur la veritas en particulier lorsqu'il s'agit de l'eucharistie. Ils signifient la préfiguration d'une réalité à venir poutant discernable et déjà donnée dans l'image de l'économie actuelle. Le rite sacramentel nous introduit dans la veritas, il nous la donne; Mais en même temps, cette veritas—parce qu'elle est donnée sous le signe sacramental: le Christ sous les apparences du pain pour l'eucharistie— postule une veritas donnée non plus sous les apparences ou dans l'image, mais en elle-même (le Christ face a face au ciel)", Ibid. p. 238.

[149] See note 143.

[150] Johanny, L'Eucharistie p. 180.

Lavorel, on the other hand, interprets De sacr. IV. 27 in a way much closer to our own.[151] For him, as for us, it is the combination of a linear and a spatial aspect which appears as most characteristic in Ambrose' interpretation of salvation.[152]

Ambrose sums up the purpose and meaning of the eucharistic celebration in a single passage from the Song of Solomon: "You have come to the altar; the Lord Jesus calls you—both your soul and the Church—and He says: 'Let him kiss me with the kiss of his mouth.'"[153] When the faithful has been cleansed of his sins he has become worth (dignus) and can approach the altar of Christ, i.e. "corpus Christi".[154] But, to be worthy of Christ's altar is the same as to be worthy of the heavenly sacrament, i.e. the heavenly feast. It is the meeting of the pure with Christ which is illustrated when Christ says: "Osculetur me". To make it quite clear, the scene is amplified: "Osculum mihi Christus infigat".[155] The Godhead meets man through Christ and marks this by touching it as in a kiss.

It is necessary, however, to stress that the purpose of Ambrose' figurative way of speaking is hardly meant to utilize the sensuality to be found in this part of the imagery itself. It is further elucidated by Ambrose' interpretation of "Quia meliora ubera tua super uinum".[156] "Ubera" in this case means "sensus, sacramenta" in which is found "iucunditas spiritalis" which is contrasted with the wine which illustrates "laetitia saecularis". "Ubera" is utilized to stress that the sacraments convey a happiness which surpasses worldly pleasure. With this, the meaning of "ubera" as a figurative element is decided: "Ubera" refers to an element of joy, but it is an inner, mental joy which is meant here. In this case, we find a figurative element taken from the Scriptures where rich associations have been so curtailed that only the one association of interest remains. It is the same with the kiss, described earlier, which

[151] "Le texte utilise l'image de l'autel céleste, telle qu'elle se trouve dans Apoc. 8. 3-5 pour demander l'acceptation définitive par Dieu du sacrifice qu'offre son Eglise ... La fonction sacerdotale du Christ dans le cieux ne suppose en aucune sorte un sacrifice rédempteur céleste différent de celui de la Croix: le Christ est mort une seule fois pour nos péchés. Dans les cieux, le Christ exerce sa fonction sacerdotale par son intercession", Lavorel, La doctrine eucharistique p. 118.

[152] "Nous avons vu que Ambroise réfère l'Eucharistie aux mystères anciens. Les mystères anciens sont l'umbra, le mystère chrétien est la veritas. Dans quelques textes cependant, *umbra* et *veritas* désigne non pas les réalités de Ancien Testament et celles du Nouveau Testament, mais les réalités de ce monde-ci et celles d'enhaut. Parfois, saint Ambroise unit ces deux perspectives ...", Ibid. p. 118.

[153] "Venisti ad altare, uocat te dominus Iesus uel animam tuam uel ecclesiam et ait: Osculetur me ab osculis oris sui", De sacr. V. 5 (SC. 25.122) with reference to Cant. 1:1.

[154] Ibid. V. 6 (SC. 25.122).

[155] Ibid. V. 7 (SC. 25.122).

[156] Ibid. V. 8 (SC. 25.124) with reference to Cant 1:4 (LXX).

represents love. Here, however, it is love between the faithful and Christ which is thematicized as a mental closeness.

Typical of the figurative usage we meet here is that the similarity established between the figurative part and the matter in question is not made clearly evident by the choice of illustration alone. It requires a comprehensive interpretation in order to convey its meaning. Without drawing too extreme conclusions, we maintain that here we can trace a tendency which distinguishes Ambrose from, for example, Cyril. Although we also find imagery requiring extensive interpretation in Cyril, the structural connections between the imagery and the matter in question seems more easily available in his work than in Ambrose'.

In conclusion, De sacr. V. 8 presents an opportunity to delve more deeply into Ambrose' interpretation of the world. The analysis of ''Quia meliora ubera tua super uinum'' demonstrated how spiritual joy was contrasted to worldly pleasure. This, however, does not imply a total underestimation of ''laetitia saecularis''. For, of the wine which illustrates what is worldly, it is said: ''illud uinum ... suauitatem habet, laetitiam habet, gratiam habet.'' That which is worldly has a value which is not to be overlooked. But Ambrose' task as a theologian is to emphasize the Divine entry into this world. It is in order to bring out the nature of the benefits represented by the Divinity that Ambrose contrasts them with the benefits of the world. As that which is Divine, by definition, surpasses anything worldly, ''laetitia saecularis'' simply must diminish in such a comparison.

This analysis may, of course, be added to the picture we have previously seen of Ambrose' relationship with the world in which he lives. In the catecheses, never, as far as we can see, do we find general, negative characterizations of the world as such. When benefits of faith are described in a worldly context, they are either contrasted to unequivocally negative aspects of life on earth (cf. p. 276), or worldly benefits are made relative. In the catecheses the faithful appear as worldly people who have organized their lives as fish in the seas.

With this as our basis we contend that we have established conformity in the dogmatic program, the ritual function and an interpretation of the world within the textual unity which Ambrose' catecheses represent.

CONCLUSION

Having presented and analyzed all our material, the time has come to sum up the results. In the introduction, this study was presented as being interdisciplinary. We contend that the results reached would not have been possible without the use of both types of sources with which we have dealt. We maintain that our iconographical study and textual study have provided a living picture of liturgical celebration in the 4th century, one well suited to demonstrate distinctive characteristics of church life during that period.

In this study, we have not occupied ourselves with the liturgy of the word because, among other reasons, we do not believe apsidal iconography to be liturgically active during this part of Divine service. Nor is the liturgical ritual led from the altar in the introductory phase. Thus, the meaning in the apsidal imagery as well as in the altar itself remains merely latent during the first part of the service. We disagree with Sinding-Larsen on this point (cf. p. XXI, note 10).

A change occurs the moment the altar becomes the centre of the liturgy and the eucharistic celebration is initiated. During the liturgical introductory invocation (Sursum corda), the congregation's attention is called upon and mental concentration is requested. As the celebration of the Eucharist involves complicated chains of thought, the participants need all the help they can get in order to understand the depths of meaning contained in the act. To the overall synthesis of the various chains of thought which contribute to the meaning of the Eucharist, the visible pictorial programs are of the greatest value. Imagery's most important quality is to recapitulate in synthesis that which words and ritual acts take such time to present. Thus, all additional elements entering the liturgy as it progresses can be retained by the congregation. In our opinion, apsidal imagery unifies and summarizes the central content of the eucharistic prayer. By doing this it furnishes a certain support for members of the congregation in their participation and understanding of the ritual celebration itself.

In a closer examination of the eucharistic prayers with which we have been working, we find that their structures differ somewhat but the theological content is concentrated around the same phenomena. On one hand, the prayers attempt to clarify distinctive characteristics in God's work of salvation. On the other hand, attention is directed towards the Divine Being itself. Our pictorial presentations have shown that these two theological themes are sublimely represented in the apsidal imagery

which we have analyzed. But, the eucharistic prayer has a further object. In the Hagios cries which constitute the prayer's first climax, the members of the congregation are drawn into the course of events related by the prayer. In this way, the congregation itself becomes part of the ritual act. The same perspective is maintained in our apsidal imagery. Thus, through the combination of eucharistic prayer and apsidal picture, the congregation is drawn into God's work. They themselves become part of the mental images evoked during the liturgical act!

We have said that the apsidal programs unify these chains of thought. In attempting to decide upon a terminology for the unity so exquisitely expressed in the pictorial programs, the term eschatology immediately suggests itself. No other theological conception captures the connection between the lives of the faithful within the church and God's previous and future work. We venture to assert that the imagery only becomes a theological whole when we establish an eschatological profile in our interpretive work. Our textual analyses have also shown how individual elements, examined in pictorial analyses, are joined together theologically when an eschatological approach to the problems is used.

In our iconographical analysis, we have made a point of emphasizing that the pictures could render a composite eschatological understanding in which the element of tension is maintained. We stressed, at the same time, that the present-time aspect was given decisive emphasis through the use of visions which, without any doubt, is one of the most characteristic aspects of iconographical and liturgical activity in the 300's. Not only do countless elements borrowed from imperial iconography represent a pioneer work within Christian iconography but the slight adjustments in the anaphora prayer's introduction reflect a corresponding interest in developing a present-time vision theme.

Our chief problem concerning the textual analyses became, therefore, the question of whether such great emphasis on visions implies that the understanding of eschatology is in the process of losing some of the elements of tension and is instead headed towards unambiguity. In other words, are we faced with a change in eschatological thinking in the 4th century? We must, first of all, stress here that this field of problems is so filled with fine nuances that there can be no question of drawing unequivocal conclusions. But, we can, without specific objections maintain a certain reservation towards the research results referred to in the introduction to the textual analyses (cf. p. 143). We recall that Schulz perceived the Antiochene Sanctus' reference to the interaction between the worldly and heavenly religious service as an expression of present-time Divine presence which clearly reduced the futuristic-eschatological perspective. Having analyzed Theodore's catecheses, we are forced to modify this

interpretation. Theodore's utilization of visions has shown that the present-time Divine presence in the ritual is genuine enough but, at the same time, it is framed in such a way as to allow a decisive place for futuristic-eschatological conceptions. The vision seen during the ritual is only a pale reflection of the future, total presence of God.

But, the catechetical visions also weaken Dix's theory of a 4th century eschatology. The visions demonstrate that things belonging to the eschaton are not primarily regarded as consecutive events in the historical process. Cyril's visions, which are particularly concerned with historical events, show that individual Christological events are placed in *one* eschatological framework which is linked to the realization of the kingdom of God. This takes place precisely because individual historical events are drawn into a visual whole which allows all individual events to be organized under a principal motif which is the meeting with God. In this way, our sources maintain an element of tension which makes it hardly reasonable to exaggerate tendencies towards a fading of eschatology within this context.

Thus, we contend that 4th century catecheses sustain an eschatological tension. If, however, we are to clarify the characteristic formulation of this tension in our catecheses, we must dig deeper. Some help is to be found if we compare the attitudes of the catecheses to tendencies within 4th century church life. For, here it is a question of theological understanding which neither yields to the political need for a sacred imperial ideology, to a church triumphant, to realization of the divinely willed life in the desert nor to anxiety that a Christian life is not to be realized here on earth. Our catecheses establish that through the religious services of the urban centres, the participants are drawn into an eschatological tension which rejects all these tendencies.

Our sources reveal, nevertheless, that there are considerable differences in the way this element of tension is organized. These arise, as we have shown in the textual analyses, partly from the various theological traditions of each catechist and partly from the various social conditions for theological work. Our catechetical study has shown that 4th century socio-political conditions were far less uniform than, for example, Hernegger leads us to believe. This tension is clearly seen when we compare Cyril's praise of the Emperor Constantine with Ambrose' threatened excommunication of the emperors in Milan. Such differences explain why our catechists treat the eschatological problem so differently.

We shall give a brief outline of the three theologians by comparing interpretations of the second part of the Lord's prayer: "Thy kingdom come".

Cyril relates the kingdom to come with a pure soul in which sin has lost its power. The interpretation has a clearly moralizing tendency which must be seen in relation to his doctrine of creation which is always closely tied to observable phenomena here on earth. Redemptive benefits may be realized in this world because they correspond with creation's own structure. As a result, Cyril creates the premise for a fundamental, positive relationship with the world around.

It is true that this theme is supplemented by speaking of redemptive benefits as a contrast to death, but the problem of death is considered almost conquered in the lives of the faithful by their closeness to the Divinity established by the ritual. In his catecheses, Cyril makes no profound reflections concerning this matter nor is his work with such questions integrated with the doctrine of creation which otherwise marks the catecheses.

Although Cyril puts decided emphasis on the realization of salvation in the rite, his interpretation of the rite does not exclude a futuristic-eschatological realization. In both his Christology and his visions, the futuristic aspect plays a certain role although Cyril hardly makes it decisive.

Theodore, on the other hand, gives the passage in the Lord's prayer quite a different futuristic orientation. Those called to the heavenly kingdom are to be moulded by transcendence, something which implies a clear qualification of everything worldly. Man is allowed into the new reality here on earth but is impelled from here to an existence freed from the miseries of this world. From beginning to end Theodore's futuristically inclined theology is centred around the problem of death. This perspective also marks his doctrine of creation in which the new creation is closely connected to present creation but, despite this, differs qualitatively from the present world's structure. One of the consequences of such a theology, permeated with tensions between present-time ritual and end-of-time events, is that interest in the present world succumbs to the contact made with the new creation.

Ambrose follows a different path in his interpretation of the doctrine of salvation to that of both Cyril and Theodore. Here, too, the utilization of the theme of creation is the determining factor. Although Ambrose sees God's work in the sacraments as a continuation of God's earlier work, this work is always perceived in contrast to the present created world. Redemptive benefits appear as miraculous acts of God. In this way, a deliberate distance springs up between God's redemptive acts and the created world while at the same time it becomes possible to introduce into this world redemptive benefits. Indeed, this does not imply that salvation is seen as wholly present but we see that Ambrose prefers to set

redemptive benefits in a heavenly sphere above the world rather than in a future world. Possibly, it is relevant to consider this as a weakening of the eschatological tension, but our material in Ambrose' case is so scant that, for the present, we must maintain some reservation.

Thus, the catecheses show that no *single* solution to the eschatological problem was found in the 4th century church. Rather, the instruction of the catechists whom we have been studying here, reveals different problems—each with its strengths and weaknesses—in describing salvation in relation to life in this world.

Once more, nevertheless, we emphasize the importance of the sources dealing with the tension so characteristic of Christian eschatology and authentic Christianity. That the tension is maintained in a new social and political situation, suggests that the ecclesiastical leaders managed to retain important aspects of the church's distinctive character in a problematical period of change.

BIBLIOGRAPHY

The abbreviated form of titles used in the notes, is given between square brackets.

1. Sources

A) *The Bible*

Novum testamentum Graece, ed. by E. Nestle, 25th ed., Stuttgart 1969.
Septuaginta, ed. by A. Rahlfs, 9th ed., 2 vols., Stuttgart 1935.
The New Oxford Annotated Bible. With the Apocrypha. Expanded edition. Revised Standard Version. Ed. by H. G. May and B. Metzger, New York 1977.

B) *Patristic texts*

Acta Xanthippae et Polyxenae, Apocrypha Anecdota, ed. by M. R. James (Texts and Studies 2.3), Cambridge 1893. [Acta Xanth. (James, Apocrypha)]
Ambrosiaster: *Commentarium in epistolam beati Pauli ad Ephesios* (PL. 17), Paris 1879. [Comm. in ep. ad Eph.]
— *Commentarium in epistolam beati Pauli ad Galatas* (PL. 17), Paris 1879. [Comm. in ep. ad Gal.]
Ambrose of Milan: *De mysteriis*, ed. by O. Faller (CSEL. 73), Wien 1955. [De myst.]
— (De mysteriis) *Des sacrements, Des mystères*, ed. by B. Botte (SC. 25 bis), Paris 1961.[De myst.]
— (De mysteriis et De sacramentis) *Saint Ambrose. Theological and Dogmatic Works*, ed. by H. Dressler (The Fathers of the Church 44), Washington 1977.
— *De sacramentis* ed. by O. Faller (CSEL. 73), Wien 1955.[De sacr.]
— (De sacramentis) *Des sacrements, Des mystères*, ed. by B. Botte (SC. 25 bis), Paris 1961.[De sacr.]
— *De spiritu sancto*, ed. by O. Faller (CSEL. 79), Wien 1964. [Spir. sanct.]
— *Explanatio Psalmi 45*, ed. by M. Petschenig (CSEL. 64), Wien 1919.[Expl. Ps.]
— (Expositio evangelii secundum Lucam) *Traité sur L'Evangile de S. Luc* 1, ed. by G. Tissot (SC. 45), Paris 1956. [Expositio]
(Apocalypsis Eliae) *Die Apokalypse des Elias*, ed. by G. Steindorff (TU. vol. 2. N.F. = vol. 17), Leipzig 1899. [Apoc. El. (Steindorff, Apokalypse)]
Athanasius of Alexandria: *De sententia Dionysii* (PG. 25), Paris 1857. [De sent. Dion.]
— *Oratio 1 contra Arianos* (PG. 26), Paris 1857. [Orat. 1 c. Arian.]
Augustine: *De sermone domini in monte* (PL. 34), Paris 1865.
Basilius of Caesarea: *Epistola 52* (PG. 32), Paris 1857. [Epist.]
— *Liber de spiritu sancto* (PG. 32), Paris 1857. [De spir. sanct.]
Clement of Alexandria: *Paedagogus* (PG. 8), Paris 1857. [Paedag.]
— *Paedagogus*, ed. by O. Stählin (GCS, 12), Leipzig 1905. [Paedag.]
— *Protrepticus*, ed. by O. Stählin (GCS, 12), Leipzig 1905. [Protrept.]
Cyprian of Carthago: *De lapsis et de ecclesiae catholicae unitate*. Text and translation by M. Bévenot, Oxford 1971. [De unit. eccl.]
Cyril of Jerusalem: *Catecheses illuminandorum* 12-18, ed. by J. Rupp (Cyrilli opera 2), München 1860.
— (Catecheses mystagogicae) *Catécheses mystagogiques*, ed. by A. Piédagnel (SC. 126), Paris 1966. [M. Cat.]
— *Epistola ad Constantium* (PG. 33), Paris 1857. [Epist. ad Const.]
— *Procatechesis et catecheses illuminandorum* 1-11, ed. by W. K. Reischl (Cyrilli opera 1), München 1848.
— *Procatechesis et catecheses illuminandorum* (PG. 33), Paris 1857. [Procat.; Cat.]

— (Prócatechesis et catecheses illuminandorum) *The Works of Saint Cyril of Jerusalem*, 2 vols., ed. by R. J. Deferrari (The Fathers of the Church 61 and 64), Washington 1969, 1970.

Didache, *The Apostolic Fathers* 1 (Loeb Classical Library 24) 11th ed., London 1975.

Egeria: (Itinerarium) *Journal de voyage*, ed. by P. Maraval (SC. 296), Paris 1982. [Itinerarium]

Epiphanius of Salamis: *Panarion seu adversus octoginta haereses* (PG. 41), Paris 1863. [Panarion]

Epistola Apostolorum, Gespräche Jesu mit seinen Jüngern nach der Auferstehung, ed. by C. Schmidt (TU. 3rd series, vol. 13 = vol. 43), Leipzig 1919. [Epist. Apost. (Schmidt, Gespräche)]

Eusebius of Caesarea: *De martyribus Palaestinae*, ed. by E. Schwartz (GCS. 9/2), Leipzig 1908. [De mart. Palaest.]

— *De vita Constantini*, (PG. 20), Paris 1857. [De vita Const.]

— *Epistola ad Constantiam Augustam* (PG. 20), Paris 1857. [Epist. ad Const.]

— (Historia Ecclesiastica) *The Ecclesiastical History* 2, ed. by J. E. L. Oulten (Loeb Classical Library 265), London 1973. [Hist. Eccl.]

Gregory of Nyssa: *De oratione dominica-oratio 5* (PG. 44), Paris 1863. [De orat dom.]

Gregory of Nazianzus: *Orationum 30 et 45* (PG. 36), Paris 1858. [Orat.]

Hippolytus of Rome: (Fragmentum in Ezech.), *Hippolyts kleinere exegetische und homiletische Schriften*, ed. by H. Achelis (GCS 1/2), Leipzig 1897. [Frag. in Ez.]

— (Traditio apostolica) *La tradition apostolique d'après les anciennes versions*, ed. by B. Botte (SC. 11 bis), Paris 1968. [Trad. apost.]

Ignatius of Antioch: *Epistula ad Magnesios The Apostolic Fathers* 1, ed. by K. Lake (LCL. 24), London 1975. [Ep. ad Magn.]

Irenaeus: (Adversus haereses) *Contre les hérésies* III, ed. by F. Sagnard (SC. 34), Paris 1952. [Adv. haer.]

Jacob of Sarug: Gedicht über das Sprachenwunder am Pfingsfest, *Ausgewählte Schriften der Syrischen Dichter. Cyrillonas, Baläus, Isaak von Antiochien und Jakob von Sarug*, ed. by P. S. Landensdorfer (Bibliothek der Kirchenväter 6), Kempten und München 1912. [Gedicht (Landensdorfer, Ausgew. Schriften)]

Jerome: *Commentarii in Matheum* (CChrSL. 77), Turnholt 1969. [Comm. in Math.]

— *Contra Joannem Hierosolymitanum* (PL. 23). Paris 1865. [Contra Joan. Hier.]

— *Epistularum* 52 et 60, ed. by I. Hilberg (CSEL. 54), Wien 1910. [Epist.]

— *Epistularum* 124 et 130, ed. by I. Hilberg (CSEL. 56), Wien 1918. [Epist.]

— *Tractatus de psalmo 1*, ed. by G. Morin (CChrSL. 78), Turnholt 1958 [Tract. de ps. 1]

John Chrysostom: *Adversus oppugnatores vitae monasticae* (PG. 47), Paris 1863. [Adv. opp.]

— *De coemeterio et de cruce* (PG. 49), Paris 1862. [De coem.]

— *Homiliae in epistulam sancti Pauli ad Hebraeos* (PG. 63), Paris 1862. [Hom. in epist. ad Hebr.]

— *Homiliae in Genesim* (PG. 53), Paris 1859. [Hom. in Genesim]

— *Homiliae in Joannem* (PG. 59), Paris 1862. [Hom. in Joh.]

— *Homiliae in Matthaeum* (PG. 57), Paris 1862. [Hom. in Matt.]

Justin: *Dialogus cum Tryphone judaeo* (PG. 6), Paris 1857. [Dialog.]

— (Dialogus cum Tryphone judaeo) *An Early Christian Philosopher. Justin Martyr's Dialogue with Trypho Chapters One to Nine. Introduction, Text and Commentary*, ed. by J. C. M. van Winden (Philosophia Patrum 1), Leiden 1971. [Dialog. (Van Winden, Philosopher)]

Lactantius: *De mortibus persecutorum* (PL. 7), Paris 1844. [De mort. pers.]

Paulinus of Nola: *Epistula 32, Paulinus' Churches at Nola. Texts, Translations and Commentary*, ed. by R. C. Goldschmidt, Amsterdam 1940. [Ep. (Goldschmidt, Paulinus' Churches)]

— *Poema 30* (PL. 62), Paris 1861.

Tertullian: *Adversus Praxean*, ed. by A. Kroymann (CSEL. 47), Wien. 1906. [Adv. Prax.]

— (De baptismo) *Traité du baptême*, ed. by R. F. Refoulé (SC. 35), Paris 1952. [De bapt.]

— *De Idololatria. Critical Text, Translation and Commentary*, ed. by J. H. Waszink and J.

C. M. van Winden (Supplements to Vigiliae Christianae 1), Leiden 1987. [De idololatria]
— *De oratione*, ed. by A. Reifferscheid and G. Wissowa (CSEL. 20),), Wien 1890. [De orat.]
— (De Oratione) *Tertullian. Disciplinary, Moral and Ascetical Works*, ed. by H. Dressler (The Fathers of the Church 40), Washington 1977.
— *Liber de Monogamia* (PL. 2), Paris 1878. [Monog.]
Theodore of Mopsuestia: (Homiliae catecheticae) *Commentary of Theodore of Mopsuestia on the Nicene Creed*, ed. by A. Mingana (Woodbrooke Studies VI), Cambridge 1932, [Mingana V]
— (Homiliae catecheticae) *Commentary of Theodore of Mopsuestia on the Lord's Prayer and on the Sacraments of Baptism and the Eucharist*, ed. by A. Mingana (Woodbrooke Studies VI), Cambridge 1933. [Mingana VI]
— (Homiliae catecheticae) *Les homélies catéchétique de Théodore de Mopsueste*, ed. by R. Tonneau and R. Devreesse (Studi e testi 145), Città del Vaticano 1949.
Victorinus of Pettau: *Commentarii in apocalypsin editio Victorini*, ed. by J. Haussleiter (CSEL. 49),), Wien 1916.[Comm. in apoc.]

Brightman, F. E. ed. *Liturgies Eastern and Western. Being the Texts Original or Translated of the Principal Liturgies of the Church*, Oxford 1896.
Dessau, H. ed. *Inscriptiones latinae selectae* vol. 1, Berlin 1892. [Inscriptiones I]
Diehl, E., ed. *Inscriptiones latinae christianae veteres.* vol. 1, Berlin 1925. [Inscriptiones I]

2. Supplementary Literature

Abramowski, L.: "Zur Theologie Theodors von Mopsuestia", *ZKG.* 72 (1961), p. 263-293). [Zur Theologie]
Abramowski, R.: "Neue Schriften Theodors von Mopsuestia (+ 428)", *ZNW.* 33 (1934) p. 66-84.
Aland, K.: "Kaiser und Kirche von Konstantin bis Byzanz" (first publ. 1960), *Die Kirche angesichts der konstantinischen Wende*, ed. by G. Ruhbach (Wege der Forschung 306), Darmstadt 1976, p. 42-73.
Alföldi, A.: "Zum Panzerschmuck der Augustus-statue von Primaporta", *MDAI.R* 52 (1937), p. 48-63. [Zum Panzerschmuck]
— "Hoc signo victor eris. Beiträge zur Geschichte der Bekehrung Konstantins des Grossen", *Konstantin der Grosse*, ed. by H. Kraft (Wege der Forschung 131), Darmstadt 1974, p. 224-246.
— *Die monarchische Repräsentation im römischen Kaiserreiche* (first publ. as "Die Ausgestaltung der monarchischen Zeremoniells am römischen Kaiserhofe", *MDAI.R* 49 (1934) p. 3-118 and "Insignien und Tracht der römischen Kaiser", *MDAI.R* 50 (1935) p. 3-158), Darmstadt 1980. [Monarchische Repräsentation]
Altaner, B./Stuiber, A.: *Patrologie. Leben, Schriften und Lehre der Kirchenväter*, 7th rev. ed., Freiburg 1966. [Patrologie]
Altendorf, H.-D.: "Die Siegelbildvorschläge des Clemens von Alexandrien", *ZNW.* 58 (1967), p. 129-138. [Siegelbildvorschläge]
Amann, É.: "La doctrine christologique de Théodore de Mopsueste", *RevSR.* 14 (1934), p. 161-190. [La doctrine chritologique]
Anton, H. H.: "Kaiserliches Selbstversändnis in der Religionsgesetzgebung der Spätantike und päpstliche Herrschaftsinterprätation im 5. Jahrhundert", *ZKG.* 88 (1977), p. 38-84.
Armstrong, G. T.: "Imperial Church Building in the Holy Land in the Fourth Century", *Biblical archaeologist* 30 (1967), p. 90-102.
— "Imperial Church Building and Church—State Relations, a.d. 313-363", *ChH.* 36 (1967), p. 3-17.
Atzberger, L.: *Geschichte der christlichen Eschatologie innerhalb der vornicänischen Zeit*, Freiburg 1896.

Aune, D. E.: "The Significance of the Delay of the Parousia for Early Christianity", *Current Issues in Biblical and Patristic Interpretation. Studies in Honor of Merril C. Tenney presented by his Former Students*, ed. by G. F. Hawthorne, Michigan 1975, p. 87-109.

Averincev, S.: "L'or dans le système des symboles de la culture protobyzantine", *Studi medievali* 3. ser. 20 (1979), p. 47-68. [L'Or]

Bandmann, G.: "Ein Fassadenprogramm des 12. Jahrhunderts und seine Stellung in der christlichen Ikonographie", *Mün.* 5 (1952), p. 1-21. [Ein Fassadenprogramm]

Bardenhewer, O.: *Geschichte der Altkirchlichen Literatur*, vol. 3. Freiburg im Breisgau 1912.

Bates, W. H.: "The Composition of the Anaphora of Apostolic Constitutions VIII", *Studia Patristica* 13 (TU. 116), Berlin 1975 p. 343-355.

Battifol, P.: *Études d'histoire et de théologie positive.* Deuxième Série: *L'eucharistie, la présence réelle et la transsubstantiation,* Paris 1920. [Études d'histoire]

Bauer, W.: *Rechtgläubigkeit und Ketzerei im ältesten Christentum* (Beiträge zur historischen Theologie 10), Tübingen 1934. [Rechtgläubigkeit]

Baumstark, A.: "Trishagion und Queduscha", *JLW* 3 (1923), p. 18-32.

Baus, K.: *Der Kranz in Antike und Christentum. Eine religionsgeschichtliche Untersuchung mit besonderer Berücksichtigung Tertullians* (Theoph. 2), Bonn (1940), reprint 1965. [Kranz]

Baus, K./Ewig, E.: *Die Reichskirche nach Konstantin dem Grossen.* Erster Halbband: *Die Kirche von Nikaia bis Chalkedon* (Handbuch der Kirchengeschichte, vol. 2, ed. by H. Jedin), Freiburg 1973. [Die Reichskirche]

Beck, H.-G.: "Constantinople: The Rise of a New Capital in the East", *Age of Spirituality. A Symposium,* ed. by K. Weitzmann, New York 1980, p. 29-38. [Constantinople]

Benz. E.: *Endzeiterwartung zwischen Ost und West. Studien zur christlichen Eschatologie,* Freiburg 1973.

Berger, K.: "Der traditionsgeschichtliche Ursprung der 'Traditio Legis' ", *VigChr.* 27 (1973), p. 104-122. [Ursprung der Traditio]

Berkhof, H.: *Kirche und Kaiser. Eine Untersuchung der Entstehung der byzantinischen und der theokratischen Staatsauffassung im vierten Jahrhundert,* Zürich 1947.

Beskow, P.: *Rex Gloriae. The Kingship of Christ in the Early Church,* Stockholm 1962. [Rex Gloriae]

Betz, J.: *Die Eucharistie in der Zeit der griechischen Väter,* vol. I/1: *Die Aktualpräsenz der Person und des Heilswerkes Jesu im Abendmahl nach der vorephesinischen griechischen Patristik,* Freiburg im Breisgau 1955. [Eucharistie]

Beukers, C.: " 'For our Emperors, Soldiers and Allies'. An attempt at dating the twenty-third Catechesis by Cyrillus of Jerusalem", *VigChr.* 15 (1961), p. 177-184. [For our Emperors]

Beumer, J.: "Die ältesten Zeugnisse für die römische Eucharistiefeier bei Ambrosius von Mailand", *ZKTh.* 95 (1973), p. 311-324.

Bianchi Bandinelli, R.: *Rome: The Late Empire. Roman Art AD 200-400,* trans. of French ed., London 1971. [Rome]

Birt, T.: *Die Buchrolle in der Kunst. Archäologisch-antiquarische Untersuchungen zum antiken Buchwesen,* Leipzig 1907. [Die Buchrolle]

Bissels, P.: "Die frühchristliche Lehre vom Gottesreich auf Erden", *Trierer Theologische Zeitschrift* 84 (1975), p. 44-47.

Bjerre-Aspegren, K.: *Bräutigam, Sonne und Mutter. Studien zu einigen Gottesmetaphern bei Gregor von Nyssa,* Lund 1977. [Bräutigam]

Bludau, A.: "Der Katechumenat in Jerusalem im 4. Jahrhundert, *ThGl.* 16 (1924), p. 225-242, [Der Katechumenat]

Bodonyi, J.: "Entstehung und Bedeutung des Goldgrundes in der spätantiken Bildkomposition", *Archaeologia Ertesitö* 46 (1932/33), p. 197-199. [Entstehung]

Bogyay, T. von: "Hetoimasia", *Reallexicon der byzantinischen Kunst* 2, col. 1189-1202. [Hetoimasia]

— "Thron (Hetoimasia)", *LCI* 4, col. 305-313. [Thron]

Bolgiani, F.: "La théologie de l'Esprit Saint de la fin du I^{er} siècle après Jésus Christ au concile de Constantinople (381)", *Les quatre fleuves. Cahiers de recherche et de réflexion religieuses* 9 (1979), p. 33-72.

Borella, P.: *Il rito ambrosiano*, Brescia 1964.
Botte, B.: "Introduction", *Ambroise de Milan, Des sacrement. Des mystères*, ed. by B. Botte, (SC. 25 bis), Paris 1961.
Bousset, W.: "Platons Weltseele und das Kreuz Christi", *ZNW.* 14 (1913), p. 273-285. [Platons Weltseele]
Bouyer, L.: *Eucharistie, théologie et spiritualité de la prière eucharistique*, Paris 1966.
Bovini, G.: *Antichità christiane di Milano, Bologna 1970. [Antichità]*
— *Mosaici paleochristiani di Roma (secoli III-VI), Bologna 1971. [Mosaici]*
Brakmann, H.: "Die angeblichen eucharistischen Mahlzeiten des 4. und 5. Jahrhunderts. Zu einem neuen Buch Klaus Gambers", *RQ.* 65 (1970), p. 82-97.
Brandenburg, H.: "Ein frühchristliches Relief in Berlin", *MDAI. R* 79 (1972), p. 123-154. [Relief in Berlin]
Brandenburg, H.: "Frühchristliche Kunst in Italien und Rom", *Spätantike und frühes Christentum*, ed. by B. Brenk, (Propyläen Kunstgeschichte. suppl. bd. 1) Frankfurt am Main 1977, p. 107-119. [Frühchristliche Kunst]
— "Stilprobleme der frühchristlichen Sarkophagkunst Roms im 4. Jh.", *MDAI. R.* 86 (1979), p. 439-471. [Stilprobleme]
— "Ars humilis. Zur Frage eines christlichen Stils in der Kunst des 4. Jahrhunderts nach Christus", *JAC.* 24 (1981), p. 71-84. [Ars humilis]
Braunfels, W.: "Nimbus und Goldgrund", *Mün.* 3 (1930), p. 321-334.
Brenk, B.: *Tradition und Neuerung in der christlichen Kunst des ersten Jahrtausends*, Wien 1966. [Tradition und Neuerung]
— *Die frühchristlichen Mosaiken in S.Maria Maggiore zu Rom*, Wiesbaden 1975. [S.Maria Maggiore]
— *Spätantike und Frühes Christentum* (Propyläen Kunstgeschichte (Neue Ausg.), Supplementband 1, Berlin 1977. [Spätantike]
— "The Imperial Heritage of Early Christian Art", *Age of Spirituality: A Symposium,* ed. by K. Weitzmann, New York 1980, p. 39-52. [Imperial Heritage]
Broek, R. van den: *The Myth of the Phoenix according to Classical and Early Christian Traditions*, Leiden 1971 [The Myth of the Phoenix]
Brown, P.: *The World of Late Antiquity. From Marcus Aurelius to Muhammed*, London 1971. [Late Antiquity]
— *The Maiking of Late Antiquity*, Cambr. Mass. London 1978. [Making]
— "Art and Society in Late Antiquity", *Age of Spirituality: A Symposium*, ed. by K. Weitzmann, New York 1980, p. 17-28. [Art and Society]
— *Society and the Holy in Late Antiquity*, London 1982.
Bruyne, L. de: "Nuove ricerche iconografiche sui mosaici dell'arco trionfale di S. Maria Maggiore", *RivAC.* 13 (1936), p. 239-269. [Mos. dell'arco trionfale]
Budde, L.: *Die Entstehung des antiken Repräsentationsbildes*, Berlin 1957. [Entstehung]
Buddensieg, T.: "Le coffret en ivoire de Pola, Saint-Pierre et le Latran", *CAr.* 10 (1959), p. 157-195. [Coffret en ivoire]
Burian, J.: "Die kaiserliche Akklamation in der Spätantike. (Ein Beitrag zur Untersuchung der Historia Augusta)", *Eirene* 17 (1980), p. 17-43. [Kaiserliche Akklamation]
Byvanck, A. W.: "Die Grabeskirche in Jerusalem und die Bauten am Grabe des heiligen Felix bei Nola in Kampanien", *Byz.* 30 (1929/30), p. 547-554. [Grabeskirche]
Cabrol, F.: "ΑΩ", *DACL.* 1, col. 1-25.
Calcaterra, C.: *La catechesi pasquale di Ambrogio di Milano. Motivazioni di pastorale liturgica* (Archivio Ambrosiano 24), Milano 1973.
Calderini, A./Chierici, G./Cecchelli, C.: *La basilica di S.Lorenzo Maggiore in Milano*, Milano 1951. [Basilica di S.Lorenzo]
Callewaert, C.: "Le Carême à Milan au temps de S.Ambroise", *Revue bénédictine* 32 (1920), p. 11-21.
Camelot, P.-T.: "Note sur la théologie baptismale des Catéchèses attribuées à saint Cyrille de Jérusalem", *Kyriakon. Festschrift Johannes Quasten*, ed. by P. Granfield and J. A. Jungmann, vol. 2, Münster Westf. 1970, p. 724-729. [Theol. baptismale]

Campenhausen, H. F. v.: *Ambrosius von Mailand als Kirchenpolitiker*, (Arbeiten zur Kirchengeschichte 12), Berlin 1929. [Ambr. als Kirchenpolitiker]
— "Die Passionssarkophage. Zur Geschichte eines altchristlichen Bildkreises", *Marburger Jahrbuch für Kunstwissenschaft* 5 (1929), p. 39-85. [Passionssarkophage]
— see Schöne, W.
Carter, R. E.: "Chrysostom's 'Ad Theodorum Lapsum' and the early chronology of Theodore of Mopsuestia", *VigChr.* 16 (1962), p. 87-101. [Early chronology]
Casel, O.: "Mysteriengegenwart", *JLW.* 8 (1928), p. 145-224.
— *Das christliche Kultmysterium*, 4th rev. ed., Regensburg 1960. [Kultmysterium]
Cecchelli, C.: "Studi, scoperte, problemi dei mosaici d'Italia", *Atti dello VIII Congresso internazionale di studi bizantini Palermo 3.-10. aprile 1951* (Studi bizantini e neoellenici 8), Roma 1953, p. 103-104.
— see Calderini, A.
Chadwick, H.: "Pope Damasus and the Peculiar Claim of Rome to St. Peter and St. Paul", *Neotestamentica et Patristica. Eine Freundesgabe Herrn Professor Dr. Oscar Cullmann zu seinem 60. Geburtstag überreicht* (Supplements to Novum Testamentum 6), Leiden 1962, p. 313-318.
Chaffin, C. E.: "Christ as Emperor. Interpretations of the Fourth Eclogue in the Circle of St. Ambrose", *Studia Patristica* 13, (TU. 116), Berlin 1975, p. 9-18.
Chierici, G.: "Di alcuni risultati sui recenti lavori intorno alla basilica di San Lorenzo a Milano e alle basiliche Paoliniane di Cimitile", *Atti del IV Congresso internazionale di Archeologia Cristiana II.* (Studi di Antichità Cristiana 16-19), Roma 1948, p. 29-47.
— see Calderini, A.
Christe, Y.: "A propos du décor absidal de Saint-Jean du Latran", *CAr.* 20 (1970), p. 197-206. [Décor absidal de Saint-Jean]
— "La colonne d'Arcadius, Sainte-Pudentienne, l'arc d'Eginhard et le portail de Ripoll", *CAr.* 21 (1971), p. 31-42.
— "Gegenwärtige und endzeitliche Eschatologie in der frühchristlichen Kunst. Die Apsis von Sancta Pudenziana in Rom", *Orbis scientiarum* 2 (1972), p. 47-59. [Gegenwärtige Eschatologie]
— *La vision de Matthieu (Matth. XXIV-XXV). Origines et développement d'une image de la seconde Parousi* (Bibliothèque des cahiers archéologiques 10), Paris 1973.
— "Apocalypse et 'Traditio legis' ", *RQ* 71 (1976), p. 42-55. [Apocalypse]
Congar, Y. M.—J.: "Le thème du 'don de la Loi' dans l'art paléochrétien", *Nouvelle revue theologique* 85 (1962), p. 915-933. ['don de la Loi']
Conlon, S.: "A Select Bibliography of Modern studies (1850-1977) on Eschatology in the Western Church of the First Four Centuries", *Ephemerides Carmeliticae* 28 (1977), p. 351-371.
Corbett, S.: See Krautheimer, R.
Cross, F. L.: "Introduction", *St. Cyril of Jerusalem's Lectures on the Christian Sacraments. The Procatechesis and the five Mystagogical Catecheses*, ed. by F. L. Cross, London 1951. [Introduction]
Cuming, G. J.: "Egyptian Elements in the Jerusalem Liturgy", *JThS* 25 (1974), p. 117-124. [Egyptian Elements]
Cumont, F.: *The Oriental Religions in Roman Paganism*, (trans. of French ed. from 1909) New York 1956. [Oriental Religions]
Cutrone, E. J.: "Cyril's Mystagogical Catecheses and the evolution of the Jerusalem Anaphora", *OrChrP.* 44 (1978), p. 52-64. [Mystagogical Catecheses]
Danbolt, G.: "Kunsthistorisk metode og begrepet om den estetiske praksis. En skisse av en hermeneutisk modell", *Norsk filosofisk tidsskrift* 1 (1977), p. 25-45.
Danbolt, G./Johannessen, K. S./Nordenstam, T.: *Den estetiske praksis* (Estetiske studier 2) Bergen 1979. [Estetisk praksis]
Daniélou, J.: *Sacramentum futuri. Études sur les origines de la typologie biblique* (Études de théologie historique), Paris 1950.
— "L'histoire du salut dans la catéchèse", *Maison-Dieu* 30 (1952), p. 19-35.
— *Les symboles chrétiens primitifs*, Paris 1961.

— *La catéchèse aux premiers siècles*, Cours de Jean Daniélou réd. par Régine du Charlat. (Ecole de la foi), Paris 1968. [La catéchèse]

Dassmann, E.: *Die Frömmigkeit des Kirchenvaters Ambrosius von Mailand, Quellen und Entfaltung* (Münsterliche Beiträge zur Theologie 29), Münster 1965.

— "Das Apsismosaik von S. Pudentiana in Rom. Philosophische, imperiale und theologische Aspekte in einem Christusbild am Beginn des 5. Jahrhunderts", *RQ*. 65 (1970), p. 67-81. [Apsismosaik]

— "Ambrosius von Mailand (339-397)", *TRE*. 2 p. 362-386.

Daut, W.: "Die 'halben Christen' unter den Konvertiten und Gebildeten des 4. und 5. Jahrhunderts", *Zeitschrift für Missionswissenschaft und Religionswissenschaft* 55 (1971), p. 171-188.

Davis-Weyer, C.: "Das Traditio-Legis-Bild und seine Nachfolge", *Münchner Jahrbuch der bildenden Kunst* 12 (1961), p. 7-45. [Traditio-Legis-Bild]

Deér, J.: "Der Globus des spätrömischen und des byzantinischen Kaisers. Symbol oder Insignie?", *ByZ*. 54 (1961), p. 53-85.

Deichmann, F. W.: "Die Lage der konstantinischen Basilika der heiligen Agnes an der Via Nomentana", *RivAC* 12 (1946), p. 213-234. [Die Lage]

— *Frühchristliche Kirchen in Rom*, Basel 1948.

— *Ravenna. Hauptstadt des spätantiken Abendlandes*, vol. 1: *Geschichte und Monumente*; vol. 2: *Kommentar, Teil 1-2* and vol. 3: *Frühchristliche Bauten und Mosaiken von Ravenna*, Wiesbaden 1958-1974. [Ravenna I, II, 1 og III]

— *Repertorium der christlich-antiken Sarkophage*, vol. 1: *Roma und Ostia*, Wiesbaden 1967. [Repertorium]

— "J. L. Maier: Le baptistère de Naples et ses mosaïques", *ByZ* 61 (1968), p. 117-121. [Maier]

— "Zur Frage der Gesamtschau der frühchristlichen und frühbyzantinischen Kunst", *ByZ* 63 (1970), p. 43-68

— *Einführung in die christliche Archäologie*, Darmstadt 1983. [Einführung]

— see Klauser, T.

Deissmann, A.: *Licht vom Osten. Das Neue Testament und die neuentdeckten Texte der hellenistisch-römischen Welt*, Tübingen 1923. [Licht vom Osten]

Delbrück, R.: *Die Consulardiptychen und verwandte Denkmähler*, Berlin 1929. [Consulardiptychen]

— *Antike Porphyrwerke* (Studien zur spätantiken Kunstgeschichte 6), Berlin 1932.

— *Spätantike Kaiserporträts. Von Constantinus Magnus bis zum Ende des Westreichs* (Studien zur spätantiken Kunstgeschichte 8) Berlin 1933. [Spätantike Kaiserporträts]

Devreesse, R.: "Les instructions catéchétiques de Théodore de Mopsueste", *RevSR* 13 (1933), p. 425-436.

— *Essai sur Théodore de Mopsueste* (Studi e Testi 141), Città del Vaticano 1948. [Essai]

Dewart, J. M.: *The Theology of Grace of Theodore of Mopsuestia* (Studies in Christian Antiquity 16), Washington D.C. 1971. [Theology of Grace]

— "The Notion of 'Person' underlying the Christology of Theodore of Mopsuestia", *Studia Patristica* 12 (TU 115), Berlin 1975, p. 199-207.

Dieterich, A.: "Der Ritus der verhüllten Hände", *Kleine Schriften*, Leipzig 1911, p. 440-448. [Ritus]

Dinkler, E.: *Das Apsismosaik von S. Apollinare in Classe* (Wissenschaftliche Abhandlungen der Arbeitsgemeinschaft für Forschung des Landes Nordrhein-Westfalen 29), Köln 1964. [S. Apollinare]

— "Das Kreuz als Siegeszeichen", *Zeitschrift fur Theologie und Kirche* 62 (1965), p. 1-20. [Das Kreuz]

Dix, G.: *The Shape of the Liturgy*, 2nd ed. Glasgow 1947. [The Shape]

Dobschütz, E. von: *Christusbilder. Untersuchungen zur christlichen Legende* (TU. N. F. vol. 3), Leipzig 1899. [Christusbilder]

Dölger, F. J.: *Sol Salutis. Gebet und Gesang im christlichen Altertum. Mit besonderer Rücksicht auf die Ostung im Gebet und Liturgie*, 2nd ed. (Liturgiegeschichtliche Forschungen 4/5), Münster im Westf. 1925. [Sol Salutis]

— "Sonne und Sonnenstrahl als Gleichnis in der Logostheologie des christlichen Altertums", *Antike und Christentum* 1 (1929), p. 271-290. [Sonne und Sonnenstrahl]
— "Beiträge zur Geschichte des Kreuzzeichens", *JAC*. 1-10 (1958-1967). [Beiträge]
Downey, G.: *A History of Antioch in Syria from Seleucus to the Arab Conquest*, Princeton 1961. [Antioch]
Drewery, B.: "Antiochien II", *TRE* 3, p. 109-111. [Antiochien]
Dudden, F. H.: *The Life and Times of St. Ambrose*, 2 vols., Oxford 1935. [Life and Times]
Duval, N.: "La représentation du palais dans l'art du bas-empire et du haut moyen âge d'après le Psautier d'Utrecht", *CAr.* 15 (1965), p. 207-254. [Représentation]
Dyggve, E.: *Gravkirken i Jerusalem. Konstantinske problemer i ny belysning* (Studier fra Sprog- og Oldtidsforskning), København 1941. [Gravkirken i Jerusalem]
Eichrodt, W.: *Der Prophet Hesekiel*, (Das Alte Testament Deutsch) 22/1), 3rd ed. Göttingen 1968. [Hesekiel]
Elliger, W.: *Die Stellung der alten Christen zu den Bildern in den ersten vier Jahrhunderten* (nach den Angaben der zeitgenössischen kirchlichen Schriftsteller) (Studien über christliche Denkmäler 20), Leipzig 1930.
Engberding, H.: "Der Gruss des Priesters zu Beginn der εὐχαριστία in östlichen Liturgien", *JLW.* 9 (1929), p. 138-143.
— "Die syrische Anaphora der zwölf Apostel und ihre Paralleltexte", *Oriens Christianus* 3. ser. 12 (1937), p. 213-247.
Engemann, J.: "Palästinensische Pilgerampullen im F. J. Dölger-Institut in Bonn", *JAC*. 16 (1973), p. 5-27. [Pilgerampullen]
— "Zu den Apsis-Tituli des Paulinus von Nola", *JAC*. 17 (1974), p. 21-46. [Zu den Apsis-Tituli]
— "Auf die Parusie Christi hinweisende Darstellungen in der frühchristlichen Kunst", *JAC*. 19 (1976), p. 139-156. [Parusie Christi]
— "Zu den Dreifaltigkeitsdarstellungen der frühchristlichen Kunst: Gab es im 4. Jahrhundert anthropomorphe Trinitätsbilder?", *JAC*. 19 (1976), p. 157-172.
Ewig, E.: see Baus, K.
Ferguson, E.: "The Liturgical Function of the 'Sursum Corda'", *Studia Patristica* 13 (TU 116), Berlin 1975, p. 360-363.
Ferrua, A.: "Sul battistero di S. Costanza", *VetChr.* 14 (1977), p. 281-290. [Sul battistero]
Fink, J.: "Beobachtungen zu umlaufenden Bildzonen in ravennatischen Kuppeln", *RQ* 75 (1980), p. 1-10. [Beobachtungen]
Finn, T. M.: "Baptismal Death and Resurrection: A Study in Fourth Century Eastern Baptismal Theology", *Worship* 43 (1969), p. 175-189.
Fischer, B.: "Hat Ambrosius von Mailand in der Woche zwischen seiner Taufe und seiner Bischofskonsekration andere Weihen empfangen?", *Kyriakon. Festschrift Johannes Quasten*, ed. by P. Granfield og J. A. Jungmann, vol. 2, Münster Westf. 1970, p. 527-531. [Ambrosius]
Florovsky, G.: "Eschatology in the Patristic Age: an Introduction", *Studia Patristica* 2 (TU. 64), Berlin 1957, p. 235-250.
Francovich, G. de: "Studi sulla scultura ravennata 1. Sarcofagi", *Felix Ravenna* ser. 3, 26/27 (1958), p. 5-172. [Studi]
Frank, H.: "Ein Beitrag zur ambrosianischen Herkunft der Predigten De Sacramentis", *Theologische Quartalschrift* 121 (1940), p. 67-82.
Franke, P.: "Traditio legis und Petrusprimat. Eine Entgegnung auf Franz Nikolasch", *VigChr.* 26 (1972), p. 263-271. [Traditio legis]
Frankl, W.: see Krautheimer, R.
Frend, W. H. C.: *Martyrdom and Persecution in the Early Church. A Study of Conflict from the Maccabees to Donatus*, Oxford 1965.
— "The Two Worlds of Paulinus of Nola", *Religion Popular and Unpopular in the Early Christian Centuries*, London 1976, nr. XV, p. 100-133. [Two Worlds]
— "Church and State. Perspective and Problems in the Patristic Era", *Studia Patristica* 17, ed. by E. A. Livingstone, Oxford 1982, p. 38-54. [Church and State]

Frutaz, A. P.: *Il complesso monumentale di Sant'Agnese e di Santa Costanza*, Città del Vaticano 1960. [Il complesso]
— "Titulo di Pudente—Denominazioni successive, clero e cardinali titolari", *RiAC.* 40 (1966), p. 53-72
Gamber, K.: *Die Autorschaft von De sacramentis*, (Studia patristica et liturgica 1), Regensburg 1967. [Autorschaft]
— *Missa romensis. Beiträge zur frühen römischen Liturgie und zu den Anfängen des Missale Romanum* (Studia patristica et liturgica 3), Regensburg 1970.
— "Zur Liturgie des Ambrosius von Mailand. Kritik an einem Buch von J. Schmitz", *ZKG.* 88 (1977), p. 309-329.
— *Sakramentarstudien und andere Arbeiten zur frühen Liturgiegeschichte* (Studia patristica et liturgica 7), Regensburg 1978. [Sakramentarstudien]
Garrucci, R.: *Storia dell'arte cristiana nei primi otto secoli della chiesa*, 4 vols., Prato 1877-1881. [Storia dell'arte]
Gerkan, A. von: see L'Orange, H. P.
Gerke, F.: "Der Ursprung der Lämmerallegorien in der altchristlichen Plastik", *ZNW.* 33 (1934), p. 160-196. [Lämmerallegorie]
— "Das Verhältnis von Malerei und Plastik in der theodosianisch-honorianischen Zeit", *RiAC.* 12 (1935), p. 119-163. [Malerei und Plastik]
— *Der Sarkophag des Iunius Bassus* (Bilderhefte antiker Kunst 4), Berlin 1936. [Iunius Bassus]
— *Christus in der spätantiken Plastik*, 3rd ed., Mainz 1948. [Christus]
Giordano, A. F.: "Lo Spirito Santo nelle Catechesi di S. Cirillo di Gerusalemme", *Nicolaus. Rivista di teologia ecumenico-patristica* 4 (1976), p. 425-430.
Giordano, N.: "Lo Spirito 'fragranza di Cristo' nelle Catechesi di Cirillo di Gerusalemme", *Nicolaus. Rivista di teologia ecumenico-patristica* 8 (1980), p. 323-328.
Goldschmidt, R. C.: *Paulinus' Churches at Nola Texts, Translations and Commentary*, Amsterdam 1940. [Paulinus' Churches]
Gottlieb, G.: *Ambrosius von Mailand und Kaiser Gratian* (Hypomnemata 40), Göttingen 1973.
Grabar, A.: *L'empereur dans l'art byzantine*, Strasbourg 1936. [L'empereur]
— *Martyrium. Recherches sur le culte des reliques et l'art chrétien antique*, 2 vols., Paris 1946. [Martyrium]
— "A. Calderini, G. Chierici, C. Cecchelli, La basilica di S. Lorenzo Maggiore in Milano", *CAr.* 9 (1957), p. 345-348. [Calderini]
— *Ampoules de terre sainte (Monza-Bobbio)*, Paris 1958. [Ampoules]
— "Erich Dinkler, Das Apsismosaik von S. Apollinare in Classe", *CAr.* 15 (1965), p. 273-276. [Dinkler]
— "Apropos des mosaïques de la coupole de Saint-Georges, à Salonique", *CAr.* 17 (1967), p. 59-81. [Mosaïques de S. Georges]
— *Christian Iconography. A study of Its Origins*, London 1969 [Iconography]
Greer, R. A.: *Theodore of Mopsuestia. Exegete and Theologian*, London 1961.
Gribomont, J.: "Askese IV", *TRE* 4, p. 204-225.
Grigg, R.: "The Cross-and-Bust Image: Some Tests of a Recent Explanation", *ByZ.* 72 (1979), p. 16-33.'
Groh, D. E.: "Changing Points of View in Patristic Scholarship", *Anglican Theological Review* 60 (1978), p. 447-465.
Grooth, M. de/Moorsel, P. van: "The Lion, the Calf, the Man and the Eagle in Early Christian and Coptic Art", *Bulletin Antieke Beschaving* 52-53 (1977-78), p. 233-245. [Lion, Calf]
Gross, J.: "Theodor von Mopsuestia, ein Gegner der Erbsündenlehre", *ZKG.* 65 (1953/54), p. 1-15. [Theodor]
Gruszka, P.: "Die Stellungnahme der Kirchenväter Kappadoziens zu der Gier nach Gold, Silber und anderen Luxuswaren im täglichen Leben der Oberschichten des 4. Jahrhunderts", *Klio* 63 (1981), p. 661-668.
Gy, P.-M.: "Bulletin de liturgie", *Revue des sciences philosophiques et théologiques* 63 (1979), p. 289-299 and p. 601-613.

Hahn, V.: *Das wahre Gesetz. Eine Untersuchung der Auffassung des Ambrosius von Mailand vom Verhältnis der beiden Testamente*, Münster Westfalen 1969. [Das wahre Gesetz]

Halsberghe, G. H.: *The Cult of Sol Invictus* (Études préliminaires aux religions orientales dans l'empire romain 23), Leiden 1972. [Cult of Sol Invictus]

Harl, M.: "From Glory to Glory", L'interprétation de II Cor. 3.18b par Grégoire de Nysse et la liturgie baptismale", *Kyriakon. Festschrift Johannes Quasten*, ed. by P. Granfield and Josef A. Jungmann, vol. 2, Münster Westf. 1970. p. 730-735. [From Glory to Glory]

Harnack, A.: *Lehrbuch der Dogmengeschichte*, vol. 2: *Die Entwicklung des kirchlichen Dogmas I*, 4th rev. ed., Tübingen 1909. [Lehrbuch II]

— *Die Mission und Ausbreitung des Christentums in den ersten drei Jahrhunderten*, vol. 2, 3rd ed., Leipzig 1915. [Mission]

Haussig, H. W.: "Der Einfluss des römischen Kaiserkultes auf die christliche Kunst gezeigt an einigen Beispielen", *Actas del VIII Congreso Internacional de Arqueologia Cristiana*, Citta del Vaticano. Barcelona 1972, p. 339-342. [Einfluss]

Hernegger, R.: *Macht ohne Auftrag. Die Entstehung der Staat- und Volkskirche*, Olten und Freiburg im Breisgau 1963. [Macht]

Herrmann, L.: "Ambrosius von Mailand als Trinitätstheologe", *ZKG.* 69 (1958), p. 197-218.

Hoogewerff, G. J.: "Il mosaico absidale di San Giovanni in Laterano ed altri mosaici romani", *Rendiconti della pontificia accademia Romana di archeologia.* 3. serie, 27 (1953). p. 297-326.

Huskinson, J. M.: *Concordia Apostolorum. Christian Propaganda at Rome in the Fourth and Fifth Centuries. A Study in Early Christian Iconography and Iconology* (BAR International Series 148), Oxford 1982. [Concordia apostolorum]

Ihm, C.: *Die Programme der christlichen Apsis-malerei vom vierten Jahrhundert bis zur Mitte des achten Jahrhunderts* (Forschungen zur Kunstgeschichte und christlichen Archäologie 4), Wiesbaden 1960. [Programme]

Illert, D.: "Die 'vollkommeneren Sakramente' bei Ambrosius", *ZKG.* 73 (1962), p. 9-15.

Immisch, O.: "Zum antiken Herrscherkult", *Römischer Kaiserkult,* ed. by A. Wlosok (Wege der Forschung 372), Darmstadt 1978, p. 122-155.

Janeras, V.-S.: "En quels jours furent prononcées les homélies catéchétiques de Théodore de Mopsueste?", *Mémorial Mgr. Gabriel Khouri-Sarkis (1898-1968)*, Louvain 1969, p. 121-133. [En quels jours]

Jenkinson, W. R.: "The Image and the Likeness of God in Man in the eighteen Lectures on the Credo of Cyril of Jerusalem (c.315-387)", *Ephemerides theologicae lovanienses* 40 (1964), p. 48-71. [The Image of God]

Jeremias, G.: *Die Holztür der Basilika S. Sabina in Rom* (Deutsches archäologisches Institut Rom. Bilderhefte 7), Tübingen 1980.

Jeremias, J.: *Golgotha* (ΑΓΓΕΛΟΣ. Archiv für neutestamentliche Zeitgeschichte und Kulturkunde. Beiheft 1), Leipzig 1926. [Golgotha]

Johannessen, K. S.: see Danbolt, G.

Johanny, R.: *L'Eucharistie. Centre de l'histoire du salut chez Saint Ambroise de Milan* (Théologie historique 9), Paris 1968. [L'Eucharistie]

Jones, A. H. M.: *The Later Roman Empire 284-602. A Social Economic and Administrative Survey*, vol. 2, Oxford 1964. [Later Roman Empire]

— "The Social Background of the Struggle between Paganism and Christianity", *The Conflict between Paganism and Christianity in the Fourth Century,* ed. by A. Momigliano, repr., Oxford 1964, p. 17-37

— *Constantine and the Conversion of Europe*, 4. impr., London 1965. [Constantine]

Jugie, J. M.: "Le 'Liber ad baptizandos' de Théodore de Mopsueste ", *Echos d'Orient* 38 (1935), p. 257-271.

Jungmann, J. A.: *Missarum sollemnia. Eine genetische Erklärung der römischen Messe,* 2 vols., 5th ed. Wien 1962. [Miss. soll.]

— *Die Stellung Christi im liturgischen Gebet* (Liturgiewissenschaftliche Quellen und Forschungen 19/20), 2nd ed., Münster 1962. [Die Stellung Christi]

— "Von der 'Eucharistia' zur 'Messe' ", *ZKTh.* 89 (1967), p. 29-40.

— *Liturgie der christlichen Frühzeit bis auf Gregor den Grossen*, Freiburg 1967. [Liturgie]

Junod-Ammerbauer, H.: "Les constructions de Nole et l'esthétique de saint Paulin", *Revue des études augustiniennes* 24 (1978), p. 22-57.

Kannengiesser, C.: "Bulletin de théologie patristique", *RSR.* 66 (1978), p. 265-309.

Karpp, H.: *Die frühchristlichen und mittelalterlichen Mosaiken in Santa Maria Maggiore zu Rom*, Baden-Baden 1966. [Mosaiken in S.M.M.]

Kee, A.: *Constantine versus Christ. The Triumph of Ideology*, London 1982.

Kelly, J. N. D.: *Early Christian Doctrines*, 2nd ed. New York 1960. [Early Christian Doctrines]

Kirigin, M.: *La mano divina nell'iconografia cristiana*, Città del Vaticano 1976.

Kirsch, J. P.: "Altar III (christlich)", *RAC.* 1, col. 334-347. [Altar]

Kirschbaum, E.: "E. Stommel, Beiträge zur Ikonographie der konstantinischen Sarkophagplastik", *ByZ.* 49 (1956), p. 142-144. [Stommel]

Kitschelt, L.: *Die frühchristliche Basilika als Darstellung des himmlischen Jerusalem* (Münchener Beiträge zur Kunstgeschichte 3), München 1938.

Kittel, G.: "εἰκών, B. Götter- und Menschenbilder im Judentum und Christentum", *Theologisches Wörterbuch zum Neuen Testament II*, Stuttgart 1935, p. 380-386. [εἰκών]

Kitzinger, E.: "The Cult of Images in the Age before Iconoclasm", *DOP.* 8 (1954), p. 83-150. [Cult of Images]

Klauser, T.: "Erwägungen zur Entstehung der alt-christlichen Kunst", *ZKG.* 76 (1965), p. 1-11. [Erwägungen]

Klauser, T./Deichmann, F. W.: *Frühchristliche Sarkophage in Bild und Wort* (Beiheft zur Halbjahresschrift Antike Kunst 3), Olten 1966. [Bild und Wort]

Klauser, T.: "Die konstantinischen Altäre der Lateranbasilika", T. Klauser, *Gesammelte Arbeiten zur Liturgiegeschichte, Kirchengeschichte und christlichen Archäologie*, ed. by E. Dassmann (Jahrbuch für Antike und Christentum. Ergänzungsband 3), Münster Westfalen 1974, p. 155-160.

— "Der Übergang der römischen Kirche von der griechischen zur lateinischen liturgiesprache", T. Klauser, *Gesammelte Arbeiten zur Liturgiegeschichte, Kirchengeschichte und christlichen Archäologie*, ed. by E. Dassmann (Jahrbuch für Antike und Christentum. Ergänzungsband 3), Münster Westfalen 1974, p. 184-194. [Übergang]

— "Akklamation", *RAC.* 1, col. 216-233.

— "Altar III (christlich)", *RAC.* 1 col. 347-354. [Altar]

— see Strathmann, H.

Klein, G.: "Eschatologie IV. Neues Testament", *TRE.* 10, p. 270-299. [Eschatologie IV]

Koch, G.: *Die Heilsverwirklichung bei Theodor von Mopsuestia* (Münchener Theologische Studien 31), München 1965. [Heilsverwirklichung]

Koch, H.: *Die altchristliche Bilderfrage nach den literarischen Quellen* (Forschungen zur Religion und Literatur des Alten und Neuen Testaments 10), Göttingen 1917. [Bilderfrage]

Köhler, W.: "Das Apsismosaik von Sta. Pudenziana in Rom als Stildokument", *Forschungen zur Kirchengeschichte und zur christlichen Kunst. Johannes Ficker am 12.XI.1931 als Festgabe zu seinem 70. Geburtstag von Freunden und Schülern*, ed. by W. Elliger, Leipzig 1931, p. 167-179.

Kötting, B.: "Endzeitprognosen zwischen Lactantius und Augustinus", *Historisches Jahrbuch* 77 (1958), p. 125-139. [Endzeitprognosen]

— *Christentum und heidnische Opposition im Rom am Ende des 4. Jahrhunderts* (Schriften d. Ges. z. Förderg. der Westfälischen Wilhelms-Universität zu Münster 46), Münster 1961.

Kollwitz, J.: "Christus als Lehrer und die Gesetzesübergabe an Petrus in der konstantinischen Kunst Roms", *RQ.* 44 (1936), p. 45-66. [Christus als Lehrer]

— "Hanns-Ulrich von Schoenebeck: Der Mailänder Sarkophag und seine Nachfolge", *Gnomon* 12 (1936), p. 601-605. [V. Schoenebeck]

— *Oströmische Plastik der theodosianischen Zeit* (Studien zur spätantiken Kunstgeschichte 12), Berlin 1941. [Oströmische Plastik]
— "Das Bild von Christus dem König in Kunst und Liturgie der christlichen Frühzeit", *Theologie und Glaube. Werkheft* 2 (1947/8), p. 95-117. [Das Bild von Christus]
— "Probleme der theodosianischen Kunst Roms", *RiAC.* 39 (1963), p. 191-233. [Probl. der theod. Kunst]
— "Christusbild", *RAC.* 3, col. 1-24. [Christusbild]
— "Christus II (Basileus)", *RAC.* 2, col. 1257-1262.
— see Schöne, W.
Krautheimer, R.: "The Constantinian Basilica", *DOP.* 21 (1967), p. 115-140. [Constantinian Basilica]
— *Early Christian and Byzantine Architecture* (The Pelican History of Art), 2nd ed. Harmondsworth 1975. [Early Christian Architecture]
Krautheimer, R./Corbett, S./Frankl, W.: *Corpus basilicarum cristianarum Romae. The Early Christian Basilicas of Rome (IV-IX Cent.)*, vol. 3 (Monumenti di antichità cristiana ser. 2, 2), Città del Vaticano 1967. [Corpus basilicarum]
Kretschmar, G.: "Die frühe Geschichte der Jerusalemer Liturgie", *JLH.* 2 (1956), p. 22-46. [Die frühe Geschichte]
— *Studien zur frühchristlichen Trinitätstheologie* (Beiträge zur historischen Theologie 21), Tübingen 1956. [Trinitätstheologie]
— "Die zwei Imperien und die zwei Reiche", *Ecclesia und res publica. Kurt Dietrich Schmidt zum 65. Geburtstag,* ed. by G. Kretschmar og B. Lohse, Göttingen 1961, p. 89-112.
— "Die Einführung des Sanctus in die lateinische Messliturgi", *JLH* 7 (1962), p. 79-86. [Einführung des Sanctus]
— "Der Weg zur Reichskirche", *Verkündigung und Forschung. Beihefte zu 'Evangelische Theologie'* 13 (1968), p. 3-44. [Der Weg zur Reichskirche]
— "Recent Research on Christian Initiation", *Studia Liturgica* 12 (1977), p. 87-106.
— "Die Geschichte des Taufgottesdienstes in der alten Kirche", *Leiturgia. Handbuch des evangelischen Gottesdienstes*, vol. 5: *Der Taufgottesdienst*, p. 1-349. [Taufgottesdienst]
— "Abendmahl III/1. Alte Kirche", *TRE.* 1, p. 59-89. [Abendmahl]
— "Abendmahlsfeier I. Alte Kirche", *TRE.* 1, p. 229-278. [Abendmahlsfeier]
Kruse, H.: *Studien zur offiziellen Geltung des Kaiserbildes im römischen Reiche* (Studien zur Geschichte und Kultur des Altertums 19), Paderborn 1934 [Studien]
Lampe, G. W. H.: "Early Patristic Eschatology", *Eschatology. Four Papers Read to The Society for the Study of Theology* (Scottish Journal of Theology Occasional Papers 2), Edinburgh 1957, p. 17-35. [Eschatology]
— *A Patristic Greek Lexicon*, ed. by G. W. H. Lampe, Oxford 1961. [Lexicon]
Latte, K.: *Römische Religionsgeschichte* (Handbuch der (klassischen) Altertumswissenschaft Abt. 5 T. 4), München 1960.
Laubscher, H. P.: *Der Reliefschmuck des Galeriusbogens in Thessaloniki* (Archäologische Forschungen 1), Berlin 1975. [Reliefschmuck]
Lavorel, L.: *La doctrine eucharistique selon Saint Ambroise.* Thèse pour le doctorat en théologie présentée devant la faculté de théologie de l'Institut catholique de Lyon. 1956. [La doctrine eucharistique]
Lawrence, M.: "City-Gate sarcophagi", *ArtB.* 10 (1927), p. 1-45. [City-Gate]
Lebon, J.: "La position de saint Cyrille de Jérusalem dans les luttes provoquées par l'arianisme", *RHE.* 20 (1924), p. 181-210 and p. 357-386. [Position de saint Cyrille]
Leclercq, H.: "Mosaïque", *DACL.* 12.1, col. 57-332. [Mosaique]
Lécuyer, J.: "Le sacerdoce chrétien et le sacrifice eucharistique selon Théodore de Mopsueste", *RSR.* 36 (1949), p. 481-516. [Le sacerdoce chrétien]
— "Théologie de l'initation chrétienne d'après les pères", *Maison Dieu* 58 (1959), p. 5-26.
— "La théologie de l'anaphore selon les pères de l'école d'Antioche", *L'Orient Syrien* 6 (1961), p. 385-412.
— "Die Theologie der Anaphora nach der Schule von Antiochien", *Liturgisches Jahrbuch* 11 (1961), p. 81-92.

Lehmann, K.: "The Dome of Heaven", *ArtB.* 27 (1945), p. 1-27. [Dome of Heaven]
— "Sta. Costanza", *ArtB.* 37 (1955), p. 193-196. [Sta. Costanza]
Lewis, S.: "San Lorenzo Revisited: A Theodosian Palace Church at Milan", *Journal of the Society of Architectural Historians* 32 (1973), p. 197-222. [S. Lorenzo]
Liebeschuetz, J. H. W. G.: *Antioch, City and Imperial Administration in the Later Roman Empire*, London 1972. [Antioch]
Liesenberg, K.: *Der Einfluss der Liturgie auf die frühchristliche Basilika*, Neustadt an der Haardt 1928.
Lietzmann, H.: *Messe und Herrenmahl. Eine Studie zur Geschichte der Liturgie* (Arbeiten zur Kirchengeschichte 8), Bonn 1926. [Messe]
— *Geschichte der alten Kirche*, vol. 4, 3rd. ed., Berlin 1961. [Alte Kirche]
— "Die Entstehung der christlichen Liturgie nach den ältesten Quellen", H. Lietzmann: *Kleine Schriften III. Studien zur Liturgie- und Symbolgeschichte zur Wissenschaftsgeschichte* (TU. 74) Berlin 1962, p. 3-27.
— "Die Liturgie des Theodor von Mopsuestia", H. Lietzmann: *Kleine Schriften III. Studien zur Liturgie- und Symbolgeschichte zur Wissenschaftsgeschichte* (TU. 74), Berlin 1962, p. 71-97. [Liturgie]
L'Orange, H. P.: "Sol invictus imperator. Ein Beitrag zur Apotheose", *Symbolae Osloenses* 14 (1935), p. 86-114. [Sol invictus]
L'Orange, H. P./Gerkan, A. von: *Der spätantike Bildschmuk des Konstantinsbogens* (Studien zur spätantiken Kunstgeschichte 10) Berlin 1939. [Bildschmuk des Konst. bogens]
L'Orange, H. P.: *Apotheosis in ancient portraiture*, Oslo 1947.
— *Studies on the iconography of cosmic kingship in the ancient world*, Oslo 1953.
MacCormack, S. G.: *Art and Ceremony in late Antiquity*, Berkeley 1981. [Art and Ceremony]
Maguire, H.: *Art and Eloquence in Byzantium*, Princeton, New Jersey 1981. [Art and Eloquence]
Maier, J.-L.: *Le baptistère de Naples et ses mosaïques. Etude historique et iconographique* (Paradosis 19), Fribourg 1964. [Baptistère de Naples]
Maraval, P.: "Introduction", *Égérie, Journal de Voyage*, ed. by P. Maraval (SC. 296), Paris 1982, p. 15-117. [Introduction]
Martimort, A.-G.: *Handbuch der Liturgiewissenschaft*, vol. 1, Freiburg im Breisgau 1963.
— "Attualità della catechesi sacramentale di Sant'Ambrogio", *VetChr.* 18 (1981), p. 81-104.
Maser, P.: "Parusie Christi oder Triumph der Gottesmutter. Anmerkungen zu einem Relief der Tür von S. Sabina in Rom", *RQ.* 77 (1982), p. 30-51.
Mathews, T. F.: "An Early Roman Chancel Arrangement and its Liturgical Functions", *RiAC.* 38 (1962), p. 73-95.
— *The Early Churches of Constantinople. Architecture and Liturgy*, London 1971. [Early Churches]
Matthiae, G.: *Mosaici medioevali delle chiese di Roma*, Roma 1967. [Mosaici]
May, G.: "Eschatology V. Alte Kirche", *TRE.* 10, p. 299-305. [Eschatologie V]
McKenzie, J. L.: "Annotations on the Christology of Theodore of Mopsuestia", *TS.* 19 (1958), p. 345-373. [Annotations]
Meer, F. van der: *Maiestas Domini. Théophanies de l'Apocalypse dans l'art chrétien*, Roma 1938. [Maiestas Domini]
Michel, R.: *Die Mosaiken von Santa Costanza in Rom*, Leipzig 1911. [Die Mosaiken]
Mitchell, L. L.: "Ambrosian Baptismal Rites", *StLi.* 1 (1962), p. 241-253.
Mohrmann, C.: "Les origines de la latinité chrétienne à Rome", *VigChr.* 3 (1949), p. 67-106 and p. 163-183. [Origines]
Moorsel, P. van: see Grooth, M. de.
Morey, C. R.: *Lost mosaics and frescoes of Rome of the mediaeval period*, Princeton 1915. [Lost mosaics]
Morin, G.: "Depuis quand un canon fixe à Milan? Restes de ce qu'il a remplacé", *Revue bénédictine* 51 (1939), p. 101-108.
Mowrey, L.: "Revelation 4-5 and the early christian liturgical usage", *Journal of biblical literature* 71 (1952), p. 75-84. [Revelation 4-5]

Murray, C: "Art and the Early Church", *JThS*. 28 N.S. (1977), p. 303, 345. [Art]

Niederberger, P. B.: *Die Logoslehre des hl. Cyrill von Jerusalem. Eine dogmengeschichtliche Studie* (Forschungen zur christlichen Literatur- und Dogmengeschichte 14) Paderborn 1923. [Logoslehre]

Niederhuber, J. E.: *Die Eschatologie des heiligen Ambrosius. Eine patristische Studie* (Forschungen zur christlichen Literatur- und Dogmengeschichte VI. 3), Paderborn 1907. [Eschatologie]

Nikolash, F.: *Das Lamm als Christussymbol in den Schriften der Väter*, Wien 1963. [Lamm als Chr. symbol]

— "Zur Deutung der 'Dominus-legem-dat'-Szene" ' *RQ*. 64 (1969), p. 35-73. [Zur Deutung]

Nilgen, U.: "Das Fastigium in der Basilica Constantiniana und vier Bronzesäulen des Lateran", *RQ*. 72 (1977), p. 1-31. [Fastigium]

— "Evangelisten und Evangelistensymbole", *LCI*. 1, col. 696-713. [Evangelisten]

Nilsson, M. P.: "Die Bedeutung des Herrscherkultes", *Römischer Kaiserkult*, ed. by A. Wlosok (Wege der Forschung 372), Darmstadt 1978, p. 291-300. [Bedeutung]

Nordenstam, T.: see Danholt, G.

Nordhagen, P. J.: *Om gull, sølv og andre materialeffekter i tidligmiddelalderens mosaikker*, Foredrag holdt under det norske Roma-instituts høstkurs 1973. [Om gull og sølv]

Nordström, C.-O.: *Ravennastudien. Ideengeschichtliche und ikonographische Untersuchungen über die Mosaiken von Ravenna*, Uppsala 1953. [Ravennastudien]

Norris, R. A.: *Manhood and Christ. A Study in the Christology of Theodor of Mopsuestia*, Oxford 1963. [Manhood]

— *God and the World in early Christian Theology*, London 1965.

Noyes, E.: *The Story of Milan*, London 1908. [The Story of Milan]

Nussbaum, O.: *Der Standort des Liturgen am christlichen Altar vor dem Jahre 1000. Eine archäologische und liturgiegeschichtliche Untersuchung* (Theoph. 18). 2 parts, Bonn 1965. [Standort]

Olivar, A: "Über das Schweigen und die Rücksichtnahme auf die schwache Stimme des Redners in der altchristlichen Predigt", *Aug*. 20, (1980), p. 267-274.

Oñatibia, I.: "La vida cristiana, tipo de las realidades celestes. Un concepto basico de la teologia de Teodoro de Mopsuestia", *Scriptorium Victoriense* 1 (1954), p. 100-133. [La vida cristiana]

Ott, H.: "Symbol und Wircklichkeit. Über das symbolische Sagen und die Wirklichkeit des Unsagbaren", *Theologische Literaturzeitung* 99 (1974), p. 561-576.

Pannenberg, W.: "Die Aufnahme des philosophischen Gottesbegriffs als dogmatisches Problem der frühchristlichen Theologie", *ZKG*. 70 (1959), p. 1-45.

Panofsky, E.: "Zum Problem der Beschreibung und Inhaltsdeutung von Werken der bildenden Kunst", *Logos. Internationale Zeitschrift für philosophie der Kultur* 21 (1932), p. 103-119.

— *Studies in iconology. Humanistic Themes in the Art of the Renaissance*, New York (1939) reprint 1972. [Studies in icon]

Paredi, A.: "Il rito ambrosiano", *Ambrosius* 40 (1964), p. 247-259.

— "Catechesi della Messa in sant'Ambrogio", *Rivista Liturgica* 53 (1966), p. 562-569.

Paulin, A.: *Saint Cyrille de Jérusalem. Catéchète* (Lex Orandi 29), Paris 1959. [Cyrill. Catéchète]

Perler, O.: "Kyrillos, Bisch. v. Jerusalem, hl.", *LThK*. 6, 2nd ed., col. 709-710. [Kyrillos]

Peterson, E.: "Himmlische und irdische Liturgie", *Benediktinische Monatschrift* 16 (1934), p. 39-47.

— *Das Buch von den Engeln. Stellung und Bedeutung der Heiligen Engel im Kultus*, Leipzig 1935. [Das Buch]

— "La Croce e la preghiera verso oriente", *Ephemerides liturgicæ* 59 (1945), p. 52-68.

Petrignani, A.: *La basilica di S. Pudenziana a Roma secondo gli scavi recentemente eseguiti*, Città del Vaticano 1934. [Basilica di S. Pudenziana]

Piédagnel, A.: "Introduction", *Cyrill de Jérusalem. Catéchèses Mystagogiques*, ed. by A. Piédagnel (SC. 126), Paris 1966, p. 9-78. [Introduction]

Pietri, C.: *Roma Christiana. Recherches sur l'Eglise de Rome, son organisation, sa politique, son idéologie de Miltiade à Sixte III (311-440)*, 2 vols. (Bibliothèque des écoles françaises d'Athènes et de Rome 224), Roma 1976.

Probst, F.: *Liturgie des vierten Jahrhunderts und deren Reform*, Münster i. W. 1893.

Quasten, J.: "The Liturgical Mysticism of Theodore of Mopsuestia", *TS.* 15 (1954), p. 431-439.

— *Patrology*, 3 vols., Utrecht/Antwerp 1975. [Patrology]

Rahner, H.: *Symbole der Kirche. Die Ekklesiologie der Väter*, Salzburg 1964.

— *Griechische Mythen in christlicher Deutung*, Zürich 1966. [Griech. Mythen]

— "Antiochenische Schule", *LThK.* 1, col. 650-652.

Ratcliff, E. C.: "The Original Form of the Anaphora of Addai and Mari: A Suggestion", *JThS.* 30 (1929), p. 23-32.

— "The Sanctus and the Pattern of the Early Anaphora, I and II", *Journal of ecclestiastical History* 1 (1950), p. 29-36 and p. 125-134.

Ratzinger, J.: "Licht und Erleuchtung. Erwägungen zu Stellung und Entwicklung des Themas in der abendländischen Geistesgeschichte", *Studium generale* 13 (1960), p. 368-378. [Licht]

Reine, F. J.: *The Eucharistic Doctrine and Liturgy of the Mystagogical Catecheses of Theodore of Mopsuestia*, Washington 1942. [Eucharistic Doctrine]

Reinhold, M.: *History of Purple as a State Symbol in Antiquity* (Collection Latomus 116), Bruxelles 1970. [History of Purple]

Renoux, A.: "Les catéchèses mystagogiques dans l'organisation liturgique hiérosolymitaine du IVᵉ et du Vᵉ siècle", *Museon* 78 (1965), p. 355-359.

Richard, M.: "La tradition des fragments du traité *peri tēs enanthōpēseōs* de Théodore de Mopsueste", *Museon* 56 (1943), p. 55-75. [Tradition]

Richardson, R. D.: "Eastern and Western Liturgies: The Primitive Basis of Their Later Differences. A Note for the Study of Eucharistic Origins", *HThR.* 42 (1949), p. 125-148.

Riley, H. M.: *Christian Initiation. A Comparative Study of the Interpretation of the Baptismal Liturgy in the Mystagogical Writings of Cyril of Jerusalem John Chrysostom Theodore of Mopsuestia and Ambrose of Milan* (Studies in Christian Antiquity 17), Washington 1974. [Christian Initiation]

Rinna, J.: *Die Kirche als Corpus Christi Mysticum beim hl. Ambrosius*, Roma 1940. [Die Kirche]

Rösch, G.: ΟΝΟΜΑ ΒΑΣΙΛΕΙΑΣ. *Studien zum offiziellen Gebrauch der Kaisertitel in spätantiker und frühbyzantinischer Zeit* (Byzantina Vindobonensia 10), Wien 1978. [ΟΝΟΜΑ ΒΑΣΙΛΕΙΑΣ]

Rordorf, W.: "Liturgie et eschatologie", *Aug.* 18 (1978), p. 153-162.

Rossi, G. B. de: *Musaici Christiani e saggi dei pavimenti delle Chiese di Roma anteriori al secolo XV*, Roma 1899. [Musaici]

Rücker, A.: *Ritus Baptismi et Missae quem descripsit Theodorus Episcopus Mopsuestenus in Sermonibus Catecheticis* (Opuscula et Textus, Series Liturgica 2), Münster 1933. [Ritus]

Ruhbach, G.: "Die politische Theologie Eusebs von Caesarea", *Die Kirche angesichts der konstantinischen Wende*, ed. by G. Ruhbach (Wege der Forschung 306), Darmstadt 1976, p. 236-258.

Ruysschaert, J.: "L'inscription absidale primitive de S.-Pierre. Texte et Contextes", *Rendiconti della pontificia accademia Romana di archeologia.* 3rd series 40 (1967-1968), p. 171-190. [L'inscription absidale]

Sansoni, R.: *I sarcofagi paleocristiani a porte di città* (Studi di antichità cristiane 4), Bologna 1969. [Sarc. a porte di città]

Savon, H.: "Zacharie, 6, 12, et les justifications patristiques de la prière vers l'orient", *Aug.* 20 (1980), p. 319-333.

Saxer, V.: "Figura corporis et sanguinis Domini. Une formule eucharistique des premiers siècles chez Tertullian, Hippolyte et Ambroise", *RivAC.* 47 (1971), p. 65-89.

Schelkle, K. H.: "Auslegung als Symbolverständnis", *Theologische Quartalschrift* 132 (1952), p. 129-151.

Schendel, E.: *Herrschaft und Unterwerfung Christi. 1. Korinther 15.24-28 in Exegese und Theologie der Väter bis zum Ausgang des 4. Jahrhunderts* (Beiträge zur Geschichte der biblischen Exegese 12), Tübingen 1971.

Schiller, G.: *Ikonographie der christlichen Kunst*, 4 vols., Gütersloh 1966-80. [Ikonographie]

Schmitz, J.: "Zum Autor der Schrift 'De Sacramentis' ", *ZKTh.* 91 (1969), p. 59-69. [Zum Autor]

— *Gottesdienst im altchristlichen Mailand. Eine liturgiewissenschaftliche Untersuchung über Initiation und Messfeier während des Jahres zur Zeit des Bischofs Ambrosius (+ 397)* (Theoph. 25), Köln 1975. [Gottesdienst]

Schneemelcher, W.: "Das konstantinische Zeitalter. Kritisch-historische Bemerkungen zu einem modernen Schlagwort", *KΛHPONOMIA* 6 (1974), p. 37-59.

Schneider, T.: "Adler", *RAC.* 1, col. 87-94.

Schöllgen, G.: "Die Teilnahme der Christen am städtischen leben in vorkonstantinischer Zeit. Tertullians Zeugnis für Karthago", *RQ.* 77 (1982), p. 1-29. [Die Teilnahme]

Schönborn, C. von: *L'icône du Christ. Fondements théologiques élaborés entre le I^er et le II^e Concile de Nicée (325-787)* (Etudes de littérature et de théologie anciennes 24), 2nd ed., Fribourg 1976. [L'icône]

Schöne, W./Kollwitz, J./Campenhausen, H. F. von: *Das Gottesbild im Abendland* (Glaube und Forschung 15), 2nd ed., Witten 1959.

Schoenebeck, H.-U. von: *Der Mailänder Sarkophag und seine Nachfolge* (Studi di antichità cristiana 10), Città del Vaticano 1935. [Mailänder Sark]

Schubert, U.: "Frühchristliche Bildkunst—ein Instrument der kirchlichen Politik", *Kairos* 21 N.F. (1979), p. 181-195. [Bildkunst]

Schulz, H. J.: *Die byzantinische Liturgie. Von Werden ihrer Symbolgestalt* (Sophia 5), Freiburg 1964. [Byzantinische Liturgie]

— "Das frühchristlich-altkirchliche Eucharistiegebet: Überlieferungskontinuität und Glaubenszeugnis", *Internationale Kirchliche Zeitschrift* 70 (1980), p. 139-153. [Eucharistiegebet]

Schultze, B.: "Die Pneumatologie des Symbols von Konstantinopel als abschliessende Formulierung der Griechischen Theologie (381-1981)", *Orientalia cristiana periodica* 47 (1981), p. 5-54

Schumacher, W. N.: " 'Dominus legem dat' ", *RQ.* 54 (1959), p. 1-39. [Dominus legem dat]

— "Eine römische Apsiskomposition", *RQ.* 54 (1959), p. 137-202. [Römische Apsiskomposition]

— see Wilpert, J.

Schuster, I.: *Sant'Ambrogio vescovo di Milano. Note storiche*, Milano 1939. [Sant'Ambrogio]

Sedlmayr, H.: "Das Licht in seinen künstlerischen Manifestationen", *Studium generale* 13 (1960), p. 313-324. [Licht]

Seibel, W.: *Fleisch und Geist beim heiligen Ambrosius*, München 1958. [Fleisch und Geist]

Şesan, V.: *Die Religionspolitik der christlich-röm. Kaiser von Konstantin d. Gr. bis Theodosius d. Gr. (313-380)* Kirche und Staat im römisch-byzantinischen Reiche seit Konstantin dem Grossen und bis zum Falle Konstantinopels, Bind 1), Leipzig (1911) reprint 1972.

Shepherd, M. H.: "The Formation and Influence of the Antiochene Liturgy", *DOP.* 15 (1961), p. 26-44. [Formation]

— "The earliest Christian Basilika", *Yearbook of Liturgical Studies* 7 (1966), p. 73-86.

— "Liturgical Expressions of the Constantinian Triumph", *DOP.* 21 (1967), p. 57-78. [Liturgical Expressions]

Sieger, J. D.: "*Pictor Ignotus": The Early Christian Pictorial Theme of "Christ and the Church" and its Roots in Patristic Exegesis of Scripture*, University Microfilms International, Michigan 1983. [Pictor Ignotus]

Sieper, J.: "Das Mysterium des Kreuzes in der Typologie der alten Kirche (I-II)", *Kyrios. Vierteljahresschrift für Kirchen- und Geistesgeschichte Osteuropas* 9 (1969), p. 1-30 and 60-82. [Myst. des Kreuzes]

Sinding-Larsen, S.: *Iconography and Ritual. A Study of Analytical Perspectives*, Oslo 1984. [Iconography]

Smith, M. T.: "The Lateran *Fastigium*. A gift of Constantine the Great", *RivAc*. 46 (1970), p. 149-175. [Fastigium]

Sotomayor, M.: "Über die Herkunft der 'Traditio legis' ", *RQ*. 56 (1961), p. 215-230. [Herkunft der 'Traditio legis']

Srawley, J. H.: "The De Sacramentis a Work of St. Ambrose", *JThS*. 44 (1943), p. 199-200.

Stephenson, A. A.: "St. Cyril of Jerusalem and the Alexandrian Heritage", *TS*. 15 (1954), p. 573-593. [Alexandrian Heritage]

— "St. Cyril of Jerusalem and the Alexandrian Christian Gnosis", *Studia Patristica* 1 (TU. 63), Berlin 1957, p. 142-156.

— "General Introduction", *The Works of Saint Cyril of Jerusalem*, vol. 1 (The Fathers of the Church 61), Washington 1968, p. 1-65. [General Introduction]

— "Introduction", *The Works of Saint Cyril of Jerusalem*, vol. 2 (The Fathers of the Church 64), Washington 1970, p. 143-151. [Introduction]

— "S. Cyril of Jerusalem's Trinitarian Theology", *Studia Patristica* 11 (TU. 108), Berlin 1972, p. 234-241. [Trinitarian Theology]

Stern, H.: "Les mosaïques de l'église de Sainte-Constance à Rome", *DOP*. 12 (1958), p. 159-218. [Les mosaïques]

Stettler, M.: "Zur Rekonstruktion von S. Costanza", *MDAI.R*. 58 (1943), p. 76-86. [Zur Rekonstruktion]

Stommel, E.: "Σημεῖον ἐκπετάσεως (Didache 16.6)", *RQ*. 48 (1953), p. 21-42. [Σημεῖον]

— *Beiträge zur Ikonographie der konstantinischen Sarkophagplastik* (Theoph. 10), Bonn 1954. [Beiträge]

Strathmann, H./Klauser, T.: "Aberkios", *RAC*. 1, col. 12-17.

Studer, B.: *Zur Theophanie-Exegese Augustins. Untersuchung zu einem Ambrosius-Zitat in der Schrift De videndo Deo (ep. 147)* (Studia Anselmiana 59), Roma 1971. [Theophanie-Exegese]

Stuiber, A.: *Refrigerium interim. Die Vorstellungen vom Zwischenzustand und die frühchristliche Grabeskunst* (Theoph. 11), Bonn 1957.

— see Altaner, B.

Styger, P.: "Neue Untersuchungen über die altchristlichen Petrusdarstellungen", *RQ*. 27 (1913), p. 17-74. [Neue Untersuchungen]

Sühling, F.: *Die Taube als religiöses Symbol im christlichen Altertum* (RQ. Supplementheft 24), Freiburg 1930. [Taube als rel. Symbol]

Süssenbach, U.: *Christuskult und kaiserliche Baupolitik bei Konstantin. Die Anfänge der christlichen Verknüpfung kaiserlicher Repräsentation am Beispiel der Kirchenstiftungen Konstantins—Grundlagen* (Abhandlungen zur Kunst- Musik- und Literaturwissenschaft 241), Bonn 1977. [Christuskult]

Sullivan, F. A.: "Some Reactions to Devreesse's New Study of Theodore of Mopsuestia", *TS*. 12 (1951), p. 179-207.

— *The Christology of Theodore of Mopsuestia* (Analecta Gregoriana 82), Roma 1956. [Christology]

Swaans, W. J.: "À propos des 'Catéchèses Mystagogiques' attribuées à S. Cyrille de Jerusalem", *Muséon* 55 (1942), p. 1-43. [A propos]

Sybel, L. von: "Mosaiken römischer Apsiden", *ZKG*. 37 (1918), p. 273-318.

Szabó, F.: *Le Christ Créateur chez saint Ambroise* (Studia Ephemerides 'Augustinianum' 2), Roma 1968. [Christ Créateur]

Szydzik, S.—E.: "Die geistigen Ursprünge der Imago-Dei-Lehre bei Ambrosius von Mailand", *ThGl*. 53 (1963), p. 161-176.

Taft, R. F.: "Some Notes on the Bema in the East and West Syrian Traditions", *OrChrP*. 34 (1968), p. 326-259. [Some Notes]

Talley, T. J.: "The Eucharistic Prayer of the Ancient Church According to Recent Research: Results and Reflections", *StLi*. 11 (1976), p. 138-158.

Tarby, A.: *La prière eucharistique de l'Église de Jerusalem* (Théologie historique 17), Paris 1972. [Prière eucharistique]

Taylor, T. F.: "Sursum Corda: No Dialogue", *Studia Patristica* 13 (TU. 116), Berlin 1975, p. 422-424.

Telfer, W.: *Cyrill of Jerusalem and Nemesius of Emesa*, London 1955.
Testini, P.: "Il sarcofago del Tuscolo ora in S. Maria in Vivario a Frascati", *RiAC.* 52 (1976), p. 65-108. [Sarc. del Tuscolo]
Tetz, M.: "Athanasius von Alexandria", *TRE.* 4, col. 333-349. [Athanasius]
Thérel, M.-L.: *Les symboles de l' "Ecclesia" dans la création iconographique de l'art chrétien du III^e au VI^e siècle*, Roma 1973.
Thompson, L.: "Cult and Eschatology in the Apocalypse of John", *JR.* 49 (1969), p. 330-350. [Cult and Eschatology]
Thraede, K.: "Eschatologie", *RAC.* 6, p. 559-564.
Torp, H.: "Monumentum Resurrectionis. Studio sulla forma e sul significato del candelabro per il cero pasquale in Santa Maria della Pietà di Cori", *Institutum Romanum Norvegiae, Acta* 1 (1962), p. 79-112. [Monumentum resurrectionis]
— *Mosaikkene i St. Georg-rotunden i Thessaloniki. Et hovedverk i tidlig-bysantinsk kunst* (Kunst og Kulturs serie), Oslo 1963. [St. Georg-rotunden]
— *Les mosaïques de la Rotunde du palais impérial de Thessalonique*, unpubl. manuscript.
Touton, G.: "La méthode catéchétique de St Cyrille de Jérusalem comparée à celles de St Augustin et de Théodore de Mopsueste", *Proche-Orient Chrétien* 1 (1951), p. 265-285.
Treitinger, O.: *Die oströmische Kaiser- und Reichsidee nach ihrer Gestaltung im höfischen Zeremoniell. Vom Oströmischen Staats- und Reichsgedanken*, 2nd ed., Darmstadt 1956. [Kaiser- und Reichsidee]
Trisoglio, F.: "Eusebio di Cesarea e l'escatologia", *Aug.* 18 (1978), p. 173-182.
Ufford, V. Q. van: "Bemerkungen über den eschatologischen Sinn der Hetoimasia in der frühchristlichen Kunst", *Bulletin Antieke Beschaving* 46 (1971), p. 193-207. [Bemerkungen]
Underwood, P. A.: "The Fountain of Life in Manuscripts of the Gospels", *DOP.* 5, (1950), p. 41-138.
Unnik, W. C. von: "παρρησία in the 'Catechetical Homilies' of Theodore of Mopsuestia", *Mélanges offerts à Mademoiselle Christine Mohrmann*, ed. by L. J. Engels, Utrecht 1963, p. 12-22.
Vanmaele, B.: *L'Eglise pudentienne de Rome (Santa Pudenziana). Contribution à l'histoire de ce monument insigne de la Rome Chrétienne ancienne du II^e au XX^e siècle* (Bibliotheca Analectorum Praemonstratensium 6), Louvain 1965. [L'Eglise pudentienne]
Visser, A. J.: "A Bird's-Eye View of Ancient Christian Eschatology", *Numen* 14 (1967), p. 4-22.
Vogt. J.: "Berichte über Kreuzeserscheinungen aus dem 4. Jahrhundert n. Chr.", *Annuaire de l'institut de philologie et d'histoire orientales et slaves* 9 (1949), p. 593-606. [Berichte]
Völker, W.: "Palästina: I. Altkirchlich", *RGG.*² 4, col. 870-871.
Volbach, W. F.: *Frühchristliche Kunst. Die Kunst der Spätantike in West- und Ostrom*, München 1958. [Frühchr. Kunst]
— *Elfenbeinarbeiten der Spätantike und des frühen Mittelalters* (Kataloge vor- und frühgeschichtlicher Altertümer 7), 3rd rev. ed., Mainz 1976. [Elfenbeinarbeiten]
Vosté, J. M.: "La chronologie de l'activité littéraire de Théodore de Mopsueste", *Revue biblique* 34 (1925), p. 54-81.
Voulgarakis, E. A.: *The Catecheses of Cyril of Jerusalem. A Missionary Approach*, Thessalonika 1977. Summary in English p. 539-558.
Vries, W. de: "Der 'Nestorianismus' Theodors von Mopsuestia in seiner Sakramentenlehre", *OrChrP.* 7 (1941), p. 91-148. [Nestorianismus]
— "Das eschatologische Heil bei Theodor von Mopsuestia", *OrChrP.* 24 (1958), p. 309-338. [Das eschatologische Heil]
— "Die Beziehungen zwischen Ost und West in der Kirche zur Zeit des ersten Konzils von Konstantinopel (381)", *Ostkirchliche Studien* 22 (1973), p. 30-43.
Waetzold, S.: *Die Kopien des XVII. Jahrhunderts nach Mosaiken und Wandmalereien in Rom* (Bibliotheca Hertziana. Römische Forschungen 18), Wien 1964. [Kopien]
Wainwright, G.: "The Baptismal Eucharist before Nicaea. An essay in liturgical history", *StLi.* 4 (1965), p. 9-36.

— *Eucharist and Eschatology*, London 1971.

Wanscher, O.: *Sella curulis. The Folding Stool. An Ancient Symbol of Dignity*, Copenhagen 1980. [Sella curulis]

Weigand, E.: "Der Monogrammnimbus auf der Tür von S. Sabina in Rom", *ByZ*. 30 (1929/30), p. 587-595. [Monogrammnimbus]

Weitzmann, K. ed.: *Age of Spirituality. Late Antique and Early Christian Art, Third to Seventh Century*. Catalogue of the exhibition at The Metropolitan Museum of Art, November 19, 1977, through February 12, 1978, New York 1979. [Age of Spirituality]

Werner, M.: *Die Entstehung des christlichen Dogmas problemgeschichtlich dargestellt*, 2nd ed., Bern 1953.

Wickhoff, F.: "Das Apsismosaik in der Basilica des H. Felix zu Nola. Versuch einer Restauration", *RQ.* 3 (1889), p. 158-176. [Das Apsismosaik]

Wilbrand, W.: "Ambrosius", *RAC.* 1, p. 365-373.

Wilkinson, J.: *Egeria's Travels. Newly translated, with supporting documents and notes*, London 1971. [Egeria's Travels]

Williams, G. H.: "Christology and Church—State Relations in the Fourth Century", *ChH.* 20 part III (1951), p. 3-33, and 20 part IV (1951), p. 3-26.

Wilpert, J.: *Die römischen Mosaiken und Malereien der kirchlichen Bauten vom IV. bis XIII. Jahrhundert*, 4 vols., 2nd ed. Freiburg im Breisgau 1917. [Mosaiken und Malereien]

Wilpert, J./Schumacher, W. N.: *Die römischen Mosaiken der kirchlichen Bauten vom IV.-XIII. Jahrhundert*, Freiburg im Breisgau 1916/1976. [Die römischen Mosaiken]

Wilpert, P.: "Auge", *RAC.* 1 col. 957-969. [Auge]

Wissowa, G.: *Religion und Kultus der Römer* (Handbuch der klassischen Altertumswissenschaft 5), München 1902. [Religion und Kultus]

— "Caelus", *Paulys Realencyclopädie der classischen Altertumswissenschaft* 3, col. 1276-1277.

Wolfson, H. A.: "Philosophical implications of the theology of Cyril of Jerusalem", *DOP.* 11 (1957), p. 3-19.

Woollcombe, K. J.: "Le sens de 'type' chez les pères", *Supplement de la vie spirituelle* 5 (1951), p. 84-100. [Le sens de 'type']

Yarbrough, A.: "Christianization in the Fourth Century: The Example of Roman Women", *ChH.* 45 (1976), p. 149-165.

Yarnold, E.: "Baptism and the Pagan Mysteries in the Fourth Century", *HeyJ.* 13 (1972), p. 247-267. [Baptism]

— "The Ceremonies of Initiation in the *De Sacramentis* and *De Mysteriis* of S. Ambrose", *Studia Patristica* 10 (TU. 107), Berlin 1970, p. 453-463.

— "'Ideo et romae fideles dicuntur qui baptizati sunt': A Note on De Sacramentis 1.1", *JThS.* 24 (1973), p. 202-207.

— "The Authorship of the Mystagogic Catecheses attributed to Cyril of Jerusalem", *HeyJ.* 19 (1978), p. 143-161. [Authorship]

— "Cyrillus von Jerusalem", *TRE.* 8, p. 261-266.

— "Did St. Ambrose know the Mystagogic Catecheses of St. Cyril of Jerusalem", *Studia Patristica* 12 (TU. 115), Berlin 1975, p. 184-189. [Did St. Ambrose know]

INDEX

PLATES

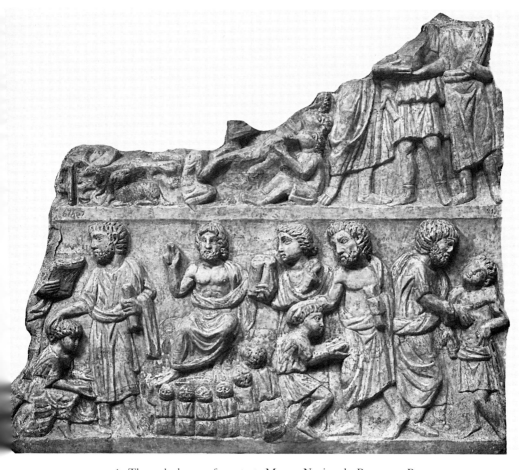

1. The polychrome fragment, Museo Nazionale Romano, Rome

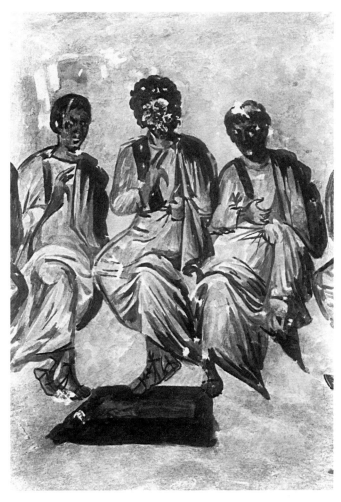

2a. Water colour painting (detail), Coemeterium Majus, Rome

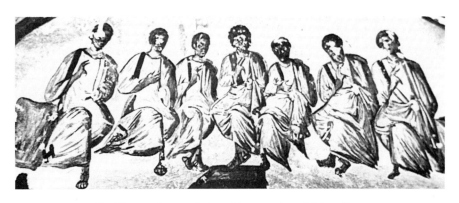

2b. Water colour painting, Coemeterium Majus, Rome

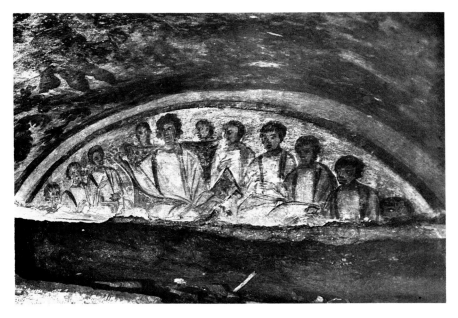

3. Water colour painting, The Domitilla catacomb, Rome

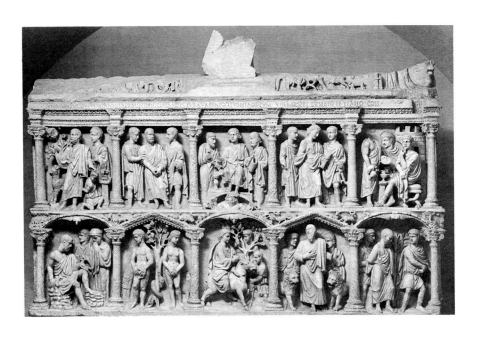

4. The Junius Bassus sarcophagus, S. Pietro in Vaticano, Rome

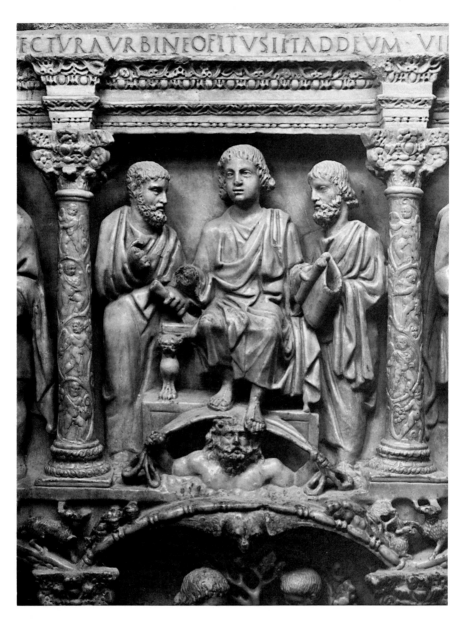

5. The Junius Bassus sarcophagus (detail), S. Pietro in Vaticano, Rome

6. Frieze on the Arch of Constantine (detail: Largitio), Rome

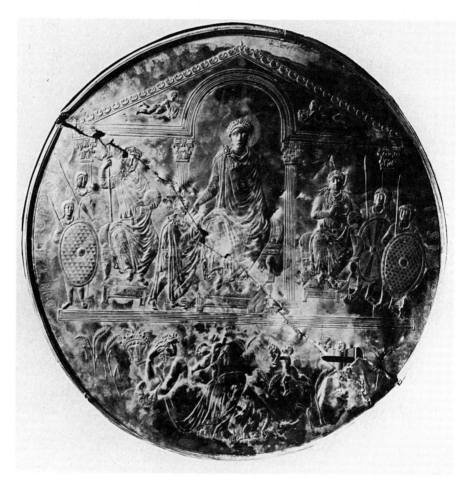

7. The Theodosian missorium, Real Academia de la Historia, Madrid

8. Niche mosaic, S. Costanza, Rome

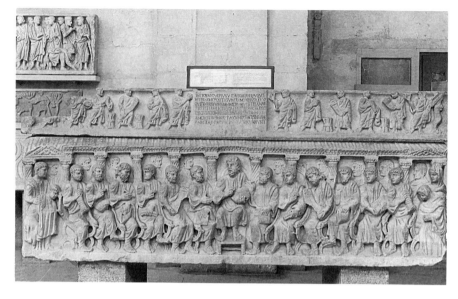

9. Concordius' 11-niche sarcophagus, Musée d'art chrétien, Arles

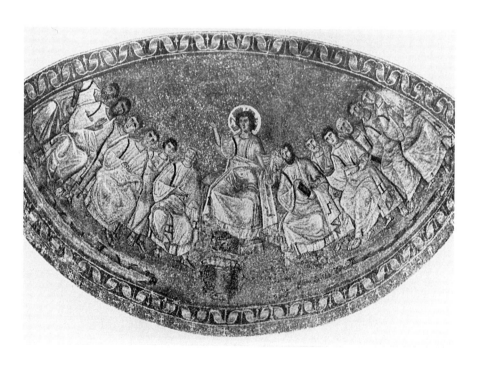

10. Niche mosaic, S. Aquilino, Milan

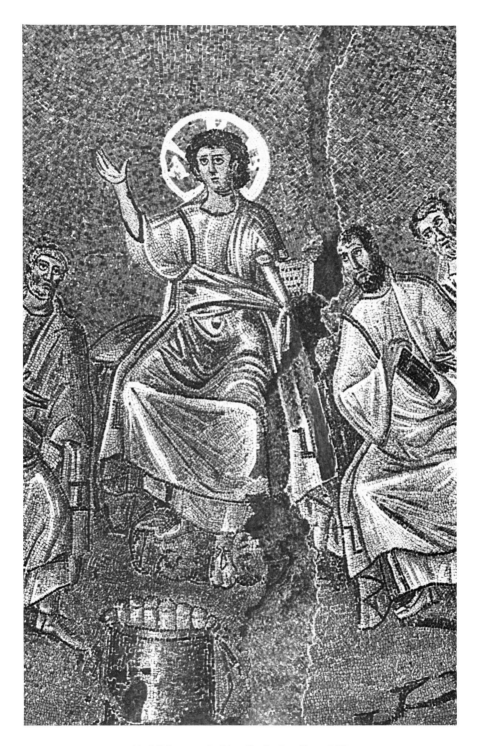

11. Niche mosaic (detail), S. Aquilino, Milan

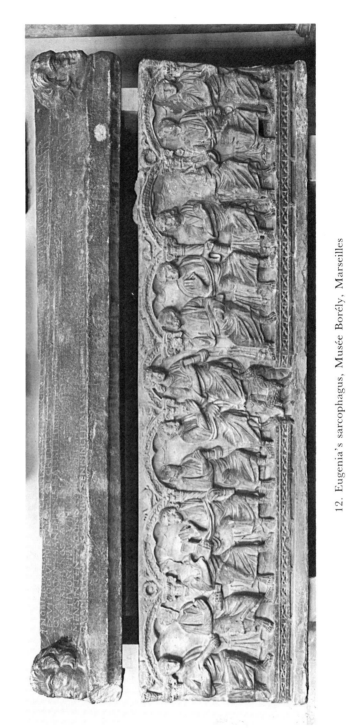

12. Eugenia's sarcophagus, Musée Borély, Marseilles

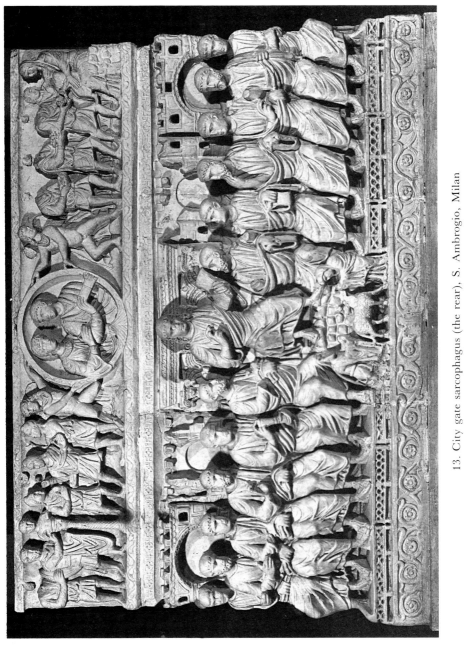

13. City gate sarcophagus (the rear), S. Ambrogio, Milan

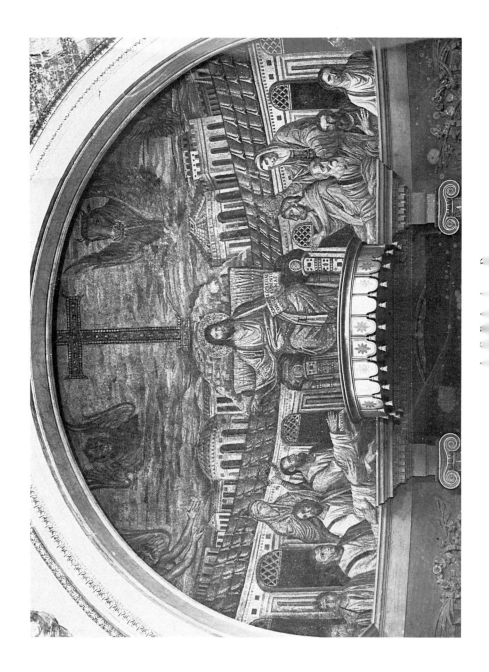

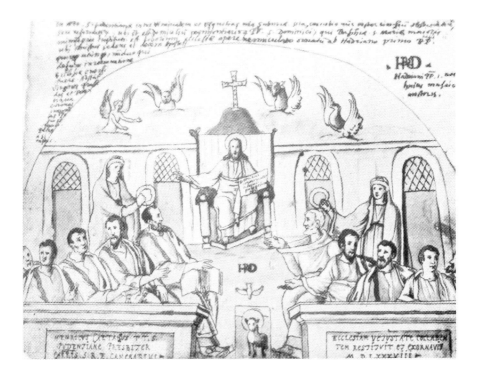

15. Ciacconio's sketch of S. Pudenziana

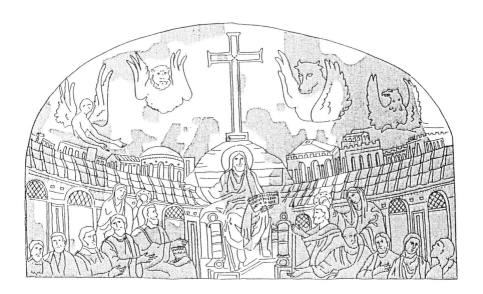

16. Matthiae's restoration drawing of S. Pudenziana

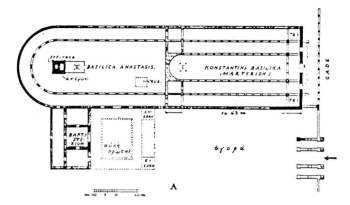

17a. Dyggve's reconstruction of the Holy Sepulchre complex in Jerusalem

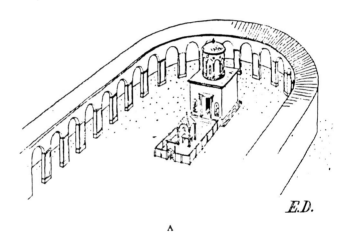

17b. Dyggve's reconstruction of basilica Anastasis

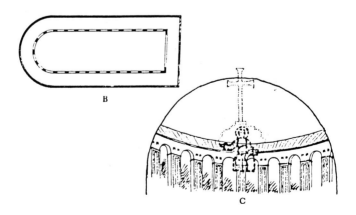

17c. Dyggve's sketch of S. Pudenziana

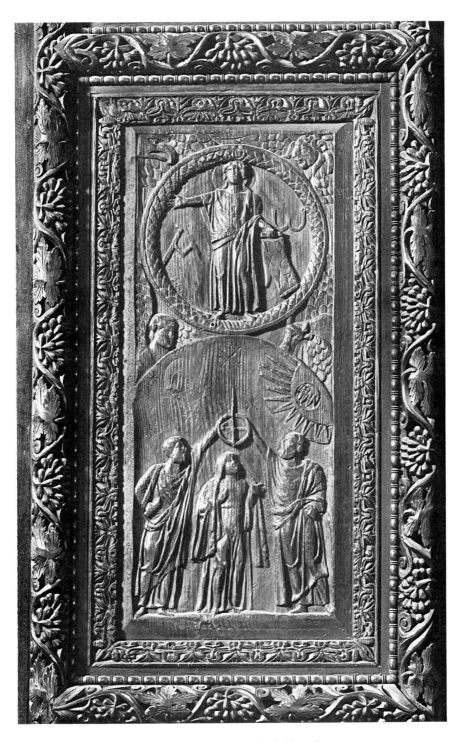

18. Panel in wooden door, S. Sabina, Rome

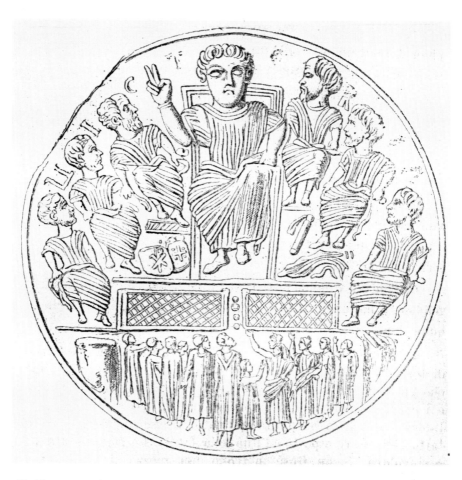

19. Terracotta plaque from the Barberini Collection, Dumbarton Oaks Collection, Washington

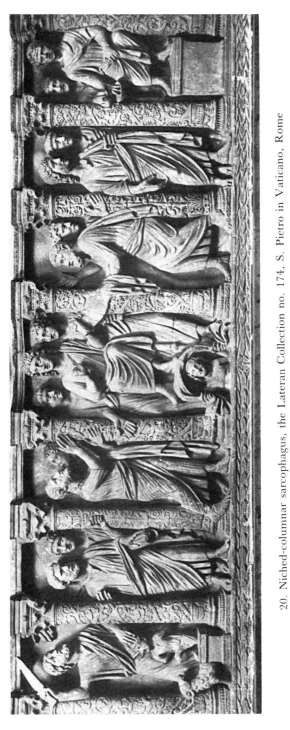

20. Niched-columnar sarcophagus, the Lateran Collection no. 174, S. Pietro in Vaticano, Rome

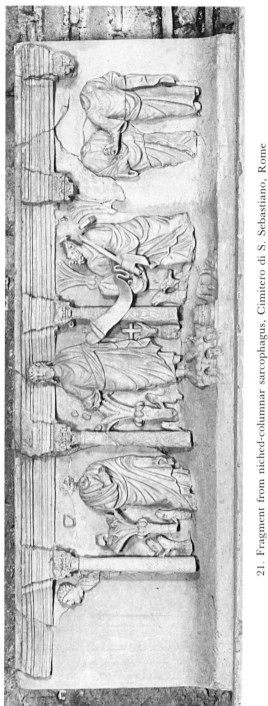

21. Fragment from niched-columnar sarcophagus, Cimitero di S. Sebastiano, Rome

22. Columnar sarcophagus, S. Pietro in Vaticano, Rome

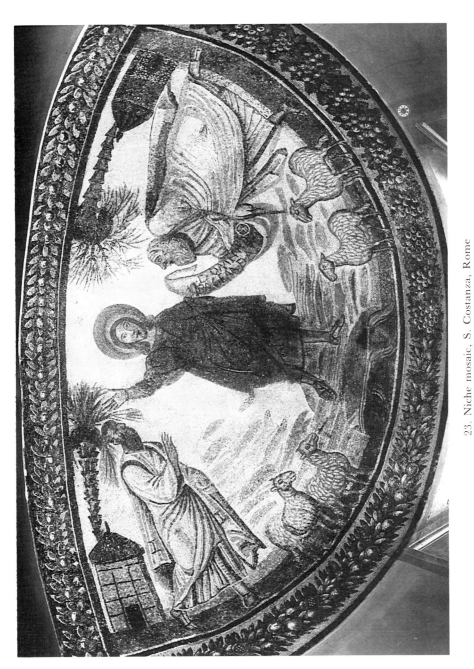

23. Niche mosaic, S. Costanza, Rome

24. A catacomb burial slab from the Priscilla catacomb, Museo Civico, Anagni

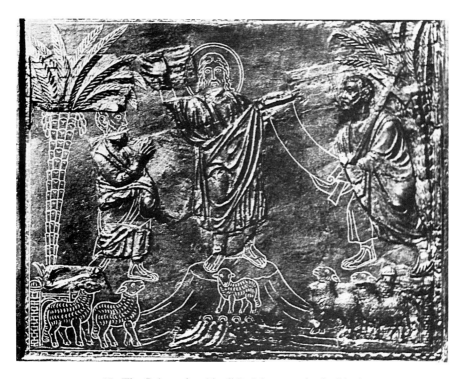

25. The Pola casket (the lid), Museo archeol., Venice

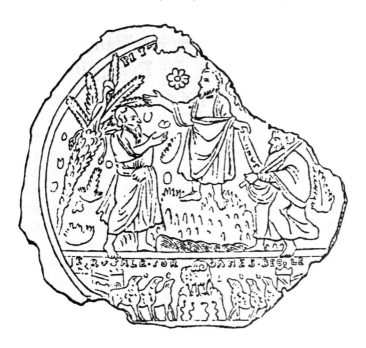

26. Gilded glass, Museo Sacro Vaticano, Rome

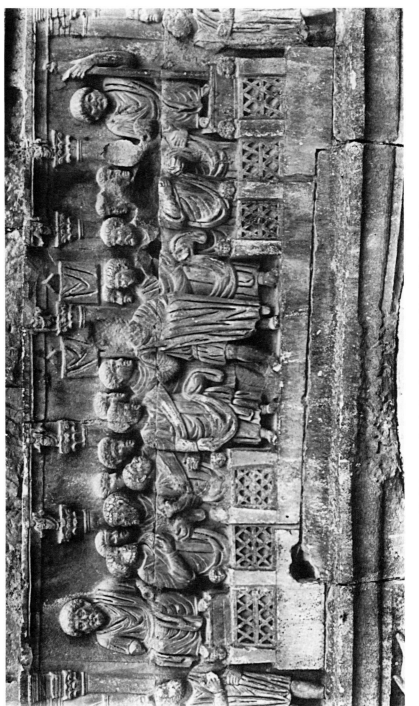

27. Frieze on the Arch of Constantine (detail: Oratio), Rome

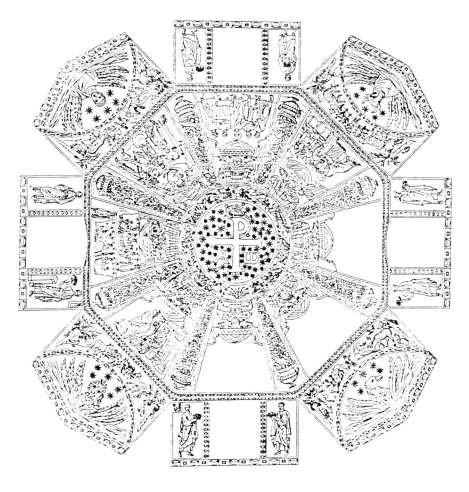

28. Vault mosaic, S. Giovanni in Fonte, Naples

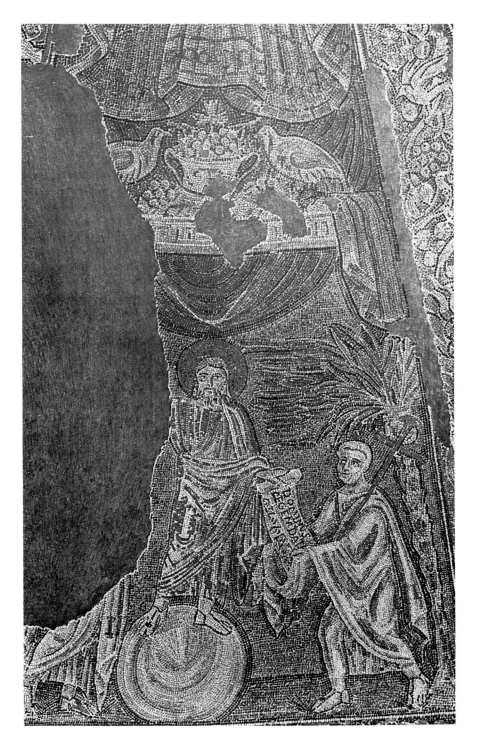

29. Vault mosaic (detail), S. Giovanni in Fonte, Naples

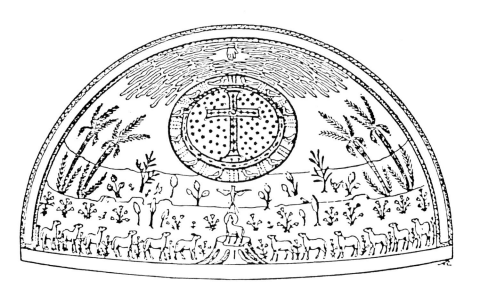

30. Apse mosaic, Basilica Apostolorum, Cimitile. Reconstruction drawing by Wickhoff

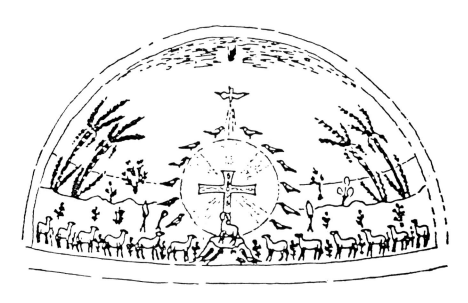

31. Apse mosaic, Basilica Apostolorum, Cimitile. Reconstruction drawing by Bandmann

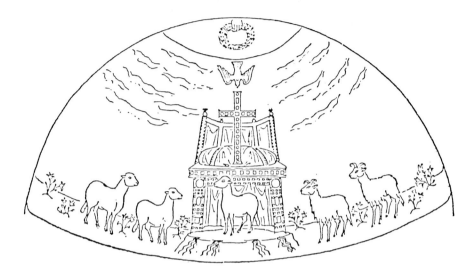

32. Apse mosaic, Basilica, Fundi. Reconstruction drawing by Ihm

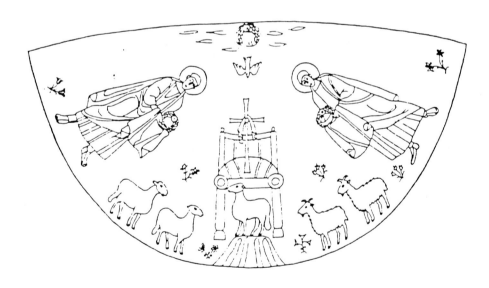

33. Apse mosaic, Basilica, Fundi. Reconstruction drawing by Engemann

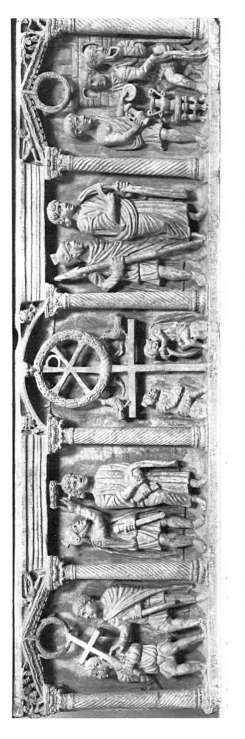

34. Niched columnar sarcophagus, the Lateran Collection no. 171, Museo Pio Cristiano, Rome

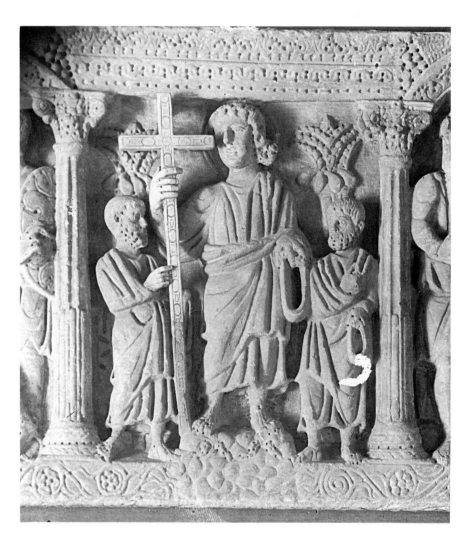

35. Fragment from niched columnar sarcophagus (detail), the Lateran Collection no. 106, Museo Pio Cristiano, Rome

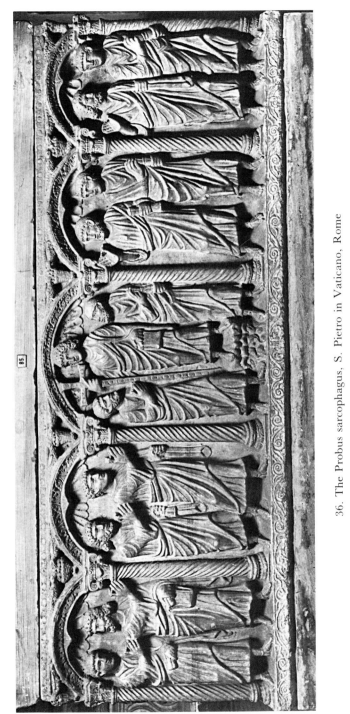

36. The Probus sarcophagus, S. Pietro in Vaticano, Rome

37. The Prince sarcophagus from Sarigüzel (the narrow side), Archeological Museum, Istanbul

38. Ivory diptych (detail), Tesoro del Duomo, Milan

39. Strigil sarcophagus from Tusculum (detail),
S. Maria in Vivario, Frascati

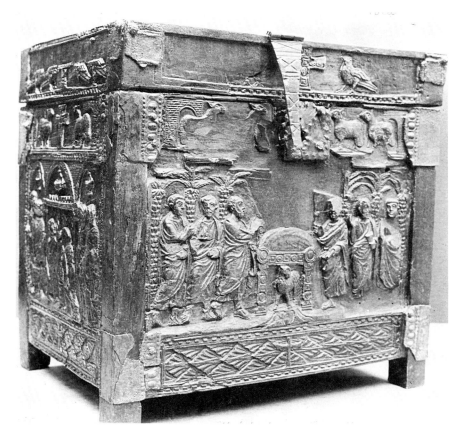

40. The Pola casket (the front), Museo archeol., Venice

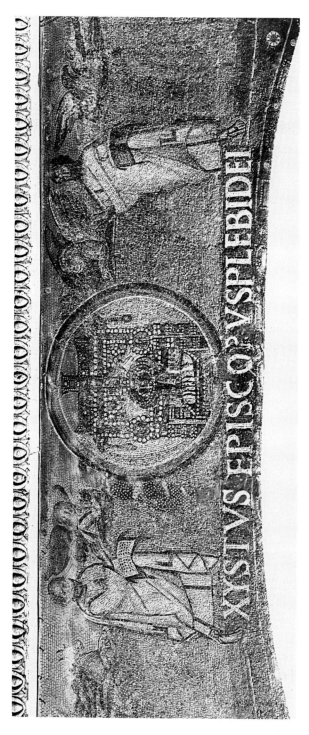

41. Triumphal arch (detail), S. Maria Maggiore, Rome

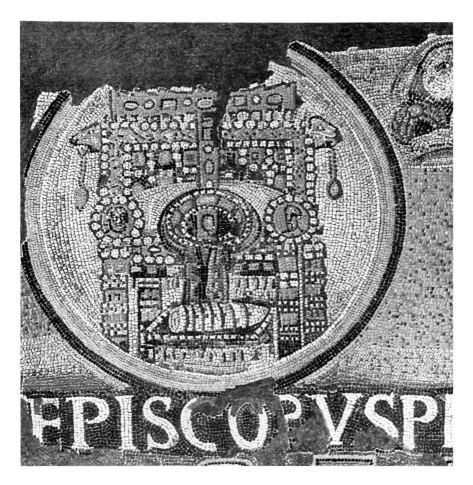

42. Triumphal arch (detail), S. Maria Maggiore, Rome

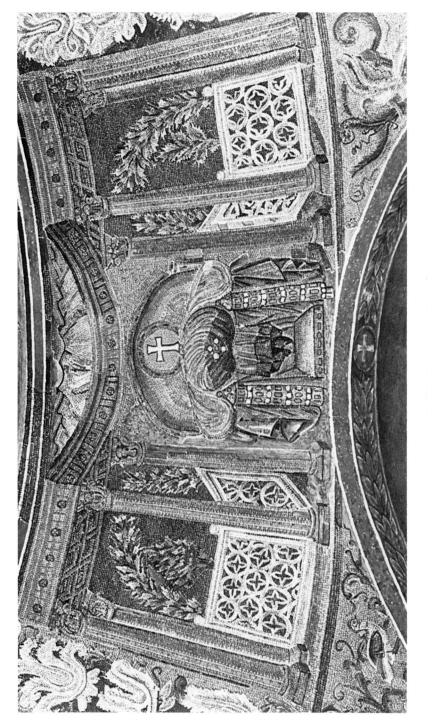

43. Vault mosaic (detail), The Baptistery of the Orthodox, Ravenna

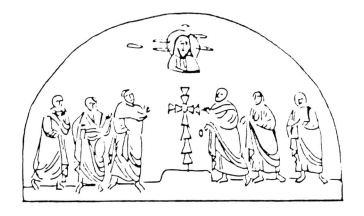

44. Apse mosaic, S. Giovanni in Laterano, Rome. Reconstruction drawing by Christe

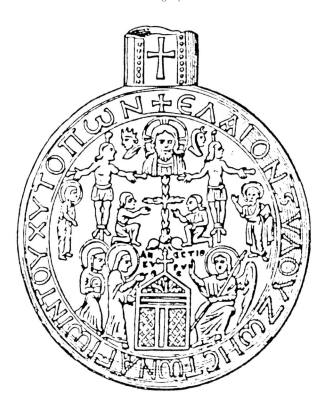

45. Monza ampulla no. 10, Tesoro del Duomo, Monza

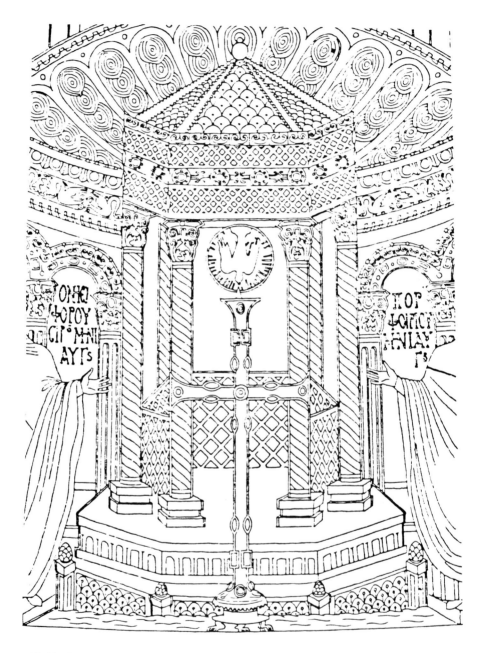

46. Vault mosaic (detail), S. George rotunda, Salonica. Reconstruction drawing by Kirk

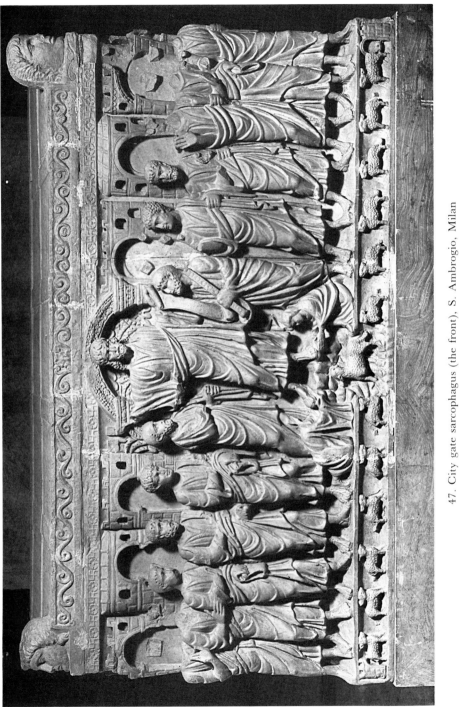

47. City gate sarcophagus (the front), S. Ambrogio, Milan

DATE DUE

HIGHSMITH #LO-45220